ART RESEARCH METHODS AND RESOURCES

A GUIDE TO FINDING ART INFORMATION

Second Edition

Revised and Enlarged

Lois Swan Jones

North Texas State University

Foreword by
Caroline H. Backlund

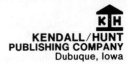
KENDALL/HUNT PUBLISHING COMPANY
Dubuque, Iowa

Back Cover Design by **Robert Preston Jones.**

Printed in the United States of America

B 403237 01

Dedication

This Second Edition is dedicated to my friends and colleagues of ARLIS/NA (Art Libraries Society/North America).

Photo Credits

Example 3, *On the Europe Bridge,* Kimbell Art Museum, Fort Worth, Texas. Back cover: Albrecht Dürer's *The Knight, Death and the Devil,* Kimbell Art Museum, Fort Worth, Texas and detail of Eadweard Muybridge's *Horse Galloping,* Courtesy Amon Carter Museum, Fort Worth. Other photographs by author: Leonardo da Vinci's *Mona Lisa,* Musée National du Louvre, Paris; Notre Dame, Paris; Rogier van der Weyden, *Annunciation,* Musée National du Louvre, Paris; Solomon R. Guggenheim Museum, New York City.

Contents

List of Examples

Foreword

When the first edition of Lois Swan Jones' *Art Research Methods and Resources: A Guide to Finding Art Information* was published in 1978, it was recognized immediately for its problem-solving approach to basic art research. Written to help a wide range of persons involved in the arts—students, professors, librarians, curators, collectors, artists, architects, designers, and so on—the author took the reader step-by-step through a series of thoroughly documented fact-finding exercises. The first of its three sections, "Art Research Methods," provided valuable information for the beginning researcher on such topics as "Compiling a Working Bibliography," "Developing Chronologies," "Understanding Art Museum Catalogues," "How to Compile Catalogue Entries." The second part of the book, a guide to "Art Research Resources" contained a well-selected list of basic reference materials with full annotations. Part three, "Obtaining Reference Material," dealt with interlibrary loan service and described major art research centers and libraries in the United States and Europe.

Recognizing the multilingual aspect of much of the art literature, Jones also included three dictionaries—French-English, German-English and Italian-English—of frequently used words, as well as a multilingual glossary of French, English, German, Italian and Spanish art terms. The breadth of information in the book was widely praised, particularly its inclusion of sources in allied disciplines such as history, education and the sciences, which are closely related to art research but often are omitted in guides to the literature.

It is not surprising, therefore, that in the five years since its publication, *Art Research Methods and Resources* has been widely used as a textbook in art history and art bibliographic instruction courses and as a basic reference work in the art and general humanities sections of many libraries. No other book has provided so effectively the valuable combination of a carefully selected list of art information resources with the practical this-is-how-you-go-about-it approach to problem solving.

What characterizes the literature on the arts and why does its study frequently present such difficulties? E. Louise Lucas, distinguished former librarian at Harvard's Fogg Museum library and author of *Art Books: A Basic Bibliography on the Fine Arts* (1968) described it this way:

"The literature of art is so amorphous and far-reaching as to defy exact boundaries. It includes the history of nations, for it is, itself, such a history. It is a review of the philosophers' aesthetics; it is a record of problems and solutions found by technicians in many fields from architecture, design, graphics, sculpture, and all the so-called minor arts; and it is a compilation of biographies and autobiographies of hundreds of artists. Thomas Carlyle's statement that 'history is the essence of innumerable biographies' is indeed true in art literature. Researchers in this field need all their accumulated backgrounds in literature, science, mythology, accepted and apocryphal books of the Bible, folklore and fable, for all enter into the field of the art historian. The literature of art is not only the literature of Art, with a capital A, but also, since art is one of the broadest of the humanities, it is dependent on and interrelated to the literature of the other humanities and sciences."[1]

The art researcher must deal with an enormous range of historical literature. Many of the writings of the past remain valid, or at least partially valid, reflecting as they often do cultural perceptions and attitudes of their time and putting into context the art in the era in which it was created. Furthermore, the subject of art itself has also continued to expand. For instance, archeological discoveries have revealed new cultures, ethnic values have overlapped into art history, urban design and planning have become an important part of architectural history, the arts and crafts movement has developed into a major study area—the examples are endless. As Trevor Fawcett, the English librarian, University of East Anglia, has written, "The potential range of art history is now vast, matching art itself. A Bronze Age sword, an eighteenth-century firework display, the structure of a Bedouin tent, a press photograph, the styling of motorcycles—are as admissible for study as a Rembrandt etching or the cathedral at Chartres."[2]

Words and pictures traditionally have gone, of course, hand in hand with the study of art. With today's rapidly developing pictorial techniques and growing resources, the image—whether in the form of a print, photograph, poster, slide, microform, videodisc, motion picture—plays an increasingly essential role. The

researcher has the potential of having thousands and thousands of pictorial reproductions to study. And to add further to the complexity of the research process, the new technology which makes available computerized indexes, online databases, and nationwide information networks provides sources of information at a rate faster than can readily be absorbed. More than ever the student and scholar need assistance in learning research techniques and in being informed of the important new reference tools.

Recognizing this need, Lois Jones has brought out an expanded and updated second edition of *Art Research Methods and Resources.* Approximately one-half of the book is completely new and the remaining portion has been considerably revised. In the intervening five years between the two editions, she has talked extensively with students, librarians and researchers and taken careful note of their recommendations. She has traveled in this country and Europe visiting libraries and visual resource collections, learning about their holdings and studying innovative and computerized techniques for gathering information and its retrieval. Jones has examined the new online catalogs and bibliographic databases which provide information in the arts and related disciplines and has included in her book advice on how best to utilize the new technology.

The second edition is further strengthened by an expanded discussion of basic procedures in art research methodology. The beginning chapter on "Before Research Begins" which includes sections on "The Purpose of the Research," "Formulating the Problem," and "Compiling Resource Materials" is essential reading for the beginning student and offers an excellent reminder for the more experienced researcher.

The chapter on "Research on Individual Works of Art" is basically new with informative sections on "The Opinion of the Artist and of Critics," "Resources Based on Bartsch's Organization of Prints," and "Changes in a Subject's Meaning." The discussion of "Influences on Art" is backed up by an exceptionally useful bibliography of sources covering such diverse topics as agriculture, geography, medicine, social history, status of the artist, technology, and theater history. This provides a good example of the kind of valuable, wide-ranged information included by Jones but seldom provided by other reference tools. To strengthen iconographic research, Jones offers St. Catherine of Alexandria as a sample topic, illustrating her life and its visual documentation with a wide range of religious and iconographic reference sources. There are new sections dealing with architectural research and special problems of researching different groups of persons such as little-known artists, contemporary artists, architects, Americans, fashion designers, collectors, and art critics. The reader will also find an expanded section on "Past Exhibitions" with subdivisions by countries and dates.

Jones effectively meets head on the need of the researcher to deal with an immensely varied number of sources. And utilizing her teaching skills, she carefully instructs the reader each step of the way and provides a basic grounding in this enormously complex subject field. As Jones has stated, "Doing research is hard work, but inexperienced researchers often make it even more difficult, because they do not know the hows, whys, and wheres of basic research: how to find pertinent data, why to use certain kinds of references, and where to locate the needed materials."[3] The users of this edition of *Research Methods and Resources* will find art research a good deal more stimulating and productive if they apply the recommendations offered in this guide and take advantage of its wealth of information.

Caroline H. Backlund
National Gallery of Art
Washington, D.C.

[1]*Encyclopedia of Library and Information Science,* edited by Allen Kent and Harold Lancour, N.Y., 1968, vol. 1, p. 621.
[2]Trevor Fawcett, "The Problem of the Artefact: Subject Limits of the Art Library," *Art Libraries Journal,* vol. 4, no. 4, Winter, 1979, p. 16.
[3]Lois Swan Jones, *Art Research Methods and Resources,* Dubuque, Iowa, 1978, p. xii.

Acknowledgments

The writing of this book owes a great deal to numerous people. Although it is impossible to list all of those who were of assistance along the way, I would like to make special mention of the following friends and colleagues who have read sections of the manuscript from various points of view and who have offered valuable suggestions. Deeply appreciated are the comments and observations of my colleagues on the art faculty of North Texas State University, especially the remarks of Larry A. Gleeson, who suggested and encouraged the writing of this guide. Of inestimable value were the comments on the organization and the writing of the manuscript by Ronald Williams, professor emeritus of North Texas State University, and Dolores C. Akins, Chairperson of the Communications Department, Northwest Campus, Tarrant County Junior College.

My sincerest thanks goes to the following scholars for giving of their time and special linguistic knowledge: Professors Arthur J. Gionet and Thomas S. Harllee, North Texas State University; Professor Harold V. Allen, Hendrix College; and Magdalene L. Dale, author of the Dale and Dale French textbook series published by D. C. Heath and Company.

Greatly valued are the encouragement and suggestions from fellow members of ARLIS/NA (Art Libraries Society of North America), especially William C. Bunce, Chief Librarian, Kohler Art Library, University of Wisconsin; Caroline H. Backlund, Reference Librarian, National Gallery of Art Library, Washington, D.C.; and Judith A. Hoffberg, editor of the *ARLIS/NA Newsletter*.

Research for the book was pursued not only in Europe but in the American cities of Chicago, Los Angeles, New York City, and Washington, D.C. Even so, a great deal of the research was done in the Dallas-Denton-Fort Worth metroplex and my sincerest thanks go to the librarians of the Kimbell Art Museum, The Amon Carter Museum, the Dallas Public Library, and the Dallas Museum of Fine Arts. In addition, a special acknowledgment must be made to the wonderful staff of the North Texas State University Library and especially to Johnnye Louise Cope and Charles Elliott Perry.

In conclusion, I wish to thank Jean Ross for typing the manuscript, Betsy Adams Gleeson for reading it, plus my family for their patience and understanding and to single out my son, Jeffrey Carl Jones, for his cheerful cooperation as my library research assistant.

Second Edition

The revision and expansion of this book was made possible by the assistance of numerous people. The research was conducted at the following institutions with special cooperation from these librarians: North Texas State University—Johnnye Louise Cope, Dean Covington, and Becky Gomez; Dallas Public Library—Karl Perkins and William Rochester Haddaway; Amon Carter Museum, Milan R. Hughston; Kimbell Art Museum, Erika Esau; National Gallery of Art, Caroline H. Backlund; Cleveland Museum of Art—Jack Perry Brown and Georgina Gy Toth; Ohio State University, Susan B. Wyngaard; Institute of Fine Arts, Evelyn K. Samuel; and the Metropolitan Museum of Art, William B. Walker.

For this second edition, some of my friends and colleagues graciously gave of their time and expertise to read various chapters of the manuscript and to offer invaluable suggestions. In great appreciation, I wish to thank and acknowledge the contributions of Caroline H. Backlund, National Gallery of Art; Sarah Scott Gibson, Case Western Reserve University; Jane S. Peters, University of Kentucky; Margaret D. Culbertson, University of Houston; Jeffrey L. Horrell, Dartmouth College; Betty Jo Irvine, Indiana University; Carole L. Cable, University of Texas; Susan E. Wyngaard, Ohio State University; and Paula Chiarmonte, SUNY at Buffalo.

At North Texas State University, I would like to thank the NTSU Faculty Research Committee for their continued support of my diverse research projects, some of which contributed to this text. Special appreciation is extended to my colleagues for their helpful suggestions, especially to Johnnye Louise Cope, Ralph Albert Rice, R. William McCarter, and Arthur J. Gionet. In addition, I would like to thank my parents—Joy and Hugo Swan—and my sons—Preston and Jeffrey—for their understanding, consideration, and assistance in the revision of this book.

Introduction

In the past five years, the number and variety of research tools have greatly expanded. Online database searches have become economically feasible for subjects in the humanities. Photographic archives are being reproduced on microforms reducing the need for researchers to travel to one specific place to view visual materials. Interlibrary loans, which are now easier to process, have become a necessity. Some institutions have closed their library card catalogues and have computerized their inventory systems. These changes have made some materials more accessible. Unfortunately, the alterations have not necessarily made research easier.

Doing research is hard work, but inexperienced researchers often make it even more difficult, because they do not know the hows, whys, and wheres of basic research: how to find pertinent data, why to use certain kinds of references, and where to locate the needed materials. For to be effective, researchers must know how to find and use the reference materials available to them. This book was written to assist students in learning research methodology and to report to scholars the latest resource tools. The book will aid all people involved in art—architects, artists, collectors, curators, designers, educators, historians, librarians, scholars, and students.

In order to answer simple questions, all that may be needed are the names of a few books and articles that discuss the subject, so that the inquirer can locate and study the necessary information. Usually, however, the posed problem is more difficult to solve, requiring the investigator to conduct an in-depth study as a means of finding a solution. Like a detective who unearths every clue, the researcher must check each lead in order to discover the existence of books and articles that can help answer the question. This necessitates the use of numerous publications from various sections of the area libraries, since art research requires a systematic, diligent inquiry into many types of materials.

The emphasis of this guide is on the methods of research, the many ways reference tools can be used to find art information. Of the four sections, the first part provides definitions and discussions on how to begin research projects and how to utilize all aspects of a library. Part II has chapters that detail, step-by-step, the methods by which research projects can be conducted by utilizing the resource tools which are cited in Part III. The second section describes the basic research for formulating bibliographies, chronologies, and catalogue entries. Special chapters give pointers for research projects concerned with people in specific professions, individual works of art, architectural monuments, and problems encountered by art/museum educators, buyers and sellers in the art market, studio artists, and film researchers. The third section of this book consists of an annotated list of more than 1,500 diverse kinds of resource tools, including microforms and online databases. Some of the chapters in Part III are more extensive and inclusive in the coverage of reference materials than other chapters. Certain highly specialized works are included in order that readers might have a fuller knowledge of the variety and types of research tools which are available in some libraries. Where to locate and how to obtain the needed material is described in Part IV.

Since no book of this nature can include an extensive list of all of the numerous research publications, only enough works are cited to lead the reader to other references in the field. English-language books are emphasized. But to assist the researcher in reading the foreign-language biographical dictionaries and museum catalogues, the appendix is composed of three dictionaries of frequently used French, German, and Italian words with their English equivalents. There is also a multilingual glossary of certain other important terms, including selected proper nouns—both geographical locations and surnames of artists and saints, plus terms denoting time, numbers, and animals. In addition, the names of the Greek and Roman gods are listed.

Art museums are often harbingers of the type of research which will be needed in the future. Recently, there have been increases in the variety of special exhibitions—fashion, decorative and commercial arts, prints, and photography—as well as additional emphases on museum education and film festivals. These subjects are covered in this guide. As in any selected list of works there will be titles of references cited

in this book that the reader believes should have been omitted, and there will be titles that in the reader's opinion should have been included. Since individual judgments differ, it is suggested that researchers add to the annotated lists in Part III the titles of reference works which they have found to be especially helpful. Although no library will have all of the resource material recorded in this guide, many of the references will be located either among the various libraries in the area in which the reader resides or from the interlibrary loan service which is available in most libraries and which is discussed in Part IV of this book. Moreover, investigators will discover that while checking research publications, time can be saved on subsequent projects if they take the time to add, next to the entries in this guide, the call numbers of the books used and the names of the libraries where the books are located. For like a successful sleuth, the researcher will find that the more one searches, the easier the search becomes.

PART I

Before Research Begins

This section provides discussions of essential information that every student and scholar should know: (1) the decisions which must be made concerning the research, (2) the ways various libraries are organized, and (3) the definitions and reasons for using some specialized art references: (a) catalogues of exhibitions, museum collections, and auction sales and (b) art historical works—catalogues raisonnés, *œuvres* catalogues, *corpora,* and *Festschriften.*

Defining the Study

Need to know more about Notre Dame Cathedral in Paris? What influence the German expressionists had on American 20th-century paintings and on the German film industry? How Pablo Picasso's paintings are doing in the art market? It makes no difference what the particular problem happens to be, there are several factors that must be considered before a study begins. Some basic questions need to be asked: the how, when, where, and whys necessary to answer any query.

Research means a systematic search or investigation of a specific topic. *True or pure research* brings new knowledge into existence or analyzes previous theories in view of additional information or recently obtained data. Most studies are not pure research. Papers written to synthesize the ideas of others or to state facts already known are simple, not true or pure, research. A term paper may be on this easier level; a thesis or dissertation requires that the nascent scholar engage in the more exhaustive inquiry. There are various kinds of scholarly investigations, each requiring different kinds of study. Although not all scholars list the same number and types, John W. Best in his *Research in Education* cites three: historical, descriptive, and experimental. Historical inquiry reports what occurred in the past. A descriptive study relates what is happening at the present, the *status quo.* Experimental research is concerned with what might transpire, if certain conditions were to occur or be changed. All three studies require students and scholars to use their powers of observation, description, and analysis.

Research requires a review of the literature which has been previously published on the chosen topic. It is essential that all of the data on the subject be gathered and studied prior to reporting any conclusions. *Data,* the plural of datum, are the facts—or identifiable information—that are derived from research of an historical, descriptive, or experimental study. The phrase, *Primary data,* means first-hand information, such as eyewitness accounts, the letters and diaries of an individual, original drawings and works of art, or personal interviews. The phrase, *Secondary data,* means subordinate or indirectly derived information which

is provided by authors who have examined the subject and have come to certain conclusions concerning it. These scholars may have studied primary data, but they have not experienced the event, painted the art work, or been the writers of the letters or diaries. These sources are important, because research, by necessity, is built upon other scholars' work. Remember that not everything published is correct. An essential part of research is to gather and to study as many of the facts as possible and then to try to ascertain which are correct or reliable.

Obviously, as much primary data as possible must be studied. In art, this may mean personally viewing numerous original works of art. Fortunately, a researcher does not always have to travel to some out-of-the-way place to obtain some types of primary data. Recently, there have been a number of facsimile copies of works and reprints of primary source materials which allow students to examine these resources first hand. For scholars interested in American creative works, for instance, the Archives of American Art has much of its extensive holdings of archival material on microfilm, which can be borrowed through an interlibrary loan.

After collecting and reading all of the published literature on the subject and scrutinizing the important visual materials needed for the study, the researcher must write the paper or speech. Care must be taken (1) to check and verify the data, since not all material which is read will be accurate; (2) not to plagiarize—to quote exactly or to use the ideas of another person without giving credit to the original author; and (3) to edit, rewrite, and proofread all material before submitting or presenting it. There are numerous guides which will aid the researcher in learning how to write a paper or speech. A list of some of these is provided in Chapter 22.

Since research requires the investigation into a variety, and sometimes a vast quantity, of material, there is a possibility for confusion as to just what items should be consulted first. For this reason various types of problems, accompanied by

methodological solutions to them, will be used as examples throughout this book. Two recurring subjects are (1) Gustave Caillebotte and (2) Monticello, which was Thomas Jefferson's home near Charlottesville, Virginia. Caillebotte was selected, because he was a French Impressionist painter as well as a collector of art. Upon his death in 1894 Caillebotte bequeathed to the French government his collection of works of art by such then avant-garde artists as Paul Cézanne, Edgar Degas, Edouard Manet, Claude Monet, Jean-François Millet, Camille Pissarro, Auguste Renoir, and Alfred Sisley. An uproar of protests was voiced as to whether or not the government should accept the works of these artists. Finally, a compromise was reached and a portion of the bequest was accepted. Today the paintings donated by Caillebotte are displayed in the Musée du Jeu de Paume—a reconverted indoor tennis court on the edge of the Tuileries Gardens—that houses the Impressionist and Post-Impressionist collection of the Musée National du Louvre, Paris.

Every research problem must have a method by which it can be solved, a virtual plan of attack. Prior to writing the text of the paper or speech, this methodology must be devised in order to accumulate all of the essential materials which are needed to examine the subject. Before the investigation begins, the study which is to be undertaken must be clearly delineated. The why, what, where, how, and when of the research should be answered. The topic must be explicitly defined and understood:

(1) why it is being done, the purpose of the research and the depth to which it is to be examined;
(2) what is going to be done, a concise, clear statement of the problem; and
(3) what is needed, a list of resource materials—bibliographies, chronologies, plus catalogue entries and reproductions of the works of art which must be compiled or obtained.

Libraries and art museums are places where the student will need to spend time. How the research will be done, the methodology, is the subject of this book. But when or the day to begin is also important. Since research takes time, the student and scholar must start early in order that letters can be written, interlibrary loans made, and illustrative materials gathered. This chapter defines and discusses some of the important first steps which researchers should take.

The Purpose of the Research

To define the purpose of a research project is to explain why the study is being conducted. Most research has an end product: a term paper to be submitted for a grade in a course, a paper to be presented in a classroom situation or for a professional conference, a thesis or dissertation, a proposal for a prospective client, a gallery talk, or an article to be submitted for possible publication. The purpose of the project determines some of the kinds of resource tools which will be needed. For each written or oral presentation, the following items must be known prior to beginning the investigation: (1) the exact form of the end product, (2) the audience who will read or view it, and (3) the depth of the study. These three items should be considered together.

If the end product is to be a formal term paper for a university professor, the depth to which the subject should be probed depends not only upon the professor but also upon the level of the class as well as the time period provided for the work and the grade sought. Obviously, a graduate seminar will require a more detailed paper. The methodology for doing the research may be the same, but the extent of the search will vary. For a speech or paper to be supplemented by visual aids, the proper illustrative materials must also be obtained. Photographs, slides, or good photocopies will have to be collected as the research progresses. If the paper or speech is to be presented to an audience, it will be necessary to have visual materials that coincide with the available equipment: slide or overhead projectors or video-tape machines. For oral presentations, the correct pronunciation of names, titles, and foreign words will become an important aspect of the project.

Research done for one study can often be reused in another form. Scholars keep a photocopy of every paper and speech in addition to retaining all of their reference notes. If the research was well done, and if the subject has a continuing interest for the scholar, the material may later be recycled. Often a study can be supplemented by additional investigation in order to produce a later paper which is more comprehensive in scope.

Formulating the Problem

In writing a proposal for a thesis or a dissertation, a graduate student must define a specific problem to be studied. This problem must be stated

as succinctly, yet completely, as possible. Anyone reading the thesis or dissertation proposal must understand exactly what research is to be conducted. The same care should be taken in formulating the problem statement for other research, in order that time is not wasted in researching a vast subject, only to have it curtailed later to accommodate the purpose of the study. If a computer online database search, which is explained in Chapter 4, is to be utilized, a vague topic or one incorrectly stated will cost the researcher not only time, but money.

Defining the problem might seem simple to do, but it can be extremely difficult. For example, wanting to find out about the artist, Gustave Caillebotte, is an ambiguous statement. If just knowing his nationality, the dates when he lived, and the titles of one or two of his paintings is all that is needed, reading an entry in an art encyclopedia may suffice. But if a twenty-page paper accompanied by footnotes and a bibliography or a twenty-minute lecture illustrated by slides is the purpose of the project, the problem statement needs to be refined.

If a topic is too broad, it can become unmanageable. It should be narrowed to an aspect that can be handled in the allotted time and be suitable for the format of the research. Often as a study progresses, the focus of the topic may need to be changed or limited, or the emphasis may shift. In the example of Gustave Caillebotte, the problem might be altered after some initial study, to an interest in the artist's bequest to the French nation. In this case, the readings would focus on the works the French artist had collected, rather than those he painted. If the study were curtailed to Caillebotte's *On the Europe Bridge,* a good color reproduction of the work of art plus details of this painting as well as illustrations of any preliminary studies and derivations of the piece would be necessary additions to the research. Writing a catalogue entry for the work would assist in the organization of essential data.

If the research topic was defined—to ascertain whether or not the works of art in the Caillebotte Bequest influenced the French artist's own paintings, this would require accumulating data concerning Caillebotte's life plus compiling a list of his paintings and a list of the works of art which composed the bequest. The following resource materials would be needed: (1) a bibliography of works written on Caillebotte and his bequest, (2) a chronology of his life that would provide the dating and present location of his paintings, (3) a list of the works of art in the bequest accompanied by the dates that they were made and purchased, and (4) as many reproductions as possible of both Caillebotte's paintings and the works in the bequest. The illustrative materials would provide the means of studying the various artistic creations side by side in order to determine if any influence from these works was present in Caillebotte's art. The dating of these pieces would be of particular importance.

Compiling Resource Materials

For any research project, it is important to consider what must be included in the final product. For an in-depth study, most of the following will be necessary: (1) bibliographies of articles, books, and catalogues in order to document pertinent data on the topic, (2) chronologies of people and of specific monuments and buildings that will place them in historical perspective, (3) catalogue entries for particular works of art, and (4) visual materials, such as reproductions of the subject, drawings, floor plans, and elevations. This section is subdivided into definitions and brief discussions on these items.

Bibliographies

All in-depth research begins with a working bibliography. After the problem is defined, the researcher should compile a list of books, articles, and catalogues that have been written on the research topic. With this list of resource materials, the reader can then locate and study the references so that the latest theories and the accepted facts pertaining to the topic can be learned. A *working bibliography* is one long compilation of the books, articles, and catalogues that were cited in the varous publications to which the reader has referred in researching the chosen topic. This working bibliography will probably contain the names of more publications than the investigator will be able to locate and read. But until the search is begun, it is impossible to determine just which works will or will not be found. Therefore, most careful researchers usually list all references. A step-by-step discussion of which kinds of materials should be used in compiling a working bibliography is provided in Chapter 4.

After a working bibliography has been developed, the researcher should locate and study as many of the references as can be obtained before writing the term paper, speech, thesis, or article which is the end product of the research. Example 17 is a working bibliography on the French artist, Gustave Caillebotte. For a formal paper, a selected bibliography must be formulated from the citations in the working bibliography which were consulted and found to be pertinent to the topic. Example 18 is a Selected Bibliography which was compiled from the Working Bibliography of Example 17.

As the publications recorded in the working bibliography are read and studied, the list should be annotated. *Annotation* involves the addition of a few sentences or phrases which briefly state the contents and merits of each particular article or book, as for example:

Scharf, Aaron. *Art and Photography.* London: The Penguin Press, 1968.
　　Discusses photography's influence upon Caillebotte's painting.

In some situations, as in a college course where the working bibliography is to be submitted, the researcher may need to provide longer, fuller annotations for the entries in order to indicate the extent to which the reader has analyzed the books and articles. For instance, in the Scharf example, the annotation might report the following:

Well-illustrated book covering the invention of photography, photography's influence on nineteenth- and twentieth-century art, representation of movement in photography and art, and photography as art. Detailed discussion on photography's influence on portraits and on the works of Edouard Manet, the Barbizon School painters, the Pre-Raphaelites, Eugène Delacroix, Gustave Courbet, Theodore Robinson, Edgar Degas, and the Italian Futurists. Includes a brief discussion of Caillebotte's *Un refuge, boulevard Haussmann,* 1880, and *Boulevard, vue d'en haut,* 1880; reproduces both of these paintings in black and white.

In a working bibliography, any important information which the researcher discovers about a particular reference should be included in an annotation of the work, even before the reference itself is located and read. If the material is never located, this fact should be recorded in the annotation; see the entry for the exhibition catalogue listed under Musée de Chartres in Example 17. Moreover, every reference that is read should be annotated, even if the information is repetitive.

As seen in Example 17, the annotations indicating that several of the articles in the working bibliography were news releases of exhibitions acted as a reminder that these items did not merit inclusion in the selected bibliography, which is illustrated in Example 18. Annotations, abstracts, and reviews multiply the usefulness of any material, for this type of data can often provide enough information to allow a preliminary judgment as to whether or not the reference must be obtained.

One of the easiest ways of organizing what could be a vast amount of material on a particular subject is to place the bibliographical information for each reference on a separate 3″ by 5″ card. This method provides space for an annotation of the material plus the call number and the name of the library where the reference was located. To this card should also be added the name of the resource tool which cited the reference. For instance, in Example 17, if the exhibition catalogue from the Museum of Fine Arts, Houston was located through the *Worldwide Catalogue Bulletin,* a notation to this fact should be added to the bibliographical card. Although research tools, such as *Worldwide Catalogue Bulletin,* are not included in the Working Bibliography, this notation may be needed for an interlibrary loan. These bibliographical cards allow researchers to alphabetize and organize the entries more easily when the bibliography is typed. A working bibliography is usually one continuous list of encyclopedias, books, articles, and exhibition catalogues, because until the references are located the exact type of reference to which a particular notation refers is sometimes unclear. On the other hand, a selected bibliography, especially if it is lengthy, is usually organized into divisions of kinds of materials. Consequently, having each reference on a separate bibliographical card facilitates this organizational process as well as the later typing.

As the various references for a working bibliography are being perused for the titles of materials relating to the subject, the reader should be careful to note all of the pertinent data on the bibliographical cards. This will facilitate matters if the material should need to be purchased, obtained through an interlibrary loan, used in a footnote citation, or rechecked. The data might prove essential. A complete bibliographical entry for a book includes authors and title of the work; the translator's name, if any; the edition; all publishing data concerning city, firm, and date; and, in the case of a multi-volume work, the total number

of volumes that have been published in the set as well as the number of the particular volume used. In addition, the researcher should add the call number and the library from which the material was obtained.

There are a number of correct methods of writing bibliographical entries. Researchers must decide which style they wish to use, since this will determine the sequence and the punctuation used to record publication data in the working and selected bibliographies. The difference may be slight, but whichever method is chosen, it should be used consistently. For instance, all of the listings below are accurate:

Sullivan, Scott. "Rembrandt's *Self-Portrait with a Dead Bittern." Art Bulletin* 62 (June 1980): 236–243.

Sullivan, Scott. "Rembrandt's *Self-Portrait with a Dead Bittern." Art Bulletin* LXII (June, 1980), 236–243.

Sullivan, Scott. "Rembrandt's *Self-Portrait with a Dead Bittern." Art Bulletin* 62 (1980): 236–243.

Sullivan, Scott. Rembrant's self-portrait with a dead bittern. *Art Bulletin,* 1980, *62,* 236–243.

The title of Rembrandt's painting is usually put in italics. The volume number of 62 is frequently followed by the month, year, or page numbers. Some bibliographical forms require the volume numbers to be cited as Roman numerals; others prescribe Arabic ones. The basic Roman numerals are M = 1000, D = 500, C = 100, L = 50, X = 10, V = 5.

Although the bibliographical style selected may not include the volume number or the name of the month, all information concerning the work should nonetheless still be collected as the research progresses. A magazine article entry requires the full name of the author; the complete title of both the article and the periodical; and specific information on the periodical, consisting of the volume number, the date of publication, and the exact page numbers of the article. All of this information is essential in obtaining an interlibrary loan. In addition, the volume and exact page numbers of all periodicals and the call numbers of all books, along with the name of the library where each is located, should be recorded on the bibliographical cards and eventually in the working bibliography in order to facilitate matters if any of the publications must be reconsulted.

There are a number of bibliographic style guides available. Some university administrators publish a special book to be used by their students. Many magazine editors record the style which persons submitting an article are expected to follow. Art educators prefer the style recommended by the American Psychological Association. Art historians often utilize the *MLA Handbook* or Turabian's book, which was based upon *A Manual of Style for Authors, Editors, and Copywriters.* No reference has a monopoly on the one best system. Consistency of style is the goal. Four important works on this subject are as follows:

American Psychological Association. *Publication Manual of American Psychological Association.* 2nd ed. Washington, D.C.: American Psychological Association, 1974.

The Chicago Manual of Style for Authors, Editors, and Copywriters. 13th edition revised and expanded. Chicago: University of Chicago Press, 1982.

Modern Language Association of America. *The MLA Handbook: For Writers of Research Papers, Theses, and Dissertations.* New York: Modern Language Association, 1977.

Turabian, Kate L. *A Manual for Writers of Term Papers, Theses, and Dissertations.* 4th ed. Chicago: University of Chicago Press, 1973.

It must be borne in mind that not all of the reference works listed in the working bibliography will be found. Moreover, how hard and how long a person searches for these references will depend upon the depth of the study undertaken as well as their relative importance.

If a reference work mentions a book or an article on the subject, but does not cite all of the necessary bibliographical data, the details provided should still be recorded, inasmuch as additional information leading to a complete bibliographical entry may be discovered later. There are certain references which will aid researchers in deciphering incomplete entries, a discussion of this process is provided in Chapter 25.

Some bibliographical entries vary in format. Whereas books and articles are usually alphabetized by the surname of the author, an encyclopedia article can be listed so as to indicate the title entry under which the research topic was found. For instance, if the fourth edition of Turabian's *A Manual for Writers of Term Papers, Theses, and Dissertations* is followed, the entry for the Caillebotte article in the *Praeger Encyclopedia of Art* would appear thus:

Praeger Encyclopedia of Art, 1971 ed. S.v. "Caillebotte, Gustave."

S.v. stands for the Latin phrase, *sub verbo,* meaning *under the heading.* Consequently, this bibliographical form indicates the name under which the artist will be located in the 1971 edition of the encyclopedia. This kind of entry can make a difference if the topic could be listed in various ways or if the artist's name has a number of different spellings. For instance, Charles-Edouard Jeanneret-Gris, the Swiss architect who was known as Le Corbusier, could be located under several names. Following the fourth edition of Turabian's guide, which includes the name of the author of any signed encyclopedia article, the citation for Le Corbusier would be as follows:

McGraw-Hill Dictionary of Art, 1969 ed. S.v. "Le Corbusier," by Theodore M. Brown.

The *MLA Handbook* entry would be:

Brown, Theodore M. "Corbusier, Le." *McGraw-Hill Dictionary of Art.* 1969 ed.

The researcher should indicate on the bibliographical card for each encyclopedia the name of the author of the article, if one is cited, and the exact encyclopedia citation under which the subject was located.

Biographical dictionaries are usually listed using the book form. However, some bibliographies use the same form as an encyclopedia for a biographical reference. Consequently, each of the following entries on Le Corbusier is correct:

Thieme, Ulrich and Becker, Felix. *Allgemeines Lexikon der bildenden Künstler von der Antike bis zur Gegenwart.* 37 vols. Leipzig: E. A. Seemann, 1907–50.

Thieme-Becker Künstlerlexikon, 1907–50 ed. S.v. "Jeanneret, Charles E."

Catalogues of exhibitions or of permanent collections of museums or galleries may also be reported in a variety of ways. For instance, the catalogues may be recorded under the name of the author or compiler, the name of the museum or gallery where the exhibition was displayed, or the name of the city or state where the exhibitor is located followed by the name of the museum or gallery. The researcher should note all of the essential data concerning a catalogue on the bibliographical cards, since all three of the following entries are correct for different bibliographical forms:

Popovitch, Olga. *Catalogue des peintures du Musée des Beaux-Arts de Rouen.* Paris: Arts et Métiers Graphiques, 1967.

Musée des Beaux-Arts de Rouen. *Catalogue des peintures du Musée des Beaux-Arts de Rouen.* Compiled by Olga Popovitch. Paris: Arts et Métiers Graphiques, 1967.

Rouen. Musée des Beaux-Arts de Rouen. *Catalogue des peintures du Musée des Beaux-Arts de Rouen.* Compiled by Olga Popovitch. Paris: Arts et Métiers Graphiques, 1967.

In writing bibliographical entries, the researcher must take special care: (1) to include all accent or diacritical marks, (2) to use the proper capitalization, and (3) to adhere to any special form which may be required by the authority to whom the reader is submitting the work. Since some bibliographical notations fail to include the proper accent or diacritical marks, researchers may need to check other resources, such as foreign-language and biographical dictionaries, to assist them in the proper form for names and foreign words.

The capitalization of the words in the title of a book or magazine article does not always follow the same procedure. Librarians keep capitalizaton to a minimum as do most scientists. In the fields of humanities and social sciences, usually the first and last words of a title in English are capitalized, as well as all other words except for articles, prepositions, and coordinate conjunctions. Moreover, the first word following a colon in a title is capitalized regardless of the word's grammatical function. In French, Italian, and Spanish titles, the first word of the title and all proper nouns are usually capitalized. In German the first word in a title is always capitalized as well as all nouns, whether proper or common nouns, but not the adjectives which are derived from nouns. Although these methods of capitalization are often followed, readers will discover a great deal of deviation from these forms. Consequently, to maintain consistency in compiling bibliographies and in writing footnotes, researchers will need to alter the capitalization of titles to conform to the bibliographic style they have chosen to follow.

Bibliographies sometimes include abbreviations. In some bibliographical forms if there are more than three authors of a book, only the first author is listed followed by *et al.,* an abbreviation for the Latin term *et alii,* which means *and others.* If a number of works by the same author are listed in the bibliography on the same page, a line may be substituted for the author's name. For an illustration of this method of substitution the

reader should refer to Example 18, the entries under "Berhaut, Marie." If the date of publication is placed in brackets, such as [1972], it denotes that the publication date was established by the reader from some other source than the title or copyright page of the book. The indication that there was no date available for the reference is *n.d.,* whereas *n.p.* relates that the publication data was unavailable. The abbreviation *ns.,* which means *new series,* signifies that the publication began a new numbering system; *f.* (or *ff.*) represents *and the following page* (or *pages*). The Latin term *sic,* meaning *so* or *thus,* is often written after words or phrases which either appear strange or may be incorrect in spelling or usage but which are quoted verbatim; *sic* is usually enclosed in parentheses or square brackets. For example: "He used a bright vermillion [sic]." In this quote the [sic] tells the reader that the researcher knew the correct spelling of vermilion.

A selected bibliography, which is part of any formal paper, is formed from the working bibliography. Comprising the *selected bibliography* are the art encyclopedias, books, articles, and catalogues that were read and found to be pertinent to the topic. These entries can be recorded in one continuous list; or if there are numerous entries, the list can be divided by categories. There are many ways the material can be organized. It can be, for instance, by types of references—encyclopedias, books, articles, and catalogues; by periods of time; by styles of art; or by individual artists. For examples of the different categories that can be used, the researcher should study the methods used to organize the bibliographies in the various books in the *Pelican History of Art Series.* These books are annotated in Chapter 13. Although the majority of bibliographies are arranged in alphabetical order by the surname of the author or editor, a bibliography can also be arranged in chronological order with the oldest publication cited first. In addition, the selected bibliography may or may not be annotated. Because the list of references on Caillebotte was relatively brief, the selected bibliography of Example 18 was organized into three sections: encyclopedias and books, articles, and museum and exhibition catalogues.

Since not all works that were read are included in a selected bibliography, a qualifying paragraph, stating how the references were chosen, is a necessary adjunct to a bibliography. This qualifying paragraph relates what additions and deletions were made, giving any particulars that would make it clearer to the prospective reader how and why the selected works were included. This statement of criteria determines what is cited in the selected bibliography. For instance, in Example 18, which is a selected bibliography on Gustave Caillebotte based upon the working bibliography in Example 17, the qualifying paragraph explains that all sales catalogues, newspaper articles, exhibition reviews, and general literature on the nineteenth century were excluded. The researcher may find that studying some of the qualifying paragraphs found in the selected bibliographies of various references—especially those found in the *Pelican History of Art Series,* as described in Chapter 13—may help the reader in formulating a statement of criteria.

Sometimes students confuse a selected bibliography with a chapter bibliography. The latter is a listing of the references quoted or referred to in a specific chapter or in a brief paper. A chapter bibliography is placed at the end of a chapter or a term paper as a method of noting material without having to type the footnotes at the bottom of each page. The bibliographic entries are always provided numbers which correspond to the footnote references in the text of the paper.

Chronologies

Another aspect of research is the formation of a chronology which will help the reader to understand the chosen topic's relationship to events of the period. A chronology should be compiled at the same time as the working bibliography, since many of the identical research tools are used. A *chronology* states all of the important events concerning a subject and lists the accurate dates when these events occurred. For an artist this should include a brief description of such salient episodes as birth, death, education, travel, influences, relationships, and writings. The title of each significant art work should be reported, accompanied by the year the piece was created and with the object's present location, when known, placed in parentheses. The media the artist favored are important, as are the retrospective exhibitions which are cited to illustrate changes in the artist's reputation. Example 1 at the end of this chapter is a chronology based upon the life, works, and bequest of Gustave Caillebotte. Chapter 5 discusses how to formulate a chronology for people; Chapter 7, for a building. Example 21 is a chronology of Jefferson's home, Monticello.

If important dates are in conflict, the authorities who differ should be noted in the chronology. For instance, several authors state that there were sixty-five paintings in the Caillebotte bequest, but Berhaut, who has written extensively on Caillebotte, lists sixty-nine works: one drawing, one watercolor, seven pastels, and sixty oils. This discrepancy is explained in a footnote in the chronology in Example 1.

A chronology can be written in the present or the past tense. Whichever verb tense is chosen, that verb form should be used consistently. For instance, if Example 1, which is written in the past tense, were to be changed to the present tense, the first entry would read as follows:

1848 Birth of Gustave in Paris on August 19th. He is the son of wealthy bourgeois parents, Martial and Céleste Daufresne Caillebotte. His father is a judge in the Commercial Tribunal of the Seine.

In compiling a chronology, some researchers add significant world or local events in order to help readers understand the chosen topic's relationship to the historic occurrences of the period. In an historically-related chronology the first entry of Example 1 might state:

1848 Born in Paris on August 19th, Gustave was the son of wealthy bourgeois parents, Martial and Céleste Daufresne Caillebotte. His father was a judge in the Commercial Tribunal of the Seine. After Louis Philippe abdicated the throne of France on February 24th, Paris experienced turmoil and revolution. However, peace was restored, and in December, Louis Napoleon Bonaparte, later called Napoleon III, was elected to the presidency of the French Republic.

Catalogue Entries and Reproductions of Visual Materials

Catalogue entries are compiled in order to provide data on specific works of art—paintings, drawings, sculpture, graphic art, photographs, ceramics, jewelry, textiles, furniture, and costumes.

For each object, the catalogue entry reports such information as artist, title, location, medium, and dimensions. Sometimes other important data are included, such as provenance or a list of the previous owners; exhibitions in which the work has been displayed; bibliographical citations of literature that discuss the piece; available conservation or restoration data; a list of any drawings, graphics, or derivations of the work which exist; plus any additional pertinent facts. A reproduction of the work of art is often included. Example 3 is a catalogue entry for Caillebotte's painting, *On the Europe Bridge.* An integral part of museum and exhibition catalogues, catalogue entries are discussed in Chapters 3 and 6.

Art is a visual medium. Researchers must scrutinize original as well as reproductions of works of art, drawings, floor plans, building elevations, and other illustrative materials. Photographs, prints, and photocopies of the visual materials essential to study the subject should be collected during the research process. Not only may this material be difficult to locate, but it may need to be ordered from a museum. If the researcher waits too long, time may not allow these illustrative aids to be obtained. The importance of visual material cannot be over emphasized. Not only is a good color reproduction of a painting indispensable, but details of more complicated works will also probably be necessary. A sculpture which was carved in the round and expected to be viewed from all angles, requires multi-viewed reproductions for proper understanding. Unfortunately, not all art remains in the location for which it was planned. Most art is no longer *in situ,* a phrase meaning in its original place. For this reason, drawings or photographs depicting the work of art in the place where the artist expected it to be displayed may be essential to the research. Two works of art can hardly be compared unless they are near each other in the same museum or adequate visual materials are available. Since reproductions of works of art usually give no indication as to the scale of the object, catalogue entries may need to be located in order to learn the dimensions of a piece.

A CHRONOLOGY OF GUSTAVE CAILLEBOTTE, 1848–1894:
HIS LIFE, WORKS, AND BEQUEST

1848 Born in Paris on August 19th, Gustave was the son of wealthy bourgeois parents, Martial and Céleste Daufresne Caillebotte. His father was a judge in the Commercial Tribunal of the Seine and headed the family textile business.

1869 After pursuing an education in law, received his Diplôme de Bacheher en droit.

1870-71 During the Franco-Prussian War, served as an officer in the Garde Mobile of the Seine.

1872 Traveled in Italy; began his studies with Léon Bonnat.

1873 Sponsored by Bonnat, entered Ecole des Beaux-Arts.

1874 Father died leaving him and his brothers well-off financially for the remainder of their lives. About this date met Edgar Degas, probably through Bonnat. First Impressionist Exhibition, Nadar's Studio, Paris; Caillebotte did not exhibit.

1875 One of his paintings--probably Les raboteurs de parquet (Musée du Jeu de Paume, Paris)--rejected by the Salon.

1876 Second Impressionist Exhibition; displayed eight paintings, including Les raboteurs de parquet and Jeune homme à sa fenêtre (Private Collection, Paris). Drafted his first will which bequeathed his Impressionist collection to the French state with provisions to finance group Impressionist exhibitions.

1877 His genre paintings indicate a knowledge, and probably some use, of the camera. Helped organize and finance the Third Impressionist Exhibition; displayed six paintings, including Les peintres en bâtiment (Private Collection, Paris); Portraits à la campagne (Musée Baron Gérard, Bayeux, France); Le Pont de l'Europe (Musée du Petit Palais, Geneva, Switzerland); Madame Godard et Madame Davoye (Private Collection, New York); Madame Martial Caillebotte, mère de l'artiste (Private Collection, Paris); and Paris, A Rainy Day (Originally entitled Rue de Paris, temps de pluie; also called Umbrellas in the Place de l'Europe. Upon being transferred to the Art Institute of Chicago in 1964 renamed Place de l'Europe on a Rainy Day; in 1971 changed to Paris, A Rainy Day.)

1878 Moved from the family home after his mother's death that year. Began painting a greater number of canvases; works were more loosely structured in the style of Claude Monet and Auguste Renoir. Painted Madame Renoir's portrait and Toits sous la neige (Musée du Jeu de Paume, Paris).

1879 Helped organize the Fourth Impressionist Exhibition; displayed twenty-five works, including Canotiers (Private Collection, Paris); Périssoires (Milwaukee Art Center, Milwaukee); Périssoires (Collection of Paul Mellon, on loan to the National Gallery of Art, Washington, D. C.); Périssoires (Musée de Rennes, Rennes, France); Mademoiselle Boissiere cousant (Private Collection, Houston, Texas); Les baigneurs (Musée d'Agen, Agen, France); and Toits sous la neige (originally entitled Vue de toits (Effet de neige); Musée du Jeu de Paume, Paris). Of the thirty-eight paintings displayed in the Fourth Impressionist Exhibition by Camille Pissarro, seven belonged to Caillebotte. Posed for Renoir's painting, Boating Party at Chatou (National Gallery, Washington, D. C.; originally entitled Les canotiers a Chatou).

1980 Scenes of isolated, detached personalities and views from his Paris apartment prevail. Helped organize the Fifth Impressionist Exhibition; displayed eleven works, including Dans un Café (Musée des Beaux-Arts de Rouen). Broke with Degas over which artists were to exhibit in the Fifth Impressionist Exhibition; Degas abstained.

1881 Posed for Renoir's painting The Luncheon of the Boating Party (The Phillips Collection, Washington, D. C.; originally entitled Le déjeuner des canotiers). Sixth Impressionist Exhibition; Caillebotte abstained.

1882 Began to organize the Seventh Impressionist Exhibition, but difficulties arose and Paul Durand-Ruel took over. Exhibited seventeen paintings, including Un balcon, Boulevard Haussmann (Private Collection, Paris).

1883 Portrait d'Henri Cordier (Musée du Jeu de Paume, Paris).

1884 Regatta at Villerville (The Toledo Museum of Art, Toledo, Ohio; originally entitled Régates à Villerville). Portrait de femme (Private Collection, St. Louis; also known as Femme à la rose).

1886 Durand-Ruel included his work in an exhibition held at the American Art Association in New York City. Eighth and last Impressionist Exhibition; Caillebotte abstained.

1887 His brother, Martial, married. Sold the philately collection that he had amassed with Martial for £5,000 to Thomas Keay Tapling of England; it is now in the British Museum, London. Moved to Petit-Gennevilliers, adjacent to Argenteuil, to live permanently. Painted mostly landscapes and seascapes.

1888 Participated in the Brussels exhibition of the group named Les XX. Painted Voiliers à Argenteuil (Musée du Jeu de Paume, Paris).

Example 1: A Chronology of Gustave Caillebotte, 1848–1894: His Life, Works and Bequest.

Example 1—Continued

1889 Bought the last of the paintings that composed the Caillebotte Bequest. Elected Conseiller municipal of Petit-Gennevilliers. Auto-portrait (Musée du Jeu de Paume, Paris).

1893 Chrysanthémes blancs et jaunes, jardin du Petit-Gennevilliers (Musée Marmottan, Paris); Régates à Argenteuil (Private Collection, Paris); La maison de Gennevilliers (Collection of the Tri-Suburban Broadcasting Company, Columbia, Maryland); Les dahlias, jardin du Petit-Gennevilliers (Private Collection, Rolling Hills, California).

1894 Died suddenly of a pulmonary infection on February 2, at age forty-five years. Painted 332 works in oil and pastel during his lifetime. From June 4 to 16, the Galerie Durand-Ruel in Paris held the Exposition rétrospective d'oeuvres de G. Caillebotte, displaying 122 works of his art. In his will left to the French government his collection of sixty-seven works[1] by the Impressionists: Cézanne, Degas, Manet, Monet, Pissarro, Renoir, and Sisley. August Renoir was named executor. Due to the importance of the Caillebotte Bequest, a complete list of the works of art are cited at the end of this chronology.

1896 During February, the thirty-eight of the sixty-seven works of the bequest that had been accepted by the government were exhibited at the Palais du Luxembourg. Later two works by Millet were offered and accepted by the government, bringing the total to forty works of art donated from Caillebotte's Collection.

1929 The Caillebotte Bequest moved from the Palais du Luxembourg to the Musée National du Louvre.

1951 Rétrospective Gustave Caillebotte au profit du Musée de Rennes was held at the Galerie Wildenstein in Paris, May 25-July 25.

1965 Caillebotte et ses amis impressionnistes, Musée de Chartres, Chartres, June 28-September 5.

1966 Gustave Caillebotte Exhibition, Wildenstein Gallery, London, June 15-July 16.

1968 Gustave Caillebotte Exhibition, Wildenstein Gallery, New York City, September 18-October 19; his first American show.

1976-77 Gustave Caillebotte: A Retrospective Exhibition, The Museum of Fine Arts, Houston, October 22, 1976-January 2, 1977 and The Brooklyn Museum, Brooklyn, February 12-April 24, 1977.

1979-80 The Crisis of Impressionism 1878-1882, The University of Michigan Museum of Art, November 2, 1979-January 6, 1980, displayed two of Caillebotte's paintings.

THE CAILLEBOTTE BEQUEST

The sixty-nine works of art listed by Marie Berhaut as being in the Caillebotte Bequest included seven pastels by Degas, a drawing and a watercolor by Millet, and sixty oil paintings. The asterisks denote the forty works accepted by the officials of the French government and exhibited at the Palais du Luxemburg. Most of these works are now located in the Musée du Jeu de Paume, the Impressionist and Post-Impressionist section of the Musée National du Louvre, Paris. The titles of the accepted works and the dates they were painted are those recorded in the 1973 catalogue, Musée du Jeu de Paume. If the work is also known by another title, it is given in parentheses beside the official title. Works not in the Musée du Jeu de Paume are cited under the title listed by the museum where they are now located or the title found in Caillebotte the Impressionist by M. Berhaut.

I. Probably acquired before the Caillebotte will of 1876:

Cézanne, Vase de fleurs, 1876 (National Gallery, Washington, D. C.).
*Manet, Angélina (Une dame à sa fenêtre), 1865, Exposition de 1867 (Musée du Jeu de Paume).
 , Die Croquetpartie (La partie de croquet), 1873 (Staedelsches Kunstinstitut, Frankfurt).
*Monet, Le déjeuner, 1872-74, Second Impressionist Exhibition, 1876 (Musée du Jeu de Paume).
 , Régates à Argenteuil, ca. 1872 (Musée du Jeu de Paume).
* , Un coin d'appartement, 1875, Third Impressionist Exhibition, 1877 (Musée du Jeu de Paume).
*Pissarro, Le lavoir, Pointoise, 1872 (Musée du Jeu de Paume).
*Renoir, La liseuse, 1874 (Musée du Jeu de Paume).
 , Torse de femme au soleil, ca. 1876, Second Impressionist Exhibition, 1876 (Musée du Jeu de Paume).
*Sisley, Les régates à Molesey, près de Hampton Court, 1874 (Musée du Jeu de Paume).
* , Une rue à Louveciennes, ca. 1873 (Musée du Jeu de Paume).[2]

II. Probably acquired during 1877:

Cézanne, Baigneurs au repos, 1875-76, Third Impressionist Exhibition, 1877 (Barnes Foundation, Marion, Pennsylvania).
*Degas, Femmes à la terrase d'un café (Un café, boulevard Montmartre), 1877, Third Impressionist Exhibition, 1877 (Musée du Jeu de Paume).[3]
* , Femme sortant du bain, 1877, Third Impressionist Exhibition, 1877 (Musée du Jeu de Paume).[3]
* , Les Choristes, les figurants, 1877 (Musée du Jeu de Paume).[3]

Example 1—Continued

_____, Chanteuse (Chanteuse de café-concert), ca. 1880 (Cabinet des Dessins, Musée National du Louvre).

*Monet, Les Tuileries, 1875, Third Impressionist Exhibition, 1877 (Musée du Jeu de Paume).

*_____, La gare Saint-Lazare, 1877, Third Impressionist Exhibition, 1877 (Musée du Jeu de Paume).

_____, La gare Saint-Lazare, sous le pont, 1877, Third Impressionist Exhibition, 1877.

_____, La gare Saint-Lazare, le signal, 1877, Third Impressionist Exhibition, 1877.

*Pissarro, La moisson à Montfaucault, 1876, Third Impressionist Exhibition, 1877 (Musée du Jeu de Paume).

*_____, Les toits rouges, coin de village, effet d'hiver, 1877 (Musée du Jeu de Paume).

*Renoir, Le moulin de la Galette, 1876, Third Impressionist Exhibition, 1877 (Musée du Jeu de Paume).

*_____, Bords de Seine à Champrosay, 1876, Third Impressionist Exhibition, 1877 (Musée du Jeu de Paume).

*_____, La balançoire, 1876, Third Impressionist Exhibition, 1877 (Musée du Jeu de Paume).

*Sisley, La Seine à Suresnes (Hauts-de-Seine), 1877 (Musée du Jeu de Paume).

III. Probably acquired between 1877 and 1879:

*Cézanne, Cour de ferme à Auvers, ca. 1879-80 (Musée du Jeu de Paume).

*Degas, L'Etoile ou Danseuse sur la scène, 1878 (Cabinet des Dessins, Musée National du Louvre).

_____, Femme nue, accroupie de dos, 1879 (Musée du Jeu de Paume).[3]

*Monet, Eglise de Vétheuil, neige, 1878-79 (Musée du Jeu de Paume).

*Pissarro, Potager et arbres en fleurs, printemps, Pontoise, 1877, Fourth Impressionist Exhibition, 1879 (Musée du Jeu de Paume).

_____, Chemin sous bois, en été, 1877, Fourth Impressionist Exhibition, 1879 (Musée du Jeu de Paume).

IV. Probably acquired between 1880 and 1888:

*Cézanne, L'Estaque (Vue du golfe de Marseille), 1882-85 (Musée du Jeu de Paume).

*Degas, Danseuse assise nouant son brodequin (Danseuse assise, se massant le pied gauche), 1881-83 (Musée du Jeu de Paume).[3]

*Manet, Le balcon, 1868-69, Salon of 1869 (Musée du Jeu de Paume).

*Monet, Le givre, 1880 (Musée du Jeu de Paume).

*_____, Les rochers de Belle-Ile, 1886 (Musée du Jeu de Paume).

*Millet, L'homme à la brouette, date unknown (Cabinet des Dessins, Musée National du Louvre).

_____, Paysage, date unknown (Cabinet des Dessins, Musée National du Louvre).

*Pissarro, Chemin montant à travers champs, Côte des Grouettes, Pontoise, 1879 (Musée du Jeu de Paume).

*_____, La brouette, verger, 1881 (Musée du Jeu de Paume).

*Renoir, Pont du chemin de fer à Chatou, 1881 (Musée du Jeu de Paume).

*Sisley, Lisière de forêt au printemps, 1880 (Musée du Jeu de Paume).

*_____, Saint-Mammès (La Seine à Saint-Mammès), 1885 (Musée du Jeu de Paume).

*_____, Cour de ferme à Saint-Mammès (Seine-et-Marne), 1884 (Musée du Jeu de Paume).

V. Works whose whereabouts are unknown as well as the date they were painted:

Cézanne--Scène champêtre

Manet--Les courses

Monet--Le mont Riboudet, à Rouen
 La plaine d'Argenteuil
 La Seine entre Vétheuil et La Roche-Guyon
 Pommiers
 Chrysanthèmes rouges
 Poirier en fleurs

Pissarro--Louveciennes
 Paysage avec rochers
 Les choux, coin de village
 Le labour
 Le jardin fleuri
 Sous-bois avec personnages
 Vallée en été
 Les orges
 Clairière
 Sous-bois
 Travailleurs des champs

Renoir--La place Saint-Georges

Sisley--Soleil couchant à Montmartre
 Effet du soir, bord de Seine
 Station de bateaux à Auteuil
 Pont de Billancourt

[1]Bernac states that there were sixty-five paintings; Rewald repeats this number. Bazin lists sixty-seven pictures. Berhaut, who has written extensively on Caillebotte, includes the drawing and watercolor by Jean-François Millet that are not cited by the other authors and lists a total of sixty-nine works: one drawing, one watercolor, seven pastels, and sixty oils. The confusion may be over whether or not some of the Degas pastels are considered completed works of art.

[2]M. Berhaut places it in the Musée National du Louvre, but it is not included in the Musée du Jeu de Paume catalogues.

[3]Listed in the Musée du Jeu de Paume catalogue of 1958 but not the 1973 publication.

Utilizing the Library

Material in a library is usually grouped by subject—art, history, literature—or by type—books, periodicals, microforms. In order to retrieve material, an inventory system for the library collection must be devised for patrons to use. This requires both a classification and catalogue scheme. Unfortunately, not all institutions use the same plan. Because researchers will need to obtain material from all areas of the library as well as to study at more than one institution, including libraries with which they may not be familiar, a brief discussion of a number of the problems which may be encountered by the following practices has been included. These are (1) library classification systems, (2) library catalogues, (3) definitions and methods of storing various forms of art library materials, (4) bibliographic computer systems, and (5) interlibrary loan service.

Library Classification Systems

In order that a book may be found, once it is placed on the shelf, each work is provided an individual classification number, which indicates its shelf location. For each work, several cards or entries are produced. These cards or entries, which give information on the book, including this specific classification number, are made available to the public through the library's catalogue. Two basic classification systems—the Library of Congress or LC and the Dewey Decimal—are widely used. Some libraries have a split system in which some of the works are arranged under the older Dewey scheme and the more recent acquisitions have an LC number. If this is the case, all of the older Dewey Decimal classified books will be separate from those classified under LC numbers. The two systems cannot be interfiled.

Under the Dewey system, the three beginning numbers state the general topic of the work. After the principal subject indicator, there is a decimal followed by other numbers which denote a narrower field. For example, the 700s are used for the Arts. The 720s represent architecture; 723. means

that the work is concerned with medieval architecture. The addition of .4 to 723.4 indicates that the architecture is Romanesque or Norman. Each number beyond the decimal point provides a more specific aspect of the primary subject. Some important Dewey numbers for art are as follows:

710s Landscape and Civic Art
720s Architecture
730s Sculpture
740s Drawing and Decorative Art
750s Painting
760s Prints and Printmaking
770s Photography

The staff of the Library of Congress, Washington, D.C., developed the LC system by which letters are used to represent specific subject areas. Instead of being confined to ten sequences—000s for General Works to 900s for History—allowed by the Dewey scheme, twenty-one letters of the alphabet are used to increase the basic number of topics. The Fine Arts are represented by N. Some of the important LC classification letters for art are as follows:

N General visual arts, including museums, exhibitions, history of art, art criticism, conservation, economics of art
NA Architecture
NB Sculpture
NC Drawing, design, commercial art
ND Painting
NE Print media
NK Decorative arts, including ceramics, glass, metalwork, woodwork, textiles, interior decoration, decoration and ornament
NX Arts in general, such as patronage and religion in art

Other important LC classifications are outside the Ns:

CC Archaeology
GT Fashion, Costumes
LB Theory and Practice of Education
TH Building Construction

TR Photography
TS Manufacture of metals, wood, leather, paper, textile
TT Handicrafts, wood, metal, industrial painting, tailoring, decorative crafts

The call number of a work is the complete set of letters and numbers which are placed on the spine of the book, inside the book, and in the upper left-hand corner of the library catalogue card. The top row of indicators usually follows the Dewey Decimal or the Library of Congress system. The second line, called the Cutter number, usually refers to the entry, which is the body—author, editor, creator, learned society, or museum—that wrote, edited, or had the work compiled. *Gothic Architecture* by Paul Frankl has an LC call number of NA440, F683. The NA refers to architecture, the 440 to Gothic, and the F to Frankl. Sometimes the Cutter number begins with the letter that represents the artist or title of the work, rather than the author or corporate body responsible for the published material.

Library Catalogues

Once the material is classified and placed on a shelf, it needs to be organized in order that someone can locate it. Through the entries in the library's catalogue, the collection of the institution is categorized and the location of the items indicated. This is one of the most valuable tools available to students and scholars. Knowing how to use it is essential to the success of any research project. Because not all institutions use the same library catalogue format, researchers must know the problems which might be encountered by using any of the three most prevalent systems. In addition, the method by which entries are filed into the catalogue system determines the accessibility of the material. This section discusses these two concerns of library catalogues: (1) their formats and (2) the difficulties in retrieving information from them.

Catalogue Formats

Containing the records of the library's collection, catalogue systems usually consist, either singly or in combination, of the following: (1) a card catalogue, (2) an online public access catalogue, and (3) a computer output microform, called COM, catalogue. All three have assets and liabilities; all are subject to human error.

Card Catalogues

The oldest and most prevalent system, the card catalogue is usually arranged alphabetically, either as a dictionary or as a divided catalogue. In a dictionary catalogue, all entries—subject; title; and author, creator, or corporate entry—are filed in one alphabetical sequence. In a divided catalogue, they are separated into more than one alphabetical sequence; subject entries in one section and author/title entries in another is a common division. Usually a good cross-reference network is provided. Acquisitions can be easily and quickly added to this flexible system. Although the researcher must know the alphabet and the method by which the cards were filed, the card catalogue is easy to use.

For easy access and clarity, descriptive material on catalogue cards is generally standardized. A card contains, where applicable, such information as author or corporate entry, title, publication data, call number, subject headings, number of pages, translator, foreign title, inclusion of bibliographies and illustrations, and whether or not the book is part of a series. In the subject section of a card catalogue file under "Caillebotte, Gustave," there is an entry for a catalogue of the exhibition of the French artist's works which was held at the Museum of Fine Arts, Houston and the Brooklyn Museum. The card, which is illustrated in Example 2, provides the following data: (1) the title of the catalogue; (2) the dates of the exhibition; (3) the notation that Varnedoe and other authors—the *et al.* meaning *and others*—contributed to the catalogue; (4) the authors—Varnedoe and Lee—of the text; (5) publisher information of Houston, Museum of Fine Arts, and c. 1976, indicating *circa* or about 1976; (6) the fact that there are 223 pages plus illustrations, some of which are in color; (7) the book measurements of 23 by 28 centimeters; and (8) a reference to the bibliography on pages 221 to 223. The Arabic numbers indicate any other subject headings under which this card would be filed in a Subject Catalogue, Caillebotte being the only one in this case. The Roman numerals report how many entries would be placed in the Author/Title Catalogue. For this book, there would be five cards: one for the title plus four other entries—for the two co-authors and for the two museums where the exhibition was displayed. The call number, which locates the book on the shelf, has an LC classification number of ND for painting and a Cutter number beginning with *C* for Caillebotte. The artist's name

```
CAILLEBOTTE, GUSTAVE, 1848-1894.

Gustave Caillebotte : a retrospective
  exhibition, 1976-1977, the Museum of
  Fine Arts, Houston-October 22 to
  January 2, the Brooklyn Museum-
  February 12 to April 24 / with
  contributions by J. Kirk T. Varnedoe
  ... [et al.] ; catalogue by J. Kirk
  T. Varnedoe and Thomas P. Lee.
  Houston : Museum of Fine Arts, c1976.
  223 p. : ill. (some col.) ; 23 x 28
cm.
    Bibliography: p. 221-223.
    1. Caillebotte, Gustave, 1848-1894.
I. Varnedoe, J. Kirk T.  II. Lee,
Thomas P.  III. Houston, Tex. Museum of
Fine Arts.  IV. Brooklyn Institute of
Arts and Scie      nces.

13 SEP 77    2645759 INTTsc        76-47141
```

Example 2: Subject Card for *Gustave Caillebotte: A Retrospective Exhibition.*

is used because he is the creator of the works of art which are a major part of the catalogue. The bottom line on the card records data needed by the library administrators for ordering.

In the subject file the cards are organized in an hierarchical order. The researcher needs to know the accepted arrangement in order to facilitate finding pertinent material. For example, if searching for books to discover the influence on art of the French medieval theater, the correct sequence of these three terms must be used when checking a library's card catalogue. For LC cards, it is "Theater-History-Medieval." For the librarys that utilize this system, there is the *Library of Congress Subject Headings,* a thesaurus-type research tool that indicates the specific subject headings used by the Library of Congress cataloguers. For effective research, this resource tool should be consulted.

Online Public Access Catalogues

The newest form of storing library records, which is rapidly gaining in popularity, is the online public access catalogue that contains computer records in machine-readable form. At some libraries the computer system is also used for circulation control. If there are numerous branch libraries, the entry may indicate the names of the institutions that own the work, the department in which it is located, and whether or not it circulates. In some systems, whether the work has been checked out is also reported.

Online means that the user interacts with the computer to retrieve records of the library's collection. Most systems are relatively easy to operate. Written instructions are usually provided near the terminals to tell patrons how to use the computer. Because the computer catalogues differ, the data reported in the main entries varies according to the way the system has been developed. Often information is added in stages as more monetary funds are available. Usually the principal entry provides data concerning author, title, publication, date of issue, call number, pagination, and subject headings. In many systems there is no retrospective data available in the computer. This means that prior to a certain date the library records for all of the books acquired before that date will not have entries in the computer system. If this is the case, the researcher will need to search both the computer and the older card catalogue.

Correct spelling can be important in using a computer catalogue. Although the number of search keys and the methods of instructing the computer varies from system to system, in some online public access catalogues, the entire title of a work must be accurately typed out. No word or letter can be omitted for a successful search. Most systems, however, utilize a method of typing parts of some of the words in a title. The following discussion will indicate to the reader the variety of online public access catalogues.

In one system the screen provides—under title, author, subject, or classification number—spaces for letters in a 5, 4, 3, 3 order. In looking for a specific title this would mean that the first five letters of the first main word in the title is typed followed by four letters of the second word, and three for the third and fourth words. To discover if a certain book is in the collection, the title would be typed as follows: *Guide to Art Ref* for *Guide to Art Reference Books; Art Rese Met* and for *Art Research Methods and Resources.*

At another system, the search commands— *ATS/* for author and title, *TLS/* for title, *AUT/* for author, or *SUB/* for subject—are typed in following a 4 and 5 letter system in which no spaces between the letters are used. Certain words—such as *to, an, or*—are not included for this type of computer search. In the above example, *TLS/guidart* would be used for *Guide to Art Reference Books* and *TLS/art resea* for *Art Research Methods and Resources.* For words which have fewer letters than the 4/5 requirements, spaces are used to fill the needed number. This explains why *art resea* has a space between the letters; the total of nine places must be completed. In the first search, *guidart,* no spaces are needed for the first word, only the second one.

The computer has the capabilities to search a subject by key words placed in any order. Unfortunately, due to expense, many online computer catalogues have no subject access at all. Often, even those which have the ability to search for material by subject do not have the necessary cross references to make a quick and productive search. In looking for material on Chartres Cathedral in Chartres, France, the researcher quickly discovers that in many computer systems the typed signals must match the exact subject headings that were used by the computer indexer. Using 5, 4, 3, 3 character-search keys, the letters *Chart Cath,* for Chartres Cathedral, sparked a signal for *no matches found for entered data, try another search.* Just *Chart* brought forth a frame of fifteen lines beginning with *charterhouse* and listing *charters, chartism, chartered banks, charter boat,* and on the last line, *Chartres, France.* Between the first and second frame, thirteen entries for the French Gothic Cathedral were recorded. If the proper access point, *Chart Fran,* was entered, all thirteen entries immediately appeared. It takes time and knowledge to learn how to search each individual computer system.

In one online public access system, a subject search requires the researcher to spend endless time checking through lists to find needed references. This system can be used for either browsing or for direct access. Neither is quick or efficient. In a subject search, *Dutch Painting* brought forth no entry; *Painting, Dutch* brought forth one. By searching the general term, *Painting,* screen after screen of fifteen bibliographical entries per screen were shown on the terminal, all of which were subdivided as to country, such as *Painting, American; Painting, Chinese;* and *Painting, Dutch.* Using this search method of the general term and patiently checking screen after screen, *Painting, Dutch* was finally found. There were forty-six entries under this subject heading. The novice might have stopped after searching *Painting, Dutch* and assumed that this main public library is a large metropolitan city only had one book on this subject.

One of the better systems is at Ohio State University. Providing the location of library materials, the files will indicate whether or not the book is at one of thirty separate campus libraries or at the State Library of Ohio, which is also in Columbus. The Library Control System, or LCS, as it is abbreviated, can be searched by (1) author, (2) title, (3) author/title, (4) subject, (5) call number, or (6) shelf position. Both books and serials can be located. The subject files utilize the *Library of Congress Subject Headings.* This reference work is located in each of the different libraries, in order that researchers can consult it prior to a search. In trying to locate a book on French 12th-century sculpture, the *LC Subject Headings* indicated that *Sculpture, Medieval* should be used. Typing this into the computer, the screen immediately showed the term *Sculpture, medieval* and the four subject headings which preceded this term and the five subject headings which followed it. The system allows for a further expansion of the subject headings, but the ten terms shown on the screen are usually sufficient for most subject searches. In this example, the computer screen indicated that in the Ohio library system, there were fifteen books classified as *Sculpture, medieval:* one as *Sculpture, medieval—catalogs;* one as *Sculpture, medieval—England;* one as *Sculpture, medieval—exhibitions;* and one as *Sculpture, medieval—France.* The last entry was requested, since this fit the research topic. The screen then provided the following reference: "Erlande-Brandenburg, Alain, *Le roi est mort: étude sur les fune* 1975 FBR." This meant the book, *Le roi est mort,* by Alain Erlande-Brandenburg, published in 1975. The *FBR* indicated that a full bibliographical record was available for the book. By typing in FBL/, which is the instruction for full bibliographical record by line, the screen provided the same type of information as other LC catalogue cards, such as seen in Example 2. For the location of the book, separate instructions—DSL/ for detailed search by line number—had to be typed to obtain yet another entry on the screen which recorded that in the Fine Arts Library there were two copies of the book, both of which circulated for a three week period. Because each online public access catalogue differs, researchers must spend the time to learn the intricacies of the computer systems which are used by the libraries they frequent.

COM Catalogues

The COM catalogue is a printout, either on microfiche or microfilm, produced directly from machine-readable records and requiring a special microform reader for viewing. It has the advantages of portability and economy of duplication.

The microfiches, which are thin microfilm cards that contain extensive text which must be magnified to be read, have the disadvantage that patrons can misfile them after using the fiches or even walk away with them. Unlike the microfiche system, the microfilm of a COM catalogue is protected in a self-contained viewer. In a COM catalogue, the library's collection is cited in lists filed by author, title, and subject headings. The main entry, which is under the author section, usually contains only author, title, publication data, and call number. The lists by title and subject headings provide only an abbreviated bibliographical citation. Cross references in the subject file are kept to a minimum. The COM catalogue provides an inventory list, but is unsatisfactory for effective subject searches. Although multiple copies of this catalogue are relatively inexpensive, the cost of reprinting the entire catalogue to include new acquisitions to the collection has caused some libraries to update the catalogue only every six months rather than every quarter or every other month. Users will be unaware of recent acquisitions, unless there is some supplementary material available. This is an inflexible system in that entries cannot be readily added or corrected.

**Retrieving Information
from the Cataloguing System**

Entries for a catalogue system are subject to the rules and regulations that are followed in cataloguing the material. Art libraries differ as to the regulations that are followed; some libraries have used several systems. Unless the library has been recently established, the catalogue network under which the collection is inventoried probably follows several sets of rules. Some areas of difficulty in using a catalogue system are the author and corporate entries and the methods by which proper names are filed. In most library catalogues, a book that contains mainly reproductions of an artist's creative work is listed in the Author File under the person's name, since he or she is the creator of the works of art which are reproduced in the book. This is difficult for many students, since the words artist and author are not synonymous. Because the entries that are listed in the Author File are usually not repeated in the Subject File, these books may not be found by the beginning student.

Under the latest accepted cataloguing rules, the name by which a person or institution is commonly known is the form of the name used. Some recent changes have made research easier, such as the shift from the Latin "Augustinus, Saint" to "Augustine, Saint" and "Degas, Hilaire Germain Edgar" to "Degas, Edgar." Other name changes have proved more confusing. Take the case of the 14th-century Italian painter. Although known as Fra Angelico in most art history books, his entries are now classified under "Fiesole, Giovanni da, called Fra Angelico." In one online public access catalogue which was studied, two reference works were cited under the subject of "Angelico, Fra." For the author search under this name, two additional different books were provided. Neither the subject nor the author search had a cross reference to his other name. Under "Fiesole, Giovanni da," the subject search listed four books; the author section, one. Again, no cross reference to "Angelico, Fra" was reported. From the list of all works recorded under the two versions of his name, only one book was cited in both. Without trying the two names, as well as the author and the subject sections, the researcher would not have realized the extent of the library's collection. Used as a back-up system at this same library, the card catalogue contained a cross reference under both names, so that the student could learn that Fra Angelico and Giovanni da Fiesole were one and the same artist.

The way a museum's name is entered in the catalogue system has changed over the years. Previously the organization was by city followed by the name of the institution. The most recent cataloguing rules, which most libraries now follow, altered this method. Presently, the name of the institution is entered directly, instead of under the city where it is located: "Museum of Fine Arts, Boston" rather than "Boston, Museum of Fine Arts." One confusing issue stems from the rule that the name of the government which administers an agency must be used first, if this corporate body is likely to be used for another agency. Instead of "Musée archéologique, Dijon" the entry will be "Dijon, Musée archéologique." This requires researchers to distinguish a municipally managed institution. The only solution to these problems is to keep on searching.

In some libraries, cross references in the card catalogue are kept to a minimum. In an online public access catalogue, these informative notations are not always added because of the cost involved. The more cross references, the greater the

expense and the larger the catalogue system, but the easier it is for researchers to discover material. Knowing the exact wording for a subject search is one of the problems encountered in all library catalogues, especially if there are no, or few, cross references. For instance, the official title of the institution is not alway utilized. The correct name of the French museum is Musée National du Louvre. Although the newest cataloguing rules cite the French institution as "Musée du Louvre," not all library catalogue systems have been changed to this entry. For example, at one online public access catalogue terminal—with 5, 4, 3, 3 character-search keys—the following names were tried under the subject search, all to no avail: *Musée du Lou, Louvr Muse, Louvr, Franc Louv, Louvr Fran, Franc Muse du Lou,* and *Paris Muse Lou.* The entry *Paris Louv* brough only one notation, to the 1966 National Broadcasting Company movie entitled *The Louvre.* The citation *Paris Muse Nat du* had to be used to discover the titles of the fifteen books, owned by the library, concerning this institution. The proper access point was found by looking in the old card catalogue file. This back-up system contained cross references for the correct entry under both "Louvre" and "Musée National du Louvre, Paris." Notice that in the online system the word *Louvre* was not even used.

The method of alphabetizing family names varies from reference work to reference work. The library catalogue may use one system, the abstracting and indexing services another, and the biographical dictionaries yet a third method. Researchers must check different possibilities for the spelling of a person's name when there is no one correct way to include the name in an alphabetical listing, such as Hans Memlinc whose surname can also be spelled Memling. Certain names present particular difficulties: (1) umlauted letters, such as the German ä, ö, and ü which may be interfiled as if there were no umlauts on the vowels, placed at the end of the *a's, o's, u's,* or respelled with *ae, oe,* and *ue* as replacements for the umlauted vowels; for instance, Otto Müller's name is sometimes spelled Otto Mueller; (2) the use of baptismal or first names without the surname or when there is no family name, for example, Leonardo da Vinci indicates that the person's name was Leonardo and that he was from the town of Vinci; (3) use of nicknames, double names, and married names, such as Paolo Caliari, called Veronese, because he came from Verona; (4) the placement of

prefixes such as *de, du, le,* and *la* in French; *da* and *di* in Italian; *von* in German; and *van, de,* and *ter* in Dutch and Flemish; for example, Herri Met de Bles; (5) the interfiling of certain letters, such as *I* and *J* in Italian-language references, since there are only twenty-one letters in the Italian alphabet; and (6) the method of filing or interfiling *M, Mc,* and *Mac.* The researcher may have to try a number of different methods of alphabetizing an artist's name before an entry on the artist will be located.

The idiosyncracies of the library catalogue system are many and varied. Partly this is due to the fact that the reference or art librarian, who assists students in retrieving information from this system, usually has no voice in how a particular work is classified and catalogued. The LC number is assigned by the staff of the Library of Congress, and most institutions accept this designation. Although there may be a legitimate difference of opinion, some of the problems stem from the fact that cataloguers can not be experts in all subject areas. Sometimes books are virtually hidden, because their classification numbers and subject headings do not make them easy to locate.

The art or reference librarians are the best information specialists on the library catalogue system; ask their advice. Not only should the librarian be consulted for assistance with the library catalogue system, but also in locating and finding the material. If a work is not on the shelf, inquire if it is checked out. A hold order can usually be put on the work so that when the material is returned, it will be kept for the student who is then notified that the book is available. If the work is neither on the shelf nor checked out, consult the librarian. A book may be on reserve, at the bindery, or checked out to a graduate student's carrel. The Locater File, which most libraries have, will indicate if the book is at one of these places.

Forms of Art Materials and Their Library Locations

For most research projects, material from the entire library will be needed. At some institutions, reference works, such as encyclopedias and dictionaries, are placed in a special reference section; other libraries interfile these research tools with the books. The library may have closed or open shelves. In the latter, patrons find their own books and can browse through special sections which interest them. In a closed-shelf system, all materials

are requested at a central desk and brought to or picked up by the reader. This requires that the researcher have all essential data concerning the book or periodical—such as call number, correct title and author, and volume number.

Not all materials have call numbers and can be located through the library's catalogue system. Because they are sometimes more difficult to find, many students forget about utilizing these other kinds of references. Although there are many forms of library materials, for this discussion they will be divided as follows: (1) books and catalogues, (2) periodicals and the abstracting and indexing services, (3) microforms and slides, and (4) vertical files and special materials.

Books and Catalogues

Most books are provided call numbers and placed on shelves. Sometimes oversized books are placed at the bottom of a shelf or on a special shelf for these extra large materials. Books can also be kept at a reserve desk, in the rare book room, and in a limited access area. The library's catalogue does not always indicate the location of each book. Catalogues are organized various ways. Exhibition catalogues can be (1) treated as a book, (2) grouped together and placed in a particular area of the library, or (3) considered ephemeral material and put in a vertical file. Sales catalogues are usually shelved together, arranged by auction house and year. As a consequence, some catalogues and usually all sales catalogues may not appear in the library's main catalogue. Each institution is different in its treatment of these materials. If the material cannot be located in the library's catalogue, ask the reference librarian for help.

Periodicals and Indexing Services

Periodical articles are essential to researchers as they often provide the most recent data on a subject. Moreover, a great deal of information discussed in these serials is never included in books and catalogues. A *serial* is a librarian's term for any publication that is issued at more or less regular intervals and numbered consecutively. In most libraries, the bound periodicals are separated from the books, although some annual publications which contain articles by various scholars are treated as books and shelved with the other book material. *Dumbarton Oaks Papers* and the *Journal of the Warburg and Courtauld Institutes* are examples.

In order to locate articles on a specific topic, an index or abstracting service may need to be consulted. An *index of periodical literature* is a reference that lists published materials under various specific subject categories. An index to the names of the authors of the material is often included. These references index articles in a particular number of different magazines on a regular basis. The number and selection of periodicals, however, may change over the years. Whereas most indices only list or provide a note on the articles, *abstracts* provide summaries of the material contained in the publications. Consequently, abstracts supply additional, often essential, information which assists researchers in deciding whether or not particular references might be pertinent to their topics. Because some of the entries published in many abstracts are submitted by the authors of the works themselves, the contents of an abstract may not depend entirely upon a consistent number of publications, but rather on who submits what material. Under the circumstances, the type, kind, and number of references included in an abstract may vary enormously with each issue. Although there is a difference between an abstract and an index of periodical literature, the general term *index* is often used to include both types of references. This general term is used in this guide.

Over the past decade, some of the indexing and abstracting services have developed specialized online bibliographic databases, which scholars and students use to find pertinent material faster. This is an important new tool to speed the research process. Because computer time can be expensive, it is essential for people using this type of computer search to understand thoroughly just exactly what they are doing. For this reason, a section of Chapter 4 has been devoted to a detailed discussion of online database searches.

The quality of the articles printed in a serial is of special importance to researchers. A scholarly article always contains footnotes and usually a bibliography. To quote an article from *Art Bulletin* has more prestige than from a popular journal, such as *American Heritage*. Care must be taken to check the indices and abstracts that cover the serials most likely to publish the type of article needed. Periodicals are notorious for changing titles, frequency of publication dates, and volume numbers. This can make them difficult to locate. To assist researchers in deciphering references to

these ever-changing materials, a discussion of some methods which can be used is provided in Chapter 25.

Once the title of an article is discovered, the serial which contains the piece must be located. For this information concerning serials, researchers should check the following: (1) the computer print-out list or the catalogue file which most institutions maintain of their serial holdings, (2) a union list of the serial collections of area libraries, or (3) with the staff of the interlibrary loan department, which is explained later in this chapter. A *union list* is a compilation of specific materials that are available in a particular group of libraries. These union lists use a variety of abbreviations, symbols, and marks that are explained in each volume. For instance, // indicates that the serial has ceased publication; *n.s.* means that the magazine began a new series with the volume numbers beginning once again with the number one. An + or − after an entry signifies that the serial is still being published. Brackets around a number usually mean an incomplete entry or an incomplete holding of that particular volume.

Microforms and Slides

Some materials within a library's collection are underused, because students do not know of their existence or how to utilize them. This is true of microforms, which have a number of advantages and disadvantages. Because of the need for reprinting specific material and because certain papers have deteriorated, a number of publications are reissued in one of the two basic kinds of microforms: *microfilm* which is a 16 or 35 mm wide film on a roll or *microfiche* which is a 4″ by 6″ laminated film card that reprints a number of double frames or single page sheets. A total of from ninety-eight to two hundred single sheets can be reproduced on an individual microfiche, depending upon the amount of magnification. There are film cards, called *ultrafiche,* that reproduce even a greater number of pages. Microforms, which require a special machine or hand viewer in order for the researcher to read the small print reproduced, have a number of assets: they are inexpensive, ship easily, and store simply; a single page of the text can be reproduced if a special photocopier is used; and they can reproduce color material. On the debit side, microforms can often be difficult, if not impossible, to locate in the library's catalogue system. Sometimes physically separated from the hard-cover books that explain or index the microform material, they require the use of inflexible machines, which students resist trying. In addition, the illustrative matter is often hard to photocopy.

However, expense outweighs the liabilities. A number of large photographic collections—such as the Collections of the Department of Prints and Photographs of the Bibliothèque Nationale, Paris and the Marburger Index of the Photographic Documentation of Art in Germany—are now available on microforms. There are also numerous microform reprints of newspapers, magazines, and exhibition catalogues. Students should learn to utilize these visual aids, which are usually deposited in a special section of the library.

Slides are another important research tool. Although the quality of the reproductions of works of art produced on film varies considerably, slides are often the best visual material available. Frequently, located in a Media Center or a Slide Library, these small images are greatly improved by good projection. Two slides shown side-by-side on a large screen provide a means of viewing art for analysis and comparison. Unfortunately, the museums which own the works of art all too often do not provide good quality color slides for the public. A notable exception is the National Gallery in London which sells quality slides of almost every work in the collection. In addition, this museum publishes catalogues that provide detailed explanations of the works of art.

Vertical Files and Special Materials

Many libraries have special material which does not appear in the library's catalogue and which may not be otherwise publicized. Such items include vertical files of artists and art subjects, picture files, rare books, prints, and photographs. Ephemera or short-lived material is usually not shelved with the books nor entered in the library catalogue. Some librarians do not even save it. But the institutions that collect ephemera can prove to be storehouses of information for researchers. These collections of archival material may include such items as architectural blueprints, old photographs of monuments, and small, sometimes rare, exhibition brochures.

Some librarians organize and maintain a Vertical File on Artists. This is a filing system in which newspaper and magazine clippings, biographical

monographs, exhibition catalogues, gallery and exhibition notices, and other kinds of ephemeral materials are collected, placed in folders, and filed under specific artists' names. Librarians often concentrate on artists working in the region in which the library is located. Consequently, the local library is often one of the best sources for data concerning artists of a particular region.

Libraries may also have a vertical file that contains reproductions of works of art. The library personnel cut illustrative material from magazines and newspapers, mount them on cardboards, organize them as to subjects, and place them in folders in file cabinets. These illustrations are not listed in the library's catalogue. But if such a file exists, the librarian will help the investigator search for the needed material.

Occasionally an institution has a large photographic reference collection where a researcher can study all of the reproductions of art objects that the library has of one artist or all of the reproductions it has under a certain subject, such as madonnas. Located in a separate visual-resource department, a photographic reference collection is an archive containing reproductions of art from all over the world. Although black-and-white, 8" × 10", glossy prints are usually preferred, any reproduction of a work of art—small or large, black and white or color, good or bad—may be saved. The reproductions, which are collected from magazines and museum and sales catalogues, are mounted on cardboard, identified insofar as is possible, and filed according to artist, country, subject, or period of history. Cross files on iconography, biography, and portraits may also be compiled. A list of some large photographic archive collections is given in Chapter 26.

Original material is sometimes available for patrons. A Rare Book Room may contain a 15th-century illuminated Book of Hours or books illustrated by famous artists. If there is not a separate Rare Book Room, such publications may be stored in a limited access area. Libraries also may have a print as well as a photograph collection. Often these items of the collection are kept in a special department or section of the building. Since there is usually no mention in the library's catalogue of the existence of this type of material, researchers will have to inquire as to the availability of these resources.

Bibliographic Computer Systems

A bibliographic computer system is an online computer file which contains citations for items which would be included in a bibliography, such as books, articles, and exhibition and auction catalogues. In order to differentiate the three types of bibliographic computer systems prevalent in libraries, they have been organized in this guide into the following categories: (1) the online public access catalogue which was discussed previously in this chapter, (2) the online cataloguing and bibliographic database systems of OCLC and RLIN, and (3) the specialized bibliographic online databases. The last two systems are discussed in this section.

Online Cataloguing and Bibliographic Database Services

Since about 1968 the U.S. Library of Congress librarians have been putting the records of the material they catalogue onto magnetic computerized tape. The system is termed MARC, an acronym for machine-readable cataloguing. The LC MARC tapes provide similar information to the LC cards which are illustrated in Examples 2 and 20. Example 25 is a reproduction of an LC MARC tape. Purchased by online cataloguing and bibliographic database services, these tapes are made available to libraries for a fee. The services have supplementary records added to their files which are used by librarians for cataloguing materials, bibliographic control, and interlibrary loans. Although the computer systems are used by librarians to assist them in their profession, students and researchers should be familiar with these services, because some aspects of these systems affect the library patron. In addition, with the proliferation of personal computers, in the future, these systems may be used by a wider audience. The two most prevalent online cataloguing and bibliographic database services are OCLC and RLIN.

Founded in 1967 by the Ohio College Association, OCLC originally was an acronym for Ohio College Library Center. In 1981, the organization name was officially changed to Online Computer Library Center, Inc. The acronym remained the same. The OCLC files consist of the LC MARC tapes from about 1968 plus records which are added by participating libraries. Since about 78% of the records have been augmented by these other institutions, some of which have put their entire

records into the system, the OCLC records contain many bibliographical entries from before 1968. There are more than 3,300 member libraries of OCLC: 52% are academic institutions, 17% are public libraries. The OCLC subsystems which are available include cataloguing, interlibrary loan, serials control, acquisitions, and a name-address directory.

RLIN, an acronym for Research Libraries Information Network, is owned by The Research Libraries Group, Inc., called RLG. Established in 1974 by the universities of Harvard, Yale, and Columbia with the New York Public Library, RLG is today a corporation owned by twenty-five U.S. research institutions. For participating libraries, the RLG computer system has four principal programs: collection development, shared resources, preservation, and technical systems and bibliographic control. In addition, there are (1) RLIN, an automated information system and (2) special subject programs, such as the East Asian Program and the Art and Architecture Program. RLIN contains the LC MARC files from 1968 plus records from the participating libraries. Although coverage is presently best for material acquired after 1977, this will change as more member institutions add retrospective records to the computer files. RLIN has the advantage of being capable of subject searches. In addition, the Art and Architecture Program has two specialized bibliographic databases—the *On-line Avery Index to Architectural Periodicals* and *SCIPIO*—both of which are discussed later. Even though the computer files are presently not as extensive as those of OCLC, RLIN is used by a number of academic and museum libraries whose scholarly research materials have been recorded into the system. Although not readily available to students, RLIN does have search-only accounts by which the specialized bibliographic databases of Avery and SCIPIO can be utilized by non-RLG members.

Specialized Bibliographic Online Databases

Obtaining all relevant material on the subject is the aim of most research. A new tool available to assist students and scholars is the specialized bibliographic online database. During the 1960s some of the abstracting and indexing services changed to a computer system for typesetting their entries or citations. A decade later, the material which was stored on these tapes was formulated into databases and made available to the public for online bibliographic searches. Although medicine and the other sciences were the first major users of online databases, the humanities now have enough computer sources to enable the art researcher to utilize this latest tool effectively.

Most university and public libraries provide online database services for their patrons. A searching specialist or the reference librarian usually does the actual search, although the researcher should be present in order to control the direction of the inquiry. This service can be expensive. Most libraries charge for the actual time spent online with the computer, and some institutions have an additional surcharge of about ten percent. It is especially important for researchers to have a thorough knowledge of just what these electronic machines can and cannot do.

Two kinds of database services are prevalent: (1) Selective Dissemination of Information or SDI Services by which researchers provide a profile of interest and the computer company automatically sends any material pertinent to their discipline to them as it is made available, a system used especially in medicine and the sciences, and (2) retrospective searches by which patrons utilize the computer to find any bibliographical references on specific subjects which are filed in the database. It is the latter type of service that most humanities researchers need.

To search some bibliographic online databases, such as those available through NEXIS, a special computer terminal must be used. Other systems, such as DIALOG, can be searched by using a number a types of computer terminals, a modem or acoustic coupler which are devices that connect the two computers via telephone, and any interface and software that may be necessary to allow the computers to communicate. Most databases can be searched by a personal computer.

Researchers must have their topics concisely, yet comprehensively, defined before the search, a process discussed in Chapter 1. Since most specialized bibliographic online databases do not speak the same language as the researcher, in order to utilize these reference tools, the search problem may need to be composed in Boolean logic. Chapter 4 details this process. After the results of the search are known, the bibliographical citations can be typed either onto the library's system—called

online printing—or issued from the computer site and mailed to the patron, a process called offline printing. Because of the speed of the electronic machines, the former can be relatively inexpensive, depending upon the number of citations. Offline printing can take three to five days to arrive. In addition, some databases, such as *The New York Times Database,* are capable of providing full-text citations by which the entire article or entry is printed.

Interlibrary Loan Service

No library can have every book and periodical that might be needed by its patrons. Fortunately, many necessary works can be obtained through the interlibrary loan service that most libraries have. The search may take a two-to-three-week period, but if the material can be found in a participating library, the book will be sent to the researcher's institution for a period varying from two to three weeks. Usually, there is no charge. A photocopy of a periodical article is often available through the same service for a price of ten to fifty cents per page; sometimes a service charge of two to four dollars is added.

This exchange between libraries has been in effect on a small scale since the latter half of the nineteenth century. During the past decade due to budgetary constraints of individual libraries, to the proliferation of reference materials, and to an increase in art scholarship, these interlibrary loans have multiplied. The use of photocopy machines, the teletype, and telefacsimile machines have improved this marvelous cooperative effort. Because of the cost of interlibrary loans, some libraries have restricted the use of this service. In academic libraries, such a loan is often available only to graduate students and faculty. Some schools require faculty approval for a student's order.

All interlibrary loan requests are filled out on a requisition form and submitted to the interlibrary loan service, which is a separate department in most large libraries. The form differs from institution to institution, but all forms require certain basic information for a book: complete name of author; correct title; translator, if any; publishing data, including city, firm, and date; particular edition if other than the first one; and a verification reference.

The *Interlibrary Loan Procedure Manual* by Sarah Katharine Thomson, published in 1970 by the American Library Association, states that all requests to a lending library should be verified. Libraries differ as to whether or not this requirement is to be fulfilled by the patron or the librarian. Good researchers, however, know how to verify their own requests. The procedure is usually simple and assures the would-be borrower that the material actually exists.

Confirming the existence of the needed item, a *verification reference* is a notation in the *National Union Catalogue,* the catalogue of the holdings of a large library, or in a union list of serials—that gives standardized bibliographical data on the book or periodical the reader is seeking. Verification is necessary, as the library must request the book or magazine using the same bibliographical data as does the institution from which the work is being requisitioned. Otherwise the needed item will not be located. Sometimes even titles differ. For instance, Germain Bazin's *Trésors de l'impressionnisme au Louvre* was published in the United States as *French Impressionists in the Louvre.* If the English translation were needed, this latter title would have to be used. Chapter 25 gives details of how to fill out an interlibrary loan request form and how to verify the needed book or periodical.

Understanding Specialized Art References

Every discipline has specialized research materials which are essential to its study. This is also true of art. Because of their importance and because the nature of these distinctive materials requires a more detailed discussion than do other art references, the following works are treated in this separate chapter: (1) museum collection and exhibition catalogues, (2) auction sales catalogues and the indices which report them, and (3) art history books.

Museum and Exhibition Catalogues

Basically there are two kinds of museum and exhibition catalogues: (1) a checklist or summary catalogue and (2) a scholarly catalogue. A *summary catalogue* provides some fundamental data on each work of art that is listed; for instance, the artist's name, the title of the work, the medium the artist used, and the object's measurements. At times, the acquisition data, as well as the approximate date when the piece was completed, are included. An illustration of the art object may or may not be reproduced.

On the other hand, each entry for a work of art in a *scholarly catalogue* usually provides: (1) the artist's name; (2) the title of the work; (3) the medium the artist used; (4) the size of the piece; (5) the acquisition data; (6) the signature and date, if any, found on the work of art; (7) the approximate date the object was finished; (8) the provenance, which is a list of all of the known owners of the work of art and of the sales in which the piece figured before it was acquired by the museum; (9) a list of all the literary references or scholarly publications on the object; (10) the names, dates, and locations of the various exhibitions in which the work has been displayed; and (11) any additional information which the museum staff might possess. Included within the last category might be restoration data, a facsimile of the artist's signature, attribution data, and information concerning the subject of the work, such as the location of the landscape which is depicted, the identification and history of the person portrayed, the meaning of the symbolism, and the location of any pertinent drawings, replicas, copies, or engravings of the work. In addition to the above information, a scholary catalogue usually includes, for identification purposes, either a black-and-white or a color reproduction of each work of art.

Museum and exhibition catalogues sometimes provide special indices and supplementary material which greatly aid researchers. Scholarly museum catalogues may include indices for the following: (1) the subjects of iconography—often subdivided into religious, historic, profane and secular, and topographical subjects and portraits; (2) the previous owners and auction houses; (3) the coats of arms and seals; (4) the location of related works; (5) the donors of the art; (6) the accession numbers, which indicate the order by which the objects were added to the collection; (7) the foreign schools to which the artists represented in the collection belong; (8) changes in attribution or a concordance to attributions in previous catalogues; and (9) media. A few examples of museums which have scholarly catalogues containing numerous indices are the National Gallery, London; the National Gallery, Washington, D.C.; the Samuel H. Kress Collection; Yale University Art Gallery; and the Rijksmuseum, Amsterdam. Scholarly exhibition catalogues may include reprints and translations of pertinent material, chronologies, glossaries, extensive bibliographies, and subject indices. For example, *Age of Spirituality: Late Antique and Early Christian Art, Third to Seventh Century,* 1979, has a chronology of events and emperors from 252 to 711, an eight-page glossary of terms, a subject index, and a forty-two page bibliography.

Of all the materials published by an art museum the most important are (1) the museum catalogue, which is an inventory list of an institution's collection, and (2) the exhibition catalogue, which is a list of works of art displayed at a specific exhibition. A catalogue of the permanent collection of an art museum is essential to art scholars and researchers in order that they may know exactly

what art is where. Unfortunately, not all art museums have published such a catalogue. Because exhibitions and the attendance records they produce are often used to measure a museum's prestige, exhibition catalogues are a more popular publication than catalogues of permanent collections. These exhibition catalogues are just as essential to art research. Often an exhibition catalogue includes both well-researched articles that provide additional insights into the objects which are displayed and a catalogue entry for each exhibited work of art.

This section has been divided into three parts concerning catalogues: (a) museum and private collections, (b) exhibitions, and (c) terminology. The last section provides a discussion of some of the words that describe attribution, time, shape and dimension, as well as various terms frequently used in catalogues. For an explanation of how to utilize museum and exhibition catalogues in research, see Chapter 4.

Catalogues of Museums and Private Collections

In 1683, the Ashmolean Museum of Oxford University was opened to the public. By 1713, a memorandum, penned in Latin, detailed the administration of the museum, the taking of an inventory of the collection, and the editing of a catalogue to be written in Latin. Unfortunately, this type of scholarly activity has not been universally copied. And yet, some institutions have had a continuous history of producing collection catalogues, even if most of the earlier ones were very brief and ambiguous as to which works of art were cited. The National Gallery in London is an excellent example of a museum which publishes a series of quality catalogues that are periodically revised and corrected.

The best source for information concerning a work of art is usually the owner—either a museum or private collector. Some museums have consistently published detailed data concerning their objects. A small group of these institutions, accompanied by a brief list of some of their catalogues, is recorded in Chapter 14. One of the problems is updating the material as new works of art are added to the collection. Information on new acquisitions, changes in attribution, removal or sale of items, and recent conservation of specific items should be made available to scholars. Some institutions report acquisitions in a separate

publication, such as *The Metropolitan Museum of Art: Notable Acquisitions,* or in annual reports, as does The British Museum.

Private collectors and museums often have only inventory lists for the works of art in their collections. Because many art works have changed ownership as well as location over the centuries, inventory lists can be very important to scholars, who use these lists to determine the provenance of a work of art and to assist them in authenticating it. Sometimes numerous versions exist of a particular painting by a famous artist. One may be the first work; the others may be later copies by the master, his or her studio, followers, imitators, or forgers. In the case of a painting by Raphael which was known to have been in the Borghese Collection, an inventory number for the work was discovered from the Italian collector's inventory list. Because only one version of the painting had this number on the back of the canvas, this work is now believed to be the first one Raphael painted.

Using inventory lists and museum catalogues which are not illustrated also presents problems for researchers. Most of the nineteenth-century or older inventory lists and museum catalogues cite works of art by title, providing little other information. Since the name can be changed at the discretion of each owner, it is difficult for scholars to decide exactly what specific objects are listed. And, unfortunately, photography had not yet been invented. In writing *Trophy of Conquest: The Musée Napoléon and the Creation of the Louvre,* 1965, Cecil Gould supplemented the early references with works of art which illustrate individual galleries in the Louvre, such as the eighteenth-century paintings by Hubert Robert and the engravings published in *Galerie du Musée Napoléon,* 1804–14 and *Musée Français,* 1803–9. These works of art assisted Gould in identifying the paintings which hung in the Louvre galleries before the French Revolution.

A patron of the arts, Caillebotte amassed a group of sixty-nine works, which he bequeathed to the French nation. The role of patronage—be it private collector or museum—has become increasingly important in art history, as museum curators try to authenticate works and to establish provenance. This research also deals with the study of changes in taste, a topic explored by Francis Haskell in *Rediscoveries in Art: Some Aspects of Taste, Fashion, and Collecting in England and France,* 1976, and *Patrons and Painters: Art and Society in Baroque Italy,* 1980.

Exhibition Catalogues

Art exhibitions come in all kinds and sizes. The works exhibited may be of any medium or from any period of time. Only a few art objects may be displayed, or the exhibition may assemble a vast collection of works of art providing the visitor to the exhibit with an encyclopedic view of the subject. There are competitive exhibitions, one-artist and multiple-artists shows, retrospective exhibitions, invitational shows, educational and historical exhibitions, and displays of the works of art of an individual collector or of a foreign country. The catalogues of these exhibitions provide permanent documentation of these temporary exhibits. Because the administration of the exhibiting institution usually underwrites the cost of publication and because a group of experts, rather than one individual author, frequently compiles the catalogue, an exhibition catalogue can often be issued in less time than a book. Consequently, since they disseminate the most current research on the subject which is represented in the exhibition, catalogues are important references for people involved in art, even if the person has not been able to attend the exhibition.

Because of the variety of different kinds of information exhibition catalogues provide, they need to be perused by everyone involved in art. Studio artists need to see reproductions of the works of art displayed in the latest exhibitions in such art centers as New York, Paris, and London in order to keep informed as to the current trends in their specific fields of art. The art purchaser must review exhibition catalogues so that fluctuations in an artist's reputation can be calculated. Art historians need to analyze the works of art displayed at the exhibitions and the research material provided in the catalogues as well as to discern influences exhibitions might have on later artists' works. Moreover, the exhibition catalogue is often an excellent source for reproductions of art objects. Frequently these illustrations include many lesser-known works of art which have not been previously reproduced. However, exhibition catalogues vary enormously. Some incorporate aspects of both a summary and a scholarly catalogue; a few do not even list the exhibited items. Nevertheless, exhibition catalogues are important reference tools for researchers, since the scholarly catalogues offer a great variety of information as well as important reproductions of works of art.

In the United States the catalogue of a traveling exhibition which is displayed in several American cities is usually written and published prior to the date of the first exhibition and the same identical catalogue is used by all of the exhibiting institutions. By publishing large quantities of one catalogue, the price per catalogue is lowered. For instance, the visitors to the exhibition of King Tutankhamun's treasures, which were displayed in six United States cities over a three-year period from 1976 through 1979, were able to purchase *Treasures of Tutankhamun,* the one catalogue that was compiled for this exhibition of Egyptian royal art. *Treasures of Tutankhamun* includes a catalogue of the fifty-five exhibited works of art, an article on the discovery of King Tutankhamun's tomb in 1922, and a listing of forty-four bibliographical references. In the catalogue section of this scholarly work, each exhibited piece is illustrated with a black-and-white reproduction. In addition, there are thirty-three color plates.

International traveling exhibitions usually have a distinct, separate catalogue for each country in which the works of art are displayed. For example, there was a different exhibition catalogue in each country where the archaeological finds of the People's Republic of China were placed on view during the years that the art objects traveled throughout Europe and the United States in the 1970s. These catalogues not only differed as to the language in which they were written but as to the quality of the material included. The American catalogue was entitled *The Exhibition of the Archeological Finds of The People's Republic of China* and was issued in two volumes. The text provides a brief historical account of each Chinese dynasty represented at the exhibition and a catalogue of the 385 displayed objects organized as to the various dynasties. The second volume includes a comparative chronology of the events in China and the western world, a pictoral chart that illustrates the various classifications of sixteen bronze vessels, a brief entry and a black-and-white illustration for each of the 385 exhibited pieces, and color plates of twenty-three of the works of art. The catalogue has no orientation maps and no articles to assist the reader who knows little or nothing about the Chinese archaeological finds that have been recovered since the establishment of the People's Republic in 1949.

Previous to the exhibition in the United States, the Chinese archaeological treasures were displayed, among other places, at the Royal Academy in London. The British exhibition catalogue,

entitled *The Genius of China,* provides more information than its American counterpart. The London catalogue includes (1) a listing of the 385 displayed objects, often providing more information but smaller black-and-white reproductions than does the American catalogue; (2) a brief historical account of each Chinese dynasty; (3) short articles on the scope of the exhibition and on early archaeology in China; (4) a chronology plus a chronological table of the Chinese dynasties; (5) an historical summary; (6) a discussion of China in the East-Asian context; (7) a selected bibliography; (8) two maps, one locating the excavated sites, the other the Silk Route; and (9) color reproductions of twenty-two of the pieces. Since the quantity and quality of information disseminated by catalogues of the same exhibition displayed in various countries can differ markedly, researchers may need to locate and examine more than one of the catalogues that have been compiled for a particular exhibition.

Unfortunately, not all catalogues have been completed before the exhibition opens. Some have missed the show entirely. *Age of Spirituality: Late Antique and Early Christian Art, Third to Seventh Century* was compiled for an exhibition which was displayed from November 19, 1977 through February 12, 1978 at the Metropolitan Museum of Art. Due to the problems of organizing the contributions of more than thirty-five international scholars—some of whom were from France, Germany, Austria, and Israel, this important reference was not published until 1979. Nor are all of the works of art cited in an exhibition catalogue necessarily displayed either at the show or at all of the various museums to which the exhibition traveled. For example, *El Greco of Toledo*—the catalogue for the 1980s exhibition which traveled to the Museo del Prado, Madrid; National Gallery of Art, Washington, D.C.; The Toledo Museum of Art; and the Dallas Museum of Art—cited sixty-six works of art. The exhibition, which was four years in the making, had one catalogue. Spanish articles were translated into English for the United States version; the reverse occurred for the Prado catalogue. Although each painting was displayed in at least one museum, none of the four institutions had all of the pieces. The Prado displayed fifty-eight paintings; Washington and Toledo, fifty-seven; and Dallas, fifty-one. Conservation concerns and the length of the borrowing time of one year influenced these decisions. Schol-ars must take these points into consideration, especially when assigning influence from a specific exhibition on contemporary artists' works.

Terminology Used in Catalogue Entries

A catalogue entry is the data provided for each work of art in a catalogue. This can be in a summary or a scholarly form. Example 3 is a scholarly entry for Caillebotte's *On the Europe Bridge.* Catalogue entries are basic components of exhibition and museum catalogues and of references which provide detailed reports on an artist's body of work, such as catalogues raisonnés, *œuvres* catalogues, and *corpora*—an explanation of these terms is given later in this chapter, under "Art History Books."

In order to determine exactly how a compiler of a catalogue measured a particular work of art or defined the degree of involvement of an artist, the reader should consult the preliminary explanations that most scholarly museum catalogues include. Because some catalogue compilers neglect to report these essential explanations, a list of terms has been compiled from some of the scholarly catalogues recorded in Chapter 14 in order to assist researchers in reading catalogues. The terms have been categorized as words that describe attribution, time, or shape and dimension as well as a miscellaneous section.

Terms of Attribution

The artist's name is usually given whenever there is conclusive evidence that the artist was the creator of the piece or whenever there has been many years of substantial scholarly agreement as to the attribution. If any doubt still exists as to whether or not the artist was the creator of the work, a question mark in parentheses or the words *Ascribed to* or *Attributed to* are often added. In most cases, *Studio of* or *Shop of* precedes the artist's name in cases where the artist had a large active *bottega* or studio. The terms signify that the work of art was produced in the artist's studio and that although the degree of the artist's involvement has probably not been determined, the artist's guidance can usually be assumed.

The following terms are used in descending order to suggest the degree of closeness to the style of a particular artist: *Close Follower of, Follower of, Imitator of,* and *Style of.* Whereas the first term may denote a degree of closeness or involve-

ment with the artist, the last term suggests only a vague relationship of one work of art to another. The term *After* usually means a copy of a work of art. Moreover, the copy, which may or may not have variations from the original piece, can be made at any date after the time of the original. The copy date could be a couple of years or several centuries later.

Not all catalogues list attributions the same way. In most catalogues a dubious work of art will be cited under the name of the artist to whom it is attributed together with a statement that the work is an attributed one. Yet, in some catalogues an attributed work may be listed under *anonymous* with a notation that some scholars credit the work to a certain artist. Sometimes the name of the person who attributed the work of art to a particular artist is provided. The date the attribution was made is seldom included, although this latter information could be of the utmost importance, especially if the date of attribution was before a work of art was cleaned or underwent x-ray or infrared study.

Often used with the name of a town or district, the terms *School* and *School of* are sometimes used to distinguish a group of artists who worked in a particular place and used a specific style. For instance, the Utrecht School is the name given to a group of painters who lived in Utrecht, Holland, during the seventeenth century and who were greatly influenced by the realist style of the Italian painter Caravaggio. When the term *School of* is used with the name of an artist—as for instance, the School of Cellini—the indication is that the artist did not have any involvement with the object, but that the artist's work influenced this particular piece.

Sometimes the artist's name is followed by the initials of the artist's society. Sir Joshua Reynolds, R.A., indicates that Reynolds was a member of the English Royal Academy. A.R.A. stands for Associate member of the Royal Academy; P.R.A. refers to a past president of the organization. R.S.A. signifies a member of the Royal Scottish Academy, whereas N.A. denotes the National Academy of Design in the United States.

Terms of Time

When reading foreign-language catalogues, the researcher should remember that the abbreviations *B.C.* and *A.D.* are not universal. Sometimes *B.C.E.* for *Before Common Era* and *C.E.* indicating *Common Era* are used. The French terms

are *Avant Jesus-Christ* and *Après Jesus-Christ;* the German, *vor Christi* and *nach Christi.* The multilingual glossary of Appendix D lists the French, English, German, Italian and Spanish words for periods of time, the months of the year, and the basic cardinal and ordinal numbers.

In designating the years during which some event occurred, the placement of a *c.* or a *ca.,* for *circa,* denotes that the episode took place around that time. If there is a discrepancy in dates, usually both years, or a range of time, will be given. For instance, Bernard Strigel (1460/61–1528) indicates that Strigel was born either in 1460 or 1461 and died in 1528. Sometimes only the periods during which an artist was producing art are known. These are signified by the term *active,* as for example, Claus Sluter, active 1380–1406.

Terms of Shape and Dimension

Paintings and their frames can be made in various shapes and dimensions. A *tondo* is a circular or round shape. A *diptych* is composed of two panels hinged together along one side which can be opened and closed like a book. This gives two outside and two inside surfaces. For instance, during the fifteenth century, small personal diptychs owned by the aristocracy often had a portrait of a person's patron saint on the top panel, related subjects depicted on the two inside sections, and the coat of arms of the owner on the back of the piece. A *triptych* has three panels usually hinged in order that the two outside pieces—which are each half the width of the center section—fold and cover the third wider panel. A *polyptych* has numerous panels that are hinged so that they can be opened and closed to show various scenes. The terms—diptych, triptych, and polyptych—are sometimes used for works of art which are either stationary parts of an altarpiece or separate related pieces. A *retable* is a large altarpiece which is composed of numerous panels. For instance, *The Retable of St. George* in the Victoria and Albert Museum of London measures twenty-two feet by sixteen feet and contains more than fifty small paintings of various sizes. A *predella,* which consists of the small pictures at the bottom of a large altarpiece, usually has five or six panels. The subjects of these works often refer to the larger figures depicted in the main part of the altarpiece. Sometimes the panels of retables and predelle— the plural of predella—are separated and appear individually in different museums.

In a catalogue entry the dimensions of a piece are always reported. Most measurements, which are written with the height of the object preceding the width, are usually provided for the area of the actual painting. Furniture dimensions are given for height, width, and depth. Sometimes the height of the arm is provided for arm chairs. Bowls and cups can be measured by the height and the diameter of the top, and sometimes the base, of the piece. The diameter of plates and saucers is all that is usually recorded.

The part of the metric system that is most important to the measurement of art objects is composed of the meter, which is slightly over 39 1/3 inches. A tenth part of a meter is called a decimeter; a hundredth part, a centimeter; and a thousandth part, a millimeter. These are abbreviated m., dm., cm., and mm. Since the equivalents in the United States measuring system can only be stated in approximate figures, the actual numbers derived may vary somewhat depending upon at what point the number is rounded off. A brief conversion table, based upon the United States system of measurements, follows:

1 meter = 39.37 inches
1 meter = 3.281 feet
1 decimeter = 3.937 inches
1 centimeter = 0.3937 inch
1 millimeter = 0.03937 inch
1 foot = 30.48 centimeters
1 foot = .305 meters
1 inch = 2.54 centimeters
1 liquid quart = 0.946 liter
1 liter = 1.0567 liquid quarts
1 dry quart = 1.101 liters
1 liter = 0.908 dry quart
1 pound = 0.454 kilogram
1 kilogram = 2.205 pounds

The dimensions of a work of art can be used in scholarly detective work. For instance, in a German inventory list, a painting may be recorded: "*Selbstbildnis,* 1889, 40.5 × 32.5 cm." A painting by the same artist is described in an American auction catalogue: "*Self-portrait,* 1889, 16 × 13 in." Are the two citations for the same work of art? Since the titles and dates are identical, the question is whether or not 40.5 centimeters is the same as 16 inches and if 32.5 centimeters equals 13 inches?

The following mathematical computation shows the comparison.

Since 1 cm. = .3937 in.
 40.5 cm. = .3937 × 40.5
 = 15.94485
 = 15.945 (rounded off to the nearest thousandth)
 = 15.95 (rounded off to the nearest hundredth)
 = 16.0 in. (rounded off to the nearest tenth or the nearest whole number)

Since 1 cm. = .3937 in.
 32.5 cm. = .3937 × 32.5
 = 12.79525
 = 12.795 (rounded off to the nearest thousandth)
 = 12.80 (rounded off to the nearest hundredth or tenth)
 = 13.0 in. (rounded off to the nearest whole number)

If the measurements were converted from inches into centimeters, the mathematics would be as follows:

1″ = 2.54 cm. 1″ = 2.54 cm.
16″ = 2.54 × 16 13″ = 2.54 × 13
 = 40.64 cm. = 33.02 cm.

The German catalogue gives the same measurements, even though in centimeters. The dimensions quoted in the United States system are probably also of the same painting. Even though 40.5 cm. equaled 16 in. in the conversion from the metric to the United States system, and even though a reversal of the procedure produced 16 in. equaling 40.64 cm.; this discrepancy was due to the rounding off of the figures. The same is true for the variance in the other equation—32.5 cm. = 13 in. and 13 in. = 33.02 cm. The conversion numbers will always vary somewhat due to the fact that a meter is slightly over 39 1/3 inches.

Other Terms

Accession numbers are the identifying marks placed on an object in order that the registrar can keep track of the numerous pieces in the museum's collections. Often the numbers indicate the year the work was acquired. For instance, 47.78 probably means the seventy-eighth work brought into the museum during 1947. The number 1972.47.5 would mean that the object was number five in lot forty-seven which entered the institution in 1972. Some works of art have numerous marks: (a) accession or acquisition numbers,

which have been assigned when the object first entered the collection as well as each time a new registration method was devised, and (b) catalogue numbers which sometimes vary in older institutions depending upon which edition of the catalogue is being discussed.

Casting Marks: the German word, *Guss.*, meaning casting or founding, and the French term, *fondeur,* for founder or caster, are often placed on the piece followed by the name of the company which cast the work.

Edition Size and Number—both for bronze castings and prints—are signified by the juxtaposition of two numbers or a number and a letter: 3/4 means the third casting or print out of four; 5/K, the fifth of eleven made, since *K* is the eleventh letter in the alphabet. On prints, *AP* refers to the artist's proof, of which any number can exist.

Fecit or *Me Fecit,* Latin for "he or she made it," is sometimes used with a signature.

Maquette is a small three-dimensional model for either a sculpture or an architectural monument or building. A French term, it can also mean a rough sketch for a painting.

Pentimento, singular for *pentimenti,* an Italian word meaning to rethink, is the revealing of an earlier form underneath the painting which the artist had painted. Through the course of time the top layer becomes more transparent to disclose the alterations which had been made earlier.

Sides of a piece: recto indicates the right-hand page of a manuscript; *verso,* the opposite side. In a painting or drawing, *recto* means the front or correct viewing side; *verso,* the reverse.

Surmoulage is the process of duplicating a bronze work by making a mould of an existing piece and using this cast, instead of the original one which the artist either made or supervised, to produce an additional work of art.

Auction Sales Information

The International Art & Antiques Yearbook lists approximately two hundred auctioneers and salerooms throughout the world. This figure includes the major branch offices of such auction houses as Phillips, Ader Picard Tajan, Sotheby's, and Christie's. The last two auction houses have been in existence for more than two hundred years. On January 7, 1744, Messrs. Sotheby held their first sale. Heading this London company was the bookseller Samuel Baker, who was the sole proprietor until 1767 when G. Leigh became his associate, an arrangement that lasted until 1778. On that date, Mr. Baker's nephew John Sotheby became a member of the firm which was then called Leigh & Sotheby. In 1964 when the English company purchased the New York firm of Parke Bernet, the name was changed to Sotheby Parke Bernet. Prior to its merger, Parke Bernet Galleries had had its origins in the American Art Association formed in 1883 and the Anderson Galleries. The firm presently has representative offices in fifty-six cities in twenty-seven countries and employs more than two hundred experts in over seventy categories of art and antiques. There are also Sotheby's Appraisal Company, Sotheby Parke Bernet International Realty Corporation, and Sotheby's Restoration, which works on furniture.

Only a few years younger, the auction house now known as Christie, Manson & Woods, Ltd. was begun in 1766. In his London auction house, James Christie originally sold a great variety of items, including seventy-two loads of meadow hay and a coffin. Throughout the years, Christie's has auctioned some of the great art collections, such as Sir Robert Walpole's Old Masters paintings which were purchased for Catherine the Great of Russia in 1777. In 1977 Christie's established a branch office in New York City, where the average price per lot is about $4,000.00. A little later, Christie's East, in the same metropolis, was opened, a place where less expensive items—the average lot sells for a few hundred dollars—are auctioned. Christie's has more than forty offices in fourteen countries. Free verbal appraisals are made, and for probate, insurance, and tax purposes, a written appraisal may be had for a fee. In addition, the firm often offers gallery talks and special seminars.

These two London-New York auction houses publish three principal kinds of references: (1) annual summaries that detail some of the outstanding items that were sold, (2) a monthly newsletter issued ten times a year, and (3) numerous catalogues of forthcoming sales. The annuals, which include all categories of art sold during each year, are beautifully illustrated and contain a number of signed essays, by various experts in different fields, that delve more deeply into various collections and different aspects of the art market. The newsletters are ten-to-twelve page publicity brochures.

In order to advertise their forthcoming sales, most of the auction houses place advertisements in the local newspapers and such publications as *Apollo, Burlington Magazine,* and *Connoisseur.* The larger auction houses produce sales catalogues, which list the works of art that are to be sold at auction. Prior to the sale, the objects are examined and appraised by the auction house's experts, grouped with similar works of art, provided an estimated presale value, and listed in a catalogue of forthcoming sales. These catalogues provide such data as artist's name, title of work, medium, dimensions, date produced, and the estimated presale value which the auction house experts have set on the object. An illustration, often in color, may be included.

Some of the auction houses list an artist's name in a particular way in order to indicate the opinion of the auctioneers as to the degree of the involvement of the artist in the stated work of art. If the complete given names and surname of an artist are provided, the entry means that the work of art is by the artist. If the surname and the initial of the first name of the artist are stated, the work of art, in the opinion of the auctioneers, is of the period of the artist and may be wholly or partly the artist's work. When only the artist's surname is printed, the work of art, the auctioneers believe, is of the school or by one of the followers of the artist or is in the artist's style.

Available approximately one month prior to the date of the auction, the catalogues of forthcoming sales may be purchased either singly or by annual subscription. Issued on such various types of items as French furniture, pre-Renaissance paintings, and Americana, these catalogues include a list of estimated prices for which the items are expected to sell. After the auction takes place, the auction house publishes a list that quotes the price for which each item sold. The sales catalogues can be purchased with or without the list of postsale prices.

As would be expected, sales catalogues can be expensive. For instance, a copy of each of the different types of sales catalogues published by Christie, Manson and Woods, Ltd., with the postsale prices included, costs more than $1,000 per year. If only one specific category is ordered, the annual subscription price is less expensive. Because of the expense of obtaining these and other similar sales catalogues, only those libraries with a real need for them buy them. Among such selective buyers are museum libraries, where the curatorial personnel by necessity must have knowledge of the current market prices. Most large museum libraries subscribe to the complete series of catalogues from a number of auction houses, especially Christie's and Sotheby's. Smaller museum libraries often purchase only the sales catalogues pertinent to the museum's particular art collection.

The indices to auction catalogues provide information on the sales of works of art from a number of auction houses for a particular year. Usually issued annually, these reference tools organize the entries under each artist's name. Although the different indices vary as to the types of information, often they include such data as the titles, media, and dimensions; whether or not the items were signed and dated; the names of the auction houses plus the dates and lot numbers of the sales; and the sales prices stated in the currencies of the countries where the auctions took place. Some of the indices include only sales of drawings and paintings or prints, while other indices are more inclusive in their coverage.

The indices to auction catalogues use abbreviations of which the reader should be aware. A *reserve* is the minimum price for which the owner of the work of art is willing to sell the piece. This amount is always confidential, known only to the seller and auction house. If the reserve price is not met, the auction ceases and the work is taken off the list of items for sale, rather than allow the object to be sold at too low of a price. The price at which the auction was stopped is called a *Brought In* or *B.I.* price.

For information on past auctions, the researcher can examine the annual indices for past years or study some of the works cited in Chapter 16 under "Past Auctions." The latter also have abbreviations and symbols which the researcher will need to learn. For instance, Bénézit's *Dictionnaire critique et documentaire des peintres, sculpteurs, dessinateurs, et graveurs* provides the prices for which some works of art sold under the heading *"Prix"*—for price or value. The abbreviation *Vte.*—for *Vente*—means sale or selling. *Vte. X* or *Vente X* indicates an anonymous sale or one where the auction was not limited to one individual collection being sold.

It is often difficult to discover the value of the international money market for any one year. In the front of Volume I of Bénézit, there is a chart—based upon the *Annuaire Statistique de la France, 1975*—which provides, for most of the years be-

tween 1901 and 1973, the average number of French francs per one U.S. dollar and one English pound. For instance, in 1968, one U.S. dollar equalled 4.9513 francs; in other words, the franc was worth about twenty cents.

In most references, abbreviations for currency are used. The following brief list will assist the reader in deciphering some of these monetary signs:

England	In the English monetary system, the money is written in this manner: 4/6/3 which represents four pounds, six shillings, and three pence. A pound, £, equals 20 shillings, which is abbreviated *s*. Often used to deceive people into thinking they are receiving a bargain, because the numbers are lower, a guinea, *Gns.*, represents twenty-one shillings. There are now five pence, *p.*, to the shilling. Before February 1971 when the British government went on the metric system, there were twelve pence to a shilling.
France	A French franc can be abbreviated *fr., F.F.,* or F.Fr. Bénézit uses *fr.* for the franc of pre-1959 and *F.* for the money after that period when the valuation was changed.
Germany	*D.M.* stands for the German Deutsches Mark. Prior to 1848, the currency was called a reichsmark.
Italy	An Italian lira is usually *L.* or *I.L.*
Belgium	A Belgium franc is *F.B.* or *B.FR.*
Denmark	A Danish krone is *Dkr.* or *D.KR.*
Holland	A Dutch florin is *Fl.* or *D.Fl.*
Switzerland	A Swiss franc is *Sfr.* or *S.FR.*

Art History Books

In the sixteenth century, Giorgio Vasari wrote *Le vite de'piu eccellenti pittori, scuttori, e architetti,* or *Lives of the Most Eminent Painters, Sculptors, and Architects.* This was the first bi-ography of famous artists. Since that date, a popular method for studying the discipline has been through knowledge of artists and their works. Reference books concerned with artists and their *œuvres* take various forms: (1) monographs, catalogues raisonnés, and *œuvres* catalogues and (2) *corpora, Festschriften,* and symposia papers.

Monographs, Catalogues Raisonnés, *Œuvres* Catalogues

There are three types of reference works written on individual artists and their *œuvres*. A *monograph,* which is a treatise on any one subject or on one individual artist, provides some historical or biographical material and, in the case of an artist, some information on a few of the artist's more famous works of art. A catalogue raisonné and an *œuvre* catalogue are critical or descriptive studies of all of the works of art of one artist or all of one artist's artistic endeavor in one medium. *Œuvre,* French for production or work, can be used to denote either the complete artistic output of an artist or all works in a specific medium. In French, *raisonné* means ordered, rational, or analytical. Often appended to a monograph on the artist, these two types of catalogues systematically list and provide a catalogue entry on each work of art in an artist's entire *œuvre*. The difference between the two is the amount of material reported for each work of art. In a *catalogue raisonné* each entry on an art object cites the title of the piece, dimensions, medium, probable date when the work was completed, and current location. Other items are included, such as the exhibitions in which the work has been displayed, the provenance or a list of the former owners, literature that has referred to the piece, and any additional pertinent information. Problems of authentication are discussed. Often samples of fakes, forgeries, and studio works are reproduced. Catalogues raisonnés published today usually include an illustration of each work of art. Although an *œuvre catalogue* may include all of the known works of art by an artist, the *œuvre* catalogue does not give as full a citation on each art piece as does the catalogue raisonné.

Corpora, Festschriften, and Symposia Papers

Because of the recurring need to bring together the research of international scholars, publications of *corpora, Festschriften,* and papers from symposia and conferences have resulted. A *corpus*—the plural is *corpora*—provides exhaustive

research material on a specific subject or type of monument. Usually a multivolume work, a *corpus* includes complete documentation, extensive bibliographical and archival data, plus every important known fact concerning the subject. A *corpus* can be written and published in individual books, called fascicles, over an extended period of time. For example, *A Corpus of Spanish Drawings,* by Diego Angulo and Pérez Sánchez is a multivolume work which, when completed, will contain all of the drawings made in this Iberian country from 1400 to 1800. Due to the magnitude of a *corpus,* the materal must be organized in some rational manner. The researcher may need to compile preliminary facts concerning the subject prior to using certain *corpora.* For instance, the *Corpus della scultura altomedievale (Complete Body of Pre-Medieval Sculpture),* published in five volumes from 1959 to 1974, includes illustrations and documentation on sculpture in Italy. Because the material in the *corpus* is organized according to the ecclesiastical districts—such as, la diocesi di Lucca—in which the art is located, the researcher must be familiar with this information prior to using the work.

A *Festschrift* is a collection of essays written in honor of a well-known person or institution. An example is the 1939 two-volume work, *Medieval Studies in Memory of A. Kingsley Porter,* edited by Wilhelm R. W. Koehler. The book contains important articles by such scholars as Mike Shapiro and Kenneth J. Conant. Often written in numerous languages, the essays in a *Festschrift* may center around a broad theme. For instance, *Studies in Late Medieval and Renaissance Painting in Honor of Millard Meiss,* a two-volume work published in 1977, consists of more than forty essays which were presented in 1974 to art historian Meiss on his seventieth birthday. Written in English, Italian, French, and German, the Meiss *Festschrift* includes a variety of subjects, as the titles of some of the essays indicate: "A Book of Hours Made for King Wenceslaus IV of Bohemia," "Pope Innocent VIII and the Villa Belvedere," "Albrecht Dürer um 1500," "Per Paolo Uccello," and "The Mystical Winepress in the *Mérode Altarpiece.*" The contributors to this *Festschrift* included such scholars as James S. Ackerman, Creighton Gilbert, Richard Krautheimer, Charles Seymour, and Charles Sterling.

Papers read at symposia and conferences, on the other hand, often are chosen not only for their scholarly content but because they relate to a specific topic. For example, the 1978 conference at the Institute of Contemporary Art in Los Angeles was entitled The New Artsspace. The publication of the conference contained twelve articles which approached various aspects of the subject, such as "Artists' Books as Alternative Space," "Art Museums and Alternative Spaces," "Placing the Artist," and "Alternative Spaces and the University." Because these individual works and the articles in *Festschriften* can be difficult to find, a discussion of references which will assist researchers to locate these materials is provided in Chapter 25.

ON THE EUROPE BRIDGE
A CATALOGUE ENTRY

ARTIST & DATES:
 Caillebotte, Gustave, 1848-1894
TITLE:
 On the Europe Bridge. Originally entitled Le Pont de l'Europe.
 Later called Sur le Pont de l'Europe. When transferred to the
 Kimbell Art Museum in 1892,it was renamed.
DATE:
 1876-77
MEDIUM:
 Oil on canvas
SIZE:
 105.3 X 129.9 cm (41 1/2" X 51 1/8")
DATA ON OBJECT:
 Stamped in blue ink, lower right: G. Caillebotte
CONDITION:
 Excellent. Unlined original canvas; the paint film in 1982
 was nearly pristine.
PRESENT LOCATION & ACQUISITION NUMBER:
 Kimbell Art Museum, Ft. Worth, Texas AP82.1
PROVENANCE:
 Martial Caillebotte (Gustave's brother), Paris
 Descendents of M. Caillebotte
 Extended loan, National Gallery of Ireland, Dublin, 1964-1971
 Private Collection, Paris by 1976
 1982 sold to the Kimbell Art museum.
EXHIBITIONS:
 Rétrospective Gustave Caillebotte, Galerie Beaux-Arts,
 Paris, May 25-July 15, 1951. Catalogue number 10.
 Gustave Caillebotte, A Loan Exhibition, Wildenstein, London,
 June-July 1966, catalogue number 5.
 Gustave Caillebotte: A Retrospective Exhibition, Museum of
 Fine Arts, Houston, and The Brooklyn Museum, October 1976-
 April 1977, catalogue number 22.
LITERARY REFERENCES:
 Wildenstein Gallery, New York. Gustave Caillebotte: A Loan
 Exhibition. New York, Wildenstein & Company, Inc., 1966,
 pp. 12; 23.
 Varnedoe, J. Kirk T. "Caillebotte's Pont de l'Europe: A New
 Slant." Art International 18 (April 20, 1974): 28-29, 41,
 58. Extensive discussion of Geneva painting.
 Museum of Fine Arts, Houston. Gustave Caillebotte:
 Retrospective Exhibition. Houston: Museum of Fine Arts,
 Houston, 1976, pp. 105-107; see Varnedoe's "Caillebotte's
 Space," pp. 60-73.
 Berhaut, Marie. Caillebotte sa vie et son oeurve: Catalogue
 raisonné des peintures et pastels. Paris: Foundation
 Wildenstein, 1978, p. 94, catalogue number 46.

RELATED WORKS:
 Sketch for On the Europe Bridge:
 Esquisse pour Le Pont de l'Europe, variant, 1876-77, oil
 sketch on canvas, 64 X 80 cm. (25 1/4 X 31 1/2 in.),
 Stephen Hahn Gallery, New York (Berhaut's catalogue
 raisonné, 1976, No. 45).

 Variation and Studies of Bridge Theme:
 Le Pont de l'Europe, 1876, oil on canvas, 131 X 181 cm. (51 5/8
 X 71 1/4 in.), Musée du Petit Palais, Geneva (Berhaut's
 catalogue raisonné, 1976, No. 44).
 Esquisse pour Le Pont de l'Europe, 1876, oil sketch on canvas,
 82 X 120 cm. (32 3/4 X 48 1/2 in.), Albright-Knox Art
 Gallery, Buffalo (Berhaut's catalogue raisonné, 1976,
 No. 38).
 Esquisse pour Le Pont de l'Europe, 1876, oil sketch on canvas,
 54 X 73 cm. (21 1/4 X 28 3/4 in.), Private Collection,
 Paris (Berhaut's catalogue raisonné, 1976, No. 40).
 Esquisse pour Le Pont de l'Europe, 1876, oil sketch on canvas,
 32 X 46 cm. (12 5/8 X 18 1/8 in.), Musée des Beaux-Arts,
 Rennes (Berhaut's catalogue raisonné, 1976, No. 39).
 Etude pour Le Pont de l'Europe-les poutres en fer, 1876, oil
 study on canvas of iron girders, 55.5 X 45.7 cm. (22 X
 18 in.), Private Collection, Paris (Berhaut's catalogue
 raisonné, No. 42).

ADDITIONAL INFORMATION:
 In the 1966 Wildenstein exhibition catalogue, On the Europe
 Bridge is described as a study for part of the larger painting,
 Le Pont de l'Europe, 1876, which is now in the Musée du Petit
 Palais, Geneva. In his 1976 catalogue, Varnedoe states that this
 highly finished work, which is preceded by its own sketch, is a
 variant of a bridge theme, rather than a study for the Geneva
 painting. The fact that both works have had the same title adds
 to the confusion. Varnedoe suggests that the two paintings might
 be a pair, with the Geneva work's sunny view contrasting with the
 wintery blue greys in the Kimbell painting.
 The Pont de l'Europe is an enormous bridge which spands the
 Gare St.-Lazare, not too far from Caillebotte's former home in the
 residential district, Quartier de l'Europe. The area reflects the
 growth and changes that transformed the city of Paris under Baron
 Georges Haussman during the Second Empire. Caillebotte's brother
 recounted to his family that in order to work in all kinds of
 weather, Gustave painted his views of the Pont de l'Europe from a
 carriage.[1] No figure in the painting is full length and totally
 seen; all are cropped. The gentleman wearing the top hat and
 looking through the iron girders is thought to be Caillebotte
 himself.

 [1]Quoted in Berhaut, 1951 and repeated in Museum of Fine Arts,
 Houston, 1976, pp. 98-99.

Example 3: *On The Europe Bridge:* A Catalogue Entry for the Caillebotte Painting at the Kimbell Art Museum,
Ft. Worth, Texas.

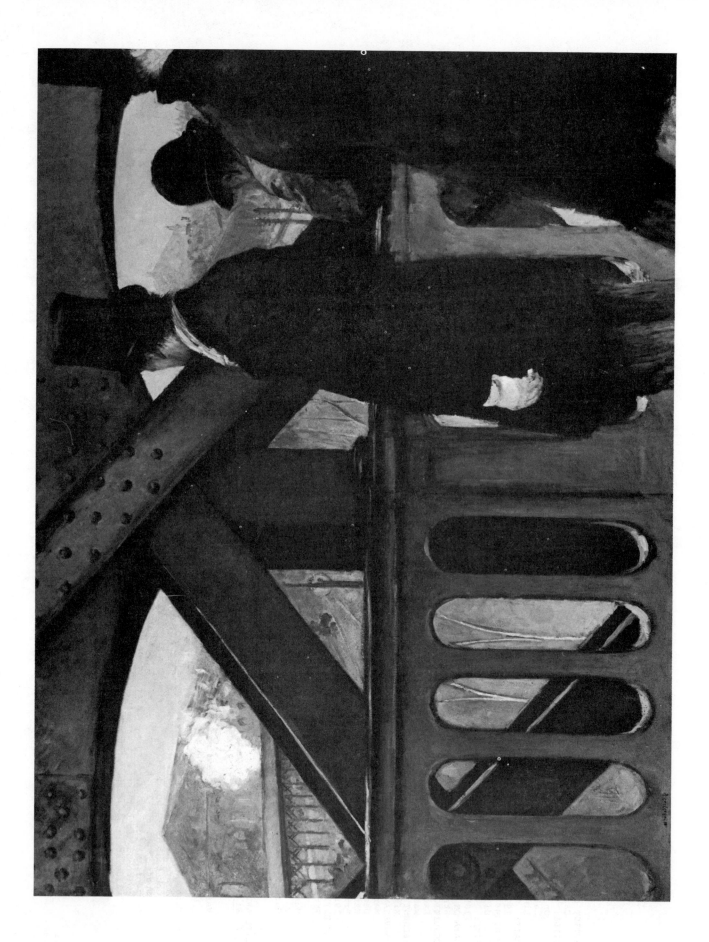

PART II

Art Research Methods

Prior to beginning this section, readers should be sure that they understand "Part I: Before Research Begins," which defines and details some important aspects of research. Part II, which explains various methods of solving research problems, contains five chapters. Chapter 4 provides a step-by-step description of how a working bibliography and a chronology are compiled. Every student should study this section; it is the core of this book. Chapters 5 through 8 discuss additional pertinent reference works needed for specific types of research. While reading Part II, the researcher will need to refer to the resource tools which are annotated in Part III.

Basic Research: Compiling Working Bibliographies and Chronologies

Research begins with a review of the literature—the published material on the subject, or as much as can be obtained for the depth of the study. This requires compiling a working bibliography, which is a list of the books, articles, and catalogues which are related to the topic. Another important aspect of research is formulating a chronology of the person, monument, or event, a process which should be done as the material is collected. Because these two items require similar procedures, they are discussed together in this chapter. As an example, Gustave Caillebotte will be used throughout this chapter.

Each library's catalogue—including author, title, and subject files—should be checked at various times during the compilation of the working bibliography in order to discover whether or not the library possesses any of the published works mentioned in the references. The required books and articles may not be available at a local library. These references usually may be obtained, if enough time has been allotted, through an interlibrary loan.

Sometimes a working bibliography is curtailed to include only those references written in English, French, German, and Italian, or to contain some combination of various languages. Unfortunately, students who are just beginning research often shy away from important foreign-language works. But it is best to make as complete a list as possible, including all foreign-language publications, because these references often provide essential information on the research topic. By consulting the lists of commonly used German, French, and Italian words found in the appendices at the end of this book, careful readers can learn a great deal about what is included in foreign-language publications. In addition, in most biographical dictionaries as well as many other research materials, the references to countries and cities are written in the vernacular of that particular dictionary. For instance, the Belgium city of Gent would be spelled Gand in a French reference and Ghent in most

English and American works. The multilingual glossary of geographic locations in Appendix D will aid the reader in finding the various spellings of these places.

There are several reasons why foreign-language publications should be consulted by the researcher who cannot read the text of the reference: (1) some foreign-language periodicals publish articles in English or provide English summaries, and the titles of these articles do not always indicate this fact; (2) the illustrations which might be reproduced could prove to be of the utmost importance; (3) bibliographies usually contain references to books and catalogues in all languages, and some of the references may be essential to the topic; (4) the chronology of the artist or building, which may be included in the foreign-language reference, could report pertinent dates and facts; and (5) for a specific work of art, the foreign-language reference may record such essential information as the title of the work, medium, dimensions, date and signature data, provenance, and present location. Before seeing the foreign-language references, it is difficult to tell whether or not any valuable information can be gleaned from the references. For this reason, researchers should list all pertinent data during the compilation of the working bibliography. The culling of the material should be postponed until the selected bibliography is written.

Basically the ten types of art reference works discussed in this chapter are the most pertinent for compiling a working bibliography. Researchers who are writing on artists or subjects for which there is a tremendous amount of material available will probably not be able to locate and read the majority of the references reported by the various sources. For example, in studying the works of artists such as Henri Matisse and Pablo Picasso, the reader will discover such quantities of material on these artists and their *œuvres* that the problem for the researcher then becomes one of determining which references are of the highest

priority. In order to ascertain which authors are the authorities on the research topic, the reader should check the credentials and read the reviews of the principal authors whose references are being studied, a process which is detailed in Chapter 5 of this guide.

No bibliography is ever complete. There are always articles published in journals and magazines which are not indexed by any of the indices of periodical literature. Consequently, the knowledge of information contained in the articles cannot be easily located. Then, too, in compiling working bibliographies, researchers are gathering all of the written material that can be found through the libraries that are accessible to them. Under the circumstances, the number and kinds of references available in the various local institutions will, to a great extent, determine the quality of the bibliographical list produced. For these reasons, other people's bibliographies should be scrutinized for possible additions to help formulate this working list. Most of the references annotated in Part III of this guide include bibliographies. When these references are examined, the bibliographies they contain should also be studied. Some of the books cited will be repetitive; thus the major resources will usually become evident because of their reoccurrence.

Although the investigator may use a number of different kinds of reference works to find material for a speech, a term paper, a thesis, or an article, not every item that is used during the research process is included in the working bibliography. Usually general art-survey books, sources of reproductions of works of art, book-review information, and sales catalogues are not cited. The various publications which provide information on the subject are listed, but not the sources which led the researcher to the informative materials. For instance, in the working bibliography of Example 17, the article by Léonce Bénédite in the *Gazette des Beaux-Arts* is reported, but not the New York Public Library catalogue of holdings, *Dictionary Catalog of the Art and Architectural Division,* where the reference to the article was found. Likewise, Waldfogel's article in *Gazette des Beaux-Arts* is cited, but not the *Art Index* which led to it.

By necessity, the reader will need to study the material in this section while referring to chapters in Part III of this book. Because the references listed in Part III are utilized in many various types of research, these works had to be separated from the methodological discussions. As a consequence, as each of the different kinds of reference works needed to compile a working bibliography is studied, the reader should also examine the annotations for the books and catalogues in the chapters which are cited.

For a working bibliography or a chronology, the researcher will need to consult the following:

1. Art encyclopedias and dictionaries furnish a broad scope on a subject and concise definitions of terms, styles, and historical periods. A list of these reference works is provided in Chapter 9.

2. Biographical dictionaries relate brief information on artists' lives. Chapter 10 has annotated entries for these resource tools.

3. Catalogues of holdings of famous libraries are reprints of the records of the collections of institutions which are noted for their extensive collections of specific reference works. These catalogues will assist readers in discovering titles of books, articles, and catalogues written on the research topic. Chapter 11 describes these catalogues.

4. Periodical articles report research on a narrow aspect of the subject. Indices and abstracts of periodical literature lead readers to titles pertinent to the study. Chapter 12 has a listing of these indices and abstracts.

5. References on artists and various aspects of art as well as subject bibliographies will be needed, because these works record previously published research on the topic. Chapter 13 cites these works.

6. Scholarly museum and exhibition catalogues relate the information which the owners of the works of art possess and often report the results of the latest research on an artist's *œuvre*. Information is cited on museum catalogues in Chapter 14 and on exhibition catalogues in Chapter 15.

7. References which provide data concerning past exhibitions in which an artist may have displayed some works of art may need to be consulted. If possible, the actual catalogue should then be studied in order to verify the material. Chapter 15 records resources for finding information about exhibitions.

8. Auction catalogues sometimes report information on works of art as well as reproduce illustrations of these objects. Chapter 16 lists the reference tools which pinpoint the auctions in which the artist's works were sold.

9. Indices to reproductions of artists' works will provide access to essential illustrative materials. Chapter 17 records these works.

10. An online bibliographic database search will sometimes shorten the process of compiling material. However, these computer searches are not the end to a research problem. Citations for specialized online databases which are pertinent to the humanities are included in several chapters; for a special listing, see Chapter 12.

Each of these ten categories will be discussed in detail in order to assist the reader in perceiving the best ways to use these various types of references. But it must be remembered that compiling a working bibliography is only one of the first steps in solving a research problem. Other materials must also be used. In addition, studying an individual artist as famous as Gustave Caillebotte presents one set of research problems. Other subjects require slightly different approaches and references. Various kinds of research problems are discussed in the other chapters of Part II.

How to Utilize Art Encyclopedias and Dictionaries. Also see Chapter 9

The primary search for works that have pertinent data on the chosen topic begins with the art encyclopedias and dictionaries. These essential works provide succinct statements on terms, styles, and artists. Since, in the titles on the list, such terms as *encyclopedia, dictionary, directory,* and *guide* have no exact meaning as to the material the works include, each of the books described in Chapter 9 has been clarified as to the contents by being classified into one of only two categories: "Art Encyclopedias" and "Art Dictionaries."

In this book, an *art encyclopedia* is defined as a multivolume illustrated work that includes signed articles and bibliographical data on various phases of art from different periods and that thus provides the type of general historical background essential to any kind of research. Example 4, a reproduction of the Caillebotte entry in the *Praeger Encyclopedia of Art,* illustrates the type of information gleaned from encyclopedic resources. Cited are Caillebotte's nationality, dates, types of paintings, and bequest of Impressionist works, plus one bibliographical reference to M. Berhaut's *Gustave Caillebotte,* Paris, 1951.

CAILLEBOTTE, Gustave (1848, Paris—1894, Gennevilliers, Seine), French painter, best known as one of the principal patrons of the Impressionists. Although he was a minor painter, his work shows some talent. From 1876 to 1882 he took part in five of the exhibitions of the Impressionist group. His portraits (*Henri Cordier,* 1883; Paris, Louvre) and landscapes may have been influenced by Degas, but his views of Paris (*Snowy Rooftops,* 1878; Louvre) and realistic scenes of working-class life (*Workmen Planing a Floor,* 1875; Louvre) are highly personal in expression. In his will Caillebotte left his collection, comprising no less than 65 Impressionist works, to the State, which, however, rejected it. After three years of negotiations and a campaign in the press, 38 of the pictures were accepted. It was not until 1928 that these works—including Renoir's *Swing* and *Moulin de la Galette,* and Pissarro's *Red Roofs*—finally entered the Louvre.

BÉRHAUT, M. *Gustave Caillebotte.* Paris, 1951.

Example 4: From *Praeger Encyclopedia of Art,* Vol. 1, p. 331, 1971. Reprinted by permission of Praeger Publishers, Inc., a Division of Holt, Rinehart and Winston.

Caillebotte is called an Impressionist in the Praeger article. If the student does not thoroughly understand this term, the entry under this word should also be read in the encyclopedia, or the term should be looked up in an art dictionary. *The Encyclopedia of World Art* is an especially good source for detailed discussions of styles, periods, and concepts.

Art dictionaries define terminology from a number of disciplines. These works, which are described in Chapter 9, are subdivided for easier reference into various categories. Readers should meticulously study the annotations that accompany these references. If the works are carefully selected, a researcher may need to peruse only one or two of the encyclopedias or dictionaries. In all probability, a couple of these references should prove adequate to yield the definition sought or to provide a beginning for the research planned.

How to Utilize Biographical Dictionaries of Artists. Also see Chapter 10

Because the succinct biographical statements provided for individual artists in the art encyclopedias are inadequate for any in-depth research, the biographical dictionaries, which are annotated in Chapter 10, should also be consulted. Some of the most highly esteemed of the biographical dictionaries are written in German, French, or Italian.

There are several kinds of information that can be gleaned from foreign-language dictionaries. This may include important dates in an artist's life, titles and locations of some works of art, sales prices of art objects, a facsimile of the artist's signature, and bibliographical citations. The information may be verified in other references which the reader may consult, but the notations in the bibliography that a particular artist is included in some of the scholarly foreign-language biographical dictionaries are an indication of that artist's esteem. In addition, the biographical dictionaries assist investigators in discovering the various spellings of artists' names as well as in determining which part of each name will most likely be used by indices and other reference works.

One of the most esteemed biographical dictionaries is *Allgemeines Lexikon der bildenden Künstler von der Antike bis zur Gegenwart* by Ulrich Thieme and Felix Becker, usually referred to as *Thieme-Becker Künstlerlexikon*. This German work of thirty-seven volumes contains signed articles which include data on the artists' lives, locations of some of their works, and bibliographical citations. The dictionary is particularly useful for discovering early periodical references. At the end of the Thieme-Becker article on Caillebotte, which is illustrated in Example 5, and immediately preceding the name of the contributor, O. Grautoff, is a list of early bibliographical references.

The books and articles that are included in the Thieme-Becker article do not have complete bibliographical entries. Moreover, the citations are abbreviated to the point that they may be hard to decipher. For instance, among the Caillebotte references, there are listings for *Le Temps*, v. 3, 1894 and J. Bernac, *The Art Journal*, 1895. In Example 17 these selections were recorded in the working bibliography, even though the details in the citations are not complete, inasmuch as the references may be essential to the topic. Information might be found later that will complete the

Caillebotte, G u s t a v e, Maler, geb. 1848 in Paris, † am 2. 3. 1894 in Gennevilliers; studierte in Paris und trat früh in Beziehungen zu den Impressionisten Monet, Renoir, Pissaro, Sisley, Cézanne, denen er sich von ihrer zweiten Ausstellung an, 1876, endgültig anschloß, in der er mit dem noch in dunklen Tönen gehaltenen Bilde „Les raboteurs du parquet" debütierte. Claude Monet gewann besonderen Einfluß auf ihn, leitete ihn an, im Freilicht zu malen und seine Palette aufzuhellen. Als Maler steht Caillebotte unter den Impressionisten in zweiter Linie; aber als Freund der großen Meister dieser Zeit hat er seinen Platz in der Geschichte. Er war

reich und unterstützte seine ärmeren Kameraden in großzügigster Weise, indem er ihnen Ausstellungslokale mietete, eine energische Propaganda für sie einleitete und selbst eine bedeutende Anzahl ihrer Werke kaufte, die er testamentarisch dem Musée du Luxembourg in Paris vermachte. Renoir war sein Testamentsvollstrecker und hatte im Verein mit Caillebottes Familie, Monet, Degas und der Elite Frankreichs häßliche Kämpfe durchzufechten, da der französische Staat sich weigerte, dieses Vermächtnis anzutreten. Endlich einigten sich Erben und Staat dahin, daß von 3 Manets 2, von 16 Monets 8, von 9 Sisleys 6, von 18 Pissaros 9, alle 7 Degas', von 4 Cézannes 2, von 8 Renoirs 6 und 2 Bilder von Caillebotte („Les Raboteurs du parquet" und „Toits sous la neige") für das Luxembourg ausgewählt wurden. Die ausgewählten Bilder wurden schon 1894 auf 400 000 Francs geschätzt.

Caillebotte hat sich auch als Radierer betätigt, von seinen Blättern seien genannt: „Die Ruderer", „Alte Frau mit Haube" und ein Porträt Storelli's.

D u r a n t y, La nouv. Peinture (1876). — C h. E p h r u s s i in Gaz. d. B.-Arts 1880 I 487 f. — D u r e t, Critique d'Avantgarde (1885); Les Peintres Impressionistes (1906). — F é n i e r, Les Impressionistes en 1886 (Paris, publ. De la Vogue). — Le Temps v. 3. 3. 1894. — Chron. des Arts 1894 p. 71, 85. — J. B e r n a c in The Art Journ. 1895 p. 230 f., 308 f., 358 f. *O. Grautoff.*

Example 5: Thieme, Ulrich and Becker, Felix. *Allgemeines Lexikon der bildenden Künstler von der Antike bis zur Gegenwart.* Leipzig: E. A. Seemann, 1907–50. Volume 5, page 361.

bibliographical entries. For example, Jean Bernac's article "The Caillebotte Bequest to the Louvre," *The Art Journal*, 1895 was reprinted in the catalogue of the 1966 Caillebotte exhibition held by the Wildenstein Gallery in London. And although additional information might not be readily located on the reference published in *Le Temps*, further searching by the investigator might unearth a complete bibliographical entry for this reference. For details on locating publications issued prior to 1900, the reader should consult Chapter 25 of this guide.

Another highly regarded biographical dictionary is the French multivolume work by Emmanuel Bénézit, *Dictionnaire critique et documentaire des peintres, sculpteurs, dessinateurs, et graveurs,* illustrated in Example 6. Although this dictionary includes little or no bibliographical data, it often indicates, under the section entitled *"Prix,"* some of the sales prices of art works. Other important features of Bénézit's work are the facsimiles of artists' signatures that are sometimes reproduced and the locations of some works of art that may be reported. These major biographical dictionaries should be consulted, as each reference may record an additional clue to the puzzle being solved. Bénézit provided some sales prices and a facsimile of Caillebotte's signature and Thieme-Becker, some early bibliographical references. The fact that Caillebotte was cited in these two works is a measure of his fame.

The ease with which biographical information on artists is discovered depends upon their reputation. World-renowned people are easily located. However, in order to find biographical material on artists who do not have an international reputation, the reader will probably need to consult one of the specialized dictionaries recorded in Chapter 10. These references are divided into categories by nationalities and media. Since some of these divisions overlap one another, the researcher should scrutinize all of the categories in which a particular artist fits. For example, an American architect and painter of the twentieth century might be included in the dictionaries covering architects, American artists, and painters.

Everyone appreciates a short cut to a long tedious job. Each of the indices to biographical information, annotated in Chapter 10, will pinpoint exactly in which of the specialized indexed dictionaries a particular artist will be cited. Under the circumstances, these indices to biographical information save the researcher from having to check individually the references that are covered by each index. Moreover, librarians sometimes add the call numbers of the reference works owned by their institutions beside the entry to the reference. Consequently, the reader knows immediately which references can be located in that library. Patricia Havlice's three-volume work, *Index to Artistic Biography,* for example, is a guide that readily reveals which artists have entries in the different biographical dictionaries that the Havlice books cover. The volumes by Bénézit and Thieme-Becker are not included in the list. The Caillebotte example will clarify the kinds of information that can be gleaned from examining Havlice's work. Under the French Impressionist painter's name are recorded his dates, nationality, and three biographical dictionaries that include entries on him. The works cited are (1) *Dictionnaire des peintres français,* Paris, Editions Seghers, 1961;

Example 6: Bénézit, *Dictionnaire critique et documentaire des peintres, sculpteurs, dessinateurs, et graveurs.* Paris, Librairie Gründ, 1976, Tome II. Reproduced by the kind permission of the editor. Selection from the Caillebotte entry.

(2) *Dictionary of Modern Painting,* New York, Tudor, 1964; and (3) *Kindlers Malerei Lexikon,* Zurich, Kindler Verlag, 1964. The researcher is thus relieved of having to check the books which Havlice indexes to find entries on Caillebotte. These indices of biographical information, which are sources for locating material, do not actually contain the biographical data. Hence, the indices, such as the Havlice books, are not listed in the researcher's working bibliography. Only dictionaries that actually record biographical information on the artist, such as *Kindlers Malerei Lexikon,* are included.

How to Utilize Catalogues of Holdings of Famous Libraries. Also see Chapter 11

Another important category of references consists of the multivolume works which many large or specialized libraries have published in order to reproduce the cards in a library's catalogue files as of a certain date. A catalogue of a library's holdings usually consists of all of the titles at the institution of (1) magazine articles, such as the *Avery Index to Architectural Periodicals;* (2) books and catalogues, such as the *Library Catalog of the Metropolitan Museum of Art;* or (3) all of the reference material—articles, books, catalogues, and vertical files, such as *Catalog of the Library of the Museum of Modern Art.* The material published in a catalogue of a library's holdings can be accessed by the names of the authors, by the book titles, by various subjects or categories, or by some combination of these means. With the subject-access catalogues, researchers can discover the resource materials which certain institutions, such as the Fine Arts Library of Harvard University, have on a specific artist or on a particular topic.

The catalogues of holdings of famous libraries, which are annotated in Chapter 11, will assist the researcher in discovering titles of various references written on the subject—monographs, catalogues raisonnés, exhibition catalogues, books, pamphlets, and articles—as well as in completing bibliographical data which might be essential in order to locate specific reference material. Some catalogues provide a variety of additional important information, such as the birth and death dates of authors, the inclusion of illustrative material or a bibliography, and the title of any series to which the work might belong. Finding a book or an article listed as owned by a particular library does not mean that the investigator must go there to read it. The work can often be borrowed or photocopied from some other institution that participates in interlibrary loans. Chapter 25 details how these cooperative loans are made.

The importance of studying the subject catalogues of large art libraries cannot be overemphasized, especially the catalogues of libraries that have special collections which reflect the same concern as the research topic. The entries in these library catalogues often provide a more definite and analytical classification of various subjects than do other kinds of references. They supply information which can be obtained nowhere else. For instance, the MOMA catalogue—MOMA is an abbreviation commonly used for the Museum of Modern Art in New York City—has subdivisions for the subject headings under a particular artist's name that enable researchers to pinpoint more accurtely exactly which references are needed for their particular studies. In the *Catalog of the Library of the Museum of Modern Art,* there are 187 entries for books, articles, and exhibition catalogues under the name of "Degas, Hilaire Germain Edgar." These numerous entries are subdivided into thirteen subject categories—general references, dancers, draftsman, exhibitions, individual works, monotypes, pastels, photographer, portraits, printmaker, reproductions, sculptor, and collection. There is also a notation of a vertical file containing miscellaneous uncatalogued material on Degas, material which is available to researchers who visit this New York City museum library. The cards which are reproduced in MOMA's catalogue include entries for the books, articles, and exhibition catalogues plus notations for references which have important sections on Degas. For instance, there is a listing for Ambroise Vollard's *Recollections of a Picture Dealer,* 1936. The entry reports that on pages 177 through 180 there is an account of Degas and the use of models. The Vollard entry card filed under the French artist's name does not provide a full bibliographical entry on Vollard's book. The researcher would need to check the main author entry card under Vollard's name in the MOMA catalogue to obtain this bibliographical data.

No less impressive is the information provided for contemporary artists in the MOMA catalogue. Larry Rivers has twenty-three entries under his name. These citations are divided into three categories—general references, draftsman, and

exhibitions—plus the notation of available uncatalogued material in a vertical file. Here too is an invaluable notification. A reference entry is included for James Thrall Soby's *Modern Art and the New Past,* 1957. This citation relates that on pages 192 through 196 there is an account of an interview with Larry Rivers. Access to this kind of analytical cataloguing is exceedingly difficult to find.

One of the largest U.S. art libraries is the Thomas J. Watson Library of the Metropolitan Museum of Art. The original 1960 publication which reproduced the cards of the collection of this New York museum's library was issued in twenty-five volumes. Between 1962 and 1980, eight supplements followed. In 1980 there was a second edition of forty-eight volumes that incorporated these additions, followed in 1982 by a supplement. In the second edition under "Caillebotte, G.," there are four entries: (1) Marie Berhaut's *Caillebotte: sa vie et son œuvre,* (2) the 1965 exhibition at the Musée de Chartres, (3) the 1976 exhibition at the Houston Museum of Fine Arts and The Brooklyn Museum, and (4) the 1966 catalogue of the exhibition at Wildenstein Gallery. There is also a cross reference to "Paris, Musée du Luxembourg, Caillebotte Collection," where another article is listed. Example 7 is a sample of one of the citations for the artist. The card for the book indicated that (1) Marie Berhaut was the author; (2) the work was published for the Wildenstein Foundation by Bibliothèque des arts in Paris in 1978; (3) there are 270 pages, a colored illustration on the frontispiece—the page preceding the title page, and 542 illustrations, thirty-one of which are in color; plus (4) the work measures 32.5 centimeters in height and includes full-page color illustrations.

For pertinent material on the research topic, the reader should examine all of the catalogues which are listed in Chapter 11 under "General Art Libraries" and that are available to the reader. The investigator should also check all of the catalogues which are annotated under "Specialized Libraries" in Chapter 11 and that have the same subject specialization as the research topic. Remember that each institution has a different group of reference materials. For example, under Caillebotte's name, the New York Public Library in New York City lists five references concerned with the French artist in the seventh volume of the catalogue of its holdings, *Dictionary Catalog of the*

Example 7: *The Metropolitan Museum of Art New York, Library Catalog,* 2nd edition, revised and enlarged. Boston: G. K. Hall & Company, 1980. Volume 9, page 600.

Art and Architecture Division. One of the references, the article in *Gazette des Beaux-Arts* by Léonce Bénédite, was not cited by other library catalogues.

Some of the catalogues of famous libraries have annual supplements to update the reference material. For example, the *Dictionary Catalog of the Art and Architecture Division of the New York Public Library* was published in thirty volumes in 1975. The annual *Bibliographic Guide to Art and Architecture* has provided access to the works which have been acquired each year by this library. Some of the catalogues of famous libraries are now in several formats. The second edition of the *Avery Index to Architectural Periodicals,* 1973 was issued in printed volumes, as were the supplements. When the hard bound volumes were no longer available, the Avery publication was reprinted on microfiche. The *On-line Avery Index to Architectural Periodicals,* a database through RLIN, has the records of this library dating from 1980. There will be no additional supplements to the printed volumes. In the future, there may be fewer printed catalogues of holdings of famous libraries, as more and more libraries have their collection records on computer tapes. This does not negate the importance of the printed catalogues. They are still some of the best sources of research materials available.

The extensive publications of the U.S. Library of Congress, which are available on microfiche, hardbound copies, and online databases, can be useful in finding research material. The *National Union Catalogs,* abbreviated NUC, provide access to the books which are catalogued by the staffs

of the Library of Congress and participating libraries. *The National Union Catalog Pre-1956 Imprints* is a retrospective catalogue of 754 volumes providing access by author or main entry to the millions of works published before 1956 owned by about 650 U.S. and 50 Canadian libraries. *The National Union Catalog: Author List* which is illustrated in Example 24, and the *Library of Congress Catalog: Books: Subjects,* which was begun in 1950, were both issued in quarterly, annual, and quinquennial cumulations through December 1982. These publications were replaced in January 1983 by the *NUC Books,* a COM catalogue which combines the *National Union Catalog Author List, Library of Congress Subject Catalog, Library of Congress Monographic Series,* and *Library of Congress Chinese Cooperative Catalog.*

Issued monthly, *NUC Books* consists of two principal parts: (1) the Register, which contains the main entry and full bibliographical record for each work catalogued, is arranged in one continuous list by numbers, and (2) the four indices— author, title, subject, and name of a series—are arranged alphabetically and are cumulated each time they are published. Since about 1968, some of the Library of Congress records have been put onto magnetic computerized tape. These LC MARC tapes are available through OCLC and RLIN, as explained in Chapter 2 under "Bibliographic Computer Systems," and as a specialized online database through DIALOG. Both *NUC Books* and the *LC MARC Database* provide access to recent material on the research topic. Using the microfiche of *NUC Books* requires several steps. First, the subject index must be consulted. Second, the number in the lower right-hand corner of the brief bibliographical citation must be noted. Finally, this number is used to locate a full bibliographical record for the book in the Register.

In the January–April 1983 *NUC Books,* under "IMPRESSIONISM (ART)—FRANCE—EXHIBITION," there was an entry for *Impressionist Group Exhibitions,* 1981. When the full bibliographical entry in the Register was read, the citation revealed that this book contained reprints of the catalogues of the eight French Impressionist exhibitions and was part of the Modern Art in Paris Series, which will be discussed later in this chapter. For the subject—"PICASSO, PABLO, 1881–1973"—the *NUC Books,* January–April 1983, reported twelve recently published works.

These were subdivided as to "ADAPTATIONS," "CATALOGUES," "EXHIBITIONS," "FICTION," and "POETRY." An online database search would have discovered similar material.

How to Utilize Abstracts and Indices of Periodical Literature. Also see Chapter 12

Indices of periodical literature are essential to readers who are trying to locate the most up-to-date information available on a topic. It often takes from one to three years from the beginning of research to the publication of the conclusions in a periodical and from two to five years for results to be issued in book form. Up to fifteen years or more can be required before new data will be included in a multivolume reference work. Thus, some of the most recent information on a subject is published in magazine and journal articles, which usually discuss some narrow aspect of the study. Furthermore, much of the material printed in serials is never published in book form. The articles often become, therefore, the only source of this information.

The indices and abstracts of periodical literature, which are defined in Chapter 2 and which are annotated in Chapter 12, may provide access to the following different kinds of information: (1) articles on a specific subject or by a certain author; (2) the existence of exhibition and sales catalogues and the reports and essays included in symposia and *Festschriften;* (3) the location of illustrations; book, film, and exhibition reviews; and obituary notices; and (4) the titles of works of art that are reproduced in the indexed magazines.

The frequency with which the indices themselves are issued is important. Those published quarterly will have more recent material than will the ones that are only issued on an annual basis. All of the volumes of an index or abstracting service published in one year do not necessarily cover all of the issues of a specific magazine for that individual time frame. In view of the fact that each index has particular strengths and emphases, it is especially important for researchers to scrutinize all of the indices that reflect their specific problems. Not only does this require the use of a number of different index and abstracting services, but every volume of that service must be checked.

Some of these services are available for online database searches. This will shorten the time

needed to check all of the volumes, but expense will be incurred. One advantage to the computer form is that the most current data is obtained, since the services update these files quicker than the book form can be sent, processed, and placed on the shelf ready for use. Because of the importance of these computer files, a section at the end of this chapter has been devoted to explaining search strategies.

In order to obtain the titles of a diverse number of articles, the reader should check various indices of periodical literature, because each index cites articles from different magazines. Even if two services have similar coverage, both should be examined. Material can be overlooked or never appear, especially since some companies are dependent upon the authors to send abstracts of their works. Moreover, since a great deal of the information found in journals is never published in books, it is necessary for the researcher to investigate all of the past issues of each index to make sure that nothing is overlooked. Obviously, the indices that provide annotations or abstracts of the articles make it easier for readers to decide on the merits of the material. However, it must be borne in mind that the length of the abstract or summary of the material is no indication of the material's importance. All of the titles of the references mentioned in the indices should be recorded in the working bibliography, inasmuch as a photocopy of an article can often be obtained through the interlibrary loan service, if no library in the researcher's immediate area has the needed references. See Chapter 25 for details.

Indices of periodical literature usually give only an abbreviated or incomplete bibliographical entry. This information must be translated into an accepted form before the researcher can add the reference to the working bibliography. For instance, many of the indices utilize an entry similar to the one found in *Art Index,* shown in Example 8.

CAILLEBOTTE, Gustave
 Caillebotte, Vollard and Cézanne's Baigneurs
 au repos. M. Waldfogel. bibliog *f* il Gaz
 Beaux Arts s6 v65:113-20 F '65
 Place de l'Europe on a rainy day. il por Chi-
 cago Art Inst Cal 59:[8-9] My '65
 Reproductions
 Les canotiers
 Arts 38:55 My '64
 Claude Monet faisant la sieste
 Apollo ns 79:lxxxviii Ap '64

Example 8: *Art Index: November 1963–October 1965.* New York: The H. W. Wilson Company, 1966. Page 197.

The first entry in Example 8 translates as an article, "Caillebotte, Vollard, and Cézanne's, *Baigneurs au repos,*" by M. Waldfogel. *Bibliog f* signifies that bibliographic footnotes, which may provide further leads on references concerned with Caillebotte, are included; *il* indicates that the material is illustrated. The article was published in the French magazine, *Gazette des Beaux-Arts,* sixth series, volume sixty-five which is the February 1965 issue, pages 113 through 120. Full titles for the publications that are cited in periodical indices are usually found in the front of each volume. These lists should be consulted, inasmuch as the abbreviated title is never used in a correct bibliographical citation. If the article is located and read, the researcher will discover that Waldfogel's first name is Melvin. The bibliographical entry, if the form advocated in the fourth edition of Turabian's *A Manual for Writers of Term Papers, Theses, and Dissertations* is used, would be as follows:

Waldfogel, Melvin. "Caillebotte, Vollard, and Cézanne's *Baigneurs au repos," Gazette des Beaux-Arts* 65 (February 1965): 113–20.

The name of the painting, *Baigneurs au repos,* is italicized, since it is within a title of an article that is in quotation marks. Only by obtaining this work would an investigator know that the article concerned a painting entitled *Baigneurs au repos.*

In some periodicals brief news entries may be written by the magazine's staff members and may be initialed but not signed. To find the name of the person who was the author of the piece, the researcher should check the list of editorial credits and should match the initials found on the news entry with the name of the one staff member with those initials. For instance, in the working bibliography on Caillebotte of Example 17, the review of the Caillebotte exhibition at the Wildenstein Gallery published in the October, 1968 issue of *Art News* was signed with the initials *H. R.* By checking the list of editorial contributors on the table of contents page, the reader would discover that the author was probably Harris Rosenstein, because this was the only member of the editorial staff with the initials of H. R.

Throughout the years of publication, an index or abstract will usually change certain methods of organizing the material and some of the specific subject headings. Although the alterations may be minor, the researcher must take them into account in order to produce an effective search. For

instance, in earlier issues of *Art Index,* all of the subheadings were organized within five major divisions: (1) first came themes, such as "ART, Bibliography," "ART, Historiography," and "ART, Psychology"; (2) second were chronological listings, such as "ART, 13th century" and "ART, 16th century"; (3) third were geographic citations, such as "ART, China" and "ART, Greece"; (4) fourth were inverted headings, such as "ART, Baroque," "ART, Chinese," "ART, Greek," and "ART, Medieval"; and (5) last were listed the phrase headings, such as "Art and economics" and "Art and psychoanalysis." Since Volume 29 (1980/81), the *Art Index* divisions have excluded the chronological section. In searching for material, the student must remember that there is often a hierarchical order for subheadings.

There are four major indices and abstracts for periodicals on general art subjects: *Art Index, RILA, ARTbibliographies MODERN,* and *Répertoire d'art et d'archéologie.* Each provides different coverage and material. All should be examined. One of the first references to which many art researchers turn is the *Art Index,* a quarterly publication with an annual cumulation that reports on articles from about 200 periodicals, two-thirds of which are published in the English language. It is probably the most popular index of art periodicals in the United States, because it covers all forms and periods of art. As seen in Example 9, which is the abbreviated 1980/81 entry for Edgar Degas, *Art Index* lists reproductions of an artist's works. The added notations— *(col)* for color; the medium used, such as pastel; and the date the work was created—assist researchers in choosing pertinent illustrations. Attributed works are cited separately. The subheading, "Influence," which was started in 1976, relates that two articles on Edward Hopper discuss Degas' influence upon this American painter's work. The illustrations listed refer to reproductions of Degas' works.

The first issue of *Art Index* covered material published in 1929. Unfortunately, this reference has not always indexed the same journals and magazines continuously. Because the staffs of the libraries which subscribe to this service periodically are asked to vote on the serials which should be covered, these references have changed over the years. For example, *Dumbarton Oaks Papers,* the most important annual on Byzantine art published in the United States, had only its first twelve

DEGAS, Edgar, 1834-1917
Degas's Angel of the Apocalypse. C. A. Nathanson and E. J. Olszewski. bibl f 18il (with cov) Cleve Mus Bull 67:243-55 O '80
Ideology of time: Degas and photography. K. Varnedoe. bibl f Art in Am 68:96-110 Summ '80
 il: Impresario; Little dancer, 14 years; col: Place de la Concorde (Vicomte Lepic and his daughters); Dancers in green and yellow; Four dancers: At the café concert Les Ambassadeurs; Dancer with a bouquet (with cov det); Before the ballet; Dancing lesson; Racehorses at Longchamp
Postmortem on Post-Impressionism. R. Cork. bibl f Art in Am 68:92 O '80
 il: Woman ironing
Uses of charcoal in drawing. T. and V. Jirat-Wasiutynski. bibl f Arts 55:129-31 O '80
 il: Study for the portrait of Diego Martelli (2); After the bath

Reproductions

Après le bain, femme s'essuyant (pastel, ca 1900) Connoisseur 205:[front] 79 N '80
Avant l'entrée en scène (la loge de danseuse) 1878-79) Archit Dig 37:122 S '80 (col)
Beach scene Burl Mag 122:516 Jl '80
Le chanteuse de cafe concert (1878) Connoisseur 205:305 Ag '80
Chez la modiste (ca 1883) Du no 10:49 '80 (col) Oeil no310:40 My '81 (col)
Danseuse basculante (1883) Archit Dig 37:56 O '80 (col)
Danseuses en scène (pastel) Apollo ns 111:[front] 33 Je '80
Deux danseuses (pastel) Artnews 79:44 My '80
Deux danseuses en repos (pastel) Artnews 79:77 My '80
Etude de nu Artnews 79:139 My '80 (col)
Eugène Manet (1874) Apollo ns 113:[front] 20 My '81 (col)
Lala im Zirkus Fernando (1879) Du no 10:46 '80 (col)
Mante family (pastel, ca 1884) Connoisseur 205:[front] 82 O '80 (col)
Portrait of Mary Cassatt (ca 1884) Connoisseur 205:34 S '80 (col)
Prinzessin Pauline von Metternich (ca 1861) Du no 10:28 '80 (col)
Le Salut de l'étoile (1880) Oeil no311:43 Je '81 (col)
Three dancers (pastel, 1883-84) Archit Dig 38:85 Je '81 (col)
Two singers (pastel, ca 1880) Art J 40 no 1/2:343 Fall/Wint '80
Young Spartans Art & Artists 15:15 Jl '80
Young woman with a hat (ca 1878-80) Art in Am 69:25 My '81 (col)

Attributed works

Seated nude (photo, 1895-1900) Artmagazine 12:52 My/Je '81

Influence

Edward Hopper: the influence of theater and film. G. Levin. bibl f Arts 55:124-6 O '80
 il: Orchestra of the Opera; Interior; Musicians of the orchestra
Edward Hopper's Nighthawks. G. Levin. bibl f Arts 55:157 My '81
 il: Absinthe; Women in a café, evening
DEGEN, Joël
After Le Corbusier. col il Crafts no49:17 Mr/Ap '81
Industrial implications: Arnolfini Gallery, Bristol; exhibit. S. Plant. il Crafts no46:53-4 S/O '80

Example 9: *Art Index: November 1980–October 1981.* Art Index Copyright © 1981, 1982 by the H. W. Wilson Company, Material reproduced by permission of the publisher. Selections from pages 258–259.

issues included in *Art Index.* Other indices must be used in order to discover (1) serials dropped from *Art Index;* (2) the numerous periodicals, exhibition catalogues, symposia proceedings,

Festschriften, and other materials not covered by this service; and (3) the publications issued prior to 1929.

RILA: International Repertory of the Literature of Art abstracts material on art from Late Antiquity of the fourth century to the present time. This semi-annual publication contains annotated citations for periodical articles from a core of about three hundred journals plus selected material from other serials, books, museum and exhibition catalogues, *Festschriften,* congress reports, and dissertations. The bibliographical entries are organized into seven categories: "REFERENCE WORKS"; "GENERAL WORKS"; "MEDIEVAL ART"; "RENAISSANCE, BAROQUE, AND ROCOCO ART"; "NEO-CLASSICISM AND MODERN ART"; "MODERN ART", from 1945 to the present; and "COLLECTIONS AND EXHIBITIONS". These broad categories—which are subdivided into such sections as architecture; sculpture; pictorial arts; decorative arts; and artists, architects, and photographers—allow researchers to browse for material within their own interests.

Each issue of *RILA* has three indices: to authors, to subjects, and to journals. The reader should become familiar with these sections of *RILA,* because they are often the most efficient way to find information. The "Author Index" provides an asterisk to indicate that the abstract refers to a review of one of the author's works. The "Subject Index" to individual artists, places, and terms provides analytical indexing. For instance, in a recent issue under "Picasso, Pablo, Sp artist, 1881–1973," there were thirty-eight subdivisions to such items as "critics on," "exhibitions," *"Guernica,"* "influence of Courbet," "influence on Gorky," "origin of Cubism," and "works, interpretation." Another feature which is important for researchers, is the "Journal Index." This section records exactly which volumes of which serials are included in that issue of *RILA.* For each serial, there are cross references provided to the abstracts in that issue. This facilitates any search for material in a specific periodical.

In order to assist readers in using this semi-annual publication, the staff of *RILA* has compiled two volumes—*The Cumulative Subject Index, 1975–1979* and *RILA Subject Headings.* The former provides detailed subject indexing to the 35,000 bibliographical entries in the first five vol-

umes of *RILA.* Under "Caillebotte, Gustave, Fr. painter, 1848–1894," there are ten entries. The citations are subdivided into such headings as "exhibitions," *"Pont de l'Europe,"* and "theme of man on balcony in cityscape." This cumulative subject index pinpoints various aspects of the topic that the researcher may need and includes two indices—to authors and to periodicals. The *RILA Subject Headings* will assist researchers in formulating search strategies for the *RILA* online database.

In *RILA,* artists and works of art are often mentioned in abstracts in which they are not the principal concern. Cross references are provided to assist readers in finding these entries. In the 1979 edition in the "Subject Index" under Caillebotte's name, there was a reference to #6558. This entry, which is shown in Example 10, reports that there was a loan exhibition from December 4, 1977, to January 8, 1978, held at the Dixon Gallery and Gardens in Memphis, Tennessee. The eighty-one page catalogue has forty illustrations, nine of which are in color. Biographies of the artists of the thirty works displayed are included. The introduction was written by Michael Milkovich. The abstract explains that this exhibition commemorated the 1877 Third Exposition of Painters held in Paris. Caillebotte is included as one of the artists. Reproductions for each work in the Memphis show are provided in the catalogue. In parentheses there is a notation of the source responsible for the abstract, in this case, the Arts Library of the University of California at Santa Barbara. This is a citation for an exhibition catalogue, not an article in a magazine. This type of information is not included in *Art Index.*

> **6558** MEMPHIS (Tenn, USA), Dixon Gallery and Gardens. **Impressionists in 1877: a loan exhibition.** *Exh.* 4 Dec 1977-8 Jan 1978. Introd. by Michael MILKOVICH. 81 p. *40 illus. (9 col.), biogs.,* 30 works shown.
> Exhibition commemorates the centennial of the *3ᵉ Exposition de* peinture held in Paris in 1877 by showing paintings of the 1870s by 14 of the 18 French artists who participated in the original exhibition. Several of the works shown were in the 1877 show. Artists represented are Caillebotte, Cals, Cézanne, Cordey, Degas, Guillaumin, Monet, Morisot, Piette, Pissarro, Renoir, Rouart, Sisley, and Tillot. Full catalogue entries with explanatory texts and reproductions of each object. *(Arts Library, University of California at Santa Barbara)*
>
> → **Merseyside: painters, people, and places: catalogue of oil paintings,** *see* 8377.

Example 10: *RILA: International Repertory of the Literature of Art,* A Bibliographic Service of The J. Paul Getty Trust, Editorial Office at Sterling & Francine Clark Art Institute, Williamstown, Massachusetts, Volume V, 1979, page 511.

Example 11: *ARTbibliographies MODERN,* 1981.
Volume 12, page 168. Reprinted by permission of ABC-
Clio, Inc., Santa Barbara, California, © 1981.

ARTbibliographies MODERN, which concen-
trates on art of the nineteenth and twentieth cen-
turies, also includes material on exhibition
catalogues as well as periodical articles. This semi-
annual publication provides abstracts or brief an-
notations for references from about 125 to 190 pe-
riodicals. The abstracts are organized under
(1) subject or classification headings and
(2) authors. Each issue has, in addition to the ab-
stracts, a list of the classification headings, a list
of periodicals, an author index, and a museum and
gallery index. The researcher should study the list
of classification headings prior to using this re-
search tool. *ARTbibliographies MODERN* also
provides access to articles and exhibition cata-
logues in which an artist is not the principal per-
son discussed. In Volume 12, number 1 of 1981,
there is a reference under "Caillebotte, Gustave"
to "see 1887 Childe Hassam's early Boston city-
scapes." The abstract, number 1887 which is re-
produced in Example 11, reports that an article
by J. A. M. Bienenstock on Childe Hassam was
printed in *Arts Magazine,* the United States pub-
lication, Volume 55, part 3, of November 1980 on
pages 168 through 171. There are nine illustra-
tions plus a bibliography. The abstract also ex-
plains that the article discusses Caillebotte.

Published since 1910, *Répertoire d'art et d'ar-
chéologie* scans more than 1,750 periodicals cov-
ering a period from about 200 A.D. to the present.
Islamic, Far Eastern, and primitive art are ex-
cluded, as are post-1940 works of art and artists
who were born after 1920. The coverage is inter-
national; a high percent of the periodicals indexed
are from Western and Eastern European coun-
tries. Titles are cited in the languages in which the

articles are written, except for titles from Eastern
European countries and from Scandanavia where
a French translation is added. Although there is
no annual cumulation of this quarterly, there is a
200-page annual index, *tables annuelles,* which
provides a number of indices for all of the year's
entries. These include (a) *"List des revues de-
pouillées,"* the magazines covered during that pe-
riod; (b) *"Liste des recueils collectifs,"* an index
to the individual essays and articles in *Festschrif-
ten* and reports of congresses which were pub-
lished that year; (c) *"Index"* subdivided into a list
of artists and of subjects; plus (d) *"Table des au-
teurs,"* a list of the authors whose works have been
indexed. The older issues are difficult to search,
but with the 1973 change in format, this French
index became more useful. Exhibition catalogues
are listed under *"Index des matières,"* under the
headings, *"Expositions"* and *"Salon."*

There are a number of special art indices; some
that cover only one periodical—such as *Burling-
ton Magazine: Cumulative Index Volumes I–CIV,
1903–1962*—are important to readers to help them
in discovering the titles of articles written prior to
the publication of *Art Index.* Other sources for
finding material are the catalogues of holdings of
the libraries that have indexed the articles which
the institutions have gathered on particular sub-
jects over the years. For example, the *Index to Art
Periodicals Compiled in Ryerson Library: The Art
Institute of Chicago,* which began indexing in
1907, lists the articles in *Bollettino d'arte* and *Oud
Holland* for the period following World War II
when these magazines were dropped from *Art
Index.*

Since one of the objects of in-depth research is
to find all of the material that has already been
written on a particular subject, the valuable work
done by nascent scholars should not be over-
looked. Such contributions can be located in *Dis-
sertation Abstracts International,* described in
Chapter 12. Entitled *Dissertation Abstracts* until
1970 when it changed its name and began to in-
clude dissertations from European universities, this
reference is especially important as much of the
research it indexes is never published in any other
form. A photocopy or microfilm of a particular
dissertation can usually be obtained, for a reason-
able price, from the Xerox University Microfilm
of Ann Arbor, Michigan; details for ordering are
given in each volume. The researcher will find that
using the *Comprehensive Dissertation Index,
1861–1972* and its supplements will facilitate

finding the pertinent information in this reference. The computer files are also available for an online search of the *Comprehensive Dissertation Index Abstract Database,* through DIALOG.

In checking the various years of the *Comprehensive Dissertation Index* for material on Caillebotte, nothing was found on the artist himself. Under the subdivision, "Fine Arts," of Volume 31: *Communications and the Arts* of the 1861–1972 cumulative index, there was a report for a 1966 New York University dissertation, "The Formation of the Impressionist Style of Painting: Its Pictorial Themes and Manner of Composition from c.1860 to 1870," by Siegried Joan Crowell. This research might prove important in understanding Caillebotte's work.

Also annotated in Chapter 12 are the indices of newspaper publications. These are important sources for finding the essential information that can be gathered from newspaper articles and news items that report on exhibitions, acquisitions, and artistic events. Researchers especially need to examine the newspaper indices for the years of important exhibitions and the year of an artist's death. In the Caillebotte example, a review of his first American one-man exhibition was recorded in *The New York Times Index 1968,* for the newspaper of September 21, page 28, column 1. It was listed under "Art-Shows-One Man" and cross referenced under "Caillebotte, Gustave." *The New York Times* and *The Times* of London, which have both published an index of their newspapers for more than a century, have no cumulative index to articles, thus necessitating a tedious search to find pertinent data unless a date is known. In the case of *The New York Times,* however, the New York Times Company has compiled reference works which facilitate the finding of obituary notices, film reviews, and book reviews published originally in that paper. Microfilm copies of *The New York Times* and *The Times* of London are owned by many large libraries. In addition, online database searches are now available for a number of newspapers; see Chapter 12.

How to Utilize References Concerned with Artists and Art History. Also see Chapter 13

Art history books are important tools for any art-oriented person. For instance, these works may (1) provide important information on the art and styles, as well as the historical background, of various periods of art; (2) furnish biographical data on artists and the titles, and sometimes the present locations, of the most famous works of art in an artist's *œuvre;* (3) contain numerous black-and-white and some color reproductions plus drawings of elevations and floor plans; (4) include glossaries, chronologies, and synoptic tables—*synoptic tables* provide, in outline form, a general view of the important events and achievements that occurred about the same period of time in either various countries or in different fields, such as art, music, literature, and science; and (5) publish extensive bibliographies, which may list monographs, catalogues raisonnés, *œuvres* catalogues, and exhibition catalogues.

There is no single reference work that lists all of the monographs, catalogues raisonnés, and *œuvres* catalogues that have been compiled on various artists. Researchers may have to search diligently to discover whether or not one of these types of references has been written on the particular artist being studied. Not all artists have been the subject of these kinds of reference works. Because a catalogue raisonné and an *œuvre* catalogue discuss or list all known works of art, or all of the artistic endeavors in one medium of an artist, the magnitude of the compilation can be tremendous. Peter Paul Rubens probably painted well over a thousand canvases, with or without the help of his studio assistants. Pablo Picasso was reported as stating that he hoped to finish 10,000 works of art before he died.

Due to the importance of catalogues raisonnés, *œuvres* catalogues, and *corpora,* researchers must be persistent in their search to discover whether or not any such references have been written concerning their artists or their works. For recent publications, the researcher should consult art journals which often review important catalogues raisonnés. A notice of the review may be located through using the indices of periodical literature, which are annotated in Chapter 12. For past publications of these reference works, the bibliographies in the art encyclopedias and biographical dictionaries should be examined. There is a list of monographs on about 550 artists in *Art Books: A Basic Bibliography of the Fine Arts,* 1968, by E. Louise Lucas. Other sources for locating the titles of these references are the bibliographies of the art history works listed in Chapter 13, especially in the bibliographies of the *Pelican History of Art Series.*

Another important group of references, which must be perused in compiling a working bibliography, are the art history references annotated in Chapter 13. There are two categories of art history reference books: multivolume art histories and art history books in series. Both of these types of books have extensive bibliographies, numerous black-and-white illustrations, and informative texts. In the early part of this century, multivolume art history reference works, such as *A History of Spanish Painting* by Chandler Post, were especially popular. These were written on one subject and by one person. Lately the trend has been toward dividing the subject into workable parts, inviting experts in each field to write on various sections, and having an editor-in-chief oversee the whole project. Thus, the highly regarded *Pelican History of Art Series* under the guidance of Nikolaus Pevsner has produced over forty volumes, covering the span of art from the prehistoric period to contemporary times. Containing extensive bibliographies that list historical references, individual monographs, catalogues raisonnés, and *œuvres* catalogues, the informative texts of the books in the *Pelican History of Art Series* are indispensable to research. And their bibliographies are important references.

George Heard Hamilton's 1972 paperback edition of *Painting and Sculpture in Europe 1880–1940,* one of the Pelican series, has an extensive bibliography, thirty-two pages long, that is organized according to references that cover the general art of the period, art movements, various European countries, and individual artists. The last section of the paperback copy, comprising twenty-three pages of the bibliographical references, records books that have been written on over 230 European artists who were active between 1880 and 1940. If a bibliographical reference is a catalogue raisonné, an *œuvre* catalogue, or an exhibition catalogue, this fact is stated. Illustrating the importance of the bibliographies in the *Pelican History of Art Series* are the entries in the Hamilton book for Georges Rouault and Egon Schiele; see Example 12. Of the six references cited in the Rouault entry, there are two exhibition catalogues plus a monograph that contains an *œuvre* catalogue. One of the seven Schiele references is a catalogue raisonné.

It would be impossible to include the titles of all of the numerous multireference publications in this guide. Only the art historical references that cover a group of artists or a long period of time are recorded in Chapter 13. In that chapter the volumes of the publications are cited individually, in view of the fact that most librarians, upon cataloguing and shelving such publications, treat each individually authored volume as a separate work rather than listing and maintaining all of the volumes together under the name of the series.

Many of the books annotated in Chapter 13 are used as textbooks in upper-level courses of universities and colleges. Reading university textbooks will give researchers a survey of the periods of art they are studying as well as extensive bibliographies to examine. For these reasons it is always valuable for students to investigate closely the textbooks currently being used in their classes or in courses that cover the same material at the local universities or colleges.

ROUAULT

Courthion, P. *Georges Rouault.* New York, 1962.
 With *œuvre* catalogue.
Dorival, B. *Cinq études sur Georges Rouault.* Paris, 1957.
Rouault. An Exhibition of Paintings, Drawings, and Documents. London, The Arts Council of Great Britain, 1966.
 Text by J. Russell.
Rouault, G. *Miserere.* Boston, 1963.
 With introduction by A. Blunt and preface by the artist.
Roulet, C. *Rouault. Souvenirs.* Neuchâtel, 1961.
Soby, J. T. *Georges Rouault. Paintings and Prints.* 3rd ed. New York, The Museum of Modern Art, 1947.
 With catalogue of an exhibition.

SCHIELE

Egon Schiele. Gemälde. Ausstellung zur 50. Wiederkehr seines Todestages. Vienna, Oberes Belvedere, 1968.
Gustav Klimt and Egon Schiele. New York, Solomon R. Guggenheim Museum, 1965.
Hofmann, W. *Egon Schiele. Die Familie.* Stuttgart, 1968.
Kallir, O. *Egon Schiele.* New York, 1966.
 Catalogue raisonné.
Leopold, R. *Egon Schiele.* New York, 1970.
Mitsch, E. *Egon Schiele. Zeichnungen und Aquarelle.* Salzburg, 1961.
Roessler, A. *Erinnerungen an Egon Schiele.* 2nd ed. Vienna, 1948.

SCHLEMMER

Hildebrandt, H. *Oskar Schlemmer.* Munich, 1951.
Oskar Schlemmer. New York, Spencer A. Samuels and

Example 12: Hamilton, George Heard. *Painting and Sculpture in Europe 1880–1940.* Revised edition. *The Pelican History of Art Series.* Baltimore, Maryland: Penguin Books, Inc., 1967; paperback edition, 1972. Page 587. Copyright © George Heard Hamilton, 1967, 1972. Reprinted by permission of Penguin Books. Ltd.

Often a researcher needs to read documents and sources from the period being studied or writings done by artists themselves. One of the sections of Chapter 13 cites these types of references. The works range from the account of 175 artists which Giorgio Vasari wrote in 1550 to the series entitled *Documents of 20th-Century Art,* edited by Robert Motherwell. The latter are translations and reprints of some of the important material written by artists of this century. A documentary source of original material for the researcher studying the life and *œuvre* of an American artist is the Archives of American Art which has microfilmed many of its documents and provides access to this material through interlibrary loans or through visits to any one of the five centers of the Archives of American Art.

In some instances, bibliographies have been compiled on specific subjects and published in book form. These works, which often include entries on the books that are particularly important to a specific topic, were compiled previous to the date of publication and therefore, although important to scrutinize, will contain no recent references. Two of the most important are Mary Chamberlin's *Guide to Art Reference Books* and the work which updates it, *Guide to Literature of Art History* by Etta Arntzen and Robert Rainwater. Although published in 1959, Chamberlin's guide is still an important reference, because it includes information on many foreign-language publications. In order to find titles of books that might have material on Caillebotte, the reader should check these art bibliographies which are annotated in Chapter 13. For instance, in Chamberlin's book under "Painting, Renaissance-Modern" is an entry to John Rewald's *The History of Impressionism.*

In Arntzen and Rainwater's 1980 guide, under "Painting, Neoclassical-Modern," there is an entry to a later edition of Rewald's work. Both books mention that Rewald's *The History of Impressionism* is the definitive history of this art movement. The longer annotation in Arntzen and Rainwater reprints part of a review for the fourth edition which was in the *Times Literary Supplement,* May 3, 1974 and provides a list of some of the artists discussed in Rewald's book, one of which is Caillebotte. If Arntzen and Rainwater's *Guide to Literature of Art History* had been consulted, the researcher would have learned immediately that Caillebotte was one of the thirteen artists that Rewald's book discusses in detail.

How to Utilize Museum and Exhibition Catalogues. Also see Chapters 14 and 15

Other indispensible tools for the investigator who is compiling a working bibliography are the various catalogues that are published for the permanent collections of museums and for temporary exhibitions. Basically, there are two kinds of catalogues: a summary catalogue and a scholarly one. A summary catalogue is little more than a checklist. The scholarly exhibition catalogue, which has a different and more enduring function, is an invaluable reference that disseminates important information on the museum's collection or on the displayed works of art at an exhibition. For a detailed discussion of these essential research tools and an explanation of the terminology used in catalogue entries, see Chapter 3, "Museum and Exhibition Catalogues." Chapter 14 is composed of a list of some museum catalogues, and Chapter 15, of some ways to discover the existence of exhibition ones.

If some of the references which are consulted on works of art report the present location of the objects, the catalogues of the institutions owning the works should be sought. A few books—such as those cited in Chapter 14 under "Indices of Museum Catalogues"—provide essential data on the museums which own some artists' works. *Paintings in Dutch Museums* indicates the location of about 30,000 paintings—by 3,500 artists who were born prior to 1870—in about 350 Dutch institutions. Moreover, there is a bibliography which, under the name of each museum, cites the title of any catalogue of the permanent collection that exists. Under Caillebotte's name there is a citation for his *Pool in a Wood* at the Stedelijk Museum 'Het Catharinagasthuis' in Gouda. *Paintings in German Museums,* which is also listed in the same chapter, records the location of about 60,000 paintings by 10,000 artists that are located in German museums. Caillebotte's *Bootshafen bei Argenteuil* at the Kunsthalle in Bremen is reported.

During the reading of the material from the working bibliography on Caillebotte, there were a number of references which mentioned some of the museums that own his paintings. In America, these institutions include the Albright-Knox Gallery in Buffalo, The Kimbell Art Museum in Fort Worth, The Art Institute of Chicago, Indiana University Art Museum in Bloomington, Milwaukee Art

Center, Minneapolis Institute of Arts, Toledo Museum of Art, Wadsworth Atheneum in Hartford, and Yale University Art Gallery. The Impressionist's work is also displayed at such French institutions as the Musée du Jeu de Paume, Paris; Musée des Beaux-Arts, Rennes; and Musée des Beaux-Arts, Rouen. If catalogues of these collections exist and are available, they may provide essential data for the study.

Besides the museum collection catalogues, the researcher should search diligently to discover if any one-person exhibition catalogues exist on the artist. These exhibition catalogues usually provide the most current research on the person and the latest bibliographical entries. An exhibition catalogue is often a monograph in that the text is on one artist and his or her *œuvre*. For example, the book published for the 1976–77 Caillebotte retrospective exhibition in Houston and Brooklyn is a scholarly monographic catalogue. Each of the seventy-seven works of art that were displayed in the exhibition is reproduced in the catalogue. Moreover, there are color plates of fourteen of the paintings. Each entry provides the title of the work of art, an English translation of the title, the probable date of the piece, the medium, dimensions in centimeters and inches, the present owner, the exhibitions in which the object figured, and a discussion of each work of art that relates pertinent facts concerning the piece. There is a brief biography on Caillebotte, a bibliography, and three in-depth articles that cover Caillebotte's use of perspective, his manipulation of space, and his method of constructing two of his paintings—*Le Pont de L'Europe* and *Paris, A Rainy Day*. Also reproduced are a number of Caillebotte's drawings, other artists' works of art which are used for comparative purposes, and some nineteenth-century photographs of Caillebotte, his family, and the environs around Caillebotte's home. Some of the articles written by art critics during Caillebotte's lifetime have been reprinted and translated, as has Caillebotte's will. The 1976–77 catalogue contains an excellent collection of illustrations of Caillebotte's works and records the most recent data on the French painter and his *œuvre*. Obviously, this scholarly exhibition catalogue is of the utmost importance for any researcher interested in Gustave Caillebotte.

Estimates on the number of exhibition catalogues which are published every year vary from 8,000 to as many as 20,000. Unfortunately, the number of catalogues which are indexed annually so that researchers can discover their existence may be as few as from 2,500 to 3,500. Some artists are the subject of a profuse number of catalogues each year—for instance, in one year there were more than sixty exhibition catalogues on the works of Pablo Picasso—while the works of other artists are rarely exhibited. The catalogue of a large important exhibition that is centered around one artist and that includes the artist's name in the title is usually the easiest to locate, such as the catalogue, *Gustave Caillebotte: A Retrospective Exhibition,* compiled for the exhibition at the Museum of Fine Arts, Houston. But, it can sometimes be extremely difficult for researchers to discover the names of the individual artists whose works of art comprise multiple-artists exhibitions, since some indices list only one or two artists whose works are exhibited in group shows.

Because there are so many exhibitions, discovering the existence of a specific one in which a particular work of art was displayed and ascertaining whether or not there was a catalogue can sometimes be a problem worthy of the best detective. One of the problems is the fact that there is no standardized way of listing an exhibition catalogue. The catalogue may be indexed under (1) the name of the author or compiler, (2) the name of the exhibiting institution, (3) the name of the city or state in which the exhibiting institution is located followed by the name of the exhibitor, (4) the title of the exhibition, or (5) the subject of the catalogue.

Compounding the difficulty of locating exhibition catalogues are the facts that (1) some references use anglicized spellings for the names of foreign cities and countries, such as East Germany for Deutsche Demokratische Republik; (2) the name of the exhibiting institution can be alphabetized by the first word or the main entry word in the title, for instance either Solomon R. Guggenheim Museum or Guggenheim, Solomon R., Museum; (3) the name of the university with which a gallery is associated may be listed before the name of the gallery, for example Harvard University, Fogg Art Museum; (4) some museums have changed their names over the years, such as the Kaiser-Friedrich Museum in East Berlin which was renamed the Bode Museum in 1956; and (5) the listing of a traveling exhibition in the United States is usually cited under the name of the institution that first displayed the works of art. The more information the researcher has on an

exhibition, the greater the chances that a reference to any exhibition catalogue which might have been compiled for the show will be located.

Sometimes a researcher has trouble finding an entry for an exhibition catalogue, because the name of the city in which the particular exhibitor is located is not known. This information can usually be discovered through the alphabetical lists of institutions found in such references as *The Official Museum Directory: United States and Canada, The World of Learning,* and *The International Directory of Art.* Although a number of the cities listed are anglicized, many are not. The multilingual glossary of Appendix D in this guide should be consulted by those who need help with the names of various locations. All of the above mentioned references are annotated in Chapter 22 under "Location Directories."

Another problem with finding exhibition catalogues is that they can be treated in several different ways in the library: (1) as a book with a specific call number and a listing in the catalogue file, (2) as one of a group of exhibition catalogues which are filed together in one particular area of the library, or (3) as ephemeral material that is placed in folders and organized in vertical files. There may be no notation as to the existence of either the exhibition catalogues or the vertical files in the library's catalogue. Due to the various ways these references can be treated, the researcher should inquire from the librarian at each institution how exhibition catalogues can be located in that particular library.

There are two kinds of resources for discovering exhibition catalogues on the desired subject: (a) those that are published quarterly or semi-annually will assist in locating current and recent titles and (b) those that are issued less frequently, or only once, can be used to discover past exhibitions, a topic discussed in the next section. Worldwide Books, Inc.—a company that sells a variety of international exhibition catalogues—publishes a quarterly bulletin that reviews these catalogues and contains several indices to the material: (1) titles, (2) artists, (3) a chronology index by century and styles, (4) media, and (5) topics such as, American, Canadian, Near and Far Eastern, primitive, political, and religious art plus surveys of current trends and women artists. There is also an annual cumulative index to each year. Example 13 from Volume 13 of *Worldwide Art Catalogue Bulletin* illustrates the extensive information which can be gleaned about the Houston

Houston

GUSTAVE CAILLEBOTTE: A RETROSPECTIVE EXHIBITION
Museum of Fine Arts, October 22, 1976-January 2, 1977; and Brooklyn Museum, February 12-April 24, 1977. Preface by William C. Agee. Introduction by Marie Berhaut. Essays by J. Kirk T. Varnedoe, Hilarie Faberman and Peter Galassi. Catalogue by Varnedoe and Thomas P. Lee. Bibliography by Faberman. Critical anthology (1876-1880). Known principally as the organizer of the impressionist shows and as a faithful patron whose bequest to the Louvre caused a scandal, Gustave Caillebotte was also a painter of considerable consequence. Rejecting the peripheral place usually accorded his work, this major exhibition established the artist's rightful position alongside Manet and Degas as an important Impressionist-Realist. The over 100 paintings and drawings assembled for this show represented his most significant and characteristic works and constituted the most comprehensive Caillebotte show since 1894. The accompanying catalogue is the best monograph in English on the artist to date. It begins with Varnedoe's and Faberman's thoroughly researched biography, which includes some new facts about the artist's life. Caillebotte painted tightly finished scenes of contemporary social life: Paris streets, bourgeois milieu

ings, almost all of which never have been previously reproduced or mentioned in the literature. Scholarly entries with exhibitions. Selected bibliography. Extensive notes. Good reproductions. Color frontispiece. Color cover illustration.
226 pp. with 122 text ills. and 120 ills. on 93 pls.(14 col.). 9 x 10¾. LC 76-47141
●12718　　　　　　　　Paperbound $15.95

Example 13: *Worldwide Art Catalogue Bulletin.* Ilene Susan Fort, editor. Boston: Worldwide Books, Inc., 1977. Volume 13, Number 4, 1977, page 60. Selections.

and Brooklyn exhibition which was previously discussed. The review provides not only data concerning the catalogue but details the focus and content of the articles. Some of the out-of-print publications are still available for sale through the company.

Other major sources for identifying recent exhibition catalogues are the index and abstracting services. Notations concerning important exhibition catalogues can be found in *RILA*—which covers most periods, kinds, and styles of art; *ART-bibliographies MODERN,* which reports only nineteenth- and twentieth-century art; and *Répertoire d'art et d'archéologie. Art Index* provides entries for reviews of exhibitions which have been published in the serials that are covered by this service, but not information on the catalogues. For current shows, an online database search may be effective, since these computer files are often updated more frequently than are the printed books. Many exhibition catalogues can be acquired through interlibrary loans.

How to Utilize References Concerning Past Art Exhibitions. Also see Chapter 15

In compiling a chronology, it is important to list the major exhibitions at which the artist's works were displayed. To discover these past exhibitions may require (1) additional resource tools and (2) different methods for obtaining copies of the actual catalogues. In Chapter 15, the section—"Indices to Exhibition Catalogues, Past Exhibitions"—is subdivided as follows: (1) "General, All Countries and Dates;" (2) "British, 18th and 19th Centuries;" (3) "North American, 19th and 20th Centuries;" and (4) "20th Century." Most of the indices cited in that section provide data on the artists that displayed works in famous exhibitions: The Royal Academy, The Royal Society of British Artists, The Academy of Fine Arts, The National Academy of Design, and The Pennsylvania Academy of Fine Arts. A different type of directory is Donald Gordon's *Modern Art Exhibitions 1900–1916,* which lists the titles of works of art displayed by 426 painters and sculptors in 851 exhibitions of modern art from 1900 to 1916 in fifteen countries and eighty-two cities. The researcher must read the annotations of the indices listed in Chapter 15 with great care in order to choose the resource tools which should be consulted.

When doing research on artists who have displayed their art in Britain, the reader should examine the numerous indices compiled by Algernon Graves: (1) *The British Institution 1806–1867;* (2) *A Century of Loan Exhibitions 1813–1912;* (3) *Royal Academy of Arts, 1769 to 1904;* (4) *The Society of Artists of Great Britain 1760–1791;* and (5) *A Dictionary of Artists Who Have Exhibited Works in the Principal London Exhibitions from 1760 to 1893,* which directs researchers to specific exhibitions. This last reference reported that Augustus Leopold Egg, R. A., exhibited from 1837 to 1860: twenty-eight times at the Royal Academy, nine at the British Institution, and nine at the Suffolk Street Exhibitions. Graves' book does not cite the specific titles of the works of art. In Graves' *Royal Academy of Arts,* Egg is recorded as exhibiting annually in the exhibitions from 1838 through 1851 and 1854 through 1860, with the exception of 1856. This is a listing of twenty shows, a figure which does not correspond to the number cited in Graves' *A Dictionary of Artists.* Nor does the number of citations in *The British Institution* coincide with the number reported in *A Dictionary of Artists.* It must be remembered that this is secondary material, not a primary source. In order to ascertain the exact number and titles of the works of art, the individual exhibition catalogues must be located and studied.

The Royal Academy of Arts holds two exhibitions annually. The Winter Exhibition is a special show of various kinds of art. For instance, in 1939, it was on Scottish Art; in 1962, Primitives to Picasso. It is the Summer Exhibitions at which the Royal Academy Academicians display their art. These are the shows indexed by Algernon Graves. In addition to the official exhibition catalogues, there are other important references which will assist researchers studying British art. In *Academy Notes,* which was published at the end of the nineteenth century, there are engravings of some of the works of art exhibited at the Summer Exhibitions. *Royal Academy Illustrated,* which began publication about 1916, provides photographs for some of the displayed works. Other sources for the Summer Exhibitions are the critical reviews published in such periodicals as *The Magazine of Art* and the two-volume illustrated exhibition catalogue, *Royal Academy of Arts Bicentenary Exhibitions 1768–1968,* 1968 compiled by St. John Gore.

Not all major exhibitions have been provided analytical indexing. Information on the Paris Salons and the numerous exhibitions of the various French independent artists groups of the nineteenth century have yet to be published in a similar form to Graves' works. In order to discover the existence of exhibitions at which an artist's works were displayed, the researcher should consult the biographical dictionaries and the books cited in the bibliographies found in art history books, especially those listed in such art reference books as the *Pelican History of Art Series*. The catalogues of holdings of famous libraries are often good sources for pertinent exhibition catalogues.

Once a reference is found to a specific exhibition catalogue, the original catalogue or a reprint of it should be obtained in order to verify the information. Remember not all published reports are true. Checking and verifying data is an integral part of research. A few libraries have extensive holdings of original exhibition catalogues, with complete or near complete runs, of the various French, English, and American academies and societies. This is not true of most libraries. Reprints of exhibition catalogues, often on microforms, have made the catalogues available to a greater audience. Unfortunately, the Summer Exhibitions of the Royal Academy of Arts have not been reprinted as of this date.

To illustrate the kinds of information that can be obtained from a nineteenth-century catalogue, Caillebotte, who exhibited with the French Impressionists, will be used as an example once again. Not all the data collected on Caillebotte stated that he had exhibited at the same particular Impressionist shows. One art museum catalogue reported that he had participated in all of them except the second and the last. This conflicted with other references. By actually studying the *livrets* of the eight Impressionist Exhibitions, it was evident that Caillebotte displayed his work in all but the first, sixth, and eighth. Example 14 of the fourth show in 1879 illustrates the type of information which can be extracted from these catalogues. By examining the entry, the reader can understand why it is often impossible for scholars to provide positive identification for the works of art which were displayed. For instance, there are two paintings entitled *Périssoires*. Because photography was not yet an integral part of an exhibition catalogue and because the titles are usually ambiguous, the researcher's job can be extremely

CAILLEBOTTE (Gustave)

31, boulevard Haussmann.

7 — Canotiers.

8 — Partie de bateau.

9 — Périssoires.

10 — Périssoires.

11 — Vue de toits.
 Appartient à M. A. C...

12 — Vue de toits. (Effet de neige.)
 Appartient à M. K...

13 — Canotier ramenant sa périssoire.

14 — Rue Halévy, vue d'un sixième étage.
 Appartient à M. H...

15 — Portrait de M. F...

16 — Portrait de M. G...

17 — Portrait de M. D...

18 — Portrait de M. E. D...

19 — Portrait de M. R...

20 — Portrait de Mme C...

Example 14: *Catalogue de la 4me exposition de peinture*, 1879. *Livret* of the Fourth Impressionist Exhibition. *Impressionist Group Exhibitions*, Garland Publishing, Inc., 1981, page 6.

difficult. In Example 4, notice that the names of the persons whose portraits were painted are identified only by initials. In *"Portrait de M. F. . . ,"* the *M* stands for *Monsieur*, French for Mr. All that is revealed concerning the painting is that the sitter was a Mr. F. *"Appartient à M. A. C."* means that the painting, *Vue de toits,* belonged to Mr. A. C. These initials, however, can sometimes be used to trace the ownership of works of art.

There are several important companies and libraries that have published out-of-print exhibition catalogues: (1) Chadwyck-Healey, Inc., (2) Garland Publishing, Inc., (3) Archives of American Art, and (4) Knoedler and Company, Inc. Since 1974, Chadwyck-Healey, Inc. has reprinted more than 3,000 exhibition catalogues on microfiche. Included are such items as the Paris Salons, 1673–1925; London's Victoria and Albert Museum catalogues, 1862–1974; and catalogues

from several New York galleries—Buchholz Gallery-Curt Valentin, 1937–1955, Galerie Chalette, 1955–1970, and Sidney Janis Gallery, 1950–1976. The *Subject Index to Art Exhibition Catalogues on Microfiche,* published by Chadwyck-Healey, Inc., provides access to the material in these catalogues.

Two important series of reprints of French exhibition catalogues are available through Garland Publishing, Inc.—(1) *Catalogues of the Paris Salon 1673 to 1881,* 60 volumes, and (2) *Modern Art in Paris 1855 to 1900,* 47 volumes. The first set of books contains facsimilies of all of the *livrets* or pamphlets which listed the artists and their works that were exhibited at the French Salons from the beginning of these exhibitions through 1881. One book sometimes includes several *livrets,* which in the early years were relatively slim.

The second Garland series is very diversified. There are numerous facsimilies: (a) the eight Parisian World's Fairs from 1855 to 1900; (b) the four Salons of the Refusés, including the most famous one in 1863; (c) the eight Impressionist Exhibitions, which are reprinted in a single volume entitled *Impressionist Group Exhibitions;* (d) the three Salons of the Indépendants, 1884–91; (e) the annual French Salons of 1890–99; (f) the Post-Impressionist shows, 1889–97; (g) shows of drawings and prints, 1887–1900; (h) the exhibitions of the Society of Printmakers, the Rosicrucian Salons, Salons des Cent, Art Nouveau, National Fine Arts, and miscellaneous group shows; and (i) various one-man exhibitions held in Paris from the one of works by Gustave Courbet in 1855 to the one for Auguste Rodin, 1900.

This reprint of primary source material in these multivolume sets is important for anyone studying a French artist who exhibited art from 1673 to 1900. Unfortunately, researachers may have a problem discovering the material in the second series. Few library catalogues will have a separate card or record for each individual catalogue reprinted in the forty-seven volumes. For instance, one of the volumes—*Catalogue of Sculptors*—contains the slim *livrets* of five separate exhibitions of the work of Barye, 1875; Barye, 1889; Carpeaux, 1894; Meunier, 1896; and Rodin, 1900. Researchers must discover which one of the forty-seven volumes in the *Modern Art in Paris Series* is pertinent to their investigations through other sources, such as an online search of the *LC MARC Database,* by using the name of the artist in a free-text search, a process explained at the end of this chapter.

During the 1960s, the Archives of American Art filmed more than 20,000 catalogues of American exhibitions held from the early nineteenth century to the 1960s. *The Archives of American Art: Collection of Exhibition Catalogues,* 1979 lists these catalogues which are on microfilm. The exhibition catalogues are indexed by institutions—museum, gallery, or society—that displayed the art and by name of individuals in a one-person show. Each entry provides the names of the artists whose works were displayed, the exhibition dates, and the ordering number for the microfilm roll. All of the material can be borrowed through an interlibrary loan or studied at one of the five regional centers.

The Knoedler Library of Art Exhibition Catalogues on Microfiche is a collection of more than 5,000 catalogues from the library of M. Knoedler and Company, Inc., one of the oldest art galleries in New York City. Although not every series is complete, there are most of the catalogues from the Royal Academy of Arts Winter Exhibitions from 1870 to 1927 and the British Institute Exhibitions 1813 to 1867. There are catalogues for the French Salons, European and American exhibitions from 1775 to 1900, Old Master Exhibitions, the major national and international expositions and world fairs, as well as the catalogues of the Knoedler Galleries.

How to Utilize Auction Catalogues and Their Indices. Also see Chapter 16

One of the references which is often not used by the beginning student is the auction catalogue. Yet, these research tools can provide essential data. Sales catalogues sometimes record (1) the provenance of a work of art, the ownership of the object which is important in determining the authenticity of a piece and in tracing artistic taste; (2) the various exhibitions in which the object was displayed, which may lead to additional pertinent material; (3) some literary references which discuss the specific work as well as other pieces from the artist's *œuvre;* (4) the statistics—medium, dimensions, and probable date—of a specific work of art; (5) either a reproduction of the piece or a published source for a photograph of it; and (6) the price for which the artist's works sold, an indicator of the market's reaction to the work of art and the artist.

Although individual sales catalogues are sometimes difficult to locate, the indices which cover them frequently provide similar data. Example 15, an entry for the 1979 *World Collectors Annuary,* illustrates the type of information which these indices report. Under "CAILLEBOTTE, Gustave/ 1848–1894/ French," there is a painting *Fruits à l'étalage* or *Displayed Fruit* cited. It was executed in 1881, signed on the lower right side—the s.lr., and measures seventy-five by one hundred centimeters. The painting has been shown at three exhibitions—1882, 1894, and 1976–1977; the numbers refer to the entries in the catalogues. Four literary references are recorded: Huysmans' article published in the 1883 *l'Art Moderne* magazine and three catalogues compiled by Marie Berhaut, one of which illustrates this piece in color. The auction was held on March 22, 1979 at Mes. Ader Picard Tajan, France—as the "List of Recorded Auction Galleries" in the front of the *World Collectors Annuary* explains the APT. The 71 followed by two asterisks indicates that it was reproduced in color in the auction catalogue in which it was the seventy-first entry. The work sold for 430,000 French francs. These facts could be essential in resolving some particular problems.

Only a few libraries possess large collections of sales catalogues. One of the better ones, owned by the Knoedler Galleries in New York City, is now available on microfiche. Due to its great expense, few institutions will own this reference tool. The sales catalogues are cited by country—American, English, French, German, Italian, Swiss, Swedish, and Hungarian—followed by the auction house, the year, and the day of the sale. One of the advantages to this particular collection is the fact that many of the entries have added notes provided by the Knoedler staff member who attended the auction. If there were any newspaper clippings on the event, these are also included.

Presently there is no index to the Knoedler collection, although one is being compiled. However, by using such resources as Bénézit's *Dictionnaire critique et documentaire des peintres, sculpteurs, dessinateurs, et graveurs,* references can often be located. Unfortunately, the French multivolume work does not provide the name of the auction house. Only the collector whose work is being sold, if this is a sale of one person's collection, plus the name of the piece and the sale date and price are provided. Under Caillebotte's name in Example 6, the *"Prix"* or price section has numerous auctions listed. One citation—"Vte. Théodore Duret, 1ᵉʳ mars, 1928: *Sur le banc,* 2,200 fr."—was checked in the Knoedler collection. The actual sales brochure—*Catalogue des Peintures: Aquarelles, Dessins, Gravures* of the collection of Théodore Duret which sold at the Hôtel Drouot, Paris—reported that the canvas painting measured ninety centimeters by one meter, sixteen centimeters and was signed in the lower right hand corner. The annotation by the Knoedler staff member indicated that the sale price was 2,200 francs and that the purchaser was Gerard fréres, meaning the Gerard brothers. Two newspaper clippings—one French, the other *The Times* of London—reported the sale of this painting. Auction catalogues are especially valuable for tracking down the provenance of a specific work of art, a process detailed in Chapter 6. For an additional discussion on sales catalogues and their terminology, see Chapter 3; for a listing of some references providing sales information, consult Chapter 16.

```
CAFFIERI, Hector / b. 1847 / British
     Searching for a subject. s. 35½x27½in-90.2x69.2cm.  Prov.: Exors of F. Barrowcliff, dec'd;
     Christie's, July 6, 1903, lot 319 (21 gns. to Garle)       C. May 25 (69*)      £ 1.300
     Water lilies. s. 47x25in-119.5x63.5cm. The artist exhibited a picture of the same title at the
     Royal Academy, 1889, no.145.                              SB Oct. 2 (214**)    £ 1.800

CAILLAUD, Aristide / b. 1902 / French
     Paysage. slr. panel. 66.5x48cm.                           GB Feb. 26 (127*)    FF 5.000

CAILLEBOTTE, Gustave / 1848-1894 / French
     Fruits à l'étalage. exec. 1881. s. lr. 75x100cm.  Exh.: 7e Exposition Impressionniste, Paris 1882,
     no. 4; Rétrospective G. Caillebotte, Paris 1894, no. 91; Exposition Caillebotte, Houston et New
     York, 1976-1977, no. 59. Lit.: J.-K. Huysmans, "l'Exposition des Indépendants en 1882", in
     "l'Art Moderne", 1883, p. 262; Marie Berhaut, "Caillebotte", 1951, p. 16, cat. no. 133; Marie
     Berhaut, "Caillebotte", 1968, p. 42; Marie Berhaut, "Caillebotte", no. 178, p. 142, et repr. en
     couleurs page 57.                                         APT March 22 (71**)  FF 430.000
     Bord de rivière. sll. (Auc.) 60x73cm.                     GB June 13 (123**)   FF 72.000

CALAME, Alexandre / 1810-1864 / Swiss
     Seelandschaft. sd. 1847. 77.5x99.5cm.                     S. Zurich May 19 (38**)  FS 40.000
```

Example 15: *World Collectors Annuary 1979,* A. M. E. van Eijk van Voorthuijsen, editor. Voorburg, Nederland: World Collectors Publishers, 1980. Volume 31, page 115.

How to Utilize References on Illustrative Materials. Also see Chapter 17

Because it is a visual discipline, art must be viewed to be studied. The genuine object provides the spectator with information that can never be gathered in any other way—such as the scale of the piece, the way the paint is applied, any pentimento which might appear, the patina of the bronze, or the color-tone of an original photograph. Artists' methods of handling media can only be studied before the actual works of art.

Unfortunately, by necessity, most people have to study reproductions of works of art that have been published in reference works or on film. The researcher who has compiled a working bibliography, a process detailed in this chapter, already has a record of numerous books, magazine articles, and catalogues that have illustrative material. Consequently, the reader should consult these sources for reproductions as each reference is read, especially catalogues raisonnés and œuvres catalogues, since these research tools usually have a black-and-white illustration for each listed work of art.

Museum collection, exhibition, and sales catalogues are also excellent sources. In addition, remember that *Art Index,* as seen in Example 9, cites the titles of works of art that are reproduced in the periodicals which that service covers. Other sources for visual materials are the Vertical Files that some librarians maintain and which are seldom mentioned in the library's catalogue system and the reproductions of art objects on slides, filmstrips, movies, and microforms which are usually located in a separate section of the library.

There are special references for locating reproductions of works of art. The list of indices to reproductions in books and periodicals recorded in Chapter 17 will assist the researcher in discovering illustrative material. These indices cover a diverse set of references and even different kinds of art. Readers should study the annotations in that chapter in order to determine which indices are best for their needs. A typical entry of an index to reproductions can be seen in Example 16, an entry from Isabel and Kate Monro's *Index to Reproductions of European Paintings.* Under the artist's name, "CAILLEBOTTE, Gustave," are recorded titles of works of art which are reproduced in the 328 books that the Monro work indexes. Accompanying these titles are the abbreviations of the titles of the books that repro-

duce the works of art. Moreover, sometimes the page numbers where the reproductions can be located in these books are added. Each of these indices of reproductions publishes a list of the books and periodicals indexed, which provides complete bibliographical entries. For instance, Monro's *Index to Reproductions of European Paintings* reports five Caillebotte paintings in three books, *Market Place* and *Seine at Argenteuil* are cited as being reproduced in Rewald. In the front of Monro's book is a list of the works which are indexed. The notation under *Rewald* records a complete bibliographical entry for John Rewald's *The History of Impressionism.* In addition, some of the books that index reproductions provide information as to the present location of some of the works of art. In Example 16, for instance, the abbreviation *FPL*—which represents *France, Paris, Louvre*—is explained in the "Key to Symbols Used for Locations of Paintings," in Monro's book. Because these indices refer to books and magazines that reproduce a specific artist's works, these indices may also guide the researcher to pertinent material on the subject. The fact that Caillebotte's work is reproduced in *The History of Impressionism* indicates that Rewald discusses the French painter.

Occasionally an institution has a large photographic reference collection where a researcher can study all of the reproductions of art objects that the library has of one artist or all of the reproductions it has under a certain subject, such as madonnas. Often located in a separate visual-resource department, a photographic reference collection is an archive containing reproductions of art from all over the world. Cross files on iconography, biography, and portraits are sometimes compiled. A list of some large reference collections is given in Chapter 26.

CAILLEBOTTE, Gustave, 1848-1894
The floor-waxers **FPL**
 Bazin. Mod ptg p50
Market place
 Rewald
Planers of the parquet flooring
 Borgmeyer p 162
Roofs under the snow
 Borgmeyer p218
Seine at Argenteuil
 Rewald

Example 16: From *Index to Reproductions of European Paintings: A Guide to Pictures in More than Three Hundred Books,* by Isabel and Kate Monro, by permission of The H. W. Wilson Company, copyright © 1956.

Recently, some of these extensive photographic reference collections have been reproduced on microforms or in printed books and are now available at other libraries. The quality of the reproductions varies with the company that publishes the material; the range is from excellent to poor. But for the researcher who needs to view a specific work of art, even an inadequate illustration may be better than none. Many of the collections are for architectural monuments and are discussed in Chapter 7. An annotated list of some of these published photographic archives is provided in Chapter 17.

One of the largest published photographic archives on microfiche is the *Marburger Index: Photographic Documentation of Art in Germany.* Containing 500,000 black-and-white photographs of architecture, painting, sculpture, and crafts produced from the Middle Ages to the present, these illustrations are printed on 5,000 microfiches. The photographs, which were taken between 1850 and 1976, are the pictorial documentation contained in the Bildarchiv Foto Marburg at the Forschungsinstitut für Kunstgeschichte der Philipps-Universität Marburg, founded in 1913, and the Rheinisches Bildarchiv Köln, founded in 1924. The objects are organized by locality. The captions accompanying the images provide the date when the photograph was taken. Each work of art and architectural monument has numerous views provided; for example, one Gothic reliquary has more than sixty-five details. The *Marburg Index* is a photographic collection of German art as well as art from both European and non-European countries owned by German museums. Sold separately is the *Index Photographique de l'art en France,* 100,000 photographs on French art on 1,000 microfiches. The visual material is from the same German institutions. These are rich resources for researchers. Unfortunately, due to their expense, only a few libraries will own this material.

Another large photographic archive, The Witt Library of the Courtauld Institute of Art, London, has had its collection of illustrative material printed on microfiches. Comprising more than 1,200,000 separate photographs and reproductions of some 50,000 European artists who lived from the thirteenth century to the present, this microfiche collection is available in North America at three libraries: the National Gallery, Washington, D.C.; J. Paul Getty Museum, Malibu,

California; and the National Gallery of Canada, Ottawa. Although principally of European artists, some Americans have been included. The book, *A Checklist of Painters c. 1200–1976,* which is available in many libraries as a guide to the Witt Collection, provides citations of name, country, and dates for all the painters represented at the London institution and on the microfiche archive. Gustave Caillebotte's works are well represented. Even though not all of the photographs are clear, dated, labeled correctly, or authenticated, this collection provides the researcher with more visual material on one artist than is possible without visiting one of the photographic archives which are listed in Chapter 26.

How to Utilize Specialized Bibliographic Online Databases. Also see Chapter 12

Although the library will have someone to assist the patron in formulating the problem and in questioning the computer, researchers should understand how to search an online database in order to have an efficient and less expensive search. There are basically three types of specialized bibliographical online databases. The first contains citations identical to those in a corresponding printed abstract or reference work, such as *ARTbibliographies MODERN,* which is available both in a printed and computer form. The second provides entries which correspond to a printed abstract or reference work, but also includes additional material or sources, such as *The Information Bank Database.* This database covers the entries in the *New York Times Index* and has citations for ten other newspapers—including the *Washington Post, Chicago Tribune,* and *Los Angeles Times*—and about forty-five magazines—*Current Biography, Time, Newsweek,* and *New Yorker.* The third type offers access to information that has never appeared in printed form, and therefore is available only through the computer. An example is *SCIPIO,* the Sales Catalog Index Project Input Online, which was begun in 1981 for auction catalogues.

Which online database to use and how to communicate with it are questions the researcher must answer prior to engaging in a search. In choosing which database, a number of items must be considered: (1) the availability and cost of the service, (2) whether or not the material in the computer files can be obtained elsewhere, (3) the

subjects and historic time periods covered, (4) the number and kinds of periodicals and source documents included, (5) the number of records within the database and the dates of the material that the files include, and (6) the frequency of updating.

Not all specialized bibliographic online databases will be available through every library. Most large libraries, however, provide access to at least one computer service. Most of these databases are available through vendors who provide access through standardized procedures and language. The vendors represent various producers—such as ERIC Processing and Reference Facility of the National Institute of Education—which are companies that are responsible for the preparation of the information on the computer tapes. One of the most widely used vendors is DIALOG Information Services, Inc., which now has more than one hundred seventy databases available. Part of its popularity is due to the fact that once an account is established, DIALOG charges for the actual computer connection time plus a small fee per citation printed. This is not true of all companies. Some charge a monthly or annual fee. Obviously, the various means of charging for the computer service will greatly determine which institutions will subscribe to the services. Many vendors are now providing access to their databases through home computers, such access will probably increase in the future. A list of vendors accompanied by their addresses is provided in Chapter 12.

The researcher must consider accessibility of the material in the computer files. If all of the hardbound copies of *ARTbibliographies MODERN* are available in the library, the computer search may not warrant the cost. But if the printed volumes of *Dissertation Abstracts International* are not owned by the user's institution, an online database search would save the expense of locating these works and traveling to another library to use them. As the years pass and the files increase, cooperative plans, such as *SCIPIO,* will become more important sources for data. The expense of a database search must be weighed against the time and effort required for obtaining the information elsewhere.

The number and kinds of serials and source documents—books, catalogues, reviews—that are included in a database determine the value of the computer's file for the researcher. Locating the titles of the periodicals covered by the databases which correspond to printed indices can be discovered by consulting the hardbound publication. But determining the material which is reported by databases that either have no printed index or provide additional sources is not easy, since this list of serials must usually be obtained from the producer of the database. Because this information is not always readily available to researchers, the computer-search librarian must be asked to explain some of the specific serials each computer file includes prior to a search. It is throwing away money to use a database that does not cover serials which publish the type of articles that might relate to the researcher's topic.

The number of records within each database varies enormously, but with each year, these citations increase. Few of the bibliographic online databases have as many entries as their cumulative hardbound equivalents. Unusual is the *Comprehensive Dissertation Index Database,* which has more than 800,000 entries dating from 1861. This corresponds to the hardbound publication. More usual is *COMPENDEX,* which is the electronic version of *Engineering Index.* The more than one million records date from 1970, not 1884 when the index began. Retrospective updating of records is expensive, and not of tremendous value in all fields, but it is essential that the researcher realize just exactly what dates are being covered. If all of the indices must be consulted, the earlier hardbound copies will have to be searched manually.

One of the assets of bibliographic online databases is that the files are usually updated frequently, and the data is available faster than the arrival on the shelf of the published work. As a consequence, the latest citations can be promptly obtained. For instance, *The Information Bank Database* adds complete entries about every week. Obviously, if the most recent material is important, this fast service is far superior to waiting for the bound copy.

Each bibliographic online database covers certain subjects and specific time periods. It is important that researchers understand just what kinds of data are in the files they are searching as well as the dates of the material indexed, before they decide which computer system to use. Not only must the topics covered be known, but the types of periodicals most likely to publish articles on the subject must be considered. Of the major

general art index and abstracting services—*RILA, ARTbibliographies MODERN,* and *Répertoire d'art et d'archéologie*—all have online databases. *Art Index* expects to be online in the late 1980s. These general art bibliographic online databases do not all cover the material in the earliest of their hardbound copies. *ARTbibliographies MODERN Database* and *RILA Database* have citations for all of the material abstracted since their 1974 publications. *Repertory of Art and Archeology Database,* the computer version of *Répertoire d'art et d'archéologie,* contains all of the information that has been indexed since the 1973 printed edition.

Besides the databases that cover general art subjects, there are other computer files which are important to art. For example, architectural researchers use *On-Line Avery Index to Architectural Periodicals Database* and the *Journal of the Society of Architectural Historians Database.* Art educators utilize the *ERIC Database,* which covers both *Resources in Education* and *Current Index to Journals in Education.* Chapter 12 includes a list of online databases organized by subjects. Information on the vendors, the dates of the material which the files include, and the frequency of updating the files are provided.

The quickest method of obtaining pertinent citations from a bibliographic online database is to use the same terms which the computer indexer used. Some companies have issued a thesaurus to aid patrons in choosing the correct words or subject headings. If no thesaurus exists for a particular database, researchers should study the indexing words used in the hardbound copy, if one is published. In an online database search, the reader must realize that not all titles which the computer locates will be relevant to the topic. The tighter the statement, the higher the percentage of hits—a computer term meaning pertinent citations—which the computer will find. Yet, if the statement is too specific, utilizing terms which may not have been used by the writers of the articles or the persons who assigned the indexing terms, important entries will not be included in the computer printout.

In order to communicate with many bibliographic online databases, the problem must be stated in Boolean logic. This is the method of using certain words—AND, OR, and NOT—in algebraic-like sentences. AND indicates that the two ideas must be linked. OR means that either of two or more words are acceptable; this expands the concept. NOT signifies that if a particular term is included in a citation, the computer is to ignore that specific citation; this narrows the search. For example, if a problem posed in Boolean logic stated (furniture OR chairs OR sofas) AND French NOT American, this would mean that the computer should look for citations with the words furniture, chairs, or sofas—any one of the terms will do—used with the word French. But if the record includes the word, American, the computer is to exclude it. The addition of the word furniture to chairs and sofas, expanded the statement; American narrowed it.

The computer can locate only the material that it is directed to find. The method of formulating the problem is the key to a successful search. The computer can be requested to investigate the database by searching one of the following: (1) titles; (2) authors; (3) descriptors or the words added to describe the contents of the entry; (4) the entire abstract, if one is included; (5) magazine names; (6) publication years of the serial; or (7) depending upon the database, the type of document, museum names, the language of the articles, or the country where the magazine was published. Because titles are not always good indicators of the subject matter in an article, a subject search which is by title alone will seldom be adequate. In the DIALOG system, a *free-text search* directs the computer to investigate the words in that specific database's Basic Index. Most online databases containing periodical information include title of article, abstract, descriptors, and identifiers in the Basic Index. But this varies with the database. Since this information is available from the database vendor, researchers must ask the computer-search librarian for details.

A free-text search is often used when there is not a descriptor for the subject. By having the computer search the Basic Index, more citations will probably be reported, but the relevancy rate will be lower. This is due to the fact that the computer ignores context in this type of search and pulls out matching terms, regardless of their meaning. For instance, in a free-text search for information on French furniture, especially chairs and sofas, the computer would report any citations that included these terms, regardless of their position in the record. This can produce a number of irrelevant citations. For example, an article on

the Asiatic furniture of a French diplomat living in Japan would probably not be pertinent to the study, although it would fit the search statement. Yet the computer would report this type of entry in a free-text search in the above statement for French furniture. The way a search statement is worded greatly determines the number of relevant citations which the computer will locate.

In formulating a search statement, there are certain symbols which can be used to refine or widen the search. A symbol can be placed between two or more words that must be used in combination. For the DIALOG databases, the symbol is *(w)*, standing for *with*. For example, fallen (w) women would mean that these two terms must be adjacent and in that specified order. In plight (1w) women, the (1w) indicates that one word, and only one, can be between the two terms. This would allow for the phrase, plight of women. A truncated word uses a symbol, such as a *?* or a *$*, to indicate that any words which have the typed letters are to be printed. If Americ? was the truncated word, the computer would seek America, American, or Americans.

One of the easiest online database searches is for material on a specific person. When utilizing *ARTbibliographies MODERN Database* through DIALOG for articles on Gustave Caillebotte, three various methods were tried. A free-text search for Gustave (w) Caillebotte, indicating both names had to be used, brought forth the report of eight articles. The same kind of search for only Caillebotte, reported nineteen titles. When a search for Caillebotte/de—which means the name of Caillebotte as a descriptor—was conducted, fourteen articles were cited. If Caillebotte was one of the descriptors used in an abstract, he was discussed in the article, not just mentioned. The computer online time for the search and the printing online of the abstracts of the entire fourteen entries took fifteen minutes and cost just under ten dollars. This eliminated the manual checking of twenty semi-annual volumes and the cost of photocopying fourteen pages.

One of the advantages of a bibliographic online database search is that two related ideas can be linked. Instead of having to investigate a single subject unilaterally, one word at a time, a concept or group of related items can be searched. For example, if the problem is to discover titles of references on the fallen woman or the plight of women depicted in nineteenth-century English or French

art, a search statement might be as follows: wom?n AND (iconograph? OR subject) AND (19th (w) century). The truncated wom?n will find either woman or women; iconograph?, iconography or inconographic. Using the *ARTbibliographies MODERN Database* through DIALOG, a free-text search brought forth the report that in this computer file there were 1,455 entries for wom?n; 2,804 for iconograph?; 3,138 for subject; and 4,546 for 19th (w) century. In the combination, as requested in the search statement, there were forty-seven citations. In order to limit the search, the statement was altered by adding (England/de OR France/de) NOT photography. Since the *de* signifies descriptors, England/de would have to be in the list of descriptive terms that were assigned to the article by the computer indexer. This changed the number of entries to eight. When the complete abstracts were printed it was found that seven of them were pertinent to the topic. The same database was searched for fallen (w) wom?n, which had three entries and plight (1w) women, which had two. Of the five additional citations, four were pertinent and only one was identical to those reported in the other search.

In the above search on 19th-century women, notice that the computer reports how many records there are that have each word, before it indicates the number of citations with the combination of the terms. By carefully checking these numbers, the researcher can obtain an idea as to which terms are most frequently used in that particular database. There were 2,804 records with words starting with iconograph? and 3,138, with the word, subject. If both terms had not been used in the search, there would have been numerous relevant articles which the computer would have excluded. It is important to use synonyms in the search statement, because the researcher does not know which terms were used by the authors of the articles or the computer indexer.

In order to obtain literary references on this same subject, a search was made of the *MLA Database* through DIALOG. Begun in 1970, this computer file provides material from the Modern Language Association. Because the references covered by this service are literary, not art oriented, a search was made to see how many works there were on the fallen woman. A free-text search—fallen (w) wom?n—brought forth four entries; all were significant to the topic.

If a large number of entries appear in a database, this number can be narrowed either by limiting the statement or by having only the titles and descriptors typed and choosing only the most pertinent ones to be reported in full. In a search for information on students and school visits to museums, the *ERIC Database* through DIALOG was used. These computer files, which date from 1966, have almost a half a million citations. The search statement—which read student?/de AND museum?/de—brought forth the answer of 102,740 references to student?/de, 591 to museum?/de, and fifty-seven to these terms combined. Since the computer always numbers the answers—such as 1 102740 student?/de, 2 591 museum?/de, and 3 57 1 and 2—the complete statement does not have to be retyped. The third set, number 3, lists fifty-seven citations for the combination of set one and two.

There are several ways to narrow the search. For example, in the above illustration utilizing the *ERIC Database,* a search for major descriptors—student?/MAJ AND museum?/MAJ—which characterize the most substantive contents of articles, curtailed the number of citations to fifteen. After having all fifteen typed only by title and descriptors, not complete entries, enough information was provided to choose eight entries to be fully reported. Another method available for the *ERIC Database* is to instruct the computer to obtain information through grade level descriptors. In the search statement, Primary education OR Elementary/de OR grade 1 OR Grade 2: Grade 6, the Grade 2:Grade 6 means a range of from Grade 2 through Grade 6. The computer reported 5,813 records for primary education; 82,220 for elementary/de; 2,099 for Grade 1; and 5,838 for grade 2 through grade 6. When the two search statements were combined, thirty citations were found.

One of the most important uses of online database searches is for current information. Even in this case, more than one news-oriented online database can be used effectively. In searching for material on photographer Karl Struss, *The Information Bank Database* through NEXIS—in which the records date from about 1969—had three entries: to an exhibit of his work in 1976 reported in the *New York Times* and to two of his 1981 obituaries, in the *New York Times* and the *Los Angeles Times.* Searching *Magazine Index Database* through DIALOG for Karl Struss produced two citations: to a biographical article in

Modern Photography, 1977, and a biographical obituary in *Time Magazine.*

Online database searches can be used to discover recent exhibition catalogues. In a search on the American artist Larry Rivers, the *ARTbibliographies MODERN Database* through DIALOG was asked how many references there were for Larry (w) Rivers; the answer was forty-two. The question of how many exhibition catalogues were abstracted in the entire database brought forth the number 5,455. When (Larry (w) Rivers) AND (exhibition (w) catalog?) was used the number of entries changed to eleven. The search and complete typing of these citations cost under ten dollars.

The same search strategy was used for *The Information Bank Database* through NEXIS; there were twenty-six entries. The coverage was not only easier and quicker, but more complete for the number of years that there are records in that computer than was the material reported in *The New York Times Index* for the same years. Under "RIVERS, Larry" the 1980 volume of *The New York Times Index,* a more complicated reference tool to use, reported "See also Art, J1 13, Ag 3. Art-Shows, Picasso, Pablo (1881–1973), Je 22." This translates: under the heading Art, refer to entries for July 13 and August 3; under Art-Shows, check Picasso, Pablo, June 22. The online computer printout provided brief abstracts for these three entries plus a February 10th review to an exhibition, Printed Art: A View of Two Decades, which included work by Larry Rivers. This last entry was not in the printed *New York Times Index.*

In 1980, a database was formed to help researchers identify the more than 4,000 auction catalogues that are published annually. *SCIPIO,* an acronym for Sales Catalog Index Project Input Online, is a cooperative project of the libraries of the Cleveland Museum of Art, the Metropolitan Museum of Art of New York City, and the Art Institute of Chicago. Librarians from each of these institutions record in the database the information taken from the title pages or the cover of auction catalogues. Each institution is responsible for the catalogues from certain auction houses. This online database is available only through RLIN, the Research Libraries Information Network. The information reported in the entries includes the title of the catalogue, the year and date of sale, the country of publication, the auction house, place

of sale, and the names of the collectors, if they appear on the title page or cover. The contents of the catalogue are not analyzed. Because only this brief information is reported, finding auctions which have included works by a specific artist depends upon whether or not that artist is listed on the cover or the title page of the catalogue. In a search for the English landscape painter, Joseph M. W. Turner, the computer command used by RLIN—FIN JW TURNER, meaning find J. W. Turner—was typed. Three records were found. The computer reported the auction houses, the cities where the sales occurred, the main titles of the catalogues, and the dates of the sales. Many of the collectors whose art is involved in an auction are often reported on the covers or title pages of the sales catalogues. *SCIPIO* is a quick way to find these specific brochures. When looking for Berthe Rose's ceramics sales, *SCIPIO* reported three auctions which included pieces from her collection, all at Sotheby Parke Bernet, New York City, on February 28, March 3, and April 22, 1981.

Researchers should be cautioned about online database searches. They are usually similar in function to an abstract or indexing service. Each database includes certain types of periodicals and files limited to specific periods of time. The indices and abstracts which cover pertinent serials, but which, for one reason or another, are not yet available in an online database, will still need to be examined in printed form. Online database searches are not the end of a research problem; they are only one tool used to facilitate finding data. If used with care, they can assist the researcher in becoming more efficient. But expense will be incurred, especially if extreme caution is not taken to define and refine the study problem.

GUSTAVE CAILLEBOTTE:
AN ANNOTATED WORKING BIBLIOGRAPHY

The following bibliography includes works that specifically discuss Gustave Caillebotte, his life, works, and bequest. Sales catalogues, newspaper articles, and general literature of the nineteenth century have been excluded. Museum and gallery catalogues are alphabetized under the name of the institution. Abbreviations for the libraries where the references are located are as follows: NTSU, North Texas State University, Denton; KAM Kimbell Art Museum, Fort Worth; and DMFA, Dallas Museum of Fine Arts, Dallas.

Bataille, H. "Enquete." Journal des Artistes, 1894.

Bazin, Germain. French Impressionists in the Louvre. Translated by S. Cunliffe-Owen. New York: Harry N. Abrams, Inc., 1958. (NTSU, 759.4.B348r). Discusses the Caillebotte Bequest; reports that thirty-eight of the sixty-seven pictures which were offered were accepted. Mentions that Léonce Bénédite was the curator of the museum at the Palais du Luxembourg during the controversy over the bequest.

Bénédite, Léonce. "La Collection Caillebotte au Musée du Luxembourg." Gazette des Beaux-Arts 17 (1897): 249-58.

Bénézit, Emmanuel. Dictionnaire critique et documentaire des peintres, sculpteurs, dessinateurs, et graveurs. 10 vols. Paris: Librairie Gründ, 1976. (NTSU, N40, B48). Facsimile of Caillebotte's signature; gives sales prices of some of his works over a span of eighty-four years, from 1889 through 1974.

Berhaut, Marie. Caillebotte the Impressionist. Translated by Diana Imber. New York: French and European Publications, Inc., 1968. (Interlibrary, Bowling Green University). Includes sections on Caillebotte's life, oeuvre, critics, and collection. Provides a list of the French titles of the works of art which composed the Caillebotte Bequest accompanied by an indication of which works were accepted by the French government. There are twenty-eight color reproductions of Caillebotte's paintings, a list of his retrospective exhibitions, and a brief bibliography.

_____. Caillebotte:sa vie et son oeuvre: Catalogue raisonné des peintures et pastels. Paris: Fondation Wildenstein, 1978. (KAM, N44, C1346, B36). Catalogue of 477 works, 31 of which are reproduced in color. Rest of works have small black-and-white identification photograph. Includes 18 illustrations of Caillebotte and his residences. Reproduces 46 letters, mailed either to or from Caillebotte. Reprints documents concerning the bequest and critical reviews of Caillebotte's work. Includes a bibliography, a list of museums which own Caillebotte's work, and 3 indices--to titles of paintings, to subjects, and to people.

_____. Gustave Caillebotte (1848-1894). Paris: Wildenstein Publications, 1951. (Did not obtain; available at Harvard University or New York Public Library).

_____. "Gustave Caillebotte." Arts (Paris), August 30, 1948.

_____. "Gustave Caillebotte: Résumé." Musées de France, October 1948, pp. 237-39.

_____. "Musées de Province: Trois tableaux de Gustave Caillebotte." Musées de France, July 1948, pp. 144-47. (Interlibrary, Northwestern University).

Bernac, Jean. "The Caillebotte Bequest to the Luxembourg." The Art Journal, 1895, pp. 230-32, 308-10, 358-61. (NTSU). Reprinted in Denys Sutton's catalogue. A lively account of the French reaction to the bequest. Reports sixty-five pictures composed the Caillebotte Bequest; mentions that the two works by Millet included a drawing and a smaller watercolor painting.

Bienenstock, J. A. M. "Childe Hassam's Early Boston Cityscapes." Arts Magazine 55 (November 1980): 168-71. (NTSU). Comparison with Caillebotte's work.

Bouret, Jean. "Un peintre de notre temps." Arts (Paris), May 25, 1951, p. 1.

Chronique des arts et de la curiosité, 1894, pp. 71, 85.

Crombie, Theodore. "London Galleries: Callebotte and Company." Apollo 84 (July 1966): 65. (NTSU).

Dixon Gallery & Gardens, Memphis, Tennessee. Impressionists in 1877: A Loan Exhibition. Memphis: Dixon Gallery and Gardens, 1977. (Did not obtain.) Exhibition commemorating the third Impressionist exhibition of 1877.

Example 17: Gustave Caillebotte: An Annotated Working Bibliography

Example 17—*Continued*

Duranty, Louis Emile Edmond. La nouvelle peinture: A propos du groupe d'artistes qui expose dans les galeries Durand-Ruel (1876). New edition. Paris: Floury. 1946. (Did not obtain; available at Harvard University.)

Duret, Théodore. Critique d'avant-garde. Paris: G. Charpentier et cie., 1885. (Did not obtain; available at Harvard University.)

_____. Histoire des peintres impressionnistes. 3rd ed. Paris: H. Floury, 1922. (Did not obtain; available at Harvard University.) Reprints Duret's Les peintres impressionnistes published in Paris in 1878.

Encyclopedia of World Art, 1963 ed. S.v. "Impressionism." (NTSU, N31, E533). Records dates Caillebotte exhibited in the French Impressionist Exhibitions.

Ephrussi, Ch. Gazette des Beaux-Arts (1880): I, pp. 487-88.

"Etude pour le Pont de l"Europe, 1876." Gazette des Beaux-Arts 85 (March 1975): 44. (NTSU). Announcement of a new acquisition by the Albright-Knox Art Gallery, Buffalo.

Failing, Patricia. "The Objects of their Affection." Art News 81 (November 1982): 122-131. (NTSU). Discusses ten different museums that responded to question of which works of art in their collection visitors liked best. At the Art Institute of Chicago one of them was Caillebotte's Rue de Paris, temps de pluie.

Fénier. Les impressionnistes en 1886. Paris: Dé la Vogué, n.d.

Galeries Durand-Ruel, Paris. Exposition retrospective d'oeuvres de G. Caillebotte. n.p./, June 1894. (Did not obtain).

Geffroy, Gustave. La vie artistique. 8 vols. Paris: E. Dentu and H. Floury, 1892-1903. (Did not obtain; available at Harvard University). Volume 3, "Histoire de l'impressionisme" [sic] includes Caillebotte.

Glueck, Grace. "New York Gallery Notes: Circa 1825-2000." Art in America 56 (September/October 1968): 108-09. (NTSU). News release of 1968 Wildenstein Retrospective Exhibition in New York City.

Hoekem, James. "Gustave Caillebotte." Arts Magazine 51 (May 77): 10. (NTSU). Review of Brooklyn Museum exhibition. Reports that Rue de Paris, temps de pluie was loaned to Houston, but not Brooklyn.

Huysmans, J.-K., "l'Exposition des Indépendents en 1882." l'Art Moderne, 1883, p. 262.

Isaacson, Joel. The Crisis of Impressionism 1878-1882. Ann Arbor: The University of Michigan Museum of Art, 1979. (NTSU, N6847.5, I4, I78). Catalogue of exhibition held November 2, 1979-January 6, 1980. Displayed Périssoires sur l'Yerres, 1877, Milwaukee Art Center and Vue prise à travers un balcon, c. 1880, private collection. Reprinted catalogues of 4th through 7th Impressionist Exhibitions.

Kindlers Malerei Lexikon. 6 vols. Zurich: Kindler Verlag, 1964-71. (KAM, ND30, K5, v. 1-6). States M. Berhaut wrote her dissertation on Caillebotte. Provides locations for some works of art.

Leroy, Alfred. Histoire de la peinture française (1800-1933): Son évolution et ses maîtres. Paris: A Michel, 1934. (Did not obtain; available at Harvard University).

McGraw-Hill Dictionary of Art, 1969 ed. S.v. "Caillebotte, Gustave." (NTSU, N33, M23, v. 1-5). General material.

Mirbeau, Octave. "Le Legs Caillebotte et l'état." Le Journal, December 24, 1894.

Musée de Chartres. Caillebotte et ses amis impressionnistes. Forward by Georges Besson. Chartres: Syndicat d'initiative de Chartres, 1965. (Did not obtain). Catalogue of exhibition held June 28-September 5, 1965.

Musée des Beaux-Arts de Rouen. Catalogue des peintures du Musée des Beaux-Arts de Rouen. Compiled by Olga Popovitch. Paris: Arts et Métiers Graphiques, 1967. (Personal copy). Catalogue entry for Au café, 1880.

Musée du Jeu de Paume, Paris. Musée du Jeu de Paume. Revised ed. Paris: Editions des Musées Nationaux, 1976. (KAM, N2050, J4, A6, 1976). Catalogue of the museum that houses the Impressionist and Post-Impressionist collection of the Musée National du Louvre. Gives the exhibitions in which the works of art figured and the dates the works were painted.

70

Example 17—*Continued*

Musée National du Louvre, Paris. Catalogue des peintures, pastels, sculptures impressionnistes. Paris: Musées Nationaux, 1958. (Personal copy). Earlier edition of the catalogue for the collection of Impressionist works exhibited at the Musée du Jeu de Paume.

Museum of Fine Arts, Houston. Gustave Caillebotte: A Retrospective Exhibition. Houston: Museum of Fine Arts, Houston, 1976. (KAM, ND553, C25, H6). Profusely illustrated catalogue of seventy-seven paintings exhibited at The Museum of Fine Arts, Houston, October 22, 1976 to January 2, 1977 and The Brooklyn Museum, February 12 to April 24, 1977. Biography written by J. Kirk T. Varnedoe and Hilarie Faberman; catalogue of the exhibition by Varnedoe and Thomas P. Lee. Includes the following articles on Caillebotte: his perspective by Varnedoe, his manipulation of space by Varnedoe and Peter Galassi, and by Galassi an essay on how Le Pont de l'Europe and Paris, A Rainy Day were constructed. Introduction by Marie Berhaut; reprints and translates Caillebotte's will and various critical articles written on Caillebotte's work from 1876 to 1880. One of the most extensive, scholarly references written on Caillebotte.

"Outstanding Exhibitions." Apollo 88 (December 1968): 494-95 (NTSU). Review of Caillebotte's first American exhibition at Wildenstein Gallery, New York City.

Perruchot, Henri. "Scandale au Luxembourg." L'Oeil 9 (September 1955): 14-19. (Did not obtain). Illustrated by reproduction of the artist's works.

Pincus-Witten, Robert. "A Caillebotte Exhibition at Wildenstein." Artforum 7 (November 1968): 55-56. (NTSU). Review of exhibition.

"Place du l'Europe on a Rainy Day." Chicago Art Institute Calendar 59 (May 1965): 8-9. (NTSU). Provides a reproduction and a short catalogue entry for this painting.

Praeger Encyclopedia of Art, 1971 ed. s.v. "Caillebotte, Gustave." (NTSU, N33, P68, v. 1-5). Gives titles and dates for three of his works in the Louvre.

Rewald, John. The History of Impressionism. 4th ed. revised. New York: Museum of Modern Art, 1973. (NTSU, ND1265, R4). Extensive, detailed discussion on the inter-relationships of the various artists who exhibited in the eight French Impressionist Exhibitions. Includes a photograph of Caillebotte and black-and-white illustrations of four of his paintings: Man at a Window, 1875; The Seine at Argenteuil,

c. 1874; Self Portrait, 1889; and Street in Argenteuil, 1883; Reports that Caillebotte posed for Renoir's painting, Boating Party at Chatou, 1879 (National Gallery of Art, Washington, D. C.).

Roberts, Keith. "Current and Forthcoming Exhibitions: London." Burlington Magazine 108 (July 1966): 386. (NTSU). Review of the exhibition at Wildenstein Gallery, London; discusses some of the exhibited paintings.

Rosenstein, Harris. "Reviews and Previews." Art News 67 (October 1968): 9. (NTSU). News release of exhibition at Wildenstein Gallery, New York City.

Russell, John. "Art News from London: The Perception of Caillebotte." Art News 65 (September 1966): 22-23. (NTSU). Review of the exhibition at Wildenstein Gallery, London.

Scharf, Aaron. Art and Photography. London: Allen Lane, 1968. (NTSU, N72, P53). Discusses photography's influence upon Caillebotte's painting.

Tabarant, A. "Le peintre Caillebotte et sa collection." Le Bulletin de la Vie Artistique, August 1, 1921, pp. 405-13.

Le Temps 3 (1894): 3.

Thieme, Ulrich and Becker, Felix. Allgemeines Lexikon der bildenden Künstler von der Antike bis zur Gegenwart. 37 vols. Leipzig: E. A. Seemann, 1907-50. (NTSU, N40, T4). Contains bibliographical data on nineteenth-century publications.

The Toledo Museum of Art: European Paintings. University Park, Pennsylvania: Pennsylvania University Press, 1976. (NTSU ND450, T64, 1976). Catalogue entry for By the Sea, Villerville.

Varnedoe, J. Kirk T. "Caillebotte's Pont de l'Europe: A New Slant." Art International 18 (April 20, 1974): 28-29, 41, 58. (NTSU). Analyzes Caillebotte's manipulation of the viewer's frame of reference in this lopsided X composition. Explores the possibility that Caillebotte utilized photographs in formulating this painting.

Example 17—*Continued*

_____. "Gustave Caillebotte in Context." Arts Magazine 50 (May 1976): 94-99. (NTSU).
Discusses the visual distortions in the cityscapes of the 1870's. Compares the Caillebotte theme of a person viewing the city and the German Romanticism theme of a view from an open window. Analyzes Rue de Paris, temps de pluie, 1877 (Art Institute of Chicago).

Waldfogel, Melvin. "Caillebotte, Vollard and Cézanne's Beigneurs au Repos." Gazette des Beaux-Arts 65 (February 1965): 113-20. (DMFA).
Mentions the first exhibition of the Caillebotte Bequest; covers principally Cézanne's work.

Werner, Alfred. "Caillebotte: A Rediscovery." Arts Magazine 43 (September/October 1968): 42-45. (NTSU).
Discusses Caillebotte's life and friendships with the other Impressionist painters. Reports that Caillebotte posed for Renoir's The Luncheon of the Boating Party and Boating Party at Chatou.

Wildenstein, Daniel. "Caillebotte." Arts (Paris) 312 (May 25, 1951): 1.

Wildenstein Gallery, London. Gustave Caillebotte 1848-1894: A Loan Exhibition in Aid of the Hertford British Hospital in Paris. Compiled by Denys Sutton. London: Wildenstein and Company, Ltd., 1966. (Personal copy).
Illustrated catalogue of an exhibition which consisted of fifty-one of his paintings held June 15-July 16, 1966. Includes a biography of the artist plus an analysis of some of his works. Reproduces four letters from Degas to Caillebotte and Jean Bernac's article, "The Caillebotte Bequest to the Luxembourg," which was originally published in 1895 in The Art Journal.

Wildenstein Gallery, New York. Gustave Caillebotte: A Loan Exhibition. New York: Wildenstein & Company, Inc., 1966. (Personal copy).
Exhibition held June 15-July 6, 1966; text by Denys Sutton and Jean Bernac. The 35-page catalogue includes letters by Edgar Degas to Caillebotte.

Wildenstein Gallery, New York. Gustave Caillebotte 1848-1894: A Loan Exhibition of Paintings for the Benefit of The Alliance Française de New York. New York: Wildenstein and Company, 1968. (Personal copy).
An eight-page pamphlet listing the seventy paintings, their dimensions and owners, exhibited September 18-October 19, 1968.

Wildenstein Gallery, New York. One Hundred Years of Impressionism: A Tribute to Durand-Ruel. Forward by Florence Gould. New York: Wildenstein and Company, Inc., 1970. (Interlibrary, University of Texas at Arlington).
Catalogue of exhibition held at Wildenstein Gallery, New York City, April 2-May 9, 1970; reproduces La Seine à Argenteuil, 1888. Includes extracts from The Memoirs of Paul Durand-Ruel.

Wykes-Joyce Max. "Maecenas at Work: Gustave Caillebotte." Arts Review 18 (June 11, 1966): 269.

Young, Mahonri Sharp. "The Detached Observer." Art News 76 (May 1977): 114. (NTSU).
News item on exhibition at Brooklyn Museum.

GUSTAVE CAILLEBOTTE:
A SELECTED BIBLIOGRAPHY

Only publications that specifically discuss in detail Gustave Caillebotte, his life, works, or bequest are included. All sales catalogues, newspaper articles, exhibition reviews, and general literature of the nineteenth century have been excluded. Arranged alphabetically, the bibliography is divided into three categories: encyclopedias and books, articles, and catalogues. All museum and gallery catalogues are alphabetized under the name of the institution.

Encyclopedias and Books

Bazin, Germain. French Impressionists in the Louvre. Translated by S. Cunliffe-Owen. New York: Harry N. Abrams, Inc., 1958.

Bénézit, Emmanuel. Dictionnaire critique et documentaire des peintres, sculpteurs, dessinateurs, et graveurs. 10 vols. Paris: Librairie Grund, 1976.

Berhaut, Marie. Caillebotte the Impressionist. Translated by Diana Imber. New York: French and European Publications, Inc., 1968.

_____. Caillebotte: sa vie et son oeuvre. Paris: Bibliothèque des arts, 1978.

Isaacson, Joel. The Crisis of Impressionism 1878-1882. Ann Arbor: The University of Michigan Museum of Art, 1979.

Kindlers Malerei Lexikon. 6 vols. Zurich: Kindler Verlag, 1964-71.

Praeger Encyclopedia of Art. 1971 ed. S.v. "Caillebotte, Gustave."

Rewald, John. The History of Impressionism. 4th ed. revised. New York: The Museum of Modern Art, 1973.

Scharf, Aaron. Art and Photography. London: Allen Lane, 1968.

Thieme, Ulrich and Becker, Felix. Allgemeines Lexikon der bildenden Künstler von der Antike bis zur Gegenwart. 37 vols. Leipzig: E. A. Seemann, 1907-50.

Articles

Berhaut, Marie. "Musées de Province: Trois tableaux de Caillebotte." Musées de France. July 1948, pp. 144-47.

Bernac, Jean. "The Caillebotte Bequest to the Luxembourg." The Art Journal, 1895, pp. 230-32, 308-10, 358-61.

Varnedoe, J. Kirk T. "Caillebotte's Pont de l'Europe: A New Slant," Art International 18 (April 20, 1974): 28-29, 41, 58.

_____. "Gustave Caillebotte in Context." Arts Magazine 50 (May 1976): 94-99.

Werner, Alfred. "Caillebotte: A Rediscovery." Arts Magazine 43 (September/October 1968): 42-45.

Museum and Exhibition Catalogues

Musée de Chartres. Caillebotte et ses amis impressionnistes. Forward by Georges Besson. Chartres: Syndicat d'initiative de Chartres, 1965.

Musée des Beaux-Arts de Rouen. Catalogue des peintures du Musée des Beaux-Arts de Rouen. Compiled by Olga Popovitch. Paris: Arts et Métiers Graphiques, 1967.

Musée du Jeu de Paume, Paris. Musée du Jeu de Paume. Revised ed. Paris: Editions des Musées Nationaux, 1976.

Musée National du Louvre, Paris. Catalogue des peintures, pastels, sculptures impressionnistes. Paris: Musées Nationaux, 1958.

Museum of Fine Arts, Houston. Gustave Caillebotte: A Retrospective Exhibition. Houston: Museum of Fine Arts, Houston, 1976.

The Toledo Museum of Art: European Paintings. University Park, Pennsylvania: Pennsylvania University Press, 1976.

Wildenstein Gallery, London. Gustave Caillebotte 1848-1894: A Loan Exhibition in Aid of the Hertford British Hospital in Paris. Compiled by Denys Sutton. London: Wildenstein and Company, Ltd., 1966.

Wildenstein Gallery, New York. Gustave Caillebotte 1848-1894: A Loan Exhibition of Paintings for the Benefit of The Alliance Française de New York. New York: Wildenstein and Company, 1968.

_____. One Hundred Years of Impressionism: A Tribute to Durand-Ruel. Forward by Florence Gould. New York: Wildenstein and Company, Inc., 1970.

Example 18: Gustave Caillebotte: A Selected Bibliography

Research on Specific People: Architects, Artists, Designers, Authors, Patrons, Critics

Studies on a specific person begin with the formulation of a working bibliography and a chronology, as described in Chapter 4 and defined in Chapter 1. A chronology is especially important, since it assists researchers in putting the individual and the person's work in perspective. In addition, the artist's works must be viewed and analyzed, a subject detailed in Chapters 6 and 7. Because research on people in different professions requires various types of resource tools, this section is composed of (1) some suggestions for developing working bibliographies and chronologies and (2) references that can be used to determine the correct pronunciation of the person's name.

Research on People: Special Problems

While following the steps outlined in Chapter 4, there are some special considerations that might prove helpful in conducting research on people. These are discussed in this section, which has been subdivided into suggestions concerning (1) architects, (2) American artists, (3) little-known artists, (4) contemporary artists, (5) fashion designers, (6) authors, (7) patrons and collectors of art, and (8) art critics. These categories sometimes overlap. Be sure to read all pertinent sections.

Architects

If research is to be done on a specific architect, data must be collected concerning all the names by which this person is known, the nationality and dates of the person, and the architectural firms with which the architect is associated. For instance, Le Corbusier, the twentieth-century Swiss architect, may be cited under his trade or his real name, which in this case was Charles-Edouard Jeanneret-Gris. Sometimes it must be determined which part of the name—of the individual or of the firm—will be used for the listing. For example, Ludwig Mies van der Rohe is cited under M for Mies. Another famous architect is listed under "Saarinen, Eero" in most library catalogues, although his firm was called Eero Saarinen and Associates. On the other hand, in these same catalogues, Kevin Roche is usually entered under K for the firm's name—Kevin Roche, John Dinkerloo and Associates. For famous architects who are members of companies that do not contain their names, the listings may be under either. Gordon Bunshaft of Skidmore, Owings and Merrill is placed under B for Bunshaft in *Art Index,* but under the firm's name in some of the other indices. Although there are cataloguing rules which explain these types of listings, the student must remember that several approaches must often be tried in order to find all entries.

For assistance in the gathering of this essential data, the reader should consult the "Specialized Biographical Dictionaries," which are cited in Chapter 10; the entries have been subdivided as to "Architects, Historically Prominent" and "Architects, Contemporary." One of the best references—for professionals both past and present—is the five-volume *Macmillan Encyclopedia of Architects,* which includes 2,450 comprehensive biographies. Under Thomas Jefferson, whose home Monticello is used as an example in Chapter 7, there is a nine-page signed article by Margaret Richardson which has photographs of Monticello, the Rotunda of the University of Virginia, and the Virginia State Capitol. There is a list of Jefferson's architectural works with their dates and a bibliography of fourteen entries.

Two outstanding references for living Americans are *Pro File: Professional File Architectural Firms* and *Contemporary Architects.* The former, which is published by the American Institute of Architects, has two indices—for firms and for principals—that allow the researcher to obtain the necessary data regardless of whether or not the name of the architect or the company is known. In this publication there is other valuable information, such as the year the firm was established, the principal officers and their professional affiliations, and the kinds of projects—commercial,

housing, industrial, medical, interior design—that the company conducts. *Contemporary Architects,* which contains signed articles from about 170 contributors, includes about 575 professionals. Each entry consists of a chronology, a list of works, citations of publications by and on the architect, and one or two short essays concerning the person's works.

American Artists

When following the steps outlined in Chapter 4, remember that American artists are included in the foreign-language biographical dictionaries. Frequently these works provide the best clues for locating other pertinent data. For instance, in searching for material on Boston painter William P. Babcock (1826–99), citations were found in the biographical dictionaries of Bénézit, and Thieme-Becker. Both articles mentioned that he displayed his works at the Royal Academy in London and at the Salons of Paris from 1868 to 1878 and that he was associated with the Boston Athenaeum.

Although material on Babcock was found in these biographical dictionaries, the entries were both brief—five or six sentences. With so little data, it is best to check Havlice's *Index to Artistic Biography* for titles of specialized biographical dictionaries. Babcock is listed in Havlice's book as being cited in Baigell's *Dictionary of American Art* and Mitchell's *Great Flower Painters.* The former reported that Babcock lived in Barbizon, France and that the Museum of Fine Arts in Boston has a number of his paintings. Mitchell's dictionary provided information on the subject matter of some of this artist's work and reproduced one of his paintings.

Armed with the facts from these four biographical dictionaries, the researcher will know which indices to exhibition catalogues, which are annotated in Chapter 15, to examine. Because Bénézit and Thieme-Becker reported that Babcock had his paintings displayed at the London Royal Academy, other indices of British exhibitions should also be consulted. Both Bénézit and Thieme-Becker reported Babcock's association with the Boston Athenaeum. In *The Boston Athenaeum Art Exhibition Index 1827–1874,* there were entries for the eight years when he displayed his work at this institution. Although no reference mentioned that Babcock exhibited his work in New York, due to the proximity of the cities, *A History of the Brooklyn Art Association with an Index of Ex-hibitions* was consulted. A citation was found for the Bostonian's work entitled *Love and Reason* for April 1872. Because of Baigell's reference, the *American Paintings in the Museum of Fine Arts, Boston* was examined. Seven entries and one reproduction of his work were discovered.

Auction catalogues and the indices which cover them will also provide important information. In the issues of *The Annual Art Sales Index* over the past decade, there were two entries for works by a person named Babcock. Both paintings are entitled *Floral Still Life;* only one was reproduced in the sales catalogue. One listing was for "Babcock, William P. (1826–1899) American;" the other was for "Babcock, P. (1826–1894), American." Although the death dates differ by five years, this may be the same artist, since the works were sold at two different auction houses, one in the United States, one in Europe. But, the actual auction catalogues must be found and studied plus further research done to resolve this problem.

Since 1980, *Leonard's Index to Art Auctions* has covered paintings, drawings, sculpture, and mixed media sold at American auction houses. No matter how low, the sale price is recorded. This is not an index just for American artists, but for artists of any nationality whose works are sold in the United States. The 1981/82 issue cited two of Babcock's works. One sold for $660, the other for $440; both were illustrated in the auction catalogues. Although no reference to Babcock's works were found, the *American Art Annual*—which often included extensive sales information during the years from 1898 to 1948—is frequently a good source for works of art sold at earlier American auctions.

One of the most extensive collections of primary research material on American painters, sculptors, and craftsmen is the Archives of American Art, which contains 5,000 collections consisting of six million items on artists. The material is photocopied and available at each of the five U.S. offices—Boston, Detroit, New York City, San Francisco, and Washington, D.C.—or through an interlibrary loan. *The Manuscript Collections of the Archives of American Art,* a ten-volume work which is annotated in Chapter 11, reproduces the library's inventory card file. This archival file lists material (1) by collections of papers and (2) by individual items or series of items. The filing is under the proper names of individual artists, collectors, and organizations. The collection includes

varied and different types of material, such as exhibition brochures, letters, photographs, sketchbooks, business records, and even diaries. At the Archives of American Art, there has been an aggressive campaign to photocopy all existing archival material on American art, not all of which is deposited at the Archives. For instance, twenty letters dating from 1866 to 1906 which Thomas Eakins wrote were copied by the Archives in 1964, but the originals are still owned by the Pennsylvania Academy of Fine Arts. In addition, for contemporary artists, there is an oral history program of taped interviews with more than 1,200 people in the arts. As for the example of William P. Babcock, under his name there is a notation that there are some clippings that refer to him among the Mary Bartlett Cowdrey 19th-Century American Artists File.

In searching for material on artists and their *œuvres,* remember that their works of art may be scattered throughout the world. In *A Checklist of Painters c. 1200–1976 Represented in the Witt Library, Courtauld Institute of Art, London,* Babcock's name is included. If the researcher went to the Witt Library or viewed the microfiche copies which have been made of this valuable photographic archive, illustrations of Babcock's works would be found.

For American art there is a special bibliography, full of marvelous little tidbits which so delight researchers. *Arts in America: A Bibliography,* edited by Bernard Karpel, is a collection of twenty-one separate annotated bibliographies written by various art experts. Many of the bibliographies have references for individual artists. "Sculpture" by William B. Walker, for instance, provides bibliographical material for about 365 sculptors; "Photography" by Beaumont Newhall has citations for approximately 170 photographers. Although the table of contents at the beginning of each bibliographical essay usually lists the specific artists included, *Volume 4: Index* should also be consulted, because it provides references to persons mentioned in the annotations as well as those for whom there are citations. For instance, Babcock has two entries in "Painting: Nineteenth Century" by J. Benjamin Townsend. But by using *Volume 4: Index,* another reference was found to Babcock. The citation was for Marchal Landgren's article, "The Two Worlds of Robert Loftin Newman," in *Antiques,* December

1975. The annotation discusses Newman's association with fellow artists, such as Babcock. Unless the index was examined, this entry would not have been located.

The two principal citations for Babcock in J. Benjamin Townsend's bibliography were for a 1970 exhibition catalogue, *American Pupils of Thomas Couture,* and *The Great American Nude: A History of Art,* 1974. References to these books were not discovered elsewhere. Townsend's bibliography also provides access to thematic categories—such as seascapes, religious art, still life, and genre—as well as works concerned with regional sections of the United States—New England, The South, and the Middle West. In using *Arts in America,* researchers on American art should not just study the specific bibliography which fits their artists, because the other essays may have pertinent material. For example, "Sculpture" by William B. Walker has citations for works concerned with the International Expositions and the World's Fairs from 1876 to 1970, including European and Japanese, as well as North American expositions. "Design: Nineteenth Century," by Demtra Pulos, includes bibliographical data on the major Industrial Exhibitions from London in 1851 to Chicago in 1893. Anyone studying American art should become familiar with this four-volume reference.

In Washington, D.C. there are two unpublished resources for researchers studying American art: (1) "The Inventory of American Painting Executed Before 1914" at the National Museum of American Art and (2) "The Catalog of American Portraits" at the National Portrait Gallery. The former was a bicentennial project begun in 1976, which presently includes information on about 230,000 paintings in a computer file and almost 45,000 photographic reproductions of these works. There are three indices to the paintings: artists, owners or locations, and subject classification. "The Catalog of American Portraits" contains photographs and documents on 60,000 historically important Americans. Paintings, sculpture, drawings, miniatures, and silhouettes are included. Organized by sitters' names, there are cross references to the artists who did the likenesses. Researchers have access to both of these resources by visiting the museum or, for simple requests, by mail. In addition, there is a "Pre-1877 Art Exhibition Catalogue Index" (see p. 193).

Little-Known Artists

If the subject of the research is not cited in the general biographical dictionaries, such as Bénézit or Thieme-Becker, the researcher should immediately consult Havlice's *Index of Artistic Biography,* a valuable reference tool for little-known artists. If the person is H. Baynton, the Havlice book will report his name—Henry Baynton, his dates—1862–1926, his nationality and media—English painter, and a reference that includes him—Mallalieu's *Dictionary of British Watercolor Artists,* 1976. This last item indicates that much of his work will be watercolors.

The exhibition catalogue references that are recorded in Chapter 15 had no listings for Baynton. It was only through the auction catalogue indices that additional material was discovered. *The Annual Art Sales Index* had four citations for his works of art which were sold between 1974 and 1981. The prices ranged from $324 to $623, paltry sums on the international art market. Only one of the sales catalogues illustrated the sold painting. Some of the catalogues might be difficult to locate, since they included the auction houses of Grant Stourport and Galerie Dobiashofsky, as well as the more familiar Sotheby Belgravia and Christie's in London. Even so, the notation of four works of art—their titles, dimensions, plus signature and date—provided additional material on Baynton. If the sales catalogues cannot be located, the auction houses can be contacted to request a photocopy of the entry and any additional information that they might have. For the address of an auction house, consult either the *International Art and Antiques Yearbook* or the *International Directory of Arts,* both of which are listed in Chapter 22 under "Location Directories."

For a little-known American artist, locating an address in a city directory can establish a person's place of residence. With this information, the library and museum of the community can be contacted to inquire as to whether or not any vertical files or exhibition data might be available on the artist. *City Directories of the United States* from Research Publications, Inc. is a reprint of these important reference tools on microforms. There are four segments: Number 1, which is on microfiche, is based upon Dorothea N. Spear's *Bibliography of American Directories Through 1860,* 1961; Number 2, on microfilm, covers the years 1861 through 1881; Number 3, on microfilm, 1882 through 1901; and Number 4, which will be on microfilm, 1902 through 1935. Each city directory provides such information as a list of city residents for that year, a list of people by professions, an indication of firms which were in business, advertisements for household goods, and a city map. These city-directory reprints can be purchased by segments for individual states. Few libraries will own all of the segments for all of the United States.

Other sources for locating little-known artists are the photographic archives, which are listed in Chapter 17, especially (1) the *Witt Library Photo Collection on Microfiche,* which has reproductions of works of art of about 50,000 artists, and (2) *Christie's Pictorial Archive,* which contains more than 70,000 photographs of works of art sold at Christie's between 1890 to 1979. There are about 5,000 artists represented in the Christie's painting and graphic sections. The two indices—*A Checklist of Painters c. 1200–1976 Represented in the Witt Library, Courtauld Institute of Art, London,* 1978 and *Christie's Pictorial Archive: Index to Artists*—were examined. Unfortunately, Baynton was not included in either photographic archive.

The indices of periodicals—both recent ones and the ones for nineteenth-century magazines—provided no leads; nothing on Baynton had been written in the major art magazines. The newspaper indices were next checked, especially for the year of his death. Baynton had no obituary in either the *New York Times* or *The Times* of London. When artists have not displayed works of art in the major exhibitions and their works are not in great demand, it is impossible to collect much data concerning them. Clue by clue, piece by piece, the puzzle may fit together. Unfortunately, even after years of searching, the information may continue to be fragmentary.

Contemporary Artists

When researching a contemporary studio artist follow the same steps detailed in Chapter 4. *The International Directory of Exhibiting Artists* and *Who's Who in American Art* may provide brief biographical information. The references which cover exhibition catalogues—especially, *Worldwide Art Catalogue Bulletin, RILA,* and *ART-bibliographies MODERN*—should be consulted. However, artists are only cited in these indices if they have been included in an important exhibition, such as the Whitney Biennial, or have had a number of one-artist shows in a cosmopolitan art city, such as New York or Los Angeles.

Another method of discovering data is through newspapers and regional magazines. This can be accomplished through checking *NewsBank Review of the Arts*, which indexes articles in 190 newspapers in 130 major cities, excluding *The New York Times*, which has its own index. Information can also be located through an online database search, especially *Magazine Index* of DIALOG. This particular database covers 370 popular American magazines—including *American Artist, American Art Review, Architectural Digest, Architectural Review, Art in America, Art News, Ceramics Monthly, Craft Horizons, Camera 35, Current Biography, Modern Photography, Newsweek,* and *Time Magazine*—plus a number of regional periodicals—*Boston Magazine, Los Angeles, New York, Philadelphia,* and *Texas Monthly*. The search can be made by adding an */NA* after the artist's name indicating that only articles which specifically cover this person will be cited.

Some libraries are excellent sources for local artists. For example, although the Dallas Public Library has a collection which was started only about twenty years ago, the Fine Arts Department has vertical files containing material—clippings from the local newspapers as well as the *New York Times* and the *Christian Science Monitor,* exhibition catalogues and announcements, gallery and museum notices, plus other ephemera—on approximately 6,000 artists who not only work in the region but anywhere else in the United States. No differentiation is made on the stature of the artist; everything is saved. The material in a library's vertical files is available to visiting researchers and sometimes, for a small fee, the material will be photocopied and sent.

One of the most extensive set of vertical files on artists from Cézanne to the present is at the Museum of Modern Art in New York City. Emphasizing living persons, the files contain rare material on approximately 15,200 artists, and the files grow yearly. There are references to this vertical file information in the *Catalog of the Library of the Museum of Modern Art*. The material is available to those who visit the MOMA Library. The directors of some galleries save similar material for the artists whom they represent. If data is needed, researchers should write the director of the gallery which represents the artist. This information is reported in the *International Directory of Exhibiting Artists*.

Fashion Designers

If the fashion designers are well known, they will probably be listed in one of the indices to biographical information described in Chapter 10. One of these biographical indices, *The Biography and Geneology Master Index*, provides information on more than 3 million people. If work is to be done on Yves Saint Laurent, this index provides information on his being in the following biographical directories: *Celebrity Register*, 3rd edition; *Current Biography Yearbook*, 1964; *International Who's Who*, 38th edition; and *Who's Who in the World*, 2nd edition. The entry in *Current Biography Yearbook* provides one of the fullest accounts of the French designer's life; included are the pronunciation of his name, his photograph, and six references for further reading. Each of the entries in the other biographical dictionaries lists similar, although not identical, information. Provided are such essential data as birth date, family background, education, a list of important designs for ballets and films, the years that he became successor to Christian Dior, and the dates of two principal awards: 1958 from Neiman-Marcus in Dallas, Texas, and 1966 from *Harper's Bazaar*.

The data that will be gleaned from the biographical dictionaries will provide a basis for more in-depth research. The investigator should begin by compiling a working bibliography and a chronology; a process detailed in Chapter 4 of this guide. But the major references that need to be examined differ somewhat from those listed in the Caillebotte example. For instance, most of the art indices cited in Chapter 12 provide insufficient coverage for researchers of fashion. Still there is one significant index, *The Reader's Guide to Periodical Literature*, which covers important fashion and news magazines, such as *Harper's Bazaar, Mademoiselle, New Yorker, Newsweek, Time,* and *Vogue*.

Articles have to be indexed in readily accessible published indices in order that later researchers may become aware of their existence. For example, some fashion-oriented newspapers, such as *Women's Wear Daily*, do not have their articles indexed by printed publications. Since 1981, *Women's Wear Daily* has been included in the *Trade and Industry Index Database*, through DIALOG. This is discussed later. As a result, the only way an individual can locate an article in one of the pre-1981 issues of this newspaper is by

checking page by page through each issue, a job that consumes more time than most readers wish to devote to this kind of research. Nevertheless, by studying the basic information found in the biographical dictionaries, researchers can often find clues that, if followed, will lead them to more pertinent data. For instance, knowing that Saint Laurent won the 1958 Neiman-Marcus award the researcher should examine that year's various issues of *Women's Wear Daily,* which is available on microfilm in many libraries. Another important period of the newspaper that should be checked for information are the times during which the collections of the couturiers are displayed for the international press and the fashion buyers. The articles and drawings over a range of years since Saint Laurent's rise to fame should be scrutinized by the reader in order to discern any changes in his popularity.

A database search is the best method for discovering recent information on fashion designers. DIALOG has four separate files that might provide pertinent information. *Newsearch Database* indexes current articles in newspapers and magazines. After one month the material from the *Newsearch Database* is placed in one of four other databases, three of which could be pertinent to fashion: (1) *Magazine Index,* which includes *Harper's Bazaar, Mademoiselle,* and *Vogue;* (2) *National Newspaper File,* which covers three papers since 1979 and two additional ones since 1983; and (3) *Trade and Industry Index,* which since 1981 has covered *Women's Wear Daily.* In a search for Yves Saint Laurent, *Newsearch*—the file that stores only the latest articles which were published within the last month—had a reference to an article in *Women's Wear Daily.* The *Magazine Index* cited nine articles; the *Trade and Industry Index Database,* which has files since January 1981, seventeen. In searching another system, the *Information Bank Database,* which covers ten newspapers plus approximately forty-five magazines, since about 1969, there were sixty-six citations. When the search was narrowed to material from one specific year, the number declined to five. The database files, which will continuously expand each year, provide a wealth of information for the fashion researcher.

Another source of material that should not be overlooked is the fashion vertical file that some libraries maintain. This material, which is cut out of magazines and newspapers and filed in envelopes or folders, is not usually listed in a library's catalogue file. If such material is available, the librarian will assist the researcher in using it. The material in vertical files in libraries not in the researcher's area can sometimes supply pertinent data. By writing the Fine Arts Librarian, the investigator may discover if a vertical file exists on the subject and the price for photocopying the material. For instance, because Yves Saint Laurent received an award from Neiman-Marcus, the Dallas Public Library might be written.

Of utmost importance to the fashion world are the seasonal showing of the couturier collections. These fashion shows receive international press coverage. Before beginning a search, consult the monthly fashion magazines to pinpoint the exact dates and months that a particular collection was shown. But remember that the fashion world is one which zealously guards its secrets.

Authors

Before quoting a book extensively, researchers should know how other scholars evaluate the work. If a book is ambiguous or difficult to understand, students have discovered that reading reviews of the work may shed light on the author's ideas. Unfortunately, finding out about writers can be an arduous task unless they have an international reputation and either write in or have their works translated into English, although there are several kinds of publications that will assist the diligent investigator.

In order to compile biographical information on authors, the reader should first consult the indices of biographical dictionaries that are annotated in Chapter 10, such as *The Biography and Geneology Master Index* and the *Marquis Who's Who Publications: Index to All Books.* If the reader is looking for a death notice, *The New York Times Obituaries Index 1858–1968* curtails checking individual volumes of the *New York Times Index.* Most of these indices to biographical information do not include the various who's who books published in foreign countries. For this reason, the reader should also examine any of these books that might be appropriate, such as *Who's Who in France* or *Who's Who in Germany.*

In addition to biographical information, facts concerning a dissertation topic and the titles of the various books by the author may assist the investigator in obtaining material relating to the author's expertise. If the author has received a

doctorate, the dissertation title, the year, and the conferring school may be listed in *Dissertation Abstracts International,* annotated in Chapter 12, which began including titles from foreign universities in 1970. There is a *Comprehensive Dissertation Index, 1861–1972,* with later supplements, which facilitates the use of this reference work. An online database is also available.

For the titles of the books that a particular author has written, the reader can check under the author's name in the many catalogues published by the Library of Congress and in the catalogues of famous libraries, all of which are described in Chapter 11. Another source is the annual publications of the R. R. Bowker Company, *Books in Print.* This reference lists all of the books published in the United States in a given year. There are nine volumes: three have entries under the name of the author, three under the book title, and three under a particular subject heading. Some foreign countries, such as England and France, have an equivalent annual listing of their books in print. These works are annotated in Chapter 22.

To discover the opinion of other authorities in the field concerning a particular author, the investigator should study the book reviews of the author's works. The annotations of sources which will assist in locating these critiques comprise Chapter 21. In each case, the year a first edition was issued plus the following three years should be checked. Often a review is written only for the first edition or for one which has been enlarged and revised.

Not all books are reviewed, and some that are may have reviews that are difficult to find. For example, to be listed in *Book Review Digest,* a nonfiction work must have been published or distributed in the United States and must have been reviewed in at least two of the more than eighty magazines this index covers. Some of the indices include an abstract of each critique, thus helping the researcher to decide which reviews might be important. The review itself can often be judged by the quality of the periodical in which it is published. For instance, a critique found in the scholarly English publication *Burlington Magazine* would most likely be written by another expert in the field.

A good book review should provide a critical analysis of the book. At times, it may give a different viewpoint or question the accuracy of the material. It should not, however, be a platform from which the reviewer expounds his or her own opinion. It should be objective. Because of their concentration on art, the art magazines often provide the more critical reviews of works relating to this discipline.

In Arntzen and Rainwater's *Guide to the Literature of Art History,* under "Painting, Neoclassical-Modern," there is a citation for John Rewald's *A History of Impressionism.* In order to learn more about the author, *Who's Who in American Art* was consulted. This reference provided information on his education—at the Universities of Hamburg, Frankfurt-am-Main, and Sorbonne; his teaching posts; his awards; and his publications. In addition, the dates for the various editions of *The History of Impressionism* are reported. Other biographical references also included John Rewald. Because he received his doctorate from a European university prior to 1970, information was not recorded in *Dissertation Abstracts International.*

There were numerous book reviews listed for the first edition of *The History of Impressionism. Book Review Digest 1946* has four entries: *Booklist, New York Times, New Yorker,* and *Weekly Book Review.* In addition, the sixth volume of *Art Index* cites three magazines having reviews of Rewald's book: *Architectural Forum, Burlington Magazine,* and *Magazine of Art.* The review in *Burlington Magazine* was signed by Herbert Read, the noted English art historian. There were also reviews for the 1961 third edition, revised and enlarged, of *The History of Impressionism.* The entries in *Book Review Digest 1962,* as Example 19 illustrates, confirm the high quality of Rewald's book.

Patrons and Collectors of Art

During the past decades, there has been considerable interest in art collectors and individual taste. This has resulted in museum exhibitions and the publication of books on the subject. *The Vatican Collections: The Papacy and Art*—the 1982 catalogue of the exhibitions held at the Metropolitan Museum of Art of New York City, The Art Institute of Chicago, and the M. H. de Young Memorial Museum in San Francisco—discusses the art collected by various Roman Catholic Popes, from the fourth century to the present. Other exhibitions have been held in order to recreate part of a specific collection. For example, in 1966 the National Gallery of Stockholm displayed some of

Example 19: *Book Review Digest 1962.* Acknowledgement: Material from *Book Review Digest* is reproduced by permission of The H. W. Wilson Company.

the art that Queen Christina had removed from Sweden after her abdication in 1654. In addition, there has been a continuous interest in the extensive collections of dictators, such as Napoleon and Hitler. Illustrating the artistic taste of kings, queens, and dukes, are such books as, *Royal Heritage: The Treasures of the British Crown,* by J. H. Plumb, 1977, and *Princes and Artists: Patronage and Ideology at Four Habsburg Courts, 1517–1633,* by Hugh Trevor-Roper, 1976.

Some collectors have built a special museum for their art, such as the J. Paul Getty Museum at Malibu, California, and the Kimbell Art Museum in Ft. Worth, Texas. Other patrons have donated their art to one or more museums, such as Samuel Kress and Paul Mellon. Books, such as Francis Henry Taylor's *The Taste of Angels,* 1948, and Aline Saarinen's *The Proud Possessors: The Lives, Times, and Tastes of Some Adventurous American Art Collectors,* 1958, relate the stories of some of the famous collectors of history. Francis Haskell in *Patrons and Painters: A Study in the Relations Between Italian Art and Society in the Age of the Baroque,* 1980, and *Rediscoveries in Art: Some Aspects of Taste, Fashion, and Collecting in England and France,* 1976, has discussed the influence patrons have had on art.

Researching material on patrons who have accumulated quantities of art requires (1) the development of a working bibliography that includes references on the person's life, any inventories of the collection, and data on each object and artist represented in the collection; (2) the formation of a chronology that encompasses the person; the dates of the purchases of the collected works; any sales which occurred; the dissolution of the collection, if this happened; and any later exhibitions of the collection; and (3) reproductions and catalogue entries for as many of the works of art as possible, a process explained in Chapter 6. Due to the problems of locating inventories, this type of

research can be time consuming, depending upon the patron and the period when the collection was formed, and whether or not the art objects have been dispersed. Follow the basic steps indicated in Chapter 4 for developing a bibliography and check the bibliographies of articles and books on the subject in order to obtain additional pertinent leads. Especially important are the museum catalogues which have indices to former owners of the works of art now in their collections. Remember that the discrepancies may be many. Caillebotte was a collector of Impressionist art. As illustrated in Example 1, some sources report sixty-five paintings in his Bequest; others cite sixty-seven or sixty-nine. In the case of this French collection, the confusion may be over whether or not some of the Degas pastels are considered complete works of art.

Art Critics

Art criticism has had a tremendous influence on art. During the French Impressionist exhibitions, the fact that the art critics castigated the works of these artists helped set the climate by which the French government officials refused many of the paintings in the Caillebotte Bequest. The role of the critic can be especially important in understanding certain artists and periods of art. George Heard Hamilton's *Manet and His Critics,* 1954, is an excellent example of an analytical study that examines the influence of French writers on the nineteenth-century painter, Edouard Manet.

Elizabeth Gilmore Holt's *The Triumph of Art for the Public: The Emerging Role of Exhibitions and Critics,* 1979, details public art exhibitions in France, England, Italy, and Germany from 1785 to 1848. A brief historical essay describes each exhibition followed by English translations of some of the critical assessments of the displayed works of art. In *The Art of All Nations, 1850–73: The Emerging Role of Exhibitions and Critics,* 1981 and a third volume which is now in preparation, Elizabeth Holt continues this format of essays on exhibitions accompanied by translations of the critiques. *French Painters and Paintings from the Fourteenth Century to Post-Impressionism* by Gerd Muehsam reproduces selections from criticisms and writings concerning the works of about one hundred French artists. All of the essays have been translated into English. *The Studies in Fine Arts: Criticism Series* has separate books on different critics. These types of references are cited in Chapter 13.

In order to discover what critics have had to say about an artist's works and to assess the quality of the critic's artistic judgment, the researcher should consult (1) the magazines and newspapers for which the critic wrote and the indices that cover these serials, (2) any books and articles written on or by the critic, (3) references of collected writings that discuss art and criticism, (4) one-artist exhibition catalogues and monographs that may reprint evaluative critiques concerning the specific artist, and (5) biographical dictionaries that provide data on critics in order to determine their credentials.

It should also be remembered that in assessing the influence or effect of criticism on artists and their works, one must gauge the nature, domicile, and extent of the audience who read the critiques. For instance, Denis Diderot (1713–84) wrote at great length, often in minute detail, on nine of the biennial Paris Salons between 1759 and 1781. These readable articles were printed in *Correspondance littéraire, philosophique et critique de Frédéric Melchior Grimm,* a newsletter which was circulated to an exclusive list of subscribers, most of whom never saw the exhibition at the French Salons. Many of the patrons, such as Catherine the Great of Russia, lived outside of France. The effect of Diderot's critiques—which were only published many years after his death—on the Parisian Salon viewer was probably nil, but these comments undoubtedly influenced the foreign market for French art as well as the method and style of writing used by later art critics.

Correct Pronunciations of Artists' Names

Often a researcher reads terms and names without knowing how to pronounce them. Recently the trend has been towards spelling and pronouncing names as they would be in their country of origin. Thus, it is important to know Tiziano's true name as well as his anglicized one, Titian; the Italian Venezia and its English equivalent, Venice. The multilingual glossary of proper names and geographic locations, which comprises Appendix D, will help the reader in finding names in French, English, German, Italian, and Spanish.

To learn how to say the names of artists correctly, the reader should consult (1) the *New Century Classical Handbook* edited by Catherine Avery, for the pronunciation of names of Greek

and Roman artists; (2) the *New Century Italian Renaissance Encyclopedia* edited by Catherine Avery, for the articulation of the names of those involved in Italian Renaissance art; and (3) G. E. Kaltenbach's *Dictionary of Pronunciation of Artists' Names*, for the pronunciation of the names of artists of the western civilization who were active from the thirteenth through the early part of the twentieth centuries. These and other guides to pronunciation are annotated in Chapter 22. Although unabridged dictionaries have valuable information concerning the pronunciation of proper names, they have not been listed.

It is especially difficult to find the correct pronunciation for contemporary artists who have yet to be included in any dictionary. Sources of pronunciation information are (1) *The Current Biography Yearbook,* which is cited in Chapter 10; (2) *Time Magazine,* which sometimes gives a word that rhymes with the name of the person about whom the article is written and is indexed in the *Reader's Guide to Periodical Literature;* and (3) *The Academic American Encyclopedia Database,* which indicates the pronunciation of artists' names for those persons who have a separate entry. In addition, another source is the Museum of Modern Art in New York City. If an artist's work has been displayed at this museum, there will probably be a record of the correct pronunciation of that person's name. Write the Registrar for information.

Research on Individual Works of Art

The end product of an artistic endeavor is an individual work of art. Researching specific pieces is an important part of any art study. Students new to this type of research should read the essay on "Historiography"—a term that means the methods by which the discipline of art history has been approached, the theories and techniques used for critical examination and evaluation—in the *Encyclopedia of World Art* and consult some of the references annotated in Chapter 13 under "References on Analyzing Works of Art." For instance, W. Eugene Kleinbauer's *Modern Perspectives in Western Art History* provides essays by famous scholars that illustrate different ways in which works of art have been analyzed.

When researching a work of art, several steps should be considered: (1) viewing the object and understanding any catalogue entry written for it; (2) reviewing the opinion of the artist and of critics, if such material exists; (3) analyzing the physical aspects or the form of an object and the stylistic classification of the work; (4) studying the subjects and symbols that might be depicted; and (5) investigating the various influences—artistic, literary, religious, theatrical, historical, geographical, and scientific—which might have affected the work of art. This chapter discusses these concerns for all kinds of art except architecture, which is explained separately in Chapter 7.

Visual Material and Catalogue Entries

Artists, researchers, and critics need to look at great quantities of art in order to study and to analyze it. There is no substitute for a personal examination of the original art object. Only by seeing the work of art *in situ*—in the place for which it was planned—can the effect of the surroundings, dimensions of the piece, and the artist's handling of the media be discerned. Unfortunately, most art is no longer *in situ,* and if it is, the environment has been altered. In addition, many works of art are (a) in museums which are difficult and expensive to visit; (b) in private collections which are not open to the public; (c) no longer in existence, because they have been de-stroyed by wars, fires, or other catastrophes; and (d) lost with no clues as to what happened. Even with these difficulties, researchers must make every effort to study the original work of art.

Even if artists and researchers were personally able to view all of the art objects they need to examine, reproductions of the works would still be needed for detailed and comparative studies. There are four main ways of obtaining this essential illustrative material: (1) by visiting the place where the work of art is located and photographing it; (2) by purchasing what the owner of the object offers in the way of photographs, slides, or postcards; (3) by locating a reproduction in a published work, such as a book or article; and (4) by studying the photographic reference collections that some museums and libraries maintain or which have been published and sold to other institutions. These last two methods were discussed in detail in Chapter 4 under "How to Utilize References on Illustrative Material;" the explanation is not repeated here. Because acquiring visual material requires time, the investigator must begin early in the research process to locate and obtain it.

The first method cited above allows the researcher to view the object first hand, but may not be practical, especially if a great many works are involved. For instance, in the example which is being used throughout this book, most of Gustave Caillebotte's paintings are in private collections in Europe. A visit to see each of the works would be impractical, if not impossible. There is also the problem that most owners will not allow photographs to be taken of their works of art.

Museum bookstores sell color reproductions, in the form of either 35 mm. slides or postcards, of many of the objects in the museum's collections. Due to the poor quality of many of these color reproductions, many scholars prefer the black-and-white glossy photographs that most institutions sell of their works of art. These photographs, which are usually priced at between five and fifteen dollars each, are often purchased through the registrar's office. This method of obtaining reproductions entails a considerable amount of time in order to write a letter to the museum staff to in-

quire as to what is available and at what price, to negotiate the sale, and to receive the desired illustration. Many foreign museums require payment in their currency. Most large banks in metropolitan cities have an International Department which can supply the researcher with a bank draft in most currencies. This method has the advantage that the researcher then owns the reproduction. It must be remembered that this does not include the right to publish the photograph. In order to reproduce the photograph in an article or book, written permission must be obtained from the owner of the work of art.

In addition to viewing the work of art, the investigator must collect as much data as possible concerning the object. A catalogue entry, which is the documentation on a specific work of art, varies from a few facts on the physical aspects of the piece to a detailed scholarly citation. An entry for a work of art in a museum catalogue should provide the most pertinent information which is known concerning that art object. Whereas everyone interested in art needs to know how to understand catalogue entries, many researchers—museum curators, individual art collectors, scholars, and students—also should know how to write entries for works of art. One of the best ways of learning about an individual art object is to write a catalogue entry for that piece.

In compiling a catalogue entry, the researcher should record all of the pertinent data which can be found concerning the object. This information, which will be discussed in detail, includes the following:

1. the artist's name and dates;
2. the title of the piece;
3. the approximate date the piece was made;
4. the medium;
5. the dimensions;
6. the specific data found on the object, such as signature and date information, a casting mark, or a watermark;
7. the condition of the work, if known or unusual;
8. the present location of the work and, where applicable, the acquisition number;
9. the provenance or listing of all known owners and sales in which the work of art figured prior to its arrival at its present destination;
10. the various exhibitions in which the work has been displayed;
11. the literary references in which the piece is discussed;
12. related works of art that are studies or sketches of the piece or are similar to it plus any engravings or graphics which are based upon the piece;
13. any additional pertinent information regarding the object that can be gathered; and
14. a method of illustrating the work.

Not all of these fourteen categories will be used for every work of art, since some entries apply only to specific art objects. For instance, some pieces have never been displayed in an exhibition. Furthermore, because a catalogue entry is a compilation of the known information on a work of art, the entry will never be absolutely complete. For as more data are uncovered, the catalogue entry will change. Example 3 illustrates a sample catalogue entry for Caillebotte's *On the Europe Bridge.*

There are a number of excellent reference works that will assist compilers in writing catalogue entries. For instance, in order to complete the first category—the artist's name and dates—the researcher should scrutinize the biographical dictionaries listed in Chapter 10, since these references will help the compiler sort out the artist's names and nicknames, as well as provide established dates for the artist. If the art object does not have an artist's name, but instead has either a monogram or a hallmark, the reader should study the facsimiles of these designations which are reproduced in the books annotated in Chapters 10 and 18. If the artist or artisan of the piece cannot be determined, perhaps the compiler of the catalogue entry may be able to discern a style or school to which the artist may have adhered. For further clarification as to terms of attribution, the reader should consult Chapter 3.

Discovering the correct title of a work of art, the second category in the catalogue entry, may be difficult, because (1) there may be no definite name for the piece, (2) the title may have been altered or modified, and (3) the title may have been translated. Many art works have no official titles, but are known by descriptive terms, such as *Ibex Handle, Greek Amphora with the Death of Orpheus,* and *Egyptian King Amenhotep III.* Obviously these descriptions are easily altered, even if a work of art has received an official title. It may have been changed, since the owners of art objects have the right to name and rename any of the works they own. For instance, Caillebotte's painting now at The Art Institute of Chicago called

Paris, A Rainy Day has had numerous names: *Rue de Paris, temps de pluie; Umbrellas in the Place de l'Europe;* and *Place de l'Europe on a Rainy Day.*

Another problem in obtaining the correct title of a work of art is that the title may be a translated title, instead of the actual name of the art object. Thus in Bénézit's *Dictionnaire critique et documentaire des peintres, sculpteurs, dessinateurs, et graveurs*—all the titles are in French, while in *Kindlers Malerei Lexikon* the titles are in German. A still-life painting when owned by a German museum would be called *Stilleben;* if owned by a French museum, *Nature Morte;* and if the property of an Italian museum, *Natura Morta.* Care must be taken to record the correct title. If a foreign museum possesses a painting, the name will usually be in the language of that country and should be so listed. Nevertheless, sometimes the title by which a work has been known will be retained by a new owner. Under the entry for the year 1879 in the chronology of Example 1, for instance, the reader can see that the painting on loan to the National Gallery of Art, Washington, D.C. retains the French title *Périssoires.* A hard title to translate, *Périssoires* means a flat-bottomed, canoelike boat. If it is desirable to record either a translation of the title or another name by which the work has been known, this second designation should be placed in parentheses: *Canotiers (Oarsmen).*

For most of the information in a catalogue entry, the owner of the work must be discovered. The owner's name may be obtained through some of the following: (1) the biographical dictionaries that list artists' principal works accompanied by their present owners; (2) in a catalogue raisonné or *œuvre* catalogue which might have been compiled on the artist's works; (3) the indices of periodical literature, which may assist the compiler in finding references to any transference of proprietorship; (4) exhibition, museum, and sales catalogues; and (5) the indices of works of art in museums.

Once the owner of a work of art is known, the researcher should consult the catalogue of the institution that possesses the object in order to obtain as much information concerning the work as possible. If the owner has not compiled a scholarly catalogue, the data might be located in one of the series of books that have been published on art collections of famous museums, such as the *Newsweek Great Museums of the World Series* and the *World of Art Library Galleries Series.* These works are annotated in Chapter 17 under "Well-Illustrated References."

If the needed data cannot be located or if the compiler wishes to check the information, a letter requesting assistance can be written to the registrar of the institution that owns the work of art. Often the registrar will send a photocopy of some of the information recorded in the registrar's files. Any knowledge regarding the price or the monetary value of the object, however, is always withheld. One exception is the Wallace Collection. London, whose catalogue entries often report the prices for which some of the objects in the collection were purchased. For a list of directories that provide the addresses of museums, the reader should refer to the material in Chapter 22.

The information needed for the next six categories of a catalogue entry can usually be obtained by inspecting and measuring the art object or by obtaining the information from the owner of the work. These facts include the date, medium, size, data on the piece, condition of the work, and acquisition number. Sometimes the date is signed on the work of art. If not, the compiler of the catalogue entry may have to research this question by using the same resource tools utilized in compiling a chronology of the artist. If the exact date of the work of art is not known, an approximation or range of dates should be provided. This is often preceded by a *c.* for *circa* or about.

The medium of the art object should be defined as accurately as possible; for instance, a fresco should have a specific designation, such as *buon fresco* or *fresco secco.* In catalogues which are published in the English-speaking countries, the dimensions should be reported in both centimeters and inches; otherwise, only the metric system is used. Most measurements are written with the height of the object preceding the width. Moreover, the overall measurements of the actual painting are usually recorded. For information on measuring works of art, see the 3rd edition, revised of *Museum Registration Methods,* by Dorothy H. Dudley, American Association of Museums, 1979. For data on changing inches to centimeters, see Chapter 3.

Any data on the work of art can prove to be of the utmost importance. A signature designation by the artist can be used to assist the investigator in ascertaining both the authenticity and the probable date of an object. For example, the *Royal*

Museum of Fine Arts Catalogue of Old Foreign Paintings—published in 1951 by the Statens Museum for Kunst, Copenhagen, Denmark—provides a number of facsimilies of the signatures on the paintings listed in the catalogue. The three illustrations of Ferdinand Bol's signature reveal how the seventeenth-century Dutch painter changed his handwriting, as well as the actual way he signed his name, during the period from 1644 to 1669. He signed his name *F.Bol-fecit* in 1644, *Bol* in 1656, and *Bol fecit* in 1669. *Fecit,* which was sometimes used in artist's signatures, is a Latin term that means "he or she made it."

If there is a signature on a particular work of art which the researcher would like to compare with other known signatures by that artist, the following references—all of which reproduce signatures of some of the artists included in their works—will be of assistance: (1) biographical dictionaries such as, *Kindlers Malerei Lexikon* and Bénézit's *Dictionnaire critique et documentaire des peintres, sculpteurs, dessinateurs, et graveurs,* both of which are cited in Chapter 10; (2) the books on monograms, such as Nagler's *Die Monogrammisten* and Goldstein's *Monogramm Lexikon,* both annotated in Chapter 18; and (3) the scholarly catalogues of such museums as the Frick Collection, New York City; the Rijksmuseum, Amsterdam; the Statens Museum for Kunst, Copenhagen; the Bayerische Staatsgemäldesammlungen, Munich; and the Hamburger Kunshalle, Hamburg.

Specific data found on the art object, obviously varies with the form of art. For instance, in the case of a piece of metal-cast sculpture, this might include the name of the casting firm or founder's mark plus the number and size of the edition of the casting. If a piece of art work has a designated side, this fact also needs to be included. For instance, in an open manuscript the term *recto* indicates the right-hand page, while the opposite side is called the *verso.* This same terminology is used to indicate the front side of a painting or drawing, the *recto,* and the reverse side, the *verso.*

An important inclusion for some drawings or prints is whether or not a particular work of art, one that is on paper, contains a watermark. Impressed or incorporated into sheets of paper at the time of their manufacture, *watermarks* are used to designate the makers or manufacturers of the papers. This kind of design or pattern first began to appear in Europe around the end of the thirteenth century. Due to their distinct characteristics, a watermark can sometimes be used to determine the location and approximate date of works of art. Several references that will assist the compiler in discovering the origins of watermarks are cited in Chapter 18.

The physical condition of a work of art should be included in the catalogue entry, especially if it has recently been cleaned, damaged, or restored. The acquisition number of a work of art is the number the owner of the piece gave to the object upon receiving it into the collection. As illustrated in Example 3, the Caillebotte painting, whose acquisition number is AP82.1, was the first item received for the museum's collection by the registrar of the Kimbell Art Museum in 1982.

The ninth category of a catalogue entry, the provenance of a work of art, requires tracing the movements of the piece from the time it left the artist's studio to its present location. In collecting data on changes of ownership and the auction sales in which it might have figured, the researcher is obtaining information which will assist in determining the authenticity or attribution of the work. The provenance of a work of art is often elusive, and may be impossible to establish. The researcher will need to investigate (1) the collectors and owners who might have owned the piece and any existing inventories or lists of their collections and (2) auction catalogues. This research is sometimes made more difficult, because it is hard to decide whether or not various references to a work of art are one and the same. The titles and dimensions can be confusing. For instance, the following may all be the same painting: (1) *Paysage,* 2.7 m. × 3.7 m.; (2) *Die Landschaft,* 273.5 cm. × 365.8 cm.; (3) *Paesaggio,* 3 m. × 4 m.; and (4) *Landscape,* 9 ft. × 12 ft. For information on changing dimensions to the metric system, see Chapter 3.

Some collectors have marked or impressed their personal seal or stamp on the edge or margin of the works of art they possess. The mark of a well-known collector may provide a means of tracing the provenance of an object, since there are references that help in identifying these designations, such as Frits Lugt's *Les marques de collections de dessins et d'estampes.* Investigating any family crest or coat of arms found on the object might provide the compiler with a valuable lead as to the past ownership of the work. Two books that will aid the reader in this kind of search

are (1) Brusher's *Popes Through the Ages*, which reproduces the personal coat of arms of each pope from St. Peter through John XXIII and (2) *Burke's Genealogical and Heraldic History of the Peerage, Baronetage, and Knightage*, which has illustrations of the emblems of the peerage of the British Empire. All three of these books are annotated in Chapter 18.

To try to discover the names of the previous owners of a work of art, the inventories of private collections and early museum catalogues can be essential. Often the best source for establishing the existence of such archival material is in other scholar's bibliographies or footnotes. For example, the bibliography in Francis Haskell's *Patrons and Painters,* 1980, has references for inventories of art collections in Baroque, Italy. Susan Foster's "Paintings and Other Works of Art in Sixteenth-Century English Inventories," *Burlington Magazine* 123 (May 1981): 273–282, provides data for that particular period.

Another means of discovering the provenance of an art object is to investigate the sales in which it might have figured. If the work of art was sold at a public auction, there may be a catalogue of the sale. This catalogue might indicate the name of the seller of the art piece, but it will not usually provide the name of the purchaser. Remember there are microform reprints of some auction catalogues, such as the microfilmed catalogues of Sotheby's of London. From the first brochure of 1734 through 1970, Sotheby's catalogues are available on 164 reels. Filmed from the auctioneer's copy, these catalogues include annotations of the sales prices and the names of the purchasers.

The indices of auction sales, annotated in Chapter 16, might assist the investigator in finding information concerning a particular work of art. Each of these indices covers somewhat different auction houses and various kinds of art. Consequently, the researcher may need to study more than one of these indices. If the exact date of a particular sale is not known, the compiler should consult all of the past issues of these indices. The kinds of information available from these auction indices are illustrated in Example 15.

Good resources for discovering the provenance of a work of art are the sales catalogues of the Knoedler Library with their many annotations. For example, in researching the provenance of a painting by William Henry Bartlett, British

1809–54, a reference was discovered in Bénézit's biographical dictionary to a sale date for January 23, 1936. Because Bénézit does not report the name of the auction house, all catalogues of auctions held on that date may need to be examined. The Knoedler Collection had the correct auction catalogue from the American Art Association Anderson Galleries, Inc. in New York City. The entry, which included a photograph of the work, reported (1) that the painting—*View of Stevens Castle Point, Hoboken*—measured seventeen by twenty-three inches; (2) that it had been exhibited in the Museum of the City of New York, 1932–33; and (3) that in 1934 the work had been sold from the Hiram Burlingham Collection by the American Art Association Anderson Galleries, Inc. The annotations, which are hand-written notes penned by the staff of the Knoedler Galleries at the time of the auction, added (1) that in 1934 the painting, which was number 99, sold for $160.00 to someone named Sperling and (2) that in 1936 the painting had been purchased for $155.00 by M. A. Linch.

The researcher then wanted to examine the previous 1934 American Art Association auction catalogue when the painting was sold by Hiram Burlingham. Unfortunately, there was no specific date provided in the 1936 catalogue, nor did the Bénézit dictionary have a reference to the Burlingham sale. Another resource tool which can often be used to resolve this type of dilemma is Lancour's *American Art Auction Catalogues 1785–1942,* which lists more than 7,300 auction catalogues owned by twenty-one libraries. The entries for the catalogues include the names of owners and of artists whose estates were sold. Under the index to owners in Lancour's book, there was a reference provided to a sale of objects owned by Hiram Burlingham for January 11, 1934. Checking this catalogue in the Knoedler Collection, entry 99 was for *Landscape View of Stevens Castle Point Hoboken.* Notice the slight title change. Similar data was printed; the annotations reported H. G. Sperling as the buyer, the price as $160.00. Because the Knoedler Collection does not yet have an index, this detective work is necessary. Little by little, a provenance can be established.

The tenth section of a catalogue entry lists all of the exhibitions, accompanied by the location and dates of the shows, in which the work of art has been displayed. These entries usually are placed in chronological, rather than alphabetical, order

to facilitate adding the names of later exhibitions in which the work of art might appear. There is sometimes difficulty in deciding whether or not a work of art is the same object as the one listed in the exhibition catalogue or in the exhibition citation. This is due to variations in titles caused by translated titles or changes in the titles by the different owners of the object.

There are two principal ways of finding exhibition information: (1) to discover the existence of a catalogue compiled for an exhibition in which the work of art figured and (2) to locate a citation indicating that the piece was part of an exhibition. Chapter 4 provides details on discovering exhibition information; Chapter 15 has a list of references which will help find exhibition data.

Compiling a list of literary references in which a work or art is discussed—the eleventh category in a catalogue entry—can be accomplished by the researcher compiling a working bibliography on the artist and reading as much of the material as can be obtained in order to determine which books refer to the particular work of art being studied. Some discretion must be used in formulating this list, since some famous works of art may be mentioned in almost all general art history books. For instance, Edouard Manet's *Le déjeuner sur l'herbe* has been the subject of so many discussions on the French painter's work that a definitive list of literary references based upon this painting would be so extensive as to be meaningless. The entry should list only the literary references that are historically important or that discuss the work of art from an innovative approach or from some data which have just been discovered. The literary references in the catalogue entry should also be recorded in chronological, rather than alphabetical order, so that any fluctuation in the interest given the work of art may be illustrated and so that later additions to the list can be easily made.

The twelfth category of a catalogue entry—the listing of any drawings, similar works of art, and engravings or graphics which are based upon the work—is usually one of the hardest sections on which to find information. Exhibitions of an artist's work often display some of the preliminary drawings the artist did before the completed work. Unless there is a famous work of art that is similar or based upon the work being catalogued, the search for such an item may be fruitless. It should be remembered that the researcher will not be able to find information for all categories of a catalogue entry for a particular piece of work.

A catalogue entry includes any information known about the work of art. For example, if a painting is a portrait, any interesting facts on the sitter's life would be added, as would any knowledge concerning the objects, furniture, costumes, and locations which are depicted. The catalogue compiler may need to consult one of the indices to portraits listed in Chapter 17. The decorative arts dictionaries described in Chapter 9 as well as the fashion and jewelry references recorded in Chapter 19 may assist the reader in finding interesting material on the objects represented. If a particular design, ornament, or art motif decorating the work of art needs to be traced, the compiler might scrutinize some of the books annotated in Chapter 13. This thirteenth section of the catalogue entry should include information concerning (1) the subjects and symbolism of the work of art, if there is any, and (2) any influences upon the piece. These topics are detailed later in this chapter.

Since a picture speaks a thousand words, the compiler can save time by obtaining a reproduction of the work of art or by locating a source of an illustration of the art object in order that the last section of the catalogue entry can be completed. Finding a good illustration of a work of art requires an examination of the books and articles written on the artist and of the references listed in the researcher's working bibliography. If a reproduction or the source of reproduction is not available, the compiler should include a written description of the art object.

The Opinion of the Artist and of Critics

Important to research are the opinions on any aspect of the artist's *œuvre,* either by the artist or by critics. The former can sometimes be discovered by consulting: (1) one of the various collections of artist's writings which have been published; (2) the material that is on deposit with the Archives of American Art; (3) newspaper and magazine articles which quote the artist; (4) one-person exhibition catalogues and monographs which occasionally reprint letters, diaries, or important correspondence concerning the artist; or (5) personally interviewing the artist. In Chapter 13 under "Documents and Sources," there is a list of some works which have been compiled on the first point. Included in this chapter, *Artists on Art: From the XIV to the XX Century* provides quotations from over 140 artists. The works edited by

Elizabeth G. Holt and the series, *Sources and Documents in the History of Art,* are especially good references for locating reprints of this kind of archival material. *The Documents of 20th-Century Art Series* publishes separate books which record specific artists' writings. Usually these resources include the more famous artists.

The Archives of American Art collects primary and secondary research material of American painters, sculptors, and craftsmen. There is also an oral-history program of taped interviews with more than 1,200 people in the art world. Most of the material, which has been microfilmed, is available through interlibrary loans. There are several indices to the data; these are annotated in Chapter 11. This extensive collection is of prime importance to anyone studying an American artist. Articles in newspapers and magazines, which frequently quote artists, can be located through the indices and abstracts to periodicals cited in Chapter 12. For quotations by contemporary artists, an online database search may give the fastest results.

Every now and then, an exhibition catalogue may reprint some archival material. Caillebotte's will which provided for his Bequest was included, along with an English translation, in *Gustave Caillebotte: A Retrospective Exhibition.* Eugène Delacroix's diary and Vincent Van Gogh's letters to his brother Theo have been published. For local contemporary artists, some researchers conduct their own interviews. Sometimes these are taped and form part of an oral history program. This material is difficult to locate.

Many of the same materials just listed can be used to discover the opinion of critics. In addition, there are special publications, which are detailed in Chapter 5 under "Art Critics" and are not repeated here, that will be of assistance in finding pertinent critiques. For current material, an online database search using the artist's name may be effective.

Analyzing the Form and Style of Works of Art

An individual work of art can be analyzed by a number of different methods, including: (1) by elements—such as line, shape, contrast, and color—and their organization, which creates balance, rhythm, proportion, and unity and (2) by the artistic style which the piece may display. There are a number of widely used texts which will assist the student in learning about the elements of art and some methods for analyzing the form of a work of art. Many of these books are used in college courses—Feldman's *Varieties of Visual Experience,* Knobler's *The Visual Dialogue,* Preble's *Artforms,* and Weismann's *The Visual Arts As Human Experience.* These references are annotated in Chapter 13.

Stylistic terms—such as Expressionism, Realism, and Minimal—are words that are applied to works of art in order that objects can be classified. Unfortunately, scholars are not always in total agreement as to the exact definition of some of these terms, much less the objects which should be included within a classification or the dates when a style begins and ends. Defining a specific style is made even harder by the many nuances and variations within it. There is also the problem of an artist's individual style. Moreover, an artist's *œuvre* is not necessarily all in one specific style, nor are all works of art easily classified. An innovative work may be predominantly of one style and yet possess the seeds of a later one. The failure of art historians and critics to agree on specific definitions has created confusion for students who are trying to learn the basic elements of the styles prevalent in art. Although the topic can be difficult to understand, there are numerous references written on artistic styles. For detailed discussions consult the books annotated in Chapter 13. The following series are particularly helpful: *The Pelican History of Art, The Arts of Mankind, The Library of Art History,* and *The Style and Civilization Series.*

One professional who must have an in-depth knowledge of how to analyze the form and style of objects is the connoisseur. Interested in the authentication of works of art, this expert must be concerned with materials and techniques—the way the media of a piece is handled and the details of the work that might indicate the hand of a specific artist. Although technology has proved a wonderful asset, the expert must still know how the object looks and feels. Connoisseurship is the ability to judge an object, the time period and the country in which it was made, and the probable artist or school which executed it. This demands detailed knowledge of media, artistic and individual styles and techniques, plus a fine aesthetic sense. Years of studying and experience are required. Although no book can teach this process,

there are a number of references which will provide a better understanding of the art of connoisseurship; these works are annotated in Chapter 18.

Subjects and Symbols

Although not all twentieth-century art depicts a theme, most of the artistic creations of the past have imparted some message or subject to the viewer. Within the work of art, symbols—objects or emblems that represent a person, idea, or concept—are often used in order to assist the observer in understanding the subject, ideas, or meaning which the artist wishes to portray. A work of art can have a subject that is also a symbol. For example, a painting of Christ seated at a table with twelve men depicts the subject of the Last Supper. In addition, the scene is a symbol for the Eucharist, the Christian sacrament of Holy Communion.

Symbols do not necessarily have the same interpretation during all periods of history. For instance, the swastika which is found in many ancient and primitive cultures probably had a number of meanings, some of which may have involved the four directions of the compass. But in the twentieth-century, the swastika became the emblem for a particular political party—the Nazis of Germany. Unfortunately many subjects and symbols are no longer intelligible to art audiences. Frequently, such art has lost its meaning for the viewer.

Two important terms in understanding discussions on the subjects depicted in art are iconography and iconology. Iconography is the study of the meaning of the subjects and symbols depicted in a work of art and of any literary reference from which they derive. Covering a broader, more in-depth scope, iconology provides a deeper meaning for the themes in relation to the history, religion, mores, customs, and social concerns of a particular milieu at a specific time. This requires multidisciplinary research on the influences on the work of art, a subject discussed at the end of this chapter. For an excellent essay on these two terms, consult "Iconography and Iconology" in the seventh volume of *The Encyclopedia of World Art,* which quotes extensively from Erwin Panofsky. Although he was not the originator of the distinction between these words, Panofsky provided one of the best discussions on their differences in his introduction to *Studies in Iconology,* 1939, a section reprinted in his *Meaning in the Visual Arts.* Panofsky's essay should be read by everyone working on an iconographical study. In addition, the student who wishes to read some historical studies of specific works of art should consult the *Art in Context Series,* listed in Chapter 13.

Because various types of iconographical research require different kinds of references, this section is divided into (1) the basic methodology used for most iconographical studies, which should be read no matter what the particular theme happens to be, (2) how to locate works of art that depict a particular theme, (3) resources based on Bartsch's organization of prints, (4) special considerations needed when the subject is the Christian Holy Family, (5) a discussion of the Apocrypha, (6) changes in the meaning of a subject during different periods of history, (7) information on Reformation themes, (8) emblem books and their importance, and (9) how to locate material if the subject illustrates social concerns. These are just a few of the types of problems encountered when studying iconography. The discussions will not answer all questions, but it is hoped, will point the direction for the student to follow.

Basic Iconographical Research: St. Catherine of Alexandria

Before beginning a research project on themes and symbols depicted in works of art, the student should read the essays on the subject found in *The Encyclopedia of World Art.* These articles, written by experts in the field, provide a general orientation to the topic. If the research is on mythology, study "Myths and Fable;" if on the everyday life of the people, see "Genre and Secular Subjects," and for the example used in this section, St. Catherine, scrutinize "Saints, Iconography of." Remember to use the index volume of *The Encyclopedia of World Art,* if the correct term cannot be easily located.

In most iconographical research, one of the best methods of approach is to start with general articles and proceed to more specific material. These steps include the following:

(1) consult both general and specialized articles in dictionaries, encyclopedias, and references related to the topic in order to obtain the first clues as to the interpretation of the piece and an overall view of the topic;

(2) if the subject or symbol was derived from a literary work, read the material—in a translation and interpretation as close as possible to the literary work which the artists of the period would have known—to determine any derivations between the written and the artistic concept;

(3) collect biographical information on the persons—real or fictitious—who may be depicted;

(4) search for periodical articles, as this may be one of the better means of locating more detailed discussions on areas of the topic; and

(5) study interdisciplinary texts and pertinent history books to provide background for understanding the historic period and the country from which the art object comes.

The student may be researching a work of art for which the title, if there is one, does not indicate the subject. This is more difficult than if the theme is known. All iconographical studies depend upon a correct description of what is illustrated in the work of art. It is particularly important to inspect the work closely in order to discern exactly what figures, subjects, or events are being depicted. Some obscure, inconspicuously placed item may be of the greatest importance. By checking the clues the artist has provided plus some detective work, the problem can often be resolved. For instance, the work of art might be a fifteenth-century Venetian statue of a young girl adorned by a halo, wearing a crown, and with a broken wheel at her feet. The first puzzle to be solved is who is the woman? Since a halo is indicative of many Christian saints, and a crown is not an unusual headdress, the best object to investigate is the wheel.

To answer the question, first the iconographical references annotated in Chapter 20 should be consulted, the general as well as the Christian dictionaries. One of the best concise, single-volume works is the second edition of James Hall's *Dictionary of Subjects and Symbols in Art*. Under "wheel," there are references to Dame Fortune, Ezekiel, Catherine of Alexandria, and Donatian. By checking the entry under Catherine of Alexandria, the student will discover a full-page entry on this Christian saint which relates that she (1) was a fourth-century virgin martyr; (2) became the patron of education and learning; (3) was removed in 1969 from the Catholic

Church Calendar; (4) was included in the *Golden Legend;* (5) in a vision, had a mystical marriage with Christ; (6) was to be tortured for her faith by being bound to spiked wheels, but was saved when the instrument was destroyed by a thunderbolt; and (7) was beheaded and her body carried by angels to a monastery on Mt. Sinai.

Hall's book reports some of Catherine's attributes—the objects by which she is identified. These attributes include the wheel, which is her special symbol; a sword by which she died; a palm, a symbol for martyrs; a ring for the mystical marriage; a book on which may be inscribed words which indicate that she became a bride of Christ; and a crown for her royal birth. Hall also describes the marriage of St. Catherine, a scene often depicted in art after the fourteenth century. Cross references are provided to some of the women saints who were sometimes illustrated with Catherine—Barbara, Mary Magdalene, Catherine of Siena, and Ursula. If all that was needed was the identity of the woman, Hall's book will have answered the question. Scholars have done extensive research to formulate references for the more prevalent subjects and symbols in western art. For less popular themes or ideas, the answer would require perusal of numerous reference tools, some of which might require time and effort to locate.

In iconographical research, the literary source, if one exists, should be consulted. Not only should the literary reference be read, but the researcher should try to discover whether or not the artist could have had access to the literature. This can be a tremendous problem, especially for the Middle Ages. Although the contents of most medieval libraries have been scattered, there are inventories that provide insight as to what was available. Unfortunately, because the brief entries usually supply only the authors' names or the citations of the first work in a collection of manuscripts, the specific selections are not always known. In addition, most literature was not written in the vernacular, but was composed in classical or medieval Latin. Few students today read this ancient language, and not every work needed for research has been translated. This can make it difficult, and sometimes impossible, to find the literary reference for a work of art in a language the researcher understands.

Hall's reference book mentions that Catherine of Alexandria is included in the *Golden Legend.* Under "Sources" in the front of Hall's work, *The*

Golden Legend is listed as Jacobus de Voragine's book which was written on the lives of the saints, the Holy Family, and some important Christian feast days. This thirteenth-century work is the first comprehensive compilation of oral legends and traditions on the saints. The book, which is readily available in English translations in most libraries, discusses the saints under their feast days—which can be the day of their death, burial, or the translation of their relics to another site. Due to its great popularity, *The Golden Legend* was published in more than 150 editions and translations between 1450 and 1550.

Not all translations of *The Golden Legend* are equal in quality. The fifteenth-century version by William Caxton may be the closest English-language translation to the text which influenced artists in the past. Jacobus de Voragine provides a detailed discussion of St. Catherine's legend. For instance, he relates that her name is a combination of *catha* meaning all and *ruina* which indicates falling. Catherine thus means an edifice from which the devil fell. "For the edifice of pride fell from her by humility that she had, and the edifice of fleshly desire fell from her virginity, and worldly covetise, for that she despised all worldly things."

Biographical data on St. Catherine will be found in the hagiographical references, annotated in Chapter 20. The term hagiography means the study of the Christian saints. Most of these works list the holy persons under their feast days. It should be remembered that in Europe the date is written with the day preceding the month. For instance, 22 juillet, 22.7, and July 22 are the same day. The correct name of the saint in the language of the particular reference must be used. For Catherine, this is simple; the variations are Katharina, German; Caterina, Italian; and Catalina, Spanish. For some saints, there can be radical differences. St. Stephen is Saint Etienne in French and San Esteban in Spanish. St. James is Saint Jacques in French, hl. Jakobus in German, San Giacomo in Italian, and Santiago in Spanish. The *hl.* in German is an abbreviation for *heiliger,* meaning saint. The multilingual glossary of Appendix D in this book will assist readers with name variations.

One of the best one-volume hagiographical references—*The Oxford Dictionary of Saints* by David H. Farmer—has the material organized under the saints' names. The full-page entry explains that Catherine was especially popular and that people prayed to her to intercede in their behalf, because she was the patron of young girls, students, the clergy, philosophers, nurses, and craftsmen whose work was based upon the wheel. The dictionary, which also reports that Catherine was the protectress of the dying, includes a bibliography of literary references on St. Catherine and a list of works of art which depict her.

Butler's four-volume work, *Lives of the Saints,* provides a discussion of Catherine's life plus citations to a Greek tenth-century mention of the saint in J. P. Migne's *Patrologiae Cursus Completus, Series Graeca,* 1857–66, as well as other foreign-language scholarly references that record her story. Catherine's history is vague, ambiguous, and differs slightly depending upon the translations and sources consulted. It must be remembered that in the early Christian Church, local authorities could proclaim sainthood. The earliest official canonization records date from about 993 with the first Roman Catholic Papal Canonization of St. Ulrich. In the twelfth century, Pope Alexander III forbade reverence to any person not authorized by the Papal See.

In tracing Catherine's legend, as many iconographical and hagiographical references as possible should be consulted, since each may supply important clues. *The New Catholic Encyclopedia* relates that after the tenth century the cult of St. Catherine was especially popular in Italy, that she was one of the Fourteen Holy Helpers, and that she was the patroness of about thirty groups. The article on the Fourteen Holy Helpers gives additional data on how Catherine was depicted in art, especially in Germany. Holweck's *A Biographical Dictionary of the Saints* reports that Catherine was the patroness of jurists, philosophers, students, millers, wagonmakers, and teachers. Drake's *Saints and Their Emblems* repeats the philosophers and students, but adds ropemakers, schools, science, and spinsters. Drake also states that St. Catherine was invoked for diseases of the tongue and by those who desired eloquence, presumably of speech. Réau's *Iconographie de l'art chrétien* provides the story of her legend, cult, and patronage plus describes the pictoral cycles and scenes in which she was depicted. Many of these titles are translated into a number of languages, including English. In addition, Réau cites specific works of art that represent St. Catherine from the twelfth through the eighteenth centuries; often the

location of the object is included. The nineteenth-century *Handbook of Legendary and Mythological Art* mentions that Catherine was the patron saint of the Italian city of Venice. This was especially pertinent to the study, since the statue was Venetian. The iconographical references discussed in the next section of this chapter may also provide pertinent data.

By checking the volumes of *Art Index, RILA,* and *Répertoire d'art et d'archéologie* for more data on St. Catherine and her attributes, the researcher might find articles important to the study. When using *RILA,* remember to use the "Subject Index" and to scan the citations which are listed under "GENERAL WORKS, Iconography." The articles do not have to be specifically on St. Catherine to be relevant. For instance, "*Aureola* and *Fructus:* Distinctions of Beatitude in Scholastic Thought and the Meaning of Some Crowns in Early Flemish Painting," by Edwin Hall and Horst Uhr, published in *Art Bulletin,* Volume 60, June, 1978, provides a discussion of the use of halos and crowns. The bibliographical references could be significant.

It would also be helpful to read about the background of the period and of that section of Italy (1) in a general humanities survey such as *Culture and Values,* 1982, by Lawrence Cunningham and John Reich; (2) in specific works, such as Jan Morris' *The Venetian Empire,* 1980; and (3) in *A History of Ideas and Images in Italian Art,* 1983, by James Hall. For an iconological interpretation of the anonymous Venetian fifteenth-century statue of St. Catherine, a study might include important items, such as (a) the history of Venice in relationship to the saint; (b) the religious importance of nunneries whose inhabitants aspired to emulate the virgin martyr as to humility, chastity, and poverty and who were also brides of Christ; (c) the new fifteenth-century emphasis on learning, erudition, and earthly justice; and (d) the importance of Catherine of Siena who has a story with many parallels to that of Catherine of Alexandria.

Locating Works of Art on Particular Themes

Often researchers need to locate and study various works of art on a particular theme in order to observe, among other things, the symbol or subject as to (a) how it is depicted in art, (b) in which countries and periods of history it was popular or

prevalent, and (c) how it may have altered over the years. As an example, the problem is to locate Italian works of art illustrating Mary Magdalene from the Renaissance and Baroque periods in order to study the different ways artists depicted the saint. To solve this problem, the researcher should (1) formulate a list of the different devotional images and scenes in art that include the saint, (2) discover which artists and which of their works of art depict these images and scenes, and (3) locate reproductions of the works of art that are cited. As much information as can be gathered concerning each work of art should be recorded, including such data as the complete original title, the medium, the size, the date the work was created, the present location, and any known sources for reproductions. The same resource tools which were discussed previously in the iconographical research on St. Catherine should be consulted, with an added emphasis on works of art which depict the subject. The references the reader will need are annotated in Chapter 20.

To learn some of the popular scenes in which the saint is depicted, the reader should consult first a general iconographical reference, such as James Hall's *Dictionary of Subjects and Symbols of Art.* Hall's book has an entry on Mary Magdalene that cites some of the scenes depicting the saint which derive not only from the gospels but also from French medieval legend. The southern part of France was especially devoted to Mary Magdalene, since there was a legend which developed in the eleventh century to the effect that after making a pilgrimage to Provence, France, Mary Magdalene died and was buried there. Hall's book explains some of the famous scenes in art that have developed particular names. In this case, Hall describes *Noli me tangere,* a scene in which Christ is portrayed as a gardener with Mary Magdalene at his feet. Deriving from the Gospel of John which states that at first Mary Magdalene mistook Christ for a gardener, *Noli me tangere* is a Latin phrase for "Touch me not." Other iconographical and hagiographical reference works should also be examined to obtain more facts concerning the saint.

To locate the works of art, the researcher will need to formulate a list of the various scenes and means of depicting Mary Magdalene and the titles of Italian works of art which illustrate them. The following should be consulted: (1) the indices to reproductions in books and periodicals, (2) the

subject or iconographical indices which some books and museum catalogues contain, and (3) specialized iconographical indices.

The first references are annotated in Chapter 17 and discussed in Chapter 4. *Art Index* and *RILA* are both good sources for locating titles of works of art on specific subjects. *Art Index* lists titles under the subject, in this case Mary Magdalene. The "Subject Index" of *RILA* will assist researchers in finding references to articles on the topic. The abstracts often include titles of works of art and their location. For instance, Volume 8/2, 1982 of *RILA* has nine references under "Mary Magdalen, S." All of the references indicate the title, artist, and location of a work of art on the saint.

Some museum catalogues have a detailed subject index which will assist researchers in locating titles of works of art on specific subjects. In the example of Italian art depicting Mary Magdalene, references were found to paintings of the saint by consulting the subject or iconographical index under "Religious Subjects, Saints" or "Saints" in the catalogues of the following museums: the National Gallery, Washington, D.C.; the National Gallery, London; the Samuel H. Kress Collection; and the Yale University Art Gallery.

Some books—such as van Marle's *The Development of the Italian Schools of Painting*—also have iconographical indices to the information in their texts. In Fredericksen and Zeri's *Census of Pre-Nineteenth-Century Italian Paintings in North American Public Collections,* 1972, there is an almost 300-page index divided into five sections: religious topics, secular subjects, portraits and donors, unidentified subjects, and fragments. Under "ST. MARY Magdalene," there are three pages of entries subdivided as to century followed by whether the saint is a single figure, placed with the madonna, with a group of other saints, or in a miscellaneous scene. The Italian artists and the North American museums which own the paintings are provided. The works cited date from the thirteenth through the eighteenth century. Fredericksen and Zeri's book is listed under "Indices of Works of Art in Museums" of Chapter 17.

Analytical indexing of art and architecture is an expensive, time-consuming task. Even so, such complicated indexing, which is especially important for iconographical research, has been undertaken. Specialized iconographical indices are available in four forms: printed books, card catalogues, microforms, and computer tapes. Listed in Chapter 20 under "Christian Subjects, Iconographical Works" are books by Réau, Kaftal, and Pigler; all should be consulted.

Louis Réau's *Iconographie de l'art chrétien* consists of three volumes in six books. The first volume discusses the sources and evolution of Christian iconography; the second covers the Old and New Testaments of the Bible; and the third is concerned with the iconography of the saints. In the last volume there is an entry under "MADELEINE" that gives variations on the saint's name, the date of her feast day, a description of the legends surrounding her, a lengthy bibliography of both ancient and modern reference books, and a section entitled "ICONOGRAPHIE" that lists the various scenes in which she is included. The latter section describes the figures, groups, cycles, and scenes that depict Mary Magdalene. Under each different kind of theme, there are recorded some of the various titles by which the scene is known in countries other than France, including an English translation; a description of the scene; and a list of works of art that depict the theme. The last list, which is divided as to centuries, sometimes cites the artist's name, the date of the work, and the present location of the piece. The entry on the saint in the third volume records more than one hundred works of art depicting Mary Magdalene. These include paintings, sculptures, miniatures, engravings, and stained glass windows. Only works of art that illustrate Mary Magdalene without Christ are mentioned in the third volume. For a list of the scenes that include Mary Magdalene and Christ, the researcher is provided a cross reference to a section of the second volume of Réau's multivolume work, a section that covers the New Testament.

Kaftal's *Iconography of the Saints in Italian Painting from Its Beginnings to the Early XVIth Century* covers the iconography of the saints in paintings from various sections of Italy. Profusely illustrated with black-and-white reproductions, Kaftal's three-volume work is written in dictionary form with numerous abbreviations. Consequently, it is especially important for the researcher to read the "Explanatory Note" that follows the introduction in each volume. For the reader's convenience, there is at the front of each book a short list of the bibliographical abbreviations of the works most frequently quoted, and at the end of each volume an extensive bibliographical index of works mentioned in the text. The latter list is subdivided into art bibliography, museum

catalogues, hagiographical references, iconography, manuscripts, and miscellanea. Because it is copiously illustrated and generally accessible, Raimond van Marle's *The Development of the Italian Schools of Painting,* which is annotated in Chapter 13, is often given by Kaftal as a source for illustrative material. In addition to the above information, Kaftal sometimes includes any inscriptions that are associated with depictions of the saint, as well as a list of the literary references for these inscriptions.

Andor Pigler's *Barockthemen: Eine Auswahl von verzeichnissen zur Ikonographie des 17. und 18. Jahrhunderts* is a three-volume reference work that helps researchers to know the kinds of subjects that were depicted during the seventeenth and eighteenth centuries. The first volume covers religious themes; the second, profane ones; the third volume contains black-and-white illustrations. Entries are written for different scenes and their many variations. Each entry cites a few references which discuss this particular theme and lists numerous artists who have depicted it. Accompanying the artist's name is the media of the work of art—painting, drawing, or engraving—plus there is often some indication as to where a reproduction of this work can be located. Thus, in the posed problem, Pigler's *Barockthemen* includes six different categories of scenes of Mary Magdalene. Under the first category alone, Pigler records over forty artists—divided as to Italian, French, Dutch, German, Swiss, and Bohemian who have depicted the theme.

There are two important card catalogue iconographical indices: the Index of Christian Art and the DIAL. These are open-ended systems to which cards are continuously being added. Begun in 1917 at Princeton University by Charles Rufus Morey, the Index of Christian Art is composed of (1) the Subject File, which consists of almost 600,000 cards that systematically index and describe the subject matter of Early Christian and Medieval works of art up to the year 1400 and records full bibliographies for each work; (2) the Photograph File, of more than 250,000 cards—containing illustrations of various quality—cited in the Subject File; and (3) supplementary files that assist researchers in using the material. Under about 25,000 subject headings—of such items as persons, scenes, objects, and some aspects of the natural world—the catalogue cards are arranged by media with the works of art filed in alphabetical

order under the place names of their present locations. Various categories of media are included: enamel, fresco, glass—including stained glass, glyptic or semiprecious and precious stones, gold glass, illuminated manuscripts, ivory, leather, metal, mosaic, painting, sculpture, terra cotta, textile, wax, plus miscellaneous and undetermined materials. No subject card is made unless an illustration for the topic is known. The supplementary files are composed of (1) an index of the illuminated manuscripts by titles including author and text; (2) a compilation of names of places, listing the buildings, collections, and museums where the works of art in the Photograph Files are located; (3) a bibliography of full titles of books, periodicals, and catalogues cited in short form in the other files; and (4) a chapter and verse file to the books of the Bible and the Apocrypha giving the corresponding heading in the Subject File. Besides the original at Princeton University, there are two other photographic copies of the complete index in the United States: the Dumbarton Oaks Research Library, Washington, D.C. and the Art Library of the University of California at Los Angeles. For a detailed discussion on how the index can be used most effectively, the reader should consult the following:

Woodruff, Helen. *The Index of Christian Art at Princeton University.* Princeton, New Jersey: University of Princeton, 1942.

Esmeijer, Anna C. and Heckscher, William S. "The Index of Christian Art." *The Indexer: Journal of the Society of Indexers* 3 (Spring 1963): 97–119.

The DIAL, which stands for A Decimal Index of the Art of the Low Countries, is an iconographical index to Dutch and Flemish art. Compiled by the staff of the Rijksbureau voor Kunsthistorische Documentatie, Den Haag, Netherlands, this is a set of post-card size black-and-white reproductions of Dutch and Flemish art which has been categorized according to subject. The files increase annually by about five hundred cards. There are now approximately 14,500 cards. Copies of the DIAL are available at about twenty United States libraries, including the Harvard University Fine Arts Library, the Cleveland Museum of Art, and the National Gallery of Art, Washington, D.C.

The DIAL utilizes an iconographical classification system—called ICONCLASS, a word derived from the first four letters of the phrase, iconographic classification—which was developed

at the University of Leiden in the Netherlands by H. van de Waal and is being edited and completed by L. D. Couprie. A complicated system, ICON-CLASS organizes material into nine main divisions: (1) God and religion, (2) nature, (3) man, (4) society, (5) abstract ideas or concepts, (6) history, (7) the Bible, (8) literary subjects, and (9) classical mythology and antiquities. Each of these main sections is subdivided into minute detailed headings. Within the system, there are about 20,000 different iconographical classifications. For example, in the DIAL file there are twenty cards under the subject of the Old Testament figure, Jonah. The numbers on each card indicate the classification scheme in the ICONCLASS. Number 71 represents Jonah; 71L1 illustrates the Lord's commandment to Jonah to go to Ninevah. For works of art which show Jonah being thrown to the whale, the number is 71L41; for Jonah being cast ashore, 71L43.1. If a scene depicts two or more ideas or subjects, that many cards are placed in the DIAL file. For example, there are two cards for a painting by G. Schalcken. Each card has a reproduction of the work of art and the following information: name of artist, title of work, dimensions, source of photograph, the number of the photograph on file at the Rijksbureau, and the classification numbers. For Schalcken's painting identified as *Woman Making Sausages with Erotic Implications,* there are two numbers: 47B18:15, in which the 47 represents "professions and trades" and 41C69.3, in which the 41 stands for "society, material life." For details on the system, the reader should consult the publication:

H. van de Waal. *Iconclass: An Iconographic Classification System, Completed and Edited by L. D. Couprie.* Amsterdam: North-Holland Publishing Company, 1973– Proposed 17 volumes.

A number of extensive photographic archives are being published on microforms; see Chapter 17. When the proposed indices to these illustrative materials are compiled, subject access will be available. The indices will be important iconographical research tools. A subject index is planned for The Alinari Photo Archive, the Marburger Index, and the Archives of the Caisse Nationale des Monuments Historiques et des Sites.

Computerization is being used in many art museums as a registration system of maintaining and obtaining data on the objects in the collection. In visual resource libraries, slides and photographs are receiving similar treatment. *Introduction to Visual Resource Library Automation,* 1980, edited by Arlene Zelda Richardson and Sheila Hannah, discusses the subject and provides case studies for seven computerized projects. Some of these slide-computer projects have been in operation for more than a decade and have developed printed manuals. The computerized systems often can provide subject access to visual materials. As yet, these systems are usually not available to students or to the general public.

Resources Based on Bartsch's Organization of Prints

One of the most important reference tools ever developed for prints was *Le peintre-graveur* by Adam von Bartsch. Between 1808 and 1821, Bartsch published twenty-one volumes which contained descriptions of Flemish, Dutch, German and Italian prints—engravings, etchings, and woodcuts. A second edition, which was published in Leipzig 1854–70, included some additions and corrections to Bartsch's monumental work. A. P. F. Robert-Dumesnil's *Le peintre-graveur francais,* 1835–71, is an eleven-volume work which follows Bartsch's organizational scheme for French prints.

Bartsch's original volumes cover about five hundred artists who worked between the fifteenth and eighteenth centuries. The material is organized by periods and regions. Under each artist's name is a brief biographical sketch and a discussion of the printmaker's *œuvre*. Most of the prints are arranged by media and subjects. Each entry for an individual work includes a description, dimensions in an ancient French system of measurement, sometimes the data inscribed on the print, and information concerning the states and editions. The example of Henri Goltzius will illustrate Bartsch's organizational system: (1) original works by the artist, subdivided by biblical subjects, saints, history and allegories, fictitious subjects, and portraits; (2) works by Goltzius based upon other artists' works; (3) doubtful attributions; (4) works of art after drawings by Goltzius but engraved by anonymous artists, subdivided by religious subjects, allegories, fictitious subjects, and portraits; and (5) works of art which were engraved by known artists, contemporary with Goltzius, and which were based upon Goltzius' drawings. In the division of the original works by Goltzius, the engravings are described first, followed by the woodcuts. Unfortunately, Bartsch's volumes and the other catalogues based

upon his organization contain no illustrations and no subject indices. To provide visual materials for Bartsch's volumes, there are three special reference tools: *The Illustrated Bartsch, Index Iconologicus,* and the Warburg Institute project.

The Illustrated Bartsch is a series of volumes which, when completed, will provide reproductions for the some 20,000 prints discussed in Bartsch and will supplement and update his material. About one hundred volumes are projected, more than half of them are already published. There will be additional volumes of illustrations and text for artists not included in Bartsch. Eventually, a computerized index volume will be published with indices for subjects, names, places, and titles of prints.

The Illustrated Bartsch is a project which has been organized into two parts: the illustration volumes or Picture Atlases and corresponding Commentary Volumes. The Picture Atlases reproduce the prints described in Bartsch. These prints are assigned the same numbers which were used in the original Bartsch publication. The Commentary Volumes provide detailed entries for each print reproduced in the companion volume, illustrations of prints not recorded in Bartsch, and supplemental data. To cover the Netherlandish artist, Hendrik Goltzius, two volumes have been published. Both are edited by Walter L. Strauss. The reproductions of the prints in the Picture Atlas correspond to Bartsch's work in organization and entry numbers. Unfortunately, Bartsch's original broad subject headings are not reprinted. For each illustration there is a brief caption, such as "2 (11) *Moses with the Tablets of the Law (Moÿse et les tables de la loi)* 1583 [SG. 168] 574 × 423. Haarlem, New York (MM), Rotterdam." The 2 is Bartsch's number; (11) refers to the page number in the original Bartsch publication. The English title is followed by the original French one in Bartsch; the print was made in 1583. The [SG. 168] is the number this print has in Walter Strauss' 1977 publication on Goltzius. All sizes—in this case the 574 × 423—are in millimeters, height before width. The last references are institutions which own impressions of the print.

In the companion Commentary Volume, there is a brief biographical sketch. Notice Goltzius' name is given in the Dutch, Hendrik, instead of the French, Henri, which Bartsch used. Entries for the reprints follow Bartsch's numbers, but use a decimal system for computer purposes. Thus

.002 refers to Bartsch's second entry. For works no longer attributed to Goltzius, the numbers are placed in brackets. For example, "[.001] [B.1(11)], *Tamar Dressed as a Courtesan*" is no longer considered to be Goltzius' work, as the [.001] indicates. The [B.1 (11)] indicates the original Bartsch number with the page numbers placed in parentheses. An S2 designates the second state of a print; an asterisk indicates that the print is part of a series. Prints not cited by Bartsch are inserted in the proper iconographic sequence: Old Testament, Christ, the Virgin, Holy family, Saints, Classical and mythological subjects, landscapes, portraits, and coats of arms. The Commentary Volume includes (1) an index to watermarks which reproduces drawings of the actual watermarks; (2) a chronological table which coordinates Goltzius' œuvre with his life and other important events; (3) a concordance of Bartsch's numbers to the ones used in publications by Strauss, 1977; Hirschmann, 1921; and Hollstein, 1954; and (4) an index to subjects and people.

A second reference source that reproduces some of the sixteenth- and seventeenth-century prints listed in Bartsch is *The Index Iconologicus,* which was developed at Duke University. Organized to provide subject access through keywords, the illustrations are printed on 433 microfiches. Unfortunately, there is no economy of space on the microfiches. If the text is horizontal and the image is vertical, two photographs of the same entry are included. Each cross reference fills a full space. As a consequence, sometimes there are as few as twenty-one actual different images printed on a 98-frame microfiche. For instance, under the term "slaughtering" there is a cross reference to December and six cross references to specific works of art. There is only one image under this subject, to an engraving after Guilio Romano. When the entry "December" is examined, there are three cross references to specific works of art plus a quote from Francis Bond's *Wood Carvings in English Churches,* 1910, which explains how during this month most of the animals had to be slaughtered, because there was not enough hay to keep them alive over the winter.

In the 1950s the Warburg Institute in London and the Institute of Fine Arts in New York City photographed the prints which were owned by the British Museum and the Metropolitan Museum of Art in order to create illustrations for Bartsch's *Le peintre-graveur.* Each reproduction is a 4 3/4″ by

6 1/2″ glossy photograph. Many of the North American and European institutions which subscribed to this project filed the reproductions according to Bartsch's original organizational scheme. The Warburg Institute created two files of prints: one using the Bartsch order, the other a key-word subject classification scheme. The Institute of Fine Arts also used a subject approach. Researchers may have access to a library that has these print reproductions, which provide partial visual material for Bartsch's works. For additional information, read Evelyn Samuel "The Illustrated Bartsch: Approaches to the Organization of Visual Materials," *Visual Resources* 1 (Spring 1980): 60–66.

The Christian Holy Family

When researching subjects concerning the Christian Holy Family—consisting of Jesus, his mother Mary, and Mary's husband Joseph—care must be taken to discover the specific literary references which influenced that particular work of art. Of the many manuscripts written during the early period of the formation of the Christian Church, twenty-seven books were accepted as canonical to form the *New Testament*. But many of the early writings which were not endorsed by the ecclesiastical authorities also had an impact on art. Some of these early Christian writings have been collected, translated, and dubbed *The Apocryphal New Testament*. This collection of stories—many of which are incomplete—consists of two main groups of works: (1) *The Infancy Gospels* and (2) *The Apocrypha Acts of the Apostles*, which relate the adventures and deaths of some of the Christian Apostles. Some of the episodes described in these apocryphal—meaning doubtful—works were later included in Jacobus de Voragine's *The Golden Legend*.

The Infancy Gospels—so named because they relate stories of the life of the Virgin Mary and the infant Jesus—were particularly popular. Two important works were (1) *The Protevangelium of James*, probably written in the second century, and (2) *The Gospel of Pseudo-Matthew*, which was composed during the eighth or ninth century and which was based upon *The Protevangelium of James*. Such symbols as the proverbial ox and ass illustrated in Nativity scenes and the midwives, who are also often included in these depictions, derive from the *Infancy Gospels*, not the *New Testament*. English translations of the fragments

that are extant of these ancient works, which were later rejected by the ecclesiastical authorities, are published in James' *The Apocryphal New Testament* and the second volume of Hennecke's *New Testament Apocrypha;* see Chapter 20.

Throughout Christianity, the Old Testament episodes were considered allegorical symbols for New Testament events. These typological or prefigurative symbols were prevalent in art. For example, Abraham's willingness to sacrifice his only son, Isaac, was seen as a symbol of the Crucifixion—God's sacrifice of his son Jesus. Some of these parallels were later published in the *Biblia Pauperum,* a popular fifteenth-century printed book, illustrated by woodcuts, which was widely circulated.

Throughout history, non-biblical writings have also been the basis for stories of the Holy Family. For example, *Meditations on the Life of Christ,* a thirteenth-century work once attributed to Saint Bonaventura, describes the Virgin Mary as standing erect against a column during the birth of Jesus and after the event, kneeling to adore her child. These scenes are often portrayed. One of the best references for discovering the literary sources that influenced the various scenes and symbols used in works of art concerning Christ is Gertrud Schiller's *Iconography of Christian Art*. Volume I covers from Christ's birth through his ministry; Volume II is on the Passion or death of Christ. Each of these extensively illustrated volumes has an index to the biblical text cited—the first book also includes in the index the *Infancy Gospels, The Golden Legend, Meditations on the Life of Christ,* and *Visions* by Bridget of Sweden. The "Thematic Index" to the first two publications, which is printed in the second volume, allows the reader to locate quickly the text which refers to certain items or scenes in works of art. Under "column," there are citations for its use in the miraculous birth, the Crucifixion, the Denial of Peter, the Flagellation, and the Baptism. Two other volumes— one covering the Resurrection and Ascension, the other The Church—have been published, but have not been translated into English.

In researching Christian stories, the translation closest to the one that would have been known at that period of history should be consulted. For instance, the seventeenth-century Douay-Rheims Bible is probably the most faithful translation of the Latin Vulgate, the official Roman Catholic Bible during the Middle Ages. The King James

version would have been read by English artists during the seventeenth and eighteenth centuries. Thus, although *Good News for Modern Man,* 1966, might be helpful to students in understanding the New Testament, it cannot be used for art historical studies. Remember, it was often the lack of details in the literary source that allowed the imagination of the artists to create varied depictions of a theme. By consulting the literary references, the innovative additions of the artists can be differentiated from details inspired by literature.

The Apocrypha

In the fourth century when St. Jerome translated the Bible into Latin, the version called the Vulgate, he based some of his work on the *Septuagint,* an early Greek translation of Hebrew writings which included some fourteen pieces of literature that were later not incorporated into the canonical or official books of the Hebrew Scriptures. In the sixteenth-century when Martin Luther translated the Bible into German, he decided that only the writings contained in the official Hebrew Scriptures should be included in the Old Testament. The fourteen pieces of literature, called the *Apocrypha,* meaning doubtful, were placed between the Old and the New Testaments in Luther's Bible. The original seventeenth-century King James Version of the Bible retained this format. Later to save printing costs, the *Apocrypha* was often deleted. In most Protestant Bibles, the *Apocrypha* is missing. It is still incorporated into the text of the Roman Catholic version of the Old Testament. Numerous stories depicted in art— such as Judith and Holofernes, Susanna and the Elders, and Tobias and Tobit—derive from the *Apocrypha.* In order to study the literary sources for these works, it is best to obtain a copy of the Douay-Rheims Catholic Bible.

Changes in a Subject's Meaning

The work of art to be studied could be a Greek vase dated 350 B.C., on which there is a scene of the three goddesses—Athena, Hera, and Aphrodite—before the youthful Paris who is tending his father's flocks and playing the lyre. This same theme of the Judgment of Paris was used by Italian Renaissance artists. The question arises, do works of art from these different historic periods have the same significance? In order to understand the different meanings which mythological subjects had during various historic periods and to obtain a general overview, the student should begin by referring to (1) James Hall's *Dictionary of Subjects & Symbols in Art,* to study the outline of the myth and, perhaps, to discover literary references from which the story derived; (2) "Myth and Fable" in the *Encyclopedia of World Art,* especially the subsections on "The Classical World" and "The Medieval and Modern West," for information on how these historic periods viewed myths; and (3) one of the many mythological encyclopedias, some of which are listed in Chapter 20, to collect data on the principal characters—Paris, Athena, Hera, Aphrodite, and Eris, the Goddess of Strife. Remember that some of the mythological names are different, while others vary slightly in spelling—Athene, Athena, Pallas Athena, and Minerva are all the identical goddess. If needed, a section of the multilingual glossary in Appendix D will provide the reader with the equivalent names of the Greek and Roman gods.

In Chapter 20 under "Subjects in Art," there are several books which the student should consult. After reading the annotations carefully, the books by Wind and Panofsky would appear promising, because they discuss Renaissance themes. Wind's *Pagan Mysteries in the Renaissance* states that the Italian philosopher Ficino wrote to Lorenzo de'Medici that there were three kinds of life: contemplative, exemplified by the wisdom of Minerva (Pallas Athena); active, by the power of Juno (Hera); and pleasurable, by Venus (Aphrodite). In the contest, Paris had chosen Venus, just as Hercules had decided on heroic virtue and Socrates, wisdom. All three men were punished. To Ficino, man must neglect none of the goddesses, but by honoring each according to her merits, will receive the attributes which she has to bestow. Wind's book provides additional mythological references for the researcher to examine. In order to have a more complete understanding of Marsilio Ficino and his influence, the student should read Panofsky's "The Neoplationic Movement in Florence and North Italy," *Studies in Iconology,* 1939, pp. 129–169.

The subject section of the library's catalogue should be checked under "Ficino" for a list of his writings, translations of his works, and books that discuss his philosophy. A search for the theme of the Judgment of Paris in *RILA* and *Art Index* will provide titles for articles which, when read, will

assist the student in understanding the various meanings. But the articles do not need to be only on Italian Renaissance artists, since the data and literary resources for works by artists of other nationalities might be pertinent to the subject.

Reformation Themes

Works of art sometimes represent theological concepts. For instance, a German painting of Christ wearing the crown of thorns with his wounds showing, but not bleeding, may represent Reformation ideas. For problems on Christ, the researcher should consult Gertrud Schiller's *Iconography of Christian Art,* which is cited in Chapter 20. In the "Thematic Index," under both "Crown of Thorns" and *"Intercesso"*—Latin for to go between—there are references to a lengthy discussion of the Man of Sorrows.

In her detailed analysis of this image, in which Christ is depicted after the Crucifixion, Schiller explains that this theme was used both by Catholics and Protestants, but that in Reformation art the wounds are usually not bleeding, because Martin Luther objected to this emphasis. Schiller also relates that during the Reformation, scenes often depicted Christ acting as intercessor or the intermediary between man and God. If a brief history of the Reformation is read, the researcher will understand that this was one of the major differences between the Protestants and Catholics. The former believed that Christians did not require priests or saints to act as interceders for them, but that they could go directly to Christ. The ideas of Martin Luther, John Calvin, and other Protestant leaders changed art during the Reformation, just as the seventeenth-century Council of Trent had its effect on the art of the Counter-Reformation. The religious views of the artists and their patrons must be considered when studying iconography.

Although Schiller provides five biblical references, none of them uses the phrase—man of sorrows; none of them quite fits the title. In order to obtain the literary source from which the name derives, a book of familiar quotations can sometimes be helpful. In *The Oxford Dictionary of Quotations,* second edition, in the index under "Man of Sorrows" is an entry to Isaiah 53:2: *He is despised and rejected of men: a man of sorrows, and acquainted with grief . . . Surely he hath borne our griefs and carried our sorrows.* The quotation is not from the Oxford dictionary but from the Douay-Rheims Bible. This is probably the closest English translation to the Vulgate, which the people knew during the sixteenth century.

Emblem Books

Emblem books were often used as source material by artists from the sixteenth through the nineteenth centuries. During the Renaissance in Italy, some of the Humanists became interested in the Egyptian hieroglyphics. They did not want to translate them, but to emulate these symbolic images. Using a variety of sources—the Bible, classical mythology, fables, bestiaries, and legends—scholars wrote descriptions of allegorical devices that represented abstract ideas, such as patriotism, liberty, charity, peace, and death. Later these ideas were (1) provided with pictorial form; (2) accompanied by a motto plus an explanatory, and often moralistic, text; and (3) printed in books. Andrea Alciati's *Emblemata* of 1531 was one of the most influential of these types of references which inspired artists as the books increased in popularity, especially during the seventeenth and eighteenth centuries in Western Europe.

Related to the emblem books, Cesare Ripa's *Iconologia* was originally published in 1593 without illustrations. Ripa's book expanded to a three-volume, multilingual illustrated work by the early 1600s. In Ripa's works the text was of prime importance. Including more devices than the emblem books, Ripa described allegorical and personification figures as well as symbols and emblems. In his later editions, the illustrations were still secondary to the lengthy text. Published repeatedly throughout Europe, emblem books and Ripa's *Iconologia* had various editions and translations, some of which added supplementary visual material and often deleted or shortened the texts. *The Renaissance and the Gods: A Comprehensive Collection of Renaissance Mythographies, Iconologies, and Iconographies,* edited by Stephen Orgel, consists of fifty-five volumes, many of which are reprints of the emblem books and various versions of Ripa's *Iconologia.*

Most emblem books were written in the sixteenth- and seventeenth-century, chiefly in Dutch, German, Italian, and Latin. For beginning students, there are two English-language versions available: *Iconology: Or a Collection of Emblematical Figures* and *Cesare Ripa: Baroque and Rococo Pictorial Imagery.* The former, written in the

eighteenth century by the London architect George Richardson, is a translation of Ripa's descriptions accompanied by illustrations designed by William Hamilton. Four hundred twenty-four subjects are included. Some of Ripa's text was shortened; more figural representations were added. This was the form of Ripa's work by which late eighteenth-century English artists knew the *Iconologia.*

Cesare Ripa: Baroque and Rococo Pictorial Imagery differs markedly from Ripa' original work. This is a translation of the 1758–60 German edition published by Johann Georg Hertel accompanied by full-page scenes designed by Gottfried Eichler, the Younger. The two hundred allegories, personifications, and symbols were chosen from various editions of Ripa's works. The long descriptive text was deleted; the illustrations are used as the major component of the book. Each scene consists of (1) the main allegory which derived from Ripa's text and (2) a small historic, literary, or mythological event, called *fatto,* placed in the background to serve as an example for the principal figure. The *fatti* provided additional material for artists, but were never part of Ripa's *Iconologia.* To help explain the allegories, the German edition also had a Latin inscription and a German couplet accompanying each scene. Remember this is an English translation of a German edition which greatly altered Ripa's work; it must be used with care. These types of books are annotated in Chapter 20. For the person studying this period, two excellent references are (1) "Emblems and Insignia, Medieval through Modern West" by Mario Praz in the fourth volume of *The Encyclopedia of World Art* and (2) "Humanist and Secular Iconography, 16th to 18th Centuries: Bibliographic Sources: A Preliminary Bibliography" by Sarah Scott Gibson, *Special Libraries,* 72 (July 1981): 249–260.

Social Concerns

If a work of art has a discernible narrative, as much genre art does, one of the best methods of obtaining insight into the piece is to read articles and books written about the same theme for works of art from the same milieu and time period. By studying the bibliographies and footnotes which accompany these articles and books, a list of essential references can be compiled. Research on social themes requires the use of multidisciplinary research materials. Often the quickest method for starting a study is through an online database search, since this allows for ideas and concepts to be linked.

Take, for instance, art which depicted the plight of women or fallen women in English and French art of the nineteenth century, a subject used as an example of an online database search in Chapter 4. In searching the computer files of *ARTbibliographies MODERN Database,* three statements were used: (1) <u>wom?n AND (iconograph? OR subject) AND 19th (w) century AND England/ de OR France/de NOT photography</u>, (2) <u>fallen (w) wom?n</u>, and (3) <u>plight (lw) women</u>. Twelve pertinent articles were located. In examining *RILA,* the "Subject Index"—under "women" and "feminism"—was found to be the quickest method for finding relevant articles. In *Art Index,* the subject headings "woman" and *"femmes fatales"* were used. By using these research tools, two references were found: (1) T. J. Edelstein's "Augustus Egg's Triptych: A Narrative of Victorian Adultery," *Burlington Magazine,* April 1983 and (2) Aaron Sheon's "Octave Tassaert's *Le Suicide:* Early Realism and the Plight of Women," *Arts Magazine,* May 1981.

The first article discusses some of the symbols in Egg's three works, presently entitled *Past and Present,* which are now at the Tate Gallery, London. The 1858 triptych is composed of three separate paintings that, in sequence, depict the dissolution of a Victorian family. One canvas shows two children constructing a house of cards with their father holding a letter which has just informed him of his wife's infidelity. The fallen woman has collapsed on the floor. The other two paintings illustrate the results of this action: one has the two children praying in their attic room after their father's death; the other portrays their outcast mother and her illegitimate baby huddled under a bridge. The symbols in the painting are reported: the rotten apple for the biblical Fall of Eve and the house of cards which the children are building referring to the flimsy structure of the parent's marriage. But Edelstein does not just discuss this triptych and its symbolism, he provides an iconological meaning of the works. Having researched the position of women and the changing laws of Victorian England, Edelstein comes to the conclusion that the paintings reflect some of the then current social debates on the 1857 Matrimonial Causes Act, which altered Victorian laws

by allowing Civil Courts to grant divorces, and on the 1839 Infant's Custody Act, which banned divorced or separated women from seeing their children. Edelstein also mentions Egg's close association with Charles Dickens, whose 1848 *Dombey and Son* used the theme of adultery as a subsidiary plot. This type of study requires knowledge not only of Egg and his *œuvre* but also of Victorian history, laws, literature, mores, and social concerns. Edelstein's article provides citations for a number of interesting references, to name just two—*The Substance or the Shadow: Images of Victorian Womanhood*, 1982, and *Victorian Treasure House*, 1973.

Sheon's article discusses Octave Tassaert's *Le Suicide*, a French painting of the late 1840s which depicts a poverty-stricken mother and daughter who have just ended their lives by asphyxiation. To Sheon, some of the concerns of the period are evident in this work: the nineteenth-century French reports which suggested legislation for limiting the working hours of women and children, the statistics compiled on the wages of women and children in relationship to men, the phenomenon of Paris having one of the highest suicide rates of any European city, and perhaps most of all, the positions of the Church and State on the burial of those who committed suicide. The French Revolution and the Napoleonic Code did not regard suicide as a crime. During this period, in spite of the opposition of the Roman Catholic Church, suicides could be buried in a churchyard. By 1847, this policy had effectively been abolished through a government pronouncement, not a repeal of the law. It was an issue that was hotly debated. Sheon's research required the study of such references as Morselli's *Suicide: An Essay on Comparative Moral Statistics*, 1882, and Levasseur's *Histoire des classes ouvrières et de l'industrie en France, de 1789 à 1870*, 1904.

Influences on Art

Art was not created in a vacuum. Upon each work of art there were many influences: artistic, educational, literary, religious, theatrical, historical, political, economical, social, geographical, and scientific. These influences had an impact on the form as well as the subject of the work of art. For instance, the art around artists—the objects they actually viewed, studied, and admired—obviously affected these artists' own works. Especially important, at certain periods of history, were the illuminated manuscripts, the prints of other artists, and the illustrations in such works as the emblem books. Where and for whom artists have exhibited their works has sometimes made a tremendous difference in what was created. The judges of the exhibitions, then as now, often chose pieces which resembled or were in accord with their own philosophical and aesthetic views on art. For example, the 1863 Salon des Refusés was held to display to the public the works refused by the French Salon judges, because Emperor Napoleon III wanted the public to realize that the rejected art was not worthy to be part of the official French Salon.

Education is a major influence on art, not only that of the artists, but of the patrons. If most viewers of the object could not read or write, the artist added an attribute, something that would distinguish that specific person, such as the flail and the crook for the Egyptian deity Osiris. Literary influence cannot be overemphasized. The literature which the artists and the patrons read was important, as was any work which the artist was illustrating.

Religious officials have often dictated what can and cannot be depicted in art. For instance, the Ecumenical Councils sometimes altered the emphasis of Christian art, such as in 692 when the Quinisext Council, which was held at Trullo, decreed that works of art should show Christ in human form rather than as a lamb. Drama is also important to art. The theatrical world and the fine arts influence each other. Jacques Louis David's interest in the theater is well documented. Other art historical periods were also partial to dramatic depictions. Two works of art which illustrate theatrical influence are Jean Fouquet's *Book of Hours of Etienne Chevalier* and the Italian sculptor Bernini's *Ecstasy of St. Theresa* in the Church of Santa Maria della Vittoria, Rome.

History—political, economic, and social—has always played a role in art. Napoleon was a master at using art for propaganda purposes. Hitler wanted art created which would glorify the German Third Reich. The subjects which artists are allowed to depict in Communist Russia are dictated by party line. But art has also been created that illustrated politicians—such as the satirical works by Englishman William Hogarth, Frenchman Honoré Daumier, and American George Caleb Bingham. The wars of history have been both glorified—Meissonier's *Campagne de France 1814*—and vilified—Picasso's *Guernica*.

Economics will always affect art, just in who can afford to buy and sell it. The influence of the rich collector can be due to power and wealth, not aesthetic judgment. Art production also depends upon supply and demand. This not only affects the object as a whole, but the media used. When the price of gold escalated, gold leaf was replaced with paint. When printing became feasible and inexpensive, illuminated manuscripts ceased being made.

One of the greatest impacts on art has been society itself—which includes such items as (1) manners, mores, and customs; (2) recreation and sports; and (3) fashion in dress and the decorative arts. These have been not only the subject of art but also an influence on it. The seventeenth-century genre painter Jan Steen was a master at illustrating the social concerns of his fellow Dutchmen. The popularity of tea in eighteenth-century England created a desire for tea services and tea tables. Even recreation and sports can be important to art. The Olympic Games and the importance of athletics was glorified in Greek art.

Dress and fashion, both the presence and lack of, influence art by providing such things as (1) the type of clothing that is depicted—high fashion in portraiture, peasant dress in rural genre scenes; and (2) the reasons for changes and the popularity of certain types of furniture and other decorative items. The first can be used in dating paintings and in discerning the artist's intentions as to illustrating the social status of the figures represented. The enormous skirts worn in eighteenth-century France, as well as the new vogue for comfort, necessitated the development of the wide cushioned chair, called a *bergère*. Because Queen Elizabeth I adorned her dresses with small ornaments and miniatures, these small portraits were especially popular in sixteenth-century England.

Geography or the location where the artist works has exerted an influence on art, especially the media popular in specific areas. Because of the lack of the ingredients to produce bronze, few statues were made of this metal in ancient Mesopotamia. The state of medicine has frequently been included in paintings, often incidentally, sometimes as the theme. As Walter S. Gibson reports in his *Bruegel,* 1977, the sixteenth-century painter's *The Blind Leading the Blind* accurately illustrates various types of ophthalmological problems. Mental illness as depicted by Francisco de Goya and Théodore Géricault indicates the early nineteenth-century view of the insane. The vast difference between Thomas Eakin's *The Gross Clinic,* 1875, and *The Agnew Clinic,* 1889, is a commentary on the improvement of surgical procedures.

The preceding discussion was not intended as an extensive discussion of everything that has had an impact on art, but rather a brief glimpse of some of the many possibilities which are to be considered. In order to find references for these interdisciplinary subjects, first the researcher should consult the library catalogue under the proper subject headings. For example, in the research problem—to discern if there is any influence from medieval theater on the sculpture of the Romanesque Church of Saint-Gilles-du-Gard in France—there are two principal starting points: medieval theater and Saint-Gilles-du-Gard. In the library's subject catalogue under "THEATER-HISTORY-MEDIEVAL, 500–1500" will be discovered titles of books which will provide a general overview of the subject and lengthy bibliographies. Under "SAINT-GILLES, FRANCE (GARD). CHURCH," a reference may be found to Whitney S. Stoddard's book, *The Facade of Saint-Gilles-du-Gard: Its Influence on French Sculpture,* 1973. And under the more specific heading—"SAINT-GILLES, FRANCE (GARD) CHURCH. FACADE"—there may be a citation for Carra Ferguson O'Meara's *The Iconography of the Facade of Saint-Gilles-du-Gard,* 1977. By reading these books, and carefully studying the footnotes and lengthy bibliographies, titles for additional reference materials will be obtained.

After consulting the library catalogue, the student should follow many of the steps outlined in Chapter 4, with the exception that resource tools for general subjects, as well as for art, should be examined. Although *The Encyclopedia Britannica* will provide more material on medieval French theater than will *The Encyclopedia of World Art,* both should be studied. Most of the catalogues of holdings of famous art libraries will have little on disciplines other than art, but they should still be inspected. For instance, the *Library Catalog of the Metropolitan Museum of Art* has a citation under "Theaters-France, Medieval" to *Stage Decoration in France in the Middle Ages,* 1910, by Donald Clive Stuart. This book might provide important information.

The "Subject Index" of *NUC Books,* which was discussed in Chapter 4, will give access to any recent publications on the topic. Pertinent articles may be located in *The Reader's Guide to Periodical Literature,* which should be consulted along with the art abstracts and indices. Because it covers all subjects, *Dissertation Abstracts International* often provides valuable leads. An online search of some of the specialized bibliographic databases may prove productive, depending upon the wording of the problem and the databases consulted.

The needed resource tools in an interdisciplinary study may be scattered throughout the library or available only at other institutions. Most special art libraries will have few, if any, books on the medieval theater. These reference materials may have to be obtained from a main library. For assistance, the researcher should ask the reference librarian of the specific discipline. At the end of Chapter 13, is a general list of selected books that might be used for certain types of research. These annotated citations are not necessarily the best works for all categories, they are only included to serve as a reminder to students of this important category of art research.

Architectural Research

Because architectural research differs somewhat from that of other disciplines, this chapter has been separated from the other methodological studies. Although there are many different ways of approaching architectural research, the methods described here are divided into (1) specific monuments and buildings, (2) architectural styles and types of buildings, (3) construction and building materials, (4) historic preservation, and (5) business and technology.

Specific Monuments and Buildings

Architectural research can be subdivided in the following manner: (a) archaeological and classical, (b) historical, and (c) contemporary and future. Each of these kinds of research has its own problems. Not only must the topic be clearly stated, but the specific terms must often be elaborated, for the method of citing particular items has altered over the years. The library catalogue may list the subject one way, the various references, another way. Because the material can be confusing, this section will describe (1) the basic steps—which should be read by all architectural researchers—that might be taken to investigate a building, using as an example, Monticello, Thomas Jefferson's home which he designed and built outside of Charlottesville, Virginia; (2) special problems pertinent to archaeology and classical works; (3) the study of historical architecture; and (4) how to discover data on contemporary and future buildings.

Basic Architectural Research: Monticello

Architectural research requires the investigation into both the completed building and the architect who designed or worked on it. Data must be collected on the architect associated with the building, if known, in order to discover (a) at what stage in the person's career and under what circumstances the designs or plans were made; (b) the art and architecture that the architect admired or studied which might have influenced the designs or plans of the building; (c) the architectural philosophy of the architect; and (d) ideas which might

have affected such items as the design, site planning, or choice of construction materials. As a consequence, the working bibliography for the architect should include the following: (1) references that provide details on the person's life and career, (2) reproductions and resource materials which influenced the architect, and (3) writings by the architect. The methodology for this type of search is detailed in Chapter 4 with special suggestions given under "Architects" in Chapter 5.

Prior to studying a specific building, the exact location—city, state or province, and country—must be determined, since citations may be listed under any one of these. For an architectural monument, information must be collected on such items as (a) the function and style of the building; (b) the preliminary designs and plans; (c) the specifications, rules, regulations, or codes that affected the building; (d) the construction site and building plans and methods; (e) the construction materials; (f) the reaction to the finished building; and (g) any restoration or preservation which has been accomplished over the years. In order to obtain this data, the researcher must (1) formulate a working bibliography and a chronology of the work and the architect, if known, who designed it; (2) view and scrutinize (a) the building—both personally, if possible, and through the various photographs or drawings which have been made over the years the work has existed—from every angle and in great detail, and (b) any visual material—floor plans, elevations, blueprints, or site location maps—both past and present, that may exist; and (3) investigate the various influences which affected the design, planning, and restoration of the work.

Bibliographies and Chronologies

When researching a specific architectural monument, a working bibliography and a chronology should be compiled providing data on the building and relevant information on the architects connected with the work. In formulating the working bibliography, the references used are similar to the ones detailed in Chapter 4, a section which should

be studied before reading the following discussion. The library's catalogue, the architectural encyclopedias and biographical dictionaries, catalogues of holdings of famous libraries, the abstract and indexing services, the art history references that pertain to architectural styles and types of buildings, and exhibition catalogues should all be consulted. Two of the categories cited in Chapter 4—references concerning past exhibitions and auction catalogues—are not used. On-line database searches, however, can often be profitable. In addition, architectural research may also use other types of resources: (1) travel and guide books, maps, and personal reactions to the monument, (2) trade literature and data on the construction materials used, (3) specifications, rules, and regulations concerning the building, and (4) archival and historical sources.

Separate chronologies for the building and for the architect should usually be compiled. In the case of Example 21 for Monticello, because this was not Jefferson's primary profession, pertinent facts concerning his career were included in the one chronology. Just as for an artist, as Example 1 on Caillebotte illustrates, a chronology does not end with a person's death or with the finished building. Information on resales, changes of ownership, alterations, and restoration is especially important to the chronology of a building.

The easiest method of conducting architectural research is to start with the architect, if the person is well known. Suggestions for this methodology are detailed in Chapter 5 and are not repeated here. If the building is also well known, care must be taken to check both the architect's name and that of the building, because references may be located under both topics. For instance, Monticello is a famous architectural monument. In most library catalogues, there are entries under the subject listings for "MONTICELLO, VIRGINIA" and "JEFFERSON, THOMAS, 1743–1826—ARCHITECT." The citations are usually different under each heading. In addition, pertinent material may be discovered under other headings. For instance, under "JEFFERSON, THOMAS, 1743–1826—EXHIBITIONS," there was a reference to *The Eye of Th. Jefferson,* an exhibition catalogue which reproduces numerous important preliminary drawings that the American statesman made of his future home, material that is not readily available. In Example 20, Arabic numbers indicate that there were two addi-

Example 20: Subject Cards for *The Eye of Th. Jefferson.*

tional subject categories, both under subheadings for "Neoclassicism (Art)." The Roman numerals report that two author or corporate entries—for William Howard Adams and the National Gallery of Art (U.S.)—plus a title entry were also used to identify this book. Reading the complete LC card of Example 20 does not help the researcher discover that this work includes data on Monticello. But the additional access points which refer to Neoclassicism would indicate (1) that this book would have references to Jefferson's architecture, and perhaps Monticello, and (2) that this architectural style might be a subject to search for other relevant material. Finding the exact information one is seeking, therefore, is in part dependent on the researcher's creativity in conducting a bibliographic search.

Of the general art encyclopedias, annotated in Chapter 9, *McGraw Hill Dictionary of Art* is especially good at covering architectural material. Under "Monticello," the lengthy signed article has a bibliographical entry plus a black-and-white

photograph of the house. Other sources are the architectural dictionaries in Chapter 9, and citations under "Architects, Historically Prominent" and "Architects, Contemporary" in Chapter 10. These sources are discussed under "Architects" in Chapter 5. The catalogues of holdings of famous libraries, annotated in Chapter 11, include architectural institutions, such as the Avery Architectural Library of Columbia University and the Royal Institute of British Architects, London. At the Avery Library, three important references have been developed: (1) *Avery Index to Architectural Periodicals,* (2) *Catalog of the Avery Memorial Architectural Library,* and (3) *Avery Obituary Index to Architects and Artists.* In addition, there is *On-line Avery Index to Architectural Periodicals Database,* which is available through RLIN.

The catalogues of the large general art libraries should be consulted. The various editions of the *Library Catalog of the Metropolitan Museum of Art,* the *Catalogue of the Harvard University Fine Arts Library,* and the *Dictionary Catalog of the Art and Architecture Division,* New York Public Library, have numerous entries under "Jefferson, Thomas." Not all books were cited in all of the catalogues. The specialized architectural bibliographies may also assist the researcher in discovering pertinent material. These resources are listed in Chapter 23.

There are special architectural indices, annotated in Chapter 12, such as the *Avery Index to Architectural Periodicals,* previously cited, *Architectural Periodicals Index* of the Royal Institute of Architects, and *Architectural Index.* In addition, *Art Index* provides extensive coverage for historical architecture. Although *ARTbibliographies MODERN's* coverage of architectural data has not always proved adequate in the past, the editorial board has just extended the number of architectural titles to be abstracted on a regular basis. This will increase the value of this service, both in hard cover and database files. In order to obtain an overall view of the Neoclassical style that permeated Jefferson's work, some of the references in the various art history books in series—such as the *Pelican History of Art* and the *History of World Architecture*—may be of assistance. Books that discuss domestic architecture should also be consulted.

Although not numerous, there have recently been a number of important exhibitions that have spotlighted specific architects, buildings, or architectural materials. These diverse exhibitions have been documented by such catalogues as *The Eye of Th. Jefferson* and *The Drawings of Andrea Palladio. The Worldwide Art Catalogue* has a special heading for Architecture under "Index of Media"; see Chapter 15. A review located in the *Worldwide Art Catalogue* indicated that the exhibition catalogue, *The Eye of Th. Jefferson,* reproduced drawings, prints, maps, books, furniture, and other decorative materials owned by the Virginia statesman. Although no specific mention was made of Monticello, the review reported that the scholarly essays discussed such related items as (1) the inhabitants and topography of Virginia; (2) British life under George III; (3) scientific, exploratory, and archaeological activities in the Age of Enlightenment; and (4) Jefferson's architectural designs.

There are several databases for architectural material. The *On-line Avery Index to Architectural Periodicals Database,* which has files dating from January 1979, has already been mentioned; the entire run of the *Journal of the Society of Architectural Historians* is available through BRS. For this specific study a free-text search was made of *ARTbibliographies MODERN Database,* which has files from 1974. Just the name of Monticello was used. Nine entries were cited. It was interesting that none of the articles used Monticello as a descriptor. This means that a search of descriptors only would not have located the articles. Seven of the abstracts had "Jefferson (Thomas)" as a descriptor; the two which did not include his name were not pertinent to the study. The nine citations included one book, one dissertation, and seven journal articles. Two were especially important: (1) "Monticello: 1856," a personal account of two visitors to the home that year printed in *Journal of the Society of Architectural Historians,* volume 34, December 1975 and (2) "Mr. Jefferson as Revolutionary Architect" published in the same issue of that journal. It was the former which provided a nineteenth-century visitor's reaction to the finished building.

An integral part of architectural research are travel books, maps—both historical and current, and personal accounts. These works will often provide information for the site on which the building was placed. Travel and guide books usually describe how the area looked in a certain year. By reading a number of these references, the

changes in the building and its environment may be discerned. Historical atlases define the changing boundaries over the centuries, alterations which sometimes result in a new nation or a different political alliance. Maps of states, cities, and even specific districts may provide essential data on the site and the surrounding environment. Personal accounts of a visit to the building—such as the description provided by two visitors which was reprinted in the article, "Monticello: 1856"—are ways to learn about any alterations which might have been made. An historical atlas with a map of Virginia in the early nineteenth century indicates that Monticello was isolated from much of the newly formed state. Unfortunately, most libraries have an inadequate supply of this type of reference material.

Trade literature is the advertising published in brochures, journals, and newspapers by (1) manufacturers of such items as hardware and bricks and (2) people who supply services, such as stone masons or carpenters. In order to discover the types of materials which were available at certain periods of history, some of the trade literature might be of assistance. For a bibliography of these resource tools, consult Lawrence B. Romaine's *The Guide to American Trade Catalogs: 1744 through 1900,* 1960. Other sources are Henry Russell Hitchcock's *American Architectural Books*—which lists builders' guides, pattern books, and other architectural books published in America before 1895—and Helen Park's "A List of Architectural Books Available in America Before the Revolution," *Journal of the Society of Architectural Historians,* 23 (October 1961):115–130. Most of the books cited in Hitchcock and Park's bibliographies have been reprinted on microfilm by Research Publications, Inc. There are also reprints of some late nineteenth- and early twentieth-century trade literature, such as (1) *Victorian Shopping: Harrod's Catalogue 1895,* 1972; (2) Montgomery Ward & Company, *Catalog and Buyers Guide No. 57, Spring and Summer 1895,* 1969; and (3) Sears Roebuck & Company, *The Great Price Maker, Catalog No. 117: 1908,* 1969. Advertisements published in nineteenth-century newspapers and journals are other sources. There are also articles, especially those in magazines such as *Historic Preservation,* that discuss the hardware and building materials available during certain historic periods.

Throughout the research, there will usually be some information on the construction materials used in the work being studied. For an understanding of how these materials affected the building, research must be done on that specific kind of brick, stone, marble, wood, or whatever the kinds of materials which were used. This can lead to a study of engineering and construction problems; these are discussed later in this chapter.

Most large cities today have building codes which limit what an architect can design. This has not always been the case. Jefferson probably had few limitations—other than money, accessibility of materials and skilled labor, and time. However, there were probably specifications and regulations concerning the restoration of the building in the twentieth century. All of these rules and regulations which might affect a building must be considered. This often entails a trip to the site and an extensive search through ancient records of primary source material.

Other sources for architectural research are the various archival materials which have been deposited in libraries and other institutions. These resource tools are annotated in Chapter 23 in a special section for architecture. For historical research, this may include the *Sanborn Maps;* the *Tax Rolls of Real Estate and Personal Property,* which by the property owner's name provides the value of the land and its improvements; and photographic material on the local area. The Sanborn Map Company, which has been in operation for more than a century, has mapped every U.S. city and town with a population of more than 2,500 people. The maps, which date from 1867 to the present, cover the commercial, industrial, and residential districts of 12,000 municipalities in the United States, Canada, and Mexico.

The updating of the *Sanborn Maps* differs with the agreement between the various municipal governments and the company. About sixty large cities have a lease agreement by which the Sanborn Map Company updates their maps on an annual basis. Other municipal governments purchase the maps and negotiate a revision every five to ten years. Some small towns have never had their maps updated. The scale of each map is usually fifty or one hundred feet to one inch. In some less dense areas, the scale is two hundred feet to one inch. The maps provide street-by-street information concerning the names of streets, the general

shapes and sizes of the structures on each plot of land, and sometimes the building materials and approximate measurements. By studying the maps over a number of years, major additions or deletions in buildings can be discerned as well as alterations in the neighborhoods. These maps can be extensive. For instance, the maps of all five boroughs of New York City are contained in seventy-nine volumes which have about 6,000 maps. These are updated annually. Researchers can usually discover the cities for which maps have been made, as well as for which years, by consulting *Fire Insurance Maps in the Library of Congress*, 1981, a checklist of the some 11,000 volumes of Sanborn maps owned by the U.S. Library of Congress. Since many of these maps can be purchased on microfilm, researchers should inquire at the libraries they frequent as to the availability of the needed maps. Because this material if often not included in the library's catalogue, the Archive Department Librarian should be consulted.

For archival material, the researcher should consult the *National Union Catalog of Manuscript Collections*, compiled by the staff of the Library of Congress. This series of publications consist of (1) annual catalogues which list archival records and provide descriptions of the contents and the locations and (2) indices which provide access to the records by names of persons, firms, associations, and location sites. In the example used in this chapter, the cumulative index for 1975–79 of the *National Union Catalog of Manuscript Collections* had two references under "JEFFERSON, Thomas, Pres. U.S., 1743–1826: Monticello." The entry for the 1978 listing indicated that the Southern Historical Collection of the University of North Carolina at Chapel Hill has 530 items plus one reel of microfilm of architectual and archaeological data pertaining to the restoration and preservation of Monticello. These records include field notes, drawings, photographs, and slides. Because numerous historical collections report their holdings, this Library of Congress publication can often be a rich source for information on archival material.

Because there are so many architectural records tucked away in unlikely places, some organizations have decided to encourage the preservation of these materials and to assist scholars and students in locating them. COPAR, the acronym for Cooperative Preservation of Architectural Records, was founded in 1973. The Prints and Photographs Division of the Library of Congress—which has maintained the records since 1980—has promoted certain aspects of COPAR, especially the development of state committees. COPAR, which issues a quarterly newsletter, has published several important surveys: (1) *Architectural Research Materials in New York City: A Guide to Resources in All Five Boroughs*, which is supplemented by *Index to the Architects and Architectural Firms Cited in "Architectural Research Materials in New York City*," compiled by Mary M. Ison, 1981 and (2) *Architectural Research Materials in Philadelphia*. These references list institutions which have preserved architectural documents, such as drawings, blueprints, photographs, and records. For each institution the entry cites name, address, telephone number, scope of collection, major holdings—often providing the name and dates of individual architects whose material is represented, admission policy, hours, and other aids. There are two other similar compilations: (1) *Architectural Records in Chicago: A Guide to Architectural Research Resources in Cook County and Vicinity*, by Kathleen Roy Cummings, 1981 and (2) *Architectural Research Materials in the District of Columbia*, by Sally Hanford, 1983.

In addition, COPAR has a "National Union Index to Architectural Records," a computerized file of more than 3,500 entries which was begun in 1973. All of the material published on the cities of New York, Philadelphia, Chicago, and Washington, D.C. plus comparable material supplied by individuals and institutions is in this bibliographic database. The main access point is by architects' names. Other access points include the personal names important to the record being described; the building's name, location, type, and construction date; and the owner and location of the record. About 1985, this data will be available through computer generated printouts. Presently information concerning the architectural records in the "National Union Index" can be obtained by writing or telephoning Mary Ison, COPAR, Prints & Photographs Division, Library of Congress, Washington, D.C. 20540, (202)-287-6399.

Visual Materials

In any art research, it is essential to view the actual artistic creation. But in architecture, which is three dimensional, it is even more important.

Because buildings are such complicated structures, numerous plans had to be made prior to their construction, in order to achieve a finished workable edifice. Researchers should be sure that they understand how to read these architectural records. The architectural dictionaries—such as Cyril Harris' *Dictionary of Architecture and Construction*—will assist the beginning student; these books are listed in Chapter 9.

If possible, the building or monument should be personally visited, as often as possible, in order to study (1) all sides, angles, and details; (2) the scale of the building; (3) the effect of the construction materials; and (4) the environment surrounding the work. Each time the site is viewed, some new facet will be observed. Even with visiting the building, numerous reproductions will be needed. Personally photographing the work can be less expensive but may be impractical, if not impossible. Commercially produced illustrations usually must be used. In Chapter 4 under "How to Utilize References on Illustrative Materials," there is a discussion of how reproductions can be gathered.

Until the use of reproductions on microforms, scholars had to do their own photographing at the actual site and spend precious time trying to locate any architectural plans or visit the various North American and European photographic archives. Now some of these collections are being reproduced, mostly on microforms. These important visual materials, which are annotated under "Published Photographic Archives" in Chapter 17, are expensive. Not all libraries will have them. Be sure to inquire if such resource material is available before traveling to a distant library.

One of the great United States architectural projects is the Historic American Buildings Survey. Begun in 1933, and greatly facilitated by the Historic Sites Act of 1935, the HABS—as the survey is abbreviated—was conducted by the National Park Service in consultation with the American Institute of Architects. Although the survey ceased between 1941 and 1956, the historic collection has continued to increase measurably since that date. With the 1966 National Historic Preservation Act, the National Park Service in cooperation with state and local governments has continued the inventorying of historic structures. This survey includes measured drawings, photographs, and data of architectural and historical importance. The collection includes about 31,000 drawings, 45,000 photographs, and

15,000 additional records. Now one of the largest collections of architectural records in the world, the material is deposited in the HABS Archives in the Division of Prints and Photographs of the Library of Congress. Much of the material can be purchased through the Photoduplication Service of the Library of Congress, Washington, D.C. 20540.

This vast HABS collection of archival material is being published in books by Garland Press and on microforms by Chadwyck-Healey, Inc. These are issued for individual states, so libraries will not necessarily own the complete set. Available are the entire HABS series, from 1933 to 1979, of the photographs and measured drawings as well as descriptions of the 20,000 sites and structures in the forty-eight states which are represented plus the District of Columbia and Puerto Rico. Alaska and Hawaii are not included.

Another great architectural project is the one started by The Dunlap Society, which was formed in 1974 to produce a visual documentation of all American art. The name of the organization derives from William Dunlap, who in 1834 published his two-volume *The Rise and Progress of the Arts of Design in the United States,* probably the first American art history book. Among the society's projects, two studies, of two volumes each, have been published on microfiche: *Architecture of Washington, D.C.,* 1980 with eighty-eight fiches containing about 3,500 images and *County Court Houses of America,* 1982 with 179 fiches and about 8,500 images of the 1,875 U.S. county court houses. The images are also available as 35 mm. slides or as photographs. Each publication consists of a looseleaf binder which has storage for the microfiches plus a printed table of contents and factual data on each structure. The visual material consists of multiple views of the exterior and interior of the buildings; preliminary drawings, some of which were not executed; photographs of the building in progress; and views of the site, both before and after the monument was erected.

Influences on Architecture

The discussion on the influences on art in Chapter 6—which every student should read—is pertinent to architectural buildings and monuments as well as to individual works of art. This material is not repeated here. Only a few examples will be provided of these numerous influences: artistic, literary, religious, theatrical, historical, political, economical, social, geographical, and

scientific. Hopefully, these illustrations will emphasize the importance of this category of research to any architectural study. The methodology for locating resources on the influence on architecture is similar to the one discussed in Chapter 6; the researcher should consult that section.

Obviously, other art has always influenced artists. This is evident in architecture. The Gothic churches that copied aspects of Notre Dame in Paris are documented. Many of the skyscrapers in international cities have such a similar look that it is often difficult to distinguish one from another. The literary effect of the writings of such famous architects as Vitruvius, Alberti, and Palladio is apparent. But there is other literature, not by architects, which has also had a tremendous impact. This is especially true of those of a theological and religious nature. In *The Mass of the Roman Rite: Its Origins and Development,* Jungmann relates the changes in the Roman Catholic rites and rituals to the alterations in ecclesiastical needs, including architecture. Certain religious ideas have dictated building requirements. Because the Carthusian monks wished to live in small separate cells, monasteries had to be designed to accommodate this community of hermits. To remind Moslems that it is time for worship, tall minarets were added to mosques, thus allowing the muezzin's call to be heard by the faithful.

Dramatic productions influenced how the actual theaters were constructed, as well as the decorative effects on other buildings. The Palazzo dei Conservatori in Rome was redesigned in the sixteenth-century, partly by Michelangelo, to provide a dramatic setting. Enormous building programs are often used by political dictators to demonstrate their benevolent effects on the country. Caesar Augustus, Napoleon, and Hitler all commissioned numerous buildings. Versailles was created to glorify the French monarch, Louis XIV. Economic factors often decide what can and can not be built and at what cost in money, power, and people. Because the French government coffers were depleted following the Hundred Years War with England, churches in the Flamboyant Gothic Style were relatively small compared with those designed earlier. Social changes bring architectural alterations. After Louis XIV's death, members of the French Court, who were weary of life at Versailles, had town houses, called hôtels, built in Paris.

Especially important to architecture are the influences created by geographical conditions, such as weather, site, location, and availability of materials and transportation. These conditions had more of an impact before engineers and scientists had the ability to develop materials and construction methods which could overcome some of the geographical limitations. For example, without the seasonal flooding of the Nile River, the Egyptians could not have floated the quarried limestone to the pyramids. Because of the cold inclement weather, English Decorated Gothic churches usually had a long rectilinear plan which allowed people to congregate, and even to hold meetings, in the first nave, without disturbing the religious services in the rest of the building. The history of architecture is in many ways closely related to scientific developments. The inventions of concrete, iron, and steel had tremendous impact on architecture. For instance, before the invention of the elevator, which required iron or steel, most apartment houses and offices were curtailed to a height of four or five stories. Without the present engineering knowledge, skyscrapers could never have been constructed.

Archaeology and Classical Antiquities

Research on archaeological and classical antiquities follows the basic resources just described. All of the names—past and present and sometimes in various languages—by which the work and the site on which it was built must be learned prior to beginning the study. A specialized dictionary, such as the ones cited in Chapter 9, will help establish these facts. For example, if the Altar of Zeus and Athena at Pergamum in present-day Turkey was the project, the *Illustrated Encyclopaedia of the Classical World* might be one of the first references to be consulted. This book would indicate that Pergamum can also be spelled Pergamon and that it is today called Bergama. The entry records some of the ancient history of the area, provides cross references to other words in the dictionary that relate to Pergamum, and provides three bibliographical entries to English-language books published in the 1970s.

It must be remembered that the countries whose scientists and historians have done the excavations and restorations will also probably publish the most scholarly reports. Thus if the Germans were the primary excavators of the ruins of an ancient monument, German will be the language of the majority of the scholarly references. If the

monument, or parts of it, have been moved, this compounds the problems for the researcher. For instance, the Altar of Zeus and Athena excavated at Pergamum in Asia Minor was relocated in 1930 to the Pergamon-Museum in East Berlin. Research would involve data on the Asia Minor site, the nineteenth-century excavations, the restoration of the temple in Germany, the damage done by bombing during World War II, and the present condition of this Hellenistic temple.

For the excavation site, the articles in *The Princeton Encyclopedia of Classical Sites* and *Pauly's Real-Encyclopädie der classischen Altertumswissenschaft,* both cited in Chapter 9, should be consulted. For information on the temple, the catalogues of the holdings of famous libraries in Chapter 11 and the index and abstracting services in Chapter 12 should be checked. In these references the material is listed under various headings: (1) "Pergamum, Altar," (2) "Pergamon, Altar of Zeus," (3) "Pergamus-Archaeology," (4) "Berlin Museen-Pergamon Museum," and (5) "Staatliche museen zu Berlin, Pergamonmuseum" with a cross reference to this entry from "Pergamonmuseum, Berlin." There were numerous entries in the catalogues for the libraries at Columbia University, Metropolitan Museum, and Harvard University. *Art Index* had a wealth of material. At least eighty percent of the titles cited in these various references were in some language other than English. Most of the articles were on the excavations, past and present; a few were on the altar. The best reference was the 1962 East German publication *The Great Altar of Pergamon,* written by Evamaria Schmidt and translated by Lena Jaeck. This book was half pictures of details of the altar and half text.

Historic Architecture

Not all architectural terminology has remained constant. For the student confused by the different historical terms, Cyril Harris' *Historic Architecture Sourcebook* or the *Illustrated Glossary of Architecture, 850–1830* by John Harris and Jill Lever should be consulted. These books are listed under "For Architects: Historic References" in Chapter 23. Because the example used in describing the basic steps to be followed in architectural research was the historic work, Monticello, most of the important resources have already been discussed. Buildings and monuments located in non-English speaking countries often have some ad-

ditional problems, as the example of the twelfth-century church of St-Pierre at Aulnay, France will illustrate. One factor to be considered is that any such structure will have most of the material written on it in the language of the country where the structure exists. Most articles on Aulnay are in French. The student must be aware of this linguistic limitation.

For historical works, all of the names for the building and the location site—past as well as present—may be needed. A list of some of the encyclopedias and dictionaries which often provide this information are cited in Chapter 9. One of the better sources is the *McGraw-Hill Dictionary of Art.* However, even in this reference, some buildings are entered under their popular name—such as the two Pantheons, one of which is in Paris, the other being in Rome—while some monuments are listed under the city or town in which they were built, such as "Aulnay St. Pierre." Popular usage is usually the key factor, but students must remember to look under more than one type of entry—city, name of building, or architect.

Choosing a specialized reference tool will more likely produce pertinent data. For French churches, there is an especially good reference, *Dictionnaire des Eglises de France.* This five-volume work includes even small French ecclesiastical buildings, regardless of historic period. The entries are under broad geographical locations—such as north, west, or south-eastern—and an atlas or travel book may be needed to pinpoint the location. It must be borne in mind that for centuries the nation now known as France consisted of feudal regions—such as Normandie, Anjou, and Bourgogne—which changed boundaries and political allegiances numerous times over the centuries. All of this changed again with the French Revolution of 1789. In order to unify the country, the ancient divisions were reapportioned into ninety-five districts, which utilized the names of natural geographical boundaries, such as mountains and rivers. Reference material on French architecture can use either the ancient feudal divisions or the present French departments.

In the *Dictionnaire des Eglises de France* in the volume of *Sud-Ouest* under "Poitou, Saintonge, Angoumois," an entry was located for the Church of St. Pierre at Aulnay. There was a 1 ½ page discussion, four illustrations, a small floor plan, and four bibliographical references. This provided information that the town, which is sometimes referred to as Aulnay-de-Saintonge—meaning the

town of Aulnay of the Saintonge district—was originally part of the feudal region of Poitou, located close to the border of the Saintonge area, hence the misnomer. It also provided the modern geographical department in which the town is now located, the Charente-Maritime. The *Répertoire d'art et d'archéologie,* which is listed in Chapter 12, had information under three terms—Aulnay, Poitou, and Charente-Maritime. This data was also necessary to locate any entries for Aulnay in the Romanesque ecclesiastical monuments series, published by the European Zodiaque Company, which had dicussions of the church in two books—*Poitou roman* and *Haut-Poitou roman.* Additional information was located under "Saintonge," because the architecture in this district influenced the builders of St. Pierre.

Another problem with researching buildings in a non-English speaking country is the difficulty of locating and obtaining the scholarly articles once the titles are discovered. Some of the material on St. Pierre at Aulnay was published in *Congrès archéologique de France* and the *Bulletin de la Société des Antiquaries de L'ouest et des Musées de Poitiers.* These references are not readily available in most North American libraries.

In order to view as many reproductions of the building being studied as possible, the researcher may need to study some of the photographic archives reprinted on microforms, which are annotated in Chapter 17. Two extensive archives are the *Marburger Index: Photographic Documentation of Art in Germany* and *Index Photographique de l'Art en France.* Both of these microfiche publications are of the photographic collection of the Bildarchiv Foto Marburg at the Forschungsinstitut für Kunstgeschichte der Phillips-Universität Marburg and the Rheinisches Bildarchiv Köln. The *Marburger Index* consists of about 480,000 photographs, taken between 1850 and 1976, which illustrate architecture, painting, sculpture, and arts and crafts from the Middle Ages to modern times. The photographs are arranged topographically according to geographic site. Each image on the microfiche has a small identifying caption which provides: (1) the location of the monument or object, (2) what detail is being illustrated, and (3) the date the photograph was taken. Also published is a supplement of an additional 300,000 photographs. To illustrate the kinds of visual materials available in the *Marburger Index,* the reproductions of the Römerberg, a

fifteenth-century square in Frankfurt-Am-Main, were studied. There were two drawings—from 1738 and one with no date; three oil paintings— 1754, 1773, and 19th-century; and photographs of the square taken in the 1920s, 1930s, and 1974. There were numerous views of the square taken in 1974. For the city of Frankfurt-Am-Main, there were hundreds of photographs of ancient city maps, views of buildings and churches in the city, and photographs of the collections in various museums.

The *Index Photographique de l'Art en France,* which has a similar organization to the *Marburger Index,* consists of about 100,000 photographs. Under "Aulnay," there were 189 photographs— mostly taken in 1925/26 and 1940/44—of the exterior and interior of the church. When using this microfiche material, the researcher must double check to be sure that all of the photographs of a particular monument are viewed. Because the photographing was done in sequence and because there can be additions to the microfiche collection, not all of the material will necessarily be in one section. Nor are the photographs of a city always completed on an individual microfiche. For instance, the photographs of Aulnay comprised most of two microfiches, plus there were four illustrations on another microfiche which was mainly of Autun, France.

Contemporary and Future Buildings

For architectural projects which have been recently completed or are in progress, the correct title of the building, the exact location, and the name of the architectural firm involved need to be known, because any of these may be used by the various references. The quickest method for finding data is through researching the architect, a process discussed in Chapters 4 and 5. If the architect is not known, the index and abstracting services, cited in Chapter 12, will be of the greatest assistance in discovering information, since these resources provide access to the latest material. When the name of a contemporary building is known, but not the architectural firm nor the exact city, several sources may have to be used. For instance, in seeking data on the Sears Building, a cross reference was found in *RILA Cumulative Index, 1975–1979* under "Sears Bank and Trust Company" to "Chicago, Illinois." With the city established, *Architectural Index 1974* was consulted. Under "Illinois, Chicago, Office Building-High Rise," a reference to the Sears Building

reported the architectural firm of Skidmore, Owings and Merrill. With these facts, the research became easier.

For important national and international projects which are announced, but not completed, the best method for obtaining material is through on-line databases. Care must be taken as to which computer files are used. For completed projects, databases which cover magazines may be searched, since periodicals usually report only finished works. But for buildings in progress, the databases that cover newspapers or local monthly magazines must be used. For large innovative major projects, such as the tower addition to the Museum of Modern Art in New York City, the material will be fairly easy to locate. From *The Information Bank Database* through NEXIS, a request—*Museum AND Modern Art AND addition*—brought forth five citations: one for the Los Angeles County Museum and four for the New York City museum. In a search of the *On-line Avery Index to Architectural Periodicals Database* through RLIN, a request for records on the Museum of Modern Art elicited a response of seventeen entries, of which ten were pertinent.

For smaller projects reported mostly in local newspapers and regional magazines, the search will be less productive. For the new building for the Dallas Museum of Fine Arts, which was not to be finished for another year, online searches of the database files of the *On-line Avery Index, ARTbibliographies MODERN, The Information Bank, Newsearch,* and *Magazine Index,* all yielded nothing. The best resources were the vertical files at the Dallas Public Library, which had a packed folder full of clippings from the local newspapers and of news releases from the museum. Copies of material from local libraries is usually available, for a small fee, to people who write the Fine Arts Librarian.

Another source is the building itself, in this case the Dallas Museum of Fine Arts. Often the building plans and pertinent material concerned with the construction can be located through writing those in charge of the actual structure which is being studied. The material is sometimes made available to researchers. The person to contact is usually the Director of Public Relations, who can channel the inquiry to the correct department. Personally interviewing those concerned with the planning and construction of the work will also add to the knowledge of the building. The researcher can inquire at the City Hall in the town where the building is located concerning the availability of any plans and papers which were deposited with the city government in order to obtain the building permit. If specific questions arise, a letter to the architect may receive a reply.

Architectural Styles and Building Types

Retrieving information concerning architectural styles is particularly easy, since this subject has been well researched. For detailed studies, the *Pelican History of Art* or the *History of World Architecture Series* should be consulted for their texts and their bibliographies. The material cited by the index and abstracting services should provide ample suggestions for current articles. Remember to follow the basic steps for a working bibliography which is discussed in Chapter 4.

Information on building types—such as museums, hospitals, or stadiums—is more scattered. Nikolaus Pevsner's *A History of Building Types* provides a brief history of the development of a number of kinds of buildings. For each chapter, there is a detailed bibliography at the end of the book. *ARTbibliographies MODERN* has numerous subheadings under "Architecture": Ecclesiastical, Military, Museums, Railway, and Theatrical. Another source are dissertations, which have research reports for places of worship, palaces, libraries, schools, hospitals, museums, theaters, prisons, and commercial buildings. In addition, there are bibliographies available on specific building types through the American Institute of Architects and in the section, "Architecture," in *Arts in America;* both references are annotated in Chapter 23.

Construction and Building Materials

For projects involving architectural materials, synonyms and alternate terms should be located, since authors, subject cataloguers, and computer indexers may have used different words than the ones the researcher is using. For example, travertine might also be termed limestone or Italian marble. There are references which define architectural vocabulary, both for current and historic terminology. The *International Dictionary of Building Construction* defines terms used in English, French, German, and Italian. For synonyms used by the abstracting and indexing services, the thesaurus that many of these companies

publish may be of assistance. In searching for information on construction and building materials, the technical references—such as *Applied Science and Terminology Index* or *Engineering Index*—should be used. Both are annotated in Chapter 12.

When a researcher seeks information on building materials, it is important that an exact statement of the problem, as well as synonyms of some of the terms be developed. "I need something on concrete?" must be refined before the project begins. The changes created by weather on the strength of reinforced concrete is, naturally, a more specific query. *The Applied Science and Technology Index,* which provides access to material in almost three hundred English-language periodicals, has eight pages of entries under "Concrete" in one volume alone. There are subdivisions for durability, strength, and temperature effect as well as a subject heading for "Concrete, reinforced." Similar coverage is available from *Engineering Index.*

If the architect or interior designer is considering a terrazzo floor, there are a number of books—cited in Chapter 9 under "Construction and Decorative Materials Dictionaries"—which will provide details on this non-structural covering. Three particularly good references are *Materials for Architecture,* by Caleb Hornbostel; *Construction Glossary,* by J. Stewart Stein; and *Construction Materials and Process,* by Don A. Watson. All three report data on the properties, types, uses, application, and history of terrazzo. Hornbostel includes a list of eleven conditions which may cause trouble. Watson records a table of the various standard sizes of terrazzo chips. Stein has the most detailed discussion of the material. For additional data, the technical indices and abstracts cited above can be used. And for the most recent material, or for information on some specific aspect, the *COMPENDIX Database,* which has material dating from 1970, should be consulted. In a search of this computer file for terrazzo/MAJ AND resistan?/MAJ—where the truncated *?* will allow for resistant or resistance and only major descriptors will be sought—two publications were discovered. The computer printout reported both as being in the *Natl Bur Stand Spec Publ.* This is an abbreviated title for *National Bureau of Standards Specifications Publications,* a pamphlet issued by the United States Government and usually kept in loose-leaf

binders or vertical files by librarians. The material may have to be requested. Since most printed versions of a database have a list of the serials covered, if the student does not know the translation of an abbreviated title, these hardbound copies can be consulted. For *COMPENDEX Database,* this is *Engineering Index.* If in doubt, ask the reference librarian for assistance.

Historic Preservation

In 1895, the National Trust—an independent, nonprofit society—was founded to safeguard England's heritage from industrialization, destruction, and neglect. Receiving no subsidy from the government, the National Trust protects manor houses, historic buildings, and land in England, Wales, and Northern Ireland. Included are villages, the remains of part of Hadrian's Roman Wall, nearly three hundred miles of unspoilt coastline, and more than two hundred houses of historic importance. In 1907, an Act of Parliament incorporated the National Trust and empowered it to declare its property inalienable, thus ensuring that such property can never be given away or sold. By an Act of 1934, the National Trust was allowed to accept a house, with or without its furnishings, as a gift and in return to allow the owners and their descendants to continue living in the house rent free. In this manner, the crippling death-duty taxes can be circumvented.

The National Trust of England was modelled on the Charter of the Massachusetts Trustees of Public Preservations, which was established in 1891. The National Trust for Historic Preservation, however, was not chartered by the U.S. Congress until 1949. A nonprofit educational organization, the American society publishes books, the monthly *Preservation News,* and the quarterly *Historic Preservation.* The U.S. government is also involved in the saving of national monuments. The National Park Service, created in 1916 under the direction of the U.S. Department of Interior, is responsible for such projects as the Historic American Buildings Survey, which was discussed earlier in this chapter; the National Register of Historic Places; and the Historic American Engineering Record. Some of the publications of this federal agency are cited in Chapter 23.

The preservation of architectural monuments is important at all levels—national, state, county, and local. In 1858 the Mount Vernon Ladies Association purchased George Washington's Virginia

home. This was the first of many tax-exempt foundations and societies to be formed to preserve individual sites in the United States. At the historic sites, there are often repositories of archival material, which the researcher may use. Some of the societies publish material on the architectural monument. Unfortunately, knowledge of these pamphlets and books may not be available except through writing the society. In 1940 the American Association for State and Local History was established in order to develop programs and activities to help communities preserve significant historical resources. This association publishes numerous books and technical pamphlets on a vast array of topics, the monthly magazine *History News,* and a *Directory of Historical Societies and Agencies.* For an example of their publications, see Chapter 23.

Business and Technology

Practicing architects need references to aid them (1) in meeting the standards and regulations set by various governmental agencies—federal, state, and local—and (2) in calculating the costs of projects. An online database search, as explained in the previous section on construction and building materials, may be profitable in the former. For the latter, the materials, of which a few samples are annotated in Chapter 23, will be of assistance. These are usually located in the Business and Technology Division of a large library. Such materials as the *Dodge Building Cost Calculator and Valuation Guide, McGraw-Hill's Dodge Manual for Building Construction Pricing and Scheduling,* and *Architectural Graphic Standards,* published by the American Institute of Architects, will help students understand the problems encountered with the business end of architecture, an area beyond the scope of this book.

A Chronology of Monticello: The Virginia Home

Designed and Built by Thomas Jefferson

1735 Tract of land on which Monticello will be built obtained by Peter Jefferson, a land surveyor and County Lieutenant of Albemarle County, Virginia.

1743 On April 13, Thomas Jefferson was born at Shadwell, the family's Virginia tobacco plantation, to Peter Jefferson and Jane Randolph.

1757 Upon Peter Jefferson's death, his son Thomas received the tract of 1,052 3/4 acres of mountainous land on which Monticello will later be built.

1760-62 Jefferson attended College of William and Mary.

1767 After studying law for five years, Jefferson admitted to the Bar. First mention of estate in Jefferson's Garden Book, a chronicle he kept from 1766 to 1824: entry of August 3, "Innoculated common cherry buds at Monticello."

1768 The top of the estate leveled.

1769 First road to estate constructed from Charlottesville, which was about two miles away. The south pavillion of Monticello was begun. Jefferson's first known study of Monticello shows a square wooden house having rectangular rooms and little axial relationship. There are no stairs or chimneys.

1770 By this date Jefferson's library probably already contained Palladio's Four Books of Architecture and James Gibbs' Rules for Drawing the Several Parts of Architecture. Before February, several plans for the house had been designed: a cruciform with wooden walls and loggia and a cruciform plan of brick construction without loggia. Notes on these two drawings indicate they were made before the final position of the house on the mountain was determined. Numerous studies for the auxiliary buildings were made. One shows a single two-story building with stables and chariot room on the lower level and a suite for the owner above. The lack of windows in the rear of the lower level and the presence of a door on that side of the upper story indicates Jefferson's intention to build the stables on the side of the mountain. A drawing marked "Summer" has the earliest general lay out of the mountain top. By autumn a design was completed for the main dwelling, utilizing the general arrangement and form of a Palladio villa. Other drawings indicate that two buildings were intended to form balancing wings on either side of the main house. The rooms were to be connected through open arcades. By September there were drawings of the slave quarters which were planned for the estate. After the family home at Shadwell burned, Jefferson moved to Monticello on November 28.

1771 Small pavilion, in which Jefferson lived, completed.

1826 On July 4th, Jefferson died at Monticello; buried in the family plot on the estate. Monticello, its furnishings and surroundings, were bequeathed to his daughter, Martha Jefferson Randolph. Due to indebtedness, Monticello advertised for sale for $26,000.

1827 In January, the household furnishings sold at public auction. Vandalism lead to the closing of Monticello to visitors.

1829 The last of the Jefferson family moved from Monticello.

1831 House and 552 acres of estate purchased for $7,000 by James T. Barclay of Albemarle County, Virginia.

1834 Monticello sold for $2,500 to Uriah Phillips Levy, a native of Philadelphia.

1836 Levy moved to Monticello.

1862 Levy died in New York City. Monticello seized by the Confederate government.

1863 Levy's heirs broke his will in which he had bequeathed Monticello to the United States government for an agricultural school for orphans of American seamen.

c. 1881 Jefferson Monroe Levy bought out other heirs and began repairing Monticello.

1882 U. S. Congress appropriated $10,000 for a monument to be placed over Jefferson's grave and for the maintenance of the site.

1916 Fiske Kimball published Thomas Jefferson's drawings, which had been collected by Jefferson's great-grandson, Thomas Jefferson Coolidge, who had deposited them with the Massachusetts Historical Society, Boston. Many of the drawings are of Monticello.

1923 On December 1st, the Thomas Jefferson Memorial Foundation, which had been organized on April 13, 1923, purchased Monticello by paying 1/5 of the $500,000 sale price. Restoration program initiated.

1940 Virginia Garden Club provided $10,000 plus skilled supervision for the restoration of some of the gardens.

1954 House structurally renovated at a cost of more than $250,000.

1959 The Thomas Jefferson Memorial Foundation began an annual $5,000 grant to the Alderman Library of the University of Virginia to purchase documents and manuscripts relating to Jefferson and Monticello. The grant made possible the assembling of more than 3/4 of the titles in Jefferson's original library.

1960 Doveton Nichols compiled a definitive checklist of Jefferson's drawings from U.S. collections.

1976 The Eye of Jefferson, an exhibition at the National Gallery, Washington, D. C. focused on Jefferson as an artist and architect.

Example 21: A Chronology of Monticello: The Virginia Home Designed and Built by Thomas Jefferson (the first and last pages).

Additional Research Problems

This chapter was written to answer specific questions that are often asked by researchers. Even if their particular problems are not exactly like the ones answered, readers will still find many helpful hints that might furnish clues which will assist them in solving their own problems. The chapter is divided into five sections, providing specific information for the readers involved in educational research, buying and selling in the marketplace, competing in art exhibitions, and film research.

Art/Museum Education and ERIC Materials

I want to do some research on the kinds of educational programs which education departments of art museums provide for grade-school children. But what has been done, and what needs to be attempted?

To try to find the answers to this educational problem, the reader should review all of the literature on the stated question. A working bibliography, as complete as possible, should be compiled and as many of the books, articles, and research reports, which can be obtained, should be read. For details on compiling a working bibliography, the reseacher is referred to Chapter 4 of this guide. There are some special educational references that will assist the reader interested in the field of art education. These references are detailed in this section.

In order to obtain a general background on the relationship between art museums and education, as well as to discover the recent trends in art education, the reader should consult some of the books annotated in Chapter 23. Most of the articles in these references provide excellent bibliographies which will help readers discover the titles of references that cover their particular problems. For instance, the four-page article by Bartlett H. Hayes, Jr., "Art Museum," published in the *Encyclopedia of Education,* edited by Lee C. Deighton, provides a succinct history of the development of education in art museums plus listing twenty-seven references which the researcher might wish to read. This same encyclopedia also has an arti-

cle, "Museum as an Educational Institution," by Leonard Carmichael that provides additional information on the subject and seven bibliographical references. Elliot W. Eisner's "Research on Teaching the Visual Arts," published in the *Second Handbook of Research on Teaching* that Robert M. W. Travers edited, discusses the problems encountered in art education research, describes some of the more recent studies in the field, and includes twenty-seven references, not one of which is the same as the references in the other two articles. Additional references can be located through such books as *Art Education: A Guide to Information Sources,* this bibliography has a section on museum art education that lists more than forty works.

In order to compile a list of the most current research, the reader will need to examine the references annotated in Chapter 12. One of the most important of these is the ERIC publication, *Resources in Education,* which is abbreviated *RIE.* In 1964 the United States Department of Health, Education, and Welfare created the Educational Resources Information Center, called ERIC, for the purposes of collecting, evaluating, abstracting, indexing, and disseminating educational research results, research-related materials, and other resource information. Abstracts of this vast amount of educational data are published in ERIC's monthly journal *Resources in Education,* which prior to 1975 was entitled *Research in Education.* Copies of this abstracted material are often available, in a paperback or a microfiche form and for a reasonable price, from ERIC Document Reproduction Service, EDRS. Many libraries own the microfiches of much of the material ERIC reports. There are more than 700 full collections of ERIC documents on microfiche, owned and maintained by the staffs of libraries and educational institutions, most of which are in the United States. Many librarians indicate, in their institution's issues of *Resources in Education,* exactly which microfiches their library owns, thus saving the researcher valuable time. If a library does not possess a particular microfiche that is

needed, the reader can usually order the desired material from ERIC Document Reproduction Service for a nominal sum.

Due to the vast amounts of educational-related material and because ERIC's *Resources in Education* did not adequately index all of the educational literature published in periodicals and journals, a second index was initiated. *Current Index to Journals in Education,* which commenced publication in 1969, is a monthly index that covers more than 780 education and educational-related journals. Although the material abstracted in *CIJE, Current Index to Journals in Education,* is not at present available from a central source, researchers can obtain copies of the articles either in their own area libraries which have the journals or through the interlibrary loan service. For details on the latter, the reader is referred to Chapter 25 of this guide. Since *CIJE* uses the same descriptors for subjects as does *RIE,* the ERIC thesaurus can be used for both journals.

Before embarking on a search in these indices, researchers should scrutinize the *Thesaurus of ERIC Descriptors* in order to discover which term or terms would be best suited to help them locate the needed material. The thesaurus lists the words that were used as filing labels by the persons doing the indexing of the reports and articles. Readers can save time in the searching process, if they consult the thesaurus first. As seen in Example 22, the words that cannot be used to trace the material abstracted by ERIC, the nondescriptors, are written in heavy-typed, lowercase letters underneath which there is the word, "USE," followed by the approved descriptor. For instance, instead of "Multiple Correlation," the term "CORRELATION" must be used. Words cited in boldface type with all capital letters are the descriptors used by the ERIC filers for indexing material. Under each of these descriptors are additional descriptors, synonyms and descriptive terms which can also be used to retrieve material. These additional terms help clarify the scope of the descriptor under which they are listed. In order to elucidate the descriptor further, a system of letters has been used: *BT* indicates a broader term; *NT,* a narrower term; and *RT,* a related term. *UF* preceding a word, means that the descriptor which is printed above it is preferred over this word; *UF,* in the thesaurus, means "used for" or "used instead of." If a term has an *SN,* standing for "Scope Notes," beside it, the word is followed by a clarification of that term.

Multiple Correlation
USE CORRELATION

MULTIPLE DISABILITIES *Mar. 1980*
 CIJE: 432 RIE: 408 GC: 220
SN Concomitant impairments, the combination of which causes adjustment and educational problems
UF Multiply Handicapped (1967 1980)
NT Deaf Blind
BT Disabilities
RT Cerebral Palsy
 Exceptional Persons
 Severe Disabilities

Multiple Discriminant Analysis
USE DISCRIMINANT ANALYSIS

 Physical Development
 Physical Education
 Physical Fitness
 Weightlifting

MUSEUMS *Jul. 1966*
 CIJE: 271 RIE: 228 GC: 920
BT Facilities
RT Anthropology
 Arts Centers
 Community Resources
 Cultural Centers
 Educational Facilities
 Exhibits
 History
 Realia
 Recreational Facilities
 Resource Centers
 Science Teaching Centers

MUSIC *Jul. 1966*
 CIJE: 763 RIE: 704 GC: 420

Example 22: *Thesaurus of ERIC Descriptors,* 9th edition, 1982, © by the Oryx Press, 2214 North Central at Encanto, Phoenix, AZ 85004. Selections, page 159.

Thus in Example 22, "MUSEUMS" is the term which is used for retrieval of information. If more material is needed the BT word, "Facilities" can be checked. There are eleven related or RT terms, starting with "Anthropology" and ending with "Science Teaching Centers." To the right of "MUSEUMS" is the date Jul. 1966. The date at which time the term was first used by ERIC indexers is provided for every term added since August 1968. Terms used previous to this time are provided the date of July 1966 when ERIC began. "MUSEUMS" has been used from the beginning, but "MULTIPLE DISABILITIES" was added in March 1980. Below the date are GC numbers. These refer to the Descriptor Group Code to which each word has been assigned; a complete list of these group codes is reported in the thesaurus.

Underneath the indexing terms in Example 22 are the abbreviations *CIJE,* and *RIE* followed by numbers. This represents the number of times that term has appeared in those abstracts up to October 1981. The term, "MUSEUMS" has been used as a descriptor for 271 articles or reports in *CIJE* and 228 times in *RIE*. These numbers are especially important to observe before developing a database strategy. If a term has been used 2,000 times as a descriptor, the researcher should consider a narrower or NT term. If the word has been utilized only three times, a BT or broader term may be needed. Descriptors are added, deleted, and changed. The thesaurus lists the ones which have recently altered their status. But some terms have numbers in parentheses after them; these refer to the period when the word was in use. For example, "MULTIPLE DISABILITIES, UF Multiply Handicapped (1967 1980)" indicates that multiple disabilities is now the correct term. "Multiply Handicapped" was in use from 1967 to 1980. When searching ERIC materials, some references may be listed under terms which are not presently used in ERIC. It is important to read the thesaurus carefully prior to searching the on-line *ERIC Database, RIE,* or *CIJE.*

Both of the above mentioned indices, *Resources in Education* and *Current Index to Journals in Education,* have the same format. Entries begin with an accession number in the upper left corner: *EJ,* which stands for education journal, refers to works abstracted in *CIJE,* while the numerals used for each accession number of *Resources in Education,* begin with *ED,* an indication that the item listed is an educational document. See Example 23.

ED 216 945 SO 013 986
Lehman, Susan Nichols, Ed. Igoe, Kathryn, Ed.
Museum School Partnerships: Plans and Programs. Sourcebook #4.
George Washington Univ., Washington, D.C. Center for Museum Education.
Spons Agency—National Endowment for the Humanities (NFAH), Washington, D.C.; Rockefeller Bros. Fund, New York, N.Y.

Pub Date—81
Note—132p.
Available from—American Association of Museums, 1055 Thomas Jefferson Place, N.W., Washington, DC 20007 ($7.25).
Pub Type— Guides - Non-Classroom (055) — Reports - Descriptive (141)
EDRS Price - MF01/PC06 Plus Postage.
Descriptors—*Cooperative Programs, Elementary Secondary Education, Higher Education, *Museums, Program Descriptions, Program Development, Program Implementation, *School Community Programs, School Community Relationship
This sourcebook has been compiled for educators in museums and schools who are interested in learning of ways in which their colleagues from cultural and educational institutions have worked together. Over 50 programs are described. Emphasis is on the collaborative effort rather than the resulting program. The following questions are answered: Why was the program developed? Did the school or museum initiate the contact? How was the contact made and how is the relationship maintained? With the benefit of hindsight, what changes would the participants make? The program descriptions are organized into seven sections: how to build museum-school bridges, early planning, working with traditional school audiences, considering post-secondary school audiences, reaching teachers, sources of financial support, and some additional information sources. Some examples of program descriptions included follow. A professor of history at a Pennsylvania community college learned about museums as learning resources. He then approached the nearby art museum for assistance in development of his own and his students' skills in the use of artifacts. A second example is that of a group of California museums that collaborated to provide interdisciplinary programs to area schools. Then there are instances in Ohio, Kentucky, and Kansas in which public schools initiated their own museums. (RM)

Example 23: *Resources in Education,* ERIC, Educational Resources Information Center, Washington, D.C.: U.S. Government Printing Office, 1982, Volume 17, Number 10 (October 1982) page 140.

The numbers in the upper right corner of each entry are another set of accession numbers, which are provided by one of the sixteen clearinghouses that are responsible for preparing the citations. Since each clearinghouse covers research in a different field of education, the two letters, which are

at the beginning of each accession number and which indicate the particular clearinghouse, relate the focus or specific field of education to which the article belongs. For instance, *PS* stands for "Elementary and Early Childhood Education"; *SO* equals "Social Studies/Social Science Education"; and *TM* indicates "Tests, Measurement, and Evaluation." For a complete listing of the meanings of these sixteen letter combinations, the reader is referred to each issue of *Resources in Education* and of *Current Index to Journals in Education.* In both *RIE* and *CIJE,* all of the entries with the same focus, as indicated by the two clearinghouse accession letters, are listed together. This enables researchers to browse through all of the related articles published in each issue of the indices.

Immediately below the two accession numbers are the authors' full names followed by the title of the research report or article. Recorded next are the name of the journal or magazine and the publication date, if these are applicable, plus other important information, such as the number of pages and the time and place a paper was presented. Descriptors, which characterize the substantive contents of the material, are then cited, followed by the abstract of the report or article and the annotator's initials in parentheses.

Each entry has up to six major descriptors, indicated by an asterisk which precedes the term, plus several other minor descriptors. These descriptors, it must be borne in mind, are the terms used by persons doing the indexing of ERIC materials. Only the major descriptors are used to list the article in *Resources in Education* or *Current Index to Journals in Education.* These major descriptors are usually sufficient for the retrieval of pertinent material. Nevertheless, the minor descriptors are used in some of the ERIC-related literature, such as *Educational Documents Index 1966–1969,* and in online database searches for retrieval of more inclusive data.

In checking the above stated problem in ERIC's thesaurus, which is illustrated in Example 22, the reader would find a number of descriptors that could be used to locate material on educational programs, which the personnel of art museums have conducted for grade-school children. These descriptors include "Educational Facilities," "Art Centers," "Resource Centers," and "Museums." If readers scrutinized all of the issues, both past and present, of *Resources in Education* and *Current Index to Journals in Education,* they would find listings for numerous reports and articles that relate to the posed problem. One of the entries under the descriptor, "Museums," listed in a semiannual index of *RIE,* has a reference to *Museum School Partnerships: Plans and Programs, Sourcebook #4.* This entry, illustrated in Example 23, relates that the research, was sponsored by the National Endowment for the Humanities and the Rockefeller Brothers Fund. Edited by Susan Nichols Lehman and Kathryn Igoe, the sourcebook of 132 pages was published in 1981 and is available from the American Association of Museums as well as through the EDRS—ERIC Document Reproduction Service—on microfiche, MF, or paper copy, PC. Only three major descriptors—Cooperative Programs, Museums, and School Community Programs—were assigned. There are six minor descriptors, two of which refer to the educational or grade level of the population discussed within the sourcebook. These leveling descriptors have been added to every document reported in *RIE* since August 1980 and in *CIJE* since September 1980. An explanation of the exact meaning of each of these leveling descriptors is recorded in issues of *RIE* and *CIJE.* In this example, Elementary Secondary Education means formal education from kindergarten or grade 1 through grade 12. The leveling descriptors can be used to limit an online database search, a process detailed in Chapter 4.

The descriptors, which are cited, provide additional information as to what kind of article is being abstracted, as well as some alternate terms that could be checked for additional material. It should be remembered that only the major descriptors, each marked with a preceding asterisk, were used in filing that particular abstract in the subject index of *RIE,* but both types of descriptors can be used in computer searches. In the search of the *ERIC Database*—used as an example in Chapter 4—the terms student?/de and museum?/de were combined. The /de indicated descriptor, and in that search there were fifty-seven documents in *RIE* and *CIJE* that had this combination of both major and minor descriptors. When the limiting /MAJ, meaning major descriptors, was used for each term, this curtailed the number to fifteen. In that search, it is interesting to note, that there were 102,740 references to student?/de and 591 to museum?/de. With such astronomical numbers, it is understandable why so

many art educators utilize the *ERIC Database* where two or more subjects or ideas can be combined to save hours of research.

In addition, the entries in the ERIC reference tools provide the publication type and, sometimes, identifiers. The Pub Type, for publication type, has up to three terms and numbers that refer to the thirty-four ERIC classifications. In the example, Guides-Non-Classroom (055) and Reports-Descriptions (141) were assigned. These numbers can be used in online database searches when a specific type of publication is required. Identifiers, of which Example 23 has none, are key words that are either proper names or concepts not yet represented as an approved descriptor. The identifiers might cite specific countries which the report discusses, if the document were on Eastern Europe, for instance. These, too, can be used for database searches. The detailed controlled vocabulary for which the administrators of ERIC strive makes computer research faster and cheaper.

Over and beyond the important references that have just been described in detail, researchers have numerous indices of educational literature and indices of art periodicals to assist them in finding pertinent material. All of these indices are annotated in Chapter 12 of this guide. Such references as *Education Index,* which is an author-subject index covering approximately 220 periodicals, and *British Education Index,* which provides coverage of English educational institutions, may supply the reader with the titles of articles containing essential data.

In order to gain information on various kinds of research, the reader should examine some of the works annotated in Chapter 22 under "Research Guides." For instance, *Research in Education,* written by John W. Best, has separate chapters that cover historical, descriptive, and experimental research. Each chapter defines and discusses the merits and liabilities of each kind of research, lists variations of these types, and relates specific case studies for illustrative purposes.

As to the last part of the question—what has been done and what needs to be attempted?—the researcher should read the periodical literature, such as *Studies in Art Education, Museum Studies Journal, Museum News, Review of Research in Visual Arts Education,* and *Art Education.* For assistance in learning about the importance of art in the life of children, examine some of the works annotated in Chapter 23, especially *Art, Culture,*

and Environment: A Catalyst for Teaching, by June King McFee and Rogena M. Degge, 1977. For understanding the stages at which children create certain types of art, study *Creative and Mental Growth,* by Viktor Lowenfeld and W. Lambert Brittain, 1970.

Marketing Problems

Entering the marketplace can be a bewildering experience for anyone—buyer, seller, or exhibitor. Consequently, everyone who enters this business arena should be armed with some knowledge of the legal ramifications that might be encountered. Several books that will assist the reader to understand some of these legal problems are (1) *The Artist's Guide to His Market* by Betty Chamberlain, (2) *Art Works: Law, Policy, Practice* by Franklin Feldman and Stephen E. Weil, and (3) *What Every Artist and Collector Should Know About the Law* by Scott Hodes. All of these works, which are annotated in Chapter 24, detail the problems of copyright; several include sections on tax laws, business contracts, and the pricing of works of art.

Since each book covers material not included in the other works, it is important for readers to study the annotations of the references cited in Chapter 24 to ascertain just which works may be essential to particular problems. Since the people who buy, and sell, in the marketplace encounter very diverse problems, the reference works they need to peruse differ. For this reason the rest of this section is subdivided so as to offer special assistance to the would-be buyer and seller.

Buying in the Art Market

Is this silver Victorian meat dish worth the money? Or would I do better to bid on the Old Sheffield Plate platter at the estate sale?

In the art market, just like any other commercial situation, the buyer must beware. The best way to make wise art purchases is either to know a great deal about what is being bought or to obtain the advice of an art expert. Since the art of connoisseurship demands years of study, an expert opinion is usually worth the price charged. Such an opinion can be sought from a reputable art dealer or a person who is an appraiser. For an informative article on the subject, read Lee Rosenbaum's two-part article, "Appraising Appraisers," *ARTnews* 82(November and December 1983).

A professional group which provides certification for its members, the American Society of Appraisers was organized in 1936 and incorporated in 1952. To be certified, the participant must have a college degree or the equivalent, be an active member of the appraisal profession for a minimum of two years, and pass an intensive written and oral examination in a field of specialization. Certification is for individuals only, not for firms or companies. There are three groups: Associates, Members, and Senior Members. Associates have not yet passed the certification examination. The affiliation of members is signified by "Member, American Society of Appraisers." Senior Members, who must have five years appraisal experience, may use the designation "ASA" after their names. Recertification on a regular five-year basis is required for Senior Members. In the certification process, the candidates are evaluated as to technical proficiency and as to their understanding of the fundamentals of appraisal ethics, principles, and concepts. In addition, copies of some of their appraisal reports are reviewed to ensure that they meet the society's professional criteria.

The American Society of Appraisers has more than 5,000 world-wide members in eight categories, some of which have specific specialties for which members are certified. The Personal Property classification includes Fine Arts, Gems and Jewelry, Residential Contents, Orientalia, Pre-Columbian Art, Silver and Metalware, and Oriental Rugs. There are numerous publications issued by the society, such as (1) *Professional Appraisal Services Directory,* an annual listing of the members and their specialties; (2) *Appraisal and Valuation of Manuals,* a series of eight volumes; (3) *Appraisal Principles and Procedures,* by Henry A. Babcock, 1968; and (4) *Valuation,* the official journal of the society. The journal provides pertinent articles on appraisals. For instance, in the November 1982 issue, there were essays on "Understanding New York States New Print Law," by Elin Lake Ewald; "Unburied Treasures: The Developing Market for Antique American Textiles," by Grace Rogers Cooper; and "Art Appraisals and Tax Consequences: How to Protect the Taxpayer's Charitable Deduction," by Michael R. Sonnenreich and William H. Kenety. For additional information read Emyl Jenkins' "The Artful Profession" in the same issue of *Valuation* or write the American Society of Appraisers, P.O. Box 17265, Washington, D.C. 20041.

For those readers who wish to consult some books that would enable them to communicate better with connoisseurs, Chapters 13 and 18 give some suggested readings. Listed in that chapter are some references that will assist researchers in distinguishing quality works of art, in learning the differences between various media, in identifying some of the ways to discover fakes, and in analyzing works of art, both historically and structurally.

Knowledge of the art market is essential to would-be purchasers—whether they are individual art collectors or museum directors or curators. Some books that describe the art market and how it functions are annotated in Chapter 24 under "Marketing Aids." These references are especially important for anyone who is just beginning to buy and collect art, because they relate many important practices of which the buyer should be aware. For instance, in *How to Make Money in the Art Market* Richard Blodgett discusses the problems of authenticating and appraising works of art; the flagrant abuses of making *surmoulages,* the casting of new bronzes from existing ones; how promotional campaigns are launched to inflate the prices of artists' works; and the practice of owners assigning reserve prices to their objects before the pieces are relegated to auction sales.

The importance of the legal references which were mentioned previously must be reiterated. In the Feldman-Weil book, *Art Works: Law, Policy, Practice,* the many chapters relating to the collector of fine arts may not always pertain to the immediate problems of the beginning collector, but the information is important for a general understanding of how the art marketplace functions. Of special interest are the sections on "Purchase and Sale of Works of Art" and "Expert Opinions and Fake Art."

No buyer wants to purchase a fake, but some mistakenly do. Studying a few books that cover the subject of how to distinguish an authentic work of art from a counterfeit one will not make the reader an instant expert, but the books will be informative and interesting. For instance, Otto Kurz's *Fakes* includes all kinds of historical forgeries: archeological materials, paintings, prints, ceramics, furniture, tapestries, glass, and metal work. Many of the books, such as Kurz's, are anecdotal: a few, such as Stuart Fleming's *Authenticity of Art: The Scientific Detection of Forgery,* examine the subject from a more scientific point

of view. Books dealing with fakes and forgeries are recorded in Chapter 18.

There is no way of obtaining an accurate measure of the monetary value of a work of art until it is sold. An object is worth only what someone is willing to pay for it. Nevertheless, the would-be buyer can become aware of the price for which various items sold during any past year by studying the different sales catalogues that some auction houses issue. In order to keep informed of forthcoming sales the researcher should either subscribe, for a modest sum, to the newsletters that several of the large auction houses publish or scrutinize the advertisements that are regularly placed by the major auction house in certain periodicals, such as *Connoisseur, Apollo,* and *Burlington.* For a listing of the publications in which the various auction houses regularly advertise, consult *International Art & Antiques Yearbook.*

Another group of important references that the would-be buyer should peruse are the indices of current auction sales, which are annotated in Chapter 16. A compilation of information on the sales of works of art from a number of auction houses for a particular year, these indices of current auction sales provide important data on the fluctuations of the art market. Some include only sales of drawings and paintings, while others are more inclusive in their coverage. In order to observe any market fluctuations for a specific artist's *œuvre,* the reader should study each issue of these indices over a period of years. For an illustration of the kinds of data provided by one of these indices, the researcher should study Example 15 and read Chapters 3 and 4.

In order to better understand the current art market and to make good value judgments on art objects which are being sold, the would-be purchaser should study some of the books annotated in Chapter 16. For instance, Geraldine Keen's *The Sale of Works of Art: A Study Based on the Times-Sotheby Index* and Gerald Reitlinger's three volumes, *The Economics of Taste,* will provide a better understanding of market fluctuations and trends in art prices. Richard H. Rush's three books—*Art As an Investment, Antiques As an Investment,* and *Investments You Can Live With and Enjoy*—detail the structure of art and antique markets, give advice on building a collection and on judging the value of antiques, plus cover the problem of fakes.

The last section of Chapter 16 "Indices of Sales Catalogues Owned by Art Libraries," cites works which have indexed sales catalogues owned by various libraries. These references will not assist the researcher in pinpointing the date and price for which a particular work of art sold. But if either the name of the collector or the name of the auction house, accompanied by the approximate date of the sale, is known, these references may help the reader in determining whether or not a sales catalogue was compiled and in discovering the location of an existing catalogue.

Over and beyond studying the market place, art collectors should learn as much as possible about the items already in their collections. Like the registrars of museums, individual art collectors should preserve all information that is pertinent to the items in their collections in order to have documentation of the pieces for insurance and tax purposes as well as to obtain a better understanding and discernment of the individual works of art in their collections. Thus these collectors sharpen their senses and business acumen so that they will make wise future purchases. In an individual folder for each work of art the following items should be saved: (1) all documents supplied by the dealer at the time of purchase or by the donor at the time the gift was given, such as the bill of sale and any papers which certify as to the authenticity of the object; (2) copies of any newspaper clippings or articles on the work of art; (3) a notation of all verbal and recorded statements concerning the piece by the artist, the previous owners, and experts in the same field of art as the object; (4) copies of any exhibition catalogues in which the work figured; (5) a good color photograph of the work; and (6) a catalogue entry for the art object. For detailed information on how to write a catalogue entry, the reader is referred to Chapter 6.

As to the problem, as stated at the beginning of this section, of whether or not it is better to buy a Victorian meat dish or an Old Sheffield Plate platter, only the would-be buyer can decide. Hopefully, it will be a wise, studied decision.

Selling in the Art Market

Where can I market my work? What books will help me sell what I have created?

The problem of selling a work of art or a manuscript written on an art subject depends, to a great

extent, on the economic laws of supply and demand. There are, nevertheless, a few references that will assist artists and writers to learn more about some of the dos and don'ts of selling.

Artists should learn as much as possible about the marketplace prior to entering it. Three of the books, suggested at the beginning of this section and annotated in Chapter 24, will be especially helpful. Betty Chamberlain's *The Artist's Guide to His Market* is a book that details such essential subjects as shopping for a gallery, showing works to dealers, cooperative galleries, publicity, artist groups and organizations, pricing and selling, business terms and agreements, and taxes and self-employed artists. Also included are a few sample forms, such as those for a contract, a bill of sale, and a receipt.

The hefty volume by Franklin Feldman and Stephen E. Weil, *Art Works: Law, Policy, Practice,* has over 1,200 pages covering numerous important subjects; especially important are those sections detailing commissioned works, the relationship between an artist and a dealer, tax problems of the artist, and obscenity. The Feldman-Weil book also reproduces sample forms which are important to the sale of art works.

What Every Artist and Collector Should Know About the Law by Scott Hodes discusses such items as creating and selling works of art, copyright, the subject matter of art works, plus the artist and taxes. Sample forms are also reproduced. Both the Hodes and the Feldman-Weil books have important sections on the pros and cons of *droit de suite,* the art-proceeds-right law that some European countries have enacted and that many American artists would like to see made a law in the United States. This is a copyright law which entitles artists to share in any monetary profits every time their works of art are resold; the law is in force in some countries during the life of the artist plus fifty years.

Finding a potential place to market one's work is a fundamental problem for an artist. Some references that will assist in solving this problem are *Artist's Market; National Directory of Shops/ Galleries, Shows/Fairs;* and *Photographer's Market.* Published annually, the entries cite addresses and kinds of material in which the dealers are interested. All of these books are annotated in Chapter 24.

Since the importance of artists obtaining recognition through the exhibition of their works is generally acknowledged, the next section of this chapter, "Locating Competitive Exhibitions," relates some ways to discover competitive exhibitions and some books that will assist would-be exhibitors in packing and sending their works of art. The would-be seller should read that section as well.

For the would-be writer, the best reference is *Writer's Market,* an annual publication that includes notes on free-lancing, on how to use photography to supplement one's writing, and on contracts and royalties. Most of the *Writer's Market* is composed of annotated lists of publishing firms divided as to the subjects covered by their publications. Each entry provides the address of the publishing firm, the names of various editors, and pertinent information concerning manuscript requirements. Another book that will assist the reader in locating names and addresses of publishers is *Literary Market Place;* both books are annotated in Chapter 22.

For details on how to type a manuscript, the reader should consult *The Chicago Manual of Style for Authors, Editors, and Copywriters* and the current edition of *Writer's Market.* The manuscript should always be sent with a self-addressed envelope to which sufficient postage for remailing has been attached, in order that the manuscript might be returned if it is rejected. The added precaution of mailing the manuscript with a return receipt requested allows the writer to know if the manuscript arrived. The staffs of some magazines publish their editorial requirements for manuscript form within the magazines themselves. For instance, *Art Bulletin* provides this information under "Notes for Contributors" in the December issue. Some publishing firms, such as the National Geographic Society, have guides to assist the would-be seller. Usually the guides can be obtained by writing the individual company, if the work is not available in the library.

Locating Competitive Exhibitions

What resources are available for helping me find competitive exhibitions for my work?

In order to discover competitive exhibitions which they might like to enter, would-be exhibitors should consult (1) the bulletin boards of the local art schools, (2) the books that describe the art marketplace, and (3) publications that include forthcoming exhibition notices. Many local exhibitions, as well as some national ones, send notices of the rules and regulations of future shows to the

art departments of universities and to art institutes. The notices are often placed on bulletin boards where everyone can read them. Would-be exhibitors should consult these notifications frequently. Before submitting works of art to a competitive exhibition, the artist should read, besides the legal books mentioned at the beginning of this section, the many valuable suggestions offered in the books referred to in Chapter 24.

Few books or magazines include extensive information on competitive exhibitions on a regular basis. All too often, by the time the would-be exhibitor obtains a copy of the book or periodical and reads it, there is not enough time to enter the show. In addition, the emphasis and extent of the coverage on competitive exhibitions in magazines change, not only annually, but monthly. Therefore, the only way the reader can discover pertinent data on these competitions is to read numerous art periodicals on a regular basis. Most up-to-date information about a competitive exhibition has to be obtained by writing the sponsor for the current rules and for the dates of the forthcoming show. The would-be exhibitor needs to write well in advance of the time when the exhibition is usually held, since the process of filling out entry forms and shipping works of art takes time.

Some periodicals have a section where competitive exhibition information is cited, such as *American Artist* in "Bulletin Boards" and *American Craft* in "Where to Show." *Ocular: The Directory of Information and Opportunities for the Visual Arts*—the quarterly publication of Ocular Publishing of Denver, Colorado—includes data on international, national, and regional competitive exhibitions. Each entry includes the nature of the prize, eligibility requirements, any fees, the exhibition dates, the deadline which must be met, and the name of a person who can be contacted in order to obtain additional information. Other good sources are *Art New England: A Visual Resource for the Visual Arts* and for photography, *Afterimage*.

Some newspapers also include data on competitive exhibitions. *Artweek* includes a page in each issue devoted to listing competitive exhibitions. Each entry relates the name of the exhibition and gives details as to who is eligible to enter, what media are acceptable, the amount of the awards, whether or not there is a jury, the entrance fee, the number of entries allowed per artist, the dead-

line for the show, and a contact who can be written for even more details about the event.

Another basic problem for exhibiting artists is that of preparing their creative work to be sent to galleries, museums, or exhibitions. This entails discovering the best means of packing, mailing, and insuring what the would-be seller has produced. The UNESCO publication, *Temporary and Traveling Exhibitions,* has important chapters on principles of packing, transportation, and insurance; its appendix reproduces a sample insurance policy for fine arts coverage. Other important references for packing and shipping works of art are annotated in Chapter 24.

Film Research

How to Discover the Influence of Art Styles on Films

Just what was the German expressionist style in movies? What specific films exemplify this style?

Two references that will assist the reader in obtaining the definition of a term or a style in films are *The Oxford Companion to Film* edited by Liz-Anne Bawden and *Film Study: A Resource Guide* by Frank Manchel. These books are annotated in Chapter 23.

The entry on expressionism in *The Oxford Companion to Film* relates that this movement, which flourished in Germany from 1903 to 1933 in the graphic arts, literature, drama, and film, stressed the external representation of man's inner world. This lengthy article lists a number of films associated with expressionism plus one literary reference, Lotte Eisner's *The Haunted Screen.*

A very important reference for any in-depth film research is Manchel's *Film Study: A Resource Guide.* In the index to subjects of Manchel's book, under expressionism, is a reference to "The Great German Silents (1919–1925)." This section relates that during the period after World War I, the Germans developed three types of films: historical, expressionistic, and melodramatic. An annotated list of six books and eight films that can be used in studying these phases of the German cinema is included.

In order to obtain knowledge of expressionism in the German cinema from 1919 to 1925, the researcher should read some of the books and articles mentioned in the previously discussed references. Additional reading material, some of which may be more up to date, can be discovered

by referring to the film indices recorded in Chapter 12. Scrutinizing the indices of current film articles, such as *Film Literature Index,* which covers 200 international periodicals, will provide readers with titles of the most current articles on film. In consulting the indices of film literature the reader should keep in mind that entries are often not cross referenced. Consequently, both the style to be researched and the specific moving pictures reflecting this style should be checked for pertinent material on the subject. In view of the fact that the indices of film literature index articles from diversified sources, all of the various editions of each of these indices should be consulted. Because the indexing of film material is relatively new, the researcher should also study the books that have indexed film articles and books retrospectively. These bibliographies of film literature are annotated in Chapter 23.

How to Find Information on Movie Directors and Film Reviews

How many film versions have there been of Tolstoy's *War and Peace* since World War II? Who were the directors and what other films have they made? Did their adaptations of *War and Peace* receive good reviews?

There are a number of reference works that will assist the reader to solve this film problem; some are annotated in Chapter 23 under "Film Resources." Each will offer a little different slant or some diverse material; therefore, as many of the books as the reader can locate should be consulted.

The Oxford Companion to Film, edited by Liz-Anne Bawden, is an excellent reference with which to begin to answer this film problem. Under the heading "WAR AND PEACE" a cross reference is given to "VOINA I MIR," which is the Russian title for the famous novel by Leo Tolstoy. The entry under "VOINA I MIR" discusses the 1966–67 Russian movie directed by Sergei Bondarchuk; the two 1915 Russian versions, one directed by Vladimir Gardin, the other by Pyotr Chardynin; and the 1956 American film directed by King Vidor. *The Oxford Companion to Film* includes separate entries on the directors Bondarchuk, Gardin, and Vidor. These brief biographical sketches record the titles and release dates of some of the films each person directed. Original titles are provided; English translations of the foreign-language film titles are added in parentheses.

Additional biographical information on the two directors—King Vidor and Sergei Bondarchuk—is easily located in the volumes cited in Chapter 23, but as would be expected, there are more articles on the American filmmaker than on the Russian Bondarchuk. Especially good coverage was found in *Dictionary of Film Makers* by Georges Sadoul, *Dictionnaire du cinéma et de la télévision* by Maurice Bessy and Jean-Louis Chardans, *The Oxford Companion to Film* edited by Liz-Anne Bawden, and *Filmlexicon degli autori e delle opere* edited by Michele Lacalamita. All of these references recorded titles to other films directed by Vidor and Bondarchuk.

Magazine articles, which usually provide more current data, will be found listed in the various film indices, which are annotated in Chapter 10. One of the first references the researcher should scrutinize is Mel Schuster's *Motion Picture Directors,* which covers 340 periodicals and lists over 2,300 directors, filmmakers, and animators. Schuster's book includes over fifty entries for Vidor and five for Bondarchuk. If this particular reference is not available, the researcher will probably find numerous references in the other film indices, inasmuch as biographical material on well-known movie directors is usually easy to find. The researcher, who is compiling an extensive list of references on a person involved in the moving picture world, should examine all of the various indices listed in Chapter 12, since the same periodicals are not indexed by the different indices. Since the articles and books may have appeared in any given year of the period, all of the issues published since the film was released should also be checked.

To ascertain whether or not *War and Peace* was well received, the researcher should read some of the film reviews for the two versions of *War and Peace.* There have probably been hundreds, if not thousands, of reviews of these two films. In Chapter 21, under "Film Reviews," are some books that will help the reader find reviews of these two adaptations of Tolstoy's novel. *The New York Times Film Reviews* is a source that actually provides reprints of the reviews, while Stanley Hockman's *American Film Directors* is a work that gives quotations from critical reviews. The other indices provide information on periodicals which have published reviews of various films. For additional information on film reviews, the researcher should read the introduction to Chapter 21.

PART III

Art Research Resources

The annotated bibliographical references provided in this section are organized according to how the material might be used. English-language books are emphasized, although a number of important foreign reference tools are cited. This is only a sampling of some of the material needed for research, it does not aim at completeness. To increase the usefulness of this section, investigators should place in the margins of this book (1) other resources which they find pertinent and (2) the call numbers assigned by the library which is frequented. Various research methodologies which relate how the material in this section might be utilized are discussed in Part II.

Art Encyclopedias and Dictionaries

All research projects should begin with the investigator scrutinizing the art encyclopedias and dictionaries in order to obtain a comprehensive definition or an overall view of the subject. However, these references provide only general knowledge on a subject, for it takes many years before new research is published in such extensive compilations. Moreover, reading the entry on a research topic in an art encyclopedia or dictionary is only the beginning step in any research problem. To read more than a couple of these references is usually repetitious. Details on how to compile a working bibliography for an in-depth research project are described in Chapter 4 of this guide.

Since the terms *encyclopedia, dictionary, directory,* and *guide* have no exact meaning as to the material they include, the books in this chapter have been clarified as to the contents by being divided into two principal sections: "Art Encyclopedias" and "Art Dictionaries." The latter has been subdivided for easier reference into eight categories: (1) general art (2) archaeology and classical antiquities, (3) architecture, (4) construction and decorative materials, (5) decorative arts, (6) fashion and jewelry, (7) graphic arts, and (8) photography. The listings for encyclopedias and dictionaries for some specialties—such as historic architecture, education, and films—are listed in Chapter 23.

The art encyclopedias are defined as multivolume references that include not only brief biographies of artists but also articles on various phases of art, thus providing the general historical background that is essential to research. The three English-language art encyclopedias fitting this description contain signed articles and bibliographical data; all are illustrated.

Art dictionaries usually include brief information on terminology, on styles of art, and sometimes on the lives of artists. By carefully studying the annotations for the books cited in this chapter, readers can discern which dictionaries would best suit their needs. To assist researchers in finding pertinent references, works that contain mainly biographical material have been listed in Chapter 10, "Biographical Dictionaries." For instance, most of the biographical information on architects is found in separate reference works rather than in the dictionaries of architectural terms which are annotated in this chapter. Consequently, the biographical dictionaries that cover architects are recorded in Chapter 10. Biographies of designers and craftsmen, however, usually are included in the decorative arts dictionaries cited in this section as well as the biographical dictionaries of Chapter 10. The reader should examine the material in both chapters. For a discussion on the kinds of information provided by the references listed in this chapter, the researcher should consult the section in Chapter 4.

Art Encyclopedias

Encyclopedia of World Art. New York: McGraw-Hill Book Company, Inc., 1958. 15 volumes.
Supplement: Volume XVI: World Art in Our Time, edited by Bernard S. Myers, 1983.

Includes biographies of artists, essays on styles, and descriptions of archaeological and topographical sites. The signed articles are by experts in the field; the bibliographies are extensive. Half of each volume is composed of illustrations, many in color. It is important for readers to use the general index, which comprises Volume 15, in order to find all of the material on the research topic. This is an especially good source for obtaining an overview of a subject, such as themes depicted in art and art styles. The supplement has a description of research in 18 general historical periods, such as Egypt, Islam, and Northern Baroque. Each section has a lengthy bibliography.

McGraw-Hill Dictionary of Art, edited by Bernard S. and Shirley D. Myers. New York: McGraw-Hill Book Company, 1969. 5 volumes.

There are over 15,000 entries covering art of all periods; has extensive articles on art of the Far East, the Near East, and primitive art. Many of the articles are signed; lists bibliographical references. Includes large categories of art, brief biographies of artists, definitions of styles and terminology, plus descriptions of archeological and topographical sites. Numerous illustrations, some in color.

Praeger Encyclopedia of Art. New York: Praeger Publishers, Inc., 1971. 5 volumes.

> There are nearly 4,000 entries and more than 5,000 illustrations (1,700 in color) integrated with the text; includes 3,000 brief biographies of artists. Based upon the 1967 French publication *Dictionnaire universel de l'art et des artistes*, it has signed articles and bibliographical data. Fifth volume contains the general index.

Art Dictionaries

General Art Dictionaries

Adeline, Jules. *The Adeline Art Dictionary: Including Terms in Architecture, Heraldry, and Archaeology*. Supplement of new terms by Hugo G. Beigel. New York: Frederick Ungar Publishing Company, Inc., 1966.

> Dictionary of terms based on *Lexique des termes d'art*, whose first English translation was in 1891.

Avery, Catherine B., editor. *The New Century Italian Renaissance Encyclopedia*. New York: Appleton-Century-Crofts, Inc., 1972.

> Covers people involved in the art, religion, and politics of the period; includes pronunciations.

Bridgeman, Harriet and Drury, Elizabeth. *The Encyclopedia of Victoriana*. New York: Macmillan Publishing Company, Inc., 1975.

> Divided into the following chapters, each having its own glossary and bibliography: furniture, photographs, clocks, pottery, porcelain, glass, sculpture, metalwork, arms and militaria, jewelry, dress, textiles, wallpaper, and juvenilia. Well illustrated.

Grabois, Aryeh. *The Illustrated Encyclopedia of Medieval Civilization*. London: Octopus Books, Ltd., 1980.

> Dictionary to terms, artists, historic persons, and concepts. Includes a few maps and a chronological table of events.

Hill, Ann, general editor. *A Visual Dictionary of Art*. Greenwich, Connecticut: New York Graphic Society, Ltd., 1974.

> More than 4,500 entries, primarily on painting and sculpture. Numerous illustrations, many in color. Contains signed introductory articles on subjects and movements in art.

Lemke, Antje and Fleiss, Ruth. *Museum Companion: A Dictionary of Art Terms and Subjects*. New York: Hippocrene Books, Inc., 1974.

> Includes media, styles, subjects, plus Christian and mythological characters.

Mayer, Ralph. *The Artist's Handbook of Materials and Techniques*. 4th ed. revised. New York: Viking Press, 1982.

> Defines pigments, kinds of paintings, and various chemical components.

————. *A Dictionary of Art Terms and Techniques*. New York: Thomas Y. Crowell Company, 1969.

> Explains technical art terms, techniques, and styles.

Medley, Margaret. *A Handbook of Chinese Art for Collectors and Students*. New York: Horizon Press Publishers, 1964.

> Dictionary of terms and iconographical motifs; divided into chapters on bronzes, Buddhism, ceramics, decoration, gems, and painting. Written for the general reader with no knowledge of the Chinese language; illustrated by line drawings. Includes notes on pronunciation, a selected bibliography, and a list of English and American museums and galleries having good Chinese art collections. Each chapter has a separate bibliography.

Mollett, John William. *An Illustrated Dictionary of Art and Archaeology, Including Terms Used in Architecture, Jewelry, Heraldry, Costume, Music, Ornament, Weaving, Furniture, Pottery, Ecclesiastical Ritual*. New York: American Archives of World Art, Inc., 1966.

> Reprint of the 1883 London edition of *Illustrated Dictionary of Words Used in Art and Archaeology;* illustrated by drawings.

Murray, Peter and Murray, Linda. *Dictionary of Art and Artists*. New York: Frederick A. Praeger, Inc., 1966.

> Definitions of terminology, styles, and techniques; provides brief biographies of over 1,000 artists living from 1300 to the present day. Includes a classified bibliography and an alphabetical one. Well illustrated.

Osborne, Harold, editor. *The Oxford Companion to Art*. Oxford: Clarendon Press, 1970.

> Dictionary of terms, styles, biographies of artists, individual monuments, and famous museums. Numbers at the end of the entries correspond to the references in the bibliography. Although the book is written by more than 100 experts, the articles are not signed.

Quick, John. *Artists' and Illustrators' Encyclopedia*. New York: McGraw-Hill Book Company, 1969.

> Illustrated dictionary of terminology.

Rachum, Ilan. *The Renaissance: An Illustrated Encyclopedia*. New York: Mayflower Books, Inc., 1979.

> Dictionary to terms, artists, historic persons, and concepts. Includes a few maps, tables of political rulers, and a brief bibliography.

Read, Herbert, consulting editor. *Encyclopaedia of the Arts*. New York: Meredith Press, 1966.

> Includes all arts: fine and applied arts, theater, cinema, photography, music, opera, and ballet. Has entries on artists, historic sites, styles, and terminology; no bibliographical data. There are numerous black-and-white illustrations.

Runes, Dagobert David and Schrickel, Harry G., editors. *Encyclopedia of the Arts.* London: P. Owne, 1965.

Signed articles covering terminology and styles of all the arts. Some bibliographical references.

Savage, George. *The Art and Antique Restorers' Handbook: A Dictionary of Materials and Processes Used in the Restoration and Preservation of All Kinds of Works of Art.* Revised ed. New York: Frederick A. Praeger, Inc., 1967.

Dictionary of technical terms.

Stevenson, George A. *Graphic Arts Encyclopedia.* New York: McGraw-Hill Book Company, 1968.

Well-illustrated dictionary of terms; contains a brief general bibliography, lists of associations and trade journals, a product index, a manufacturers' index, and tables of comparable sizes and weights.

Stoutenburgh, John Leeds, Jr. *Dictionary of Arts and Crafts.* New York: Philosophical Library, 1956.

Covers terminology; no illustrations or bibliography.

Verhelst, Wilbert. *Sculpture: Tools, Materials, and Techniques.* Englewood Cliffs, New Jersey: Prentice-Hall, Inc., 1973.

Well-illustrated dictionary which explains terminology, kinds of tools, and sculptural processes. Has a bibliography and an annotated list of suppliers and manufacturers.

Walker, John Albert. *Glossary of Art, Architecture, and Design Since 1945: Terms and Labels Describing Movements, Styles, and Groups Derived from the Vocabulary of Artists and Critics.* 2nd ed. revised. London: Clive Bingley, Ltd., 1977.

Includes over 375 entries on styles and art movements; provides some bibliographical data.

Archaeology and Classical Antiquities Dictionaries

Avery, Catherine B., editor. *New Century Classical Handbook.* New York: Appleton-Century-Crofts, Inc., 1962.

Covers people involved in the art, mythology, and politics of the period; includes pronunciations of names.

Bray, Warwick and Trump, David. *A Dictionary of Archaeology.* London: Allen Lane, 1970.

Well illustrated; includes a series of maps.

Daniel, Glyn, consulting editor. *An Illustrated Encyclopedia of Archaeology.* New York: Thomas Y. Crowell Company, Inc., 1977.

Although articles are not signed, there were 21 contributors; has 1,000 entries of terms, people, and concepts.

Devambez, Pierre, chief editor. *Praeger Encyclopedia of Ancient Greek Civilization.* New York: Frederick A. Praeger, 1967.

Well illustrated; includes signed articles on Greek artists as well as explanations of terms, sites, mythology, and historical persons.

Hammond, N. G. L. and Scullard, H. H., editors. *The Oxford Classical Dictionary.* 2nd edition. Oxford: Clarendon Press, 1970.

Signed articles that contain bibliographies. Subjects covered include biographies, monuments, and sites from classical Greece to the death of Constantine in 337 A.D. Includes and index to names.

Hansford, S. Howard. *A Glossary of Chinese Art and Archaeology.* London: The China Society, 1954; reprint ed., New York: Beekman Press, Inc., 1972.

Dictionary of Chinese terminology for metals, gems, sculptures, paintings, ceramics, and miscellaneous items, such as ivory, glass, and textiles. Entries are cited under their Chinese characters, but the definitions are in English. The index lists the anglicized version of the Chinese terms accompanied by the equivalents in Chinese characters.

Nash, Ernest. *Pictorial Dictionary of Ancient Rome.* New York: Frederick A. Praeger, 1962. 2 volumes.

Numerous plans and photographs of individual buildings. Includes old prints and photographs of the buildings and individual bibliographies of the structures discussed.

Pauly, August F. *Paulys Real-Encyclopädie der classischen Altertumswissenschaft.* 2nd edition. Stuttgart: J. B. Metzler, 1894–1974. 34 volumes in 29 books plus supplement of 15 volumes in 14 books.

Detailed articles on persons, monuments, and sites. Partially indexed by John P. Murphy's *Index to the Supplements and the Supplemental Volumes of Pauly-Wissowa's R. E.* Chicago: Ares Publishers, Inc., 1976.

Stillwell, Richard, editor. *The Princeton Encyclopedia of Classical Sites.* Princeton, New Jersey: Princeton University Press, 1976.

The signed articles, written by 375 scholars from seventeen countries, cover about 3,000 sites of the remains of cities, towns, and other settlements of the classical era, 750 B.C. to 565 A.D. There are sixteen area maps to which each site is keyed. Has a glossary and a list of abbreviations to the references which are mentioned, including ancient sources plus books and periodicals. Each entry includes a brief history of the site during the classical era, a listing of present Greek and Roman remains, an indication of the present location of some of the artifacts found at the site, and bibliographical references.

Travlos, John. *Pictorial Dictionary of Ancient Athens.* New York: Praeger Publishers, 1971.

Numerous plans, photographs—both old and new, and bibliographies for individual structures.

Yonah, Michael Avi and Shatzman, Israel. *Illustrated Encyclopaedia of the Classical World.* New York: Harper & Row, Publishers, 1975.

Covers artists, sites, monuments, famous people, and gods and goddesses. Includes maps, tables of

kings, selected bibliography, and an index of names, terms, and subjects that are not main entries in the book.

Architectural Dictionaries

Baumgart, Fritz Erwin. *A History of Architectural Styles.* Translated by Edith Küstner and J. A. Underwood. New York: Praeger Publishers, Inc., 1970.

> A well-illustrated dictionary of major styles citing general characteristics, materials, major architects, and examples. Includes a glossary, an index of personal names, and an index of buildings.

Dictionnaire des Eglises de France, Editor-in-Chief, Jacques Brosse. Paris: Editions Robert Laffont, 1966. 5 volumes.

> Well-illustrated dictionary of all styles and periods of French churches, divided as to geographic location. Signed entries, by more than 150 experts, such as André Chastel and René Crozet, have bibliographies. In addition, the first volume contains essays on such subjects as church construction, stained glass, church furniture, religious iconography and symbolism, church liturgy, and five centuries of vandalism. Also has an extensive dictionary of architectural terms.

Fletcher, Sir Banister Flight. *A History of Architecture on the Comparative Method for Students, Craftsmen, and Amateurs.* 18th ed. revised by J. C. Palmes. New York: Charles Scribner's Sons, 1975.

> Each architectural style analyzed; entries include influences, architectural characteristics, examples, comparative analyses, and a list of references. Profusely illustrated; contains a glossary. First edition in 1896.

Harris, Cyril M. *Dictionary of Architecture and Construction.* New York: McGraw-Hill Book Company, 1975.

> A dictionary of terminology; illustrated by over 1,700 drawings.

Hunt, William Dudley, *Encyclopedia of American Architecture.* New York: McGraw-Hill Book Company, 1980.

> Covers types and styles of architecture, construction materials, and elements, about 45 famous architects, and other related material, such as Ecole des Beaux Arts, criticism, and ecology.

Pevsner, Nikolaus; Fleming, John; and Honour, Hugh. *Dictionary of Architecture.* Revised and enlarged. Baltimore, Maryland: Penguin Books, Inc., 1975.

> Dictionary of terminology; includes brief biographies on architects. Illustrated by drawings; has no bibliographical data. A hardcover edition of *The Penguin Dictionary of Architecture.*

———. *An Outline of European Architecture.* Baltimore: Penguin Books, 1943; numerous reprints and editions.

> Brief discussion of architecture from 6th century to the present. Includes a bibliography and a glossary of technical terms.

———. *Studies in Art, Architecture, and Design.* New York: Walker and Company, 1968. Volume I: *From Mannerism to Romanticism.* Volume II: *Victorian and After.*

> Well-illustrated scholarly discussion of artistic styles from 1520 to 1963.

Polon, David D., editor. *Dictionary of Architectural Abbreviations, Signs, and Symbols.* New York: Odyssey Press, 1965.

> Extensive list of abbreviations; includes signs which are used on drawings, abbreviations on maps, graphic symbols depicted on structural drawings, and silhouettes used in rendering landscape architecture and city planning.

Smith, George Kidder. *The Architecture of the United States.* Garden City, New York: Anchor Press, 1981. 3 volumes.

> Well-illustrated book providing details on specific buildings, excluding most private homes. Arranged by state, each chapter has a map locating the structures, a listing of the cities and the buildings followed by the entries which provide location, name of architect, sometimes literary citations, and an illustration of the structure. Each volume has a glossary and an index.

Sturgis, Russell. *A Dictionary of Architecture and Building: Biographical, Historical, and Descriptive.* New York: Macmillan Company, 1902; reprint ed., Detroit: Gale Research Company, 1966. 3 volumes.

> Short biographies citing some references to the bibliography at the end of the third volume. Includes entries on terminology plus famous buildings and sites; well illustrated.

Whiffen, Marcus. *American Architecture Since 1780: A Guide to the Styles.* Cambridge, Massachusetts: M.I.T. Press, 1969.

> Discussion of numerous styles prevalent in America from 1780 to present. Includes a bibliography and a glossary.

Construction and Decorative Materials Dictionaries

Technical material needed by architects and interior designers. For multilingual glossaries of building terms and books on historic construction materials, see Chapter 23, under "For Architects."

Brooks, Hugh. *Illustrated Encyclopedic Dictionary of Building and Construction Terms.* Englewood Cliffs, New Jersey: Prentice-Hall, Inc., 1976.

> Definitions of about 2,200 terms. Includes an index by function that cites the terms under 23 subject headings, such as hardware, plastering, or concrete.

Hornbostel, Caleb. *Materials for Architecture: An Encyclopedic Guide.* New York: Reinhold Publishing Company, 1961.

Dictionary of terms and techniques. Includes selected bibliography.

Huntington, Whitney Clark, et al., *Building Construction Materials and Types of Construction*. New York: John Wiley & Sons, 1981.
Organized by general subject headings, defines building and construction terms and methods. Includes a bibliography.

O'Connell, William J. *Graphic Communications in Architecture*. Champaign, Illinois: Stipes Publishing Company, 1972.
Explains the standard format and symbols used in architectural plans, sections, and working drawings.

Putnam, R. E. and Carlson, G. E. *Architectural and Building Trades Dictionary*. 3rd ed. Chicago: American Technical Society, 1974.
Also includes sections on legal terms and material sizes.

Schuler, Stanley. *Encyclopedia of Home Building and Decorating*. Reston, Virginia: Reston Publishing Company, Inc., 1975.
Dictionary of terms; includes list of the words defined under subject headings with cross references to the main entry. Defines such items as decorative art terms, woods, fabrics and yarns, furniture parts, electrical equipment, paints and finishing materials, flooring, hardware, and masonry.

Stein, J. Stewart. *Construction Glossary: An Encyclopedic Reference and Manual*. New York: John Wiley & Sons, Inc., 1980.
Provides in-depth discussion of construction terms. Organized by 16 divisions, such as site work, concrete, masonry, wood and plastics, doors and windows, finishes, professional services, and electrical. Includes tables of abbreviations for scientific, engineering, and construction terms and of weights and measures.

Watson, Don A. *Construction Materials and Processes*. 2nd ed. New York: McGraw-Hill Book Company, 1978.
Organized under general subject headings, such as concrete, masonry, carpentry, finishes, equipment, furnishings, and electrical systems. Has bibliographical references for each division.

Decorative Arts Dictionaries

Aronson, Joseph. *The Encyclopedia of Furniture*. 3rd ed. revised. New York: Crown Publishers, Inc., 1965.
Profusely illustrated dictionary for furniture, terms, and styles. Includes a general bibliography and a list of designers and craftsmen citing their countries and dates.

Boger, Louise Ade. *The Complete Guide to Furniture Styles*. Enlarged ed. New York: Charles Scribner's Sons, 1969.
Profusely illustrated historical presentation; includes an extensive bibliography and two indices: to artists and craftsmen and to general subjects.

——— *The Dictionary of World Pottery and Porcelain*. New York: Charles Scribner's Sons, 1971.
Includes biographies of potters with a facsimile of their signatures and an extensive bibliography. Numbers after the entries refer to the illustrations and notes on photographs.

——— and Boger, H. Batterson, editors. *The Dictionary of Antiques and the Decorative Arts: A Book of Reference for Glass, Furniture, Ceramics, Silver, Periods, Styles, Technical Terms, etc.* 2nd ed., enlarged. New York: Charles Scribner's Sons, 1967.
Includes biographical material and an extensive bibliography; illustrated. There is a supplement which includes Victorian and Modern art plus a classified list of subjects and terms.

Bridgeman, Harriet and Drury, Elizabeth. *The Encyclopedia of Victoriana*. New York: Macmillan Publishing Company, Inc., 1975.
Divided into well-illustrated chapters, each with its own bibliography and glossary, that cover such subjects as furniture, pottery, porcelain, sculpture, metalwork, photographs, jewelry, dress, textiles, and wallpaper.

Charleston, Robert J. *World Ceramics: An Illustrated History*. New York: McGraw-Hill Book Company, 1968.
Profusely illustrated history covering ceramics from the prehistoric period to the contemporary day. Includes a glossary of hallmarks.

Comstock, Helen, editor. *The Concise Encyclopedia of American Antiques*. New York: Hawthorn Books, Inc., 1958. 2 volumes.
Signed articles followed by dictionary-type entries; includes bibliographical references. Well illustrated.

Dodd, Arthur Edward. *Dictionary of Ceramics: Pottery, Glass, Vitreous Enamels, Refractories, Clay Building Materials, Cement and Concrete, Electroceramics, Special Ceramics*. New York: Philosophical Library, 1964.
Dictionary of technical terminology.

Edwards, Ralph. *The Shorter Dictionary of English Furniture From the Middle Ages to the Late Georgian Period*. London: Country Life, Ltd., 1964.
Divided into two sections: (1) definitions of terminology and styles and (2) brief biographical entries of over 180 cabinetmakers and designers. Occasionally includes a few bibliographical references.

——— and Ramsey, L. G. G., editors. *The Connoisseur's Complete Period Guides to the Houses, Decoration, Furnishing, and Chattels of the Classic Periods*. New York: Bonanza Books, 1968.
Covers from the Tudor Period 1500–1603 through the Early Victorian Period 1830–1860; includes separate essays on historical events, architecture and interior design, furniture, paintings, sculpture, silver, ceramics, textiles, jewelry, portrait miniatures, and printing.

Fleming, John and Honour, Hugh. *The Penguin Dictionary of Decorative Arts*. London: Allen Lane, 1977.

> Illustrated dictionary of styles, technical terms, materials, biographies, and brief histories of notable factories. Entries often have a literary reference. Includes ceramic marks, hallmarks on silver, and makers marks on silver and pewter.

Gloag, John. *A Short Dictionary of Furniture: Containing Over 2,600 Entries that Include Terms and Names Used in Britain and the United States of America*. Revised and enlarged ed. London: George Allen and Unwin, Ltd., 1969.

> Includes a chapter on furniture design; a bibliography; a chronology of periods from 1100 to 1950 citing types of furniture, construction methods, materials, and craftsmen; a biographical section on British and American designers and cabinetmakers; and a dictionary of terms and styles. Illustrated by over 1,000 drawings.

Haggar, Reginald G. *The Concise Encyclopedia of Continental Pottery and Porcelain*. New York: Hawthorn Books, Inc., 1960.

> Includes biographical and bibliographical data, facsimile of marks, and a bibliography. Illustrations, some in color.

Harling, Robert, editor. *Studio Dictionary of Design and Decoration*. New York: Viking Press, Inc., 1973.

> Profusely illustrated; includes biographical entries for architects, designers, and decorators plus definitions of terms and styles.

Honey, William Bowyer. *European Ceramic Art from the End of the Middle Ages to About 1815: A Dictionary of Factories, Artists, Technical Terms, et cetera*. London: Faber and Faber, Ltd., 1949–52. 2 volumes.

> Includes biographical and bibliographical data, facsimile of signatures, an index to marks, and a general bibliography.

Jaques, Renate and Flemming, Ernst. *Encyclopedia of Textiles: Decorative Fabrics from Antiquity to the Beginning of the 19th Century Including the Far East and Peru*. New York: Frederick A. Praeger, 1958.

> Profusely illustrated history.

Kovel, Ralph and Kovel, Terry. *Know Your Antiques: How to Recognize and Evaluate Any Antique— Large or Small—Like An Expert*. New York: Crown Publishers, Inc., 1967.

> Well-illustrated encyclopedia; each chapter includes definitions and a selected bibliography. There is also a list of price guides on antiques, a general bibliography, and a list of antique collectors' groups.

Lockwood, Luke Vincent. *The Furniture Collectors' Glossary*. New York: The Walpole Society, 1913; reprint ed., New York: Da Capo Press, 1967.

> Small dictionary of terms; illustrated by drawings.

Macquoid, Percy. *A History of English Furniture*. London: Lawrence and Bullen, Inc., 1904–08; reprint ed., New York: Dover Publications, Inc., 1972. 4 volumes.
Volume I: The Age of Oak, 1500–1660
Volume II: The Age of Walnut, 1660–1720
Volume III: The Age of Mahogany, 1720–1770
Volume IV: The Age of Satinwood, 1770–1820

> Profusely illustrated history of English furniture; fourth volume has a general index.

Mankowitz, Wolf and Haggar, Reginald G. *The Concise Encyclopedia of English Pottery and Porcelain*. New York: Frederick A. Praeger, 1968.

> Includes biographical and bibliographical data, facsimiles of hallmarks, a bibliography, and a list of engravers for pottery and porcelain. Illustrations, many in color.

Osborne, Harold, editor. *The Oxford Companion to the Decorative Arts*. London: Oxford University Press, 1975.

> Dictionary-type volume on terms, styles, designers, cabinetmakers, and craftsmen. Has some large general categories, such as "Egypt, Ancient;" "Greek and Roman Antiquity;" "China;" and "Japan." Includes costume and fashion terms. The numbers at the end of some entries correspond to the references cited in the bibliography at the end of the book.

Pegler, Martin. *The Dictionary of Interior Design*. New York: Crown Publishers, Inc., 1966.

> Covers terminology, styles, and designers; no bibliographical data. Profusely illustrated by drawings.

Phillips, Phoebe, editor. *The Collectors' Encyclopedia of Antiques*. New York: Crown Publishers, Inc., 1973.

> Well-illustrated reference work with signed articles from thirty-four experts. Divided into chapters covering arms and armour, bottles and boxes, carpets and rugs, ceramics, embroidery and needlework, furniture, glass, jewelry, metalwork, and pewter. Each chapter includes an explanation of the technique of the craft, an historical account, a glossary of terms, a brief discussion of repairs and maintenance, suggestions on how to distinguish fakes and forgeries, and a list of museums having outstanding collections of that particular kind of art.

Phipps, Frances. *The Collector's Complete Dictionary of American Antiques*. Garden City, New York: Doubleday & Company, Inc., 1974.

> Illustrated dictionary divided into twelve sections that cover such broad areas as historic periods and styles; rooms their placement and use; crafts, trades, and useful professions; terms used by joiners and cabinetmakers; pottery, porcelain, and minerals; glass; and furnishings, which includes apparel, jewelry, textiles, and leather.

Ramsey, L. G. G., editor. *The Complete Color Encyclopedia of Antiques.* 2nd ed. New York: Hawthorn Books, Inc., 1975.

> Dictionary of terminology in fields of furniture; jewelry; pottery and porcelain; prints and drawings; needlework and embroidery; glass; carpets and rugs; sculpture and carvings; books and bookbindings; painting; metal work; and silver. Adapted from *The Concise Encyclopedia of Antiques,* 5 volumes, and *The Concise Encyclopaedia of American Antiques,* 2 volumes. Includes a bibliography, and a list of museums and galleries that have particularly good specimens of the defined terms.

————. *The Concise Encyclopedia of Antiques.* New York: Hawthorn Books, Inc., 1955–61. 5 volumes.

> Well illustrated; has signed articles followed by dictionary-type entries. Includes bibliographical references; fifth volume has the general index.

Random House Collector's Encyclopedia: Victoriana to Art Deco. Introduction by Roy Strong. New York: Random House, 1974.

> A well-illustrated decorative arts dictionary covering terminology, techniques, craftsmen, and designers working from 1851 to 1939. Includes facsimiles of ceramic and silver hallmarks plus an extensive bibliography.

Savage, George. *Dictionary of Antiques.* New York: Praeger Publishers, Inc., 1970.

> Well illustrated; includes brief biographies of designers, an extensive bibliography, and an appendix of hallmarks.

———— and Newman, Harold. *An Illustrated Dictionary of Ceramics.* New York: Van Nostrand Reinhold Company, 1974.

> Profusely illustrated dictionary of terms. Includes a list of principal European ceramic factories and facsimiles of their hallmarks; this list was compiled by John Cushion.

Wilson, José and Leaman, Arthur. *Decorating Defined: A Dictionary of Decoration and Design.* New York: Simon and Schuster, 1970.

> Well-illustrated dictionary of terminology, styles, and designers. Includes a selected bibliography and a few pronunciations.

Wingate, Isabel B. *Fairchild's Dictionary of Textiles.* 6th ed. New York: Fairchild Publications, Inc., 1979.

> Terms of fiber construction and finishes; no fashion terms.

Fashion and Jewelry Dictionaries

Calasibetta, Charlotte Mankey. *Fairchild's Dictionary of Fashion.* Edited by Ermina Stimson Goble. New York: Fairchild Publications, Inc., 1975.

> Dictionary of terminology and styles; numerous illustrations, many in color. Includes a biographical dictionary of fashion designers.

Cunnington, Cecil Willett; Cunnington, Phillis; and Beard, Charles. *A Dictionary of English Costume, 900 to 1900.* New York: Barnes and Noble, 1968.

> Illustrated with drawings; contains a glossary of materials and a list of obsolete color names.

Kybalová, Ludmila; Herbenová, Olga; and Lamarová, Milena. *The Pictorial Encyclopedia of Fashion.* Translated by Claudia Rosoux. New York: Crown Publishers, Inc., 1968.

> Numerous illustrations, many in color. Contains a glossary of various garments and accessories plus an index of artists whose work is reproduced.

Linton, George E. *The Modern Textile and Apparel Dictionary.* 4th ed. revised. Plainfield, New Jersey: Textile Book Service, 1973.

> Includes fashion and style terms.

Mason, Anita. *An Illustrated Dictionary of Jewellery.* New York: Harper and Row Publishers, Inc., 1974.

> Illustrated dictionary of terms; contains a bibliography.

Osborne, Harold, editor. *The Oxford Companion to the Decorative Arts.* London: Oxford University Press, 1975.

> Dictionary-type volume on terms, styles, designers, cabinetmakers, and craftsmen. Includes some fashion terms and a lengthy article on costumes. The numbers at the end of some entries correspond to the references cited in the bibliography at the end of the book.

Picken, Mary Brooks. *The Fashion Dictionary: Fabric, Sewing, and Dress as Expressed in the Language of Fashion.* Revised and enlarged. New York: Funk & Wagnalls Company, 1973.

> Original 1939 publication entitled *The Language of Fashion.* Illustrated by drawings; contains an index of reproductions. Gives the pronunciation of many terms.

Wilcox, Ruth Turner. *The Dictionary of Costume.* New York: Charles Scribner's Sons, 1969.

> Illustrated by drawings.

Graphic Arts Dictionaries

These tools are for advertising students and commercial photographers.

Mintz, Patricia Barnes. *Dictionary of Graphic Art Terms: A Communication Tool for People Who Buy Type and Printing.* New York: Van Nostrand Reinhold Company, 1981.

> Includes reprint of Code of Fair Practice of the Joint Ethics Committee of New York.

Stevenson, George A. *Graphic Arts Encyclopedia,* 2nd ed. New York: McGraw-Hill Book Company, 1979.

> Illustrated dictionary of terms and equipment; includes photographic and commercial print terms. Has a bibliography, product index, manufacturers' index, plus conversion tables for the metric system and for paper sizes. Also records mathematical symbols.

Photography Dictionary

Stroebel, Leslie and Todd, Hollis N. *Dictionary of Contemporary Photography*. New York: Morgan & Morgan, Inc., 1974.

> Dictionary of terms; illustrated by line drawings.

Biographical Dictionaries of Artists

Research on an artist—whether an architect, designer, painter, photographer, or sculptor—begins with the biographical dictionaries. Data on the person's life and works will start the researcher on the path of discovery. This chapter is composed of three kinds of references: (1) general biographical dictionaries—subdivided as to works that cover historically prominent and contemporary people; (2) specialized biographies—sub-divided by nationalities and by media; and (3) indices to biographical dictionaries. For a discussion of the kinds of information provided by the references listed in this chapter, the reader should consult the section in Chapter 4.

Not all sources of biographical data are annotated in this chapter. For instance, some books that contain biographical information on craftsmen and designers of interiors, furniture, ceramics, and textiles are cited under "Decorative Arts Dictionaries" in Chapter 9. The references that relate biographical data on people working in films or moving pictures are described under "Film Resources" in Chapter 23. These entries have not been relisted here. Moreover, it must be borne in mind that some of the biographical dictionaries recorded in this chapter, especially the ones covering the nineteenth- and twentieth-century artists, may include data on interior designers and filmmakers. The reader should check the annotations carefully in order to be sure that no important source is overlooked.

General Biographical Dictionaries

Historically Prominent

Bénézit, Emmanuel. *Dictionnaire critique et documentaire des peintres, sculpteurs, dessinateurs, et graveurs.* Paris: Librairie Gründ, 1924, 3 volumes; revised ed., Paris: Librairie Gründ, 1948–55, 8 volumes; revised and enlarged ed., Paris: Librairie Gründ, 1976. 10 volumes.

A biographical dictionary which as it has been revised has expanded to about 300,000 entries covering painters, sculptors, designers, and graphic artists of Eastern and Western art from 5 B.C. to the present. Includes brief data on the lives of the artists, lists of awards won, locations of some art works, and sometimes facsimiles of the artists' signatures. Under the category *"Prix,"* the French word for price or value, there are listed the prices for which some of the various works of art sold over a wide range of time. *Vte.* is the abbreviation for *vente,* a term meaning sale or selling; *Vte. X* indicates an anonymous sale or one in which more than one collection was sold. Monetary values are listed in the currency of the country where the sale took place. At the end of each letter of the alphabet are biographical entries for artists whose monograms are known, but not their names. The 1976 edition has added a brief bibliography to some of the entries.

Thieme, Ulrich and Becker, Felix. *Allgemeines Lexikon der bildenden Künstler von der Antike bis zur Gegenwart.* Leipzig: E. A. Seemann, 1907–50; reprint ed., Leipzig: F. Allmann, 1964. 37 volumes.

One of the most scholarly biographical dictionaries; includes all types of artists. Signed articles give data on artists' lives and the locations of some of their works; sometimes includes sales prices. Indispensable bibliography of older publications; last volume contains articles on anonymous artists known by various names or monograms. *I* and *J* are alphabetized together; umlauted words are spelled with the vowel plus an *e.* The true name, not an anglicized version, of the artist must be used. For instance, there is no entry for Titian under this anglicized version of the Italian painter's name. Under Tiziano there is a cross reference to Vecellio where a lengthy entry is found. The supplement by Hans Vollmer covering artists born after 1870 is listed below. Valerie D. Meyer's brief work, *Index of the Most Common German Abbreviations Used in Thieme-Becker's Künstler-Lexikon* was compiled in 1972 for the University of Michigan. A new edition of Thieme-Becker is in preparation.

Vollmer, Hans. *Allgemeines Lexikon der bildenden Künstler des XX. Jahrhunderts.* Leipzig: E. A. Seemann, 1953–62. 6 volumes.

A supplement to the Thieme-Becker dictionary, this publication covers artists born after 1870. Contains signed articles and bibliographical data. Volumes 5 and 6 are supplements to the initial 4-volume work by Vollmer.

Contemporary

Contemporary Artists. New York. St. Martin's Press. 2nd edition, 1983; to be revised every 5 years.

For more than 1,000 artists provides biographical data, a list of exhibitions, a bibliography of

books and articles, plus a signed critical essay. Includes 1,250 black-and-white photographs of the artists' works.

Current Biography Yearbook. New York: H. W. Wilson Company. Volume 1 (1940)+

Each entry appears in only one volume; the fact that entries are not repeated in subsequent volumes necessitates the use of an index, such as *Biography and Geneology Master Index,* which is annotated in the last section of this chapter. People are indexed both by their names and by their professions; this latter category includes architecture, art, education, fashion, motion pictures, photography, and television. The correct pronunciation of the person's name is sometimes provided.

Dictionary of Contemporary Artists, see next entry under *International Directory of Exhibiting Artists.*

International Directory of Exhibiting Artists, edited by Veronica Bobington Smith. Santa Barbara, California: Clio Press, 1982 + 2 volumes.

Previously entitled *Dictionary of Contemporary Artists.* Annual edition; includes all studio artists. The more than 9,500 entries provide biographical data, exhibitions, and galleries representing the artists. Separate indices to artists, calligraphers, draughtsmen, glass painters, painters, and printmakers. Two indices to exhibiting institutions: private and public.

Oxford Companion to Twentieth-Century Art, edited by Harold Osborne. New York: Oxford University Press, 1981.

Illustrated dictionary to artists, critics, styles, movements, and institutions. Includes lengthy selected bibliography, pp. 601–648, divided by general works and specific books to persons and movements.

Who's Who in American Art: A Biographical Directory. New York: R. R. Bowker Company. Volume 1(1936/37)+

Now published biennially. Contains biographical sketches of over 10,500 artists, collectors, scholars, art administrators, art historians, and critics. Gives brief bibliographies, lists of awards, and names of exhibitions; includes a geographical index and a professional index. Companion volume to *The American Art Directory;* in 1898 both volumes appeared as part of the *American Art Annual.*

Who's Who in Art: Biographies of Leading Men and Women in the World of Art Today: Artists, Designers, Craftsmen, Critics, Writers, Teachers, Collectors, and Curators With an Appendix of Signatures. Havant, Hantsford, England: The Art Trade Press, Ltd., 1927.+

Published erratically; majority of the biographies are of people in England.

Specialized Biographical Dictionaries

By Nationalities

American Artists

American Art Annual. New York: R. R. Bowker Company. 1898+

Published irregularly. Name changed to *American Art Directory* after Volume 37 (1945/48). The publication was separated into *American Art Directory* and *Who's Who in American Art* after 1952. The early volumes had numerous types of information, including brief biographical data on artists and sometimes a directory of architects.

The Britannica Encyclopedia of American Art. Chicago: Encyclopaedia Britannica Educational Corporation, 1973.

Signed articles on artists and styles; latter part of the volume includes a glossary and bibliographical data on individual artists. Numerous illustrations, many in color.

Baigell, Matthew. *Dictionary of American Art.* New York: Harper and Row Publishers, 1979.

Brief biographical data on painters, sculptors, printmakers, and photographers from 16th century to 1970s. Sometimes has literary reference and location of major collections of artists' works. Includes essays on subjects, styles, academies, and schools.

Cummings, Paul, editor. *Dictionary of Contemporary American Artists.* New York: St. Martin's Press, 4th edition, 1982; to be revised every 5 years.

Brief biographies of over 780 artists. Numbers at the end of the entries correspond to the works cited in the selected bibliography.

Dawdy, Doris Ostrander. *Artists of the American West: A Biographical Dictionary.* Chicago: Sage Books, 1974.

A list of 1,350 artists born before 1900, all of whom depicted western America; of the artists cited, 300 are each given a brief biographical entry.

Fielding, Mantle. *Dictionary of American Painters, Sculptors and Engravers.* Enlarged and edited by Genevieve C. Doran. Green Farms, Connecticut: Modern Books and Crafts, Inc., 1974.

A reissue of Fielding's original 1926 publication with the addition of over 2,500 more American artists of the 17th, 18th, and 19th centuries. Various editions and revisions are available.

Groce, George C. and Wallace, David H. *New York Historical Society's Dictionary of Artists in America 1564–1860.* New Haven, Connecticut: Yale University Press, 1957.

A biographical dictionary of about 10,000 American painters, draftsmen, sculptors, engravers, lithographers, and allied artists; includes brief bibliographies.

Tuckerman, Henry Theodore. *Book of the Artists: American Artist Life Comprising Biographical and Critical Sketches of American Artists: Preceded by an Historical Account of the Rise and Progress of Art in America.* 2nd ed. New York: James F. Carr, 1966.

> A reprint of Tuckerman's 1867 publication. Discusses over 200 painters and sculptors. The appendix lists the works found in some of the public and private American collections in the nineteenth century.

Young, William. *A Dictionary of American Artists, Sculptors and Engravers: From the Beginning through the Turn of the Twentieth Century.* Cambridge, Massachusetts: William Young & Company, 1968.

> Alphabetized by artist, each entry gives dates, media used, and a brief biographical sketch.

Oriental Artists

Beale, Thomas William. *An Oriental Biographical Dictionary.* Revised and enlarged by Henry George Keene. London: W. H. Allen & Company, 1894; reprint ed., New York: Kraus Reprint Company, 1965.

> Alphabetized by anglicized name; no bibliographical data.

Giles, Herbert A. *A Chinese Biographical Dictionary.* London: B. Quaritch, 1898; reprint ed., New York: Paragon Book Reprint Corp., 1966.

> Alphabetized by anglicized name, with Chinese characters given: no bibliographical data. Has four indices: to literary names, to nicknames, to canonizations, and to persons who are mentioned.

Roberts, Laurance P. *A Dictionary of Japanese Artists: Painting, Sculpture, Ceramics, Prints, Lacquer.* New York: John Weatherhill, Inc., 1976.

> Alphabetized under the western names of the Japanese artists, the biographical entries often include lists of museums that possess some of the artists' works and bibliographical citations. Contains a list of institutions having works of art by the artists who are cited; a list of Japanese art organizations and institutions; a list of art periods of Japan, Korea, and China; a list of Japanese provinces and prefectures; a glossary; an extensive bibliography; an index of alternate names or other names by which the artist may be known; and an index to the artists' names as written in Japanese characters.

Society of Friends of Eastern Art. *Index of Japanese Painters.* Tokyo: Institute of Art Research, 1940; reprint ed., Rutland, Vermont: Charles E. Tuttle Company, 1958.

> About 600 brief biographies; artists' names given in English and Japanese. Includes explanations of various schools.

By Media

Architects, Historically Prominent

Colvin, Howard Montagu. *A Biographical Dictionary of English Architects, 1660–1840.* London: John Murray, 1954. Revised edition including Scotland and Wales, New York: Facts on File, Inc., 1980.

> Covers more than 1,000 architects; each entry provides some biographical data, a list of major architectural and design works, and a brief bibliography.

Harvey, John, compiler. *English Mediaeval Architects: A Biographical Dictionary Down to 1550, Including Master Masons, Carpenters, Carvers, Building Contractors, and Others Responsible for Design.* London: B. T. Batsford, Ltd., 1954.

> Biographical entries written by various experts; each entry relates some of the pay received for the artistic work done and lists bibliographical references. The key to abbreviations is both to the authorship of the entries and to the biographical material cited. Includes (1) a key to the Christian names of the architects; (2) the location of portraits of a few medieval architects; (3) some tables of renumeration; (4) a topographical index; (5) an index by English counties, by Welsh counties, and by foreign countries; (6) a chronological table; (7) a subject index of buildings; and (8) a general index.

Macmillan Encyclopedia of Architects, edited by Adlof Placzek. New York: Macmillan Co., 1982. 4 volumes.

> Excellent biographical reference of 2,450 architects, planners, engineers, designers, landscape architects, and firms. Signed entries, written by 600 international contributors, include discussions of architects and their works, lists of works with dates and locations, and selected bibliographies. Illustrated by 1,500 pictures. Spans 4,600 years from ancient Egypt to persons born before 1931 or already deceased. Also contains a chronological table of architects from Imhotep, active 2635–2595 B.C. to Stanley Tigerman, born 1930. Has a general bibliography and a glossary of architectural terms. In the indices to names and to works, the architecture is listed under the most commonly used name—Abbey of Melk, Austria, but Château Mirwart, Belgium.

Pehnt, Wolfgang, editor. *Encyclopedia of Modern Architecture.* Translated by Harold Meek et al. New York: Harry N. Abrams, Inc., 1964.

> Illustrated biographical dictionary of architects written by thirty-one architects in sixteen countries. Signed articles include bibliographical data. Has an index to names and a brief bibliography. Originally published in 1963 as *Knaurs Lexikon der modernen Architektur,* edited by Gerd Hatje.

Richards, James M., editor. *Who's Who in Architecture: From 1400 to the Present.* New York: Holt, Rinehart and Winston, 1977.

> Consists of 50 long signed articles on prominent architects providing several bibliographical references plus 450 shorter entries for less prominent people. Essays are by about 30 international contributors. Illustrated; has brief bibliography and an index to buildings mentioned in the text.

Sharp, Dennis. *Sources of Modern Architecture: A Critical Bibliography.* 2nd edition. Westfield, New Jersey: Eastview Editions, Inc., 1981.

> Provides biographical data which includes bibliographical references for about 125 architects. Has an index to architects and authors plus a select list of architectural periodicals.

Sturgis, Russell. *A Dictionary of Architecture and Building: Biographical, Historical, and Descriptive.* New York: Macmillan Company, 1902; reprint ed., Detroit: Gale Research Company, 1966. 3 volumes.

> Short biographies listing some references to the bibliography at the end of the third volume. Includes entries on terminology plus famous buildings and sites; well illustrated.

Withey, Henry F. and Withey, Elsie Rathburn. *Biographical Dictionary of American Architects (Deceased).* Los Angeles: Hennessey & Ingalls, Inc., 1970.

> Biographical entries for about 2,000 architects living between 1740–1952; includes some literature references.

Architects, Contemporary

American Institute of Architects. *Pro File: Professional File Architectural Firms.* Edited by Henry W. Schirmer. Topeka, Kansas: Archimedia, Inc., 3rd edition, 1983.

> Official AIA Directory of architectural firms and individual members. Arranged by state followed by city, each entry includes address, type of organization, year firm established, names of principal architects with their professional affiliations and their responsibilities within the company, and the number of personnel by disciplines—architects, interior designers, landscape architects, and engineers. Has essays on (1) how to find, evaluate, select, and negotiate with an architect, (2) you and your architect, and (3) the AIA Code of Ethics and Professional Conduct. May be published annually.

Contemporary Architects, edited by Muriel Emanuel. New York: St. Martin's Press, 1980.

> Provides data on more than 400 internationally famous architects who worked from 1920 to 1980. Includes a biography list of constructed works, a bibliography of books and articles plus a signed critical essay. This work, which is to be revised every 5 years, also provides a black-and-white reproduction of a representative work for each entry.

Authors

Contemporary Authors. Detroit: Gale Research Company. Volume I(1962)+

> Entries are in one volume and not repeated in subsequent ones; this necessitates using the cumulative indices.

Cabinetmakers

Bjerkoe, Ethel Hall. *The Cabinetmakers of America.* Garden City, New York: Doubleday & Co., Inc., 1957.

> Illustrated biographical dictionary of cabinetmakers who worked from 1680–1900. Includes a glossary.

Honour, Hugh. *Cabinet Makers and Furniture Designers.* London: Hamlyn Publishing Company, Ltd., 1972.

> Well-illustrated biographical material on more than fifty designers from the sixteenth century to the present. Literature references on each designer are listed under "Bibliography."

Fashion Designers

Calasibetta, Charlotte Mankey. *Fairchild's Dictionary of Fashion.* Edited by Ermina Stimson Goble. New York: Fairchild Publications, Inc., 1975.

> Dictionary of terminology and styles; numerous illustrations, many in color. Includes biographical data on fashion designers.

Lambert, Eleanor. *World of Fashion: People, Places, Resources.* New York: R. R. Bowker Company, 1976.

> This book is divided into parts which represent the continents and subdivided into chapters which represent the countries on those continents. Each chapter has a very diversified kind of information: citing names of current fashion designers with a biographical sketch on each; a list of persons, other than designers, who influenced fashion; trade associations and organizations involved in fashion; kinds of fashion education available; names of costume and fashion archives; and titles of fashion publications. Under "Hall of Fame," gives brief biographical sketches on fashion designers who are deceased. The appendix lists the Coty Award winners from 1943–1973.

Lynam, Ruth, editor. *Couture: An Illustrated History of the Great Paris Designers and Their Creations.* Garden City, New York: Doubleday & Company, Inc., 1972.

> A history of the couturier system. Includes biographical chapters on Coco Chanel, Christian Dior, Courrèges, Emanuel Ungaro, Pierre Cardin, and Yves Saint Laurent.

Illuminators and Miniaturists

Aeschlimann, Erardo and Ancona, Paolo d'. *Dictionnaire des miniaturistes du Moyen Âge et de la Renaissance dans les différentes contrées de l'Europe.*

2nd ed., revised. Milan: Ulrico Hoepli, 1949; reprint ed., Nendeln, Liechtenstein: Kraus Reprint, 1969.

 Illustrated biographical dictionary giving some bibliographical data. Index of artists by stylistic periods; lists artists' works with their locations.

Bradley, John William. *A Dictionary of Miniaturists, Illuminators, Calligraphers, and Copyists: From the Establishment of Christianity to the Eighteenth Century.* London: Quaritch, 1887–89; reprint ed., New York: Burt Franklin, 1958. 3 volumes.

 Entries provide brief comments on the artists' works; also included is a list of the patrons of the artists.

Foskett, Daphne. *A Dictionary of British Miniature Painters.* New York: Praeger Publishers, Inc., 1972. 2 volumes.

 Covers artists active between 1520 and 1910. Volume I includes the biographical data, 100 color illustrations, and a selected bibliography. Volume II reproduces 967 monochrome plates.

Foster, Joshua James. *A Dictionary of Painters of Miniatures (1525–1850) with Some Account of Exhibitions, Collections, Sales, etc. Pertaining to Them.* Edited by Ethel M. Foster. London: P. Allan & Company, Ltd., 1926: reprint ed., New York: Burt Franklin Company, 1968.

 Biographical dictionary which includes some exhibition data, but no bibliographical information.

Long, Basil S. *British Miniaturists.* London: G. Bles, 1929; reprint ed., London: Holland Press, 1966.

 Illustrated biographical dictionary of miniaturists who worked in Great Britain and Ireland 1520–1860. Includes a list of provincial towns accompanied by the names of the miniaturists who worked there. Provides brief bibliographical data and the locations of some works of art.

Schidlof, Leo R. *The Miniature in Europe in the 16th, 17th, 18th and 19th Centuries.* Graz, Austria: Akademische Druck-U. Verlagsanstalt, 1964. 4 volumes.
Volume I: A–L Dictionary
Volume II: M–Z Dictionary and Catalogue of Reproductions
Volume III: Plates A–K
Volume IV: Plates L–Z

 No bibliographical data. Over 600 illustrations.

Painters

Archibald, E. H. H. *Dictionary of Sea Painters.* Woodbridge, England: Antique Collectors' Club, Ltd., 1980.

 Entries for about 800 artists; often reports museums that own the works of art. Contains 700 reproductions, many in color. Includes depictions of European historic maritime flags, an essay on ship profile development that records the sterns and riggings of various types of ships, and an illustrated section on coastal craft.

Berckelaers, Ferdinand Louis (Michel Seuphor). *Dictionary of Abstract Painting: With a History of Abstract Painting.* Translated by Lionel Izod et al. New York: Tudor Publishing Company, 1957.

 Lists more than 500 artists; contains a few brief bibliographical entries plus a general bibliography of abstract art.

Bernt, Walther. *The Netherlandish Painters of the Seventeenth Century.* Translated by P. S. Falla from the 3rd, 1969, German edition. London: Phaidon Publishers, Inc., 1970. 3 volumes.

 Gives brief biographical and bibliographical data on 800 Dutch and Flemish artists; includes facsimiles of signatures of artists. Well illustrated; third volume has a list of artists with their teachers, their pupils, and other artists who used a similar style. First edition in 1948.

Bryan, Michael. *Bryan's Dictionary of Painters and Engravers.* Enlarged and revised by George C. Williamson. New York: Macmillan and Company, 1926–34; reprint ed., New York: Kennikat Press, Inc., 1964. 5 volumes.

 A biographical dictionary citing brief data on artists' lives and the locations of some of their works; first published in two volumes in 1816. Includes some signed articles and a few illustrations.

Champlin, John Denison, Jr., editor. *Cyclopedia of Painters and Paintings.* New York: Scribner, 1885–87; reprint ed., Port Washington, New York: Kennikat Press, Inc., 1969. 4 volumes.

 A biographical dictionary that sometimes reproduces artists' signatures; lists some works of art providing titles, dates when painted, and locations in the nineteenth century. Often includes bibliographical references which are abbreviated and which refer to the titles in the extensive bibliography printed in the front of the first volume.

Comanducci, Agostino Mario. *Dizionario illustrato dei pittori, disegnatori, e incisori italiani moderni e contemporanei.* Amplified by Luigi Pelandi and Luigi Servolini. 3rd ed. Milan: Leonilde M. Patuzzi Editore, 1962. 4 volumes.

 Illustrated biographical dictionary of Italian painters, designers, and engravers of the nineteenth and twentieth centuries; includes some bibliographical data. First edition was in 1935.

Dictionary of Italian Painting. New York: Tudor Publishing Company, 1964.

 Signed articles by eight contributors; no bibliographical data. Covers about 250 painters from the thirteenth to the end of the eighteenth century. Includes important styles, major cities, and biographies of some of the famous popes.

Dizionario Enciclopedico Bolaffi dei pittori e degli incisori italiani: Dall' XI al XX sècolo. Turin, Italy: Giulio Bolaffi Editore, 1972–76. 11 volumes.

 Biographical dictionary of Italian painters and graphic artists; each entry includes bibliographical data, often some recent sale prices, and frequently a facsimile of the artist's signature.

Grant, Maurice Harold. *A Chronological History of the Old English Landscape Painters from the XVIth Century to the XIXth Century: Describing More than 800 Painters.* Revised and enlarged. Leigh-on-Sea, England: F. Lewis Publishers, Ltd., 1957–61. 8 volumes.

>Originally published in two volumes in 1927, with a supplement in 1947; gives biographical entries and locations of works of art. Includes 700 illustrations. Volume 8 has an index of artists to all the volumes.

Kindlers Malerei Lexikon. Zurich: Kindler Verlag, 1964–71; reprint ed., Hannover: Max Büchner, 1976.

>Signed biographical articles on painters giving locations, media, and dimensions of many art works plus bibliographical references. Includes 1,000 facsimiles of painters' signatures plus 1,200 color and 3,000 black-and-white reproductions. Volume 6 is composed of a dictionary of terms, styles, and techniques; a list of literary references; an artist index; and a list of reproduction sources.

Lake, Carlton and Maillard, Robert, general editors. *Dictionary of Modern Painting.* Translated by Lawrence Samuelson et al. 3rd ed., revised. New York: Tudor Publishing Company, 1964.

>Signed articles by thirty-four contributors; includes about 250 entries which cover terms, styles, and artists. No bibliographical data.

Larousse Dictionary of Painters. New York: Larousse and Company, Inc., 1981.

>Signed articles of 550 artists by about 140 scholars. No bibliographical references, but does give locations of many of the works of art. More than 600 illustrations, many in color.

Mitchell, Peter. *European Flower Painters.* London: Adam & Charles Black, Ltd., 1973.

>American edition by Overlook Press published as *Great Flower Painters.* Biographical information on 320 artists who worked from the seventeenth through the twentieth centuries.

Myers, Bernard S., editor. *Encyclopedia of Painting.* 4th revised ed. New York: Crown Publishers, Inc., 1979.

>A one-volume review of painting; provides brief biographies of artists, but no bibliographical data. Includes more than 1,000 illustrations, many in color.

Pavière, Sydney. *A Dictionary of Flower, Fruit, and Still Life Painters.* Leigh-on-Sea, England: F. Lewis Publishers, Ltd., 1962. 3 volumes in 4 books.
Volume I: 15th–17th Centuries
Volume II: 18th Century
Volume III: Part I: 19th Century: Artists Born 1786–1840
Volume III: Part II: 19th Century: Artists Born 1841–1885
Illustrated biographical data.

Phaidon Dictionary of Twentieth-Century Art. New York: Phaidon Publishers, Inc., 1973.

>Includes brief biographical and bibliographical data on artists and movements of this century.

Tufts, Eleanor. *Our Hidden Heritage: Five Centuries of Women Artists.* London: Paddington Press, Ltd., 1974.

>Well-illustrated; covers twenty-two women from the sixteenth century to the present. Includes bibliographical footnotes plus a general bibliography.

Wood, Christopher. *Dictionary of Victorian Painters.* Woodbridge, Suffolk, England: Antique Collector's Club, 2nd ed., 1978.

>Well-illustrated biographical dictionary of over 11,000 artists who worked during Victoria's reign, 1837–1901. Includes the names of exhibitions they entered, bibliographical data, and some 500 illustrations. At the beginning of the book is an explanation of the abbreviations used; at the end of the volume is a group of facsimiles of artists' monograms and two indices: to monograms and to artists.

Zampetti, Pietro. *A Dictionary of Venetian Painters.* Leigh-On-Sea, England: F. Lewis Publishers, Ltd., 1969–79.
Volume I: 14th and 15th Centuries, 1969.
Volume II: 16th Century, 1970.
Volume III: 17th Century, 1971.
Volume IV: 18th Century, 1971.
Volume V: 19th and 20th Centuries, 1979.
Illustrated biographical dictionary listing principal works, their locations, and bibliographical data.

Photographers

Newhall, Beaumont and Newhall, Nancy, editors. *Masters of Photography.* New York: George Braziller, Inc., 1958.

>Well-illustrated book with brief biographies of nineteen photographers.

Pollack, Peter. *The Picture History of Photography: From the Earliest Beginnings to the Present Day.* Revised and enlarged. New York: Harry N. Abrams, Inc., 1969.

>Well illustrated; includes biographies of photographers.

Walsh, George et al. *Contemporary Photographers.* New York: St. Martin's Press, 1983; to be revised every 5 years.

>Provides data on more than 600 internationally famous photographers. Entries include a list of individual and group exhibitions, the collections which contain works by the artist, bibliographical references, plus signed critical comments. Illustrated.

Witkin, Lee D. and London, Barbara. *The Photograph Collectors' Guide.* Boston: New York Graphic Society, 1979.

Biographical material on more than 230 photographs, providing dates, nationality, brief discussion of work, list of subject of works, list of notable collections of works, selected bibliographies, and a reproduction of one of works. Often includes facsimile of photographer's signature which is useful in identifying or verifying photographs. Also has a section on Limited-Edition Portfolios put out by individual artists plus sections on daguerreotypists and a list of additional photographers which only provides country of origin and dates. Includes (1) essays on the art of collecting and the care and restoration of photographs, (2) a glossary of terms, (3) a chronology of the history of photography, (4) a listing of museums, galleries, auction houses, and exhibition spaces, (5) a bibliography for histories and surveys, color photography, and current periodicals, and (6) an index to names. The index is important, since artists, such as Karl Struss, often have no direct biographical entry, but will be listed in other sections, such as the Limited-Edition Portfolios or under *Camera Work*.

Printmakers, Historically Prominent

Andresen, Andreas. *Der deutsche Peintre-Graveur; oder, Die deutschen Maler als Kupferstecher nach ihrem Leben und ihren Werken, von dem letzten Drittel des 16. Jahrhunderts bis zum Schluss des 18. Jahrhunderts. . . .* Leipzig: Rudolph Weigel, 1864–78; reprint ed., New York: Collectors Editions, Ltd., 1969. 5 volumes.

Over 140 German engravers who worked from 1560–1800 are catalogued. Each entry includes biographical information and a list of works citing title, size, and pertinent information. Initials used by engravers either precede the article or are found at the end of the volume under "Monogrammel Tafel." Each volume contains a table of contents; the last volume, the general index.

———. *Die deutschen Maler-Radirer (peintres-graveurs) des neunzehnten Jahrhunderts., nach ihren Leben und Werken.* Leipzig: Verlag von Rudolph Weigel, 1866–70; reprint ed., New York: Georg Olms Verlag, 1971. 5 volumes.

Over seventy German engravers of the nineteenth century covered; each entry includes biographical information and a list of works citing title, dimensions, and pertinent data.

Bartsch, Adam von. *Le peintre graveur.* Vienne, France: Degen, 1802–21; reprint ed., Leipzig: Barth, 1854–76; reduced size reprint ed., Nieuwkoop, Holland: B. de Graaf, 1970. 21 volumes in 4.

Describes the works of about 640 artists, 200 of whom were either unknown or were only known by initials. Volumes 1–5, Dutch and Flemish; Volumes 6–11, German; Volumes 12–21, Italian masters plus supplements to the other volumes. Covers artists through the seventeenth century; includes brief biographical sketches but no illustrations. Has a cumulative index to all the artists in Volume 21 preceding the supplements. For a discussion of Bartsch and the various publications and projects which have provided illustrations for this work, see Chapter 6.

Baudicour, Prosper de. *Le peintre-graveur français continué, ou Catalogue raisonné des estampes gravées par les peintres et les dessinateurs de l'école française nés dans le XVIIIe siècle, ouvrage faisant suite au Peintre-graveur français de M. Robert-Dumesnil.* Paris: Bouchard-Huzard, 1859–61. 2 volumes.

Covers sixty French engravers born in the eighteenth century; each entry includes biographical information and a list of the engraver's *œuvre* citing title, dimensions, plus signature and other pertinent data. Artists are not placed in alphabetical order; the arrangement necessitates the use of the table of contents found in the front of each volume.

Hollstein, F. W. H. *Dutch and Flemish Etchings, Engravings, and Woodcuts, ca. 1450–1700.* Amsterdam: Menno Hertzberger & Company, 1949– . Volumes 1–20 and 26 now complete.

Includes a brief biography of each artist; cites literary references. Each work is illustrated; title, size, medium, and additional information are given.

———. *German Engravings, Etchings, and Woodcuts, ca. 1400–1700.* Amsterdam: Menno Hertzberger & Company, and A. L. van Gendt & Company, 1954– .

Includes a brief biography of each artist; cites literary references. Each work is illustrated; title, size, medium, and additional information are given.

Passavant, Johann David. *Le peintre-graveur: Contenant l'histoire de la gravure sur bois, sur métal et au burin jusque vers la fin du XVI. siècle. L'histoire du nielle avec complément de la partie descriptive de l'Essai sur les nielles de Duchesne aîné. Et un catalogue supplémentaire aux estampes du XV. et XVI. siècle du Peintre-graveur de Adam Bartsch.* Leipzig: Weigel, 1860–64; reprint ed., New York: Burt Franklin, 1966. 6 volumes in 3 books.

A history of engraving through the sixteenth century. Each volume has an artist index and facsimiles of monograms.

Portalis, Roger and Béraldi, Henri. *Les graveurs du dixhuitième siècle.* Paris: Morgand et Fatout, 1880–82; reprint ed., New York: Burt Franklin, 1970. 3 volumes.

Biographical information of over 350 engravers followed by a list of some of their prints. Last book includes a general index; each volume has index to artists in that work.

Robert-Dumesnil, A. P. F. *Le peintre-graveur français, ou Catalogue raisonné des estampes gravées par les peintres et les dessinateurs de l'école française.* Paris: Gabriel Warée, 1835–71. 11 volumes.

Includes biographical data and a list of works citing dimensions and other pertinent information. Volume 11 is a supplement by Georges Duplessis and contains a general index.

Stauffer, David McNeely and Fielding, Mantle. *American Engravers Upon Copper and Steel*. New York: Burt Franklin, 1964. 3 volumes.

Consists of three sections: Parts I and II by Stauffer were originally published in 1907. Part I includes brief biographies, with no bibliographical data, on about 700 artists plus an index to engravings described in Part II. The checklists of Part II include, under the artist's name, the title of each engraving, the medium, the size, and inscription. Part III, published by Mantle Fielding, is an addendum of about 120 additional artists; it has the same format as Stauffer's work.

Strutt, Joseph. *A Biographical Dictionary: Containing an Historical Account of All the Engravers, from the Earliest Period of the Art of Engraving to the Present Time, and a Short List of Their Most Esteemed Works*. London: J. Davis, 1785–86; reprint ed., Geneva, Switzerland: Minkoff Reprint, 1972. 2 volumes in one book.

Brief biographical data; each volume has facsimiles of monograms and an index to engravers' initials. Last volume has a chronological list of principal engravers active from 1450 to 1770.

Printmakers, Contemporary

Amstutz, Walter. *Who's Who in Graphic Art*. Zurich: Amstutz and Herdeg Graphis Press, 1962.

Illustrated biographical directory of over 400 twentieth-century international artists; one page is devoted to each one. Each entry cites artist's name, address, scope of work, and literature references. Text in English, French, and German. Some entries are completed on pages 566–73, but main entries neglect to indicate this continuation. Appendix includes a list of abbreviations, a list of artists' societies, and an index of artists.

Printworld Directory of Contemporary Prints and Prices. Bala-Cynwyd, Pennsylvania: Printworld, Inc., 1982.

Entries under artists' names cite education, awards, exhibitions, collections, galleries which represent the persons, and their mailing addresses.

Sculptors

Berman, Harold. *Encyclopedia: Bronzes, Sculptors, and Founders 1800–1930*. Calne, England: Hilmarton Manor Press, 1974–79. 4 volumes.

Volume I has introduction and definitions plus a list of foundaries. Other volumes provide data on sculptors, founders, and seals. Has 4,700 illustrations plus facsimile of some signatures.

Gunnis, Rupert. *Dictionary of British Sculptors 1660–1851*. Revised ed. London: The Abbey Library, 1968.

Includes the titles and dates of important works, some price and bibliographical data, plus the exhibitions in which each artist's work was displayed. Has two indices: to places and to names.

Horswell, Jane. *Bronze Sculpture of "Les Animaliers": Reference and Price Guide*. Woodbridge, England: The Antique Collectors' Club, 1971.

Biographical data on 19th-century sculptors, 7 major essays and 29 brief entries. Includes illustrations of their works, essays on founding practice and methods of casting, list of artists' signatures, and list of some of the artists and the titles of the exhibition pieces displayed in various French Salons.

Lami, Stanislas. *Dictionnaire des sculpteurs de l'école française*. Paris: Champion, 1898–1921; reprint ed., New York: Kraus Reprint, 1970. 8 volumes.
Tome I: Du Moyen Âge au règne de Louis XIV
Tome II: Sous le règne de Louis XIV
Tomes III–IV: Au dix-huitième siècle
Tomes V–VIII: Au dix-neuvième siècle

Biographical dictionary listing titles and present locations of works plus giving some bibliographical data. Includes Salon and exhibitions in which works were displayed.

Maillard, Robert, general editor. *New Dictionary of Modern Sculpture*. Translated by Bettina Wadia. New York: Tudor Publishing Company, 1971.

Biographies of about 475 artists; illustrated. Signed articles; no bibliographies.

Souchal, François. *French Sculptors of the 17th and 18th Centuries: The Reign of Louis XIV*. Translated by Elsie and George Hill. Oxford: Bruno Cassirer Publishers, Ltd., 1977–.

Projected series to cover French sculptors from the Middle Ages to the late 19th century. Profusely illustrated by good black-and-white photographs. Under artists' names, provides biographical data, a list of all known works accompanied by scholarly catalogue entries and photographs and drawings where available. Each volume includes a list of bibliographical abbreviations, a list of photographic sources, and an index to artists, sites, titles of works, and collections. Reproduces a number of geneological trees for such artists as Le Brun and Lemoyne. For a sculptor, such as Antoine Coysevox cites 119 works, illustrating all those not destroyed or lost.

Wasserman, Jeanne, editor. *Metamorphoses in Nineteenth-Century Sculpture*. Cambridge, Massachusetts: Fogg Art Museum, Harvard University Press, 1975.

A scholarly exhibition catalogue that provides in-depth data on 6 sculptors: biography, discussion of some of their works, and a selected bibliography. Well-illustrated reference with essays on serial sculpture in 19th-century France and a technical view of the sculpture of the period.

Indices to Biographical Information

These references cite under the person's name, the books and articles that provide biographical data. This is a two-step process: locate the artist, then search for the book or article which contains the needed information.

Arts in America, see listing under Karpel.

Avery Obituary Index of Architects and Artists. 2nd edition. Boston: G. K. Hall, 1980. One volume.

 Entries for obituary notices on about 16,000 people; cites the deceased's dates and the periodical, out of a list of about 500, that published the article.

Bachmann, Donna G. and Piland, Sherry. *Women Artists: An Historical, Contemporary, and Feminist Bibliography.* Metuchen, New Jersey: The Scarecrow Press, Inc., 1978.

 Covers 161 artists from the Middle Ages to the 20th century.

Biography and Geneology Master Index. 2nd ed. Detroit: Gale Research Company, 1980. 8 volumes. Frequent supplements.

 Indexes the biographical information in hundreds of reference works, including *Current Biography Yearbook* and the who's who books. Has entries for more than 2 million people. For the online database, see below.

Biography Index: A Cumulative Index to Biographical Material in Books and Magazines. New York: H. W. Wilson Company. Volume I (January, 1946–July, 1949) +

 Published every three years until 1974 when it changed to a quarterly with an annual cumulation. Regularly scans 2,600 periodicals and works of collective biography. Has an index by individuals' surnames and by professions; the latter includes painters, sculptors, designers, architects, art historians, critics, art collectors, art teachers, artists, and museum directors. Some of the categories are subdivided by nationality. These volumes replace the biographical entries which were found in the other Wilson publications before 1946.

Biography Master Index Database, DIALOG.

 Complete files of the 2nd edition plus the supplements. Material from more than 700 editions and volumes of about 400 titles.

Havlice, Patricia Pate. *Index to Artistic Biography.* Metuchen, New Jersey: Scarecrow Press, Inc., 1973. 2 volumes. *First Supplement,* 1981.

 A guide to 64 different biographical dictionaries published between 1902 and 1970 in 10 languages. Supplement indexes an additional 70 books. Entries, alphabetized under artists' names, list artists' dates, media in which they worked, and abbreviations that refer to the particular dictionaries indexed that include the artists. Does not cover the dictionaries by Bénézit and Thieme-Becker. Variant spellings and alternate names of each artist are given in parentheses following the artist's name. Indexes all kinds of artists. First 2 volumes contain about 70,000 artists; supplement, approximately 44,000.

Karpel, Bernard, editor. *Arts in America: A Bibliography.* Washington, D.C.: Smithsonian Institution Press, 1979.

 Sections include annotated bibliographical data on individual artists, many of whom are not well known. Artists who work in more than one media, may be cited in more than one section. Although most of the tables of contents at the beginning of each section provide a list of the specific persons covered, the index, which is Volume 4, should be used since this includes references to persons mentioned in the annotations.

 "Architecture," by Charles B. Wood III, Volume 1 lists 125 architects and architectural firms divided into those of the 18th and 19th centuries, academic 20th century, and Modern Movement.

 "Art of the West," by Jeff C. Dykes, Volume 1 lists 131 artists in a broad category that includes such people as Georgia O'Keeffe and Grant Wood.

 "Design: Twentieth Century," by Kathleen Church Plummer, Volume 1 lists 50 designers.

 "Film," by George Rehrauer, Volume 3 lists 300 actors, directors, and producers.

 "Graphic Arts: Seventeenth-Nineteenth Century," by Elaine Johnson, Volume 2 lists 176 artists.

 "Graphic Artists: Twentieth Century," by Elaine Johnson, Volume 2 lists 105 artists.

 "Painting: Seventeenth-Eighteenth Century," by John Lovari, Volume 2 lists 94 painters.

 "Painting: Nineteenth Century," by J. Benjamin Townsend, Volume 2 lists 347 painters.

 "Painting: Twentieth Century," by Bernard Karpel, Volume 2 lists 263 painters.

 "Photography," by Beaumont Newhall, Volume 3 lists 170 photographers.

 "Sculpture," by William B. Walker, Volume 1 lists 368 sculptors, divided by those born before 1876 and those born after. Includes multimedia artists, such as Larry Rivers and Jasper Johns.

Lucas, E. Louise. *Art Books: A Basic Bibliography on the Fine Arts.* Greenwich, Connecticut: New York Graphic Society, Ltd., 1968.

 "Monographs on Artists" provides bibliographical entries for about 550 artists from the 13th century to the 1960s; most are painters, sculptors, and architects. Includes many foreign-language references, but no annotations.

Mallett, Daniel Trowbridge. *Mallett's Index of Artists: International-Biographical Including Painters, Sculptors, Illustrators, Engravers, and Etchers*

of the Past and the Present. New York: R. R. Bowker Company, 1935; reprint ed., New York: Peter Smith Publisher, Inc., 1948.

> Covers about 27,000 artists; each entry lists artist's name, nationality, and dates, plus initials and numbers that refer to the reference works Mallett has indexed. The list of these references, found at the beginning of the book, includes twenty-four general art reference books and 957 selected ones, many of the latter are monographs. For supplement, see next entry.

————. *Supplement to Mallett's Index of Artists.* New York: R. R. Bowker Company, 1940; reprint ed., New York: Peter Smith Publishers, Inc., 1948.

> Covers artists not listed in the 1935 edition; indexes eighteen general art reference works and sixty selected books. Includes a list of early American silversmiths and a necrology, 1935–1940, of artists deceased since their inclusion in the 1935 edition.

Marquis Who's Who Publications: Index to All Books. Chicago: Marquis Who's Who, Inc., 1974.

> Index to the more than 200,000 names found in the ten biographical dictionaries published by Marquis; such as *Who's Who in America* and *Who's Who in the World.*

Mason, Lauris and Ludman, Joan. *Print Reference Sources: A Selected Bibliography 18th–20th Centuries.* 2nd edition. Millwood, New York: Kraus International Publications, 1979.

> Has bibliographical data on about 1,800 printmakers, includes contemporary artists.

New York Times Obituaries Index: 1858–1968. New York: New York Times Company, 1970.

> Over 353,000 names listed; each entry cites year person died, plus the date, page, and column of the original story in the *New York Times.*

Smith, Ralph Clifton. *A Biographical Index of American Artists.* New York: Williams and Wilkins, 1930; reprint ed., Detroit: Gale Research Company, 1976.

> Entries covering about 4,700 artists include dates, media used, and references to citations in forty-two books, catalogues, and dictionaries.

Wodehouse, Laurence. *American Architects from the Civil War to the First World War: A Guide to Information Sources.* Detroit: Gale Research Press, 1976.

————. *American Architects from the First World War to the Present: A Guide to Information Sources.* Detroit: Gale Research Press, 1977.

> Entries under architect's name provides a list of annotated bibliographical references and sometimes the location of archival material such as drawings. First volume lists 221 architects; second, 174. Includes general index and an index to building locations arranged by state followed by city.

————. *British Architects 1840–1976: A Guide to Information Sources.* Detroit: Gale Research Press, 1979.

> Similar organization to the above.

Catalogues of Holdings of Famous Libraries

The catalogue of the holdings of a particular library is a book, or a series of books, that contains reproductions of the cards in the catalogue files of that individual library. This means that all of the reference material of a specific nature contained in the institution just prior to the date of publication is recorded. For clarification on the kinds of data provided on a library's catalogue card, the researcher should read Chapter 4.

This chapter is divided into three kinds of institutions that publish catalogues of their holdings: (1) general art libraries, (2) national libraries, and (3) specialized libraries. The last category is subdivided by kinds of specialization: by professions, by geographic areas, and by centuries of art history. Entries are indexed under the name of the city where the institution is located followed by the name of the library.

In this particular chapter, the list of annotated references is especially long and specialized, because it is often difficult for researchers to obtain detailed information as to which libraries have published catalogues of their holdings and as to what kinds of collections the holdings of the libraries may reflect. Many of the institutions listed under "Specialized Libraries" are not art libraries. Yet, the catalogues of these libraries may be important to the researcher, since the librarians of these institutions often include, among the many indexed works, some art publications as well as numerous historical references. A number of the libraries whose catalogues have been printed are now including their records in one of the bibliographical databases. For some libraries, there will be no additional hardbound supplements published. This does not diminish the usefulness of the catalogues which have been published. These resource tools will continue to be necessary for research.

General Art Libraries

CAMBRIDGE, MASSACHUSETTS, HARVARD UNIVERSITY

Catalogue of the Harvard University Fine Arts Library, the Fogg Art Museum. Boston: G. K. Hall & Company, 1971. 15 volumes. *Catalogue of Auction Sales Catalogues,* 1971. One volume. *First Supplement,* 1975. 3 volumes.

One of the world's largest university art libraries; more than 130,500 volumes included in the 1971 edition. In the *Catalogue of Auction Sales Catalogues,* there are entries for about 20,000 items. Dictionary author-subject catalogue with excellent listings of literature on Romanesque sculpture, Italian primitives, Dutch seventeenth-century art, and master drawings.

For Additional Listings, see entries under "Archaeology," "Architecture," "Italy," and "Classical and Byzantine Periods."

CHICAGO, THE ART INSTITUTE OF CHICAGO

Index to Art Periodicals Compiled in Ryerson Library, The Art Institute of Chicago. Boston: G. K. Hall & Company, 1962. 11 volumes. *First Supplement,* 1974. One volume.

Subject entries with particular emphasis on nineteenth- and twentieth-century painting, decorative art, Oriental art, and Chicago architecture. Begun in 1907, this index covered many periodicals before *Art Index* published its first volume which indexed 1929 material and included periodicals during periods when they were dropped from *Art Index.* Some reproductions are listed. Notations for the *Scrapbook* indicate newspaper articles which have been preserved from Chicago newspapers and which pertain to art and artists in the Chicago area; photocopies of these articles can be obtained through interlibrary loan. Includes articles from about 350 English and foreign-language periodicals.

LONDON, VICTORIA AND ALBERT MUSEUM, SOUTH KENSINGTON NATIONAL ART LIBRARY

National Art Library Catalogue: Author Catalogue. Boston: G. K. Hall & Company, 1972. 10 volumes. *Catalogue of Exhibition Catalogues,* 1972. One volume.

This museum houses the British National Art Library—one of the largest collections of art books

in the world. Specializes in works on design as well as applied and fine arts; tenth volume records works published before 1890. Lists over 50,000 exhibition catalogues from the past 150 years. Because there is no subject indexing, this author catalogue is limited in its usefulness.

The Victoria and Albert Museum Library: Subject Catalogue. London: Mindata, Ltd.

On microfiche, dictionary format with more than 1.5 million entries. Index to artists and names as well as large subject headings such as Archeology, Bronzes, and Sculpture. At the end of each of these special headings has a list of pertinent periodicals and exhibition catalogues. There are 4 separate catalogue sections which can be purchased separately: General Alphabetical Sequence, Fine Art & Archeology, Applied & Minor Arts, and Book Art.

NEW YORK CITY, THE FRICK ART REFERENCE LIBRARY

The Frick Art Reference Library Original Index to Periodicals. Boston: G. K. Hall & Company, 1983. 12 volumes.

An index to the titles of articles in 84 art periodicals dating from mid-19th century. Includes *Gazette des Beaux-Arts,* since 1859 and *Burlington Magazine* from 1903.

NEW YORK CITY, METROPOLITAN MUSEUM OF ART

Library Catalog of the Metropolitan Museum of Art. Boston: G. K. Hall & Company, 2nd edition revised and enlarged, 1980. 48 volumes. *First Supplement,* 1982. One volume.

Author-subject catalogue of one of the largest art museum libraries in the world. Covers the whole history of art; special emphases on the Near and Far East, the classical period, European and American art, and the Pre-Columbian period. Exhibition catalogues are interfiled with the other material. Second edition has about 778,000 entries. Auction catalogues, which are cited in the last three volumes, are listed under subjects, names of collectors, and auction houses. Supplements after the 1982 publication, will no longer list sales catalogues which are now noted in SCIPIO.

NEW YORK CITY, THE RESEARCH LIBRARIES, NEW YORK PUBLIC LIBRARY

Dictionary Catalog of the Art and Architecture Division. Boston: G. K. Hall & Company, 1975. 30 volumes.

Author-subject catalogue of one of the largest research collections in the fine and applied arts. Contains entries for books, exhibition catalogues, and some periodical articles.

Bibliographic Guide to Art and Architecture. 1975. Boston: G. K. Hall & Company. 1975+.

A one-volume annual supplement to *Dictionary Catalog of the Art and Architecture Division.*

For Additional Listings, see entries under "Photography," "Printmaking" and "North American Art and Pacific Region."

OTTAWA, ONTARIO, CANADA, NATIONAL GALLERY OF CANADA

Catalogue of the Library of the National Gallery of Canada. Boston: G. K. Hall & Company, 1973. 8 volumes. *First Supplement, 1980,* 1981, 6 volumes.

Canada's major art library; an author-subject catalogue on the history of Western art from Renaissance to contemporary times. Special emphasis on Canadian art.

SANTA BARBARA, CALIFORNIA, UNIVERSITY OF CALIFORNIA AT SANTA BARBARA

Catalogs of the Art Exhibition Catalog Collection of the Arts Library, University of California at Santa Barbara. New York: Chadwyck Healey, Inc., 1977. Updates 1980 and 1981.

A computer index on microfiches; provides material on the 20,000 catalogues owned by the university. The index includes the following information: (1) name and city of the exhibitor; (2) title of the exhibition catalogue; (3) subject terms which are used to describe or clarify the contents of the catalogue; (4) the year of the exhibition; (5) such data on the catalogue as number of pages and illustrations; (6) notations of the inclusion of bibliographies, chronologies, and bibliographical footnotes; and (7) the name of the author. There are two principal indices: to the exhibitors and to subject categories.

National Libraries

Many countries have a national library; three of the largest of these national reference centers, all of which are discussed in this section, are The British Library, London; the Bibliothèque Nationale, Paris; and the Library of Congress, Washington, D.C. In order for researchers to know what reference materials are contained in these national libraries, the personnel of the institutions have compiled a variety of catalogues of the holdings. Although a definitive list of these catalogues of holdings has not been included in this guide, a representative group of the catalogues has been cited, as well as the title of the books-in-print publication which each of the three library's issues.

LONDON, THE BRITISH LIBRARY (FORMERLY THE BRITISH MUSEUM LIBRARY)

The British Library Publications List. London: The British Library.

General Catalogue of Printed Books to 1955. London: Trusties of British Museum, 1956–65. 263 volumes.
> Regular 5 year supplements; some on microfiche. This is England's depository library that possesses a copy of most books published in Great Britain. Publishes numerous catalogues.

PARIS, BIBLIOTHÈQUE NATIONALE

Les catalogues du département des imprimés. Paris: Bibliothèque Nationale.

Catalogue général des livres imprimés de la Bibliothèque Nationale. Paris: Paul Catin, 1929–1974. 220 volumes.
> Author catalogue of works published before 1960.

Catalogue général des livres imprimés: Auteurs, Collectivités-Auteurs, Anonymes 1960–1964. Paris: Bibliothèque Nationale, 1965–1967. 12 volumes.
> Author catalogue. Volume 11 lists works in Cyrillic; Volume 12, works in Hebrew.

WASHINGTON, D.C., LIBRARY OF CONGRESS

The extensive publications of the Library of Congress—which are available on microfiche, hardbound copies, and databases—include various catalogues, such as (1) the *National Union Catalogs,* abbreviated *NUC,* whose entries are indexed by the names of the authors; (2) *Books: Subjects,* a subject index; (3) *Films and Other Materials for Projection,* which was formerly entitled *Motion Pictures and Filmstrips;* (4) *Monographic Series,* which lists monographs catalogued by the Library of Congress as parts of series; (5) *Music, Books on Music, and Sound Recordings,* previously called *Music and Phonorecords;* (6) *National Register of Microform Masters;* (7) the *National Union Catalog of Manuscript Collections,* which helps scholars, especially those concerned with architecture and history, to locate archival material; and (8) *Newspapers in Microform,* which is subdivided into those of the United States and those of foreign countries. The catalogues pertaining to motion pictures and filmstrips are listed under the category, "Films or Motion Pictures," in this chapter, while annotations for the author and subject catalogues follows:

The National Union Catalog: Pre-1956 Imprints. Chicago: The American Library Association, 1968–1981. 754 volumes.
> A retrospective author catalogue of books published before 1956. Includes listing of holdings of about 650 U.S. and 50 Canadian participating libraries.

A Catalog of Books Represented by the Library of Congress Printed Cards: Issued to July 31, 1942. Paterson, New Jersey: Rowman & Littlefield, Inc., 1963. 167 volumes.

Library of Congress and National Union Catalog Author Lists, 1942–1962: A Master Cumulation. Detroit: Gale Research Company, 1969. 152 volumes.
> Since 1955 the cards represent those catalogued by the Library of Congress and by other libraries contributing to this cooperative cataloguing program; hence the additional name, National Union, by which it will hereafter be called.

The National Union Catalog 1956 through 1967, Books: Author List. Totowa, New Jersey: Rowman & Littlefield, 1970–1972. 125 volumes.

The National Union Catalog: Author List 1968–1972. Ann Arbor, Michigan: J. W. Edwards Publishing, Inc., 1973. 128 volumes.

The National Union Catalog: Author List 1973–77. Totowa, New Jersey: Rowman and Littlefield, 1978. 150 volumes.

The National Union Catalog: Author List 1978–82. Annual cumulations.
> Printed in nine monthly issues, three quarterly cumulations, and in annual and quinquennial cumulations, the *National Union Catalog* contains facsimiles of the Library of Congress printed cards for books, pamphlets, maps, atlases, periodicals, and other serials that were issued during the inclusive dates of the catalogue. An author index to the reference works owned by the Library of Congress and 600 other North American libraries, the *National Union Catalog* generally excludes doctoral dissertations, as well as the works, such as music books and films, which are reported in other Library of Congress publications. These printed catalogues contain abbreviations which indicate the participating U.S. and Canadian libraries that own the material. After December 1982, ceased publication as a hardbound copy. Available on microfiche and computer tape for the *LC MARC Database;* see listing below.

Library of Congress Catalog: Books: Subjects:
> *1950–1954.* Ann Arbor, Michigan: J. W. Edwards Publisher, Inc., 1955. 20 volumes.
> *1955–1959.* Paterson, New Jersey: Pageant Books, Inc., 1960. 22 volumes.
> *1960–1964.* Ann Arbor, Michigan: J. W. Edwards Publisher, Inc., 1965. 25 volumes.
> *1965–1969.* Ann Arbor, Michigan: J. W. Edwards Publisher, Inc., 1970. 42 volumes.
> *1970–74.* Totowa, New Jersey: Rowman & Littlefield, 1976. 100 volumes.
> *1975–82.* Annual cumulations.
> Published in three quarterly issues, plus annual and quinquennial cumulations, these catalogues, which index books that have been catalogued by

the National Union system, use the categories outlined in the thesaurus of terms, the *Library of Congress Subject Headings;* see next entry. Ceased publication in 1982; as of January 1983, merged with *NUC: Author List* into *NUC Books,* see listing below.

Library of Congress Subject Headings. 9th ed. Washington, D.C.: Library of Congress, 1980. 2 volumes.
> A thesaurus which facilitates the use of the Library of Congress Subject Catalogues.

NUC Books. Washington, DC: Cataloguing Distribution Service, 1983 +
> A COM (Computer Output Microfiche) catalogue that combines the *National Union Catalog, Author List, Library of Congress Subject Catalog, Library of Congress Monographic Series,* and *Library of Congress Chinese Cooperative Catalog.* However, the list of libraries that have copies of the works are now in a separate COM catalog entitled *The NUC Register of Additional Locations. NUC Books* consists of the (1) Register, which provides the main entry for the work to which additions are made on a regular basis, and which is organized by author or corporate entry and (2) the 4 indices—by name, title, subject, and name of a series of works—which are cumulated each month or quarter and provide cross references to the main entry in the Register. This provides greater access to the material catalogued by the Library of Congress.

Databases for LC Catalogued Materials
> *The National Union Catalogs* cited above can be searched only by author. *The Library of Congress Catalog: Books: Subjects* has provided subject access just since 1950. Through an online database search, various methods can be used to locate the needed reference—for instance, title, publisher, year, or name of series. There are two major files: *LC MARC* and *REMARC.*

LC MARC Database, DIALOG
> The computer tapes of the English language monographic works processed by the Library of Congress since 1968. For the foreign-language works, the following dates apply: 1973, French; 1975, German, Portuguese, Spanish; 1976–77, other Roman alphabet languages; 1979, South Asian and Cyrillic alphabet languages in romanized form; and 1980, Greek in romanized form. Updated monthly, these files differ from the printed version, in that there is no indication as to which libraries might own the book. These records are available through DIALOG and are also part of the files of OCLC and RLIN.

REMARC Database, DIALOG
> Provides access to the catalogued collections of the U.S. Library of Congress from 1897 to between 1968 and 1980, depending upon the language of the work; see above listing.

National Union Catalog of Manuscript Collections
> Usually published annually. Uses a register format with cumulative indices for 1959–62, 1963–66, 1967–69, 1970–74, 1975–79, and 1980–81. Under name of manuscript collection gives a description of the contents and the location of the material. Can be used to find architectural drawings and the papers of artists and patrons.

Specialized Libraries

By Professions

Archaeology

CAMBRIDGE, MASSACHUSETTS, HARVARD UNIVERSITY

Catalogue of the Library of the Peabody Museum of Archaeology and Ethnology: Authors. Boston: G. K. Hall & Company, 1963. 26 volumes. *Catalogue of the Library of the Peabody Museum of Archaeology and Ethnology: Subjects.* Boston: G. K. Hall & Company, 1963. 27 volumes plus an *Index to Subject Headings. First Supplement,* 1970. 12 volumes. *Second Supplement,* 1971. 6 volumes. *Third Supplement,* 1975. 7 volumes.
> The 1963 editions list about 82,000 publications; includes periodical articles.

Architecture

CAMBRIDGE, MASSACHUSETTS, HARVARD UNIVERSITY

Catalogue of the Library of the Graduate School of Design. Boston: G. K. Hall & Company, 1968. 44 volumes. *First Supplement,* 1970. 2 volumes. *Second Supplement,* 1974. 5 volumes. Third Supplement, 1979, 3 volumes.
> Author-subject-title catalogue, covers about 140,000 volumes, bound periodicals, and theses in the 1968 publication; indexes designers. Covers broad scope of material, such as urban affairs, housing, zoning, pollution, and noise control.

LONDON, ROYAL INSTITUTE OF BRITISH ARCHITECTS, BRITISH ARCHITECTURAL LIBRARY

Catalogue of the Royal Institute of British Architects Library. London: Royal Institute of British Architects, 1937–1938; reprint ed., London: Dawsons of Pall Mall, 1972. 2 volumes.
> First volume is an author catalogue of the books and manuscripts owned by this English library which has one of the world's greatest architectural collections. Second volume contains a classified index and an alphabetical subject index. Covers architecture, archaeology, rare topography prints, landscape and military architecture, sculpture, mosaics, stained glass, tapestries,

armor, costume design, metal work, furniture design, ornament, interior decoration, and city planning. The library owns some early publications in the original editions and has files on more than 1,200 journals and periodicals; receives 225 professional publications in fifteen different languages.

Royal Institute of British Architects. London: World Microfilm.

There are numerous reels being filmed of the actual collection in this library, such as *Comprehensive Index to Architectural Periodicals, 1956–1972,* 21 reels; *Microfilm Collection of Rare Books,* 35 reels; *Unpublished Manuscripts,* 14 reels; *Catalogue of the Great Exhibition, 1851,* 5 reels; and *Transactions and Proceedings 1835–93,* 20 reels.

NEW YORK CITY, COLUMBIA UNIVERSITY, AVERY ARCHITECTURAL LIBRARY

Avery Index to Architectural Periodicals. 2nd ed. Boston: G. K. Hall & Company, 1973. 15 volumes.

One volume supplements 1975, 1977, and 1979. Since 1980, the records have been placed in a specialized online database through RLIN. The library contains one of the world's fine architectural collections. A subject index to articles on architecture, architects, archaeology, decorative arts, interior design, furniture, landscape architecture, city planning, and housing. Emphasizes the historical aspects of the topics. Began indexing in 1934, but has indexed some magazines retrospectively from the first publication date: *American Architect,* 1876; *Architectural Forum,* 1892; *Architectural Record,* 1891; *Progressive Architecture,* 1920.

On-line Avery Index to Architectural Periodicals Database through RLIN.

Records since 1980.

Avery Obituary Index to Architects and Artists. Boston: G. K. Hall & Company, 2nd edition, 1980. One volume.

Entries for the obituary notices which the library staff has collected on about 13,500 people; cites the deceased's dates and the periodical that published the article. Includes some artists, art historians, and city planners.

Catalog of The Avery Memorial Architectural Library. 2nd ed. Boston: G. K. Hall & Company, 1968. 19 volumes. *First Supplement,* 1973. 4 volumes. *Second Supplement,* 1975. 4 volumes. *Third Supplement,* 1977, 3 volumes. *Fourth Supplement,* 1980. 3 volumes.

Covers architecture, archaeology, rare topography prints, landscape and military architecture, sculpture, mosaics, stained glass, tapestries, armor, costume design, metal work, furniture design, ornament, interior decoration, and city planning. The library owns some early publications in the original editions and has files on more than 1,200 journals and periodicals; receives 225 professional publications in fifteen different languages.

Conservation

NEW YORK CITY, NEW YORK UNIVERSITY, INSTITUTE OF FINE ARTS

New York University, Institute of Fine Arts, *Library Catalog of the Conservation Center,* Boston: G. K. Hall & Company, 1980. 1 volume.

Contains over 6,500 volumes related to the study and practice of conservation of works of art.

Decorative Arts

PARIS, BIBLIOTHEQUE FORNEY

Catalogue d'articles de périodiques: Arts décoratifs et beaux-arts (Catalog of Periodical Articles: Decorative and Fine Arts). Boston: G. K. Hall & Company, 1972. 4 volumes.

Subject index to over 1,300 periodical articles from 245 French magazines and 80 foreign ones.

Catalogue des Catalogues de Ventes d'Art (Catalog of the Catalogs of Sales of Art). Boston: G. K. Hall & Company, 1972. 2 volumes.

Lists about 14,000 sales catalogues arranged under collectors, places of sales, and dates of auctions.

Catalogue matières: Arts-décoratifs, beaux-arts, métiers, techniques. Paris: Société des Amis de la Bibliothèque Forney, 1970. 4 volumes. *Supplement,* 1979.

A subject catalogue.

WILMINGTON, DELAWARE, HENRY FRANCIS DU PONT WINTERTHUR MUSEUM

The Winterthur Museum Libraries Collection of Printed Books and Periodicals. Wilmington, Delaware: Scholarly Resources, Inc., 1974. 9 volumes.

The museum houses works of art made or used by Americans between 1600 and 1840; the library reflects this interest. Author-subject index to a collection that greatly emphasizes works on the decorative arts. Volume 8 lists rare books; Volume 9, rare books and auction catalogues.

Education

NEW YORK CITY, COLUMBIA UNIVERSITY

Dictionary Catalog of the Teachers College Library. Boston: G. K. Hall & Company, 1970. 36 volumes. *First Supplement,* 1971. 5 volumes. *Second Supplement,* 1973. 2 volumes. *Third Supplement,* 1970. 10 volumes. Since 1974 updated by annual editions of *Bibliographic Guide to Education.*

Author-subject catalogue of over 400,000 works; library receives more than 1,800 periodicals.

LONDON, NATIONAL FILM ARCHIVE, BRITISH FILM INSTITUTE. Originally called the National Film Library.

Catalogue of the Book Library of the British Film Institute. Boston: G. K. Hall & Company, 1975. 3 volumes.

Divided into four sections: authors, titles, scripts, and subjects. Covers virtually all English-language books on the cinema. Includes over 20,000 book titles, 4,000 film scripts, plus some television and mass-media materials.

National Film Archive Catalogue. London: British Film Institute.

Part I: Silent News Films, 1895–1933, 2nd ed., 1965.

Films listed chronologically by the date the news event occurred or the release date of the film. Each film entry gives a description of the newsreel, all of which are 35 mm. Numbers in parentheses indicate the film footage.

Part II: Silent Non-Fiction Films, 1895–1934, 1960.

Part III: Silent Fiction Films, 1895–1930, 1966.

Part IV: The National Film Archive Catalogue. Volume One: Non-Fiction Films, 1980.

Both Parts II and III have film title entries arranged in chronological order under the name of the country where the film was produced. Each entry provides (1) a list of credits—producer, director, author, script writer, choreographer, photographer, and leading players; (2) a synopsis of the story; (3) the type of film—drama, comedy, cartoon, or detective; and (4) the amount of film footage placed in parentheses. All films are 35 mm. Part II lists over 1,000 titles and provides some bibliographical references; Part III cites about 2,000 titles. Part IV has records for about 10,000 titles.

LOS ANGELES, UNIVERSITY OF CALIFORNIA, THEATER ARTS LIBRARY

Motion Pictures: A Catalog of Books, Periodicals, Screenplays and Production Stills. Boston: G. K. Hall & Company, 1972. 2 volumes.

Volume I is composed of an author index to the books and periodicals as well as a title index to the more than 3,000 unpublished screenplays owned by the library. Volume II lists the more than 86,500 production stills owned. This two-volume work includes only the motion picture holdings of the Theater Arts Library.

WASHINGTON, D.C., LIBRARY OF CONGRESS

Motion Pictures from the Library of Congress Paper Print Collection 1894–1912. Kemp R. Niver, compiler. Los Angeles: University of California Press, 1967.

A list of the paper prints that are bromide paper copies made of early motion pictures and sent to the U.S. Copyright Office to protect the producer's rights before a motion picture copyright law was ratified in 1912. Producers from Europe as well as America made these paper prints, which have now been transferred to motion picture safety film. The over 3,000 films are divided into twelve categories including advertising, cartoons, comedy, newsreels, and vaudeville. Under the film title are given the producer, length of footage, and a synopsis of the film. Various indices are provided including those to directors, to film titles, to major cities, to foreign films, and to sports.

The George Klein Collection of Early Motion Pictures in the Library of Congress: A Catalog. Washington, D.C.: Library of Congress, 1980.

Describes 456 titles produced between 1898 and 1926.

Library of Congress: Motion Pictures: Catalog of Copyright Entries. Washington, D.C.: U.S. Government Printing Office.

Motion Pictures 1894–1912, by Howard Lemarr Walls, 1953.

Motion Pictures 1912–1939, 1951.

Motion Pictures 1940–1949, 1953.

Regular ten year updates. Under the film title each entry lists production company, date, length and type of film, identification of the copyrighter, and notes concerning a series or other titles with which the movie was concerned. Includes an index of producers.

Library of Congress Catalogs: Films and Other Materials for Projection:

Library of Congress Author Catalog: A Cumulative List of Works Represented by the Library of Congress Printed Cards 1948–1952: Films. New York: Rowman & Littlefield, Inc., 1964. *Volume 24* of series.

The National Union Catalog: Motion Pictures and Filmstrips 1953–1957. Totowa, New Jersey: Rowman & Littlefield, Inc., 1966. 2 parts in one volume.

Regular five year updates.

Library of Congress Catalogs: Films and Other Materials for Projection. Washington, D.C.: Library of Congress. One volume.

Published quarterly with annual and quinquennial cumulations. In September, 1951, the librarians of the Library of Congress began issuing printed cards for the motion pictures and filmstrips that were catalogued by the Library of Congress or by institutions cooperating in the National Union Cataloging Program. These printed cards, which were compiled and reproduced in the above catalogues, cover films of educational or instructional value released in the United States and Canada. In 1972, film cataloguing records, transparencies, and slides were included; this necessitated the change in the name of the catalogues in 1973 to reflect this expanded coverage. Each reference is divided into two sections: Part I covers titles; Part II is a subject index.

Each entry lists the title of the work, the releasing company, the viewing time, the author and title of any work upon which the film is based, a summary of the material, and such essential facts as whether or not it is 8mm, 16mm, or a filmstrip; black and white or color; sound or silent. The subject index—which uses the categories indicated in the thesaurus, *Library of Congress Subject Headings,* that is annotated in this chapter under the Library of Congress entry—cites the titles of works that have a fuller entry in Part I of the reference.

Photography

NEW YORK CITY, GEORGE EASTMAN HOUSE

Library Catalog of the International Museum of Photography at George Eastman House. Boston: G. K. Hall & Company, 1982. 4 volumes.

One of the outstanding photographic libraries. An author-title-subject dictionary that includes 47,000 cards for books, articles, and exhibition catalogues. There are special entries for 19th-century books illustrated by photographs.

NEW YORK CITY, NEW YORK PUBLIC LIBRARY

Photographica: A Subject Catalog of Books on Photography. Boston: G. K. Hall & Company, 1983.

Collection especially rich in 19th-century works; about 5,500 entries.

Printmaking

NEW YORK CITY, THE RESEARCH LIBRARIES, NEW YORK PUBLIC LIBRARY

Dictionary Catalog of the Prints Division. Boston: G. K. Hall & Company, 1975. 5 volumes.

Includes the titles of reference works on the history and techniques of printmaking, book illumination, and biographical material on printmakers.

By Geographic Areas

Asia

BERKELEY, CALIFORNIA, THE UNIVERSITY OF CALIFORNIA

East Asiatic Library: Author-Title Catalog. Boston: G. K. Hall & Company, 1968. 13 volumes. *First Supplement,* 1973. 2 volumes.

East Asiatic Library: Subject Catalog. Boston: G. K. Hall & Company, 1968. 6 volumes. *First Supplement,* 1973. 2 volumes.

Includes Chinese, Korean, Japanese, and other Far Eastern materials.

CHICAGO, THE UNIVERSITY OF CHICAGO

Catalogs of the Far Eastern Library. Boston: G. K. Hall & Company, 1973. 18 volumes.

Divided into three sections: *Author-Title Chinese Catalog* (8 volumes), *Author-Title Japanese Catalog* (4 volumes), and *Classified and Subject Index* (6 volumes). Library contains 265,000 volumes, 5,000 reels of microtext, 6,000 pamphlets, and 1,000 periodicals.

WASHINGTON, D.C., SMITHSONIAN INSTITUTION, FREER GALLERY OF ART

Dictionary Catalog of the Library of the Freer Gallery of Art. Boston: G. K. Hall & Company, 1967. 6 volumes.

Indexes about 40,000 books and articles on the art and culture of the Far East, Near East, Indo-China, and India plus James Abbott McNeill Whistler and his contemporaries. Analyzes periodical articles, as most of them are not found in the standard indices. Four volumes are for works in the Western languages, two for Oriental works.

Egypt and the Near East

BROOKLYN, NEW YORK, BROOKLYN MUSEUM

Egyptology Titles. Cambridge, England: Aris & Phillips, Ltd.

Small pamphlet issued quarterly in cooperation with the Faculty of Oriental Studies, University of Cambridge. Replaces *Wilbour Library of Egyptology Acquisitions Lists,* which were published from 1962 to 1972 (19 issues).

CHICAGO, THE UNIVERSITY OF CHICAGO

Catalog of the Oriental Institute Library. Boston: G. K. Hall & Company, 1970. 16 volumes.

Library includes 50,000 volumes and receives 220 journals covering the Near East, Ancient Mesopotamia, Egypt, Palestine, Anatolia, and Iran; owns works published from the sixteenth century to the present.

WASHINGTON, D.C., SMITHSONIAN INSTITUTION, FREER GALLERY OF ART, see entry under "Asia."

Italy

FIRENZE, ITALIA, THE BERENSON LIBRARY

Catalogues of The Berenson Library of the Harvard University Center for Italian Renaissance Studies at Villa I Tatti (Florence, Italy). Boston: G. K. Hall & Company, 1973. 4 volumes.

Collection of books and photography on Italian painting from the late Middle Ages to the Renaissance. Considerable sections on classical art, Near Eastern archaeology, and medieval illuminated manuscripts. Two volumes index the more than 70,000 works by author; two volumes index by subject headings. Exhibition catalogues are included.

FIRENZE, ITALIA, THE INSTITUTE
FOR THE HISTORY OF ART
(KUNSTHISTORISCHES INSTITUT)

Katalog des Kunsthistorischen Instituts in Florenz (Catalog of the Institute for the History of Art in Florence). Boston: G. K. Hall & Company, 1964. 9 volumes. *First Supplement,* 1968. 2 volumes. *Second Supplement,* 1972. 2 volumes.

Author catalogue of about 60,000 volumes concerned with the history of Italian art. All entries are hand-written and thus difficult to read. Each supplement covers about 14,000 titles; includes exhibition and sales catalogues.

North America and the Pacific Region

ANN ARBOR, MICHIGAN,
UNIVERSITY OF MICHIGAN

Author-Title and Chronological Catalogs of Americana, 1493–1860, in the William L. Clements Library. Boston: G. K. Hall & Company, 1970. 7 volumes.

Lists over 30,000 books covering American history from 1493–1860.

BERKELEY, CALIFORNIA,
UNIVERSITY OF CALIFORNIA

The Bancroft Library, University of California, Berkeley: Catalog of Printed Books. Boston: G. K. Hall & Company, 1964. 22 volumes. *First Supplement,* 1969. 6 volumes. *Second Supplement,* 1974. 6 volumes.

Author-subject catalogue of Western North America and the Pacific Islands.

CHICAGO, NEWBERRY LIBRARY

Catalogue of the Everett D. Graff Collection of Western Americana. Chicago: University of Chicago Press, 1968. One volume.

Author-title index to about 4,800 entries.

Dictionary Catalog of the Edward E. Ayer Collection of Americana and American Indians. Boston: G. K. Hall & Company, 1961. 16 volumes. *First Supplement,* 1970. 3 volumes.

Author-subject entries of about 90,000 works; the supplement indexes about 9,500 additional books to the Ayer Collection and 285 to the Graff Collection.

DENVER, COLORADO,
DENVER PUBLIC LIBRARY

Catalog of the Western History Department. Boston: G. K. Hall & Company, 1970. 7 volumes. *First Supplement,* 1975. One volume.

Author-subject catalogue of the West and Southwest; includes over 36,000 works.

HONOLULU, HAWAII, BERNICE
P. BISHOP MUSEUM

Dictionary Catalog of the Library of the Bernice P. Bishop Museum, Boston: G. K. Hall & Company,

1964. 9 volumes plus two supplements of one volume each, issued in 1967 and 1969.

Devoted to the study of the Pacific region.

NEW HAVEN, CONNECTICUT,
YALE UNIVERSITY

Catalog of the Yale Collection of Western Americana. Boston: G. K. Hall & Company, 1961. 4 volumes.

An author-subject catalogue; the fourth volume, a shelf list, is divided into Indian territories.

NEW YORK CITY, RESEARCH LIBRARIES,
NEW YORK PUBLIC LIBRARY

Dictionary Catalog of the History of the Americas Collection. Boston: G. K. Hall & Company, 1961. 28 volumes. *First Supplement,* 1974. 9 volumes.

Author-subject catalogue of over 100,000 volumes on North and South America.

WASHINGTON, D.C., ARCHIVES
OF AMERICAN ART

McCoy, Garnett. *Archives of American Art: A Directory of Resources.* New York: R. R. Bowker Company, 1972. One volume.

Breton, Arthur; Zembala, Nancy; and Nicastro, Anne; compilers. *A Checklist of the Collection.* Washington, D.C.: Archives of American Art, 1975.

The Card Catalogue of the Manuscript Collection of the Archives of American Art. Wilmington, Delaware: Scholarly Resources, Inc., 1980. 10 volumes.

Includes more than 5,000 collections of papers, parts of collections, and individual items. The indexing is chiefly by personal names; there is no subject index.

South America

AUSTIN, TEXAS, THE
UNIVERSITY OF TEXAS

Catalog of the Latin American Collection of the University of Texas. Boston: G. K. Hall & Company, 1969, 31 volumes. *First Supplement,* 1971. 5 volumes. *Second Supplement,* 1973. 3 volumes. *Third Supplement,* 1975. 8 volumes.

Author-subject catalogue; 1969 volumes include about 175,000 works. Some newspapers, especially those published before 1890, are cited.

NEW ORLEANS, TULANE UNIVERSITY

Catalog of the Latin American Library of the Tulane University Library. Boston: G. K. Hall & Company, 1970. 9 volumes. *First Supplement,* 1973. 2 volumes. *Second Supplement,* 1975. 2 volumes.

Previously known as the Middle American Research Institute Library; owns one of the outstanding Latin American holdings.

NEW YORK CITY, THE HISPANIC
SOCIETY OF AMERICA

Catalogue of the Library of the Hispanic Society of America. Boston: G. K. Hall & Company, 1962. 10 volumes. *First Supplement,* 1970. 4 volumes.

Author-subject list of holdings in the Hispanic field including Spain, Portugal, and Hispanic America. There is an author card for every book printed before 1700, although cards for such early works are not included in the subject file; manuscripts and most periodicals are excluded.

Printed Books, 1468–1700, compiled by Clara L. Penny, 1965.

NEW YORK CITY, RESEARCH LIBRARIES, NEW YORK PUBLIC LIBRARY, see listing under "North America and Pacific Region."

By Centuries

Primitive Art

NEW YORK CITY, METROPOLITAN MUSEUM OF ART

Catalog of the Robert Goldwater Library of Primitive Art. Boston: G. K. Hall & Company, 1982. 4 volumes.

Author-title-subject catalogue arranged by geographic locations followed by country and tribe. Library has 25,000 books plus periodicals dating from early 1800 to present.

Classical and Byzantine Periods

ATHENS, GREECE, AMERICAN SCHOOL OF CLASSICAL STUDIES

Catalogue of the Gennadius Library. Boston: G. K. Hall & Company, 1968. 7 volumes. *First Supplement,* 1973. One volume.

Concerned with Greece from antiquity to the present; emphases on the medieval period and on modern times to 1900. Includes works on the beginnings of classical archaeology, 1750–1825.

LONDON, UNIVERSITY OF LONDON

Catalog of The Warburg Institute Library. 2nd ed. Boston: G. K. Hall & Company, 1967. 12 volumes. *First Supplement,* 1971. One volume.

An institute concerned with classical antiquity, its survival and revival, in European civilizations. A subject index to about 60,000 volumes that is divided into four parts: (1) "Social Patterns and History"; (2) "Religion, Magic and Science, Philosophy"; (3) "Literature"; and (4) "Art and Archaeology." Each volume reproduces a list of the sub-headings. Twelfth volume records the reference works in the Reading Room of the Library and includes the periodical list. Sales catalogues are interfiled with the other material.

WASHINGTON, D.C., DUMBARTON OAKS RESEARCH LIBRARY, HARVARD UNIVERSITY

Dictionary Catalogue of the Byzantine Collection of the Dumbarton Oaks Research Library. Boston: G. K. Hall & Company, 1975. 12 volumes.

A collection of over 82,000 volumes; besides Byzantine includes the Greco-Roman world, early and medieval Islam, and the world of the Orthodox Slavs.

Modern Times

NEW YORK CITY, THE MUSEUM OF MODERN ART

Catalog of the Library of the Museum of Modern Art. Boston: G. K. Hall & Company, 1976. 14 volumes.

Author-title-subject catalogue; articles which are not covered by *Art Index* or *Répertoire d'art et d'archéologie* are indexed by subject category only. Includes the book collection of the Department of Photography and some material from the Architecture Study Center and the Film Study Center. The catalogues of all museum and public art galleries are filed under the city where the exhibitor is located followed by the name of the institution. However, private galleries are listed by their distinctive names. MOMA, as the Museum of Modern Art is called, was founded in 1929 and is interested in art since 1850; the library contains about 30,000 bound volumes and 700 periodicals. Provides specialized cataloguing which gives access to publications which can be found nowhere else.

NEW YORK CITY, WHITNEY MUSEUM OF AMERICAN ART

Catalog of the Library of the Whitney Museum of American Art. Boston: G. K. Hall & Company, 1979. 2 volumes.

Contains about 10,000 books and exhibition catalogues, mostly related to 20th-century American art. Sometimes subject entries are provided for individual artists who displayed work in a major group show.

Indexing and Abstracting Services and Databases

In order for others to benefit from a researcher's labor, the results of these efforts should be written, published, and indexed. For if a research report or article is not indexed, the knowledge cannot be easily retrieved by another researcher. Consequently, indices and abstracts are essential for obtaining the titles of the most recently published information on a subject. It often takes from one to three years from the beginning of research to the publication of a magazine article, two to five years for a book, and up to fifteen years or more before new data will be included in a multivolume research publication.

This chapter is divided into seven sections: (1) art abstracts and indices—subdivided into major general abstracts and indices, specialized periodical indices, and one-periodical indices; (2) dissertation and thesis abstracts; (3) humanities and social science indices; (4) newspaper indices; (5) nineteenth-century periodical indices; (6) science, technology, and engineering indices; and (7) specialized bibliographic online databases. A number of the catalogues of famous libraries, which are annotated in Chapter 11, include listings for periodicals; most are not relisted here. A discussion of the definitions of indexing and abstracting services as well as databases is provided in Chapter 2. For details on using the references cited in this chapter, the researcher should consult Chapter 4 under "How to Utilize Abstracts and Indices of Periodical Literature" and "How to Utilize Specialized Bibliographic Online Databases." For a discussion of foreign-language indices, the investigator should read the article "Abstracts and Indices" by Alexander D. Ross, published in *Art Library Manual: A Guide to Resources and Practice;* see listing in Chapter 22.

Art Abstracts and Indices

This section is subdivided into (1) the four major general art abstract and indices to which many libraries subscribe; (2) specialized periodical indices, subdivided by architecture, art education, film research, and photography; and (3) one-periodical indices that cover only an individual serial.

Major General Art Abstracts and Indices

ARTbibliographies MODERN Tony Sloggett, editor. Santa Barbara, California: American Bibliographical Center-Clio Press. Volume 1 (1969)+
> This semi-annual publication is concerned with all kinds of art since 1800. Includes architecture only from historical aspect. The main body of each index provides abstracts of articles from about 125 to 190 magazines and journals; however, the staff screens for possible pertinent material more than 500 periodicals and books plus numerous exhibition catalogues. Including both artists and subjects in one alphabetical listing, the abstracts are divided under more than 150 classifications. Provides an author index and a listing of exhibition catalogues under "Museum and Gallery Index"; the latter entries are cited under the name of the city followed by the name of the museum where the exhibition was held. Covers about 385 art museums and galleries in Europe and North America. All titles of books, articles, and catalogues are listed in their original language with an English translation added. Excludes newspaper articles, book reviews, and obituary notices. The first three volumes, 1969–1971, were published annually under the title, *LOMA: Literature of Modern Art;* the editor was Alexander Davis. For online database, see next entry.

ARTbibliographies MODERN Database, DIALOG. Files from 1974, updates semi-annually.

Art Index. Bertrum Delli, editor. New York: H. W. Wilson Company. Volume 1 (1929)+
> A quarterly author-subject index which at one time had annual, biennial, and triennial cumulations. Since Volume 16 (November 1967–October 1968), only annual cumulations are available. Covers about 200 journals, two-thirds of which are written in the English language. Indexes all forms and periods of art. Exhibition catalogues and books are mentioned only if reviewed in periodicals; under the name of the artist, cites titles of some of the works of art that

are reproduced in the indexed periodicals. Includes some film publications. Since Volume 22 (November 1973–October 1974), book reviews have been listed in a separate section at the end of each volume and are indexed under the name of the author of the book being reviewed. In 1977 began the subheading, "Influence," so that a listing might read "RUBENS, Sir Peter Paul, Influence."

Répertoire d'art et d'archéologie. Joanna Szczepinska-Tramer, editor. Under direction of Comité Français d'Historie de l'Art. Paris: Centre de Documentation Sciences Humaines. Volume 1 (1910)+
 Scans articles from over 1,750 periodicals on art and history from ancient Christian times or about 200 A.D. to the present. Excludes Islamic, Far Eastern, and primitive art. Many entries are annotated. It is an international quarterly; of the materials now indexed, about 30% are written in English, 16% in French. There are no annual cumulation. However, at the end of each year a cumulated index for that year is published; it is composed of four separate indices: to magazines that are indexed, to artists, to subjects, and to authors of the articles. Titles of exhibition catalogues are listed in the "Index des matières." Originally difficult to use and not readily accessible in most libraries, the format was changed in 1973, thus increasing the usefulness of this French art index. Since 1972, excludes post-1940 works of art and artists born after 1920. Supplemented by *Art et archéologie: Proche-Orient, Asie, Amérique,* published quarterly by the Centre National de la Recherche Scientifique of Paris since 1970. Using the same format, *Art et archéologie* covers Near Eastern archaeology, Far Eastern art, and Pre-Columbian art and archaeology. Of the material now indexed, about 39% is written in English, 31% in French. Both of these French abstracts are available on online databases, see next entry.

Repertory of Art and Archeology: Paleochristian Period to 1939, File 530 of the *Francis-H Database,* QUESTEL.
 Files since 1973; updates 8 times a year. Contains same citations as *Répertoire d'art et d'archéologie,* see entry above.

Art and Archeology: Near East, Asia, America, File 526 of the *Francis-H Database,* QUESTEL.
 Files since 1972; updates 8 times a year. Contains same citations as *Art et archéologie,* see entry above.

RILA: International Repertory of the Literature of Art, A Bibliographic Service of The J. Paul Getty Trust. Michael Rinehart, editor. Editorial office Sterling and Francine Clark Art Institute. *Demonstration Issue,* 1973; Volume 1 (1975)+
 Sponsored by the College Art Association of America; Volume I was a two-part double issue covering publications of 1974 and of the first half

of 1975. Published twice a year, *RILA* abstracts articles from about 300 periodicals covering art from the Late Antiquity of the 4th century to the present. Consists of (1) a journal index; (2) the abstracts which are divided into 7 principal categories—reference works; general works; Medieval Art, 4th–14th centuries; Renaissance, Baroque, and Rococo Art, 15th–18th centuries; Neo-Classicism and Modern Art (late 18th century to 1945); Modern Art (1945 to present); and Collections and Exhibitions; (3) under "Exhibition List" provides cross references to the main entries in the abstract section; (4) an author index in which an asterisk denotes a review of an author's book and the numbers refer to the main entries in the abstract section; (5) a subject index which includes individual artists, places, and terms; and (6) a list of abbreviations used in *RILA.* Exhibition catalogues are cited under the name of the city followed by the name of the exhibitor. The individual name of each artist appearing in a group exhibition is usually indexed. Indicates the source of the abstracted material. Includes as many as 1,200 exhibition catalogues a year. An online database for *RILA* is available. Supplemented by the following:

RILA Cumulative Subject Index, 1975–1979, 1980. Merges 9 subject indices of volumes 1 through 5 into one alphabetical listing. Has 2 cumulative lists of authors and of periodicals. Detailed subject indexing to 35,000 bibliographical citations.

RILA Subject Headings, 1983. A comprehensive listing of terms currently used in *RILA.* There are 1,045 cross references which guide the reader to the appropriate term. Includes 4 appendices: geographic divisions, cultural and stylistic designations, subheadings for Christ and the Virgin Mary, and indexing principles and examples.

RILA Database, DIALOG. Records from 1975; updated semi-annually.

Specialized Abstracts and Indices

Architecture

Architectural Index. Erwin J. Bell, editor, Boulder, Colorado: The Architectural Index. Volume 1 (1950)+
 Annual subject index of eight to ten magazines. Articles on works by particular architects are listed under the general subject heading, "Architect or Designer"; specific buildings, under the name of the general building type.

Architectural Periodicals Index. London: Royal Institute of British Architects. Volume 1 (August 1972–December 1973)+
 Since 1933 the staff of the British Architectural Library of the Royal Institute of British Architects, known as RIBA, has published an index to the architectural periodicals received by this library, which is one of the finest architectural libraries in the world. From 1933 until 1972, this

information was published in the quarterly, *RIBA Library Bulletin*. In 1967 the *RIBA Annual Review of Periodical Articles* was published; volume 1 (1965–66) recorded all of the references which had been listed in volume 20 of the *RIBA Library Bulletin*. In 1972 the index was changed to its present name and provided with new volume numbers. This is a subject index which is published quarterly with the last issue being a cumulation for the year. Prior to 1978, only the cumulative issues contained an index of authors, architects, and planners who were mentioned during the year in the quarterly issues. Every quarterly now includes a name index. Since 1978, the cumulative edition has a topological index and an index to names of buildings. Indexes more than 500 international journals; covers numerous engineering and construction periodicals.

Avery Index to Architectural Periodicals: Columbia University. 2nd ed. Boston: G. K. Hall & Company, 1973. 15 volumes. *First Supplement*, 1976. *Second Supplement*, 1977. *Third Supplement*, 1979. *Fourth Supplement*, 1983. All one volumes each.

The Avery Architectural Library has one of the world's finest architectural collections. A subject index to articles on architecture, architects, archaeology, decorative arts, interior design, furniture, landscape architecture, city planning, and housing. Emphasizes the historical aspects of the topics; excludes book reviews and Russian periodicals. Began indexing in 1934, but has indexed some magazines retrospectively from the first publication date: *American Architect*, 1876; *Architectural Forum*, 1892; *Architectural Record*, 1891; and *Progressive Architecture*, 1920. The second edition of this reference includes more than 650 different periodicals. From 1980, material is available only through an online database, see next entry.

On-line Avery Index to Architectural Periodicals Database, RLIN. Files from 1980.

Avery Obituary Index to Architects and Artists. Boston: G. K. Hall & Company, 2nd ed., 1980.

Entries for the obituary notices which the staff of the Avery Architectural Library of Columbia University has collected on about 17,000 people; cites the deceased's dates and the periodical that published the article. Includes architects, archaeologists, and city planners from the 19th and 20th centuries. A clipping file at the Avery Library contains the actual newspaper obituary; copies may be requested from the library.

RIBA Annual Review of Periodical Articles, see listing under *Architectural Periodicals Index* in this section.

Art Education

Art educators have a special group of indices of educational material. Since the results of many educational research projects are not readily accessible to a great number of readers, the U.S. Department of Health, Education, and Welfare has created a means of disseminating this vast amount of data. Through the Educational Resources Information Center, called ERIC, the results of these contributions to the educational field are often made available, for a reasonable price, in paperback copies and on microfiches. For a discussion on how to use the ERIC materials, the reader is referred to the section for art educators in Chapter 8 of this guide.

British Education Index. Librarians of Institutes of Education, compilers. London: Library Association. Volume 1 (1954–1958)+

As of 1975, the index is published quarterly with an annual cumulation; covers over 160 periodicals. Divided into two indices: one to subjects, the other to authors. Book reviews and short news items are excluded; sometimes brief annotations are added.

Current Index to Journals in Education. Phoenix, Arizona: Oryx Press. Volume 1 (1969)+

Conceived as a supplement to *RIE (Resources in Education)*, *CIJE* briefly abstracts articles from more than 780 education and educational-related journals and uses the same descriptors for subjects as does the ERIC (Educational Resources Information Center) publication. *Resources in Education*. *CIJE* is issued monthly with semi-annual cumulations; the latter is composed of two volumes. The first volume contains the main entry section of the abstracts and the journal contents index. The second volume has two indices: to subjects and to authors. Copies of many of the articles are available, for a price through the University Microfilms International; see one of the volumes for details. Use the *Thesaurus of ERIC Descriptors*, see listing under *Resources in Education*. For database search, see entry under ERIC.

Education Index: A Cumulative Author-Subject Index to a Selected List of Educational Periodicals, Proceedings, and Yearbooks. New York: H. W. Wilson Company. Volume I (January, 1929–June, 1930)+

Author-subject index to over 300 periodicals; lists book reviews. Published ten times a year with an annual cumulation.

ERIC (Educational Resources Information Center) see *Resources in Education* for entry on printed copy, *Current Index to Journals in Education* for supplement, and next entry for *ERIC Database*.

ERIC Database, DIALOG, BRS, ORBIT

A computer file of all the material in *Resources in Education* (RIE) and *Current Index to Journals in Education* (CIJE). Files are from 1966 when RIE was initiated; updated monthly. Use *Thesaurus of ERIC Descriptors*, cited at end of this section.

Psychological Abstracts: Nonevaluative Summaries of the World's Literature in Psychology and Related Disciplines. Washington, D.C.: American Psychological Association, Inc. Volume 1 (1927)+

Now published monthly with annual and three-year cumulations. Scans over 900 journals, and 1,500 books and other scientific documents. Useful for checking psychology of color and shapes, aesthetics, and art education research. Divided into three sections, the abstracts plus two indices: to subjects and to authors. All authors, not just the primary one, are listed. The company also has a retrieval service; for additional information the reader should consult the inside back cover of the current issue. The *Thesaurus of Psychological Index Terms,* 3rd ed., published by the American Psychological Association in 1982 will assist the reader in using the index. For online database, see next entry.

Psycinfo Database, DIALOG.

Files of *Psychological Abstracts* with additional material from *Dissertation Abstracts International* date from 1967; updated monthly.

Research in Education, see *Resources in Education.*

Resources in Education. ERIC, Educational Resources Information Center. Washington, D.C.: U.S. Government Printing Office. Volume 1 (1966)+

Published by the U.S. Department of Health, Education, and Welfare, this is one of the most valuable indices for art educators. Most of the research material is available through ERIC Document Reproduction Service. In 1975 changed its name from *Research in Education* to reflect a broader scope of material. This is a monthly abstract journal, which has an annual cumulative index but which has published only a semi-annual cumulative index since 1975. Each issue is divided into four sections: abstracts of documents plus three indices—to subjects, to authors, and to institutions. For a detailed discussion on how to use this material, remember to see Chapter 8. For computer search of material, see *ERIC Database* entry above.

Other References to be Used with ERIC Material

Complete Guide and Index to ERIC Reports: thru December 1969. Englewood Cliffs, New Jersey: Prentice-Hall, Inc. 1970.

Cumulative index for the educational material collected and disseminated by ERIC through 1969; all numbers are for the ED classification. Includes a subject index, an author index, a clearinghouse index, and a numerical title list. Numbers 01001–02740 refer to the abstracts published in *Educator's Complete ERIC Handbook* (see listing below): 02747–03960, to those in *Office of Education Research Reports 1956–65. Résumés* (also cited below); and 10000–31604, to those in the various volumes of *Research in Education.*

Current Index to Journals in Education, see listing this section.

Educational Documents Index 1966–1969. New York: C.C.M. Information Corporation, 1970. 2 volumes. *Educational Documents Index 1970–1971.* New York: C.C.M. Information Corporation, 1972. One volume.

Each index is divided into three sections: (1) a cumulative subject index using ERIC major descriptors, (2) a cumulative subject index using ERIC minor descriptors, and (3) an author index. For an explanation of major and minor descriptors, see Chapter 8.

Educator's Complete ERIC Handbook. Prentice-Hall Editorial Staff, compilers. Englewood Cliffs, New Jersey: Prentice-Hall Inc., 1967.

Abstracts more than 1,700 research reports on education for disadvantaged or culturally deprived children. Has individual chapters on twenty-three pioneering, community educational projects, giving abstracts of the research connected with them. Includes a subject index to these projects.

Office of Education Research Reports 1956–65. Washington, D.C.: U.S. Government Printing Office, 1967. *Résumés and Indexes.* 2 volumes.

The volume, *Résumés,* provides abstracts for about 1,200 research projects, which were received by the Bureau of Research before the publication of *Research in Education.* The other volume indexes the abstracted material by author, by subject, and by institutions under which the research was conducted.

Thesaurus of ERIC Descriptors. Frederick Goodman. compiler. 9th ed. New York: C.C.M. Information Corporation, 1982.

Film Research

Film information is indexed in a number of indices of periodical literature, such as the *Reader's Guide to Periodical Literature,* however, separate indices for current film literature are relatively new. Therefore, it is especially important for the film researcher to also consult the books listed in Chapter 23 under "Bibliographies of Film Literature," since a number of these references have indexed film periodicals retrospectively. Moreover, film-review indices are annotated in Chapter 21 of this guide. For details on how to use the film indices, the reader is referred to the section in Chapter 8: "Film Research."

Film Literature Index. Albany, New York: Filmdex, Inc. Volume I (1973)+

Quarterly author-subject index to about 200 international periodicals: an annual cumulation is available. Film reviews are listed under individual film titles: however, recent publications concerned with the cinema are listed under "Book Reviews."

Photography

International Photography Index. William S. Johnson, editor. Boston: G. K. Hall and Company, Volume 1 (1983)+

Indexes books, articles, and exhibition reviews; covers more than 2,000 photographers. Johnson also edited *An Index to Articles on Photography 1978,* published by Visual Studies Workshop Press, 1979.

Photographic Literature, edited by Albert Boni. New York: Morgan and Morgan, Inc., 1962. 2 volumes. *Volume I: 1927–1960. Volume II: 1960–1970.*

List of about 12,000 books, pamphlets, and articles on subjects and about 200 leading figures in the history of photography.

One-Periodical Indices

Some periodicals include an annual index in the last publication for the year; some have an index every 5 or 10 years. For instance, *Dumbarton Oaks Papers* has an index to volumes 1–20 in the 20th volume; volumes 21–30 in the 30th. Some magazines, a sample of which are cited below, have separate cumulative indices.

Antiques Cumulative Indexes, Volumes I–LX, 1922–1951. New York: Editorial Publications, Inc. A collection of four separate indices, covering Volumes I–XXX, 1922–1936; Volumes XXXI–XL, 1937–1941; Volumes XLI–L, 1942–1946; and Volumes LI–LX, 1947–1951. Each volume of *Antiques* consists of six issues or half a year's subscription. Items in the indices are listed in alphabetical order; entries include titles of articles followed by the surnames of the authors, names of craftsmen accompanied by terms identifying their crafts, and such general subject categories as glass, furniture, and designers. There is a separate listing of book reviews at the end of each index; entries are of the titles of the books reviewed.

Art Bulletin: An Index to Volumes I–XXX, 1913–1948. Rosalie B. Green, compiler. New York: Columbia University Press, 1950.

Art Bulletin Index XXXI–LVI: 1949–73. Janice L. Hurd, compiler. New York: College Art Association, 1980.

Indispensable for discovering the articles written in the *Art Bulletin* magazine before *Art Index* began publication. Material indexed by the authors of articles, the names of artists, the titles of works of art, and subject headings. Reproduces the table of contents for all thirty volumes.

Burlington Magazine: Cumulative Index Volumes I–CIV, 1903–1962. London: Burlington Magazine Publications, Ltd., 1969.

Burlington Magazine 10 Year 1963–1972 Index, 1973. A third index covering 1973–1982 is planned for 1984.

Provides numerous kinds of indices to the first fifty-four volumes. Includes an index to the authors of the articles and one to the titles of the articles; the latter is subdivided by medium and by country. There are two indices to the works of art illustrated in the magazines, one for attributed works, the other for unattributed works. The former are listed under the artist's surname with the name of the owner of the work given in parentheses and the attributed or studio works listed at the end of the entry. Unattributed works of art are subdivided by medium and by country. Book reviews are indexed both by authors of the books and by titles of the books reviewed; the latter category is subdivided by medium and by country. There is an index to the persons for whom obituary notices have been published. Throughout the index the volume numbers of the magazines are in italics followed by the page numbers in Roman type.

Index to the Bulletin of the Metropolitan Museum of Art, Volumes I–XXII, 1905–1927, by Francis B. Hawley. New York: The Metropolitan Museum of Art, 1928.

This subject index updates a previous title index produced in 1916 of the first decade of the *Bulletin.*

Dissertation and Thesis Indices

"Dissertations and Theses on the Visual Arts," by William Innes Homer, published in *Arts in America: A Bibliography,* edited by Bernard Karpel. Washington, D.C.: Smithsonian Institution Press, 1979.

Lists 1,361 titles concerned with American art. This list is kept current at the Archives of American Art; write for information.

Dissertation Abstracts International: Abstracts of Dissertations Available on Microfilm or as Xerographic Reproductions. Ann Arbor, Michigan: Xerox University Microfilms. Volume I (1938)+

Issued monthly with a cumulative author index for each section; receives abstracts from 285 universities. Entitled *Dissertation Abstracts* until Volume 30 (1970) at which time it began to include dissertations from European universities. With Volume 27 (1966–67) it was divided into two sections: (A) Humanities and (B) Sciences. This is a keyword index; an average of about six principal words—words that are actually used in the title of the dissertation and that also describe the subject matter of the dissertation—are chosen as keywords to be used in the indexing. Most of these words are nouns, verbs, or adjectives that introduce an impotant concept. Under each keyword are listed all of the dissertations which have that word in their titles. Each entry cites the complete title of the dissertation, the full name of the author, the date the degree was granted, the school conferring the degree, the number of pages in the dissertation, and an order number if

a copy of the manuscript is available from Xerox University Microfilms. Dissertations without an order number are usually available from the university that granted the degree. See below for database.

Supplemented by:

Comprehensive Dissertation Index, 1861–1972, 1973. 37 volumes.

An index to more than 417,000 dissertations which are listed in *Dissertation Abstracts International, American Doctoral Dissertations,* and the catalogues of the Library of Congress. Volume 17 covers the social sciences; Volumes 20–24, education; Volume 28, history; Volume 31, communications and the arts; and Volumes 33–37, an authors index.

Comprehensive Dissertation Index Supplement.

An annual supplement; same format as the above cited index.

Comprehensive Dissertation Index Database, DIALOG

Files from 1861 to present; updates periodically. Includes information from *Dissertation Abstracts International, American Doctoral Dissertations, Comprehensive Dissertation Index,* and *Masters Abstracts.*

Dissertation Abstract International Database, BRS

Same as entry above but without any citations from *Masters Abstracts.*

Humanities and Social Science Indices

America: History and Life. Santa Barbara, California: ABC-Clio, Inc. Volume 1 (1964)+

Abstracts of articles on America were originally part of *Historical Abstracts* (1955–69). The material was taken from these issues and published as *America: History and Life,* Volume 0. Covering the United States and Canada, this multivolume work is divided into 4 sections: Part A, article abstracts and citations; Part B, index to book reviews; Part C, American history bibliography; and Part D, the annual index. Published at different intervals, the material in the various parts is available through an online database, see next entry.

America: History and Life Database, DIALOG

Files since 1964; updated quarterly.

Annual Magazine Subject Index. Boston: Boston Book Company, 1907–1918 and Boston: F. W. Faxon Company, 1919–1948; reprint ed., divided into two sections, both published Boston: G. K. Hall & Company. *Cumulated Magazine Subject Index, 1907–1949: A Cumulation of the F. W. Faxon Company's Annual Magazine Subject Index,* 1964. 2 volumes. *Cumulated Dramatic Index, 1909–1949: A Cumulation of The F. W. Faxon Company's Dramatic Index,* 1965. 2 volumes.

An annual index that covered articles in 140 to 160 English and American periodicals in the forty-two years it was published; the index specialized in history, art, geography, and travel. First issue, called *Magazine Subject-Index,* covered seventy-nine periodicals.

Arts & Humanities Citation Index. Philadelphia: Institute for Scientific Information. Volume 1 (1979)+

A multivolume work which includes indices to citations, to sources, and to subjects. The citations, which are alphabetized under the names of authors or artists, provide data on books and periodicals that have cited a person's works. Gives specific titles for works of art which are cited. The other indices provide cross references to these citations. An online database will soon be available.

British Humanities Index. London: Library Association. Volume 1 (1962)+

A subject index to about 360 publications, most of which are English; a quarterly with an annual cumulation. Superseded *The Subject Index to Periodicals.*

Historical Abstracts. Santa Barbara, California: ABC-Clio, Inc. Volume 1 (1955)–Volume 16 (1970). *Part A: Modern History Abstracts (1450–1914)* Volume 17 (1971)+ *Part B: Twentieth-Century Abstracts (1914 to the Present)* Volume 17 (1971)+

This multivolume work is issued quarterly with the 4th volume being the cumulative annual index. Since 1969, excludes material on U.S. and Canada; see entry for *America: History and Life.* Five-year cumulative indices are available. Covers about 2,000 journals from 90 countries in 30 languages. See below for online database.

Historical Abstracts Database, DIALOG

Files from 1973; updates quarterly.

Humanities Index. New York: H. W. Wilson Company. Volume 28 (April 1974–March 1975)+

Quarterly with an annual cumulation. Author-subject index to articles in about 300 periodicals: previous volumes listed as *International Index* and *Social Sciences and Humanities Index.* Includes archaeology, broadcasting, drama, film, history, literature, philosophy, and other related areas. Book reviews are listed in a separate section.

International Index: A Guide to Periodical Literature in the Social Sciences and Humanities. New York: H. W. Wilson Company. Volume 1 (1907–1915) to Volume 18 (April, 1964–March, 1965). Starting with Volume 19 was called *Social Sciences and Humanities Index.*

Covers periodicals in such fields as anthropology, history, economics, literature, and sociology.

Magazine Index Database, DIALOG.

A computer file begun in 1976 that covers 370 of the most popular magazines in America, including those indexed by the *Reader's Guide to Periodical Literature.* Indexing material was purchased for these magazines, so the files date

from 1959, but those from 1977 are more inclusive. Has monthly updates. Includes 15 art/architecture/crafts serials, 9 educational magazines, and 7 film and photography publications.

MLA International Bibliography of Books and Articles on the Modern Languages and Literature. New York: Modern Language Association. Volume 1 (1919)+

Covers approximately 3,000 periodicals. Includes data on recently published books. *Festschriften* are indexed as entries as well as by separate essays. See below for database. From 1919–35, title was *American Bibliography.*

MLA Bibliography Database, DIALOG, BRS.

Files since 1970; updates annually.

Reader's Guide to Periodical Literature: An Author and Subject Index. New York: H. W. Wilson Company. Volume 1 (1900–1904)+

Author-subject index to articles in over 180 periodicals; now published semi-monthly—September to January and March to June, monthly—February, July, and August. There is an annual bound cumulation. Lists cinema reviews under "MOTION picture reviews." Covers a wide variety of magazines, such as *American Artists, Atlantic, Ceramics Monthly, Craft Horizons, Film Quarterly, Harper's Bazaar, Mademoiselle, National Geographic Magazine, Newsweek,* and *Time.*

Social Sciences and Humanities Index. New York: H. W. Wilson Company. Volume 19 (1965–1966) to Volume 27 (April, 1973–March, 1974).

An author-subject index to some 200 periodicals in the fields of anthropology, archaeology, area studies, classical studies, economics, geography, history, language and literature, philosophy, political science, religion, sociology, and related subjects. The first eighteen volumes beginning with Volume 1 (1907–1915) were entitled *International Index.* Beginning with Volume 28, it was divided into two publications: *Social Sciences Index* and *The Humanities Index.*

Social Sciences Index. New York: H. W. Wilson Company. Volume 28 (April, 1974–March, 1975)+

Quarterly with an annual cumulation. Author-subject index to articles in about 300 periodicals; previous volumes entitled *International Index* and *Social Sciences and Humanities Index.* Includes anthropology, geography, psychology, sociology, and other related subjects. Book reviews, which are in a separate section, are cited under the name of the author of the book being reviewed.

The Subject Index to Periodicals. London: Library Association, 1915–1961.

Published from 1915 to 1961 except for the years 1923 to 1925. Originally an annual, it was issued quarterly from 1954 to 1961 when it was superseded by *The British Humanities Index.* Divided into a subject index and an author index, it covered over 285 English periodicals.

Newspaper Indices

Many large newspapers are published on microfilm. Unfortunately, there are few of them that have comprehensive indexing, such as the *New York Times* and *The Times* of London. Even these indices are difficult to use. Since the 1970s selective newspaper indexing has been available through databases. This section is divided into (1) indices of selected newspapers—by database searches and by microfiche and (2) indices for individual newspapers—the *New York Times* and *The Times* of London.

Indexing of Selected Newspapers

By Online Database Search

NEXIS has full-text databases for a number of individual newspapers, such as *The New York Times,* since 1980, and *The Washington Post,* since 1977.

The Information Bank Database, formerly the *New York Times Information Services,* now part of NEXIS.

Indexes the *New York Times,* since 1969, and 10 other newspapers—*The Chicago Tribune, The Times* of London, *Washington Post* plus 45 magazines, such as *Time* and *Newsweek.* Most of these other periodicals have been indexed since 1971 to 1974. Files are updated daily, weekly, and monthly.

National Newspaper Index Database, DIALOG.

Since January, 1979 indexes the *New York Times, Wall Street Journal,* and *Christian Science Monitor.* In 1982 began indexing *Washington Post* and *Los Angeles Times.* Updated monthly. Supplemented by *Newsearch Database,* see below.

Newsearch Database, DIALOG.

Covers 1,700 titles daily with complete indexing. Files stay in this database for 45 days and then are divided between 4 other databases: *Magazine Index, National Newspaper Index, Trade and Industry Index,* and *Legal Resource Index.*

Trade and Industry Index Database, DIALOG.

Selective coverage of the 4 newspapers covered by *National Newspaper Index Database* plus more than 280 trade publications. Includes advertising, apparel-fashions, marketing, construction, and interior design periodicals. One of few places where indexing of these journals—such as *Woman's Wear Daily*—are indexed.

By Microfiche

NewsBank Review of the Arts. Greenwich, Connecticut: NewsBank, Inc. First issue (1975)+

An index to information from over 100 newspapers in major U.S. cities excluding *The New York Times.* Reproduces the complete articles on mi-

crofiches. Published monthly plus an annual cumulation of the index. The index is divided into four categories: (1) "Fine Arts and Architecture," (2) "Film and Television," (3) "Literature," and (4) "Performing Arts."

Individual Newspaper Indices

The New York Times published since 1851.

New York Times Index. New York: New York Times Company. Volume I (September, 1851–1862) to volume 15 (1912); new series not listed as volume numbers. First issue (1913)+

Obituary citations listed under "Deaths"; film reviews under "Motion Pictures." In 1974 began including length indicators: *L* stands for a long story of over two columns; *M*, a medium length article of up to two columns; and *S*, for a short item of half a column or less. Sunday sections of the newspaper are identified by Roman numerals following the date. There is no cumulative index for the whole newspaper. However, there are cumulative indices for film reviews, book reviews, and obituary notices; see entries in this section. All of these references, except the film review index, require access to the microfilmed newspaper. Indexed in *The Information Bank Database, National Newspaper Index Database,* and *Newsearch Database.* See entries above.

New York Times Film Reviews: 1913–1968. New York: New York Times Company, 1970. 6 volumes. Plus supplements covering a couple of years of reviews which are published about every other year.

Reprints the entire reviews of the films. Each review includes title and cast credits plus often the name of the director. The sixth volume of the original publication has an addendum, a list of film awards, and a portrait gallery composed of almost 2,000 photographs of movie stars. There is a separate index to film titles, to personal names, and to corporations.

New York Times Book-Review Index, 1896–1970. Wingate Froscker, editor. New York: New York Times Company, 1973. 5 volumes.
Volume I: Author Index
Volume II: Title Index
Volume III: Byline Index
Volume IV: Subject Index
Volume V: Category Index

Almost 800,000 entries in the five volumes. The byline index includes the names of the reviewers or the writers of letters or other items concerned with books. Has published *The Times Thesaurus of Descriptors* to assist in using the subject index; see entry in this section.

New York Times Obituaries Index: 1858–1968. New York: New York Times Company, 1970.

Over 353,000 names listed; each entry cites the year the person died plus the date, page, and column of the obituary in *The New York Times.*

The New York Times Thesaurus of Descriptors: A Guide for Organizing, Cataloguing, Indexing, and Searching Collections of Information on Current Events. 2nd ed. New York: New York Times Company, 1968.

Assists the researcher in using the subject indices.

The Times (London) published since 1790.

Index of the Times. Reading, England: Newspaper Archive Departments, Ltd. First issue (1906)+

Originally published annually, now every two months. No cumulative index; includes *The Times, The Sunday Times, The Sunday Times Magazine, The Times Literary Supplement, The Times Educational Supplement,* including the Scottish edition, and *The Times Higher Education Supplement.* For indexing of articles in earlier editions use *Palmer's Index to The Times, Newspaper (London),* published quarterly from 1790–95, to 1940–41 and reprinted by Kraus Reprint, 1965–66.

Nineteenth-Century Periodical Indices

The Concordia University Art Index to Nineteenth-Century Canadian Periodicals. Hardy George, editor. Montreal: Concordia University, 1981.

Covers 26 journals published from 1830 to 1900.

Cumulative Author Index for Poole's Index to Periodical Literature 1802–1906. C. Edward Wall, editor. Ann Arbor, Michigan: Pierian Press, 1971.

An index to the authors whose works are included in the six Poole subject indices. See listing in this section for *Poole's Index to Periodical Literature.*

Nineteenth-Century Reader's Guide to Periodical Literature 1890–1899, With Supplementary Indexing 1900–1922. Helen Grant Cushing and Adah V. Morris, editors. New York: H. W. Wilson Company, 1944. 2 volumes.

Author-subject index to more than fifty periodicals published in the 1890s; fourteen of the magazines are indexed beyond the 1890–99 period to complete the indexing of the periodical from that date until they were indexed in another of the H. W. Wilson Company's indices. Includes book reviews and such subjects as literature, history, education, and geography. Covers 13 English journals.

Poole's Index to Periodical Literature. William Frederick Poole and William I. Fletcher, compilers. 3rd ed. Boston: J. R. Osgood & Co., 1882; reprint ed., Gloucester, Massachusetts: Peter Smith, 1957. One volume plus 5 supplements.

An index of broad subject categories that covers about 250 periodicals from 1802 to 1881. Supplements index material during the following periods: 1882–1887, 1887–1892, 1892–1896, 1897–1902, and 1902–1906. Titles of the articles are not recorded. For assistance in decipher-

ing the periodical abbreviations use *Transfer Vectors for Poole's Index to Periodical Literature* compiled by Vinton A. Dearing and published by the Pison Press of Los Angeles in 1967. The *Cumulative Author Index for Poole's Index to Periodical Literature 1802–1906* facilitates using the material: see entry above.

Wellesley Index to Victorian Periodicals 1824–1900. Walter E. Houghton, editor. Toronto: University of Toronto Press, 1966. 3 volumes, 4th volume will be published about 1984.
> Each volume includes from 8 to 15 19th-century English magazines. Organized under magazine title, each entry provides a brief history of the serial followed by a record of the table of contents for each issue of the magazine. "Bibliographies of Contributors" lists the authors who had articles in the magazines covered by that specific volume with references to those articles. There is also a list of pseudonyms plus abbreviations used in that volume.

Science, Technology, and Engineering Indices

Art also has a technical aspect. Articles on such items as construction and sculpture materials and chemicals and supplies used by studio artists are indexed by these references.

Applied Science and Technology Index. New York: H. W. Wilson Company. Volume 1 (1913)+
> Published eleven months a year, excluding July, with an annual cumulation. A subject index to about 120 English-language periodicals in such disciplines as industrial and mechanical arts, chemistry, construction, electricity and electronics, engineering, and metallurgy. Volumes 1–45 (1913–1957) entitled *The Industrial Arts Index.*

COMPENDEX Database, see entry below.

Engineering Index: Engineering's First and Most Comprehensive Collection of Time Saving Abstracts on Worldwide Developments in All Related Disciplines. New York: Engineering Index, Inc. Volume 1 (1884–1891)+
> An important index for finding information on technical materials that are used in such art subjects as ceramics and sculpture. A monthly publication with an annual cumulation; the 1975 annual edition (Volume 74) is composed of four books. A subject index to about 2,000 journals and 1,000 reports from conferences. The first book includes a list of abbreviations, units, and acronyms. The last book has (1) an author index that lists all of the authors for each paper that is indexed and (2) an author-affiliation index in which the organizational affiliation of the first author of each report is cited. In the subject index, each entry provides the abstract number, the title of the paper, an abstract, the number of bibliographical references, the author's name and institutional affiliation, and pertinent data on the journal or periodical in which the material was published. The subject headings have been chosen from *Subject Headings for Engineering* published in 1972 by Engineering Index, Inc., with a 1981 supplement, and are accompanied by subheadings and related subjects which can be used for finding relevant entries. A photocopy of most of the material can be obtained, for a fee, from the Engineering Societies Library or the National Technical Information Service; see the first book of the current issue for details. Volume 1 (1884–1891) was entitled *Descriptive Index of Current Engineering Literature;* from 1919 to 1934 the index was published by The American Society of Mechanical Engineers. See below for database.

COMPENDEX Database, DIALOG, ORBIT
> Files from 1970; updates monthly. Computerized version of *Engineering Index.*

COMPENDEX Database, BRS
> Files from 1976; updates monthly. Notice the difference in the date of the DIALOG and the BRS files.

Thesaurus of Engineering and Scientific Terms: A List of Engineering and Related Scientific Terms and Their Relationships for Use As A Vocabulary Reference in Indexing and Retrieving Technical Information. New York: Engineers Joint Council, 1967.
> A revision of the 1964 *Thesaurus of Engineering Terms* published by the Engineers Joint Council. Uses the same format as ERIC materials: *UF* indicates that the term is used for another word; *BT* signifies a broader term; *NT,* a narrower term; and *RT,* a related term. See Chapter 8 for details on how to use ERIC materials.

Specialized Bibliographic Online Databases

New databases are constantly being formed; information on computer searches is frequently out of date before it is printed. This is a list of some of the databases which might produce material for art and art-related subjects. Because the databases are offered by vendors, as discussed in Chapter 2, and these vendors have different methods of charging, no one library will have access to all of these bibliographic databases. In many institutions, only one vendor will be used.

This section is subdivided into (1) a list of databases arranged by subjects and (2) the names and addresses of some important vendors. See Chapter 4, "How to Utilize Specialized Bibliographic Online Databases." For updating the ma-

terial, see *Directory of Online Databases,* Santa Monica, California: Cuadra Associates, Inc., 1979+.

Online Databases and Subjects

In the following list, the databases are cited under various subjects. The vendors, the years the files cover, and the frequency with which the files are updated are recorded. If the database has not been discussed in another entry in this book, some indication of the coverage is provided.

ARCHITECTURE/DESIGN

Cecile, QUESTEL, 1973+, monthly, covers 19th–20th centuries; includes industrial design, visual communication, architecture, and space planning.

Journal of the Society of Architectural Historians, BRS, 1941+, semi-annually, small file covering only this one serial.

On-line Avery Index to Architectural Periodicals, RLIN, 1980+, periodically, see entry this chapter.

ART/GENERAL

ARTbibliographies MODERN, DIALOG, 1974+, semi-annually, see entry this chapter.

RILA, DIALOG, 1975+, semi-annually, see entry this chapter.

Repertory of Art and Archeology, File 530 of *FRANCIS-H,* QUESTEL, 1973+, eight times per year, see entry under *Répertoire d'art et d'archéologie* in this chapter.

Art and Archeology, File 526 of *FRANCIS-H,* QUESTEL, 1972+, eight times per year, see same entry as above.

ART/SALES

ArtQuest, Art Sales Index, Ltd., October 1970+, 9 to 10 times a year, see Chapter 16.

SCIPIO, RLIN, 1980+, periodically, see Chapter 16.

BIOGRAPHY

Biography Master Index, DIALOG, periodically, see Chapter 10.

BOOK REVIEWS

Book Review Index, DIALOG, 1969+, periodically, see Chapter 21.

CURRENT INFORMATION

Information Bank, NEXIS, 1969+, weekly, see entry this chapter.

Magazine Index, DIALOG, 1977+, monthly, see entry this chapter.

National Newspaper Index, DIALOG, 1979+, monthly, see entry this chapter.

New York Times, NEXIS, 1980+, daily, see entry this chapter.

Newsearch, DIALOG, current month only, daily, see entry this chapter.

DISSERTATIONS

Comprehensive Dissertation Index, DIALOG, 1861+, monthly, see entry this chapter.

Dissertation Abstracts International, BRS, see above entry.

EDUCATION

ERIC, DIALOG, BRS, and ORBIT, 1966+, monthly, see entry this chapter.

Ontario Education Resources Information, BRS, 1970+, 6 times a year, corresponds to this Canadian service.

ENGINEERING

COMPENDEX, DIALOG and ORBIT, 1970+, monthly, see entry this chapter.

COMPENDEX, BRS, 1976+, monthly, see entry this chapter.

ENCYCLOPEDIAS

Academic American Encyclopedia, BRS, DIALOG, 1983+, 2 times per year, a full-text document for 30,000 varied topics, includes bibliographies for many of the subjects plus pronunciations of personal names.

LIBRARY

Books in Print, DIALOG and BRS, 1900+, monthly, see Chapter 22.

L C MARC, DIALOG, 1968+, monthly, see Chapter 11.

REMARC, DIALOG, 1897–1980, complete, see Chapter 11.

Ulrich's International Periodicals Directory, DIALOG and BRS, 1980+, monthly, see Chapter 22.

LITERATURE/HISTORY

America: History and Life, DIALOG, 1964+, quarterly, see entry this chapter.

MLA Bibliography, DIALOG and BRS, 1970+, annually, see entry this chapter.

Historical Abstracts, DIALOG, 1973+, quarterly, see entry this chapter.

TRADE & INDUSTRY

Trade & Industry Index, DIALOG, 1981+, monthly, see entry this chapter.

Database Vendors

For information, write or call the following:

Art Sales Index, Ltd., Pond House, Weybridge, Surrey KT13 8SQ, England. Telex: 929476 Apex G (ASI).

BRS, 1200 Route 7, Latham, New York, 12110, (800)–833–4707 in U.S.; (800)–553–5566 in New York State.

DIALOG Information Services, Inc., 3460 Hillview Avenue, Palo Alto, California 94304, (800)–227–1927 in U.S.; (800)–982–5838 in California.

NEXIS, Mead Data Central, 9333 Springboro Pike, P.O. Box 933, Dayton, Ohio 45401, (800)–543–6862.

ORBIT, SDC Information Services, 2500 Colorado Avenue, Santa Monica, California 90406, (800)–421–7229 in U.S.; (800)–352–6689 in California

QUESTEL, Inc., Suite 818, 1625 I Street, N.W., Washington, D.C. 20006, (800)–424–9600.

RLIN, The Research Libraries Group, Inc., Jordan Quadrangle, Stanford California 94305, (415)–328–0920.

Art References

There are numerous books concerned with art published each year. Some are coffee-table books that reproduce beautiful color illustrations but include few, if any, bibliographical references. Other art books have excellent scholarly texts, extensive bibliographical footnotes and bibliographies, but often relatively few color illustrations. Some of the former books are annotated in Chapter 17 of this guide under "Well-Illustrated References"; while some of the latter works are cited in the first section of this chapter. Since it would be impossible to include the titles of all of the numerous art history reference books, only English-language works that cover a group of artists over a long period of time and that are readily available are recorded. The references in this chapter have been divided into eight sections: (1) art history books—multivolume works and important volumes published as a series; (2) references on analyzing works of art; (3) references on ornaments and the migration of art motifs; (4) patrons, collectors, and changes in taste; (5) references on art criticism; (6) documents and sources that reprint, and often translate original documents; (7) bibliographical guides to general art references; and (8) books that can be used to determine the influences on art. For information on why and how to use these art history references, the reader should consult the section in Chapter 4.

Art History Books

Multivolume Art Histories

Friedländer, Max J. *Early Netherlandish Painting.* Translated by Heinz Norden. New York: Phaidon Publishers, Inc., 1967–76. 14 volumes in 16 books. Translation of his *Die altniederländische Malerei,* published 1924–37. Contains bibliographical footnotes; profusely illustrated. Covers from van Eyck to Bruegel; includes a catalogue for each artist's works and a topographical index.

Hofstede de Groot, Cornelis. *A Catalogue Raisonné of the Works of the Most Eminent Dutch Painters of the Seventeenth Century: Based on the Work of J. Smith.* Translated and edited by Edward G. Hawke. London: MacMillian and Company, Ltd.,

1908–1927. 8 volumes. (For reprint, see next entry.) Although there are only descriptions of the paintings, this early catalogue raisonné is indispensable in compiling the provenance of certain works. A table is provided for identifying works described by John Smith whose catalogue raisonné it updates. The original German version, *Beschreibendes und kritisches Verzeichnis der Werke des hervorragendsten holländischen Maler des XVII. Jahrhunderts,* published in 10 volumes, 1907–28, included ten artists that have been deleted from the English text.

———. *A Catalogue Raisonné of the Works of the Most Eminent Dutch Painters of the 17C,* 8 volumes, and *Beschreibendes und kritisches Verzeichnis der Werke des hervorragendsten holländischen Maler des XVII. Jahrhunderts.* 2 volumes. Teaneck, New Jersey: Somerset House, 1976. 10 volumes in 3 books.
A reduced-format facsimile reprint.

Marle, Raimond van. *The Development of the Italian Schools of Painting.* The Hague: M. Nijhoff, 1923–38; reprint ed., New York: Hacker Art Books, 1970. 19 volumes.
A well-illustrated history of Italian painting from the sixth century through the Renaissance painters of Venice. Each volume has a geographical index, an index of artists, and bibliographical footnotes. All of volume six is an iconographical index to the first five volumes. The last volume is a general index by Charlotte van Marle which is divided into two sections: an index to names of places where the paintings were located when Marle's work was published and an index to artists' names.

Pope-Hennessy, John. *An Introduction to Italian Sculpture.* New York: Phaidon Press Ltd., 1970–72. 3 volumes.
Part I: Italian Gothic Sculpture, 2nd ed., 1972.
Part II: Italian Renaissance Sculpture, 2nd ed., 1971.
Part III: Italian High Renaissance and Baroque Sculpture, 2nd ed., 1970.
Biographical data and an extensive bibliography are given after each artist's name in the section, "Notes on the Sculptors and on the Plates." Well illustrated; contains two indices: to places and to sculptors.

Post, Chandler Rathfon. *A History of Spanish Painting.* Volumes 13–14 edited by H. E. Wethey. Cambridge, Massachusetts: Harvard University Press, 1930–66; reprint ed., New York: Kraus Reprint

Company, 1970. 14 volumes in 18 books.

Covers Spanish art from the Pre-Romanesque period to the late Renaissance period in Castille. Each volume, except the second and third, contains a bibliography. The thirteenth and fourteenth volumes have two indices: to artists and to places. There is no general index to the entire work.

Sirén, Osvald. *Chinese Painting: Leading Masters and Principles*. London: Ernest Benn, Ltd., 1928; reprint ed., New York: Hacker Art Books, Inc., 1973. 7 volumes.

The first three volumes, which cover the first millennium of Chinese art, are divided into historical periods. Under each category are the names of individual artists for whom brief biographies and lists of works of art are cited. The second volume has a bibliography and three indices: to Chinese names and terms, to Japanese names and terms, and to Western names. The third volume consists of reproductions of the works of art. Following the same format, the next three volumes cover the later periods of Chinese painting. The fourth volume contains the bibliography; the fifth volume has three indices for names and terms in the Chinese, Japanese, and Western languages; and the sixth volume consists of reproductions. The last volume is composed of an annotated list of paintings and reproductions of paintings by Chinese artists.

————. *Chinese Sculpture from the Fifth to the Fourteenth Century: Over 900 Specimens in Stone, Bronze, Lacquer, and Wood Principally from Northern China*. London: Ernest Benn, Ltd., 1925; reprint ed., New York: Hacker Art Books, 1970. 4 volumes in 2 books.
Volume I: Text
Volumes II-IV: Plates

Includes chapters on general characteristics, evolution of styles, and iconography; has the general index in the first volume. Contains bibliographical footnotes.

Smith, John. *A Catalogue Raisonné of the Works of the Most Eminent Dutch, Flemish, and French Painters*. London: Smith & Son, 1829–42; reprint ed., London: Sands & Company, 1908, 8 volumes in 9 books.

The earliest catalogue raisonné compiled; valuable for establishing the provenance of certain works. Sales prices are usually provided. Includes forty artists: thirty-three Dutch, four Flemish, and three French.

Books in Series

Arts of Mankind. André Malraux and George Salles, general editors. New York: G. Braziller, Odyssey Press, and Golden Press, 1961–1973.

Well-illustrated volumes with glossaries, floor plans, maps, and chronological tables. Have extensive bibliographies and scholarly texts.

Sumer: The Dawn of Art, by André Parrot, 1961.
The Arts of Assyria, by André Parrot. 1961.
Persian Art: The Parthian and Sassanian Dynasties 249 B.C.-A.D. 651, by Roman Ghirshman, 1962.
The Arts of the South Pacific, by Jean Guiart, 1963.
The Arts of Ancient Iran: From Its Origins to the Time of Alexander the Great, by Roman Ghirshman, 1964.
The Birth of Greek Art, by Pierre Demargne, 1964.
The Flowering of the Italian Renaissance, by André Chastel, 1965.
Studios and Styles of the Italian Renaissance, by André Chastel, 1966.
The Golden Age of Justinian: From the Death of Theodosius to the Rise of Islam, by André Grabar, 1967.
African Art, by Michel Leiris and Jacqueline Delange, 1968.
Early Christian Art: From the Rise of Christianity to the Death of Theodosius, by André Grabar, 1969.
Europe of the Invasions, by Jean Hubert, Jean Porcher, and W. F. Volbach, 1969.
The Carolingian Renaissance, by Jean Hubert, Jean Porcher, and W. F. Volbach, 1970.
Rome: The Center of Power, 500 B.C. to A.D. 200, by Ranuccio Bianchi Bandinelli, 1970.
Archaic Greek Art 620 B.C.-480 B.C., by Jean Charbonneaux, Roland Martin, and François Villard, 1971.
Rome: The Late Empire, A.D. 200–400, by Ranuccio Bianchi Bandinelli, 1971.
Classical Greek Art (480–330 B.C.), by Jean Charbonneaux, Roland Martin, and François Villard, 1972.
Hellenisic Art 330 B.C.-50 B.C., by Jean Charbonneaux, Roland Martin, and François Villard, 1973.

Great Art and Artists of the World. New York: Franklin Watts, Inc., 1965. 9 volumes.

Well illustrated; each volume includes an introduction to the historical period followed by biographies of the major artists listing their important works and the titles of one or two monographs on each artist.
Chinese and Japanese Art, edited by Michael Sullivan, 1965.
Origins of Western Art, by Donald E. Strong, Giuseppi Bovini, David Talbot Rice, Peter Lasko, G. Zarnecki, and George Henderson, 1965.
Flemish and Dutch Art, edited by A. M. Hammacher and R. Hammacher Vandenbrande, 1965.
Italian Art to 1850, edited by Mario Monteverdi, 1965.
French Art from 1350 to 1850, edited by Michel Laclotte, 1965.

British and North American Art to 1900, edited by Kenneth Garlick, 1965.

German and Spanish Art to 1900, edited by Horst Vey and Xavier de Salas, 1965.

Impressionists and Post-Impressionists, edited by Alan Bowness, 1965.

Modern Art, edited by David Sylvester, 1965.

History of World Architecture. Pier Luigi Nervi, general editor, New York: Harry N. Abrams, Inc., 1971–1980. 14 volumes.

Well illustrated: good bibliographies. Each volume contains synoptic tables and brief biographies of the architects who are mentioned.

Primitive Architecture, by Enrico Guidoni, 1977.

Ancient Architecture: Mesopotamia, Egypt, Crete, Greece, by Seton Lloyd, Hans Wolfgang Müller, and Roland Martin, 1974.

Roman Architecture, by J. B. Ward-Perkins, 1976.

Byzantine Architecture, by Cyril A. Mango, 1975.

Romanesque Architecture, by Hans Erich Kubach, 1975.

Gothic Architecture, by Louis Grodecki, 1978.

Oriental Architecture, by Mario Bussagli et al., 1974.

Pre-Columbian Architecture of Mesoamerica, by Paul Gendrop and Doris Heyden, 1975.

Islamic Architecture, by John D. Hoag, 1977.

Renaissance Architecture, by Peter Murray, 1971.

Baroque Architecture, by Christian Norberg-Schulz, 1971.

Late Baroque and Rococo Architecture, by Christian Norberg-Schulz, 1974.

Neoclassical and 19th-Century Architecture, by Robin Middleton and David Watkin, 1980.

Modern Architecture, by Manfredo Tafuri and Frencesco Dal Co, 1979.

Landmarks of the World's Art. Bernard S. Myers and Trewin Copplestone, general editors. New York: McGraw-Hill, Inc., 1965–1967. 10 volumes.

Surveys the history of general art periods; numerous illustrations, many in color. Each volume includes biographical notes on the artists, a selected bibliography, plus sometimes a glossary and a chronological table.

Prehistoric and Primitive Man, by Andreas Lommel, 1966.

The Ancient World, by Giovanni Garbini, 1966.

The Classical World, by Donald Strong, 1965.

The Early Christian and Byzantine World, by Jean Lassus, 1967.

The World of Islam, by Ernst J. Grube, 1967.

The Oriental World, by Jeannine Auboyer, 1967.

The Medieval World, by Peter Kidson, 1967.

Man and the Renaissance, by Andrew Martindale, 1966.

The Age of Baroque, by Michael Kitson, 1966.

The Modern World, by Norbert Lynton, 1965.

Library of Art History. Horst Woldeman Janson, general editor. Englewood Cliffs, New Jersey: Prentice-Hall, Inc. and New York: Harry N. Abrams, Inc., 1970–1976. 5 volumes.

Well illustrated; each volume has bibliographical footnotes grouped at the end of the book and an extensive bibliography that emphasizes English-language references.

Art of the Ancient World: Painting, Pottery, Sculpture, Architecture, by Henriette A. Groenewegen-Frankfort and Bernard Ashmole, 1972.

Art of the Medieval World: Architecture, Sculpture, Painting and the Sacred Arts, by George Zarnecki, 1976.

History of Renaissance Art: Painting, Sculpture, Architecture Throughout Europe, by Creighton Gilbert, 1973.

17th and 18th Century Art: Baroque Painting, Sculpture, and Architecture, by Julius S. Held and Donald Posner, 1971.

19th and 20th Century Art: Painting, Sculpture, Architecture, by George Heard Hamilton, 1970.

Oxford History of Art. Thomas Sherrer Ross Boaz, general editor. London: Oxford University Press. 1949–.

Each illustrated book has an extensive bibliography. Eleven volumes are projected.

Volume II: English Art 871–1100, by David Talbot Rice, 1952.

Volume III: English Art 1100–1216, by Thomas Sheerer Ross Boaz, 1953.

Volume IV: English Art 1216–1307, by Peter Brieger, 1957.

Volume V: English Art 1307–1461, by Joan Evans, 1949.

Volume VII: English Art 1553–1625, by Eric Mercer, 1962.

Volume VIII: English Art 1625–1714, by Margaret Whinney and Oliver Millar, 1957.

Volume IX: English Art 1714–1800, by Joseph Burke, 1975.

Volume X: English Art 1800–1870, by Thomas Sherrer Ross Boaz, 1959.

Volume XI: English Art 1870–1940, by Denis Farr, 1979.

Panorama of World Art. New York: Harry N. Abrams, Inc., 1968–1971. 10 volumes.

Numerous illustrations, many in color.

Prehistoric European Art, by Walter Törbrugge, 1968.

Art of the Ancient Near and Middle East, by Carel J. du Ry van Beest Halle, translated by Alexis Brown, 1969.

Art of Rome, Etruria, and Magna Graecia, by German Hafner, 1971.

Art of India and Southeast Asia, by Hugo Munsterberg, 1970.

Art of Islam, by Carel J. du Ry van Beest Halle, translated by Alexis Brown, 1971.

Art of the Byzantine World, by Christa Schug-Wille, 1969.

Art of the Dark Ages, by Regine Dölling and Magnus Backes, 1969.

Art of the Early Middle Ages, by François Souchal, 1968.

Renaissance and Mannerist Art, by Robert Erich Wolf, 1968.

Art of Nineteenth Century Europe, by Jurgen Schultze, 1970.

Pelican History of Art. Nikolaus Pevsner and Judy Nairn, joint editors. Baltimore, Maryland: Penguin Books, Inc., 1953–

Considered some of the best research volumes written. Each book has a scholarly text accompanied by bibliographical footnotes, a glossary, and an extensive foreign-language bibliography. Well illustrated by floor plans, drawings, and black-and-white reproductions.

Prehistoric Art in Europe, by Nancy K. Sandars, 1975.

Art and Architecture of the Ancient Orient, 4th revised edition, by Henri Frankfort, 1970.

Art and Architecture of Ancient Egypt, by W. Stevenson Smith, 1958.

Art and Architecture of India: Buddhist, Hindu, Jain, 3rd edition revised, by Benjamin Rowland, 1967.

Art and Architecture of China, revised edition, by Laurence Sickman and Alexander Soper, 1971.

Art and Architecture of Japan, revised edition, by R. T. Paine and Alexander Soper, 1974.

Art and Architecture of Russia, 2nd edition, by George Heard Hamilton, 1976.

Art and Architecture of Ancient America, 2nd edition, by George Kubler, 1976.

Arts in Preshistoric Greece, by Sinclair Hood, 1978.

Greek Architecture, by Arnold W. Lawrence, 1962.

Etruscan and Roman Architecture, by Axel Boethius and John Ward-Perkins, 1970.

Roman Art, by Donald Strong, 1976.

Roman Imperial Architecture. 2nd edition, by John B. Ward-Perkins, 1981.

Early Christian and Byzantine Art, by John Beckwith, 1970.

Early Christian and Byzantine Architecture, by Richard Krautheimer, 1965.

Painting in Europe 800–1200, by Charles Dodwell, 1971.

Ars Sacra 800–1200, by Peter Lasko, 1972.

Carolingian and Romanesque Architecture: 800–1200, revised edition, by Kenneth John Conant, 1974.

Architecture in Britain: The Middle Ages, by Geoffrey F. Webb, 2nd edition, 1965.

Painting in Britain: The Middle Ages, 2nd edition, by Margaret Josephine Rickert, 1965.

Sculpture in Britain: The Middle Ages, by Lawrence Stone, 1955.

Gothic Architecture, by Paul Frankl, 1963.

Art and Architecture in Italy: 1250–1400, by John White, 1966.

Sculpture in Italy: 1400–1500, by Charles Seymour, Jr., 1966.

Sculpture in the Netherlands, Germany, France, and Spain: 1400–1500, by Theodor Müller, 1966.

Architecture in Italy: 1400–1600, by Ludwig Heydenreich and Wolfgang Lotz, 1974.

Painting in Italy: 1500–1600, by Sydney Joseph Freeberg, 1971.

Painting and Sculpture in Germany and the Netherlands: 1500–1600, by Gert von der Osten and Horst Vey, 1969.

Art and Architecture in Spain and Portugal and Their American Dominions: 1500–1800, by George Kubler and Martin Soria, 1959.

Art and Architecture in France: 1500–1700, revised edition, by Anthony Blunt, 1973.

Art and Architecture in Italy: 1600–1750, revised edition, by Rudolf Wittkower, 1973.

Art and Architecture of the Eighteenth Century in France, by Wend G. Kalnein and Michael Levey, 1973.

Painting in Britain: 1530–1790, by Ellis K. Waterhouse, 4th edition, 1978.

Sculpture in Britain: 1530–1830, by Margaret D. Whinney, 1964.

Architecture in Britain: 1530–1830, revised edition, by John N. Summerson, 1963.

Art and Architecture in Belgium: 1600–1800, by Horst Gerson and E. H. ter Kuile, 1960.

Dutch Art and Architecture: 1600–1800, by Jakob Rosenberg, Seymour Slive, and E. H. ter Kuile, 3rd edition, 1977.

Baroque Art and Architecture in Central Europe, by Eberhard Hempel, 1965.

England in the Eighteenth Century, by John Harold Plumb, 1963.

Painting and Sculpture in Europe: 1780–1880, by Fritz Novotny, 1960.

Painting and Sculpture in Europe: 1880–1940, revised edition, by George Heard Hamilton, 1972.

Architecture: 19th and 20th Centuries, 3rd edition, by Henry Russell Hitchcock, 1968.

American Art, by John Wilmerding, 1976.

Propyläen Kunstgeschichte. Berlin: Propyläen Verlag. 1966–

Each volume—which reproduces numerous illustrations, most of which are in black-and-white—includes drawings, floor plans, and elevations of buildings; an extensive catalogue entry for every illustration; an index to abbreviations; an extensive bibliography; a synoptic table; and an index to names and subjects. Several similar series were previously published by the same company; for a listing of these earlier titles, the reader should consult the book by Mary Chamberlin which is annotated in this chapter under "Bibliographical Guides to General Art Reference Material."

Die Griechen und Ihre Nachbarn, by Karl Schefold, 1967.

Das römische Weltreich, by Theodor Kraus, 1967.

Byzanz und der christliche Osten, by Wolfgang Fritz Volbach and Jacqueline Lafontaine-Dosogne, 1968.

Die Kunst des Islam, by Janine Sourdel-Thomine and Bertold Spuler, 1973.

Das Mittelalter I, by Hermann Fillitz, 1969.

Das Mittelalter II: Das Hohe Mittelalter, by Otto von Simson, 1972.

Spätmittelalter und Beginnende Neuzeit, by Jan Bialostocki, 1972.

Die Kunst des 16. Jahrhunderts, by George Kauffmann, 1970.

Die Kunst des 17. Jahrhunderts, by Erich Hubala, 1970.

Die Kunst des 18. Jahrhunderts, Harald Keller, 1971.

Die Kunst des 19. Jahrhunderts, by Rudolf Walter Zeitler, 1966.

Die Kunst des 20. Jahrhunderts, 1880–1940, by Guilio Carlo Argan, 1972.

Frühe Stufen der Kunst, by Machteld Johanna Mellink and Jan Filip, 1974.

Der alte Orient, by Winfried Orthmann, 1975.

Das alte Ägypten, by Claude Vandersleyen, 1975.

Indien und Südostasien, by Herbert Härtel and Jeannine Auboyer, 1971.

China, Korea, Japan, by Jan Fontein and Rose Hempel, 1968.

Das alte Americka, by Gordon R. Willey, 1974, Supplements:

Spätantike und frühes Christentum, by Beat Brenk, et al., 1977.

Kunst der Gegenwart, by Edward Lucie-Smith, et al., 1978.

Kunst der Völkerwanderungazeit, by Helmut Roth, 1979.

Das Porzellan de europäischen Manufakturen, by Friedrich H. Hofmann et al., 1980.

Time-Life Library of Art. Horst Woldemar Janson, consulting editor. New York: Time-Life Books, 1966–1970. 28 volumes.

Numerous illustrations, many in color. Each volume includes a discussion of the historical background of the period, reproductions of famous works of art which were produced during that time, and brief bibliographies. The last volume, *Seven Centuries of Art,* provides a general survey of art and an index to all of the artists mentioned in the complete series.

The World of Bernini, by Robert Wallace, 1970.

The World of Bruegel, by Timothy Foote, 1968.

The World of Cézanne, by Richard W. Murphy, 1968.

The World of Copley, by Alfred Frankenstein, 1970.

The World of Delacroix, by Tom Prideaux, 1966.

The World of Marcel Duchamp, by Calvin Tomkins, 1966.

The World of Dürer, by Francis Russell, 1967.

The World of Gainsborough, by Jonathan Norton Leonard, 1969.

The World of Giotto, by Sarel Eimerl, 1967.

The World of Goya, by Richard Schickel, 1968.

The World of Winslow Homer, by James Thomas Flexner, 1969.

The World of Leonardo, by Robert Wallace, 1966.

The World of Manet, by Pierre Schneider, 1968.

The World of Matisse, by John Russell, 1969.

The World of Michelangelo, by Robert Coughlan, 1966.

The World of Picasso, by Lael T. Wertenbaker, 1967.

The World of Rembrandt, by Robert Wallace, 1968.

The World of Rodin, by William Harlan Hale, 1969.

The World of Rubens, by Cicely Veronica Wedgewood, 1967.

The World of Titian, by Jay Williams, 1968.

The World of Turner, by Diana Hirsh, 1969.

The World of Van Gogh, by Robert Wallace, 1969.

The World of Velazquez, by Dale Brown, 1969.

The World of Vermeer, by Hans Koningsberger, 1967.

The World of Watteau, by Pierre Schneider, 1967.

The World of Whistler, by Tom Prideaux, 1970.

American Painting: 1900–1970, by the Editors of Time-Life Books, 1970.

Seven Centuries of Art, by the Editors of Time-Life Books, 1970.

Style and Civilization. Baltimore, Maryland: Penguin Books, Inc., 1967–1975. 11 volumes.

In-depth discussions of artistic styles.

Pre-Classical: From Crete to Archaic Greece, by John Boardman, 1967.

Byzantine Style and Civilization, by Steven Runciman, 1975.

Early Medieval, by George Henderson, 1972.

Gothic, by George Henderson, 1967.

Early Renaissance, by Michael Levey, 1967.

High Renaissance, by Michael Levey, 1975.

Mannerism, by John Shearman, 1967.

Baroque, by John Rupert Martin, 1977.

Neo-Classicism, by Hugh Honour, 1968.

Romanticism, by Hugh Honour, 1979.

Realism, by Linda Nochlin, 1971.

References on Analyzing Works of Art

Arnheim, Rudolf. *Art and Visual Perception: A Psychology of the Creative Eye.* London, Faber & Faber, Ltd., 1954; reprint edition, Berkeley: University of California Press, 1974.

Discusses balance, shape, form, growth, space, light, color, movement, tension, and expression.

————, *Visual Thinking.* Berkeley, California: University of California Press, 1969.

Discusses images of thought, concepts of shape, symbols, abstraction, and art and thought.

Art in Context. John Fleming and Hugh Honour, editors. New York: Viking Press, 1972–76. 18 volumes.

Each book covers the historical aspects of an individual work of art, providing a color reproduction of the discussed work plus numerous black-and-white illustrations. Each volume includes an historical table of events.

Van Eyck: "The Ghent Altarpiece," by Elisabeth Dhanens, 1973.

Turner: "Rain, Steam and Speed," by John Gage, 1972.

Edward Munch: "The Scream," by Reinhold Heller, 1973.

David, Voltaire, "Brutus," and the French Revolution: An Essay in Art and Politics, by Robert L. Herbert, 1973.

Leonardo: "The Last Supper," by Ludwig H. Heydenriech, 1974.

Monet: "Le déjeuner sur l'herbe," by Joel Isaacson, 1972.

Trumbull: "The Declaration of Independence," by Irma B. Jaffe, 1976.

Piero della Francesca: "The Flagellation," by Marilyn Aronberg Lavin, 1972.

Courbet: "The Studio of the Painter," by Benedict Nicolson, 1973.

Watteau: "A Lady at Her Toilet," by Donald Posner, 1973.

Fuseli: "The Nightmare," by Nicolas Powell, 1973.

Van Dyck: "Charles I on Horseback," by Roy C. Strong, 1972.

Poussin: "The Holy Family on the Steps," by Howard Hibbard, 1974.

Manet: "Olympia," by Theodore Reff, 1976.

Marcel Duchamp: "The Bride Stripped Bare by her Bachelors, Even," by John Golding, 1973.

Delacroix: "The Death of Sardanapolus," by Jack J. Spector, 1974.

Goya: "The Third of May 1808," by Hugh Thomas, 1972.

The Statue of Liberty, by Marvin Trachtenberg, 1976.

Berenson, Bernhard B. *Rudiments of Connoisseurship: Study and Criticism of Italian Art.* New York: Schocken Books, 1962.

A paperback edition of *The Study and Criticism of Italian Art,* 1902. The last chapter, "Rudiments of Connoisseurship," details some ways to establish the artist of a work of art.

Bouleau, Charles. *The Painter's Secret Geometry: A Study of Composition in Art.* Translated by Jonathan Griffin. New York: Harcourt, Brace & World, Inc., 1963.

A well-illustrated book that presents an in-depth study of the structural analyses of paintings from Medieval to modern times.

Feldman, Edmund Burke. *Varieties of Visual Experience.* Basic edition. Englewood Cliffs, New Jersey: Prentice-Hall, Inc., 1973.

Profusely illustrated book which is divided into four main parts: the functions of art, the structure of art, the interaction of medium and meaning, and the problems of art criticism. Includes a bibliography and two indices: to names and works and to subjects. Abridged edition of *Art as Image and Idea,* 1967.

Hauser, Arnold. *The Social History of Art.* Translated by Stanley Godman. New York: Alfred A. Knopf, Inc., 1951; reprint ed., New York: Vintage Books, 1957–58. Original edition in 2 volumes; reprint in 4 books.

Provides an historical background for art from prehistoric times to the film age.

Huberts, Kurt. *The Complete Book of Artists' Techniques.* New York: Frederick A. Praeger, 1958.

Profusely illustrated book explaining various kinds of art: techniques dependent on the support or ground, on the material, and on the tools. Appendix includes an article on reconstructing historical techniques.

Kleinbauer, W. Eugene. *Modern Perspectives in Western Art History: An Anthology of 20th-Century Writings on the Visual Arts.* New York: Holt, Rinehart & Winston, Inc., 1971.

Introduction includes discussion of art history, determinants of art historical investigation, and genres of modern scholarship. Takes two perspectives and reprints articles that illustrate these principles: (1) intrinsic perspectives—connoisseurship, syntactical analysis, formal change, period distinctions, documentary studies in architectural history, plus iconography and iconology; and (2) extrinsic perspectives—art history and psychology; art history, society, and culture; plus art history and the history of ideas.

———— and Slavens, Thomas P. *Research Guide to the History of Western Art.* Chicago: American Library Association, 1982.

Part I, which is concerned with art history, includes chapters on art history and its related disciplines, determinants of writing art history, studying the art objects, perspectives on change, psychological approaches, and art and society. Provides brief discussions of historical aspects of art history; each chapter has lengthy bibliographies.

Knobler, Nathan. *The Visual Dialogue: An Introduction to the Appreciation of Art.* New York: Holt, Rinehart and Winston, Inc., 1967.

Includes numerous black-and-white and color reproductions of works of art plus line drawings that illustrate the text. Explains the principles, media, and vocabulary of art.

Panofsky, Erwin, "The History of Art as a Humanistic Discipline" and "Three Decades of Art History in the United States," reprinted in *Meaning in the Visual Arts.* Garden City, New York: Doubleday & Company, Inc., 1955; reprint ed., New York: Overlook Press, 1974.

> A must for anyone who has not read these classics.

Preble, Duane. *Artforms.* New York: Canfield Press, 1973.

> Second edition of *Man Creates Art Creates Man.*

Roskill, Mark. *What Is Art History?* New York: Harper & Row, 1976.

> A discussion of the discipline; includes case histories of some historical detective work.

Schapiro, Meyer, "Style," reprinted in several anthologies: *Anthropology Today,* edited by A. L. Kroeber, Chicago: University of Chicago Press, 1953 and *Aesthetics Today,* edited by Philipson Morris. Cleveland: Meridan Press, 1961.

> Important essay

Weismann, Donald L. *The Visual Arts As Human Experience.* Englewood Cliffs, New Jersey: Prentice-Hall, Inc., 1974.

> Well-illustrated book on the visual elements in art; has an excellent section on the illusion of space in art.

References on Ornaments and the Migration of Art Motifs

Evans, Joan. *Pattern: A Study of Ornament in Western Europe from 1180 to 1900.* Oxford: Clarendon Press, 1931; reprint ed., New York: Hacker Art Books, 1975. 2 volumes.

> Well-illustrated history of ornament; includes bibliographical footnotes. Volume I covers the period from 1180 to the Renaissance; Volume II, Renaissance to 1900 and the general index.

Glazier, Richard. *A Manual of Historic Ornament: Treating Upon the Evolution, Tradition, and Development of Architecture and the Applied Arts Prepared for the Use of Students and Craftsmen.* 5th ed. revised. New York: Charles Scribner's Sons, 1933; reprint ed., Detroit: Gale Research Company, 1972.

> Divided into two parts: historical accounts and various applied arts. First edition in 1899.

Hamlin, Alfred Dwight Foster. *A History of Ornament.* New York: Century Company, 1916; reprint ed., New York: Cooper Square Publishers, Inc., 1973. 2 volumes.
Volume I: Ancient and Medieval
Volume II: Renaissance and Modern

> Well illustrated; each volume has a separate index and each chapter has a bibliography.

Jairazbhoy, Rafique Ali. *Oriental Influences in Western Art.* New York: Asia Publishing House, 1965.

> Traces motifs from Eastern to Western art. Covers decorative use of Arabic lettering, inlay, tour-

nament scenes, hunting scenes, dragon genera, kingship of heroes, zoomorphic frieze, fused and interlocked fauna, lions as guardians, and the ascension theme. Includes three indices: to names, to places, and to subjects.

Jones, Owen. *The Grammar of Ornament.* New York: J. W. Bouton, 1880; reprint ed., New York: Van Nostrand Reinhold Company, 1972.

> Describes and traces principal motifs used by various civilizations, such as primitive societies, Egyptian, Grecian, Roman, Arabic, Persian, and Indian, plus the motifs used in different periods of art history, such as the Middle Ages, Renaissance, and Elizabethan. Profusely illustrated by line drawings; first edition in 1856.

Mackenzie, Donald A. *The Migration of Symbols and Their Relations to Beliefs and Customs.* New York: Alfred A. Knopf, 1926; reprint ed., Detroit: Gale Research Company, 1968.

> Taking four symbols—swastika, spiral, ear symbols, and tree symbols—Mackenzie traces their development and variations in different cultures. Illustrated, mostly with drawings.

Slomann, Vilhelm. *Bicorporates: Studies in Revivals and Migrations of Art Motifs.* Edited by Ulla Haastrup. Translated by Eve M. Wendt. Copenhagen: Munksgaard, 1967. 2 volumes.

> Traces the sources and migration of bicorporates which are representations of animals or men with two bodies and a single head that appeared in Western Europe during the eleventh century. Volume I, which is the text, includes bibliographical footnotes and an extensive bibliography. Volume II consists of over 700 illustrations.

Speltz, Alexander. *Styles of Ornament: From Prehistoric Times to the Middle of the Nineteenth Century.* Translated by David O'Conor from the 2nd ed. revised by R. Rhene Spiers. New York: E. Weyhe Company, 1910; reprint ed., New York: Dover Publications, Inc., 1959.

> Illustrated guide to historic ornaments.

Stafford, Maureen and Ware, Dora. *An Illustrated Dictionary of Ornament.* New York: St. Martin's Press, 1974.

> Dictionary of terminology associated with ornament; profusely illustrated by drawings. Includes a selected bibliography and an index to persons and places. Lists and illustrates the heraldic ornaments.

Patrons, Collectors, and Changes in Taste

Dickens, A. G., editor. *The Courts of Europe: Politics, Patronage and Royalty 1400–1800.* New York: McGraw-Hill Book Company, 1977.

> An historical discussion which includes art patronage. Has some geneological charts of the ruling families. Illustrated; has bibliography.

179

Haskell, Francis. *Patrons and Painters: A Study in the Relations Between Italian Art and Society in the Age of the Baroque.* Revised edition. New Haven, Connecticut: Yale University Press, 1980.

A discussion of patronage of the popes and the nobility. Well footnoted; lengthy bibliography.

————. *Rediscoveries in Art: Some Aspects of Taste, Fashion, and Collecting in England and France.* 2nd edition. Ithaca, New York: Cornell University Press, 1979.

Discusses the influences on the changes in artistic taste from about 1780 to 1870. Well footnoted; excellent bibliography.

———— and Penny, Nicholas. *Taste and the Antique: The Lure of Classical Sculpture 1500–1900.* New Haven, Connecticut: Yale University Press, 1981.

Part I discusses the influences on the artistic changes during these centuries. Part II is a scholarly catalogue of more than 90 of the most celebrated classical statues; each entry is illustrated. Includes lengthy bibliography.

Holst, Niels von. *Creators, Collectors and Connoisseurs: An Anatomy of Artistic Taste from Antiquity to the Present Day.* London: Thames and Hudson, 1967.

Well-illustrated, footnoted discussion of the history of collecting. Extensive bibliography.

Levey, Michael. *Painting at Court.* New York: New York University Press, 1971.

Well-illustrated discussion of royal patronage of art between the 14th and 19th centuries.

Plumb, J. H. and Wheldon, H. U. W. *Royal Heritage: The Treasures of the British Crown.* New York: Harcourt Brace Jovanovich, 1977.

Well-illustrated book which was published in co-ordination with the television series.

Saarinen, Aline. *The Proud Possessors: The Lives, Times, and Tastes of Some Adventurous American Art Collectors.* New York: Random House, 1958.

Essays on 15 American collectors; includes list of resources.

Taylor, Frances Henry. *The Taste of Angels: A History of Art Collecting from Rameses to Napoleon.* Boston: Little, Brown & Company, 1948.

An illustrated entertaining book of brief essays on numerous collectors. Has length bibliography.

Treue, Wilhelm. *Art Plunders: The Fate of Works of Art in War and Unrest.* Translated by Basil Creighton. New York: John Day Company, 1961.

Discusses looters of art, which is a form of collecting, from antiquity through World War II. Includes lengthy section on the French Revolution and Napoleon.

Trevor-Roper, Hugh. *Princes and Artists: Patronage and Ideology at Four Habsburg Courts 1517–1633.* New York: Harper & Row, Publishers, 1976.

Discusses Charles V, Philip II, Rudolf II, and the rulers of the Spanish Netherlands.

References on Art Criticism

Art Criticism Series, U.M.I. research Press.

Separate volumes on specific critics.

The Spectator and the Landscape in the Art Criticism of Diderot and His Contemporaries, by Ian J. Lochhead, 1982.

George L. K. Morris, Artist and Critic, by Melinda A. Lorenze 1982.

Charles H. Caffin: A Voice for Modernism, 1897–1918, by Sandra Lee Underwood, 1983.

Connoisseurship, Criticism, and Art History in the 19th Century Series: A Selection of Major Texts in English, selected by Sydney J. Freedberg. New York: Garland Publishing, Inc.

Reprints of 23 English-translations and English-language books. Includes works on Charles Baudelaire and John Ruskin.

Holt, Elizabeth Gilmore, editor. *The Triumph of Art for the Public: The Emerging Role of Exhibitions and Critics.* Garden City, New York: Anchor Press, 1979.

Covers art exhibitions from 1785 to 1848 in France, England, Italy, and Germany. The entry for each exhibition includes a brief historical essay accompanied by English translations of some of the critical assessments of the displayed works of art. Has a short introduction to the history of criticism and art exhibitions plus a brief bibliography.

————, editor. *The Art of All Nations, 1850–73: The Emerging Role of Exhibitions and Critics.* Princeton, New Jersey: Princeton University Press, 1981.

Provides brief historical essays on exhibitions held in France, England, Germany, Italy, and Austria accompanied by articles written by various critics concerning the works of art which were displayed. All of the critiques have been translated into English. Includes a bibliography and an index to the artists, critics, painting titles, associations, patrons, and political persons mentioned in the text. A third volume covering late 19th-century criticism is in progress.

Muehsam, Gerd, editor. *French Painters and Paintings from the Fourteenth Century to Post-Impressionism.* New York: Frederick Ungar Publishing Company, 1970.

For about 100 artists, entries provide a brief biography and English translated critiques and comments dating from the artist's time to the 20th century. The introduction provides a brief survey of the history of art criticism. There are a general bibliography of art criticism and art critics, a selected bibliography for individual artists, an index of painters and paintings, and an index to critics.

Warner, Eric and Hough, Graham, editors. *Strangeness and Beauty: An Anthology of Aesthetic Criticism 1840–1910.* New York: Cambridge University Press, 1983. 2 volumes.

Volume I: Ruskin to Swinburne

Volume II: Pater to Symons
Includes the authors mentioned in the title plus Rossetti, William Morris, Théophile Gautier, Baudelaire, Whistler, Wilde, and Yeats.

Venturi, Lionello. *History of Art Criticism.* Translated by Charles Marriott. New York: W. P. Dutton & Company, Inc., 1936, reprinted 1964.
Good introduction to the subject.

Documents and Sources

Archives of American Art. *The Card Catalogue of the Manuscript Collections of the Archives of American Art.* Wilmington, Delaware: Scholarly Resources, Inc., 1980. 10 volumes.
A national research institute for American art that became a bureau of the Smithsonian Institution in 1970. The collection of primary, secondary, and printed research material of American painters, sculptors, and craftsmen was started in 1954. Any artist who was born in America or immigrated here is considered an American artist. All of the original source material is microfilmed with a duplicate film for each branch office; see Chapter 24 for the addresses of the five locations. Interlibrary loans are handled out of the Detroit office. Includes more than 3,000,000 items: letters, clippings, journals, and scrapbooks, plus 3,000 rolls of microfilm. There is an oral history program of taped interviews with more than 1,200 artists and other people.

Diamonstein, Barbaralee. *Inside New York's Art World.* New York: Rizzoli International Publications, Inc., 1979.
Interviews made between 1975 and 1978 with 27 artists, dealers, critics, museum directors, and designers.

Dunlap, William. *A History of the Rise and Progress of the Arts of Design in the United States.* New York: George P. Scott and Company, 1834; reprint ed., New York: Dover Publications, Inc., 1969. 2 volumes in 3 books.
Contains biographical material on 289 American architects, sculptors, painters, and engravers. Another 161 American artists are mentioned briefly in the appendix. The 1969 edititon added new notes, 394 illustrations, and an index. Dunlap was a painter and an author who knew many of the artists to whom he refers personally.

Edwards, Edward. *Anecdotes of Painters Who Have Resided or Been Born in England with Critical Remarks on Their Productions.* London: Luke Hanfard & Sons, 1808; reprint ed., London: Cornmarket Reprints, 1970.
Conceived as a continuation and completion of Walpole's *Anecdotes of Painting,* which is listed in this section. The anecdotes are provided under the artist's name; includes Gainsborough, Reynolds, Romney, and van Dyck of the over 190 artists who are cited.

Friedenthal, Richard. *Letters of the Great Artists.* Translated by Daphine Woodward et al. London: Thames and Hudson, 1963. 2 volumes.
Volume I: From Ghiberti to Gainsborough
Volume II: From Blake to Pollock
Illustrated publication of various artists' letters. Each volume includes a list of sources and references from which the material was collected.

Goldwater, Robert and Treves, Marco, editors. *Artists on Art: From the XIV to the XX Century.* New York: Pantheon Books, Inc., 1945.
The writings of famous painters and sculptors from Cennino Cennini to Pablo Picasso have been translated, where needed, by the two editors. A self-portrait or a likeness of the artist has been added to many of the entries. Includes a list of sources from which the material was collected.

Holt, Elizabeth Gilmore, editor. *A Documentary History of Art.* Garden City, New York: Doubleday & Company, Inc., 1957–1966.
Original writings by artists of various periods of art accompanied by a brief biographical sketch.
Volume I: The Middle Ages and Renaissance, 1957.
Volume II: Michelangelo and the Mannerists: The Baroque and the Eighteenth Century, 1958.
Volume III: From the Classicists to the Impressionists: A Documentary History of Art and Architecture in the 19th Century, 1966.

Janson, Horst Woldemar, general editor. *Sources and Documents in the History of Art Series.* Englewood Cliffs, New Jersey: Prentice-Hall, Inc., 1965–1972. 12 volumes.
Reproduces documents important in the history of art and the original writings of artists.
The Art of Greece: 1400–31 B.C., by Jerry Jorden Pollitt, 1965.
The Art of Rome: c. 753 B.C.-337 A.D., by Jerry Jorden Pollitt, 1966.
Early Medieval Art: 300–1150, by Caecila Davis-Weyer, 1971.
Art of the Byzantine Empire, 312–1453, by Cyril A. Mango, 1972.
Gothic Art: 1140-c. 1450, by Teresa Frisch, 1971.
Italian Art: 1500–1600, by Robert Klein and Henri Zerner, 1966.
Northern Renaissance Art: 1400–1600, by Wolfgang Stechow, 1966.
Italy and Spain: 1600–1750, by Robert Enggass and Jonathan Brown, 1970.
American Art: 1700–1960, by John W. McCoubrey, 1965.
Neo-classicism and Romanticism: 1750–1850, by Lorenz Eitner, 1970. 2 volumes.
Realism and Tradition in Art: 1848–1900, by Linda Nochlin, 1966.
Impressionism and Post-Impressionism: 1874–1904, by Linda Nochlin, 1966.

Johnson, Ellen H., editor. *American Artists on Art from 1940 to 1980.* New York: Harper & Row Publishers, 1982.

Reprints about 55 articles by one or more artists; organized by such stylistic areas as Abstract Expressionism, Color Field Paintings, Happenings and Pre-Pop Art, Pop Art, Minimal, Systemic and Conceptual Art, Photo-Realist Painting and Super-Realist Sculpture, Earth and Process Art, Site and Architectural Sculpture, and Performance Art.

Jones, Henry Stuart, editor. *Select Passages from Ancient Writers Illustrative of the History of Greek Sculpture.* Edited and translated by Henry Stuart Jones. New York: Macmillan and Company, 1895; reprint ed., with introduction, bibliography, and index by Al. N. Oikonomides, Chicago: Argonaut, Inc., 1966.

Organized in two columns: one reprints the original Greek, the other the translation. The introduction and indices of the new edition are valuable additions; the former gives an historical account of the ancient writers whose works are quoted in the book. There are four indices: to ancient artists, to ancient and modern authors, to geographical locations, and to general subjects.

Motherwell, Robert, general editor. *The Documents of 20th-Century Art.* New York: Viking Press, 1971– Boston: G. K. Hall & Company, 1980–.

A series reprinting the artist's own writing; some volumes include a brief historical background of the period and a selected bibliography. The "Notes on the Contributors," found in a few of the volumes, has entries which provide very brief biographical and bibliographical data on the people included in the text.

Apollinaire on Art: Essays and Reviews, 1902–1918, edited by LeRoy C. Breunig, translated by Susan Suleiman, 1971.

Arp on Arp: Poems, Essays, Memories, by Jean Arp, edited by Marcel Jean, translated by Joachim Neugroschel, 1972.

Art As Art: The Writings of Ad Reinhardt, edited by Barbara Rose, 1975.

Blaue Reiter Almanac, edited by Wassily Kandinsky and Franz Marc, documentary edition by Klaus Lankheit, translated by Henning Falkenstein, 1974.

Dialogues With Marcel Duchamp, by Pierre Cabanne, edited by Robert Motherwell, translated by Ron Padgett, 1971.

Flight Out of Time: A Dada Diary, by Hugo Ball, edited by John Elderfield, translated by Ann Raimes, 1974.

Functions of Painting, by Fernand Léger, edited by Edward F. Fry, translated by Alexandra Anderson, 1973.

Futurist Manifestos, edited by Umbro Apollonio, 1973.

Henry Moore on Sculpture, edited by Philip James, 1971.

Memoirs of a Dada Drummer, by Richard Huelsenbeck, edited by Hans J. Kleinschmidt, translated by Joachim Neugroschel, 1974.

My Galleries and Painters, by Daniel-Henry Kahnweiller and Francis Crémieux, translated by Helen Weaver, 1971.

My Life in Sculpture, by Jacques Lipchitz with H. H. Arnason, 1972.

Picasso on Art, edited by Dore Ashton, 1972.

Russian Art of the Avant-Garde: Theory and Criticism 1902–1934, edited and translated by John E. Bowlt, 1976.

Tradition of Constructivism, edited by Stephen Bann, 1974.

Kandinsky: Complete Writings on Art, edited by Kenneth C. Lindsay and Peter Vergo, 1980, 2 volumes.

The Dada Painters and Poets: An Anthology, 2nd edition edited by Robert Motherwell and Jack D. Flam, with a revised bibliography by Bernard Karpel, 1981.

Rose, Barbara, editor. *Readings in American Art Since 1900: A Documentary Survey.* New York: Frederick A. Praeger, 1968.

Includes brief writings of sixty-eight American artists; an illustrated work with an extensive bibliography.

Vasari, Giorgio. *Lives of the Most Eminent Painters, Sculptors, and Architects.* Translated by Gaston du C. de Vere. London: Macmillan & Company, Ltd. and The Medici Society, Ltd., 1912–15. 10 volumes.

A painter, an architect, and one of the first art historians, Vasari discussed 175 artists in his first publication of two volumes in 1550. The second edition of 1568 that mentions 250 artists is the one usually translated. Three hundred years are covered from Cimabue to Michelangelo, including Vasari himself; most of the biographies are on painters. In the 1568 edition, Vasari added woodcut portraits of the artists. There are numerous editions and abridgements.

Vertue, George. *Anecdotes of Painting in England,* see listing under Walpole.

Walpole, Horace. *Anecdotes of Painters,* see listing under Edwards.

Walpole, Horace. *Anecdotes of Painting in England with Some Account of the Principal Artists and Incidental Notes on Other Arts Collected by the Late Mr. George Vertue and Now Digested and Published from His Original Mss. by Mr. Horace Walpole.* Strawberry Hill, England: Thomas Farmer, 1762–71; reprint of 1937 edition, New York: Arno Press, 1969. 4 volumes.

Walpole's work has had a number of editions, which vary in length from three to five volumes. The book is divided into chapters covering various monarch's reigns, beginning with the rule of James I. The chapters are subdivided as to kinds of artists; includes architects, carvers, coopersmiths, glasspainters, painters, masons, and

sculptors. Anecdotes of about 500 artists are provided under these categories. Includes bibliographical footnotes, an index to artists, and in some of the editions, an appendix that provides copies of some important documents of the period covered, such as a seventeenth-century appointment to the king's painter.

Bibliographical Guides to General Art Reference Material

Specialized bibliographies are annotated in Chapters 10 and 23.

Arntzen, Etta and Rainwater, Robert. *Guide to the Literature of Art History*. Chicago: American Library Association, 1980.

> Divided into 4 large categories: (1) general reference sources, subdivided into bibliography, directories, sales records, visual resources, dictionaries and encyclopedias, and iconography; (2) general primary and secondary sources—historiography and methodology, sources and documents, plus histories and handbooks; (3) particular arts—architecture, sculpture, drawings, paintings, prints, photography, plus decorative and applied arts; and (4) serials—periodicals and books in series. Includes 2 indices: author-title and subject. Considered a continuation of Chamberlin's *Guide to Art Reference Books,* 1959, this hefty book includes, and updates, about 40% of the works cited by Chamberlin. The more than 4,000 entires, most of which were published prior to 1977, are predominantly in Western languages; English translations are listed if available. Under "Series" provides access to the names of some of the foreign groups that publish scholarly works; only records a sample of individual titles.

Art and Architecture Information Guide Series. Sydney Starr Keaveney, general editor. Detroit: Gale Research Company, 1974.

> A series of extensive annotated bibliographies. Some volumes include lists (1) of individual artists accompanied by specialized bibliographies and (2) of museums that have important collections accompanied by an annotated list of the museum catalogues which cover the works in the collections.
>
> *American Architects from the Civil War to the First World War,* edited by Lawrence Wodehouse, 1976.
> *American Architects from the First World War to the Present,* edited by Lawrence Wodehouse, 1977.
> *American Architecture and Art,* edited by David M. Sokol, 1976.
> *American Decorative Arts and Old World Influences,* edited by David M. Sokol, 1980.
> *American Drawing,* edited by Lamia Dourmato, 1979.

> *American Painting,* edited by Sydney Starr Keaveney, 1974.
> *American Sculpture,* edited by Janis Ekdahl, 1977.
> *Art Education,* edited by Clarence Bunch, 1978.
> *British Architects, 1840–1976,* edited by Lawrence Wodehouse, 1979.
> *Color Theory,* edited by Mary Buckley, 1974.
> *Historic Preservation,* edited by Arnold L. Markowitz, 1980.
> *Indigenous Architecture Worldwide,* edited by Lawrence Wodehouse, 1980.
> *Pottery and Ceramics,* edited by James E. Campbell, 1978.
> *Stained Glass,* edited by Darlene A. Brady and William Serban, 1980.

Art Books 1876–1949: Including an International Index of Current Serial Publications. New York: R. R. Bowker Company, 1981.

Art Books 1950–1979: Including an International Directory of Museum Permanent Collection Catalogs. New York: R. R. Bowker Company, 1980.

> Includes a subject index, author index, title index, and art books in print index. The subject area directory assists the reader in finding the correct subject heading to be used. There is also an index to more than 3,300 permanent collection catalogues of museums arranged under the name of the institution in the 1950–79 volume. There is a Serials-Subject Index and a Serials-Title Index in the 1876–1949 volume that lists more than 2,500 publications.

Arts in America: A Bibliography, edited by Bernard Karpel. Washington, D.C.: Archives of American Art, Smithsonian Institution Press, 1979. 4 volumes.

> An annotated bibliography with almost 25,000 entries compiled by 20 scholars. There are 21 divisions: art of native Americans; architecture; decorative arts; design—19th and 20th century; sculpture; art of the west; painting—17th and 18th, 19th, plus 20th century; graphic arts—17th–19th and 20th century; graphic artists, 20th century; photography; film; theater; dance; music; serial and periodicals on the visual arts; dissertations and theses; plus visual resources. There is so much excellent material in these volumes that it is difficult to write an adequate annotation. Although each division has its own table of contents and organization, many include general references, works on artistic styles and techniques, bibliographical data for individual Americans, studies of geographical regions, and critical reviews of serials and periodicals. Each division has specialties that assist researchers of that discipline, such as the trade catalogues in "Decorative Arts," pattern books under "Architecture," and references on international exhibitions and world fairs cited under "Design: Nineteenth Century" and "Sculpture." Because this is the most complete and important bibliography of American art

to have been compiled, some additional indexing of the material is included in other sections of this book. The comprehensive index in Volume 4 provides access to names in the annotations.

Bibliographic Index: A Cumulative Bibliography of Bibliographies. Marga Franck and Ann Massie Case, editors, New York: H. W. Wilson Company. Volume 1 (1937–1942)+

A subject index to books, pamphlets, and periodicals that contain bibliographical material. Examines about 1,900 periodicals for entires; concentrates on Germanic and Romance languages. From 1960–1962 to 1966–1968 the volumes were issued every two years; in 1969 it became an annual.

Chamberlin, Mary W. *Guide to Art Reference Books.* Chicago: American Library Association, 1959.

An essential work for all art researchers; this annotated book includes 2,565 entries. Has an extensive section on art history books covering histories and handbooks of art, architecture, sculpture, drawings, paintings, prints and engravings, and applied arts. Divided into chapters on bibliography, methodology, documents and sources, series, iconography, sales records, and special collections in the United States and Europe. Cites many foreign-language works.

Ehresmann, Donald L. *Applied and Decorative Arts: A Bibliographic Guide to Basic Reference Books, Histories, and Handbooks.* Littleton, Colorado: Libraries Unlimited, Inc., 1977.

Has over 1,200 annotated entires on books covering ceramics, enamels, furniture, glass, ivory, leather, metalwork, textiles, arms and armor, clocks, costume, jewelry, lacquer, medals and seals, musical instruments, and toys and dolls.

————. *Fine Arts: A Bibliographic Guide to Basic Reference Works, Histories, and Handbooks.* Littleton, Colorado: Libraries Unlimited, Inc., 2nd edition, 1979.

Originally conceived as a supplement to Chamberlin, this annotated work includes 1,670 entries of books published prior to September 1978. Includes an extensive section on histories and handbooks of world art history divided as to periods of art and subdivided as to country. The chapter on bibliographies has 1,127 entries.

G. K. Hall Art Bibliographies Series. Boston: G. K. Hall & Company. There are plans for about 50 individual annotated bibliographies to be compiled on specific subjects written within 9 broad classifications: Art of Antiquity; Medieval Art & Architecture; Italian Renaissance; Art of Northern Europe, 15th & 16th Centuries; 20th Century Art in Europe and America; Non-Western Art; Afro-American Art; Southern Baroque and Rococo, 17th & 18th Centuries; and Northern Baroque and Rococo, 17th & 18th Centuries. A sample of how varied this series will be follows:

Dugento Painting: An Annotated Bibliography, by James H. Stubblebine, 1983.

Italian Romanesque Sculpture: An Annotated Bibliography, by Dorothy F. Glass, 1983.

Stained Glass Before 1540: An Annotated Bibliography, by Madeline Harrison Caviness, 1983.

Hieronymus Bosch: An Annotated Bibliography, by Walter Gibson, 1983.

Lucas, Edna Louise. *Art Books: A Basic Bibliography on the Fine Arts.* Greenwich, Connecticut: New York Graphic Society, 1968.

A list of art history books divided into six sections: history and theory, architecture, sculpture, painting, graphic arts, and minor arts. The chapter, "Monographs on Artists," cites references on about 550 artists from the thirteenth century to the present; most are painters, sculptors, and architects. Includes many foreign-language references, but no annotations.

Muehsam, Gerd. *Guide to Basic Information Sources in the Visual Arts.* Santa Barbara, California: Jeffrey Norton Publishers/ABC Clio, Inc., 1978.

Assists the reader in finding specific dictionaries, histories, periodicals, and reference works concerned with various periods of western art history, such as Ancient, Medieval, Renaissance and Mannerism, Baroque and Rococo, and Modern Art. Includes sections on art forms and techniques and on national schools of art.

References that Relate to Influences on Art

This literature is varied and vast. The following brief list is only to provide an idea of the types of subjects and references which can be explored. Consult the librarian for assistance in locating pertinent material.

Academies and Exhibitions

Boime, Albert. *The Academy and French Painting of the 19th Century.* London: Phaidon Press, Ltd., 1971.

Discusses the establishment of the French Academy and the Ecole des Beaux-Arts, the ateliers, the importance of the sketch, and the academic copy.

Pevsner, Nicholas. *Academies of Art Past and Present.* New York: Macmillan Company, 1940; reprint ed., 1973.

History of development of European academies.

Agriculture

Fussell, George E. *Farming Technique from Prehistoric to Modern Times.* London: Pergamon Press, Ltd., 1966.

Covers from prehistoric to the present. Each chapter has a bibliography plus there is a general bibliography.

Lee, Norman E. *Harvests and Harvesting Through the Ages*. Cambridge: Cambridge University Press, 1960.

 Brief history; includes chronology of important dates.

Prentice, E. Parmalee. *Hunger and History: The Influence of Hunger on Human History*. New York: Harper & Brothers Publishers, 1939.

 History of food, its abundance and lack; has a bibliography.

Dress

Hollander, Anne. *Seeing Through Clothes*. New York: The Viking Press, 1975.

 Discusses drapery, nudity, undress, costume, dress, and mirrors and their impact on artists and viewers. Illustrated by more than 450 paintings, drawings, statues, photographs, and scenes from movies. Includes footnotes and a bibliography.

Knötel, Richard, et al. *Uniforms of the World 1700–1937*. New York: Charles Scribner's, 1980.

 Details of military dress.

Education of the Artists and the Patrons

Bowen, James. *A History of Western Education*. London: Methuen & Company, Ltd., 1972.

 Vol. I: The Ancient World: Orient and Mediterranean 2000 BC—AD 1054, 1972.

 Vol. II: Civilization of Europe Sixth to Sixteenth Century, 1975.

 Each volume contains extensive footnotes and a lengthy bibliography.

Graves, Frank Pierrepont. *A History of Education Before the Middle Ages*. New York: The Macmillan Company, 1912.

 Covers from primitive people through the Early Christian period. Although an old publication, there are good bibliographies after each chapter, unfortunately only authors and titles are included.

———. *A History of Education During the Middle Ages and the Transition to Modern Times*. New York: Macmillan Company, 1928. See above.

Geography

Jacobs, Michael and Warner, Malcolm. *The Phaidon Companion to Art and Artists in the British Isles*. London: Phaidon Press, Ltd., 1980.

 Discusses painters born after 1700 who lived in 9 geographical locations. Brief essays on the scenery of the area and on the artists working there are followed by entries under artists' names that provide biographical data plus some literary references. Has indices to persons and to places.

James, Preston E. and Martin, Geoffrey, J. *All Possible Worlds: A History of Geographical Ideas*. 2nd edition. New York: John Wiley & Sons, 1972.

 An overview; has extensive bibliography.

Taylor, Griffith. *Geography in the Twentieth Century: A Study of Growth, Fields, Techniques, Aims and Trends*. 3rd edition. New York: Philosophical Library, Inc., 1957.

 Written by 24 international scholars, the 29 essays all include individual bibliographies. Has articles on such subjects as climactic influences, urban geography, and sociological aspects of geography.

Medicine

Bettmann, Otto L. *A Pictorial History of Medicine*. Springfield, Missouri: Charles C. Thomas Publishers, 1956.

 Interesting work illustrated with black-and-white drawings and prints.

Lyons, Albert S., et al. *Medicine: An Illustrated History*. New York: Harry N. Abrams, Inc., 1978.

 Profusely illustrated, with works of art, mostly in color; covering from the prehistoric period to the present.

Political and Economic History

Braudel, Fernand. *The Structures of Everyday Life: The Limits of the Possible*. Translated and revised by Siân Reynolds. New York: Harper & Row Publishers, 1981. Volume 1.

———. *The Wheels of Commerce*, 1982. Volume 2.

 Scholarly texts covering economic and social history of the world from the 15th through the 18th century. A third volume is planned.

Clapp, Jane. *Art Censorship: A Chronology of Proscribed and Prescribed Art*. Metuchen, New Jersey: Scarecrow Press, 1972.

 A chronological account, from 3400–2900 B.C. until 1971 A.D., of the censorship of art. The censorship news items—all of which are reprinted in the text—are derived from the 641 references listed in the bibliography. Includes an extensive index: excludes censorship of photography and motion pictures.

Leith, James A. *The Idea of Art as Propaganda in France 1750–1779*. Toronto: University of Toronto Press, 1965.

 Essay in the history of transmitting ideas.

Religious Ritual, Liturgy, and Councils

Hardison, O. B., Jr. *Christian Rite and Christian Drama in the Middle Ages*. Baltimore: Johns Hopkins Press, 1965.

 Discusses the Roman Mass as sacred drama.

Jungmann, Josef Andreas. *The Mass of the Roman Rite: Its Origins and Development (Missarum Sollemnia)*. Translated by Frances A. Brunner. New York: Benziger Brothers, Inc., 1951. 2 volumes.

 Discusses the history of the rite of the mass of the Roman Catholic Church from the time of the primitive church, thus provides reasons for certain changes that were made in religious architecture and liturgical objects. The author is a Jesuit scholar.

Kedourie, Elie, editor. *The Jewish World: History and Culture of the Jewish People*. New York: Harry N. Abrams, Inc., 1979.

Historic essays by 19 experts; well illustrated with works of art.

Percival, Henry R. *The Seven Ecumenical Councils of the Undivided Church: Their Canons and Dogmatic Decrees*. New York: Charles Scribner's Sons, 1900.

Provides information on declaration of the early church from First Council of Nicea in 325 through the Second Council of Nicea in 787.

Schroeder, Henry Joseph. *Disciplinary Decrees of the General Councils: Text, Translation, and Commentary*. St. Louis: B. Herder Book Company, 1937.

Provides decrees for the 18 ecumenical councils from 325 to 1215.

Weiser, Francis X. *Handbook of Christian Feasts and Customs: The Year of the Lord in Liturgy and Folklore*. New York: Harcourt, Brace, and Company, 1958.

Discusses the various Christian feast days, their symbols, and their customs. Includes a dictionary of terms and a list of abbreviations used for references cited in the text.

Social History

Laver, James. *The Age of Illusion: Manners and Morals 1750–1848*. New York: David McKay Company, Inc., 1972.

————. *Manners and Morals in the Age of Optimism 1848–1914*. New York: Harper & Row Publishers, Inc., 1966.

Discusses social history of period; includes some illustrations.

Status of the Artist

Feldman, Edmund B. *The Artist*. Englewood Cliffs, New Jersey: Prentice-Hall, Inc., 1982.

Covers from prehistoric art to the present; includes child, naive, and peasant artists. Has extensive bibliography.

Status of Women and Children

de Mause, Lloyd, editor. *The History of Childhood*. New York: The Psychohistory Press, 1974.

Historic survey from 9th through 19th centuries of European treatment of children.

Giele, Janet Zollinger and Smock, Audrey Chapman. *Women: Roles and Status in Eight Countries*. New York: John Wiley & Sons, 1977.

Essays on changes in status of women from Middle Age to present.

Technology

Burke, James. *Connections*. Boston: Little, Brown and Company, 1978.

Not necessarily on art, but a fascinating book on how discoveries of the past have assisted in the inventions of the present.

Hodges, Henry. *Technology in the Ancient World*. Baltimore: Penguin Books, Inc., 1970.

An important source for understanding the development of art and architecture. Covers from prehistoric to 5th century A.D.

Singer, Charles Joseph, et. al., editors. *A History of Technology*. Oxford: Clarendon Press, 1954–58. 5 volumes. Continued by Williams.

Williams, Trevor I. *A History of Technology*. Oxford: Clarendon Press, 1978. Volumes 6 & 7.

A scholarly work of 7 volumes covering technology since prehistoric times. Illustrated; each chapter has footnotes and an individual bibliography. Volumes 1–5 and 7 have 3 indices: to personal names, to companies, and to subjects.

Theater History

Brockett, Oscar G. *History of the Theatre*. Boston: Allyn and Bacon, Inc., 1968.

Covers from ancient Greece to the present.

Chambers, Edmund K. *The Medieval Stage*. Oxford: Clarendon Press, 1903. 2 volumes.

Includes discussions of minstrels, folk drama, and religious drama, plus an essay on the rise and development of the 15th-century theater. Second volume has a subject index.

Freedley, George and Reeves, John A. *A History of the Theatre*. New York: Crown Publishers, 1954.

Traces the history of theater from Ancient Egypt to the present.

Young, Karl. *The Drama of the Medieval Church*. Oxford: Clarendon Press, 1933; reprint ed., Oxford University Press, 1962. 2 volumes.

Discusses the history and development of the liturgy of the Roman Catholic Church and the various ecclesiastical related dramatizations. Source for the Latin versions of numerous medieval tropes and liturgical plays.

Information on Museum Catalogues of Permanent Collections

In order to obtain detailed information on a specific work of art, the researcher should consult the catalogue of the collection which owns the particular art object. This chapter consists of (1) some references that index museum catalogues and (2) a list of seventeen of the larger art museums that regularly publish scholarly catalogues. Only a few of the catalogues of the permanent collection by these institutions are recorded. A more complete list can be found by consulting the references cited in the first section.

Indices of Museum Catalogues

Provide access to the catalogues which have been published by museums on their collections.

Art Books 1950–1979: Including an International Directory of Museum Permanent Collection Catalogs. Ann Arbor, Michigan: R. R. Bowker Company, 1980.

> Has a section that gives dates, prices, and publishers for more than 3,300 museum collection catalogues.

Old Master Paintings in Britain: Index of Continental Old Master Paintings Executed before c. 1800 in Public Collections in the United Kingdom, compiled by Christopher Wright. New York: Sotheby Parke Bernet Publishers, 1976.

> Although principally an index to the works of art located in British museums, there are (1) an "Index of Locations" that cites the museums and some of the artists represented and (2) a "Bibliography" that under the museum's name lists any catalogues which may have been compiled. Includes about 1,750 artists in 233 collections.

Paintings in Dutch Museums: An Index of Oil Paintings in Public Collections in the Netherlands by Artists Born Before 1870, compiled by Christopher Wright. New York: Sotheby Parke Bernett Publishers, 1980.

> Uses the same format as the above reference, only for Dutch museums. Includes over 3,500 artists and 350 institutions.

World Museum Publications: A Directory of Art and Cultural Museums, Their Publications, and Audio-Visual Materials. New York: R. R. Bowker Company, 1982.

> Lists museum publications and audio-visual materials.

Some Scholarly Museum Catalogues

A number of museums have published visual catalogues by reprinting some of their collection on microforms; see Chapter 17 under "Published Photographic Archives." Some of the important printed catalogues are cited below.

BAYERISCHE STAATSGEMÄLDESAMMLUNGEN, MÜNCHEN, DEUTSCHLAND (GERMANY)

Alte Pinakothek:

Altdeutsche Malerei, by Christian Altgraf zu Salm and Gisela Goldberg, 1963.

Aldeutsche Gemälde: Köln und Nordwestdeutschland, by Gisela Goldberg and Gisela Scheffer, 1972.

Deutsche und niederländische Malerei zwischen Renaissance und Barock, by Ernst Brochhagen and Kurt Löcher, 2nd ed., 1973.

Francesco Guardi in der Alten Pinakothek, by Rolf Kultzen, 1968.

Französische Meister des 19. Jahrhunderts. Kunst des 20. Jahrhunderts, 1966–67. 2 volumes.

Holländische Malerei des 17. Jahrhunderts, by Ernst Brochhagen and Brigitte Knüttel, 1967.

Meisterwerke der deutschen Malerei des 19. Jahrhunderts, 1967.

Italienische Malerei, edited by Rolf Kultzen, 1975.

Meisterwerke des 18. Jahrhunderts, 1966.

Spanische Meister, by von Halldor Soehner, 1964. 2 volumes.

Französische und spanische Malerei, by Halldor Soeher and Johann G. Prinz, 1972

Neue Pinakothek:

Neue Pinakothek München, 1981.

THE BRITISH MUSEUM, LONDON, ENGLAND

Historical prints reproduced on microfilm; see chapter 17.

Catalogue of British Drawings: XVI and XVII Centuries, by Edward Croft-Murray and Paul Hulton, 1961. One volume in 2 books.

Catalogue of Engraved British Portraits, by Freeman O'Donoghue, 1908–25. 6 volumes.

Catalogue of Drawings by Dutch and Flemish Artists, by Arthur M. Hind and A. E. Popham, 1915–32. 5 volumes.

Italian Drawings: The Fourteenth and Fifteenth Centuries, by A. E. Popham and Philip Pouncey, 1950. 2 volumes.

Italian Drawings: Artists Working in Parma in the Sixteenth Century, by A. E. Popham, 1967. 2 volumes.

Italian Drawings: Michelangelo and His Studio, by Johannes Wilde, 1953. One volume.

Italian Drawings: Raphael and His Circle, by Philip Pouncey and J. A. Gere, 1962. 2 volumes.

Italian Drawings: Artists Working in Rome, c. 1550–1640, by J. A. Gere and Philip Pouncey, 1982.

FITZWILLIAM MUSEUM, UNIVERSITY OF CAMBRIDGE, CAMBRIDGE, ENGLAND

Catalogue of Paintings: Volume I: Dutch, Flemish, French, German, Spanish, by H. Gerson, J. W. Goodison, and Denys Sutton, 1960.

Catalogue of Paintings: Volume II: Italian Schools, by J. W. Goodison and G. H. Robertson, 1967.

Catalogue of Paintings: Volume III: British School, by J. W. Goodison, 1977.

THE FRICK COLLECTION, NEW YORK CITY.

The Frick Collection: An Illustrated Catalogue:
> *Volume I: Paintings: American, British, Dutch, Flemish, and German,* 1968.
> *Volume II: Paintings: French, Italian, and Spanish,* 1968.
> *Volume III: Sculpture: Italian,* by John Pope-Hennessy, 1970.
> *Volume IV: Sculpture: German, French, Netherlandish, and British,* French and British works by Terence W. I. Hodgkinson, 1970.
> *Volume V: Furniture,* to be published.
> *Volume VI: Furniture,* to be published.
> *Volume VII: Oriental Porcelains and French Porcelains,* by John A. Pope and Marcelle Brunet, translated by Joseph Focarino, 1974.
> *Volume VIII: Enamels, Rugs, Silver,* 1977.
> *Volume IX: Prints, Drawings, Recent Acquisitions,* to be published.

KUNSTHISTORISCHES MUSEUM, WIEN (VIENNA), ÖSTERREICH (AUSTRIA).

Katalog der Gemäldegalerie: Teil I: Italiener, Spanier, Französen, Englander, 2nd ed., by Vinzenz Oberhammer, 1965.

Katalog der Gemäldegalerie: Teil II: Vlamen, Hollander, Deutsche, Französen, 2nd ed., by Vinzenz Oberhammer, 1963.

Katalog der Gemäldegalerie: Hollandische Meister des 15., 16., und 17. Jahrhunderts, by Klaus Demus, 1972.

Katalog der Antikenensammlung: Teil I: Vom Altertum zum Mittelalter, 2nd ed., Rudolf Noll, 1974. *Teil II: Funde Aus Ephe Sos und Samothrake,* by A. Bammer et al., 1978.

Katalog der Neuen Galerie in der Stallburg, by Klaus Demus, 1967.

Katalog der Sammlung Für Plastik und Kunstgewerbe: Teil I: Mittelalter, by Hermann Fillitz, Erwin Neumann, and Ernst Schuselka, 1964.

Katalog der Sammlung Für Plastik und Kunstgewerbe: Teil II: Renaissance, 1966.

METROPOLITAN MUSEUM OF ART, NEW YORK CITY.

Updated by frequent publications of *Notable Acquisitions.* See also entry for "Samuel H. Kress Foundation."

American Paintings: Volume I: Painters Born by 1815, by Albert Ten Eyck Gardner and Stuart P. Feld, 1965.

American Paintings: Volume II: Artists Born from 1816 through 1845, to be published.

American Paintings: Volume III: A Catalogue of Works by Artists Born Between 1846 and 1864, by Doreen Bolger Burke and edited by Kathleen Luhrs, 1980.

American Sculpture, by Albert Ten Eyck Gardner, 1965.

The Scepter of Egypt:
> *Volume I: From the Earliest Times to the End of the Middle Kingdom,* by William C. Hayes, 1953.
> *Volume II: The Hyksos Period and the New Kingdom (1675–1080 B.C.),* by William C. Hayes, 1959.

Catalogue of Early Flemish, Dutch, and German Paintings, by Harry B. Wehle and Margaretta Salinger, 1947.

Catalogue of French Paintings:
> *Volume I: XV–XVIII,* by Charles Sterling, 1955.
> *Volume II: XIX Century,* by Charles Sterling and Margaretta Salinger, 1966.
> *Volume III: Late XIX Century and XX Century,* by Charles Sterling and Margaretta Salinger, 1966.

Catalogue of Italian, Spanish, and Byzantine Paintings, by Harry B. Wehle, 1940.

Chinese Sculpture in the Metropolitan Museum of Art, by Alan Priest, 1944.

The Cloisters, by James J. Rorimer, 1972.

Handbook of the Greek Collection, by Gisela M. A. Richter, 1953.

Islamic Art in the Metropolitan Museum of Art, edited by Richard Ettinghausen, 1972.

Italian Paintings: Florentine Schools, by Federico Zeri, 1971.

Italian Paintings: Venetian Schools, by Federico Zeri, 1973.

Italian Paintings: Sienese and Central Italian Schools, by Federico Zeri and Elizabeth E. Gardner, 1980.

European Paintings in the Metropolitan Museum of Art, 1981. 3 volumes.

MUSEE NATIONAL du LOUVRE, PARIS.

Catalogues des peintures, 1972.
 Volume I: Ecole française
 Volume II: Ecoles étrangères
Catalogue raisonné des figurines et reliefs en terre-cuite grecs, étrusques et romains.
 Volume I: Epoques préhellénique, géométrique, archaïque et classique, 1954.
Catalogue raisonné des peintures du Moyen-Âge, de la Renaissance et des temps modernes: peintures flamendes de XVᵉ et du XVIᵉ siècle, 1953. 2 volumes.
Description raisonnée des sculptures du Moyen-Âge, de la Renaissance et des temps modernes, by Marcel Aubert, 1950.
Inventaire général des dessins des écoles du Nord: Ecole allemande et suisse, by Louis Demonts, 1937–38. 2 volumes. *Ecole hollandaise*, by Frits Lugt, 1929–33. 3 volumes. *Ecole flamande*, by Frits Lugt, 1949. 2 volumes. *Maîtres des anciens: Pays-Bas nés avant 1550*, by Frits Lugt, 1968.
Inventaire général des dessins du Louvre et du Musée de Versailles: Ecole française, by Jean Guiffrey et al., 1907–38. 11 volumes.
Inventaire général des dessins italiens: Vasari et son temps: Maîtres toscans nés après 1500, morts avant 1600, by Catherine Monbieg-Goguel, 1972.
Musée du Jeu de Paume, by Hélène Adhémar, 1973.
Peinture au Musée du Louvre:
 Ecole françiase XIVᵉ, XVᵉ, et XVIᵉ siècles, by Charles Sterling and Hélène Adhémar, 1965.
 Ecole française XVIIᵉ et XVIIIᵉ siècles, by Pierre Rosenberg, Nicole Reynaud, and Isabelle Compen, 1974. 2 volumes.
 Ecole française XIXᵉ siècle, by Charles Sterling and Hélène Adhémar, 1965. 4 volumes.
Vingt ans d'acquisitions au Musée du Louvre 1947–1967, by M. André Parrot and Hélène Adhémar, 1967.

MUSEUM OF FINE ARTS, BOSTON.

American Paintings in the Museum of Fine Arts, Boston, 1969.
 Volume I: Text, introduction by Perry Townsend Rathbone.
 Volume II: Plates.
Ancient Egypt as Represented in the Museum of Fine Arts, Boston, 4th ed. revised by William Stevenson Smith, 1960.
Ancient Glass in the Museum of Fine Arts, Boston, by Axel von Saldern, 1968.
Greek, Etruscan and Roman Art: The Classical Collections of the Museum of Fine Arts, Boston, revised edition by Cornelius Vermeule, 1963.
Museum of Fine Arts, Boston: Oriental Art, by Jan Fontein and Pratapaditya Pal, 1969.

THE NATIONAL GALLERY, LONDON.

Some of the finest catalogues written; each school has a text catalogue and one that reproduces the paintings in black-and-white plates. Only the text volumes are listed. Kept up-to-date by publications such as *The National Gallery Acquisitions: 1953–1962* of 1962 and the Trustee's reports issued every other year.

British School, by Martin Davies, 1959.
Dutch School, by Neil Maclaren, 1960.
Earlier Italian Schools, by Martin Davies, 1961.
Early Netherlandish School, by Martin Davies, 1968.
Flemish School: Circa 1600-Circa 1900, by Gregory Martin, 1970.
French School, by Martin Davies, 1970.
French School: Early 19th Century, Impressionists, Post-Impressionists, etc., by Martin Davies and Cecil Gould, 1970.
German School, by Michael Levey, 1959.
Seventeenth and Eighteenth-Century Italian Schools, by Michael Levey, 1971.
Sixteenth-Century Italian Schools (excluding the Venetian), by Cecil Gould, 1975.
Sixteenth-Century Venetian Schools, by Cecil Gould, 1971.
Spanish School, 2nd ed., by Neil Maclaren and revised by Allen Braham, 1970.

NATIONAL GALLERY OF ART, WASHINGTON, D.C.

See also entry for "Samuel H. Kress Foundation."
Catalogue of the Italian Paintings, by Fern Rusk Shapley, 1979. 2 volumes.
Renaissance Small Bronze Sculpture and Decorative Arts at the National Gallery of Art, by Carolyn C. Wilson, 1983.

NATIONAL GALLERY OF CANADA, OTTTAWA.

Catalogue of Painting and Sculpture:
 Volume I: Older Schools, edited by R. H. Hubbard, 1961.
 Volume II: Modern European Schools, by R. H. Hubbard, 1959.
 Volume III: Canadian School, by R. H. Hubbard, 1960.
 Volume IV: European Drawings, by A. E. Popham and K. M. Fenwick, 1965.

ROYAL COLLECTION, LONDON.

This is only a partial listing. Other catalogues, including the drawings and watercolors at Windsor Castle, are available on microforms; see Chapter 17.

The Bolognese Drawings of the XVII and XVIII Centuries in the Collection of Her Majesty the Queen, by Otto Kurz, 1955.
The Dutch Drawings in the Collection of His Majesty the King at Windsor Castle, by Leo van Puyvelde, 1944.
The English Drawings: Stuart and Georgian Periods in the Collection of His Majesty the King at Windsor Castle, by Adolph Paul Oppé, 1950.
The French Drawings in the Collection of His Majesty the King at Windsor Castle, by Anthony Blunt, 1945.

The German Drawings in the Collection of Her Majesty the Queen at Windsor Castle, by Edmund Schilling, 1971.

Italian Drawings and Paintings in the Queen's Collection, edited by Oliver Millar. London: Waterlow & Sons, Ltd., 1965.

The Later Georgian Pictures in the Collection of Her Majesty the Queen, by Oliver Millar, 1969. 2 volumes.

Roman Drawings in the Collection of Her Majesty at Windsor Castle, by Anthony Blunt and Hereward Lester Cooke, 1960.

The Tudor, Stuart and Early Georgian Pictures in the Collection of Her Majesty the Queen, by Oliver Millar, 1963. 2 volumes.

Dutch Pictures from the Royal Collection, by Oliver Millar. London: Lund Humphries, 1971.

Venetian Drawings of the XVII and XVIII Centuries in the Colection of Her Majesty The Queen at Windsor Castle, by Anthony Blunt and Edward Croft-Murray, 1957.

SAMUEL H. KRESS FOUNDATION, NEW YORK CITY

Decorative Art from the Samuel H. Kress Collection at the Metropolitan Museum of Art: The Tapestry Room from Croome Court, Furniture, Textiles, Sèvre Porcelains, and Other Objects by James Parker, Edith Appleton Standen and Carl Christian Dauterman, 1964.

Italian Paintings, by Fern Rusk Shapley.
 Volume I: Thirteenth to Fifteenth Century, 1966.
 Volume II: Fifteenth to Sixteenth Century, 1968.
 Volume III: Sixteenth to Eighteenth Century, 1973.

Renaissance Bronzes from the Samuel H. Kress Collection, by John Pope-Hennessy, 1965.

Renaissance Medals from the Samuel H. Kress Collection at the National Gallery of Art, based on G. F. Hill's catalogue of the Gustave Dreyfus Collection, revised and enlarged by Graham Pollard, 1967.

Tapestries from the Samuel H. Kress Collection at the Philadelphia Museum of Art: The History of Constantine the Great Designed by Peter Paul Rubens and Pietro de Cortona, by David Dubon, 1964.

Paintings from the Samuel H. Kress Collection: European Schools Excluding Italian, by Colin T. Eisler, 1977.

TATE GALLERY, LONDON.

Kept up-to-date by such publications as *The Tate Gallery Acquisitions 1968–1969* of 1969 and the trustee's reports issued every other year.

William Blake: A Complete Catalogue of the Works in the Tate Gallery, revised edition by Martin Butlin, 1971.

The Foreign Paintings, Drawings, and Sculpture in the Tate Gallery, by Ronald Alley, 1959.

Tate Gallery Collection: Foreign Schools, by Ronald Alley, 1980.

The Modern British Paintings, Drawings, and Sculpture: Volume I: Artists A-L and *Volume II: Artists M-Z,* by Mary Chamot, Dennis Farr, and Martin Butlin, 1964.

VICTORIA AND ALBERT MUSEUM, LONDON.

For microform material available; see Chapter 17.

Catalogue of the Constable Collection, by Graham Reynolds, 1973.

Catalogue of Foreign Painting, by C. M. Kauffmann, 1973. Volume I: Before 1800; Volume II: 1800–1900.

Catalogue of Italian Sculpture in the Victoria and Albert Museum, by John Pope-Hennessy, 1964.
 Volume I: Text: Eighth to Fifteenth Century
 Volume II: Text: Sixteenth to Twentieth Century
 Volume III: Plates

British Watercolours in the Victoria and Albert Museum, by Lionel Lambourne and Jean Hamilton, 1980.

WALLACE COLLECTION, LONDON.

For microform material; see Chapter 17.

Furniture, by F. J. B. Watson, 1976.

Pictures and Drawings: Volume I: Text, 16th edition by F. J. B Watson, R. A. Cecil, and A. V. B. Norman, 1968, *Volume II: Illustrations,* 1970.

Sculptures, by James G. Mann, 1931; *Supplement,* 1981.

European Arms and Armour, by James G. Mann, 1962. 2 volumes.

Catalogue of Miniatures, by Graham Reynolds, 1980.

YALE UNIVERSITY ART GALLERY, YALE UNIVERSITY, NEW HAVEN, CONNECTICUT.

Early Italian Paintings in the Yale University Art Gallery, by Charles Seymour, Jr., 1970.

French and School of Paris in the Yale University Art Gallery, by Françoise Forster-Hahn, 1968.

Selected Far Eastern Art in the Yale University Art Gallery, by George J. Lee, 1970.

Selected Paintings and Sculpture from the Yale University Art Gallery, by Andrew C. Ritchie and Katherine B. Neilson, 1972.

Resources for Exhibition Information

Discovering information on exhibition catalogues—both recent and past—is essential to most art research. There are two kinds of publications which will assist the investigator: (1) indices that provide information on which exhibitions artists displayed their works or the subjects of the exhibitions and (2) reprints of the actual catalogues, if original ones are not available. These latter are especially important, because the indices to exhibition information are not always complete and may be inaccurate. This chapter is divided into these two categories. For a discussion of this material, the student should read, in Chapter 4, "How to Utilize Museum and Exhibition Catalogues" and "How to Utilize References Concerning Past Art Exhibitions."

Indices to Exhibition Catalogues

The references will indicate if particular artists displayed their works or if specific subjects were covered in an exhibition catalogue. This only indicates which references to pursue. The actual exhibition catalogue must be obtained and studied in order to verify the data in these resource tools.

Recent Exhibitions

Worldwide Art Catalogue Bulletin and *Worldwide Art Catalogue Bulletin: Annual Index.* Margaret Prescott, editor. Boston: Worldwide Books, Inc. Volume I (1963) +

Providing reviews of catalogues, the quarterly has been published since 1963. The annual index began with Volume VI in 1969. Culling catalogues from about 3,500 different museums and galleries, the Worldwide Books staff chooses from 700 to 900 catalogues each year that the staff considers to be of significant value. Over the years catalogues from over 2,000 art museums in fifty-one different countries have been listed for sale. In each bulletin, which includes around 200 per issue, the catalogues are alphabetized under the name of the country followed by the name of the city where the museum or gallery is located. Each entry includes the complete title of the catalogue; the name of the compiler; the place and date of the exhibition; the number of pages, illustrations, and plates in the catalogue; the price and size; a review of the material in the catalogue; and the language in which the catalogue is written. Each bulletin has five indices: (1) titles of the exhibition catalogues; (2) the names of artists who are either the subjects of monographic catalogues or whose works figure significantly in the texts or in the illustrative material of the catalogues; (3) Western Art, which is subdivided by periods of art history and geographical locations and then categorized by media; (4) Non-Western Art; (5) special media—architecture, ceramics and glass, environmental/land art, manuscripts and book design, medals and coins, metalwork, mixed media, photography, textile/fiber art, and video/film/performance; and (6) topical items such as commercial and industrial design, conceptual art, decorative arts and design, illustration, poster, and women artists. The annual index, which cumulates the material in the indices in the bulletins, uses the same format as the above listed five indices; moreover, in recent editions an index to the museums and galleries whose catalogues are listed has been added. For an illustration of the types of information disseminated by these brochures, the reader should study Example 13.

Art Abstracts and Indices, these are annotated in Chapter 12. *ARTbibliographies MODERN* and *RILA* provide access to bibliographical data on exhibition catalogues. *Art Index* cites reviews of exhibitions. Online databases are available.

Newspaper Indices, reported in Chapter 12, provide access to the most recent exhibitions, especially if online databases are used.

Past Exhibitions

Because researchers are often looking for specific exhibitions at which a particular artist's works were displayed, these indices have been divided according to the country or date of the exhibitions: (1) general, for all countries and dates; (2) British, 18th and 19th centuries; (3) North American, 19th and 20th centuries; and (4) 20th Century. Although this kind of extensive indexing for American, British, and Canadian art has yet to be done for other countries, remember that such biographical dictionaries as the one by Bénézit often provide access to information concerning exhibitions.

General, All Countries and Dates

Catalogs of the Art Exhibition Catalog Collection of the Arts Library, University of California at Santa Barbara. New York: Chadwyck-Healey, Inc., 1978.

Provides material on 42,000 catalogues in the Santa Barbara Collection, many of which are available for interlibrary loans. The microfiche index includes the following information: (1) name and city of the exhibitor; (2) title of the exhibition catalogue; (3) subject terms which are used to describe or clarify the contents of the catalogue; (4) the year of the exhibition; (5) such data on the catalogue as number of pages and illustrations; (6) notations of the inclusion of bibliographies, chronologies, and bibliographical footnotes; and (7) the name of the author. There are two principal indices: to the exhibitors and to subject categories. Indexes the catalogues sold by Chadwyck-Healey, Inc. and Worldwide Books. Updated periodically.

Catalogues of Holdings of Famous Libraries cited in Chapter 11 usually include exhibition catalogues.

Subject Index to Art Exhibition Catalogues on Microfiche. New York: Chadwyck-Healey, Inc.

A subject index to the numerous exhibition catalogues Chadwyck-Healey reprints on microfiche. Uses the same format as the index for the Santa Barbara collection; see above entry.

British, 18th and 19th Centuries

The British Institution 1806–1867: A Complete Dictionary of Contributors and Their Work from the Foundation of the Institution, compiled by Algernon Graves. London: George Bell and Sons, 1908; reprint ed., West Orange, New Jersey: Albert Saifer Publishers, 1969.

Alphabetized under the artist's name, each entry lists title and size of work, year exhibited, and catalogue number. Over 28,000 works were displayed during this time span. Contains an index to portraits, which were chiefly in sculpture.

A Century of Loan Exhibitions 1813–1912, compiled by Algernon Graves. London: H. Graves, 1913–15; reprint ed., New York: Burt Franklin, 1965. 5 volumes originally; some reprints are in 3 books.

Lists European artists whose works were displayed in the most important English and Scottish exhibitions from 1813 to 1912. Each entry under an artist's name includes title of the work, the date and dimensions of the object, the gallery where the work was exhibited, the date of the exhibition, the exhibition catalogue number, and the name of the owner. The last volume has two indices: to portraits and to owners.

A Dictionary of Artists Who Have Exhibited Works on the Principal London Exhibitions from 1760 to 1893, compiled by Algernon Graves. 3rd ed. London: H. Graves, 1901; reprint ed., New York: Burt Franklin, 1970.

Records about 25,000 artists who exhibited in the shows of sixteen societies; includes the Society of Artists, Royal Academy, British Institution, and Grosvenor Gallery. Under the artist's name, each entry states the first and last years plus the number of times the artist exhibited with each society. No titles of works are listed.

Royal Academy of Arts: A Complete Dictionary of Contributors and Their Work from Its Foundation in 1769 to 1904, compiled by Algernon Graves. London: H. Graves, 1905–06; reprint ed., New York: Burt Franklin, 1970. 8 volumes in 4 books.

Under the artist's name, each entry includes all of the titles of the works exhibited accompanied by the years of the shows and the exhibition catalogue numbers.

Royal Society of British Artists, compiled by Maurice Bradshaw. Leigh-on-Sea, England: F. Lewis Publishers, Inc., 1973–75. 3 volumes.
Volume I: Members Exhibiting 1824–1892, 1973.
Volume II: Members Exhibiting 1893–1910, 1975.
Volume III: Members Exhibiting 1911–1930, 1975.

Entries alphabetized by names of artists; each entry includes a list of the years the artist exhibited with the Royal Society of British Artists plus the titles and catalogue numbers of the works displayed. Entries in the second and third volumes also indicate the prices the artists placed on their exhibited works.

Works Exhibited at the Royal Society of British Artists 1824–1893 and the New English Art Club 1888–1917, compiled by Jane Johnson. Woodbridge, England: The Antique Collectors' Club, 1975.

Under artists' names gives their addresses, titles of works of art, dates of exhibitions, and prices for which items sold.

The Society of Artists of Great Britain 1760–1791: The Free Society of Artists 1761–1783: A Complete Dictionary of Contributors and Their Work from the Foundation of the Societies to 1791, compiled by Algernon Graves. London: G. Bell & Sons, 1907; reprint ed., Bath, England: Kingsmead Reprints, 1969.

Lists the artists whose works were exhibited by these two societies before the formation of the Royal Academy. Includes the titles of some 1,300 exhibited works, a brief history of the societies, and a portrait index.

North American, 19th and 20th Centuries

American Academy of Fine Arts and American Art-Union, by Mary Bartlett Cowdry. New York: New York Historical Society, 1953. 2 volumes.

First volume has introduction 1816–1852; second has exhibition records for these years. Lists European and American works of art exhibited during this period; states artist's dates and status of membership plus titles of works, exhibition dates, names of owners, and some sales prices.

The Archives of American Art. *Collection of Exhibition Catalogs*. Boston: G. K. Hall & Company, Inc., 1979.

> An index to more than 20,000 exhibition catalogues which date from the early 19th century to the 1960s. Arranged by gallery, museum, and personal names. Only one-person shows or exhibitions of no more than 3 people are cited under the individual artists' names. All of these catalogues have been put on microfilm and are available through an interlibrary loan.

Boston Athenaem Art Exhibition Index 1827–1874, compiled by Robert F. Perkins, Jr. and William J. Gavin, III, Boston: Library of the Boston Athenaeum, 1980.

> Lists more than 1,500 artists from 133 catalogues, all of which are available at the Boston Athenaeum. Under artists' names, there are dates they worked, addresses, dates of exhibitions, titles and catalogue numbers of paintings, and the owners of the works. If no owner was cited in the catalogue, it is assumed that the work still belonged to the artist. If the same title was displayed at several exhibitions, these are recorded under the name of the work; it is not known if these are the same work. All changed titles are listed as separate works.

Cumulative Record of Exhibition Catalogues: The Pennsylvania Academy of the Fine Arts 1807–1870; The Society of Artists 1800–1814; The Artists' Fund Society 1835–1845, edited by Anna Wells Rutledge.

> Contains a list of seventy-nine exhibition catalogues of painting and sculpture from the three societies listed. Has three indices: by artist, by owner, and by subject.

A History of the Brooklyn Art Association with an Index of Exhibitions, compiled by Clark S. Marlor. New York: James F. Carr, 1970.

> Includes a history of the association and an index to the exhibitions, from 1859 to 1892, organized under artists' names. Records dates of exhibitions, and titles and catalogue numbers of the works. The *fs* means the work was for sale; an asterisk indicates that there is additional information in the original catalogue. There are two lists: a chronology of exhibitions and of the catalogues.

National Academy of Design Exhibition Record 1826–1860. New York: New York Historical Society, 1943. 2 volumes

> Covers the first thirty-five annual exhibitions listing artist's name, dates, and status of membership plus titles of works, exhibition dates, and names of owners. Includes an index of artists, owners, subjects, and places.

National Academy of Design Exhibition Record 1861–1900, compiled by Maria Naylor. New York: Kennedy Galleries, Inc., 1973. 2 volumes.

> Indexes 22,000 different works of art under each individual artist's name. Provides the catalogue numbers and the titles of the works of art plus the prices which the artists placed on the objects which were for sale.

"Pre-1877 Art Exhibition Catalogue Index," National Museum of American Art, Washington, D.C.

> Provides multiple access to detailed information from about 1,000 unpublished catalogues from exhibitions held throughout the United States and Canada in major cities as well as less significant art centers, such as Albany, St. Louis, Louisville, and New Orleans. The exhibitions were all held before 1877 and include private collections, galleries, clubs, and fairs. Excludes the exhibitions which have previously been the subject of a publication, such as the American Academy of Fine Arts, the Boston Athenaem, Brooklyn Art Association, National Academy of Design, and The Pennsylvania Academy of Fine Arts. Provides information concerning artist, titles of work, subject of work, location and date of exhibition, owner if known, and institution which owns the catalogue. There are about 130,000 entries organized by artist. A 4 or 5 volume publication containing this data will probably be ready about 1985. For information prior to the date of publication, contact the Office of Research Support at the National Museum of American Art, Washington, D.C.

Royal Canadian Academy of Arts/Académie Royale des Arts du Canada: Exhibitions and Members 1880–1979, compiled by Evelyn de Rostaing McMann. Toronto: University of Toronto Press, 1981.

> Indexes more than 3,000 artists who exhibited. Provides biographical data, Academy status, titles of works exhibited, plus, where available, the present location of the work of art. Artists from the United States and Europe also exhibited in these exhibitions.

20th Century

International Directory of Exhibiting Artists. Santa Barbara, California: Clio Press, 1981+ 2 volumes.

> Under artist's name, cites major exhibitions: Includes all types of artists.

Modern Art Exhibitions 1900–1916: Selected Catalogue Documentation, compiled by Donald E. Gordon. Munich: Prestel-Verlag, 1974. 2 volumes.

> Lists the works displayed by 426 painters and sculptors in 851 exhibitions of modern art from 1900 to 1916 in fifteen countries and eighty-two cities whose catalogues were owned by fifty-two different libraries. Many are inaccessible catalogues: eighty-nine in Russia, thirty-six in Hungary, and twenty in Czechoslovakia. The first volume has an explanation of how to use the material; an essay on modern art; a chronological list of exhibition catalogues consulted; over 1,900 small, black-and-white illustrations of works by 272 artists; and an index of artists that cites ex-

hibition dates and cross references to the catalogue entries in the second volume. The latter volume has a listing for each exhibition catalogue; each entry includes the names of the artists who displayed works of art in that exhibition, the titles of the works of art listed in the language used by the exhibition catalogue, and the medium of each of the works. An asterisk denotes works of art that are illustrated in the original exhibition catalogue and that are also reproduced in the first volume of Gordon's work. The second volume also contains an index to cities and exhibitors mentioned in the two volumes. In the second volume under the list of catalogues consulted, each entry includes the name of the original place of the exhibition and the present library where the catalogue can be located.

Royal Academy of Arts. *Royal Academy Exhibitors 1905-1970: A Dictionary of Artists and Their Work in the Summer Exhibitions of the Royal Academy of Arts.* Wakefield, Yorkshire, England: E. P. Publishing, Ltd., 1973-82. 6 volumes.

Under the artist's name, the titles of all of the works exhibited accompanied by the catalogue numbers of the works and the dates of the exhibitions. All artists who displayed their work in the Summer Exhibitions of Living Artists are included.

Reprints of Exhibition Catalogues

A number of the large North American and European libraries, especially those associated with museums, have excellent collections of original exhibition catalogues. If one of these institutions is nearby, reprints are unnecessary. However, for many researchers this is the only form in which these essential materials are available. A library's catalogue usually does not indicate individual catalogues within one of these reprint sets. In addition, the microforms may be located in a separate section of the library. If searching for a specific exhibition catalogue which is not listed in the library's catalogue, ask the reference librarian for assistance.

The Archives of American Art. *Collection of Exhibition Catalogs.* Boston: G. K. Hall & Company, Inc., 1979.

This is a listing of the exhibition catalogues which are available through interlibrary loan or one of the centers of the Archives. Arranged by gallery, museum, and personal names, the more than 20,000 exhibitions were held from the early 19th century to the 1960s. Microfilm roll and frame numbers, which are needed for ordering, are indicated on each entry. Includes most catalogues

that are indexed in books cited in the previous section of this chapter, "North American, 19th and 20th Centuries."

Art Exhibition Catalogues on Microfiche. New York: Chadwyck-Healey, Inc.

Reprints of important exhibitions: London—Arts Council of Great Britain 1940-1979, Fine Arts Society 1878-1976, Royal Academy of Arts Winter Exhibitions 1852-1976, and Victoria and Albert Museum 1862-1974—and Paris—French Salon Catalogues 1673-1925, Musée des Arts Decoratifs 1904-1976, and National Museums of France 1885-1974. Also a wide range of catalogues for North American exhibition: Chicago Museum of Contemporary Art 1967-1976, Los Angeles County Museum of Art 1932-1976, and in New York—American Federation of Arts 1929-1975, Buchholz Gallery-Curt Valentin 1937-1955, Galerie Chalette 1954-1970, Sidney Janis Gallery 1950-1976, and Solomon R. Guggenheim Museum 1953-1972. *Subject Index to Art Exhibition Catalogues on Microfiche* is available to assist the researcher.

Catalogues of the Paris Salon 1673 to 1881. Horst Woldemar Janson, compiler. New York: Garland Publishing, Inc., 1977. 60 volumes.

A facsimile edition of 101 *livrets* issued by the Paris Salon, which was the official French art exhibition sponsored by the Académie Royale de Peinture et de Sculpture until 1789 when the sponsorship changed to the Direction des Beaux-Arts. Reproduces all the catalogues from 1673 through 1881.

Encyclopédie des arts décoratifs et industriels modernes au XX ème siècle. Wolfgang M. Freitag, advisory editor. New York: Garland Publishing, Inc., 1977. 12 volumes.

Facsimile edition of the official publication of the 1925 Paris exhibition; includes over 1,100 full-page illustrations.

Exhibition Catalogues from the Fogg Art Museum. New York: Garland Publishing, Inc., 1977. 10 volumes.

Reprint of ten catalogues published for exhibitions at the Fogg Art Museum, Harvard University.

The Knoedler Library of Art Exhibition Catalogues on Microfiche. New York: Chadwick-Healey, Inc., and Knoedler Gallery.

Contains most of the catalogues for the Royal Academy of Arts Winter Exhibitions 1870-1927, British Institute Exhibitions 1813-1867, Paris Salons 1673-1939, Salon d'Automne 1905-1970, Société des Artistes Français 1885-1939, and other individual European exhibition catalogues. The holdings of catalogues of American exhibitions—which include the National Academy of Design, 1832-1918 and the Pennsylvania Academy, 1812-1969—are extensive.

Modern Art in Paris, 1855 to 1900, selected and organized by Theodore Reff. New York: Garland Publishing, Inc., 47 volumes.

Reproduces 200 exhibition catalogues; includes World's Fair 1855–1900; the Salon of the *Indépendants,* French Salons 1884–99; Salons of the Rèfusals, including the famous one in 1863; all 8 of the Impressionist Exhibitions in one book entitled *Impressionism;* Society of Printmakers, Rosicrucian Salons, Salons des Cent, Art Nouveau, and numerous other exhibition catalogues.

Resources for Sales Information

This chapter, which lists the names of references that contain information on auctions or sales of art works, is divided into three sections: (1) indices of auction sales, (2) sales catalogues reprinted on microforms, and (3) indices of sales catalogues owned by large art libraries. The information disseminated by these references is especially important for the researcher who is tracing the provenance of a work of art or is analyzing trends and fluctuations in the art market and for the would-be purchaser of works of art who must keep informed of forthcoming sales, as well as study past sales, in order to analyze the current market. Since one of the functions of an art museum is that of collecting works of art, the curatorial staff of the museum must keep informed of the art market. Consequently, a museum library often has a good collection of these types of references. For detailed information on how to use the references annotated in this chapter, the reader should consult Chapter 4. For additional information on this subject see Caroline Backlund, "Art Sales—Sources of Information," *ARLIS/NA Newsletter* 6 (Summer 1978): 65–72 and such books as *Auction Companion* by Daniel J. and Katharine Kyes Leab, New York: Harper and Row Publishers, 1981 and *Auction: A Guide to Bidding, Buying, Bargaining, Selling, Exhibiting, and Making A Profit,* by William C. Ketchum, Jr., New York: Sterling Publishing Company, 1980.

Indices of Auction Sales

A number of references provide data on auctions. Usually only one or two media are covered, such as painting and drawing or prints. The annotations must be read carefully. This section has been divided into (1) indices that are readily available and that cover recent sales, (2) works that provide data on past auctions, and (3) books that give a review of the auction season.

Recent Auctions

The Annual Art Sales Index. Richard Hislop, editor. Weybridge, Surrey, England: Art Sales Index, Ltd. First edition (1969/70) +

A computer-based information processing organization that covers more than 1,000 sales of drawings and paintings held by about 170 different international auction houses. Includes auctions held in London, New York, Amsterdam, Paris, Munich, Stockholm, and Vienna. Originally published under the title, *Connoisseur Art Sales Annual.* The 1975/76 publication was divided into two volumes: one for oil paintings, the other for drawings and watercolors. Previous to that date drawings were not included. Each entry, which is listed under an individual artist's name, cites the price for which the work of art sold, both in English pounds and United States dollars; sales data of date, auction house, and the object's lot number; plus the title of the work of art, the dimensions, medium, and whether or not the work is signed and dated. An *R* is used to indicate the works of art that are illustrated in a catalogue. If the sale was negotiated in some currency other than that used by England or the United States, this additional information is provided in parentheses after the entry. Includes only sales of works of art that bring a certain price. In 1983 this was £ 300 for oil paintings and £ 250 for watercolors and drawings. For a complete list of the monetary abbreviations, the reader should consult the currency exchange rates that are listed at the beginning of each volume. The annual index contains a chronological list of the sales and in earlier issues included several signed articles that reviewed the auctions for the year. Issued ten months of the year, October through July, *The Monthly Art Sales Index* includes only oil paintings, but covers the same season as the annual index. Since all of the information is computer based, various services to compile information from the Data Bank are also available. For example, there is an artist card index which provides information on sales of a particular artist's works over the past seasons. The format of this card index is the same as that used in the annual. For current information on these services, the reader should write the company. Also publishes *Auction Prices of American* Artists, which cumulates the information from the annual and provides an essay that analyzes American art sold during that period. Volume I: 1970/78, Volume II: 1978/80, Volume III: 1980/82. For online database, see next entry.

ArtQuest: The Art Sales Index Database, available through an annual membership fee plus connect-time

per hour from Art Sales Index, Ltd. Files date from October 1970; updated about once a month. Includes works from some 60,000 artists; adds 1,000 to 2,000 new artists' names per year.

Gordon's Print Price Annual. Thomas Wolf, editor. New York: Martin Gordon, Inc. Volume 1 (1972)+
Contains (1) alphabetical listing of works sold under artist's name citing title; medium; edition size; date; references; dimensions recording image size and for intaglio prints, the boundaries of the plate marks; data on signatures of artists, printers, and patrons; condition of print; any information placed in margins of print; and sales data—auction house, date, lot number, and price in equivalent U.S. dollars and the actual currency in which it sold; (2) a cross index of publications which provides access to auctioned prints that are found in the important print literature; (3) an index by artist's name to the catalogue number by which many prints are identified in the important print references; and (4) an extensive bibliography. Includes a guide to using the annual and a separate listing of auction houses which reports the dates of sales and the commissions charged. Covers the auctions in about 19 houses in Europe and the United States.

International Art Market: A Monthly Report on Current World Market Prices of Art, Antique Furniture, and Objects d'Art. New York: Art in America, Inc. Volume 1 (March 1961–February 1962) +
In some libraries, this monthly report is bound with the annual index to provide a sales record for the year. A regular feature is the editor's "Thoughts on the Art Market." Provides prices on paintings, drawings, prints, posters, antiquities, art nouveau, clockmakers, furniture, objects of art, Orientalia, paperweights, photographs, pottery, porcelain, rugs and carpets, plus silver. All sale prices are listed in U.S. dollars as well as the purchase currency. Often includes the B. I. or Brought-In price at which the auction ceased rather than allow the work to be sold at too low a price. Sometimes photographs of the items are included. Back issues of this monthly report are available on microfilm.

Kovel, Ralph M. and Kovel, Terry H., compilers. *The Complete Antiques Price List: A Guide to the Market for Professionals, Dealers, and Collectors.* New York: Crown Publishers, Inc. First issue (1969) +
Published annually. Provides prices on items sold during the year; all monetary values reported in United States dollars. Only lists the items in a general way, such as "Furniture, Armchair, Windsor, Comb Back, New England, c. 1800 . . . $575.00." or sometimes cites a price range within which the item would probably sell, such as "Pressed Glass, Goblet, Frosted Ribbon . . . $12.50 to $25.00."

Leonard's Index of Art Auctions. Susan Theran, editor. Newton, Massachusetts: Auction Index, Inc. Volume 1 (1980) +
Index to art—paintings, drawings, mixed media, and sculpture—sold at American auction houses, 16 are usually included. Because there is no minimum price, the index provides data on works that sold over a wide monetary range, from $5 up. This is the only index that cites low-priced items and, therefore, includes many artists whose names would not appear in the other indices to auction catalogues. Indexed by artists' names, reports title; date and dimensions of the work; exhibition information of auction house, date, and catalogue number; and if catalogue includes provenance, literature, or a reproduction. An asterisk indicates that the 10% buyer premium has been included in the price. Volumes also have a glossary of terms and abbreviations. Lists auction houses accompanied by their addresses.

Mayer, Enrique. *International Auction Records: Engravings, Drawings, Watercolors, Paintings, Sculpture.* Paris: Editions Enrique Mayer. First English edition (1967) +
A translation of *L'annuaire international des ventes.* The first English edition was entitled *The International Yearbook of Sales.* An annual that records over 40,000 sales listed under five main headings: engravings, drawings, watercolors, paintings, and sculpture. Each category has an alphabetical list of artists' names. Each entry cites the title of each work sold; the year made; medium; dimensions in centimeters accompanied by the corresponding size in inches placed in parentheses; and a number that corresponds to the list in the front of the book which records, in chronological order, the date of the sale price quoted in United States dollars and in the currency of the country where the sale took place. Most titles of the works of art have been translated into English. Under "Index" has a chronological listing of the sales for the year; each entry records the date of sale plus the name and location of the auction house. Also includes the monetary rates of exchange; covers the auction houses in New York, London, Paris, Amsterdam, Copenhagen, Stuttgart, Hamburg, and Vienna.

Silver Auction Records. Calne, England: Hilmarton Manor Press.
Volume I: 1969/70, edited by H. Baile de Laperriere
Volume II: 1970/71, edited by H. Baile de Laperriere
Volume III: 1978/79, edited by Sarah and Charles Baile de Laperriere.
Volume IV: 1979/80, edited by Sarah and Charles Baile de Laperriere.
Price guide to antique silver, divided into British and American and Canadian silverware.

World Collectors Annuary. A. M. E. van Eijk van Voorthuijsen, editor. Voorburg: World Collectors Annuary. Volume 1 (1946–49) +

Now published annually. Provides information on paintings, watercolors, pastels, and drawings sold at a number of auction houses around the world, a number which varies between thirty and fifty auction houses each year. Under an individual artist's name, each entry cites the title of the work sold, probable date the work was finished, dimensions in centimeters, place and date of sale, lot number of the item, plus the sale price stated in the currency of the country where the sale took place. An asterisk accompanying the lot number of the object indicates that the piece is reproduced in the auction catalogue; a double asterisk means that the illustration is in color. Anonymous works of art are listed at the end of the volume. Entries sometimes record exhibitions in which works of art were displayed, literary references that refer to the pieces, and provenances. Company will supply photostat copies of original catalogue entries. Each volume has a list of the rates of exchange. To save time the researcher should use the *World Collectors Index 1946–1972,* see next entry.

World Collectors Index 1946–1972: An Alphabetical Index to Volumes I–XXVI of World Collectors Annuary. Jan J. B. van Eijk van Voorthuijsen, compiler. Voorburg: World Collectors Annuary, 1976.

An alphabetical listing of artists' names; each entry indicates (1) under the letter *a,* the years of the *World Collectors Annuary* which contained data on the artist's works of art; (2) under *e,* the number of entries per artist; and (3) under *p,* the number of pages employed by the staff to describe the works of the artist during the period from 1946 to 1972. Supplements are published.

Past Auctions

The following entries provide valuable records of retrospective sales:

American Art Annual. New York: R. R. Bowker Company. 1898+

Published irregularly; name and format changed to *American Art Directory* after Volume 37 (1945/48). Prior to the revisions, the publication usually included extensive sales information about American auctions, sometimes as many as 100 pages. Provided data on date and place of auction; artists accompanied by dates, country, and memberships; title and dimensions of work; and the name of the buyer and the price. Some issues reported all of the works sold from a famous collection.

Art-Price Annual. Hertha Wellensiek and Robert Keyszelitz, compilers. London: Art & Technology Press. Volume 1 (1945/46)—Volume 34 (1978/79) was an English edition of one volume each year. In 1980 changed the name to *Kunstpreis-Jahrbuch,* issued in 2 annual volumes in German only.

Covers important public sales, mostly in Europe and the United States. Divided into five sections: furniture, antiques, non-European art, paintings, and prints. The non-European category is subdivided into Antiquities, Eastern Art, and Primitive Art. Under artist's name or under description of sold item, cites title of work; signature and date data; medium; dimensions; and information on the sale, including the name of the auction house, date, and sale price quoted in the currency of the country where the sale was negotiated. Includes a currency table. Many entries are illustrated with small black-and-white reproductions. Previously entitled *European Art Prices Annuary.*

Art Prices Current: A Record of Sale Prices at the Principal London, Continental, and American Auction Rooms. London: William Dawson & Sons, Ltd. 1907/08–1972/73//.

No volumes for the years 1917 to 1920 were produced. Still important for pricing early works of art, this index cited prices of European and American auction houses. Divided into two sections; Part A includes sales of paintings, drawings, and miniatures. Each entry is listed under the date and place of auction followed by the artist's name and cites title of work, medium, signature data, dimensions, probable date work was completed, sale price, and sometimes the name of the buyer or seller of the object. There is a separate artist index to the material. Following the same format, Part B covers the sales of engravings, etchings, lithographs, and prints and has a separate artist index to this material. Also includes (1) a list of the prevailing rates of exchange for the year (2) a separate chronological list of sales which cites, under the date of the sale, the name of the auction house and the kinds of objects sold at the particular sale; and (3) a list of the abbreviations used for the reference works referred to in the text.

Bénézit. Emmanuel. *Dictionnaire critique et documentaire des peintres, sculpteurs, dessinateurs, et graveurs.* Paris: Librairie Gründ, 1924, 3 volumes; revised ed., Paris: Librairie Gründ, 1948–55, 8 volumes; revised and enlarged ed., Paris: Librairie Gründ, 1976. 10 volumes.

A biographical dictionary which as it has been revised has expanded to about 300,000 entries covering all kinds of artists of Eastern and Western art from 5 B.C. to the present. Includes brief data on the lives of artists, lists of awards won, and the locations of some art work. Under the category, *"Prix,"* the French term for price or value, there are listed some of the prices for which various works of art sold over a wide range of years. *Vte.* is the abbreviation for *vente,* which means sale or selling; *Vte. X* indicates an anonymous sale or where there was more than just one collection sold. Monetary values are listed in the currency of the country where the sale took place. In the front of the first volume of the 1976 edition is a table that provides French franc equivalents to U.S. and British currency from 1901 to 1973.

Bérard, Michèle. *Encyclopedia of Modern Art Auction Prices*. New York: Arco Publishing Company, Inc., 1971.

> Covers paintings, drawings, watercolors, gouaches, works in tempera, and pastels; all done by nineteenth- and twentieth-century artists and sold from 1961 to 1969, a period of time which is considered to be one of the greatest decades of change in the twentieth century. Includes about 275 artists whose works have sold for $2,000 or more. Provides short biographies of the artists plus data on the works sold: title, size, medium, price, plus place and date of sale. Has an index of sales.

Garnier, John H. *Auction Prices of American Antique Paintings 1968 through 1972*. Charleston, South Carolina: Garnier & Company, 1973.

> Paintings classified under artists' names. Each entry gives the titles of works sold during this five-year span; the date, medium, and dimensions of each work; and the date sold plus the sale price for each piece. Does not provide either the locations or the names of the auction houses.

Graves, Algernon. *Art Sales from Early in the Eighteenth Century to Early in the Twentieth Century (Mostly Old Master and Early English Pictures)*. London, 1918–21; reprint ed., New York: Burt Franklin, 1970. 3 volumes.

> Compilation of paintings sold at English auction houses. Catalogued under individual artists' names, entries are in chronological order from the earliest to the most recent sales. Each entry reports the date of the sale, the name of the auction house, the name of the owner of the work of art to be sold, the lot number of the piece, the title of the object, the size and date, the name of the purchaser, and the sale price quoted in English pounds.

Keen, Geraldine. *The Sale of Works of Art: A Study Based on the Times-Sotheby Index*. London: Thomas Nelson & Sons, Ltd., 1971.

> Well-illustrated book that gives an analysis of the art market from 1951 to July, 1969. Chapters cover how the art market works, fashions in the art market, old master paintings, drawings and prints, English pictures of the eighteenth and nineteenth centuries, the Impressionists, and twentieth-century paintings. The index includes charts which illustrate the rise in prices, over an eighteen-year range, of various types of art and of the works of different artists. Prices are quoted in English pounds and United States dollars.

Mireur, Hippolyte. *Dictionnaire des ventes d'art faites en France et à l'étranger pendant les XVIII^me et XIX^me siècles: tableaux, dessins, estampes, aquarelles, miniatures, pastels, gouaches, sépias, fusains, émaux, eventails peints, et vitraux*. Paris: Maison d'éditions d'œuvres artistiques, chez de Vincenti, 1911–12. 7 volumes.

> Covers auction sales of the 18th and 19th centuries. Listed under individual artists' names, each entry cites (1) title of work sold; (2) medium, if other than an oil painting; (3) dimensions in centimeters as indicated by two sets of numbers placed in parentheses, with height preceding width; (4) name of seller; (5) an appropriate indication if some city other than Paris was the location of the sale; (6) date of sale, and (7) sale price, which is quoted in French francs. Anonymous sales or those of several collections are listed as *Vente X*. The abbreviation *B.* indicates *bois* or wood; *C.* equals *cuivre* or copper; *T.* stands for *toile* or canvas. An especially good source for early French auctions.

Reitlinger, Gerald. *The Economics of Taste, 1961–1970*. 3 volumes.

> *Volume I: The Rise and Fall of the Picture Market 1760–1960*. New York: Holt, Rinehart, and Winston, 1961.
> *Volume II: The Rise and Fall of the Objets d'Art Market Since 1750*. New York: Holt, Rinehart, and Winston, 1963.
> *Volume III: The Art Market in the 1960's*. London: Barrie and Jenkins, 1970.
> Analyzes the art market; first two volumes include a bibliography and an index. All prices quoted in English pounds.

Rush, Richard H. *Art As an Investment*. Englewood Cliffs, New Jersey: Prentice-Hall, Inc., 1961.

> Analyzes the price market for paintings from all periods of art history. Includes chapters on the structure of the art market, the art experts, and building an art collection.

————. *Antiques As an Investment*. Englewood Cliffs, New Jersey: Prentice-Hall, Inc., 1968.

> Provides historical data as well as analyses of the market prices for various important styles of furniture from Italian Renaissance to Victorian. Includes chapters on the value of antiques, methods of determining authenticity, and antique dealers.

———— and the editors of U.S. News and World Report Books. *Investments You Can Live With and Enjoy*. Washington, D.C.: U.S. News & World Report, Inc., 1974.

> Analyzes the sales prices for all kinds of art, including paintings, drawings, prints, sculpture, furniture, silver, ceramics, glassware, bronzes, carpets, coins, and jewelry.

Savage, George, editor. *International Art Sales*. New York: Crown Publishers, Inc., 1961–62. 2 volumes.

> Includes: "Review of the Art Market," "Notable Sales and Prices Realized," "Price Trends in the Principal Categories," "Illustrated Catalogue of Important Sale-Room Items," "Directory of Auction Houses," plus an index to artists and works of art.

Reviews of the Auction Season

Christie, Manson and Woods, Ltd., London. *Christie's Review of the Season*. London: Weidenfeld and Nicolson.

> Review published annually; called *Christie's Season,* 1928–1961, then *Christie's Review of the Year* from 1962–63 to 1970–71. Numerous illustrations, many in color. Signed articles on various aspects of objects sold at Christie's auction house; these include paintings, drawings, jewelry, silver, porcelains and glass, ceramics, manuscripts, furnishings, and sculpture. For each work of art reproduced cites title and size of work, name of seller, and sometimes the buyer, and price of item both in English and U.S. currency.

Sotheby Parke Bernet, New York. *Art at Auction: The Year of Sotheby's*. London: Sotheby Parke Bernet Publications.

> Parke-Bernet, which was founded in New York City in the late 1930s by two art dealers, Hiram H. Parke and Otto Bernet, was acquired by the prestigious English auction house of Sotheby's in 1965. Presently there are auction rooms in London, New York City, and Los Angeles plus official representatives in fourteen other countries including France, Italy, Germany, Holland, Argentina, and Australia. The review, which is published annually, is profusely illustrated in color with photographs from the sales catalogues and has signed articles on the various classifications of works auctioned. Includes all categories of art sold during the year; prices are quoted in English pounds and U.S. dollars. For each work of art reproduced cites the name of the artist, title of the work, medium, dimensions, date, the price for which the item sold, and the date and place of sale. The annual has had various titles: *The Ivory Hammer: The Year at Sotheby's, Sotheby's 216 Season 1959–60,* and *Art at Auction 1965–66.* Sotheby's also publishes numerous catalogues of forthcoming sales plus a newsletter. Recently the past sales catalogues have been made available on microfilm; see entry below.

Sales Catalogues Reprinted on Microforms

Archives of American Art. "American Auction Catalogues on Microfilm."

> About 15,000 sales catalogues published in America between 1785 to 1960 have been filmed. All of the material is available at one of the Archives centers or through an interlibrary loan. There is no separate published catalogue to the auction catalogues. In ordering, use the number for the catalogue provided in Lancour's *American Art Auction Catalogues,* see listing below.

The Knoedler Library on Microfiche. New York: Knoedler Gallery.

> A fabulous collection of sales and exhibition catalogues reprinted on about 21,000 fisches. Only a few libraries own the complete set. However, parts of the collection can be purchased separately. Many of the approximately 13,000 sales catalogues have been annotated by the Knoedler staff, thus providing additional pertinent data on the works of art, as described in Chapter 6 under the provenance section of the explanation of catalogue entries. Sales catalogues—which are organized by country, auction house, then date—are for 14 countries, including the United States, Great Britain, France, Germany, Italy, Switzerland, Sweden, and Hungary. Earliest auction catalogue dates from 1744; the strength of the collection is in late 19th- and early 20th-century publications, particularly those of France and the United States. Although an index is not yet published, the correct catalogue can often be located through the indices of auctions sales.

Sotheby's Sales Catalogues. Ann Arbor, Michigan: University Microfilms.

> Microfilmed reprint of all of the sales catalogues issued at Sotheby's London auction house. From the first brochure in 1734 through 1970 is now available on 164 reels. Filmed from an auctioneer's copy, the catalogues include annotations of the sale price and the name of the purchaser. Each catalogue is preceded by an identification card indicating date of sale, name of collector, number of lots, contents, and number of pages.

Indices of Sales Catalogues Owned by Art Libraries

Art Institute of Chicago, see entry under SCIPIO.

Bibliothèque Forney, Paris. *Catalogue des Catalogues de Ventes d'Art (Catalog of the Catalogs of Sales of Art).* Boston: G. K. Hall & Company, 1972. 2 volumes.

> Lists about 14,000 sales catalogues arranged under collectors, places of sales, and dates of auctions. Includes references to auction catalogues written between 1778 and 1971.

Cleveland Museum of Art, see entry under SCIPIO.

Harvard University, Cambridge, Massachusetts. *Catalogue of Auction Sales Catalogues.* Boston: G. K. Hall & Company, 1971.

> Additional sales catalogues are listed in the 1975 supplement to the *Catalogue of the Harvrd University of Fine Arts Library, the Fogg Art Museum.*

Lancour, Harold. *American Art Aúction Catalogues 1785–1942: A Union List.* New York: New York Public Library, 1944. Updated on microfilm through 1962; available through the Archives of American Art.

> A list of the sales catalogues owned by twenty-one libraries. Includes the sales catalogues held by the Frick Art Reference Library, the New York Historical Society, the Philadelphia Museum of Art, the Brooklyn Museum, and the Cleveland

Museum of Art. Entries are recorded chronologically by date of auction. Each entry cites name of owner of the works which were sold, descriptive title of catalogue, name of auction house, plus number of pages in and present location of a copy of the catalogue. Includes an alphabetized list of the auction houses with their addresses and an index to the owners of the materials that were sold. Because the sale of an artist's estate may be cited, the index to owners can be an important research tool for locating data on some artists. Covers all forms of art sales. The numbers assigned to the more than 7,300 catalogues are often used by other reference material.

Lugt, Frits. *Répertoire des catalogues de ventes publiques intéressant l'art ou la curiosité, tableaux, dessins, estampes, minatures, sculptures, bronzes, émaux, vitraux, tapisseries, céramiques, objets d'art, meubles, antiquités, monnaies, médailles, camées, intailles, armes, instruments, curiosités naturelles, etc.* The Hague: Martinus Nijhoff, 1938–64. 3 volumes.
Volume I: Première période vers 1600–1825, 1938.
Volume II: Deuxème période 1826–1860, 1953.
Volume III: Troisième période 1861–1900, 1964.
Gives the location of sales catalogues in about 150 libraries, twenty-five of which are in the United States. Listed chronologically as to the date of the sale, each entry records the place of the sale, the owner of the works which were sold, the number and kinds of items the sale contained, the total number of items in the sale, the name of the auction house, the number of pages in the sales catalogue, and the abbreviations for the institutions that own copies of the sales catalogue. Under "Observations Pratiques," cites the names of the 150 institutions that possess the catalogues which are indexed. Of special importance to the researcher is the index to the names of the collectors whose works were sold. Unfortunately, there is no index to artists' names. Numbers assigned to the catalogues are often used by other reference material. The sale of an individual work of art cannot be located in these volumes; however, if the date of the sale and the name of the collector are known, Lugt's volumes may help in determining whether or not a sales catalogue exists and in discovering where a copy of an existing catalogue may be located. Volume I lists over 11,000 sales catalogues; Volume II, 14,900; and Volume III, 32,800.

Metropolitan Museum of Art, New York City. *Library Catalog of the Metropolitan Museum of Art.* Boston: G. K. Hall & Company. 2nd ed., 1980. 48 volumes.
Last 3 volumes list the sales catalogues. See listing under SCIPIO.

SCIPIO (Sales Catalog Index Project Input Online). Database available through RLIN.
A computer index of the exhibition catalogues owned by The Art Institute of Chicago, The Cleveland Art Museum, and The Metropolitan Museum of New York City. Files started January 1980; about 3,000 titles will be added annually to this union list. Also included in this file are reprints of sales catalogues of past auctions which these museums have purchased. Each reprint catalogue is being (1) provided a separate classification number and (2) the number which Lugt's *Répertoire des catalogues de ventes* assigned to it. For a discussion of this computer file, read Chapter 4, "How to Utilize Specialized Bibliographic Online Databases."

Winterthur, Henry Francis du Pont Museum. Wilmington, Delaware. *The Winterthur Museum Libraries Collection of Printed Books and Periodicals.* Wilmington, Delaware: Scholarly Resources, Inc., 1974, *Volume IX: Auction Catalogues.*
Lists the auction catalogues and the Edward Deming Andrews Memorial Shaker Collection. Cites about 4,800 catalogues.

Sources for Reproductions of Works of Art and Architecture

By necessity researchers must view reproductions of works of art. A list of some of the references that will aid readers in finding illustrations, or the location of works of art which they are seeking, has been compiled and annotated. This chapter has been divided into the following sections: (1) indices of works of art in museums—paintings plus photographs and prints; (2) indices of reproductions in books and periodicals—subdivided as to those which indicate several media, paintings, photography, sculpture, and costumes; (3) indices to portraits; (4) directories of picture sources; (5) facsimilies of graphics and drawing and of illuminated manuscripts; (6) well-illustrated references of art museum collections and general books; and (7) photographic archives reprinted in books and on microforms, subdivided by media covered.

Sources for illustrative material on drawings and graphics are the biographical dictionaries of graphic artists reported in Chapter 10 and the museum catalogues of Prints and Drawing Departments recorded in Chapter 14; these references have not been relisted here. Another good source for color reproductions of the works of art are the foreign-language encyclopedias, especially those published in Italy; only a few of these publications are annotated in this chapter. Excellent illustrative material can often be located in the exhibition catalogues referred to in Chapter 15, the sales catalogues discussed in Chapter 16, and the many art history references, especially catalogues raisonnés and *œuvres* catalogues, described in Chapter 3. For details on other ways of obtaining reproductions of works of art, the researcher should refer to Chapter 4 in this guide.

Indices of Works of Art in Museums

These references locate works of art if the artist is known. The institution can then be written to try to obtain a reproduction of the work or if a catalogue of the collection has been published, the researcher may find a photograph of the object in the catalogue.

Paintings

Census of Pre-Nineteenth-Century Italian Paintings in North American Public Collections, compiled by Burton B. Fredericksen and Federico Zeri. Cambridge, Massachusetts: Harvard University Press, 1972.

Divided into 3 main indices: artists, subjects, and collections. All contain similar data but are organized differently. In Part I under artist's name, provides data on the works in various institutions. Includes titles and, if known, locations of reproductions in books and journals. Index to subjects has 5 sections: religious works, secular subjects, portraits and donors, unidentified subjects, and fragments. Part III is organized by city. The appendices include a register of places listed by states.

Old Master Paintings in Britain: Index of Continental Old Master Paintings Executed before c. 1800 in Public Collections in the United Kingdom, compiled by Christopher Wright. New York: Sotheby Parke Bernet Publishers, 1976.

Under the individual artist, provides names of British mueseums that own work by the artist; gives the title of the work and a reference to any catalogue in which it might have been reported. Also includes a map of the locations, an "Index of Locations" that cites the museums and some of the artists represented there, and "Bibliography" that under the museum's name lists any catalogues which may have been compiled. Includes 1,750 artists in 233 collections.

Paintings in Dutch Museums: An Index of Oil Paintings in Public Collections in The Netherlands by Artists Born before 1870, compiled by Christopher Wright. New York: Sotheby Parke Bernet Publishers, 1980.

Uses the same format as the above reference, except for Dutch museums. Includes over 3,500 artists and 350 institutions.

Paintings in German Museums: Gemälde in Deutschen Museen, compiled by Hans F. Schweers. Munich: K. G. Saur, 1981. 2 volumes.

Indexes about 10,000 artists in more than 350 German museums. Under "Verzeichnis der Museen und Galerien," provides name, address, and

telephone number of the museums, alphabetized by cities. For each work of art gives title and dimensions.

Photographs and Prints

Index to American Photographic Collections, edited by James McQuaid. Boston: G. K. Hall & Company, 1982. One volume.

Alphabetically arranged by state, city, and institution, entries provide a listing of photographers represented in more than 450 American collections; often the number of prints is reported. The index to the more than 19,000 photographers has cross references to the collections that own their works.

American Prints in the Library of Congress: A Catalog of the Collection, compiled by Karen F. Beall. Baltimore: Johns Hopkins Press, 1970.

Under artist's names, gives brief outline of biographical data and list of works citing title, date, medium, dimensions, number in edition, signature data, and acquisition information. Has 2 indices: to subjects and geographical locations depicted in works of art and to names. Illustrated; selected bibliography.

Indices to Reproductions
in Books and Periodicals

These publications locate reproductions of works of art in specific books and periodicals. Some of these references index objects by subjects as well as by artists.

Several Media

Art Index. New York: H. W. Wilson Company. Volume 1 (1929)+

Under the artist's name lists some titles of works of art illustrated in the some 200 periodicals it indexes.

The Burlington Magazine: Cumulative Index Volumes I–CIV, 1901–1962. London: Burlington Magazine Publications, Ltd., 1969.

Burlington Magazine 10 Year 1963–1972 Index, 1973.

Includes two indices to the illustrations in *Burlington Magazine:* to attributed works of art and to unattributed ones.

Clapp, Jane. *Art in Life.* New York: Scarecrow Press, Inc., 1959.

Indexes the reproductions of paintings and graphic art—plus a selective group of photographs of architecture, sculpture, and decorative arts—that were published in *Life Magazine* from the first issue, November 23, 1936 through 1956. All illustrations that are listed are in color unless otherwise noted.

————. *Art in Life: Supplement 1965.* New York: Scarecrow Press, Inc., 1965.

Covers the seven years from 1957 through 1963.

Havlice, Patricia Pate. *Art in Time.* Metuchen, New Jersey: Scarecrow Press, Inc., 1970.

Index to the reproductions found in the art section of *Time Magazine* from the first issue in 1923 through 1969; entries listed by the names of artists and by the titles of the works.

Hewlett-Woodmere Public Library. *Index to Art Reproductions in Books.* Metuchen, New Jersey: Scarecrow Press, Inc., 1974.

Indexes the reproductions of paintings, sculpture, graphic art, photography, stage design, and architecture published in sixty-five books. Divided into two indices: of artists and of titles.

RILA: International Repertory of the Literature of Art. Volume 1 (1975)+

In the "Subject Index" under the artists' names, often cites specific works of art.

Thomson, Elizabeth W. *Index to Art Reproductions in Books.* Metuchen, New Jersey: Scarecrow Press, Inc., 1974.

An index to the reproductions in sixty-five books, published between 1956 and 1971. Covers architecture, paintings, sculpture, graphic art, photography, and stage design. Each entry, which is listed under the artist's name, cites the title of the work, the book in which the work of art is reproduced, the size of the reproduction, and whether or not the illustration is in color or black and white. There is also an index to the title of works of art which refers the reader to the main entry under the artist's name.

Paintings

Havlice, Patricia Pate. *World Painting Index.* Metuchen, New Jersey: Scarecrow Press, Inc., 1977. 2 volumes.

Under the artists' names provides references to the 1,167 books and catalogues, published between 1940 and 1975, that the book covers. Designates whether reproduction is in color and if a detail or the entire painting. Volume II is an index to titles of paintings.

Monro, Isabel Stevenson and Monro, Kate M. *Index to Reproductions of American Paintings: A Guide to Pictures Occurring in More than Eight Hundred Books.* New York: H. W. Wilson Company, 1948.

Indexes the reproductions of American paintings in more than 500 books and 300 exhibition catalogues. There are entries for individual artists, titles of works of art, and various subjects depicted in art. Locations of the actual paintings are reported when known.

————. *Index to Reproductions of American Paintings: A Guide to Pictures Occurring in More than Four Hundred Works. First Supplement.* New York: H. W. Wilson Company, 1964.

Using the same format, covers 400 additional works. Updated by Smith and Moure; see below.

————. *Index to Reproductions of European Paintings: A Guide to Pictures in More than Three*

Hundred Books. New York: H. W. Wilson Company, 1956.

Using the same format as the *Index to Reproductions of American Paintings,* covers 328 books.

Smith, Lyn Wall and Moure, Nancy D. W. *Index to Reproductions of American Paintings: Appearing in More than 400 Books, Mostly Published Since 1960.* Metuchen, New Jersey: Scarecrow Press, Inc., 1977.

Updates Monro's books; see above. Using the same format indexes 400 books. Includes 30,000 paintings. Cites 1,500 monographs published since 1950 after the artist who is the subject of the work.

Photographs

Moss, Martha, *Photography Books Index.* Metuchen, New Jersey: Scarecrow Press, Inc., 1980.

Give access to photographs reproduced in books. Full citations given in "List of Books Indexed." Has 3 sections: photographers, subjects, and portraits.

Parry, Pamela Jeffcott. *Photography Index: A Guide to Reproductions.* Westport, Connecticut: Greenwood Press, 1979.

For about 90 English-language works, indexes by name of photographer, subjects of prints, and titles of works. A chronological index to anonymous photographers is included.

Sculpture

Clapp, Jane. *Sculpture Index.* Metuchen, New Jersey: Scarecrow Press, Inc., 1970. 2 volumes in 3 books.
Volume 1: Sculpture of Europe and the Contemporary Middle East
Volume 2: Sculpture of the Americas, the Orient, Africa, the Pacific Areas and the Classical World.

Covering about 950 books, this dictionary indexes reproductions under subjects, names of artists, and historic persons represented in sculpture. Often provides the location of the work of art.

Costumes

Greer, Roger C. *Illustration Index.* Metuchen, New Jersey: Scarecrow Press, 1973.

Supplement to the book by Vance and Tracey, cited below. Indexes reproductions in fourteen books and periodicals which were issued between July, 1963 and December, 1971. Entries, which are alphabetized by subject, emphasize costume illustrations. Reproductions of paintings, portraits, and furniture are excluded.

Monro, Isabel Stevenson and Cook, Dorothy E., editors. *Costume Index: A Subject Index to Plates and Illustrative Text.* New York: H. W. Wilson Company, 1937.

An index to illustrations of costumes in 942 volumes; *The National Geographic Magazine* is the only periodical included. Under specific types of costume or dress of a particular period or country, entries cite titles of books, pages, and volumes of references, plus indicating whether the reproductions are in color. At the end of the volume is a union list of thirty-three libraries that own the 942 books to which the index refers.

———— and Monro, Kate M., editors. *Costume Index Supplement.* New York: H. W. Wilson Company, 1957.

Indexes 347 books in twenty-seven libraries using the same format as the previous book. Costumes of the nineteenth and twentieth centuries are indexed under the century and subdivided by decades rather than separate countries.

Vance, Lucile E. and Tracey, Esther M. *Illustration Index.* 2nd ed. New York: Scarecrow Pres, Inc., 1966.

Lists reproductions published in twenty-four magazines from 1950 through June, 1963. Alphabetized by subjects; entries emphasize costumes and exclude furniture, paintings, and portraits. For the supplement, see listing under Greer.

Indices to Portraits

These references list the sitters who have been depicted in art. Usually some biographical data on these people is provided; often there is an index to the artists who created the works.

American Library Association. *A.L.A. Portrait Index: Index to Portraits Contained in Printed Books and Periodicals.* William Coolidge Lane and Nina E. Browne, editors. Washington, D.C.: American Library Association, 1906; reprint ed., New York: Burt Franklin, 1965. 3 volumes.

An alphabetical listing of the names of famous sitters, giving their dates, occupation, and if applicable, the maiden name where known. Indexes more than 1,000 titles of periodicals and books where illustrations of the portraits are reproduced. Needs updating.

Art Institute of Chicago. *European Portraits 1600–1900 in the Art Institute of Chicago,* edited by Susan Wise. Chicago: Art Institute of Chicago, 1978.

For 50 portraits, provides a scholarly entry for the work of art and a biography of the sitter. Includes a bibliography.

Cirker, Hayward and Cirker, Blanche, editors. *Dictionary of American Portraits: 4045 Pictures of Important Americans from Earliest Times to the Beginning of the Twentieth Century.* New York: Dover Publications, Inc., 1967.

Photograph or engraving of Americans; provides dates of sitter and occupation; no biographies. Sometimes gives location of work of art. Many of the illustrations are only identification photographs.

Clapp, Jane. *Sculpture Index*, see listing in previous section.

Fletcher, C. R. L. *Historical Portraits: Richard II to Henry Wriothesley 1400–1600*. Oxford: Clarendon Press, 1909.

> Biography of person and photograph of work of art; all English.

Lee, Cuthbert. *Portrait Register*. Baltimore: Baltimore Press, 1968.

> A listing of portraits owned in the United States. Includes (1) names of sitters with dates followed by name of painter and location of work of art and (2) list of painters with artists' years followed by the portraits mentioned in book.

National Portrait Gallery, London. London: Her Majesty's Stationery Office.

> *Tudor and Jacobean Portraits*, by Roy C. Strong, 1969. 2 volumes.
>
> > Provides biography of person, scholarly catalogue entry, plus section on iconography of the work. Second volume has illustrations. Has indices to artists, to engravers, and to collections.
>
> *Early Georgian Portraits*, by John F. Kerslake, 1977. 2 volumes.
>
> > Same format as above only has 2 indices: to owners and collectors and to artists.

National Portrait Gallery, Washington, D.C. *Portraits of Americans: Index to the Microfiche Edition*, edited by Sandra Shaffer Tinkham. Teaneck, New Jersey: Chadwyck-Healey, Inc.

> Printed index to the 33 color microfiche publication which contains 1,926 portraits from the museum collection. A wide range of media, including photographs, is represented.

New York Historical Society. *Catalogue of American Portraits in the New York Historical Society*. New Haven, Connecticut: Yale University Press, 1975. 2 volumes

> Catalogues more than 2,240 portraits; provides biographical data on the sitters.

The Royal Society. *The Royal Society Catalogue of Portraits*, by Norman H. Robinson. London: The Royal Society, 1980.

> Biographical sketch and illustration. Provides information on the work of art and an index to the artists.

Directories of Picture Sources

√ *The Picture Researcher's Handbook: An International Guide to Picture Sources and How to Use Them*. Hilary and Mary Evans and Andra Nelki, compilers. New York: Charles Scribner's Sons, 2nd edition, 1979.

> Includes a directory of institutions that thave illustrative material; the directory is divided into two kinds of sources: general and specialists. The former is subdivided into public collections, historic and modern; commerical historical; and commercial modern. The latter is divided into nine specialist fields, one of which is art, architecture, and archaeology. Each entry gives the name and address of the distributing institution, the material and services available, and the procedure which needs to be followed in order to obtain the material. The book also includes a brief historical account of illustrative material, and four indices: to subjects discussed, to geographical sites, to specialized subjects, and to the sources that are cited. Most museum and gallery sources have been excluded.

√ *Picture Sources 4: Collections of Prints and Photographs in the U.S. and Canada*. New York: Special Libraries Association, 1983.

> Entires are divided into large subject categories, such as fine, graphic, and applied arts; geography and history; and performing arts. Each entry gives the name and address of the distributing institution, the kinds and subjects of available material, and procedures for viewing, photocopying, and reproducing the material. The book includes a brief introduction on the tools and techniques of picture research and four indices: a numerical list of sources, an alphabetical list of sources and major collections, a geographic list of sources, and a subject index. All of the numbers in these indices refer to the entry numbers.

Facsimiles

These reprints of original material include either the complete work or specific selections.

Graphics and Drawings

Benesch, Otto. *The Drawings of Rembrandt*. Enlarged and edited by Eva Benesch. New York: Phaidon Publishers, Inc., 1973. 6 volumes.

> *Volumes I-II: Leiden Years 1625–1631 and Early Amsterdam Period 1632–1640*
> *Volumes III-IV: Middle Period 1640–1650*
> *Volumes V-VI: Late Period 1650–1669*
>
> > Illustrated catalogue raisonné; each entry cites title, medium, dimensions, date, provenance, exhibitions, literary sources, and pertinent data. Drawings within the above periods are grouped according to subject. First volume includes a bibliography and a list of exhibitions. Sixth volume has a concordance between Benesch's catalogue entries and those in catalogues by Hofstede de Groot and Valentiner. Has an index to collections, which cites location of drawings, and an index to subjects.

Berenson, Bernhard. *The Drawings of the Florentine Painters*. Chicago: University of Chicago Press, 1903; later impression, 1970. 3 volumes.

> *Volume I: Text*
> *Volume II: Catalogue*

Volume III: Illustrations

Covers over fifty artists from Fra Angelico to Rosso Fiorentino. Drawings cited under institution where they are located. Second volume includes a list of the signs and abbreviations used in the work, a place index, and a general index.

Delteil, Loys. *Le peintre-graveur illustré (XIXᵉ et XXᵉ siècles).* Paris: Chez l'auteur, 1906–1930; reprint ed., New York: Collectors Editions, Ltd. and DaCapo Press, 1969. 31 volumes. *Appendix and Glossary.* Under supervision of Herman J. Wechsler. New York: DaCapo Press, 1969.

Illustrations of the graphic works of thirty-one artists. Ten volumes of the reprint edition cover Daumier's work; two volumes, Goya; and two volumes, Toulouse-Lautrec. Appendix includes a history of Loys Delteil, 1869–1927, a chronology for each of the thirty-one artists, an explanation of abbreviations and signs used in the work, and a glossary of French terms with their equivalents in English, German, and Spanish.

Hirth, George. *Picture Book of the Graphic Arts 1500–1800.* Munich: Knorr & Hirth, 1882–90; reprint ed., New York: Benjamin Blom, Inc., 1972. 6 volumes.

Covers over 340 artists who lived from the fifteenth through the eighteenth centuries.

The Illustrated Bartsch: Le Peintre-Graveur Illustré. Walter L. Strauss, general editor. New York: Abaris Books, 1979–

A multi-volume work of a projected 100 books, which will be a complete pictorial encyclopedia of European prints, based upon the work in Adam von Bartsch's *Le peintre graveur,* 1802–21, which is listed in Chapter 10. There are 4 phases to the publication: (a) a series of books with more than 20,000 prints of European masters, from the 14th to the 18th centuries, who are cited by Bartsch; (b) these will be supplemented by commentary volumes which will include illustrations of prints not known to Bartsch, accompanied by entries for each print; (c) illustrated catalogue volumes of artists omitted by Bartsch or active after his death, which will bring the material up to date; and (d) an index volume for subjects, names, places, titles of works, and iconographical features. For a discussion of this publication, see Chapter 6.

Moskowitz, Ira, editor. *Great Drawings of All Time.* New York: Shorewood Publishers, Inc., 1962. 4 volumes.
Volume I: Italian
Volume II: German, Flemish, and Dutch
Volume III: French
Volume IV: Oriental, Spanish, English, American, Contemporary
Beautifully illustrated volumes; lists literature references and provenance when known. Last volume contains a glossary and a bibliography.

Sérullaz, Maurice and Bacou, Roseline. *Great Drawings of the Louvre Museum.* New York: George Braziller, 1968.
Volume I: The French Drawings, by Maurice Sérullaz.
Volume II: The Italian Drawings, by Roseline Bacou.
Volume III: The German, Flemish and Dutch Drawings, by Roseline Bacou.
All drawings reproduced in color; has scholarly catalogue entries. Contains an index of former owners plus a list of publications and exhibitions of the Cabinet des Dessins of the Musée National du Louvre.

Tietze, Hans and Tietz-Conrat, Erica. *The Drawings of the Venetian Painters in the 15th and 16th Centuries.* New York: J. J. Augustin Publisher, 1944; reprint ed., New York: Collectors Editions, Ltd., 1970. 2 volumes.
Volume I: Text
Volume II: Plates
Has biographical entries for about eighty artists, followed by an alphabetical listing of the institutions having their works. Each entry cites title, medium, dimensions, provenance, exhibitions, and literary references. Includes a place index of drawings and a general index.

Illuminated Manuscripts

The Belles Heures of Jean, Duke of Berry Prince of France. Introduction by James J. Rorimer. New York: Metropolitan Museum of Art, 1958.

The Belles Heures of Jean, Duke de Berry. Legends by Millard Meiss and Elizabeth H. Beatson. New York: George Braziller, 1974.

The Book of Kells: Reproductions from the Manuscript in Trinity College, Dublin. Text by Françoise Henry. New York: Alfred A. Knopf, 1974.

The Cloisters Apocalypse: An Early Fourteenth-Century Manuscript in Facsimile. Text by Florens Deuchler, Jeffrey M. Hoffeld, and Helmut Nickel. New York: The Metropolitan Museum of Art, 1971. 2 volumes.

The Farnese Hours. Text by Webster Smith. New York: George Braziller, 1976.

The Grandes Heures of Jean, Duke of Berry. Introduction and legends by Marcel Thomas. New York: George Braziller, 1971.

The Grimani Breviary: Reproduced from the Illuminated Manuscripts Belonging to the Biblioteca Marciana, Venice. Legends by Lorenzo Mellini; translated by Simon Pleasance et al. London: Thames and Hudson, Ltd., 1972.

The Hours of Catherine of Cleves. Introduction and legends by John Plummer. New York: George Braziller, 1966.

The Hours of Etienne Chevalier by Jean Fouquet. Preface by Charles Sterling; legends by Claude Schaefer. New York: George Braziller, 1971.

The Hours of Jeanne d'Evreux, Queen of France, at the Cloisters, The Metropolitan Museum of Art. Introduction by James J. Rorimer. Greenwich, Connecticut: New York Graphic Society, 1957.

King René's Book of Love. Introduction and commentaries by F. Unterkircher. New York: George Braziller, 1975.

The Library of Illuminated Manuscripts. Walter Oakeshott, editor. New York: Thomas Yoseloff Company, 1959–62.
> These books reproduce only a few pages of the original, but have informative texts with them.
> *The Parisian Miniaturist Honoré,* by Eric G. Millar, 1959.
> *The Benedictional of St. Ethelwold,* by Francis Wormald, 1959.
> *The Great Lambeth Bible,* by Charles Reginald Dodwell, 1959.
> *The Rohan Book of Hours,* by Jean Porcher, 1959.
> *The Vienna Genesis,* by Emmy Wellesz, 1960.
> *A Fifteenth-Century Italian Plutarch,* by Charles Mitchell, 1961.
> *The York Psalter in the Library of the Hunterian Museum, Glasgow,* by Thomas Sherrer Boase, 1962.
> *The Douce Apocalypse,* by A. G. and W. O. Hasall, 1961.

Master of Mary of Burgundy: A Book of Hours for Engelbert of Nassau, the Bodleian Library, Oxford. Introduction by Jonathan James Graham Alexander. New York: George Braziller, 1970.

Masterpieces of Manuscript Painting. New York: George Braziller, Inc.
> Each volume discusses the historical period and has color reproductions from about 40 pages of various manuscripts.
> *Celtic and Anglo-Saxon Painting: Book Illumination in the British Isles 600–800,* by Carl Nordenfalk, 1977.
> *Hebrew Manuscript Painting,* by Joseph Gutmann, 1978.
> *The Icon: Holy Images—Sixth to Fourteenth Century,* by Kurt Weitzmann, 1978.
> *Late Antique and Early Christian Book Illumination,* by Kurt Weitzmann, 1977.
> *Early Spanish Manuscript Illumination,* by John Williams, 1977.
> *The Decorated Letter,* by J. J. G. Alexander, 1978.
> *Carolingian Painting,* by Florentine Mütherich and Joachim E. Gaehde, 1976.
> *The Golden Age of English Manuscript Painting 1200–1500,* by Richard Marks and Nigel Morgan, 1981.
> *Manuscript Painting at the Court of France: The Fourteenth Century,* by François Avril, 1978.
> *The Golden Age: Manuscript Painting at the Time of Jean, Duke of Berry,* by Marcel Thomas, 1979.

Italian Renaissance Illuminations, by J. J. G. Alexander, 1977.
Persian Painting, by Stuart Cary Welch, 1976.
Imperial Mughal Painting, by Stuart Cary Welch, 1977.
The Miraculous Journey of Mahomet. Text by Marie-Rose Séguy, 1977.
The Prayer Book of Michelino da Besozzo. Text by Colin Eisler and Patricia Corbett, 1981.

The Psalter of Robert de Lisle. Text by Lucy Freeman Sandler. London: British Museum, 1983.

The Rohan Master: A Book of Hours. Introduction by Millard Meiss; legends by Marcel Thomas. New York: George Braziller, 1973.

Les très riches heures du duc de Berry, Musée Condé à Chantilly. Introduction by Jean Porcher. Paris: Les Editions Nomis, 1950.

Les Très riches heures of Jean, Duke of Berry, Musée Condé, Chantilly. Introduction by Millard Meiss; legends by Jean Longnon. Translated by Victoria Benedict. New York: George Braziller, 1969.

The Trinity College Apocalypse. Introduction and text by Peter H. Brieger. London: Eugrammia Press, 1967. 2 volumes.

The Visconti Hours. Introduction and legends by Millard Meiss and Edith W. Kirsch. New York: George Braziller, 1972.

Well-Illustrated References

These books contain numerous colored reproductions of works of art.

Art Museum Collections

Great Galleries of the World. Ettore Camesasca, general editor. New York: Arco Publishing Company, Inc., 1973. 6 volumes.
> Each volume includes a history of the museum, a list of directors, and a list of catalogues published by the museum. The bulk of each volume is composed of illustrations of some of the masterpieces of the museum; the masterpieces are reproduced in color and provided some information on the piece. Other important paintings are reproduced in a more diminutive size and in black and white. At the end of each volume is a catalogue of all of the works of art illustrated in the book. Each entry provides the title of the work, an English translation of the title, medium, dimensions in inches accompanied by the corresponding size in centimeters in parentheses, plus signature and date information.
> *The Alte Pinakothek of Munich and the Castle of Schleissheim and Their Paintings,* edited by Edi Baccheschi, 1974.
> *The National Gallery of London and Its Paintings,* edited by Marina Anzil, 1974.
> *The National Gallery of Washington and Its Paintings,* edited by Mia Cinotti, 1975.

The Prado of Madrid and Its Paintings, edited by Mia Cinotti, 1973.

The Rijksmuseum of Amsterdam and Its Paintings, edited by Paolo Lecaldano, 1973.

The Uffizi of Florence and Its Paintings, edited by Sergio Negrini, 1974.

Newsweek: Great Museums of the World. Carlo Ludovico Ragghianti, and Henry A. La Farge, general editors. New York: Newsweek, Inc., 1967–1982.

Each volume reproduces some of the masterpieces of the museum; all illustrations are in color. All titles are translated into English. Medium and size are given for each work of art reproduced; often some pertinent information is added. Each volume includes a history of the museum, a selected bibliography, an index to illustrations, and an index to names.

Art History Museum, Vienna Picture Gallery, 1969.

Brera, Milan, 1970.

British Museum, London, 1967.

Egyptian Museum, Cairo, 1969.

Hermitage, Leningrad, 1980.

Louvre, Paris, 1967.

Metropolitan Museum of Art, New York, 1978.

Museum of Art, São Paulo, 1981.

Museum of Fine Arts, Boston, 1969.

Museum of Fine Arts, Budapest, 1982.

Museums of Cracow, 1981.

Museums of Egypt, 1980.

Museums of the Andes, 1981.

Museums of Yugoslavia, 1977.

National Archaeological Museum, Athens, 1979.

National Gallery, London, 1969.

National Gallery, Washington, 1968.

National Museum of Anthropology, Mexico City, 1970.

National Museum, Tokyo, 1968.

Paintings Gallery, Dresden, 1979.

Pinakothek, Munich, 1969.

Pompeii and Its Museums, 1979.

Prado, Madrid, 1968.

Rijksmuseum, Amsterdam, 1969.

Uffizi, Florence, 1968.

Vatican Museums, Rome, 1968.

World of Art Library: Galleries. London: Thames and Hudson; New York: Harry N. Abrams, Inc.; Paris: Editions Aimery Somogy, 1964–73.

A series published in various countries; each volume is on a specific museum. Contains color reproductions of about 100 works of art in the museum's collection accompanied by such data as titles, media, dimensions in inches and centimeters, catalogue numbers, and other pertinent interesting facts. At the end of each volume there are about 200 small, black-and-white reproductions of works of art; entries for the illustrations cite titles, media, and dimensions of the works of art. All titles are translated into English.

French Impressionists in the Louvre, by Germain Bazin, 1958. (English publication entitled., *Impressionist Paintings in the Louvre)*

The National Gallery, London, by Philip Hendy, 1960.

The School of Paris in the Musée d'Art Moderne, by Bernard Dorival, 1962.

The Dresden Gallery, by Henner Menz, 1962.

The Tate Gallery, revised ed., by John Rothenstein, 1963.

The National Gallery of Art, Washington, D.C., by John Walker, 1963.

The Louvre, revised ed., by Germain Bazin, 1966.

The Uffizi and Pitti, by Filippo Rossi, 1967.

The Prado, revised ed., by F. J. Sanchez-Canton, 1966.

The Rijksmuseum and Other Dutch Museums, by Remmett Van Luttervelt, 1967.

The Hermitage, revised ed., by Pierre Descargues, 1967.

The Art Institute of Chicago, by John Maxon, 1970.

The Munich Gallery, Alte Pinakothek, by Wolf-Dietter Dube, 1970.

The Berlin Museum: Paintings in the Picture Gallery, Dahlem-West Berlin, by Rüdiger Klessmann, 1971.

Treasures of the British Museum, edited by Frank Francis, 1971.

The National Gallery of Victoria, by Ursula Hoff, 1973.

General Books

Ars Hispaniae: Historia universal del arte hispánico. Madrid: Editorial Plus-Ultra, S.A., 1947–77. 22 volumes.

Profusely illustrated Spanish art history reference written by experts in various fields. Each volume includes a bibliography and three indices: to subjects, to geographic locations, and to proper names.

Arts of Japan. New York: John Weatherhill, Inc., 1974. Translation of a series published in Japan since 1966 under the title *Nihon no Bijutsu;* it is a project of the Agency for Cultural Affairs of the Japanese Government. These profusely illustrated volumes examine an art or craft of Japan and include bibliographies and glossaries.

Design Motifs, by Saburo Mizoguchi, 1973.

Kyoto Ceramics, by Masahiko Sato, 1973.

Tea Ceremony Utensils, by Ryoichi Fujoika, 1973.

The Arts of Shinto, by Haruki Kageyama, 1973.

Narrative Picture Scrolls, by Hideo Okudaira, 1973.

Meiji Western Painting, by Minoru Harada, 1974.

Ink Painting, by Takaaki Matsushita, 1974.

Haniwa, by Fujio Miki, 1974.

Grande Dizionario Enciclopedico Utet: fondato da Pietro Fedele. 3rd ed. revised and enlarged. Turin, Italy: Unione Tipografico Editrice Torinese, 1966–73. 19 volumes.

Contains numerous color reproductions of art works.

The History of World Sculpture. Germain Bazin, compiler. Translated by Madeline Jay. Greenwich, Connecticut: New York Graphic Society, 1968.

> Color reproductions of 1,024 pieces of sculpture covering art from prehistoric times to the contemporary period.

Key Monuments of the History of Architecture. Henry A. Millon, editor. New York: Harry N. Abrams, Inc., 1965.

> Reproduces 425 black-and-white illustrations of architecture from the prehistoric to the contemporary periods. Includes a glossary and an index to persons and places. Published as a companion to Janson's *Key Monuments of the History of Art;* see next entry.

Key Monuments of the History of Art: A Visual Survey. Horst Woldemar Janson, compiler. New York: Harry N. Abrams, Inc., 1959.

> Reproduces 1,000 black-and-white illustrations of architecture, sculpture, and painting. Each entry for a work of art reports the title, medium, dimensions, location, and possible date. Covers art from the prehistoric to the contemporary periods.

Larousse Encyclopedia. René Huyghe, general editor. New York: Prometheus Press, 1962–65. 4 volumes.
Volume I: Prehistoric and Ancient Art, 1962.
Volume II: Byzantine and Medieval Art, 1963.
Volume III: Renaissance and Baroque Art, 1964.
Volume IV: Modern Art: From 1800 to the Present Day, 1965.

> Numerous illustrations, a few in color. Based upon *L'art et l'homme,* published in Paris, 1957–61. Contains signed articles on society, art forms, and works of art of different art periods; the general index at the end of each volume lists the reproductions.

Lessico Universale Italiano di Lingua Lettere Arti, Scienze e Tecnica. Rome: Instituto della Enciclopedia Italiana, 1968–73. 24 volumes + supplement.

> Excellent color reproductions, many of works of art.

New International Illustrated Encyclopedia of Art. John Rothenstein, editorial consultant. New York: Greystone Press, 1967. 24 volumes.

> Extensive color reproductions. No biographical entries or bibliographical data.

A Pictorial Encyclopedia of the Oriental Arts. Kadokawa Shoten, editor. New York: Crown Publishers, Inc., 1969. 7 volumes.
Volumes 1–2: China
Volumes 3–6: Japan
Volume 7: Korea

> Color reproductions. Each Volume includes a brief glossary and essays on each general period.

Tesori d'arte cristiana. Stefano Bottari and Carlo Pelloni, editors. Bologna: Officine grafiche poligrafici Il Resto del Carlino, 1966–68. 5 volumes.

> Profusely illustrated, mostly with color reproductions. Covers Christian art from the catacombs to contemporary times. Each entry includes a separate bibliography while each volume contains a general bibliography and a glossary. The fifth volume has a general index and the table of contents for all five volumes.

Time-Life Books: This Fabulous Century: Sixty Years of American Life. New York: Time-Life Books, Inc., 1969.
Volume I: 1900–1910
Volume II: 1910–1920
Volume III: 1920–1930
Volume IV: 1930–1940
Volume V: 1940–1950
Volume VI: 1950–1960
Volume VII: Prelude 1870–1900

> Picture books depicting each era with photographs, posters, cartoons, and art of the decade.

Published Photographic Archives

Listed by media, these works are reproductions of visual material which are in museums, libraries, or photographic archives. Most of them are printed on microfiche or microfilm. The quality of these visuals varies greatly, from excellent to poor. In some of these publications, the typed text is difficult to read; in others, the illustrations are too dark to distinguish details. Furthermore, pertinent research data has often been excluded, such as scale of work, exact measurements, and date of sale of item. There are other productions like those by The Dunlap Society which are distinguished for their high quality work and the inclusion of full information. However, like any other detective work, sometimes a bad image is better than none.

There is sometimes no clear title to the microform sets, or date of publication provided. Issued over a number of years, the sets have the advantage of rarely going out of print. Because microforms are not always cited individually in the library's inventory catalogue system, the researcher should ask the librarian at the Media Center or the place where the microforms are stored, if the needed work is available and for information on the contents of the material. Many of the images in the published version—microfiche or book—are available as individual photographs through the archive which owns the material. Because of the expense of these photographic archives, few libraries will have extensive holdings of this material. It is, therefore, prudent to write or call prior to making a trip to distant libraries to discover if the desired item is avail-

able. A survey, made by Paula Chiarmonte, of four major microform collections—National Gallery of Art, Washington, D.C.; University of California at Santa Barbara; University of Texas, Austin; and the New York Institute of Art, New York City—was published in *Art Documentation,* 2(December 1983):173–76.

Several Media

Bibliothèque Nationale: Collections of the Department of Prints and Photographs. Paris: Studios Photographiques Harcourt.

> Created in 1667 by Louis XV, this is the oldest such department in the world. Since 1689 it has been the official print repository for all of France. The collection comprises 14,000,000 items. Microfilming, which began in 1981, continues. Because the reels are sold in sets, most of them have been placed under the particular subjects which they depict. See Archaeology, Architecture, Costumes, and Photographs.

The Complete Alinari Photo Archive on Microfiche. Zug, Switzerland: Inter Documentation Company.

> In 1854 Leopoldo Alinari and his brothers founded Fratelli Alinari Fotografi Editori, a firm whose members systematically photographed all of the major Italian works of art in private and public collections. Other photographic collections were purchased, and the photographing continued, both in and out of Italy, until today there are about 220,000 photographic plates, not all of which have been catalogued. However, each photograph is dated as to the time it was taken, thus making it possible to compare a building or other work of art prior to World War I with a photograph taken in 1970, as well as to view monuments which have since been destroyed. The media within these several collections—Alinari, Brogi, Anderson, Manelli, and Fiorentini—include architecture, sculpture, paintings, and miscellaneous works of art. The photographs are classified topographically with the Italian region—such as Tuscany, Piedmont, or Venezia—cited first, followed by the city then the museum or street, the title of the work, and the name of the artist. From the Alinari Archives in Florence, Italy, it is possible to purchase any of the photographs that are on the microfiche. This edition contains 1,285 fiches or a total of about 126,000 images. Several finding aids are projected, but not yet published: (1) alphabetical listing of names of Italian cities providing the province in which they are located, (2) the table of contents of the 15 sections, and (3) a correlation list that will cross reference the photograph numbers with the print's location within the microfiche collection and the page in the proposed detailed catalogues—which are also to be on microfiches—where the photographs are described. These microfiche catalogues, which will be reprints of

the catalogues that have been published on the various collections within the Alinari Archive, will have descriptions of the art objects—artist, subject, date, technique, and photograph number. In addition, there will be on microfiche (1) a subject index for four categories—biblical subjects, saints, mythological motifs, and the antique world; and (2) for the Alinari Collection only, an alphabetically arranged name index to persons shown in the photographs.

Early Alinari Photographic Archives. London: Mindata, Ltd.

> A selection of 7,000 photographs, mainly from the 19th century, from the Alinari Collection which the Victoria and Albert Museum acquired after World War II.

Alinari Photographic Archives.

> Some libraries have purchased individual photographs directly from Alinari, and thus have a collection the size of the microform publications.

Index Photographique de l'Art en France. Munich: K. G. Saur.

> Part of the Collection of the *Marburger Index,* see next entry. Sold separately, contains 100,000 photographs on 1,000 microfiches, which are organized geographically. Includes architecture, especially medieval; sculpture; paintings; prints; manuscripts; and Greek, Roman, and Egyptian antiquities. Some are from the Musée National du Louvre.

Marburger Index: Photographic Documentation of Art in Germany. Munich: K. G. Saur.

> The collection, which is reprinted on about 4,800 microfiches, contains 480,000 photographs—taken between 1850 and 1976—of architecture, painting, sculpture, and arts and crafts from the Middle Ages to modern times. The photographs are arranged topographically according to geographical site. Each image on the microfiche has a small identifying caption as to the location of the monument or object, what detail of the object is being illustrated, and the date the photograph was taken. The collection is owned by the Bildarchiv Foto Marburg at the Forschungsinstitut für Kunstgeschichte der Philipps-Universität Marburg and the Rheinisches Bildarchiv Köln. Photographs of the images on the microfiche can be ordered from these archives. The work is being supplemented by an addititonal 300,000 photographs on 3,000 microfiches from these German archives to be published from 1983 to 1987. A COM-Fiche Index, covering both editions, will be published at the same time.

Photographic Archives of the Caisse Nationale des Monuments Historiques et des Sites, Paris. London: Mindata, Ltd.

> Established by the French Ministry of Culture in the 19th century, this collection has photographs, which date from 1851, of paintings, drawings, sculpture, decorative arts, aniquities, and illuminated manuscripts. Published on microfiche,

there are 70,000 items from 300 museums and galleries. Sections of the various media can be purchased separately. Several indices are planned: (1) a printed *Index of Artists,* which will cover only the paintings and drawings, will provide a cross reference to the photographs; (2) a microfiche *Subject Index,* which will cover subjects and names of people, places, buildings, and historic events; and (3) a microfiche *Inventory,* which will list the museums and galleries that own the works of art.

Portraits of Americans. Teaneck, New Jersey: Chadwyck-Healey, Inc.

Reproduces 1,926 portraits from the National Portrait Gallery, Washington, D.C. On 33 color microfiches, the portraits represent a wide range of media, including photographs. See notation of printed index under "Indices to Portraits" in this chapter.

The Wallace Collection. London: Mindata, Ltd., 1980.

On 74 microfiches, there are black-and-white prints for paintings, ceramics, enamels, furniture, sculpture, miniatures, and arms and armour. The captions, which are difficult to read, provide artist's name. No index to material.

Archaeology and Classical Antiquities

Ancient Roman Architecture. Chicago: University of Chicago Press Distributor.

The photographs, which are from the archives housed at the American Academy in Rome, are divided into 3 sections: Rome, Italy, and The Empire. Alphabetized by name of site—except for the last section which is arranged by name of modern country followed by site, each photograph is labelled and has a bibliographical reference plus the date the photograph was taken. Prints can be purchased from the American Academy in Rome. There are printed indices. Issued in two sections: one with about 14,000 images, the second with about 12,000.

Bibliothèque Nationale: Archaeology and Exploration. Paris: Studios Photographiques Harcourt.

Contains 4 series of 19th-century photographs of ancient antiquities on one reel each.

Louis De Clercq, Archeologist (1836–1901), Middle East

Auguste Salzmann, Painter and Archeologist (1824–1872), Egypt and Palestine

Félix Téynard, Civil Engineer (1817–1892), Egypt and Nubia

John Bulkley Greene, Archaeologist (1838–1856), Egypt

Architecture, Sculpture, Interior Design

Armenian Architecture: A Documented Photo-Archival Collection on Microfiche. Zug, Switzerland: Inter Documentation Company.

Five volumes of this quality production are planned to include the architecture of Transcau-

casia and the Near and Middle East covering the historic periods from the Medieval to the present. The text of Volume I has a brief introduction to Armenian architecture; discussions of Armenian language, geographical features of Caucasus and Anatolia, and Armenian history accompanied by historical maps; glossary of Armenian terms; and a bibliography. For each building, provides old and recent photographs and engravings, if possible; location map; floor plan; elevation; drawings; plus a brief history.

Bibliothèque Nationale: Architecture and Early Photography in France. London: Mindata, Ltd.

Architecture and Monuments in France, 17,000 late 19th-century photographs printed on microfiche. Alphabetized by French departments, each print has a brief caption. A topographical index to the series is included.

Paris Views and Early Photography in France, more than 6,000 photographs of Paris plus photographs by such men as Nadar, Atget, and Lefevre-Pontalis. On microfiche.

Bibliothèque Nationale: Collections of the Departments of Prints and Photographs. Paris: Studios Photographiques Harcourt.

Destailleur Collection: 18th and 19th Century Drawings, architectural and sculptural details—made by such artists as Hubert Robert and Jongkind—of Paris and the rest of France, on 8 reels. *Topographie de la France,* arranged by departments, then towns, the collection contains architectural surveys dating from the 17th century. Includes a million items of drawings, engravings, press clippings, and photographs. Paris, 89 reels; Ile de France, 17 reels.

Courtauld Institute Illustration Archives. London: Harvey Miller Publishers. (1976/77)+

Utilizing the extensive photographic collections of the Witt and Conway Libraries, each Archive contains more than 800 detailed illustrations depicting a particular theme. The Archives, which are published quarterly each year, are available in printed editions. One of the aims of this series is to produce reproductions of works of art that are not readily available in other publications. Four Archives are presently being issued: (1) *Cathedrals and Monastic Buildings in the British Isles,* (2) *15th and 16th Century Sculpture in Italy,* (3) *Medieval Architecture and Sculpture in Europe,* and (4) *Late 18th and 19th Century Sculpture in the British Isles.*

The Drawings of Robert and James Adam in the Sir John Soane's Museum. New York: Chadwyck-Healey, Inc.

Reproductions of more than 10,000—of which 2,000 are in color—drawings of architecture, interiors, ornaments, ceilings, furniture, woodwork, and textiles. More than 360 buildings are depicted on 11 reels. *Catalogue of the Drawings of Robert and James Adam in Sir John Soane's*

Museum, a hardbound book compiled by Walter L. Spiers, 1979, contains for each drawing, brief descriptions plus names of the buildings, the clients, and the types of subjects. Also includes indices to buildings, to clients, and to objects.

The Dunlap Society Visual Archives. Princeton, New Jersey: Princeton University Press.

The following volumes which are discussed in Chapter 7, have detailed captions and printed text to accompany the microfiche. This quality production has reference numbers on the images by which slides or prints can be ordered from The Dunlap Society, Lake Champlain Road, Essex, New York 12936.

The Architecture of Washington, D.C., edited by Bates Lowry, 2 volumes on 88 fiches.

The County Court Houses of America, 2 volumes on 179 fiches.

Historic Buildings in Britain. New York: Chadwyck-Healey, Inc.

Publication of Royal Commissions on Historic Monuments in England, Scotland, and Wales, which provides inventories of buildings built before 1850 and recommended for preservation. Since 1909, 70 volumes have been published providing detailed descriptions and visual materials—photographs, line drawings, maps, and floor plans. Divided by parishes, the entries are subdivided under prehistoric monuments, Roman monuments, ecclesiastical buildings, secular buildings, and unclassed monuments. Also has glossaries of heraldic, archaeological, and architectural terms, plus indices to names and to subjects. These are available on microfiche: England, Scotland, and Wales. Can be purchased separately by regions.

Historic American Buildings Survey, see Library of Congress entry below.

The Index of American Design New York: Chadwyck-Healey, Inc.

Part of the Federal Art Project of the 1930s, this was a visual survey consisting of the objects of decorative, folk, and popular arts made in America up to about 1900. There are 10 sets of color microfiche, which can be purchased as a group or separately: Textiles, Costume, and Jewelry; Art and Design of Utopian and Religious Communities; Architecture and Naive Art; Tools, Hardware, Firearms; Domestic Utensils; Furniture and Decorative Accessories; Wood Carvings and Weathervanes; Ceramics and Glass; Silver, Copper, Pewter, and Toleware; plus Toys and Musical Instruments. The printed, *Catalog to the Index of American Design* contains 4 separate indices: to renderers (the ones who did the drawings), to owners; to craftsmen, designers, and manufacturers; and to subjects. The original renditions are kept at the National Gallery of Art, Washington, D.C.

Library of Congress: Prints and Photographs Division: The Historic American Buildings Survey.

Begun in 1933, this survey, which was discussed in Chapter 7, is now one of the largest collections of architectural records in the world. Available in books or microforms. Single prints can be ordered from Photoduplication Service, Library of Congress, Washington, D.C. 20540.

Historic American Buildings Survey. New York: Chadwyck-Healey, Ltd. Reproduces 45,000 photographs and 35,000 pages of text describing 20,000 architecturally significant structures on 1,400 microfiches. Arranged by sets for 48 states—Alaska and Hawaii are not included—plus the District of Columbia and Puerto Rico. Can be purchased separately.

Historic American Buildings, edited by David G. De Long. New York: Garland Publishing, Inc., 1979. Volumes by states; can be purchased separately. Series reproduces the drawings in the HABS and includes photographs of many of the buildings.

Royal Institute of British Architects: The Drawings Collection. London: World Microfilms Publication.

Drawings by architects—Colen Campbell, Jacques Gentilhâtre, Inigo Jones, John Webb, Alfred Stevens, Antonio Visentini, & C.F.A. Voysey—on microfilm. Each drawing includes reference to architect and scale. Printed index links drawings to entries in *Catalogue of the Drawings Collection of the Royal Institute of British Architects,* see entry under "Architectural Resources," chapter 23.

Victoria and Albert Museum: The Department Collections. London: Mindata, Ltd.

Microfiche reprints of *Architecture and Sculpture,* 152 fiches; *Ceramics,* 237 fiches; *Furniture and Woodwork,* 110 fiches; *Metalwork,* 138 fiches; and *Textiles,* 166 fiches. Each set of photographs from these departments has a brief index to that section. Can be purchased by department. Photographs can be ordered from the museum.

Victoria and Albert Museum: English Architectural Drawings. London: Microform, Ltd.

More than 4,000 architectural designs by such men as Sir Christopher Wren and Robert Adam; on 23 reels.

Costumes

Bibliothèque Nationale: Collections of the Department of Prints and Photographs. Paris: Studios Photographiques Harcourt.

Costumes de Regne de Louis XIV, reproduces, on 7 reels, 17th-century engravings made of the then contemporary fashions.

Costumes du XVIII ème Siècle, reproduces, on one reel, the engravings made, between 1778 and 1785 by the Parisian firm of Esnault and Rapilly, of the then current fashions, furniture, and manners.

"La Mésangère" Parisian Costumes, 1797–1839, reproduces on 4 reels, the drawings made by Mésangère and others for the *Journal des Dames et des Modes,* that depicted contemporary society, including costumes and furniture.

Victoria and Albert Museum: The House of Worth: Fashion Designs, A Photographic Record 1895–1927. London: Mindata, Ltd.

Reproduces 7,000 photographs, on microfiche, of the fashions created by Charles Frederick Worth, the Englishman who was largely responsible for Parisian pre-eminence in the world of fashion. Most of the clothing is shown worn by store mannequins with a full-length mirror to provide a rear view of the garment.

Paintings and Graphics

Christie's Pictorial Archive. London: Mindata, Ltd., 1980.

More than 70,000 photographs are reproduced from Christie's Archives dating from 1890 to 1979. Most of the works were sold at the London salesrooms. Includes (1) painting and graphic art, especially the British, Netherlandish, and Italian Schools of painting; and (2) decorative and applied art—furniture, silver, ceramics, Oriental, and general and applied art. *Christie's Pictorial Archive: Index to Artists* provides a list of 5,000 artist's names to the painting and the graphic arts sections. Although these microfiche images have numerous disadvantages—poor photographs, no size reported, labels are indistinct and often difficult to read, plus the dates of the sale and the sale prices are deleted—they can be used for identification purposes. Each photograph has a vendor reference number which can be used to write Christie's to inquire about the date of the sale, the sale price, and the provenance of the work. At their discretion, Christie's may provide an answer. By using the vendor numbers, prints can be otained for most of the photographs through A. D. Cooper, Ltd., 10 Pollen Street, London.

Royal Library, Windsor Castle: The Royal Collection of Drawings and Watercolors. London: Mindata, Ltd.

This collection of more than 30,000 Old Master drawings has been catalogued in a series of volumes published by Phaidon Press over a period of forty years. The drawings reproduced on microfilm follow these printed catalogues, which are being reprinted and are cited in Chapter 14 under "Royal Collection, London."

Victoria and Albert Museum.

British Oil Paintings, 1400–1900. London: Ormonde Publishing, Ltd., over 1,000 works reproduced on color microfiche.

The National Collection of Watercolours. London: Ormonde Publishing, Ltd., nearly 6,500 paintings by more than 1,600 artists reproduced on color microfiche. Arrangement follows *British Watercolours in the Victoria and Albert Museum,* published by Sotheby Parke Bernet, 1980. For each work on the microfiche, there is the following information: artist, title of work, and museum number.

Visual Catalogue of Miniature Paintings in the Victoria and Albert Museum. Haslemere, England: Emmett Microform, 1981. On color microfiches, reproduces 2,300 miniatures from the largest and most comprehensive collection in the world. There is a *Summary Catalogue of Miniatures in the Victoria and Albert Museum* which provides references for the microform material. Under artist's name, provides title of miniature, medium, measurements, and inscription, if any. There are indices to artists, miniatures; to artists, silhouettes; and to sitters, which gives their dates. Color slides can be ordered from the company; prints from the museum.

Witt Library Photo Collection on Microfiche.

A private publication of the collection at the Witt Library, Courtauld Institute of Art, London. In North America only three museums have the microfiche collection: The National Gallery of Ottawa, Canada; National Gallery of Art, Washington, D.C.; and J. Paul Getty Museum, Malibu, California. Contains more than 1,200,000 reproductions of about 50,000 artitsts' works; covers painting from about 1200 to the present. The microfiche images include the back of the card on which the photograph was mounted, if this contains notations concerning the location of the work. Articles from the files are also copied. Some of the illustrative material comes from sales and exhibition catalogues, in which case the text on the page has been included. *A Checklist of Painters c. 1200–1976 Represented in the Witt Library, Courtauld Institute of Art, London,* London: Mansell Information Publishing, 1978, can be used as an index to the names of the artists which are included in the Witt Library Collection.

Photographs and Prints of Historic Nature

Bibliothtèque Nationale: Collections of the Department of Prints and Photographs. Paris: Studios Photographiques Harcourt.

Collections of individual photographers are also available on one reel, including work by Blériot, Gustave Le Gray, Victor Hugo and Family, Eugéne Atget, and Henri Le Secq.

The de Vinck Collection: The Revolution of 1830 and the July Monarchy, shows, in 4 reels, life in France during the 1830s through prints.

La Guerre de Crimée (1854–1856), photographs on one reel.

British Museum: Historical Prints. London: Mindata, Ltd.

> More than 10,000 prints on microfiche representing history of Europe from 15th to 20th century. Arranged chronologically by event depicted; prints are captioned and can be ordered singly from the museum.

Royal Archives at Windsor Castle: Victorian Photographic Collection. London: World Microfilms Publication.

> More than 7,000 photographs, mostly made from 1845 to 1901, on 15 reels.

Victoria and Albert Museum: Early Rare Photographic Collection. London: World Microfilms Publication.

> One of the largest collections in the world, dating from 1850, the photographs are reprinted on 17 reels. *The Register,* on 7 reels, records the original records to the collection, providing photographer, subjects, and date the work was taken.

References that Assist in Authenticating and Preserving Art

This chapter is divided into three sections: (1) books that will assist investigators in discovering the origins of works of art, (2) books that discuss the problems of fakes and art theft, and (3) works that discuss the preservation of art objects. The references annotated in the first section of the chapter will assist the reader in learning more about the artist, collector, or firm that uses a particular designation found on some works of art. In order to assist the investigator in finding the specific type of reference which is needed, the first category has been subdivided into books that are concerned with designations of artists, designers, and collectors; ceramic marks; coats of arms of peerage and popes; hallmarks of silver- and goldsmiths; and watermarks. The last division, "Preserving Art Objects," annotates books that will help the owner of a work of art to understand the complicated and expensive process of conservation and that suggest ways artists can help prevent deterioration of their work.

Discovering the Origins of Works of Art

Designations of Artists, Designers, and Collectors

Contag, Victoria and Wang, Chi-ch'ien. *Seals of Chinese Painters and Collectors of the Ming and Ch'ing Periods.* Revised edition with supplement. Hong Kong: Hong Kong University Press, 1966.
 Reproduces the seals used in stamping documents to certify authenticity. Gives Chinese characters and names.

Goldstein, Franz. *Monogramm Lexikon: Internationales Verzeichnis der Monogramme bildender Künstler seit 1850.* Berlin: Verlag Walter de Gruyter, 1964.
 Alphabetized by the monograms; each entry cites artist's name, nationality, dates, media used, and bibliographical references to Thieme-Becker, Vollmer, and Bénézit (see biographical dictionaries, Chapter 10). Includes an index to names and a section on artists who used figures, signs, or symbols. Covers artists active since 1850, thereby supplementing Nagler's *Die Monogrammisten* which is listed in this same section.

Lugt, Frits. *Les marques de collections de dessins et d'estampes: Marques estampillées et écrites de collections particulières et publiques. Marques de marchands, de monteurs et d'imprimeurs. Cachets de vente d'artistes décédés. Marques de graveurs apposées après le tirage des planches. Timbres d'édition. Etc. Avec des notices historiques sur les collectionneurs, les collections, les ventes, les marchands et éditeurs, etc.* Amsterdam: Vereenigde drukkerijen, 1921.
Supplément. Den Haag: Martinus Nijhoff, 1956.
 Each volume reproduces identification marks that may be placed on drawings and prints. Marks are grouped into the following categories: (1) names, inscriptions, and monograms; divided as to each letter of the alphabet and subdivided as to names and inscriptions and as to initials; (2) figures, including armorial bearings, human figures, animals, plants and flowers, suns and stars, crosses, and geometric figures; (3) marks which are difficult to decipher and Japanese marks; (4) numbers, and (5) specimens of writings. Each volume reproduces over 3,000 facsimiles and has an index to names of collectors, artists, merchants, and publishers.

Nagler, Georg Kaspar. *Die Monogrammisten und diejenigen bekannten und unbekannten Künstler aller Schulen. . . .* Munich: G. Franz, 1858–79. 5 volumes. *General-index zu dr. G. K. Nagler Die Monogrammisten.* Munich: G. Hirth Verlag, 1920. One volume. Reprint edition of all 6 volumes. Nieuwkoop, Holland: De Graaf, 1966.
 Has over 30,000 facsimiles of monograms. Alphabetized by chief initials in the monograms or by symbols used by the artists. Covers artists and artisans who were active before about the middle of the nineteenth century and who worked in any medium. Includes painters, sculptors, architects, engravers, lithographers, gold- and silver-smiths, and ceramists. Last volume has a general index and a bibliography. Brings together the work done by Adam von Bartsch, Charles le Blanc, Franz Brulliot, Joseph Heller, and A.P.F. Robert-Dumesnil. Fourth volume was continued by Andreas Andresen; fifth volume by Andreas Andresen and Carl Clauss.

Ris-Paquot, Oscar Edmond. *Dictionnaire encyclopédique des marques et monogrammes, chiffres, lettres, initiales, signes, figuratifs, etc.* Paris: Henri

Laurens, 1893; reprint ed., New York: Burt Franklin, 1963. 2 volumes.

Contains over 12,000 monograms and marks. The second volume has two indices: to names and to geographic locations.

Ceramic Marks

Burton, William and Hobson, Robert Lockhart. *Handbook of Marks on Pottery and Porcelain.* London: Macmillan and Company, Ltd., 1909; reprint ed., edited by Ethel Paul and A. Petersen and entitled *Collector's Handbook to Marks on Porcelain and Pottery.* Green Farms, Connecticut: Modern Books and Crafts, 1974.

Reproduces hallmarks and includes a chronological listing of marks under particular geographic locations.

Chaffers, William. *Marks and Monograms on European and Oriental Pottery and Porcelain.* 15th revised ed. London: William Reeves Bookseller, Ltd., 1965. 2 volumes.

The chapters, all of which are on different potteries, provide some historical background, a reproduction of the hallmarks, bibliographical data, and sales prices covering a fifty-five year span.

Evans, Paul E. *Art Pottery of the United States: An Encyclopedia of Producers and Their Marks.* New York: Charles Scribner's Sons, 1974.

Divided into chapters on various potteries. Reproduces the hallmarks of the pottery firms. Well-illustrated book with bibliographical footnotes, a bibliography, and a geographic listing of art potteries.

Godden, Geoffrey A. *Encyclopaedia of British Pottery and Porcelain Marks.* New York: Crown Publishers, Inc., 1964.

Alphabetized by names of pottery firms, entries cite addresses and reproduce hallmarks. Contains a glossary, a bibliography, and two indices: to monograms and to signs and devices.

Kovel, Ralph and Kovel, Terry. *Dictionary of Marks: Pottery and Porcelain.* New York: Crown Publishers, Inc., 1963.

Consists of an alphabetical listing of hallmarks. Includes two indices: to hallmarks and to manufacturers.

———. *The Kovels' Collector's Guide to American Art Pottery.* New York: Crown Publishers, Inc., 1974.

Entries on pottery companies provide historical background and some bibliographical data plus reproducing the various hallmarks used.

Paul, Ethel and Petersen, A., editors. *Collector's Handbook to Marks on Porcelain and Pottery,* see listing under Burton.

Coats of Arms of Peerage and Popes

Brooke-Little, John Philip, *An Heraldic Alphabet.* London: Macdonald & Company, Ltd., 1973.

An illustrated dictionary of heraldic terms; includes an essay on the history, development, grammar, and law of heraldry.

Brusher, Joseph Stanislaus. *Popes Through the Ages.* Princeton, New Jersey: Van Nostrand Company, Inc., 1959.

Covers the Popes from St. Peter through John XXIII; each entry has a brief biography, a portrait, and a reproduction of the personal coat of arms of each Pope which can be essential in tracing ownership.

Burke, John Bernard. *A Genealogical History of the Dormant, Abeyant, Forfeited, and Extinct Peerages of the British Empire.* London: Harrison and Sons, 1883; reprint ed., London: William Clowes and Sons, Ltd., 1969.

Has illustrations of coats of arms; includes an historical account of the lineage cited.

Burke's Genealogical and Heraldic History of the Peerage, Baronetage, and Knightage. Edited by Peter Townend. London: Burke's Peerage, Ltd. First edition, 1826; frequent editions.

Reproduces coats of arms; includes historical accounts of lineage. Titles of different editions vary slightly.

Fox-Davies, Arthur Charles. *A Complete Guide to Heraldry.* Revised and annotated by John Philip Brooke-Little. London: T. C. & E. C. Jack, 1909; reprint ed., London: Thomas Nelson & Sons, Ltd., 1969.

Illustrated history of the shields, crests, and symbols of heraldry.

Franklyn, Julian and Tanner, John. *An Encyclopaedic Dictionary of Heraldry.* New York: Pergamon Press, 1970.

Well-illustrated dictionary of heraldic terms; appendix has an index to terms illustrated in the drawings.

Gough, Henry and Parker, James. *A Glossary of Terms Used in Heraldry.* Oxford, England: James Parker & Company, 1894; reprint ed., Detroit: Gale Research Company, 1966.

Illustrated dictionary of heraldic terms; contains synoptical tables of chief terms used in British heraldry.

Hallmarks of Silver- and Gold-Smiths

Clayton, Michael. *The Collectors' Dictionary of the Silver and Gold of Great Britain and North America.* New York: World Publishing Company, 1971.

Covering terms and artisans, entries include bibliographical references and reproduce hallmarks. Extensive bibliography; numerous illustrations, some in color.

Grimwade, Arthur. *London Goldsmiths 1697–1837: Their Marks and Lives from the Original Registers at Goldsmith's Hall and Other Sources.* London: Faber and Faber, Ltd., 1976.

Covers London goldsmiths, provincial English goldsmiths, and unregistered hallmarks. Divided into two principal sections: (1) facsimiles of hallmarks accompanied by (a) the name of the person using it; (b) the category or type of work the artisan made, such as candlestickmaker, goldsmith, saltmaker, or silversmith; (c) the year the mark was first registered; plus (d) a number preceding each name which provides access to the biographical entries in the second section and (2) a biographical dictionary. In the latter, the numbers in parentheses following each artist's name corresponds to the number of the hallmark facsimile which is reproduced in the first part of the volume. Includes an index of hallmarks which are not reproduced in the first portion of the book.

Jackson, Charles James. *English Goldsmiths and Their Marks: A History of the Goldsmiths and Plate Workers of England, Scotland, and Ireland.* 2nd ed. London:Macmillan & Company, Ltd., 1921; reprint ed., New York: Dover Publishers, Inc., 1964.

In a chronological table, reproduces facsimiles of goldsmith's hallmarks. Chapters divided by various cities in the British Isles; entries list goldsmiths who lived from 1090 to 1850, produce their hallmarks, and provide the years of the earliest and latest literary references. Has chapters covering the legislation concerned with goldsmiths and an historical survey plus two indices: to general subjects and names and to hallmarks.

Kovel, Ralph and Kovel, Terry. *A Dictionary of American Silver, Pewter, and Silver Plate.* New York: Crown Publishers, Inc., 1961.

Under the name of companies and artisans, entries reproduce hallmarks and cite dates, geographic locations, and numbers that refer to the bibliographical data at the end of the volume. Includes an index to initials that are used as hallmarks.

Rainwater, Dorothy T. *Encyclopedia of American Silver Manufacturers.* New York: Crown Publishers, Inc., 1975.

Illustrated dictionary of American silver manufacturing firms; reproduces facsimiles of hallmarks. Includes a list of trade names accompanied by the name of the firm that produced these items, a key to the unlettered trademarks, a glossary of terms, and a table of the equivalents of troy and silver standards weights.

Turner, Noel D. *American Silver Flatware 1837–1910.* South Brunswick, New Jersey: A. S. Barnes and Company, Inc., 1972.

Illustrated dictionary of firms that produced flatware silver; reproduces facsimiles of hallmarks. Includes a glossary of terms and an extensive bibliography.

Wyler, Seymour B. *The Book of Old Silver: English, American, Foreign, with All Available Hallmarks Including Sheffield Plate Marks.* 2nd ed. New York: Crown Publishers, 1937.

An illustrated history that also reproduces the hallmarks of gold- and silver-smiths in North America plus Great Britain, France, Germany, and other European countries.

Watermarks

Briquet, Charles Moïse, *Les filigranes: Dictionaire historique des marques du papier des leur apparition vers 1282 jusqu'en 1600.* 2nd ed. Paris: A. Picard & Fils, 1907; reprint ed., New York: Hacker Art Books, 1966. 4 volumes.

Includes over 16,000 facsimiles of watermarks used from the thirteenth through the fifteenth century. Entries for each watermark are listed under descriptions of the watermarks, such as "Tête de Boeuf," "Sphere," "Pot à une anse," and "Cercle." At the end of each volume are line drawings of the watermarks. Fourth volume contains four indices: to principal subject matter, to names of paper makers, to names of paper manufacturers, and to names of papers.

Churchill, William Algernon. *Watermarks in Paper in Holland, England, France, etc., in the XVII and XVIII Centuries and Their Interconnection.* Amsterdam: Menno Hertzberger & Company, 1935; reprint ed., Meppel, Netherlands: Krips Reprint Company, 1967.

Reproduces 578 watermarks used from 1635 to 1800; explanations for the watermarks given under "Particulars Concerning Watermarks." Includes a brief history of European watermarks and papermakers during the seventeenth and eighteenth century.

Hunter, Dard. *Papermaking: The History and Technique of an Ancient Craft.* 2nd ed. revised and enlarged. New York: Alfred A. Knopf, 1947.

A well-illustrated history of writing substances, paper, and watermarks. Includes a "Chronology of Paper and Allied Subjects," which ranges from 2700 B.C. to 1945; bibliographical footnotes; and a bibliography. Has a chapter on famous case histories in which watermarks were used to detect forgeries.

Fakes and Art Theft

Burnham, Bonnie. *Art Theft: Its Scope, Its Impact, and Its Control.* New York: International Foundation for Art Research, Inc., 1978.

A fascinating study of the problems and extent of art thefts.

Cescinsky, Herbert, *The Gentle Art of Faking Furniture.* 2nd ed. New York: Dover Publications, Inc., 1967.

Profusely illustrated.

Fleming, Stuart J. *Authenticity of Art: The Scientific Detection of Forgery.* New York: Crane, Russak and Company, Inc., 1976.
> Covers paintings, ceramics, and metals; each chapter has a bibliography. There is a general bibliography and an appendix covering x-ray fluorescence of a Chinese blue-and-white porcelain, radiocarbon analysis, and lead isotope analysis of ancient objects.

Goodrich, David L. *Art Fakes in America.* New York: Viking Press, 1973.
> Includes some historical accounts plus chapters on the marketplace, fakes in American museums, detection, lawsuits, and prints and sculpture.

Kurz, Otto. *Fakes.* 2nd ed. revised and enlarged. London: Faber & Faber, 1948; reprint ed., New York: Dover Publications, Inc., 1967.
> Case histories of fakes on a variety of art objects: paintings, sculpture, bronzes, glass, porcelain, furniture, jewelry, drawings, and graphics. Well illustrated; contains bibliographical footnotes.

Minneapolis Institute of Arts. *Fakes and Forgeries.* Minneapolis: The Minneapolis Institute of Arts, 1973.
> An exhibition catalogue which provides important data on detecting fakes and an extensive bibliography.

Rieth, Adolf. *Archaeological Fakes.* Translated by Diana Imber. London: Barrie and Jenkins, 1970.
> History of some outstanding forgeries.

Yates, Raymond Francis. *Antique Fakes and Their Detection.* New York: Harper & Brothers, 1950.
> An illustrated guide to detecting fakes in furniture, glassware, chinaware, silverware, pewter, clocks, jewelry, prints and paintings, and brass.

Preserving Art Objects

André, Jean-Michel. *The Restorer's Handbook of Ceramics and Glass.* Translated by Denise André. New York: Van Nostrand Reinhold Company, 1976.
> Well-illustrated guide to restoration techniques.

Emile-Mâle, Gilbert. *The Restorer's Handbook of Easel Painting.* Translated by J. A. Underwood. New York: Van Nostrand Reinhold Company, 1976.
> Well-illustrated guide to restoration techniques. Includes a bibliography and a table indicating the kinds of deterioration, the causes, and the treatments.

Fall, Freida Kay. *Art Objects: Their Care and Preservation, A Handbook for Museums and Collectors.* La Jolla, California: Laurence McGilvery, 1973.
> Well-illustrated book on the preservation and packing of paintings, watercolors, pastels, prints and drawings, sculpture, ceramics, textiles, tapestries, furniture, jewelry, and books as well as objects of metal, enamel, ivory, and glass. Each chapter has an extensive bibliography, plus there is a general bibliography.

Hours, Madeleine. *Conservation and Scientific Analysis of Painting.* Translated by Anne G. Ward, New York: Van Nostrand Reinhold Company, 1976.
> Well-illustrated book that explains a highly technical field to the layman.

Keck, Caroline K. *A Handbook on the Care of Paintings, for Historical Agencies and Small Museums.* Nashville: American Association for State and Local History, 1965.
> An introductory book on the anatomy of paintings; contains a glossary of terms, a list of supply sources, a brief bibliography, and a short list of some conservators of paintings and paper.

Lewis, Ralph H. *Manual for Museums.* Washington, D.C.: U.S. National Park Service, 1976.
> The chapter, "Caring for a Collection," describes some of the problems that can be encountered from insects, molds, and pollution. Each chapter has an extensive bibliography.

Plenderleith, Harold James and Werner, A.E.A. *The Conservation of Antiquities and Works of Art: Treatment, Repair, and Restoration.* 2nd ed. New York: Oxford University Press, 1971.
> Has a chapter on the influence of the environment. Divided into two sections—organic materials and metals—relating how to conserve these materials. Numerous appendices on chemical properties. Includes a list of restoration materials and their suppliers.

Taubes, Frederic. *Restoring and Preserving Antiques.* New York: Watson-Guptill Publications, 1969.
> An illustrated book covering the treatment of wood; finishing non-antiques; gilding and silvering; repairing antique wooden sculpture and decorative objects; restoring stone, terracotta, and other stone-like materials; treating metals; and restoring paintings. Includes notes on materials, equipment, and sources of supplies.

Fashion and Jewelry

Divided into two sections, this chapter consists of (1) fashion and costume histories and (2) references on gems and jewelry. The fashion and jewelry references cited are books that often illustrate the history of costume and gems with drawings and reproductions of famous paintings. These works can be used to trace the development and change in people's dress as well as assist researchers in dating paintings in which contemporary costumes were depicted.

References on Fashion and Costumes

Black, J. Anderson and Garland, Madge. *A History of Fashion.* New York: William Morrow & Company, Inc., 1975.
 Numerous color illustrations. Contains a glossary, a selected bibliography and a list of institutions having excellent costume collections.

Boehn, Max von. *Modes and Manners.* Translated by Joan Joshua. Philadelphia: J. B. Lippincott Company, 1932; reprint ed., New York: B. Blom, 1971. 4 volumes in 2 books.
 Volume I: From the Decline of the Ancient World to the Renaissance
 Volume II: The Sixteenth Century
 Volume III: Seventeenth Century
 Volume IV: Eighteenth Century
 Well illustrated by paintings of the period.

————. *Modes and Manners: Ornaments: Lace, Fans, Gloves, Walking-sticks, Parasols, Jewelry, and Trinkets.* New York: E. P. Dutton & Company, Inc., 1929; reprint ed. entitled *Ornaments*, New York: B. Blom, 1970.

————. *Modes and Manners of the Nineteenth Century as Represented in the Pictures and Engravings of the Time.* Translated by Oskar Fischel and M. Edwardes. New York: E. P. Dutton & Company, Inc., 1927. 4 volumes. Reprint ed., New York: B. Blom, 1970. 4 volumes in 2 books.
 Volume I: 1790–1817
 Volume II: 1818–1842
 Volume III: 1843–1878
 Volume IV: 1879–1914

Boucher, François. *20,000 Years of Fashion: The History of Costume and Personal Adornment.* New York: Harry N. Abrams, Inc., 1967.
 Profusely illustrated history; many reproductions are in color. Contains a general bibliography and a glossary. A translation of *Histoire du costume en Occident.*

Braun-Ronsdorf, Margarete. *Mirror of Fashion: A History of European Costumes 1789–1929.* Translated by Oliver Coburn. New York: McGraw-Hill Book Company, 1964.
 Using paintings and illustrations from fashion magazines, describes the costumes of the period. Has brief bibliography which includes a list of the 35 fashion magazines used in the research.

Brooke, Iris. *English Costume in the Early Middle Ages: The Tenth to the Thirteenth Centuries.* London: A. & C. Black, Ltd., 1936; reprint ed., New York: Barnes & Noble, 1964.

————. *English Costume of the Later Middle Ages: The Fourteenth and Fifteenth Centuries.* New York: Barnes & Noble, 1935; reprint ed., New York: Barnes & Noble, 1956.

————. *English Costume in the Age of Elizabeth: The Sixteenth Century.* 2nd ed. London: A. & C. Black, Ltd., 1950; reprint ed., London: A. & C. Black, Ltd., 1963.

————. *English Costume of the Seventeenth Century.* New York: Barnes & Noble, Inc., 1958.

————. *English Costume of the Eighteenth Century.* London: A. & C. Black, Ltd., 1931; reprint ed., London: A. & C. Black, Ltd., 1958.

————. *English Costume 1900–1950.* London: Methuen and Company, Ltd., 1951.
 All of the illustrations are drawn by Brooke.

Contini, Mila. *Fashion: From Ancient Egypt to the Present Day.* New York: Odyssey Press, 1965.
 Well-illustrated history.

Corson, Richard. *Fashions in Makeup From Ancient to Modern Times.* New York: Universe Books, 1972.
 Well-illustrated history.

Cunnington, Cecil Willett and Cunnington, Phillis. *Handbook of English Costume.* London: Faber & Faber, Ltd., 1970–72. 3 volumes.
 Volume I: In the Sixteenth Century, revised ed., 1970.
 Volume II: In the Seventeenth Century, 3rd ed., 1972.
 Volume III: In the Eighteenth Century, revised ed., 1972.

————. *Handbook of English Medieval Costume.* 2nd ed. London: Faber & Faber, Ltd., 1969.

————. *Handbook of English Costume in the Nineteenth Century.* 3rd ed. London: Faber & Faber, Ltd., 1970.
 Illustrated histories; each book includes a glossary of materials and a list of sources of reproductions.

Cunnington, Phillis Emily and Lucas, Catherine. *Costumes for Births, Marriages, and Deaths*. London: A. & C. Black, Ltd., 1972.
Information on the customs, rites, and ceremonies of funerals, marriages, and births in England.

Davenport, Millia. *The Book of Costume*. New York: Crown Publishers, 1962. 2 volumes in one book.
A catalogue of works of art depicting costumes. Each entry, which is reproduced in black and white, cites the date and location of the object. Often includes information concerning the sitter; has a general index which includes the names of the artists whose works are represented. A later printing of the 1948 edition.

Drobná, Zoroslava and Durdík, Jan. *Medieval Costume, Armour, and Weapons (1350–1450)*. Edited by Eduard Wagner. Translated by Jean Layton. London: Andrew Dakers, 1957.
Profusely illustrated; even includes horse harnessings.

McClellan, Elisabeth. *Historic Dress in America 1607–1870*. New York: B. Blom, 1967. 2 volumes in one book.
Reprint of *Historic Dress in America, 1607–1800*, 1900 and *Historic Dress in America, 1800–1870*, 1910. Well-illustrated history; includes a glossary.

Payne, Blanche. *History of Costume: From the Ancient Egyptians to the Twentieth Century*. New York: Harper & Row, Publishers, Inc., 1965.
Well illustrated with black-and-white drawings; includes a section on pattern drafts.

Warwick, Edward; Pitz, Henry C.; and Wyckoff, Alexander. *Early American Dress: The Colonial and Revolutionary Periods*. New York: Benjamin Blom, 1965.
Numerous black-and-white illustrations of famous paintings.

Wilcox, Ruth Turner. *The Mode in Costume*. New York: Charles Scribner's Sons, 1958.

———. *Five Centuries of American Costume*. New York: Charles Scribner's Sons, 1963.
Both are illustrated by drawings.

References on Gems and Jewelry

British Museum: *Jewellery Through 7000 Years*. London: British Museum Publications, Ltd., 1976.
Utilizing photographs of about 500 actual jewelry and scholarly catalogue entries, traces the history from 5000 B.C. to mid-19th century. Includes glossary and bibliography.

Evans, Joan. *A History of Jewellery, 1100–1870*. 2nd ed. London: Faber & Faber, Ltd., 1970.
Illustrated history.

———. *Magical Jewels of the Middle Ages and the Renaissance, Particularly in England*. Oxford: The Clarendon Press, 1922; reprint ed., New York: Dover Publication, Inc., 1976.
Discusses the historical importance of gems.

Gregorietti, Guido. *Jewelry Through the Ages*. Translated by Helen Lawrence. New York: American Heritage Press, 1969.
Beautifully illustrated history book. Includes (1) a list of gems with their hardness, coloring, countries with large deposits, varieties, and historic period of greatest use and (2) a chronological bibliography.

Jewelry: Ancient to Modern. New York: The Viking Press, 1980.
A beautifully illustrated catalogue of an exhibition held at the Walters Art Gallery, Baltimore providing (1) a glossary of foreign jewelry terms and (2) scholarly entries for 715 pieces.

Laufer, Berthold. *Jade: A Study in Chinese Archaeology and Religion*. Chicago: Field Museum of Natural History, 1912; reprint ed., New York: Dover Publication, Inc., 1974.
A comprehensive illustrated reference book covering the historical, symbolic, and ornamental uses of jade. There are two appendices; "Jade in Buddhist Art" and "The Nephrite Question of Japan."

Steingräber, Erich. *Antique Jewelry*. New York: Frederick A. Praeger, Inc., 1957.
Profusely illustrated history; includes a list of twenty gems citing for each the color, chemical composition, crystal system, degree of hardness, and countries of origin.

References on Subjects and Symbols in Art

This chapter is divided into ten sections: (1) general references, (2) mythology, (3) Christian subjects, (4) subjects in art, (5) emblem books, (6) references on animals and beasts, (7) floral symbolism, (8) musical iconography, (9)Non-Christian iconography, and (10) bibliographies of iconographical references. For detailed information on how to use the references annotated in this chapter, the reader should consult the iconographical problems that are discussed in Chapter 6 in this guide.

General References

Chevalier, Jean, editor. *Dictionnaire des symboles: Mythes, rêves, coutumes, gestes, formes, figures, couleurs, nombres.* Paris: Robert Laffont, 1969.
> Large concepts emphasized; some signed entries. Includes an extensive bibliography to which abbreviations in the articles refer; asterisks denote terms covered in the text.

Cirlot, Juan Eduardo. *A Dictionary of Symbols.* Translated by Jack Sage. 2nd ed. London: Rutledge & Kegan Paul, 1971.
> Large concepts emphasized; excludes narrative themes.

Daniel, Howard. *Encyclopaedia of Themes and Subjects in Painting.* London: Thames and Hudson, 1971.
> Profusely illustrated dictionary of people and themes that were depicted in art from the early Renaissance to the mid-nineteenth century.

Fingesten, Peter. *The Eclipse of Symbolism.* Columbia, South Carolina: University of South Carolina Press, 1970.
> Chapters covering art motifs as symbols of life and society, the craft of creation, the eye of God, the smile of Buddha, symbolic or visual presence, symbolism of nonobjective art, symbolism and allegory, a sixfold schema of symbolism, and the eclipse of symbolism.

Hall, James. *Dictionary of Subjects and Symbols in Art.* New York: Harper and Row, Publishers, Inc., 2nd edition revised, 1979.
> One of the most comprehensive references on themes and symbols in European art, commencing with the time of classical Greece. At the beginning of the book there is a bibliography of iconographical studies and a list of sources which the author consulted.

Hangen, Eva Catherine. *Symbols, Our Universal Language.* Wichita, Kansas: McCormick-Armstrong Company, 1962.
> Dictionary of symbols from all periods of history and all countries. Includes a list of honored patrons, guardians, and protectors plus a selected bibliography.

Jobes, Gertrude. *Dictionary of Mythology, Folklore, and Symbols.* New York: Scarecrow Press, Inc., 1961. 3 volumes.
> Dictionary of terminology, symbols, deities, and heroes; covers every phase of culture since prehistoric times. The third volume is a subject index to the entries in the other volumes; under themes, such as "Destroyer," "Happiness," and "Justice," cites deities and heroes described in the other volumes plus listing the culture from which they came and the pages where the entries can be found. At the end of the second volume is a bibliography.

Jung, Carl G., editor. *Man and His Symbols.* Garden City, New York: Doubleday & Company, Inc., 1964.
> A theory of the importance of symbolism, especially those revealed in dreams, by the Swiss psychologist, Carl Jung. Has a chapter on symbolism in the visual arts by Amiela Jaffé. Includes bibliographical footnotes and numerous illustrations, some in color.

Waters, Clara Erskine Clement. *A Handbook of Legendary and Mythological Art.* 2nd ed. Boston: Houghton, Mifflin Company, 1881; reprint ed., Detroit: Gale Research Company, 1969.
> A dictionary-type index arranged in four categories: symbolism in art, legends of the saints, legends of places, and ancient myths. A list of some paintings illustrating these themes is included accompanied by the location of these art works in the nineteenth century.

Mythology

Avery, Catherine B., editor. *The New Century Handbook of Greek Mythology and Legend.* New York: Appleton-Century-Crofts, Inc., 1972.
> Alphabetical guide to the gods, goddesses, heroes, and heroines of ancient Greece; contains pronunciation guides.

Beckwith, Martha. *Hawaiian Mythology.* Hartford, Connecticut: Yale University Press, 1940; reprint ed., Honolulu: University of Hawaii Press, 1970.
> Divided into sections covering the Hawaiian gods, children of the gods, the chiefs, and heroes and lovers in Hawaiian fiction.

Bonnerjea, Biron. *A Dictionary of Superstitions and Mythology.* London: Folk Press, Ltd., 1927; reprint ed., Detroit: Singing Tree Press, 1969.

> Includes non-Christian and Christian superstitions; has bibliographical footnotes plus an extensive bibliography.

Bulfinch's Mythology: The Age of Fable, The Age of Chivalry, and Legends of Charlemagne. New York: Thomas Y. Crowell Company, 1970.

> There are numerous editions of reprints of Thomas Bulfinch's mythological and legendary lore which were published 1855–1863. This edition includes two dictionaries: of archaeological sites and of names and terms used in the text.

Dowson, John. *A Classical Dictionary of Hindu Mythology and Religion, Geography, History, and Literature.* London: Kegan Paul, Trench, Trubner and Company, Ltd., 1928; reprint ed., Boston: Milford House, 1974.

> Written for the person who does not read Sanskrit; has an index of names in Sanskrit accompanied by their western equivalents and an explanation of Sanskrit.

Fox, William Sherwood. *The Mythology of All Races.* Boston: Marshall Jones Company, 1916. 13 volumes.

> Each volume has an extensive bibliography; thirteenth volume is a complete index to the series. First volume, *Greek and Roman Mythology,* has had a number of reprints.

Frazer, James George. *The Golden Bough: A Study in Magic and Religion.* 3rd ed. revised and enlarged. London: Macmillan and Company, Ltd., 1955. 13 volumes.

> First edition published in 1890. This is a study of comparative religions. Twelfth volume contains an extensive bibliography and the general index; thirteenth volume originally published in 1936 as *Aftermath: A Supplement to the Golden Bough.*

Grant, Michael and Hazel, John. *Gods and Mortals in Classical Mythology.* Springfield, Massachusetts: G. & C. Merriam Company, 1973.

> Illustrated dictionary which includes a list of Greek and Roman writers who are mentioned in the text, several geneological trees of Greek heroes, and a few maps of the classical world. English edition of same year entitled *Who's Who in Classical Mythology.*

Guirand, Felix, general editor. *New Larouse Encyclopedia of Mythology.* Translated by Richard Aldington and Delano Ames. Revised ed. New York: G. P. Putnam's Sons, 1968.

> Illustrated history of various non-Christian beliefs, including Egyptian, Assyro-Babylonian, Phoenician, Greek, Roman, Celtic, Slavonic, Finno-Ugric, Ancient Persian, Indian, Chinese, Japanese, North and South American, Oceanian, and African.

Mayers, William Frederick. *The Chinese Reader's Manual: A Handbook of Biographical, Historical, Mythological, and General Literary Reference.* Shanghai: American Presbyterian Mission Press, 1874; reprint ed., Detroit: Gale Research Company, 1968.

> Biographical material on more than 1,000 persons: Part I lists individual names; Part II, those in multiple categories. Entries include the Chinese characters for the person's name. Has chronological tables to the Chinese Dynasties and an index of Chinese characters.

Mythology of the World. London: Paul Hamlyn, 1967–70. 14 volumes.

> A series of books which are profusely illustrated by works of art.
> *Egyptian Mythology,* by Veronica Ions, 1968.
> *Near Eastern Mythology: Mesopotamia, Syria, Palestine,* by John Gray, 1969.
> *Greek Mythology,* by John Pinsent, 1969.
> *Roman Mythology,* by Stewart Perowne, 1969.
> *Celtic Mythology,* by Proinsias MacCana, 1970.
> *North American Indian Mythology,* by Cottie Burland, 1968.
> *South American Mythology,* by Harold Osborne, 1968.
> *Mexican and Central American Mythology,* by Irene Nicholson, 1967.
> *Oceanic Mythology,* by Roslyn Poignant, 1967.
> *African Mythology,* by Edward Geoffrey Parrinder, 1967.
> *Chinese Mythology,* by Anthony Christie, 1968.
> *Japanese Mythology,* by Juliet Piggott, 1969.
> *Indian Mythology,* by Veronica Ions, 1967.
> *Christian Mythology,* by George Every, 1970.

Parrinder, Edward Geoffrey. *A Dictionary of Non-Christian Religions.* Philadelphia: Westminister Press, 1971.

> Illustrated dictionary of deities, beliefs, and practices; discusses some pre-Columbian and African beliefs.

Ross, Nancy Wilson. *Three Ways of Asian Wisdom: Hinduism, Buddhism, Zen, and Their Significance for the West.* New York: Simon and Schuster, 1966.

> An explanation of these Asian philosophies and of the arts that grew from them. Includes a glossary.

Werner, Edward Theodore Chalmers. *A Dictionary of Chinese Mythology.* Shanghai: Kelly and Walsh, Ltd., 1932; reprint ed., New York: Julian Press, Inc., 1961.

> Names given in Chinese characters as well as English. The bibliography is divided into works written in Chinese and those written in languages of western Europe. Also has a list of Chinese dynasties and an index to myths.

Christian Subjects

The literature is so vast that only a small fraction of the references pertaining to this subject can be recorded. This section is subdivided into (1) iconographical works, (2) hagiography, (3) literature, and (4) Bible dictionaries.

Iconographical Works

Benson, George Willard. *The Cross: Its History and Symbolism.* Buffalo, New York: Private Printing, 1934; reprint ed., New York: Hacker Art Books, 1976.
> An illustrated history.

Bles, Arthur de. *How to Distinguish the Saints in Art By Their Costumes, Symbols, and Attributes.* New York: Art Culture Publications, 1925; reprint ed., Detroit: Gale Research Company, 1975.
> Covers the saints and how they are depicted in art. Includes a chronological list of the Bishops of Rome and the Popes up to the end of the sixteenth century, an alphabetized list of emblems relating which saints used them, and an alphabetical list of the means by which saints were martyred naming the saints who died in that manner.

Didron, Adolphe Napoleon. *Christian Iconography: The History of Christian Art in the Middle Ages.* Translated by E. J. Millington. London: Henry G. Bohn, 1851–86; reprint ed., New York: Frederick Ungar Publishing Company, 1965. 2 volumes.
> A reprint of the French edition but with additions and appendices supplied by Margaret Stokes. Volume I relates the history and symbols of the Nimbus or Glory and of God. Volume II comprises the iconography of the Trinity, angels, devils, death, and the soul. Includes a discussion of the influence of the Christian scheme and Medieval drama on iconography; reprints an English translation of the "Byzantine Guide to Painting," which may be a tenth- or eleventh-century version of the manuals that described religious scenes to be painted.

Drake, Maurice and Wilfred. *Saints and Their Emblems.* London: T. W. Laurie, Ltd., 1916; reprint ed., New York: Burt Franklin, 1971.
> Divided into two main sections: a biographical dictionary of saints which includes some bibliographical data and a dictionary of emblems that lists the saints associated with them. Has five appendices: (1) patriarchs and prophets with their emblems; (2) sibyls and their emblems; (3) patron saints of arts, trades, and professions; (4) patron saints of various classifications; and (5) saints who were envoked for particular reasons. In all categories, the saint's feast day is provided in parentheses beside the saint's name.

Evans, Joan. *Monastic Iconography from the Renaissance to the Revolution.* Cambridge, England: University Press, 1970.
> Chapters discuss Benedictines, Cistercians, Augustinians, Carthusians, Carmelites, Dominicans, Franciscans, and Jesuits.

Ferguson, George. *Signs and Symbols in Christian Art.* New York: Oxford University Press, 1954; reprint ed., New York: Oxford University Press, 1967.
> Illustrated dictionary approach to various symbols. Divided into fourteen chapters that cover the life of the Holy Family and the saints; the meanings of animal, floral, earthly, and human-body symbols; and the symbolism of letters, numbers, and religious dress and objects.

Grabar, André. *Christian Iconography: A Study of Its Origins.* Princeton, New Jersey: Princeton University Press, 1968.
> Well-illustrated historical account; includes an extensive bibliography.

Hulme, F. Edward. *The History, Principles, and Practice of Symbolism in Christian Art.* London: Swan Sonnenschein and Company, 1891; reprint ed., Detroit: Gale Research Company, 1969.
> Includes symbols of signs, animals, and saints.

Kaftal, George. *Iconography of the Saints in Italian Painting from Its Beginnings to the Early XVIth Century.* Florence: Sansoni, 1952–
Volume I: Iconography of the Saints in Tuscan Painting, 1952.
Volume II: Iconography of the Saints in Central and South Italian Schools of Painting, 1965.
Volume III: Iconography of the Saints in the Painting of North East Italy, 1978.
> Volume I covers paintings and frescoes from the thirteenth to the end of the fifteenth century and includes 319 saints; Volume II discusses the period from the second century to the early sixteenth and includes 436 saints, some of whom are unidentified. Volume III records 347 works of art in Romagna, Emilia, and the Veneto from the 5th to 16th century. Each of the published volumes is divided into two sections. Part I contains an alphabetical listing of the saints; entries give dates, attributes, usual inscriptions found on any scrolls they might carry, types of representations and scenes in which the saints are usually depicted, literary sources of the scenes, some sources of reproductions of the scenes, and brief hagiographical bibliographies. There are numerous black-and-white illustrations. Part II consists of (1) an index of attributes, distinctive signs, and scenes; (2) an index of painters; (3) a topographical index of paintings that provides the locations for the works of art; (4) a list of the reference books mentioned in the text; and (5) an index of saints and the Blessed. Because there are so many abbreviations, it is important for the researcher to read the "Explanatory Note" which follows the introduction in each volume.

Kirshbaum, Engelbert and Braufels, Wolfgang, editors. *Lexikon der christlichen Ikonographie*. Rome: Verlag Herder, 1968–76.
Volumes I–IV: Gemeine Ikonographie
Volume V–VIII: Ikonographie des Heiligen

An illustrated multivolume work which is one of the most scholarly iconographical references available. The first four volumes cover general iconographical terms and Biblical characters; the lives of the saints commence with the fifth volume. Written in a dictionary format, entries are signed, have numerous illustrations, and include bibliographical references. At the beginning of the first and the fifth volumes there are four lists which explain the abbreviations used: for terms, for museums, for cities, and for bibliographical references. These lists are especially important since so much of the information in these volumes is in an abbreviated form. Volume IV includes two indices to the material in the first four books: one is in English with the German equivalents, the other in French with the German equivalents.

Pigler, Andor. *Barockthemen: Eine Auswahl von verzeichnissen zur Ikonographie des 17. und 18. Jahrhunderts*. Budapest: Akademiai-Kiadó, 2nd ed., 1974. 3 volumes.

An illustrated list of works of art which depict Baroque themes used during the 17th and 18th centuries. Volume 1 covers religious subjects; Volume 2, profane ones, Volume 3 has illustrations. Under each theme, such as "Salomo und die Königin von Saba" (Solomon and the Queen of Sheba), is a brief list of references that describe the scene, such as Kings III:10, 1–13 in the Bible, plus a list of artists who depicted the scene. The list of artists, which is divided as to the artists' nationalities and cited chronologically, is sometimes accompanied by various information related to the works of art: media, locations, and sources of reproductions. Everything is in outline form; many words are abbreviated. At the beginning of the first volume is an explanation of the abbreviations; at the end of the second volume is a general index. At the end of each volume is a table of contents.

Réau, Louis. *Iconographie de l'art chrétien*. Paris: Presses Universitaires de France, 1955–59; reprint ed., Nendeln, Liechtenstein: Kraus Reprint, Ltd., 1974. 3 volumes in 6 books.

Volume I, which is a general introduction, has articles on the sources and evolution of Christian iconography; on animal, human, and liturgical symbolism; and on the iconography of the saints. Volume II, which contains the iconography of the Bible, is divided into two books, one covering the Old Testament and the other, the New. Volume III, the iconography of the saints, covers three books, the last of which has several indices: to the

names of the saints in various languages including Russian, Swedish, Hungarian, and Dutch; to the patronage of the various saints; and to the attributes of the saints. A general bibliography is published in the first volume. The entries in the third volume describe scenes in which the saints are depicted in art, often including the English title for the scene and containing bibliographical data and an extensive list of works of art that illustrate the saint or symbol discussed; these lists, which are divided by century, include the locations of the works of art.

Schiller, Gertrud. *Iconography of Christian Art*. Translated by Janet Seligman. Greenwich, Connecticut: New York Graphic Society, Ltd., 1971. 2 volumes.

Volume I covers the life of Christ from the Incarnation through the miracles; Volume II, the Passion of Christ. Profusely illustrated with black-and-white reproductions. Each book contains a selected bibliography; second volume has a general index for both works. These are two of the volumes of *Ikonographie der christlichen Kunst*. Four volumes have been issued in German—one on the Ressurection and Ascension, the other on The Church.

Webber, Frederick Roth. *Church Symbolism: An Explanation of the More Important Symbols of the Old and New Testament, the Primitive, the Mediaeval, and the Modern Church*. 2nd ed., revised. Cleveland, Ohio: J. H. Jansen, 1938; reprint ed., Detroit: Gale Research Company, 1971.

Includes nineteen chapters on Christian symbolism, a list of the more important saints of church art accompanied by their date of martyrdom and their attributes, a glossary of some common symbols, and an index. An illustrated book which has an important chapter on the many variations of the cross.

Hagiography, the Study of the Christian Saints

Attwater, Donald. *A Dictionary of Saints: Being also an Index to the Revised Edition of Alban Butler's "Lives of the Saints."* 2nd ed. London: Burns, Oates, and Washbourne, Ltd., 1948.

Alphabetized by saint's name, each entry, which is based on Butler's *Lives of the Saints,* gives volume and page references to Butler's work.

Butler, Alban. *Lives of the Saints*. Edited and supplemented by Herbert Thurston and Donald Attwater. New York: P. J. Kenedy and Sons, 1956. 4 volumes.

Considered one of the standard authoritative references; includes bibliographical data and footnotes. Each volume covers three months; saints are listed under their feast day. The fourth volume includes the general index. Butler's original work was published between 1756 and 1759.

Coulson, John, editor. *The Saints: A Concise Biographical Dictionary*. New York: Hawthorn Books, Inc., 1958.

> Illustrated dictionary alphabetizing saints by name. Includes a calendar of feast days listing the saints associated with them.

Farmer, David Hugh. *The Oxford Dictionary of Saints*. Oxford: Clarendon Press, 1978.

> One of the best one-volume sources. Although mainly concerned with English saints and saints for whom there was an English cult, the book includes most famous saints, except those of the Byzantine Period. Organized by people, rather than feast day. Prior to the 16th century, the listing is under the Christian name; after that date, the surname. Provides bibliographical references. Has a good introduction to hagiography which has a discussion of the 1969 reform of the Roman Calendar when many saints' feast days were downgraded.

Holweck, Frederick George. *A Biographical Dictionary of the Saints: With a General Introduction on Hagiology*. St. Louis: B. Herder Book Company, 1924; reprint ed., Detroit: Gale Research Company, 1969.

> Alphabetized by saint's name, entries include some bibliographical data.

Jacobus de Voragine. *The Golden Legend or Lives of the Saints, as Englished by William Caxton*. Translated by William Caxton. London: J. M. Dent and Company, 1900. 7 volumes.

> First published in Latin in 1275 by Jacobus de Voragine, the Archbishop of Genoa. The name is also spelled Varagine, and in French translations he is listed as Jacques de Voragine. The edition by Caxton, who died in 1491, is based upon a French version of the Latin text. Saints are listed by their feast day. There are numerous translations and editions; some editions are in one volume.

Jameson, Anna Brownell Murphy. *Legends of the Madonna As Represented in the Fine Arts*. 3rd ed. London: Longmans, Green and Company, 1864; reprint ed., Detroit: Gale Research Company, 1972.

> Gives legends and titles of art works in which the madonna figures; includes a general index. First edition was in 1852; Mrs. Jameson died in 1860.

————. *Sacred and Legendary Art*. 10th ed. London: Longmans, Green, and Company, 1870; reprint ed., Saint Claire Shores, Michigan: Scholarly Press, 1972. 2 volumes.

> Gives legends, history, attributes, and titles of art works in which the saints figured. Second volume includes a topographical and a general index; first edition, 1848.

Mann, Horace K. *The Lives of the Popes in the Early Middle Ages*. 2nd ed. St. Louis: B. Herder Book Company, 1925–32; reprint ed., Nendeln, Liechtenstein: Kraus Reprint, Ltd., 1964–66. 18 volumes in 19 books.

> Covers from St. Gregory the Great to Benedict XI; includes bibliographical footnotes and a list of references at the beginning of each entry. Volumes 6 through 18 have the title: *Lives of the Popes in the Middle Ages*.

New Catholic Encyclopedia. New York: McGraw-Hill Company, 1967. 15 volumes.

> Signed articles and bibliographical data; asterisks refer to other terms discussed under that name in the encyclopedia. Last Volume consists of the general index and a bibliography of the most frequently cited works.

Voragine, Jacobus de—see listing under Jacobus de Voragine.

Literature

This vast body of work includes the Bible; the writings of the Four Latin Fathers—St. Augustine, St. Jerome, St. Gregory, and St. Ambrose; St. Thomas Aquinas; and numerous other theologians and religious philosophers. This list is only a small fraction of the available material.

Biblia Pauperum. Budapest: Corvina Press, 1967.

> Consisting of blockprints and very little text, this Bible of the Poor was popular with the advent of inexpensive printing. This is a facsimile copy of a 15th-century book. Similar to other such works, it consists of prints that depict stories from the Bible. Each print has three major scenes—2 from the Old Testament which prefigured the one from the New Testament. The scenes are accompanied by 4 prophets and a brief explanatory text.

Hennecke, Edgar. *New Testament Apocrypha*. Edited by R. McL. Wilson. Translated by A. J. B. Higgins et al. Philadelphia: Westminster Press, 1963–66. 2 volumes.

> *Volume I: Gospels and Related Writings*
> *Volume II: Writings Relating to the Apostles; Apocalypses and Related Subjects. Index to Volumes I and II.*
>
> This translation is based upon the third edition of *Neutestamentliche Apokryphen*, edited by Wilhelm Schneemelcher and published in 1959, eight years after Hennecke's death. The first edition was in 1904. Volume I contains the Infancy Gospels upon which so much Medieval and Renaissance art is based, such as the "Protevangelium of James" and extracts from the "Gospel of Pseudo-Matthew."

Jacobus de Voragine, *The Golden Legend*, see entry under "Hagiography."

James, Montague Rhodes. *The Apocryphal New Testament: Being the Apocryphal Gospels, Acts, Epis-

tles, and Apocalypses. Oxford: Clarendon Press, 1924; reprinted numerous times.

> Contains translations of the Infancy Gospels, the Apocryphal Acts of the Apostles, and the Apocryphal Apocalypses.

Meditations on the Life of Christ: An Illustrated Manuscript of the Fourteenth Century, edited by Isa Rogusa and Rosalie B. Green. Translated by Isa Rogusa. Princeton, New Jersey: Princeton University Press, 1961; several reprintings.

> At one time attributed to St. Bonaventura, this work is now believed to have been written by a Franciscan monk living in Italy in the 13th century. This volume is a translation and reproduction of an extensively illustrated 14th-century Italian manuscript. The text relates the story of the Virgin Mary and Christ.

Bible Dictionaries

Addis, William Edward and Arnold, Thomas. *A Catholic Dictionary.* St. Louis: Herder Books. Numerous editions and revisions.

> One volume covering major themes, concepts, rites, ceremonies, councils, and religious orders. First published in 1884.

Dictionary of the Bible, by John L. McKenzie. New York: Macmillan Publishing Company, Inc., 1965.

> One volume providing accounts of books of the Bible, major themes and concepts, persons, and geography. Includes a bibliography.

Subjects in Art

Hall, James. *A History of Ideas and Images in Italian Art.* New York: Harper & Row, 1983.

> Traces the survival of images, the changing attitude of the Christian church, the belief in the magical powers of art, and the role of patrons in Italy from the time of the Etruscans to the 19th century. Has a section on Greek and Latin alphabets and inscriptions, a glossary, and 3 indices: to general subjects, of primary sources, and of artists and subjects.

Katzenellenbogen, Adolf Edmund Max. *Allegories of the Virtues and Vices in Mediaeval Art: From Early Christian Times to the Thirteenth Century.* New York: W. W. Norton and Company, Inc., 1964.

> Divided into two parts: (1) dynamic representations of the conflict between virtues and vices and (2) static representations of systems of virtues and vices. Illustrated; includes bibliographical footnotes, a list of abbreviations, and two indices: to places and to names and subjects.

Knipping, John Baptist. *Iconography of the Counter Reformation in the Netherlands: Heaven on Earth.* Nieuwkoop, Holland: B. de Graaf, 1974. 2 volumes.

> Based on *Iconografie van de Contra-Reformatie in de Nederlanden,* 1939–41. Chapters entitled "Humanism," "The New Asceticism," "The New

Devotions," "The Bible," "The Saint in Cult and Culture," "Christian Love and Life," "The Militant Church," "Form and Content," and "The Great Stream of Tradition." Includes a general bibliography and numerous illustrations.

Mâle, Emile. *The Gothic Image: Religious Art in France of the Thirteenth Century.* Translated by Dora Nussey. New York: Dutton, 1913; reprint ed., New York: Harper and Row Publishers, 1958.

> A translation of *L'art religieux du XIIIᵉ siècle en France,* originally published in 1898. Concerned with the influence upon symbolism: (1) by the *Speculum Majus* written by Vincent of Beauvais in the thirteenth century, (2) by the Bible, (3) by *The Golden Legend* written by Jacobus de Voragine and published in 1275, and (4) by the secular history of the period. It is illustrated and includes a chart citing the various attributes given the twelve apostles represented on six French Gothic churches. Lacks a general index although there is an index to buildings that are mentioned in the text.

————. *Religious Art: From the Twelfth to the Eighteenth Century.* New York: Pantheon Books, Inc., 1949.

> Mâle, who is considered one of the great iconographical authorities, wrote four books on French medieval iconography: (1) *L'art religieux du XIIᵉ siècle en France,* (2) *L'art religieux du XIIIᵉ siècle en France,* (3) *L'art religieux de la fin du moyen âge en France,* (4) *L'art religieux de la fin du XVIᵉ siècle, du XVIIᵉ siècle et du XVIIIᵉ siècle: Etude sur l'iconographie après le Concile de Trente.* This book is a collection of translated sections from all four works.

————. *Studies in Religious Iconography.* Edited by Henry Bober. Princeton, New Jersey: Princeton University Press. *Volume I: Religious Art in France: The Twelfth Century: A Study of the Origins of Medieval Iconography,* 1977.

> A translation of Mâle's first book.

Marle, Raimond van. *Iconographie de l'art profane au Moyen-Âge et à la Renaissance, et la décoration des demeures.* The Hague: Martinus Nijhoff, 1931–32; reprint ed., New York: Hacker Art Books, 1971. 2 volumes.

> Important source for secular iconography; well illustrated. First volume, *La Vie Quotidienne,* has chapters covering the nobles, nature, hunting and fishing, war, rural life, and the rapport between the sexes. The second volume, *Allégories et symboles,* deals with ethical and philosophical allegories plus love and death.

Panofsky, Erwin. *Studies in Iconology: Humanistic Themes in the Art of the Renaissance.* Cambridge, England: Oxford University Press, 1939; reprint ed., New York: Harper and Row, Publishers, Inc., 1962.

> Illustrated book covering such subjects as Father Time, blind cupid, the Neoplatonic movement in Florence and North Italy, and the Neoplatonic

movement and Michelangelo. Includes bibliographical footnotes plus a bibliography of references cited.

———. *Meaning in the Visual Arts: Papers in and on Art History.* Garden City, New York: Doubleday & Company, Inc., 1955.

A collection of Panofsky's previously published works. Illustrated articles include subject of human proportion, Abbot Suger of St. Denis, Titian, Vasari, Dürer and Classical antiquity, Poussin, and a brief essay on three decades of U.S. art history.

Paulson, Ronald. *Emblem and Expression: Meaning in English Art of the Eighteenth Century.* Cambridge, Massachusetts: Harvard University Press, 1975.

Chapter titles include "Illustration and Emblem," "The Poetic Garden," "Industry and Idleness," and "The Conversation Piece in Painting and Literature." Special chapters on Hogarth, Reynolds, Watteau and Chardin, Zoffany, Stubbs, Wright of Derby, and Gainsborough.

Seznec, Jean. *The Survival of the Pagan Gods: The Mythological Tradition and Its Place in Renaissance Humanism and Art.* Translated by Barbara F. Sessions. New York: Pantheon Books, Inc., 1953; reprint ed., New York: Harper and Row, Publishers, Inc., 1961.

Part I, "The Concepts," has chapters on the historical, physical, moral, and encyclopedic traditions. Part II, "The Forms," includes chapters on the metamorphoses of the gods and the reintegration of the gods. The last section covers the science of mythology in the sixteenth century, the theories regarding the use of mythology, and the influence of the manuals. Includes bibliographical footnotes.

Studies in Iconography Series. Linda Seidel, series editor. Ann Arbor, Michigan: UMI Research Press.

Series on varied subjects. Some of the titles are as follows:

Alchemical Imagery in Bosch's "Garden of Delights," by Laurinda S. Dixon, 1981.

Political Ideas in Medieval Italian Art: The Frescoes in the Palazzo dei Priori, Perugia, by Jonathan B. Riess, 1981.

"With Bodilie Eyes": Eschatological Themes in Puritan Literature and Gravestone Art, by David H. Watters, 1981.

Masks of Wedlock: Seventeenth-Century Dutch Marriage Portraiture, by David R. Smith, 1982.

How the West was Drawn: American Art and the Settling of the Frontier, by Dawn Glanz, 1982.

Boerenverdriet: Violence Between Peasants and Soldiers in Early Modern Netherlands Art, Jane Susannah Fishman, 1982.

The Child in Seventeenth-Century Dutch Painting, by Mary Frances Durantini, 1983.

Tervarent, Guy de. *Attributs et symboles dans l'art profane, 1450–1600: Dictionnaire d'un langage perdu.* Librairie E. Droz, 1958. *Supplément et index,* 1964.

The entries for the symbols give sources, some examples, and abbreviations which refer to the general bibliography.

Wind, Edgar. *Pagan Mysteries in the Renaissance.* Revised and enlarged. New York: W. W. Norton & Company, Inc., 1958.

Discusses the literature and mythology which influenced Renaissance art. Illustrated; includes an index of sources which is subdivided into (1) the literary texts used during the Renaissance and the passages quoted in the book and (2) secondary sources. There is also a subject index.

Emblem Books

Emblem Books. Zug, Switzerland: Inter-Documentation Company.

Microform edition reprinting 354 emblem books.

Henkel, Arthur and Schöne, Albrecht. *Emblemata: Handbuch zur Sinnbildkunst des XVI. und XVII. Jahrhunderts.* Stuttgart: J. B. Metzler, 1967.

Illustrated dictionary of emblems, including those of the elements, plants, animals, people, and myths. Entries are detailed; the many indices include those to illustrations, to meanings, and to notables in "Physiologus Graecus." Has a list of abbreviations and a bibliography.

Praz, Mario. *Studies in Seventeenth-Century Imagery.* 2nd edition. Roma: Edizioni di Storia e Letteratura, 1964.

Part II: Addenda and Corrigenda, 1974.

Discussion of subjects and symbols and Emblem Books. Half of the book is an extensive bibliography of emblem books.

Ripa, Cesare, *Iconologia,* see next entry.

The Renaissance and the Gods: A Comprehensive Collection of Renaissance Mythographies, Iconologies, and Iconographies, edited by Stephen Orgel. New York: Garland Publishing Company, Inc., 1979.

Fifty-five volumes, many of which are reproductions of Emblem Books, variations of Ripa's *Iconologia,* and George Richardson's *Iconology* of 1779.

References on Animals and Beasts

Ball, Katherine M. *Decorative Motives of Oriental Art.* New York: Dodd, Mead and Company, 1927; reprint ed., New York: Hacker Art Books, 1969.

Profusely illustrated; each chapter discusses the use of an animal form. Includes an extensive bibliography.

Daly, Lloyd William, translator and editor. *Aesop Without Morals: The Famous Fables and a Life of Aesop.* New York: Thomas Yoseloff, Publisher, 1961.

The introduction gives a brief history of the two works which are translated into present-day

English: (1) Ben Edwin Perry's edition of a tenth-century manuscript in the Pierpont Morgan Library describing Xanthus the Philosopher and his slave, Aesop, and (2) Aesop's fables based upon Perry's *Aesopica,* published by the University of Illinois Press in 1953. The numbers listed before each fable refer to the numbers of the fables in Perry's book where the original Greek or Latin version may be found. The Appendix lists separately the moral to each of the fables.

Dent, Anthony Austen. *The Horse: Through Fifty Centuries of Civilization.* London: Phaidon Press, Ltd., 1974.
Covers the history of the horse in art from prehistoric times to the present.

Evans, Edward Payson. *Animal Symbolism in Ecclesiastical Architecture.* London: William Heinemann, 1896; reprint ed., Detroit: Gale Research Company, 1969.
Covers the animals described in the *Physiologus* as well as satirical and whimsical depictions of animals.

Friedmann, Herbert. *The Symbolic Goldfinch: Its History and Significance in European Devotional Art.* Washington, D.C.: Pantheon Books, Inc., 1946.
Illustrated book tracing the symbol of the goldfinch in art. Includes bibliographical footnotes, a list of paintings accompanied by their locations, and a list of literature cited and consulted.

Janson, Horst Woldemar. *Apes and Ape Lore in the Middle Ages and the Renaissance.* London: Warburg Institute, University of London, 1952.
Illustrated history of the ape in art; contains bibliographical footnotes.

Klingender, Francis Donald. *Animals in Art and Thought to the End of the Middle Ages.* Edited by Evelyn Antal and John Harthan. Cambridge, Massachusetts: M.I.T. Press, 1971.
Well-illustrated historical account of the depictions of animals from the prehistoric caves through the Middle Ages; concentrates on stylistic changes. Includes bibliographical footnotes.

Lascault, Gilbert. *Le monstre dans l'art occidental un problème esthétique.* Paris: Editions Klincksieck, 1973.
Discusses the symbolism of monsters; illustrated. Has an extensive bibliography.

Lenaghan, R. T., editor. *Caxton's Aesop.* Cambridge, Massachusetts: Harvard University Press, 1967.
An edition of William Caxton's *Aesop,* which contained 167 fables and a life of Aesop. The 186 woodcuts, which Caxton published in his fifteenth-century edition, are reproduced. Includes bibliographical footnotes, a glossary to the old English terms, and an index to the fables and tales.

Lloyd, Joan Barclay. *African Animals in Renaissance Literature and Art.* Oxford, England: Clarendon Press, 1971.

An illustrated work which gives special treatment to the crocodile, chameleon, and elephant. Includes bibliographical footnotes.

Mode, Heinz Adolph. *Fabulous Beasts and Demons.* London: Phaidon Press, Ltd., 1975.
Originally published in 1973 under the title *Fabeltiere und Dämonen in der Kunst.* Profusely illustrated history; includes a bibliography and a glossary of monsters.

Sheridan, Ronald and Ross, Anne. *Gargoyles and Grotesques: Paganism in the Medieval Church.* Boston: New York Graphic Society, 1975.
Well-illustrated glossary of beasts.

Varty, Kenneth. *Reynard the Fox.* Leicester, England: Leicester University Press, 1967.
Well-illustrated book on the history and symbolism of the fox. Includes a selected bibliography, a list of fox carvings and drawings in England, bibliographical footnotes, and two indices: to proper names and to subjects.

White, Terence Hanbury, editor. *The Bestiary: A Book of Beasts.* New York: G. P. Putnam's Sons, 1960.
An illustrated translation from a Latin Bestiary of the twelfth century; the appendix gives a brief history of the bestiary, which was a compilation of animal stories based upon the *Physiologus.* Developed between the second to the fifth century A.D., these tales were sermonized to illustrate the Bible during the Middle Ages. The symbolism of animals in Christian art is often based upon these stories.

Floral Symbolism

Haig, Elizabeth. *The Floral Symbolism of the Great Masters.* London: Kegan Paul, Trench, Trübner & Company, Inc., 1913.
Includes some fruits.

Lehner, Ernst and Johanna. *Folklore and Symbolism of Flowers, Plants, and Trees.* New York: Tudor Publishing Company, 1960.
Brief entries plus illustrations of about 75 plants. Includes (1) a flower calendar, which tells which plants were considered representative of the various months and (2) an index to sentiments and symbolism, that cites under the name of the plant, what it represented.

Seward, Barbara. *The Symbolic Rose.* New York: Columbia University Press, 1954.
Concerned with the Medieval heritage and the symbolism of roses in British poetry.

Musical Iconography

Fischer, Pieter. *Music in Paintings of the Low Countries in the 16th and 17th Centuries.* Amsterdam: Swets & Zeitlinger, 1975.
Well-illustrated book on musical instruments and notations in Dutch and Flemish paintings from

the sixteenth and seventeenth centuries. Includes footnotes and an index to persons and places.

Mirimonde, Albert P. de. *L'Iconographie Musicale sous les Rois Bourbons: La musique dans les arts plastiques* (XVII⁴—XVIII⁴ siècles). Paris: Editions A. & J. Picard, 1977. 2 volumes.

A discussion of music depicted in art in the 17th and 18th centuries. Illustrated; has extensive bibliography.

Winternitz, Emanuel. *Musical Instruments and Their Symbolism in Western Art.* New York: W. W. Norton & Company, Inc., 1967.

Discusses the depiction of musical instruments in works of art; mostly concerned with fifteenth and sixteenth century art.

Non-Christian Iconography

Allen, Maude Rex. *Japanese Art Motives.* Chicago: A. C. McClurg and Company, 1917.

Illustrated book that has chapters on plants, animals and fabulous creatures, deities, symbols and symbolic objects, festivals and ceremonies, garden and flower arrangement, and crests.

Ball, Katherine M. *Decorative Motives of Oriental Art.* New York: Dodd, Mead and Company, 1927; reprint ed., New York: Hacker Art Books, 1969.

Profusely illustrated; each chapter discusses the use of an animal form. Includes an extensive bibliography.

Banerjea, Jitendra Nath. *The Development of Hindu Iconography.* 2nd ed. revised. Calcutta: University of Calcutta, 1956; reprint ed., Columbia, Missouri: South Asia Books, 1974.

Illustrated; includes a selected bibliography. In the appendix are English translations of Brhat-samhitā and Pratimāmānalaksanam and the tables of measurements according to Dasātala.

Bhattacharyya, Benoytosh. *The Indian Buddhist Iconography: Mainly Based on the Sādhanamālā and Cognate Tāntric Texts and Rituals.* 2nd ed. revised. Calcutta: K. L. Mukhopadhyay, 1958.

First published in 1924; illustrated. Includes a glossary.

Coomaraswamy, Ananda Kentish. *Elements of Buddhist Iconography.* 2nd ed. New Delhi: Munshiram Manoharlal, 1973.

First issued in 1935; illustrated. Part I: "Tree of Life," "Earth-Lotus," and "Word Wheel." Part II: "Place of the Lotus-Throne."

————. *The Origin of the Buddha Image.* New Delhi: Munshiram Manoharlal, 1972.

Illustrated; bibliographical footnotes.

Edmunds, William H. *Pointers and Clues to the Subjects of Chinese and Japanese Art As Shown in Drawings, Prints, Carvings, and the Decorations of Porcelain and Lacquer.* London: Sampson Law, Marston and Company, Ltd., 1934.

Chapter entitled "Pointers and Clues" gives iconographical background of symbols. Includes biographical entries of Chinese, Buddhist, and Japanese subjects plus a glossary of Japanese words.

Encyclopaedia of Religion and Ethics, edited by James Hastings. New York: Charles Scribner's Sons, 1928. 13 volumes, last one is index.

Provides discussions on broad categories, especially of comparative religions. Does include articles on Christianity.

Garrett, John. *A Classical Dictionary of India: Illustrative of the Mythology, Philosophy, Literature, Antiquities, Arts, Manners, Customs of the Hindus.* Madras, India: Higginbotham, 1871, supplement, 1873; reprint ed., New York: Burt Franklin, 1974.

Dictionary of terminology and symbols.

Goodenough, Erwin Ramsdell. *Jewish Symbols in the Greco-Roman Period.* New York: Pantheon Books, 1953. 13 volumes.

Well-illustrated work on the art symbols discovered during the excavations of the Greco-Roman world. Twelfth volume contains a summary and the conclusion; thirteenth volume includes the index to names, the subject index, and maps of the area.

Gopinātha Rāo, T. A. *Elements of Hindu Iconography.* Madras, India: Law Printing House, 1914–16; reprint ed., New York: Paragon Book Reprint Corporation, 1968. 2 volumes in 4 books.

Illustrated; contains a bibliography.

Gordon, Antoinette K. *The Iconography of Tibetan Lamaism.* Revised ed. Rutland, Vermont: Charles E. Tuttle Company, Inc., 1959; reprint ed., New York: Paragon Book Reprint Corporation, 1972.

Illustrated; includes a bibliography, a brief Sanskrit-English dictionary, and a guide to the pronunciation of Sanskrit.

Williams, Charles Alfred Speed. *Outlines of Chinese Symbolism and Art Motives: An Alphabetical Compendium of Antique Legends and Beliefs as Reflected in the Manners and Customs of the Chinese.* 3rd ed., revised. Shanghai: Kelly and Walsh, Ltd., 1941; reprint ed., Rutland, Vermont: Charles E. Tuttle Company, Inc., 1974.

A dictionary of symbolism which includes Chinese characters and literary references. First edition was in 1932; illustrated by drawings.

Zimmer, Heinrich, *Myths and Symbols in Indian Art and Civilization.* Edited by Joseph Campbell. New York: Pantheon Books, Inc., 1946; reprint ed., Princeton, New Jersey: Princeton University Press, 1972.

Illustrated chapters on eternity and time, mythology of Vishnu, guardians of life, cosmic delight of Shiva, and the Goddess.

Bibliographies of Iconographical References

Many of the books cited in this chapter have extensive bibliographies, such as Réau's *Iconographie de l'art chrétien* and Kirschbaum's *Lexikon der christlichen Ikonographie*. There is coverage of the subject under "GENERAL WORKS, Iconography" in *RILA*, "Iconography" in *Art Index*, and "PRINCIPES ET ORGANI-SATION, Sciences de l'art, Iconographie" in *Répertoire d'art et d'archéologie*. The researcher should also consult the works under "Iconography" in Arntzen and Rainwater's *Guide to the Literature of Art History*, which is annotated in Chapter 13. Other references include the following:

Gibson, Sarah Scott. "Humanist and Secular Iconography, 16th to 18th Centuries, Bibliographic Sources: A Preliminary Bibliography." *Special Libraries* 72 (July 1981): 249–260.

Includes a discussion of the subject plus a bibliography.

Kleinbauer, W. Eugene and Slavens, Thomas P. *Research Guide to the History of Western Art*. Chicago: American Library Association, 1982.

Includes bibliographical material after subsections of "Iconography," "Morey and the Princeton School," "Twentieth-Century German Iconography," "Other Contemporary Iconography," and "Iconography of Architecture."

Waal, H. van de. *Iconclass: An Iconographic Classification System, Completed and Edited by L. D. Couprie*. Amsterdam: North-Holland Publishing Company, 1973– Proposed 17 volumes.

Provides a systematic arrangement for specific subjects and includes extensive bibliographical material.

Book- and Film-Review Sources

This chapter is divided into two kinds of source material: indices of book reviews and indices of film reviews. Researchers may need to read the reviews of particular books in order to assist them (1) in discovering how authoritative various authors are considered by their peers, (2) in understanding books that are confusing or difficult to comprehend, (3) in deciding whether or not specific books warrant being used as textbooks or as references to be studied in-depth, and (4) in staying informed of current publications. Since a book review is also someone's opinion, it too must be judged. Is the reviewer nit-picking or do the comments and criticisms discussed deserve merit? Although it may give a different viewpoint or question the accuracy of the material, a good book review should provide an objective critical analysis of the material. Sometimes a review becomes an important essay on the subject and provides additional insight into the discipline. Often the book review itself can be judged by the quality of the periodical in which it is published. For example, a critique printed in *Art Bulletin* would most likely be written by an expert in the art field covered by the reviewed book.

When checking to find references on book reviews, researchers should scrutinize the volume covering the year when the first edition of the book was issued, plus the following three years, as well as the volumes covering the periods during which later editions were published. This checking is necessary because a review is often written only for the first edition of a book or for a work that has been enlarged and revised. Moreover, not all books are reviewed, and some may have reviews that are difficult to find. It should also be borne in mind that books are sometimes issued under one title in the United States and under a different title when published in a foreign country. The book by Peter Mitchell, which was entitled *European Flower Painters* in the English edition, was called *Great Flower Painters* in the American publication. For additional information on book reviews, the reader should consult Chapter 5 under "Authors."

The second section of this chapter is composed of reference works that will help the reader locate reviews of motion pictures. Film reviews are read by researchers in order to help them (1) in deciding upon whether or not particular movies should be viewed, (2) in discovering critics' views of films, and (3) in learning additional information on the movies and their background. Movie reviews are usually written by film critics, who do not necessarily possess any expertise in the discipline of cinema and who often express only subjective opinions. Nevertheless, there are some reviewers who are eminent scholars, such as Roger Manvell, or who are involved in film production, such as British director Lindsay G. Anderson.

In checking the references listed in this chapter, researchers should examine not only the different indices, but also all of the various issues of each index, since there is not always a correlation between the date a movie is released and the date the film is reviewed and since there are often retrospective reviews published for historically significant films. It should also be remembered that movies are sometimes released under more than one title, and subsequently reviewed under these various names, and that there may be different film versions of the same title, such as *War and Peace*. For additional details on film reviews, the researcher should read the section on films in Chapter 8.

Book Reviews

Art Bulletin: An Index to Volumes I–XXX, 1913–1948. Rosalie B. Green, compiler. New York: Columbia University Press, 1950.

Art Bulletin: An Index to Volumes XXXI–LV, 1949–1973. Janice L. Hurd, compiler. New York: College Art Association of America, 1980.
 Reviews listed under the names of both the author and the reviewer.

Art Index. New York: H. W. Wilson Company. Volume 1 (1929) +
 A quarterly with an annual cumulation; covers about 200 journals. Reviews are indexed under the name of the author of the reviewed book. Since 1975 all book reviews are listed in a separate section at the end of each volume.

Book Review Digest. New York: H. W. Wilson Company. Volume I (1905) +

Issued monthly, except February and July, plus an annual cumulation. The material, which is abstracted, is indexed by author of the book which was reviewed. Each of these reviewed books must have been published or distributed in the United States; furthermore, the review must have been printed within eighteen months following the book's issue, and the book must have had at least two reviews in the more than 80 magazines that are indexed. Each volume also contains a subject and title index. To facilitate finding material, the reader should consult the *Book Review Digest Cumulated Index: Subject and Title Index,* which is published by the same company.

Book Review Index. Detroit: Gale Research Company. Volume 1 (1965) +

A quarterly with an annual cumulation; covers about 380 periodicals.

Book Review Index Database, DIALOG.

Files from 1969.

British Book News. London: The British Council. Volume 1 (1940) +

Provides about 240 book reviews in each monthly publication; covers only books published in the United Kingdom. Has an annual index to titles, subjects, and authors.

British Humanities Index. London: Library Association. Volume 1 (1962) +

A quarterly with annual cumulations. Superseded *The Subject Index to Periodicals,* published 1915–61, with the exception of the years 1923–25. Includes the London *Times Literary Supplement* in the about 360 English publications it indexes.

Burlington Magazine: Cumulative Index Volumes I–CIV, 1903–1962. London: The Burlington Magazine Publications, Ltd., 1969.

Burlington Magazine 10 Year 1963–1972 Index, 1973.

Includes two types of indices to book reviews: by authors of books reviewed and by titles of books. The latter is subdivided into three classifications of books; those concerned with paintings, drawings, and graphic arts; those relating information about works of art, other than the kinds of art listed above; and those which do not fit into the other two groups.

Combined Retrospective Index to Book Reviews in Humanities Journals, 1802–1974. Woodbridge, Connecticut: Research Publications, Inc., 1982. 10 volumes.

Citations for 500,000 reviews in 150 journals.

Education Index: A Cumulative Author-Subject Index to a Selected List of Educational Periodicals, Proceedings, and Yearbooks. New York: H. W. Wilson Company. Volume 1 (July, 1929–June, 1932) +

Author-subject index to approximately 225 periodicals; published ten times a year with an annual cumulation. Since 1976 the book reviews have been placed at the end of each volume; previous to that date the reviews were listed under "Book Reviews."

Film Literature Index, reviews books concerned with films; see listing under "Film Reviews" in this chapter.

Humanities Index. New York: H. W. Wilson Company. Volume 28 (April, 1974–March, 1975) +

Quarterly with an annual cumulation; book reviews are listed in a separate section. Indexes some 300 periodicals; previous volumes listed as *International Index* and *Social Sciences and Humanities Index*.

Index to Book Reviews in the Humanities. Williamston, Michigan: Phillip Thomson. Volume 1 (1960) +

Published annually. Scans over 600 periodicals; includes about 360 each year, one of which is the London *Times Literary Supplement*.

Index to Critical Film Reviews in British and American Film Periodicals, reviews book concerned with films; see listing under "Film Reviews" in this chapter.

New York Times Book-Review Index, 1896–1970. Wingate Froscker, editor. New York: New York Times Company, 1973. 5 volumes.

Volume I: Author Index
Volume II: Title Index
Volume III: Byline Index
Volume IV: Subject Index
Volume V: Category Index

Almost 800,000 entries in the five volumes. Byline index is one including the reviewer or the writer of a letter or other item concerned with a book. In 1968 published the second edition of *The Times Thesaurus of Descriptors* to assist readers in using the subject index.

Nineteenth-Century Reader's Guide to Periodical Literature 1890–1899: With Supplementary Indexing 1900–1922. Helen Grant Cushing and Adah V. Morris, editors. New York: H. W. Wilson Company, 1944. 2 volumes.

Covers over fifty periodicals; book reviews are listed under the name of the author of the reviewed book.

Reader's Guide to Periodical Literature: An Author and Subject Index. New York: H. W. Wilson Company. Volume 1 (1900–1904) +

Author-subject index to articles in over 180 periodicals; now published semi-monthly September to January and March to June, monthly February, July, and August. There is an annual cumulation. Since 1976 book reviews have been placed at the end of each volume; previous to that date, the reviews were listed under the name of the author of the book reviewed under the category, "Book reviews—Single books."

RILA. Williamstown, Massachusetts: Sterling and Francine Clark Art Institute. Volume 1 (1976) +
Published twice a year; abstracts articles from over 300 periodicals. Reviews are listed following the main entry for the book in the subject index of *RILA*. In the author-subject index an asterisk before the abstract number indicates that the entry relates information concerning a review of the work.

Social Sciences Index. New York: H. W. Wilson Company. Volume 28 (April, 1974–March, 1975) +
Quarterly with annual cumulation; covers about 300 periodicals; book reviews are listed in a separate section. Previous volumes entitled *International Index* and *Social Sciences and Humanities Index*.

Film Reviews

American Film Directors. Stanley Hockman, compiler. New York: Frederick Ungar Publishing Company, 1974.
Quotations from critical reviews of the movies of sixty-five directors. In a separate section, "Filmographies," lists all of the movies and their date of issue directed by the sixty-five directors.

Film Criticism: An Index to Critics' Anthologies. Richard Heinzkill, compiler. Metuchen, New Jersey: Scarecrow Press, Inc., 1975.
Relates in which of forty anthologies a review of a particular film will be found. All foreign films are listed under the English-translated title.

Film Literature Index. Albany, New York: Filmdex, Inc. Volume 1 (1973) +
Quarterly author-subject index of over 200 periodicals with an annual cumulation. Film reviews are listed under individual film titles; however, recent publications concerned with the cinema are listed under "Book Reviews."

Index to Critical Film Reviews in British and American Film Periodicals. Stephen E. Bowles, compiler. New York: Burt Franklin and Company, Inc., 1974. 2 volumes.
Lists over 20,000 film reviews and 6,000 reviews of books about cinema. Does not include journals indexed in *Reader's Guide to Periodical Literature*. Indexed under film title with the director or author's name in parentheses, each entry gives name of magazine, volume, date, page numbers, and author of review. Second volume includes five indices: to directors, to film reviewers, to authors of the films, to book reviewers, and to the subjects of the books on film.

Media Review Digest: The Only Complete Guide to Reviews of Non-Book Media. Ann Arbor, Michigan: Pierian Press. First issue (1970–1972) +
First issue was entitled *Multi-Media Reviews Index*. Originally an annual in two volumes, but since 1977 it has been incorporated into one volume. There are sections covering films and videotapes, filmstrips, records and tapes, plus miscellaneous media. Each entry, which is listed alphabetically by title under the appropriate section, cites the name of the production company; the release date; a snyopsis and the subject of the material; essential data, such as the projection size and color of the film; plus a source for a review of the material. Includes a list of film awards and prizes, a list of general subject indicators, a classified subject index, an alphabetical subject index, and a list of the names and addresses of producing and distributing firms.

New York Times Film Reviews. New York: New York Times Company. Volume I: 1916–1931; Volume II: 1932–1938; Volume III: 1939–1948; Volume IV: 1949–1958; Volume V: 1959–1968; Volume VI: Appendix Index (1913–68); Volume 1969–70 +
Reprints the entire review of the film which includes cast credits. The appendix has a list of film awards, a portrait gallery composed of almost 2,000 photographs of movie stars, plus 3 separate indices: to film titles, to personal names, and to corporations. Beginning with 1969–70 the volumes which cover two years also have a section that reports the various annual awards.

Reader's Guide to Periodical Literature: An Author and Subject Index. New York: H. W. Wilson Company. Volume 1 (1900–1904) +
Author-subject index to articles in over 180 periodicals; now published semi-monthly September to January and March to June, monthly February, July, and August. There is an annual bound cumulation. Since the first volume, cinema reviews have been listed under varying subheadings: "Moving picture plays," "Moving Pictures," and "MOTION picture reviews." No references are made under individual titles of films.

Retrospective Index to Film Periodicals 1930–1971. Linda Batty, compiler. New York: R. R. Bowker Company, 1975.
Index of nineteen periodicals. Divided into three indices: to reviews of individual films, to film subjects, and to reviews of books on films.

Variety Film Reviews. New York: Garland Publishing, Inc., 1983– Proposed 16 volumes, last one will be index.
Reprints of actual movie reviews published in *Variety* between 1907 and 1980. Also includes silent and foreign films.

Reference Aids and Directories

Listed in this chapter are (1) location directories—for art museums, art schools, art organizations, and auction houses; for art libraries; and for cities; (2) works which will assist readers in completing bibliographical data—for books, for periodicals, and for *Festschriften;* (3) writer's aids; (4) guides to the correct pronunciation of artists' names; (5) research guides; and (6) library reference works. The information found in the references cited in this section quickly becomes out of date, especially the data which refer to personnel. Often the periodicals that some museums publish report the names of the current staff; however, if in doubt, a letter can always be addressed to the attention of the Registrar, the Director, or the Librarian. The multilingual glossary of proper names, found in Appendix D, will assist the researcher in using the international location directores. It should also be borne in mind that Europeans write the number seven, $\overline{7}$, which resembles the capital F; although this provides a clear distinction between the numbers one and seven, it can be confusing to Americans.

Location Directories

These volumes provide access to names, addresses, personnel, and other essential data.

Art Museums, Art Schools, Art Organizations, and Auction Houses

American Art Directory. New York: R. R. Bowker Company. Volume 1 (1898) +

Published erradically; now about every 2 years. Covers over 2,300 museums and art organizations in the United States, 190 in Canada, and 420 foreign ones. Each entry cites address; personnel; opening times; the emphasis of the collection; library facilities; and kinds of exhibitions, activities, and publications. Also includes over 1,600 art schools providing the address, name of the chairman, degrees offered, major fields of concentration, and tuition data. There are lists of art magazines, of newspapers that carry art notes citing the art editor and critic, of art scholarships and fellowships, of the booking agents of traveling exhibitions, and of open exhibitions.

The Directory of Museums. Kenneth Hudson and Ann Nicholls, editors. 2nd edition. London: Macmillan Press, Ltd., 1981.

Alphabetized by country followed by city, each entry cites address, hours, and emphasis of collection. Includes a classified index of specialized and outstanding collections. Records an English translation of the museum's name rather than the correct name. Includes select bibliography of national museum directories and articles.

Handbuch der Museen: Deutschland B. R. D., D. D. R., Österreich, Schweiz. Gudrun Birgit-Kloster, editor. Munich: Verlag Dokumentation and New York: R. R. Bowker Company, 1971. 2 volumes.

Lists over 3,000 museums located in Germany, German Democratic Republic, Austria, and Switzerland. Entries cite name of director, address, hours, entrance fees, and kinds of publications. Volume I covers the Federal Republic of Germany; Volume II, the rest of the countries.

International Art & Antiques Yearbook: A Worldwide Dealers' and Collectors' Guide to the Art and Antiques Trade. London: National Magazine Company, Ltd. Annual

Organized by countries. Provides names, addresses, telephone numbers, specialties, and kinds of publications for (1) antiques and art dealers, (2) packers and shippers, and (3) auctioneers and salesrooms. For each country has a specialist index, a map, and often a glossary of important terms. Includes 3 lists: to antique dealers' associations, to antique and art periodicals, and to international antique fairs.

International Directory of Arts: Internationales Kunst-Addressbuch. Frankfurt-am-Main: Verlag Müller G.M.B.H. & Company. 2 volumes. Published every 2 years.

The first edition was published under the title, *German Art Directory.* Divided by subject: museums and art galleries; universities, academies, colleges; associations; artists (painters, sculptors, engravers); collectors; art and antique dealers; galleries; auctioneers; art publishers; art periodicals; book-sellers; and restorers. Each entry includes the address and is alphabetized by country followed by city and institution.

Museums of the World: Museen der Welt. Eleanor Braun, compiler. 2nd edition. New York: R. R. Bowker Company, 1975.

Alphabetized under country followed by city and name of museum, each entry cites address and type of museum. Covers 17,500 museums in 148

countries. Includes indices to subjects, to names, and to geographical locations, plus a list of international and national associations.

The Official Museum Directory: United States and Canada. Washington, D.C.: American Association of Museums. First issue (1971) +

Published biennially. Alphabetized under state followed by city, each entry includes address, names of museum personnel, collection data, number of volumes and specialization of the library, plus hours and entrance fees of the museum. Includes an alphabetized list of institutions, an alphabetized list of personnel, and a category list of museums. Under the latter division, cites art associations, councils and commissions, plus foundations and institutions; art association galleries; art museums and galleries; arts and crafts museums; china, glass and silver museums; civic art and cultural centers; decorative arts museums; folk art museums; and textile museums.

The World of Learning. Detroit: Gale Research Company. First issue. (1947) + 2 volumes.

Under the category of each country cited, this annual provides lists of (1) learned societies and research institutes, (2) libraries and archives, (3) museums, (4) universities, (5) colleges, and (6) schools of art, architecture, and music. Under "Museums" includes for each entry the address, founding date, type of art collection, size of book collection in the library, and director's name. Under "Libraries and Archives" provides for each entry the address, size of collection, and librarian's name. The first volume contains a guide to abbreviations and a list of international organizations, such as U.N.E.S.C.O., International Association of Critics, International Council of Museums, and International Union of Architects. The second volume has an "Index of Institutions" that lists the names of all the various institutions—museums, libraries, universities—accompanied by the names of the cities where the institutions are located and the page numbers where the entries can be found.

Art Libraries

American Library Directory: A Classified List of Libraries in the United States and Canada with Personnel and Statistical Data. New York: R. R. Bowker Company. Volume 1 (1908) +

Published biennially. Alphabetized by state followed by city, each entry cites address, director's name, special subjects covered, and number of volumes.

Directory of Archives and Manuscript Repositories, by the National Historic Publications and Records Commission. Washington, D.C.: National Archives and Records Service, 1978.

Includes all 50 states plus U.S. territories and districts. Organized by state, city, and institution, the directory gives holdings of total volumes and a description of the archives.

Directory of Art Libraries and Visual Resource Collections in North America. Judith A. Hoffberg and Stanley W. Hess, editors. New York: Neal-Schuman Publishers, Inc., 1978. *Addendum,* 1979.

Includes listings of art libraries and visual resource collections in the United States and Canada. Has 2 indices: to subjects and to institutions. Entries consist of name and address of institution, hours, name of librarian or curator, and the subject strengths of the collection. A revised edition is scheduled for 1984.

Directory of Special Libraries and Information Centers. 7th ed. Detroit: Gale Research Company, 1982. 2 volumes.

Includes nearly 14,000 institutions in the United States and Canada. Under the alphabetized name of the library, each entry in Volume I cites address, telephone number, name of director, subject concentrations, size of holdings, special services rendered, and special collections. The first volume contains a subject index; the second volume, a geographic and personnel index. Published in conjunction with *Subject Directory of Special Libraries and Information Centers;* see entry under this name.

The World of Learning, see listing above.

City Directories

City Directories of the United States in Microform. Woodbridge, Connecticut: Research Publications, Inc.

Published in 4 divisions. Segment 1 on microfiche covers from the earliest known directories through 1860; based upon Dorothea N. Spear's *Bibliography of American Directories Through 1860,* Worcester, Massachusetts, American Antiquarian Society, 1961. Segment 2 on microfilm covers 1861–1881; segment 3 on microfilm, 1882–1901; and segment 4 on microfilm, 1902–1935. The actual city directories of major cities and regions of the individual states in the United States are reproduced. Directories list city residents, occupations, place of residents, plus firms and companies, and include some advertising. The sets can be purchased separately.

Completing Bibliographical Data

For Books

The catalogues of famous libraries, cited in Chapter 11 can also be used for this purpose; these are not repeated here.

Bibliographie de la France. *Livres d'étrennes.* Paris: Cercle de la Librairie. Annual.

The publicity brochures that French publishing houses issue to sell their books are collected and alphabetized; however, the firms are not always placed in alphabetical order, necessitating using

"Table des éditeurs" to locate them. Includes two alphabetical lists: of authors and of titles.

Books in Print. New York: R. R. Bowker Company. 9 volumes. Annual.

Currently in 9 volumes: 3 for titles and 3 for authors and 3 under *Subject Guide to Books in Print.* Lists books that are published by the firms that contribute to *The Publishers' Trade List Annual,* which the Bowker Company also compiles. Sometimes includes foreign books when there is an American distributor. At the end of volume 6 is a key to the publishers' abbreviations and a directory of publishers that provides their addresses and telephone numbers. For the *Books in Print Database,* see next entry.

Books in Print Database, DIALOG.

Includes books currently in print, about-to-be published titles 6 months in advance, and books declared out-of-print by publishers since 1979. Updated monthly. Provides information to all the publications cited above.

British Books in Print: The Reference Catalogue of Current Literature. London: J. Whitaker and Sons, Ltd. 2 volumes. Annual.

Authors, titles, and subject headings interfiled; includes a list of publishers accompanied by their addresses.

Le catalogue de l'édition française: Une liste exhaustive des ouvrages disponibles publiés, en français, de par le monde. Paris: Catalogue de l'Édition Française. Annual.

A books-in-print reference with volumes for authors, for titles, and for subjects. Also available on microfiches. Introduction in French and English; covers about 208,350 titles of books published by over 3,900 publishers in forty-three countries. Entries give a complete bibliographical report of each book plus citing the number of pages, whether it is illustrated, dimensions in centimeters, and price, which is in French francs unless otherwise noted. There is an "Index des sujets" which facilitates using these works. Often lists the name of any series of which the book might be a part.

Cumulative Book Index: A Word List of Books in the English Language. New York: H. W. Wilson Company. First issue (1928) +

Since 1969 published eleven months a year plus an annual cumulation. Authors, titles, and subject headings interfiled. Covers books published in the English language.

The Publishers' Trade List Annual. New York: R. R. Bowker Company. Annual.

The publicity brochures that American publishing houses issue to sell their books are collected and alphabetized by the name of the firm. This multivolume work includes the addresses of the publishing houses and bibliographical entries for the books that are in print that year.

Titles in Series: A Handbook for Librarians and Students, by Eleanora A. Baer. Metuchen, New Jersey: The Scarecrow Press, Inc., 1978. 4 volumes.

First 2 volumes have under the name of the series, the titles, authors, and dates of the books in that series plus a reference to the entry in the "Authors and Titles Index," which constitutes the next 2 volumes. Last volume includes a "Series Title Index," which facilitates finding the main entry plus a list of the publishers.

For Periodicals

Arntzen, Etta and Rainwater, Robert. *Guide to the Literature of Art History.* Chicago: American Library Association, 1980.

Has special chapter with 356 periodicals cited and annotated.

British Union-Catalogue of Periodicals: A Record of the Periodicals of the World, from the Seventeenth Century to the Present Day, in British Libraries. New York: Academic Press, Inc., 1955–58. 4 volumes. Regular supplements.

British Union-Catalogue of Periodicals: Incorporating World List of Scientific Periodicals: New Periodical Titles 1960–1968. London: Butterworth & Company, Ltd., 1970. Regular supplements.

Union list of serial publications in some major British libraries. Supplements include serials that commenced publication and which altered titles or began a new series. Some newspapers are cited.

Catalogue collectif des périodiques du début du XVII^e siècle à 1939. Paris: Bibliothèque Nationale, 1967–81. 5 volumes.

A union list of serial publications owned by some of the major libraries of France: *B. N.* refers to the Bibliothèque Nationale.

Chamberlin, Mary W. *Guide to Art Reference Books.* Chicago: American Library Association, 1959.

One of the most essential reference works for art researchers; lists important art histories and handbooks many of which are foreign-language references. Chapter 18 lists 250 magazines that were current in 1958 citing their various title changes and in what indices they were found at that time.

Irregular Serials and Annuals: An International Directory. New York: R. R. Bowker Company.

A classified guide to current foreign and domestic serials. Entries of about 20,000 publications are alphabetized under subject headings; each entry cites address, subscription price, foundation date, frequency of publication, and name of editor. Includes a cessation list, an index to publications of international organizations, and a title index. Companion volume to *Ulrich's International Periodicals Directory.*

Karpel, Bernard, editor. *Arts in America: A Bibliography.* Washington, D.C.: Smithsonian Institution Press, 1979. 4 volumes.

> Volume 3 has section on "Serials and Periodicals on the Visual Arts," by William J. Dane, which provides data on 533 publications.

Katz, William Armstrong. *Magazines for Libraries for the General Reader and School: Junior College, College, and Public Libraries.* New York: R. R. Bowker Company, 1982.

> An annotated list of magazines arranged by subjects; includes art, architecture, archaeology, and interior decoration. Each entry gives title of magazine, publisher, address, name of editor, date of first publication, subscription rate, where indexed, whether or not book reviews are included, the audience for which it is written, and a paragraph citing some of the kinds of articles found in the magazine. The supplement contains a combined index for both volumes.

New Serial Titles: A Union List of Serials Commencing Publication After December 31, 1949: 1950–1970 Cumulative. New York: R. R. Bowker Company, 1973. 4 volumes.

New Serial Titles: A Union List of Serials Commencing Publication After December 31, 1949: 1971–1975 Cumulation. Washington, D.C.: Library of Congress, 1976. 2 volumes. Regular updates.

> Issued in eight monthly issues, four quarterly publications and annual, five- and ten-year cumulations. Supplements *Union List of Serials.* Each entry cites title of the periodical, various title changes, and frequency of publication.

Ulrich's International Periodicals Directory: A Classified Guide to Current Periodicals, Foreign and Domestic. New York: R. R. Bowker Company.

> First published in 1932, lists in-print periodicals that are issued more than once a year and usually at regular intervals. Alphabetized under such general headings as "Art" and "Art Galleries and Museums," each entry cites the title and address of the periodical, the date of the first publication, the subscription price, and the indices that cover the magazine's articles. Includes a cessation list, an index to publications of international organization, an index to new periodicals, and a title index. Companion to *Irregular Serials and Annuals: An International Directory.* See next entry for online database.

Ulrich's International Periodical Directory Database, DIALOG.

> Files from 1974; updated every 6 weeks.

Union List of Serials in Libraries of the United States and Canada. 3rd ed. New York: H. W. Wilson Company, 1965. 5 volumes.

> Includes about 55,000 titles of periodicals; each entry gives date of first publication, any changes in title, years when publication ceased, by what periodical it was superseded, and which ones of the more than 900 cooperating libraries own copies. Beginning of each volume lists these cooperating institutions. Supplemented by *New Serial Titles;* see entry in this section.

For *Festschriften*

Leistner, Otto. *International Bibliography of Festschriften.* Osnabrück, Germany: Biblio Verlag, 1976.

> Provides two lists arranged by name of person or institution honored and by subjects. Does not list individual authors and titles of the essays. Includes an appendix of frequently employed terms with both German and English translations and of general abbreviations.

New York Public Library. *Guide to Festschriften.* Boston: G. K. Hall & Company, Inc., 1977.

> *Volume I: The Retrospective "Festschriften" Collection of the New York Public Library: Material Cataloged Through 1971,* reproduction of more than 6,000 *Festschriften* listed on catalogue cards. Entries under editor, institution, and title. However, the honored persons are not listed in this dictionary format, nor is there an index to these people. Cards often provide detailed cataloguing of table of contents with authors and titles of essays.

> *Volume II: A Dictionary Catalog of "Festschriften" in the New York Public Library (1972–1976) and the Library of Congress (1968–1976),* computer produced entries. Has entries to titles of *Festschriften* and to honoree. Ones from Library of Congress are in *LC MARC Database.*

Rave, Paul Ortwin. *Kunstgeschichte in Festschriften.* Berlin: Verlag Gebr. Mann, 1962.

> Consists of 3 sections: "Verzeichnis der Festschriften," the main entries are under the person honored; "Aufgliederung der beiträge nach sachgebieten," a listing of articles by subjects subdivided by country; and "Register festschriftensachtitel Verfasser der beiträge Künstler-und andere personennamen länder und orte," a listing of people who wrote the essays which gives a reference to the main entry which is under the person honored.

RILA: International Repertory of the Literature of Art. Williamstown, Massachusetts: Sterling and Francine Clark Art Institute, Volume I (1975) +

> Contains listings under *"General Works: Collected Works to Festschriften"* and conference and colloquium reports. *Festschriften* are listed under person honored. Table of Contents reported with title and author of each entry provided, the numbers in parentheses refer to the abstracts for the articles which are given fuller, separate treatment in the appropriate subject category. Any reviews of the *Festschriften* are recorded in the next entry.

Répertoire d'art et d'archéologie. Paris: Centre de Documentation Sciences Humaines. Volume 1 (1910) +

In 1981 began "Liste des recueils collectifs" which lists the *Festschriften* and reports of Congresses that are recorded in that specific issue.

Writer's Aids

These references provide information on how to write and where to sell.

Barnet, Sylvan. *A Short Guide to Writing About Art.* Boston: Little, Brown & Company, 1981.

Has chapters on analyzing works of art, writing comparisons, style in writing, manuscript form, the research paper, and essay examinations.

Barzun, Jacques and Henry F. Graff. *The Modern Researcher.* 3rd edition. New York: Harcourt, Brace, Jovanovich, Inc., 1977.

Details problems of historical research plus the reorganizing and writing of term papers. Includes important chapters on "Finding the Facts," which discusses the changes in the calendar, and "Verification." Discusses note taking.

The Chicago Manual of Style for Authors, Editors, and Copywriters. 13th edition revised and expanded. Chicago: University of Chicago Press, 1982.

With this edition changed the title from *The Manual of Style.* Has important sections on manuscript preparation, and rights and permissions to republish or quote from other works; reproduces a sample request to reprint material. Includes a glossary of technical terms and an annotated bibliography.

Literary Market Place. New York: R. R. Bowker Company. Annual.

Lists books and periodical publishers; entries cite addresses, names of various editors, plus kinds and numbers of books published. Includes a subject index to book publishers and lists of artists and art services, of photo and picture resources, and of United States agents of foreign publishers.

Turabian, Kate. *Students' Guide for Writing College Papers.* 3rd edition. Chicago: University of Chicago Press, 1976.

A basic guide.

Van Til, William. *Writing for Professional Publication.* Boston: Allyn and Bacon, Inc., 1981.

Has chapters on "Publishing Opportunities," "The Writer at Work," and "In the Editorial Offices." Has brief discussion on copyright rules.

The Writer's Manual. Palm Springs, California: ETC Publications, 1977.

Written by twelve authors; includes chapters on the mechanics of writing and getting published, how to write for academic publication, and how books are promoted.

Writer's Market. Cincinnati, Ohio: Writer's Digest. Annual.

Under various subject headings provides an annotated list of publishers. Entries include addresses, names of various editors, and pertinent information about the manuscript requirements. Includes notes on freelancing, on a writer with a camera, and on contracts and royalties.

Guides to Pronunciations

Academic American Encyclopedia Database, BRS, DIALOG

A full-text file which corresponds to the 1983 hardbound 21 volume set published by Grolier, Inc. Files updated twice a year. Provides pronunciations of many proper names.

Current Biography Yearbook. New York: H. W. Wilson Company. Volume 1 (1940) +

Entries in one volume are not repeated in subsequent ones. Provides pronunciation guides for some of the names.

Greet, William Cabell. *World Words: Recommended Pronunciations.* 2nd ed., revised. New York: Columbia University Press, 1948.

Published for the Columbia Broadcasting System; has two sections: a good, lengthy discussion of how sounds are pronounced in various countries and a list of recommended pronunciations of proper names.

Kaltenbach, Gustave Émile. *Dictionary of Pronunciation of Artists' Names.* 2nd ed. Chicago: The Art Institute of Chicago, 1938.

Includes more than 1,500 names of artists; covers artists of the western civilization from the thirteenth century to the 1930s.

The New Century Classical Handbook. Catherine B. Avery, editor. New York: Appleton-Century-Crofts, Inc., 1962.

Includes pronunciation guides.

The New Century Handbook of Greek Mythology and Legend. Catherine B. Avery, editor. New York: Appleton-Century-Crofts, Inc., 1972.

Pronunciation guides provided in this dictionary of Greek myths and legends.

The New Century Italian Renaissance Encyclopedia. Catherine B. Avery, editor. New York: Appleton-Century-Crofts, Inc., 1972.

Includes pronunciation guides.

Picken, Mary Brooks. *The Fashion Dictionary: Fabric, Sewing, and Apparel as Expressed in the Language of Fashion.* Revised and enlarged. New York: Funk & Wagnalls Company, 1973.

Gives pronunciation of many fashion terms.

Webster's Biographical Dictionary: A Dictionary of Noteworthy Persons With Pronunciations and Concise Biographies. Springfield, Massachusetts: G. & C. Merriam Company, 1980.

Includes all classifications of artists.

Webster's New Geographical Dictionary: A Dictionary of Names of Places With Geographical and

Historical Information and Pronunciations. Springfield, Massachusetts: G. & C. Merriam Company, 1984.

Includes maps to help locate the geographical locations.

Research Guides

Allen, George Richard. *The Graduate Students' Guide to Theses and Dissertations: A Practical Manual for Writing and Research.* San Francisco: Jossey-Bass Publishers, 1973.

Using a question-and-answer format, the chapters cover academic research, selecting the research topic, the research proposal, data collection and analysis, writing the research report, and the dissertation defense. Includes a bibliography and an index to the questions asked in the text.

Best, John W. *Research in Education,* 3rd ed. Englewood Cliffs, New Jersey: Prentice-Hall, Inc., 1977.

Basic text; each chapter has a separate bibliography. Appendix includes a glossary and a series of statistical formulae. Has two indices: to subjects and to authors.

Travers, Robert Morris William. *An Introduction to Educational Research.* 4th ed. New York: Macmillan Company, 1978.

Basic text.

Van Dalen, Deobold B. *Understanding Educational Research: An Introduction.* 4th ed. New York: McGraw-Hill Book Company, 1979.

Includes a section on statistical research.

Library Reference Works

ART Documentation: Bulletin of the Art Libraries Society of North America. Erika Esau & George Boeck, editors. Tucson, Arizona: ARLIS/NA. Volume 1 (February 1982) +

Replaces *ARLIS/NA Newsletter* which was published for ten years, Volume 1 (November 1972–October 1973)—Volume 10 (December 1981). Published quarterly since 1984, this informative publication of the Art Libraries Society of North America is indispensable to all art and slide librarians. The extensive book review section, which is included in each issue, provides detailed and analytical critiques on art reference works.

Art Library Manual: A Guide to Resources and Practice. Philip Pacey, editor. New York: R. R. Bowker Company, 1977.

Written by twenty-one experts in association with the Art Libraries Society of England. Within each chapter there is extensive information on what, why, and where to purchase references for the art library; each chapter includes a bibliography. Provides information on general art bibliographies, museum and gallery publications, exhibition catalogues, sales catalogues, periodicals and serials, abstracts and indices, microforms, slides and filmstrips, photographs and reproductions of works of art illustrations, and photographs as works of art.

Visual Resources Association. Contact Nancy Schuller, University of Texas, Department of Art, Austin, Texas 78712.

A series of booklets for the visual resoruce librarian.

Guide for the Management of Visual Resources Collections, edited by Nancy Schuller, 1979.

Guide to Equipment for Slide Maintenance and Viewing, by Gillian Scott, 1978.

Guide for Photograph Collections, edited by Nancy Schuller and Susan Tamulonis, 1978.

Guide to Copy Photography for Visual Resource Collections, edited by Rosemary Kuehn and Arlene Zelda Richardson, 1980.

Slide Buyers Guide, edited by Nancy DeLaurier, 1980.

Introduction to Visual Resource Library Automation, edited by Arlene Zelda Richardson and Sheila Hannah, 1981.

Picture Librarianship, edited by Helen P. Harrison, Phoenix, Arizona: The Oryx Press, 1981.

This series of essays by experts in the librarian field has chapters on photography and printing, picture sources, selection, processing, preservation and storage, arrangement and indexing, recent technological developments, microforms, exploitation, copyright in artistic works, administration, plus education and training. Also includes a number of case studies and an extensive bibliography.

Slide Libraries: A Guide for Academic Institutions and Museums. Betty Jo Irvine, compiler. Littleton, Colorado: Libraries Unlimited, Inc., 2nd ed., 1979.

A reference book which covers all aspects of slide librarianship. Chapters include administration and staffing, classification and cataloguing, use of standard library techniques and tools, acquisitions, storage, projection systems, and equipment and supplies. Each chapter has a separate bibliography; plus there is an extensive bibliography on all aspects of slides and slide librarianship. Includes a directory of distributors and manufacturers of equipment and supplies and a directory of slide libraries.

Special References: for Architects, Art/Museum Educators, Commercial Designers, Film Researchers, Photographers, and Printmakers

This chapter includes only brief lists of some of the types of references needed by (1) architects, (2) art/museum educators, (3) art appraisers, (4) commercial designers, (5) film researchers, (6) photographers, and (7) printmakers. These books are cited in order to give these people an idea of the types of resource tools that are available to them. Consult the art librarian for additional assistance.

For Architects

The following material is divided as to works concerned with (a) architectural resources, (b) bibliographies and information sources, (c) building types, (d) historic references, (e) multilingual glossaries of building terms, (f) historic preservation, and (g) cost guides, standards, and technical references for practicing architects.

Architectural Resources

COPAR, *Architectural Research Materials in New York City: A Guide to All Five Boroughs.* New York: COPAR, 1977.

> For each entry cites name, address, telephone number, scope of collection, major holdings—often giving the name and dates of individual architects whose material is represented, plus admission policy and hours of the institution. Supplemented by *Index to the Architects and Architectural Firms Cited in "Architectural Research Materials in New York City,"* compiled by Mary M. Ison, 1981.

COPAR. *Architectural Research Materials in Philadelphia.* New York: COPAR, n.d.

> Uses same format as above entry.

Cummings, Kathleen Roy, *Architectural Records in Chicago: A Guide to Architectural Research Resources in Cook County and Vicinity,* Chicago: Art Institute of Chicago, 1981.

> Similar format to the above entries.

Hanford, Sally. *Architectural Research Materials in the District of Columbia.* Washington, D.C.: American Institute of Architects Foundation, 1983.

> Similar format to the COPAR publications.

Historic American Buildings Survey, see entry Chapter 17, "Published Photographic Archives: Architecture, Sculpture, Interior Design" under *Library of Congress: Prints and Photographs Division.*

Historic Buildings in Britain, see entry Chapter 17, "Published Photographic Archives: Architecture, Sculpture, Interior Design."

Royal Institute of British Architects. *Catalogue of the Drawings Collection of the Royal Institute of British Architects.* London: Gress International, 1968–

> About 21 volumes are planned. There are separate volumes on Colen Campbell, Jacques Gentilhâtre, Inigo Jones and John Webb, Edwin Lutyens, J. B. Papworth, Alfred Stevens, Antonio Visentini, C. F. A. Voysey, the Pugin family, the Scott family, and the Wyatt family. A separate volume is planned for Palladio's work. Each volume has an index to names and places. The actual drawings are being printed on microfilm by World Microfilms, see entry in Chapter 17.

Sanborn Maps. Pelham, New York: Sanborn Map Company, Inc.

> Dating from 1867 to the present, these maps provide street-by-street information for the commercial, industrial, and residential districts of 12,000 cities and towns in the United States, Canada, and Mexico. *Fire Insurance Maps in the Library of Congress,* U.S. Government Printing Office, 1981, is a checklist for the holdings of the some 11,000 volumes of Sanborn maps owned by this Washington, D.C. library. Some maps are available on microfilm from the Library of Congress.

Stierlin, Henri. *Encyclopaedia of World Architecture.* New York: Facts on File, Inc., 1977. 2 volumes.

> A book of architectural plans of buildings from ancient Egypt to the 1960s. Includes color photographs of the buildings recorded.

Bibliographies and Information Sources

American Association for State and Local History, 708 Berry Road, Nashville, Tennessee 37204.

Numerous books and technical brochures on varied subjects are published, such as *A Bibliography on Historical Organization Practices,* edited by Frederick L. Rath, Jr. and Merrilyn Rogers O'Connell, which will eventually consist of 6 volumes. Already published are *Historic Preservation, Care and Conservation of Collections, Interpretation, Documentation of Collections,* and *Administration.*

American Association of Architectural Bibliographers. *Papers.* Charlottesville: University Press of Virginia. Paper I (1965) +

Annual index to reference material on various architects from the seventeenth century to the present. Some volumes are a bibliography on one individual architect, such as *Papers X* on Antonio Gaudí. *Papers XI* of 1974 is a cumulative index to the first ten books.

American Institute of Architects. *AIA Library Bibliographies.* 1735 New York Avenue, N.W., Washington, D.C. 20006.

Have more than 300 bibliographies available on aesthetic and behavioral aspects of architecture, architectural practice, energy, historic preservation, history and styles, technical and urban concerns, and various facilities: commercial, cultural, educational, governmental, health, industrial, and recreational. If a need for material is evident, a bibliography is created.

Art and Architecture Information Guide Series. Sydney Starr Keaveney, general editor. Detroit: Gale Research Company. *American Architecture and Art,* edited by David M. Sokol, 1976. *Indigenous Architecture Worldwide,* edited by Lawrence Wodehouse, 1980.

Extensive annotated bibliographies.

Arts in America: A Bibliography, edited by Bernard Karpel. Washington, D.C.: Archives of American Art, Smithsonian Institution Press, 1949. 4 volumes.

Volume I includes "Architecture," by Charles B. Wood III, which contains a section on building types. Cites bibliographical data for such structures as log cabins, domestic architecture and interiors, hospitals, theaters, schools, hotels, apartments, airports, and barns. Contains bibliographical entries for pattern books and references on 18th- and 19th-century building materials and methods.

Ehresmann, Donald. *Architecture: A Bibliographic Guide to Basic Reference Works, Histories, and Handbooks.* Littleton, Colorado: Libraries Unlimited, Inc., 1983.

Covers about 1,400 entries dating from 1875. Reprints the table of contents for the references. The index includes information in the annotations which accompany the citations.

Fowler, Laurence Hall and Baer, Elizabeth. *The Fowler Architectural Collection of The Johns Hopkins University: Catalogue.* Baltimore: The Evergreen House Foundation, 1961; reprint microform ed, Woodbridge, Connecticut: Research Publications, Inc.

The Fowler Architectural Collection, donated in 1945, has been supplemented by other gifts and now includes 482 works by notable architects up to the end of the 18th century. The texts of all 482 titles are now available on 86 reels of microfilm through Research Publications, Inc.

Hitchcock, Henry Russell. *American Architectural Books.* Minneapolis: University of Minnesota Press, 1962.

Lists builders' guides, house pattern books, and other architectural books published in America before 1895. Most of the books listed have been reproduced in their entirety on microfilm by Research Publications, Inc. This microfilm set, titled *American Architectural Books* is available at many large libraries.

Kamen, Ruth H. *British and Architectural History: A Bibliography and Guide to Sources of Information.* London: The Architectural Press, 1981.

An annotated reference to societies, institutions, libraries, guides to architectural literature, and printed sources of architects and buildings.

Romaine, Lawrence B. *The Guide to American Trade Catalogs: 1744 through 1900.* New York: R. R. Bowker Company, 1960.

The chapter on building materials lists over 300 trade catalogues on building materials and indicates which library owns the catalogue. Other chapters cite catalogues on ornamental ironwork, fences, and plumbing.

Roos, Frank John, Jr. *Bibliography of Early American Architecture: Writings on Architecture Constructed Before 1860 in Eastern and Central United States.* Chicago: University of Illinois Press, 1968.

There is an introduction on architectural styles and sources. Includes a list of 4,377 references divided as to general, colonial, Early Republican, New England, Middle Atlantic States, Southern States, North Central States, Architects—both general and about 40 specific architects—and bibliographies of architectural references.

Vance Architectural Bibliographies. Montecello, Illinois: Vance Bibliographies.

Numerous brief bibliographies on all architectural subjects.

Building Types

Meeks, Carroll L. V. *The Railroad Station: An Architectural History.* New Haven, Connecticut: Yale University Press, 1956.

Illustrated book that discusses railroad stations from 1830 to 1956. Has an essay on the 19th-century style plus a bibliographical essay.

Pevsner, Nikolaus. *A History of Building Types.* Princeton, New Jersey: Princeton University Press, 1976.

> Well-illustrated discussion of buildings for various uses—national monuments, government buildings, townhalls and law courts, theaters, libraries, museums, hospitals, prisons, hotels, banks, warehouses and office buildings, railway stations, exhibition halls, department stores, and factories. Bibliographies for each section; emphasis on 19th century.

Historic References

Davey, Norman. *A History of Building Materials.* London: Phoenix House, 1961.

> Relates the development of building materials and construction techniques through the centuries. Has a section on building tools. Includes bibliographical references.

Harris, Cyril M. *Historic Architecture Sourcebook.* New York: McGraw-Hill Book Company, 1977.

> A dictionary of historic terms and styles; illustrated by 2,100 drawings.

Harris, John and Lever, Jill. *Illustrated Glossary of Architecture, 850–1830.* New York: Crown Publishers, 1967.

> Well-illustrated, easy-to-read book on terminology.

Pevsner, Nikolaus, editor. *Buildings of England.* London: Penguin Books, Inc., 1951–74. 46 volumes.

> Arranged by shires or cities, the volumes are usually classified individually by title—*Cornwall, North Devon, Hampshire, Hertfordshire, London.* Each volume, some of which are in a second edition, consists of a site by site travel guide to the area. Provides historic background, maps, some photographs and floor plans, a glossary, and a selected reading list.

Salzman, L. F. *Building in England Down to 1540: A Documentary History.* Oxford: Clarendon Press, 1952.

> History of building materials and processes. Appendix A, medieval writers on buildings, 675 AD to 1526; Appendix B, building contracts, for 14th to 16th centuries, which provides notes on the medieval English terms. Has indices to persons and places and to subjects.

Sears, Roebuck, and Company. *The 1902 Edition of the Sears Roebuck Catalogue.* New York: Crown Publishers, 1970.

> Source material for interior furnishings and finishes available on that date.

Multilingual Glossaries of Building Terms

Cognacci Schwicker, Angelo. *International Dictionary of Building Construction: English, French, German, Italian.* New York: McGraw-Hill Book Company, 1972.

> Arranged by English building terms accompanied by translation of words in the 3 languages. Indices to French, to German, and to Italian terms which provide cross reference to entry in main section. Includes more than 20,500 terms, but no definitions.

Elsevier's Dictionary of Building Tools and Materials: In Five Languages, Multi-lingual Glossary of Terms in English with French, Spanish, German and Dutch Translations. New York: Elsevier Scientific Publishing Company, 1982.

> Main entry under English term with indices in the other languages providing cross references to it. Also includes British spellings or terms if these are different from the American usage.

Historic Preservation

American Association for State and Local History. Nashville, Tennessee.

> One of the best sources for books and technical brochures on preservation. Numerous publications; to name just three:
>
> *A Bibliography on Historical Organization Practices,* edited by Frederick L. Rath, Jr. and Merrilyn Rogers O'Connell. Proposed 6 volume work; already published: *Historic Preservation, Care and Conservation of Collections, Interpretation, Documentation of Collections,* and *Administration.*
>
> *Historic Preservation in Small Towns,* by Arthur P. Ziegler, Jr. and Walter C. Kidney.
>
> *Local Government Records: An Introduction to Their Management, Preservation, and Use,* by H. G. Jones.

Hosmer, Charles B., Jr., *Preservation Comes of Age: From Williamsburg to the National Trust, 1926–1949.* Charlottesville, Virginia: University Press of Virginia, 1981. 2 volumes.

> Discussion of some specific preservation projects, local and state preservation programs, U.S. Federal Government programs, and restoration techniques. Has chronology, 1920–1953; a bibliography; and copious footnotes.

Insall, Donald W. *The Care of Old Buildings Today: A Practical Guide.* London: The Architectural Press, 1972.

> Discusses techniques of conservation, administration problems, and some case histories.

Markowitz, Arnold L. *Historic Preservation: A Guide to Information Sources.* Detroit: Gale Research Co., 1980.

> Serves as a guide to the various commercial and government publications dealing with historic preservation, including financial, legal, and planning aspects, description and documentation, materials and technology, and renovation and restoration.

The National Register of Historic Places, Ronald M. Greenberg, editor-in-chief. Washington, D.C.: U.S. Department of the Interior, National Park Service, 1976.

A listing by state, followed by city or town, of some of the historic places cited in the Register. Map of each state places site. Entries provide addresses, reasons for inclusion in register, and sometimes the architects. Includes some illustrations.

The National Trust, England, publishes such books as: *The National Trust Book of British Castles,* by Paul Johnson. New York: G. P. Putnam's Sons, 1978.

A history of some of the properties of the National Trust. Illustrated; includes glossary of technical terms and selected bibliography.

The National Trust Book of Great Houses of Britain, by Nigel Nicolson. London: David R. Godine, 1978.

Illustrated history.

The National Trust for Historic Preservation, United States: America's Forgotten Architecture, by Tony P. Wrenn and Elizabeth D. Mulloy. New York: Pantheon Books, 1976.

Photo essay of types of buildings. Includes preservation information and funding sources plus a bibliography.

Cost Guides, Standards, and Technical References

American Institute of Architects. 1735 New York Avenue, N.W.; Washington, D.C. 20006.

Publishes numerous works to assist the practicing architect. Write for the *Member Resource Catalog* for a complete listing. These references include such items as *The Architects Handbook of Professional Practice,* 3 volumes; *Masterspec 2; Architect's Handbook of Energy Practice;* and *Guide to Historic Preservation.* See next entry.

American Institute of Architects. *Architectural Graphic Standards,* edited by Robert T. Packard. 7th ed. New York: John Wiley & Sons, Inc., 1981.

Prepared by more than 140 professional firms, the material is organized according to the principles of the Uniform Construction Index. This new edition emphasizes conservation of energy, designs for the handicapped, environmental protection, anthropometric data, and the metric system.

DeChiara, Joseph. *Time-Saver Standards for Building Types.* 2nd ed. New York: McGraw-Hill, 1980.

Intended for use by architects, designers, and students, this volume provides basic data on the functional requirements of a wide variety of building types. Most of the criteria are presented in graphic form, floorplans, sections, and charts, for easy reference and use. The building types dealt with include residential, educational, cultural, religious, commercial, and industrial.

Dodge Building Cost Calculator and Valuation Guide. New York: McGraw-Hill Information Systems Company.

An annual guide, formerly called the *Dow Building Cost Calculation.* Cost figures are at the low- to mid-range of competitive bidding. By choosing a similar building to the proposed project, and multiplying the base cost of this type of construction by the floor area of the proposed structure, a base cost can be figured. By then using the "Local Building Cost Multipliers" index to find the appropriate cost factor for the city in which the structure will be constructed and multiplying this number by the base cost, an approximate dollar amount for the building can be calculated. Examples of older buildings are included.

McGraw-Hill's Dodge Manual for Building Construction Pricing and Scheduling. Princeton, New Jersey: McGraw-Hill Information Systems Company.

An annual publication to assist architects and builders in determining costs and man-hours required for a project. Organized into 16 subject divisions, such as site work, masonry, finishes, and furnishings. The productivity data was derived from information from 20 large cities. The unit costs reported represent average costs. The general contractor's overhead and markup are excluded from all prices reported. Includes a special section on remodeling and renovation, a list of abbreviations, adjustment indices, and index to items of work.

Neufert, Ernest. *Architects' Data.* 2nd International English edition. New York: Halsted Press, 1980.

A book concerned with the spacial needs of people in buildings. Has had more than 30 editions in Germany; has been translated into 9 languages. Arranged under types of community and commercial type buildings, provides outline of uses for structure accompanied by floor plans, elevations, and technical diagrams concerned with human scale and design practices. Units of measurements vary; be sure to read explanations of them carefully. Uses a mixture of British and American terms, but all British spellings. Includes an index to terms for quick access to the material plus an extensive bibliography.

Sweet's Catalog File. New York: McGraw-Hill Information Systems Company. Annual publication of numerous volumes organized under specific titles which can be purchased separately:
Products for General Building
Products for Industrial Construction and Renovation and Renovation Extension
Products for Light Residential Construction
Products for Interiors
Products for Engineering
Products for Canadian Construction

All of the series contain the advertising brochures from producers, which provide color illustrations and pertinent information on the

products as well as technical information. Organized under large subject headings. Includes lists of firms, of products, and of trade names.

Time-Saver Standards for Architectural Design Data, John Hancock Callender, editor-in-chief. 6th ed. New York: McGraw-Hill, 1982.

A useful compilation of a wide variety of standards and statistical information required in the design process. Charts, tables, and schematic drawings are provided on such subjects as solar, angles, floor framing systems, skylights, and fire alarm systems.

Wiley Series of Practical Construction Guides, New York: John Wiley & Sons.

Publishes more than 20 books concerned with construction. Stein's *Construction Glossary* is cited in Chapter 9 under "Construction and Decorative Materials Dictionaries." Series includes such helpful guides as *Construction Measurements,* by B. Austin Barry; *Construction Specification Writing,* by Harold J. Rosen; and *Construction Bidding for Profit,* by William R. Park.

For Art/Museum Educators

Bibliographies and Current Issues

Alternatives for Art Education Research: Inquiry into the Making of Art, by Kenneth R. Beittel. Dubuque, Iowa: William C. Brown Company, 1973.

Discusses some non-statistical kinds of research.

Art Education: A Guide to Information Sources, edited by Clarence Bunch. Detroit: Gale Research Company, 1978.

A bibliography that includes all types of topics of interest to art educators, such as research, creativity, exceptional and disadvantaged children, teaching processes and materials, teacher resource materials, financing art education, and children's art books.

A Cyclopedia of Education, edited by Paul Monroe. New York: Macmillan Company, 1911–13; reprint ed., Detroit: Gale Research Company, 1968. 5 volumes.

Out of date but can be useful for the collection of articles on terminology, historical periods, and educators. Includes bibliographical references; fifth volume has a group of analytical indices.

Dictionary of Education, Prepared Under the Auspices of Phi Delta Kappa, edited by Carter V. Good. 3rd ed. New York: McGraw-Hill Book Company, Inc., 1973.

Dictionary of educational terminology; lists about 25,000 words. Third edition has a separate section for terms that differ from United States meanings; includes Canadian, English, and Welsch terms. The first edition (1945) and the second (1959) also has sections for word differentiations used in France, Germany, and England. Sometimes includes pronunciation of difficult words.

The Educator's Encyclopedia, by Edward W. Smith, et al. Englewood Cliffs, New Jersey: Prentice-Hall, Inc., 1961.

Subjects divided into fifteen categories covering education and measurements, materials and resources, instructional improvement, and student activities. Includes a glossary of educational terms and an extensive bibliography.

The Encyclopedia of Education, editor-in-chief Lee C. Deighton. New York: Macmillan Company and The Free Press, 1971. 10 volumes.

A collection of more than 1,000 signed articles; each article contains a selected bibliography. Tenth volume has a directory of contributors, which includes some biographical material on the authors, and a guide to the articles, which is a table of contents of each volume citing the author of each entry.

The Encyclopedia of Educational Research. American Educational Research Association. New York: Macmillan Company. 1st edition, edited by Walter S. Monroe, 1940. 2nd revised edition, edited by Walter S. Monroe, 1950. 3rd edition, edited by Chester W. Harris, 1960. 4th edition, edited by Robert L. Ebel, 1969. 5th edition, edited by Harold E. Mitzel, 1982.

A collection of articles written by eminent scholars. Under such topics as art, attitudes, and audio-visual communication, the articles present critical evaluations, syntheses, and interpretations of pertinent research and include extensive bibliographies. Later editions are not revisions but usually have new subjects and different authors.

Handbook on Contemporary Education, edited by Steven E. Goodman. New York: R. R. Bowker Company, 1976.

A collection of signed articles which include a bibliography and a list of additional resources. Sections on such topics as educational change and planning, teaching and learning strategies, and some alternatives and opinions in education. Has two indices: to authors and to key-words.

Handbook of Research on Teaching: A Project of the American Educational Research Association, edited by Nathaniel Lees Gage. Chicago: Rand McNally and Company, Inc., 1963.

A collection of scholarly articles by thirty-one experts; each signed article has an extensive bibliography. Analyzes educational research.

Second Handbook of Research on Teaching: A Project of the American Educational Research Association, edited by Robert M. W. Travers. Chicago: Rand McNally College Publishing Company, 1973.

A collection of scholarly articles by sixty-nine contributors; each signed article has an extensive bibliography. Includes research on teaching the visual arts.

The Teacher's Handbook, edited by Dwight W. Allen and Eli Seifman. Glenview, Illinois: Scott, Foresman and Company, 1971.

> A collection of articles by eminent scholars; each article includes an annotated bibliography. Contains sections on such subjects as curriculum, instructional process, the teacher, and contemporary issues. Written by eighty-six educators for whom brief biographical entries are given.

References on Art Instruction

Chapman, Laura H. *Approaches to Art in Education.* New York: Harcourt, Brace, Jovanovich, Inc., 1978.

> Discusses the foundations for art education as well as children's artistic development. Includes suggested activities and program planning and evaluation.

Gaitskell, Charles D. and Hurwitz, Al. *Children and Their Art: Methods for the Elementary School.* 3rd ed. New York: Harcourt, Brace, Jovanovich, Inc., 1975.

> A textbook for teaching art to children.

Hubbard, Guy. *Art for Elementary Classrooms.* Englewood Cliffs, New Jersey: Prentice-Hall, Inc., 1982.

> A textbook for teaching art to children.

Lowenfeld, Viktor and Brittain, W. Lambert. *Creative and Mental Growth.* 5th ed. New York: The Macmillan Company, 1970.

> Discusses the meaning of art for education and the various stages of children's artistic development. First published in 1947, Lowenfeld's book has had a tremendous influence on art education.

McFee, June King and Degge, Rogena M. *Art, Culture, and Environment: A Catalyst for Teaching.* Belmont, California: Wadsworth Publishing Company, Inc., 1977; reprint paperback, Dubuque, Iowa: Kendall/Hunt Publishing Company, 1980.

> Discusses designing and creating art plus gives art activities. Has important chapters on exploring the cultural meaning of art, art and environmental design, theory and research, and teaching and assessment of art.

Mager, Robert F. *Goal Analysis.* Belmont, California: Lear Siegler, Inc./Fearon Publishers, 1972.

> Explains setting goals for teaching.

―――. *Preparing Instructional Objectives.* 2nd edition. Belmont, California: Fearon Publishers, Inc., 1975.

> Discusses how to define and state teaching objectives.

Mattil, Edward L. and Marzan, Betty. *Meaning in Children's Art: Projects for Teachers.* Englewood Cliffs, New Jersey: Prentice-Hall, Inc., 1981.

> Discusses various art activities for children.

Plummer, Gordon S. *Children's ART Judgment: A Curriculum for Elementary Art Appreciation.* Dubuque, Iowa: William C. Brown Company, 1974.

> Discusses the changes in children's opinions concerning art.

Silberstein-Storfer, Muriel and Jones, Mablen. *Doing Art Together.* New York: Simon and Schuster, 1982.

> Discusses various art activities for children.

For Art Appraisers

Babcock, Henry A. *Appraisal Principles and Procedures.* Washington, D.C.: American Society of Appraisers, 1968.

> Discusses the discipline.

The Bibliography of Appraisal Literature. Washington, D.C.: American Society of Appraisers, 1974.

> Covers all kinds of appraisals, including personal property which includes fine arts and antiques.

Appraisal and Valuation Resource Manuals. Washington, D.C.: American Society of Appraisers, 1955–

> Eight volume set covering various kinds of appraisals.

For Commercial Designers

The Design Directory: A Listing of Firms and Consultants in Industry, Graphic, Interior, and Exterior Design. W. Daniel Wefler, editor. Evanston, Illinois: Wefler & Associates, Inc.

> Reports more than 1,350 firms in geographical order by state then city. Cites date firm was established, number of employees, names of major personnel, list of services, plus a list of some of their clients. Includes an alphabetical listing of firms.

Graphis Annual: The International Annual of Advertising and Editorial Graphics. Walter Herdeg, editor. Zurich, Switzerland: Graphis Press Corporation. Annual, since 1944+

> Reproduces advertisements, many in color. Written in English, German, and French. Includes indices to artists; to designers; to art directors; to agencies, studios, and producers; to publishers; and to advertisers. Includes advertisements, annual reports, book covers, booklets, calendars, house organs, letterheads, magazine covers and illustrations, newspaper illustrations, packaging, record covers, and trade magazines.

PHOTOGRAPHIS: The International Annual of Advertising and Editorial Photography. Walter Herdeg, editor. Zurich, Switzerland: Graphis Press Corporation. Annual, since 1966+

> Same format as *Graphis Annual,* see above entry. Instead of index to artists, has one to photographers. Includes magazine and newspaper advertisements, annual reports, booklets, calendars, corporate publications, editorial photography, magazine covers, packaging, television, and trade magazines. Also publishes *Graphis Posters* and *Graphis Packaging.*

For Film Researchers

Film Resources

Academy of Motion Picture Arts and Sciences. *Who Wrote the Movie and What Else Did He Write? An Index of Screen Writers and Their Film Works 1936–1969.* Los Angeles: The Academy of Motion Picture Arts and Sciences and The Writers Guild of America, West, 1970.

> Includes three sections: 2,000 entries on writers of screenplays, 13,000 listings of film titles, and a list of various motion picture awards.

American Film Institute. *American Film Institute Catalog of Motion Pictures Produced in the United States.* New York: R. R. Bowker Company.
Feature Films, 1921–1930, edited by Kenneth W. Munden, 1971. 2 volumes.
Feature Films, 1961–1970, 1976. 2 volumes.

> A project that will include, decade by decade, catalogues of American produced films: features, shorts, and newsreels. A feature film is defined as one with 4,000 feet or more film or of at least four reels. Under the title of the film, each entry lists production company, type of film, release date, number of reels and feet, cast credits, plus a synopsis of the movie story. Includes two indices: to production and cast credits and to subjects.

Bawden, Liz-Anne, editor. *The Oxford Companion to Film.* New York: Oxford University Press, 1976.

> International coverage of terms, styles, films, directors, and performers. Films listed with English translations provided in parentheses. Includes biographical material and, at times, a literary reference. Words, names, or titles printed in small capital within an entry signifies that the capitalized term also has an entry in the book.

Bessy, Maurice and Chardans, Jean-Louis. *Dictionnaire du cinéma et de la télévision.* Paris: Jean-Jacques Pauvert, Editeur, 1965–71. 4 volumes.

> International coverage of terms, filmmakers, movies, film styles, and film-producing countries. Film titles are listed in French, German, English, Italian, or Spanish, depending upon the country that produced them. For countries speaking a language other than those listed, the film title has been translated into French. Well-illustrated volumes.

Boussinot, Roger, editor. *L'encyclopédie du cinéma.* Paris: Bordas, 1967.

> Biographical directory of filmmakers; lengthy articles include a list of movies with which the person was connected and a brief bibliography of French publications.

Cawkwell, Tim and Smith, John M., associate editors. *The World Encyclopedia of Film.* London: Studio Vista Publishers, 1972.

> Biographical entries of performers, directors, photographers, writers, set designers, choreographers, composers, and producers. Each entry includes a list of the filmmaker's movies with the release dates. Has an index to films mentioned in the text.

Daisne, Johan. *Dictionnaire filmographique de la littérature mondiale. (Filmographic Dictionary of World Literature.)* Ghent, Belgium: Story-Scientia PVBA, 1971–78.

> An index of authors of films. Each entry cites the titles of the movies, the releasing country and year, the director, and the cast credits. Has an index to film titles accompanied by the name of the author of the screenplay.

Geduld, Harry M. and Gottesman, Ronald. *An Illustrated Glossary of Film Terms.* New York: Holt, Rinehart and Winston, Inc., 1973.

> Easy-to-read, well-illustrated dictionary; includes bibliographical references.

Gifford, Denis. *The British Film Catalogue 1895–1970: A Reference Guide.* New York: McGraw-Hill Book Company, 1973.

> Lists over 14,000 movies produced by British film companies. Each film is listed by year of release and a catalogue number necessitating the use of the "Title Index" to discover the correct catalogue number. Each entry includes title, date, producer, director, story source, author of screenplay, cast credits, subject of film, and any awards won.

Halliwell, Leslie. *The Filmgoer's Companion.* 7th ed. revised and enlarged. New York: Hill and Wang, 1980.

> Dictionary-type reference to terms, directors, producers, writers, photographers, musicians, performers, and fifty-five fictional characters, such as Frankenstein. Includes a representative list of films with release dates. Aimed at the general moviegoer. Has several hundred entries on important films; emphasizes British and American movies. Article on title changes cites some that have altered through the years or from country to country.

Jordan, Thurston C., Jr. *Glossary of Motion Picture Terminology.* Menlo Park, California: Pacific Coast Publishers, 1968.

> An illustrated dictionary.

Lacalamita, Michele, editor. *Filmlexicon degli autori e delle opere.* Rome: Edizioni di Bianco e Nero, 1958–67. 7 volumes.

> Biographical dictionary of more than 50,000 entries covering directors, producers, story and script writers, cameramen, composers, art designers, and performers. Each entry includes the filmmaker's movies accompanied by the issue dates and bibliographical data where applicable. Introduction in Italian and English. Film titles are in their original language.

Low, Rachael. *The History of the British Film.* London: George Allen and Unwin, Ltd., 1948–71. 4 volumes.
Volume I: 1896–1906, with Roger Manvell, 1948.

Volume II: 1906–1914, 1949.

Volume III: 1914–1918, 1950.

Volume IV: 1918–1929, 1971.

Continued by: *Films of Comment and Persuasion of the 1930s,* 1979 and *Documentary and Educational Films of the 1930s,* 1979.

Each volume is divided into sections on the movie industry, films, and film techniques.

Magill, Frank N., editor. *Magill's Survey of Cinema: English Language Films.* Englewood Cliffs, New Jersey: Salem Press.

First Series, 1980. 4 volumes.

Under title of movie provides production data, list of principal characters, and a synopsis of the movie. These are signed essays, of 515 major films released from 1927 to 1980, written by more than 100 contributors. First volume has a brief glossary of cinema terms.

Second Series, 1981. 6 volumes.

Same format; covers 751 additional films, 1928–81.

Silent Films, 1982. 3 volumes.

Same format; covers films from 1902–1936. Also includes glossary of film terms and 17 essays on silent film.

Foreign Films, projected future publication.

Manchel, Frank. *Film Study: A Resource Guide.* Rutherford, New Jersey: Fairleigh Dickinson University Press, Inc., 1973.

General reference work with chapters on film literature, representation of genre in film, stereotyping in film, the thematic approach to movies, comparative film literature, approaching the history of cinema, and film study. Each section includes an annotated list of books and movies on the subject. Has a glossary, a list of film critics and film periodicals, a selective list of dissertations on films, and seven indices: to titles of articles, to authors of articles, to authors of books, to book titles, to film personalities, to film titles, and to subjects.

Manvell, Roger, general editor. *The International Encyclopedia of Film.* New York: Crown Publishers, Inc., 1972.

Illustrated dictionary of terms, of biographical material, and of films produced by various countries. Includes an extensive bibliography and three indices: to title changes, to film titles, and to filmmakers.

Michael, Paul, editor-in-chief. *The American Movies Reference Book: The Sound Era.* Englewood Cliffs, New Jersey: Prentice-Hall, Inc., 1969.

Well-illustrated reference with a chapter on the history of the talkies and subsequent chapters covering movie stars, films, directors, producers, and awards. Each of the more than 600 movie star entries includes biographical data and a list of the star's feature films, accompanied by the producers' names and the release dates. Each of

the over 1,000 American films are cited with release date, producer, director, cameraman, art director, musical director, editor, and running time. The cast credits include the part each star played. The listings of over fifty directors and fifty producers follow the same format as that of the movie stars. Includes a bibliography, a general index, and a list of film awards through 1967. The film awards cited are for those given by the Academy of Motion Picture Arts and Sciences, the National Board of Review, New York Film Critics, and Photoplay Magazine Company, plus the Patsy Award for skill in handling animals and compliance with the American Humane Association, and the top-grossing films of each year.

Pickard, R. A. E. *Dictionary of 1,000 Best Films.* New York: Association Press, 1971.

Indexed by film titles, each entry includes release country and date, director, photographers, cast credits, and story synopsis.

Sadoul, Georges. *Dictionary of Film Makers.* Translated and edited by Peter Morris. Berkeley: University of California Press, 1972.

Biographical directory of producers, directors, photographers, musical directors, and other persons associated with films. Lists the filmmaker's movies with the release dates. International coverage; asterisk following a film title indicates that the movie is described in the companion volume, *Dictionary of Films.*

————. *Dictionary of Films.* Translated and edited by Peter Morris. Berkeley: University of California Press, 1972.

Indexed by film titles, each entry includes release country and date, director, photographer, music composer, story source, cast credits, and story synopsis. Film titles are listed in their original language; however, cross references are provided under the English translation of the movie title.

Thomson, David. *A Biographical Dictionary of Film.* New York: William Morrow and Company, Inc., 1976.

Biographical data on directors, producers, and performers; includes a few literature references. Gives original film titles under entries for directors.

Bibliographies of Film Literature

Batty, Linda. *Retrospective Index to Film Periodicals 1930–1971.* New York: R. R. Bowker Company, 1975.

Indexes nineteen periodicals. Divided into three indices: to review of individual films, to film subjects, and to reviews of books on films.

Gerlach, John C. and Gerlach, Lana. *The Critical Index: A Bibliography of Articles on Film in English, 1946–1973.* New York: Teachers College Press, 1974.

Includes 5,000 items from twenty-two film journals and sixty general periodicals. Covers two lists

of articles on topics and on filmmakers. Each entry cites name of the author, title of the article, title of the magazine, volume, date, and page numbers. The dictionary of topics in the introduction is an index to subjects that are covered by this book; has a separate index of film titles.

Leonard, Harold, editor. *Film Index: A Bibliography.* New York: Museum of Modern Art Library & H. W. Wilson Company, 1941; reprint ed., New York: Arno Press, Inc., 1966.

> Has numerous subject categories divided into two parts: the history and technique of films and film reviews. Includes annotated entries on books, articles, and individual films. There are over 8,500 bibliographical entries.

MacCann, Richard Dyer and Perry, Edward S. *New Film Index: A Bibliography of Magazine Articles in English, 1930–1970.* New York: E. P. Dutton & Company, Inc., 1975.

> Conceived as a supplement to *Film Index: A Bibliography,* edited by Leonard. Annotated lists of articles from more than sixty periodicals arranged, from the earliest article to the latest, under large subject classifications: references, motion-picture arts and crafts, film theory and criticism, film history, biography, motion picture industry, film and society, nonfiction films, and case histories of film making.

Prichard, Susan Perez. *Film Costume: An Annotated Bibliography.* Metuchen, New Jersey: Scarecrow Press, Inc., 1981.

> Has more than 3,600 entries cited by authors. Includes index for subject and designer access.

Rehrauer, George. *Cinema Booklist.* Metuchen, New Jersey: Scarecrow Press, Inc., 1972. *Supplement One,* 1974. *Supplement Two,* 1977.

> There are over 2,900 annotated entries on all kinds of published material pertinent to the cinema in the two volumes. Includes several indices: to film scripts, to souvenir books, to interviews with filmmakers, to authors, and to subjects.

———. *The Macmillan Film Bibliography: A Critical Guide to the Literature of the Motion Picture.* New York: Macmillan Publishing Company, Inc., 1982. 2 volumes.

> Volume I is an annotated bibliography arranged by book titles. Volume II has 3 indices: to subjects, to authors, and to scripts or titles of the movie.

Schuster, Mel. *Motion Picture Directors: A Bibliography of Magazine and Periodical Articles, 1900–1972.* Metuchen, New Jersey: Scarecrow Press, Inc., 1973.

> Lists over 2,300 articles—written on directors, filmmakers, and animators—that were published in 340 periodicals.

———. *Motion Picture Performers: A Bibliography of Magazine and Periodical Articles, 1900–1969.* Metuchen, New Jersey: Scarecrow Press, Inc., 1971. *Supplement No. 1: 1970–1974,* 1976.

> Indexes articles in over 140 periodicals.

For Photographers

Freudenthal, Juan R. and Lyders, Josette A. "Photography as Historical Evidence and Art: Steps in Collection Building," *Collection Building,* 2 (1980): 64–98.

> Bibliography of photographic references.

Gernsheim, Helmut and Gernsheim, Allison. *History of Photography.* New York: McGraw-Hill, 1969.

> Detailed discussion; one of first books on subject.

Ludman, Joan and Mason, Lauris. *Fine Print References: A Selected Bibliography of Print-Related Literature.* Millwood, New York: Kraus International Publications, 1982.

> Under subject headings, has citations for about 1,500 books and catalogues. Has an index to authors and museums.

Mason, Lauris and Ludman, Joan. *Print Reference Sources: A Selected Bibliography 18th–20th Centuries.* 2nd edition. Millwood, New York: Kraus International Publications, 1979.

> Has bibliographical data on about 1,800 printmakers, includes contemporary artists.

Newhall, Beaumont. *The History of Photography: From 1839 to the Present Day.* Revised edition. New York: Museum of Modern Art, 1964.

> Basic text.

Professional Photographic Illustration Techniques. Rochester, New York: Eastman Kodak Company, 1978.

> Includes discussion of photographic tools; basic lighting; how to photograph the invisible, food, indoor shots, commercial images; preparing reproductions; layouts; and care of clients. Beautifully illustrated, all in color.

Scharf, Aaron, *Art and Photography.* Baltimore: Penguin Books, Inc., 1968.

> Well-illustrated book covering the invention of photography, photography's influence on 19th- and 20th-century art, representation of movement in photography and art, and photography as art. In-depth discussion on photography's influence on various artists.

Time-Life Library of Photography Series. New York Time, Inc., 1970–

> Individual well-illustrated books on pertinent concerns of photography. A continuing series covering theory, history of photography, conservation of photographs and special subjects. Each volume contains an excellent bibliography.

For Printmakers

Eichenberg, Fritz. *The Art of the Print: Masterpieces, History, Techniques.* New York: Harry N. Abrams, Inc., 1976.

> A profusely illustrated, encyclopedic reference which covers every technique of printmaking from 15th-century Far Eastern prints to those of the present.

Hind, Arthur Mayger. *A History of Engraving and Etching: From the 15th Century to the Year 1914.* 3rd ed. revised. Boston: Houghton, Mifflin, 1923; reprint ed., New York: Dover Publishers, Inc., 1963.

> An illustrated history with a chapter devoted to processes and materials, an extensive bibliography, an index of monographs on famous engravers, and a list of engraving collections accompanied by a list of catalogues of these collections. Includes a classified list of engravers arranged chronologically under various geographic locations; each entry cites master's name, medium used, and the names of those who were influenced by the master.

————. *An Introduction to a History of Woodcut With a Detailed Survey of Work Done in the Fifteenth Century.* Boston: Houghton Mifflin Company, 1935; reprint ed., New York: Dover Publishers, Inc., 1963. 2 volumes.
Volume I: The Primitives, Single Cuts, and Block-Books
Volume II: Book-Illustration and Contemporary Single Cuts

> Illustrated history with a chapter on processes and materials. Each section has its own extensive bibliography. Includes numerous indices: to designers and engravers of woodcuts, to printers and publishers citing the dates they worked and their geographic locations, to books illustrated with woodcuts, to subjects, and to prints mentioned or reproduced.

Ivins, William M., Jr. *How Prints Look: Photographs With a Commentary.* New York: Metropolitan Museum of Art, 1943; reprint ed., Boston: Beacon Press, 1958.

> Well-illustrated book explaining how to distinguish various graphics. Has a chapter on copies and facsimiles.

Lumsden, Ernest S. *The Art of Etching: A Complete and Fully Illustrated Description of Etching, Drypoint, Soft-Ground Etching, Aquatint and Their Allied Arts, Together with Technical Notes upon Their Own Work by Many of the Leading Etchers of the Present Time.* London: Seeley Service and Company, Ltd., 1924; reprint ed., New York: Dover Publications, Inc., 1962.

> Well-illustrated how-to-do book.

Mayor, Alpheus Hyatt. *Prints and People: A Social History of Printed Pictures.* New York: Metropolitan Museum of Art, 1971.

> Well-illustrated text covering historical information and how to differentiate certain graphics.

Wilder, F. L. *How to Identify Old Prints.* London: G. Bell and Sons, Ltd., 1969.

> Illustrated book containing biographical, historical, and analytical material on woodcuts, line-engravings, etchings, mezzotints, stipples, aquatints, lithography, printing, color-printing from intaglio plates, and hard-color prints. Includes some hints for collectors.

Zigrosser, Carl and Gaehde, Christa M. *A Guide to the Collecting and Care of Original Prints.* New York: Crown Publishers, Inc., 1965.

> Sponsored by The Print Council of America, this book includes a glossary of terms relating to prints plus chapters on the print market and the conservation of prints.

CHAPTER 24

Marketing Aids and Suppliers of Products and Services

The first section of this chapter, which is composed of a list of references that will assist the reader in entering the marketplace, is subdivided into three categories: (1) "Assistance in the Marketplace," (2) "The Legal Aspects," and (3) "Handling and Shipping Works of Art." Since some of these books overlap as to contents, researchers should read the annotations carefully in order to obtain the titles of all of the works pertinent to their particular problems. For details on how to use these references, the investigator should consult "Marketing Problems" in Chapter 8.

The second section on suppliers of products and services provides material for locating items:

(1) for art and antique buyers and sellers, directories that list art appraisers and antique dealers.
(2) for the artist, suppliers of materials used in sculpture, printmaking, ceramics, and weaving.
(3) for researchers concerned with film and multimedia, the names of books that list and evaluate multimedia materials.
(4) for interior designers, such products as materials for restoring historical homes and various kinds of furniture and furnishings.

Marketing Aids

Assistance in the Marketplace

American Art Directory. New York: R. R. Bowker Company, Volume I (1898)+
 Now published about every two years; includes a list of open exhibitions.

Artist's Market. Cincinnati, Ohio: Writer's Digest. First edition (1974)+
 A guide on how to sell art work. Lists firms interested in purchasing art; the firms are divided into categories, such as advertising, craft dealers, and galleries. Entries cite their addresses plus information as to what the firms buy and how they pay for it. Includes an alphabetical listing of the associations that are recorded, a glossary of terms, copyright information, and notes on marketing

art work. Reproduces a typical commission agreement and a sample model's release.

Blodgett, Richard E. *How to Make Money in the Art Market.* New York: Peter H. Wyden, 1975.
 Provides information on buying at auction and from a dealer, fakes, caring for a collection, art and taxes, how to sell a painting, and artists' rights.

Burnham. Sophy. *The Art Crowd.* New York: David McKay Company, Inc., 1973.
 A description of the art market.

Chamberlain, Betty. *The Artist's Guide to His Market.* Revised ed. New York: Watson-Guptill Publications, 1983.
 Indispensable book for all studio artists. Chapters cover business terms and agreements, pricing and selling, copyright and royalties, governmental and national aids to art, co-operative galleries, taxes and self-employed artists, and artists groups. Includes sample forms for contracts, bill of sales, and receipts of payment.

Frischer, Patricia and Adams, James. *The Artist in the Marketplace: Making Your Living in the Fine Arts.* New York: M. Evans & Company, Inc., 1980.
 Discusses galleries, presentation of art, pricing, contracts, copyright, taxes, and the government and the arts.

National Directory of Shops/Galleries, Shows/Fairs: Where to Exhibit and Sell Your Work. Cincinnati: Writer's Digest Books. Annual.
 Organized by region. Discusses contracts and artists plus photographing your work. Originally entitled *Craft Worker's Market.*

Photographer's Market: Where to Sell Your Photographs. Cincinnati: Writer's Digest Books. Annual
 Lists companies which purchase photographs. Gives tips on selling work. Contains list of professional associations, annual workshops, and a glossary.

Legal Aspects

Chernoff, George and Sarbin, Hershel. *Photography and the Law.* 5th ed. Garden City, New York: American Photographic Book Publishing Company, Inc., 1978.
 Chapters cover taking pictures, right of privacy, ownership of pictures, loss or damage to film, nudes in photography, copyright, and libel. Reproduces some typical forms such as for the reg-

istration of a claim to copyright a photograph and a release form to use with models.

Crawford, Tad. *Legal Guide for the Visual Artist.* New York: Hawthorn Books, Inc., 1977.

Chapters cover such important subjects as copyright, rights of the artist, content of works of art, contracts, video-art works, publishing, income taxation, fine prints, and the artist's estate. Reproduces sample forms for contracts and sales agreements, commission agreements, releases, print documentation, and deeds of gift.

DuBoff, Leonard D. *The Desk Book of Art Law.* Washington, D.C.: Federal Publications, Inc., 1977.

Deals with customs, definitions, international movement of art, censorship, federal aids to the arts, authentication, insurance, auctions, taxation, copyright, and museum problems.

Duffy, Robert E. *Art Law: Representing Artists, Dealers, and Collectors.* New York: Practicing Law Institute, 1977.

Covers commercial transactions, auctions, copyright, tax problems, invasion of privacy, obscenity, and the art collection.

Feldman, Franklin and Weil, Stephen E. editors, *Art Works: Law, Policy, Practice.* New York: Practicing Law Institute, 1974.

A comprehensive book of more than 1,150 pages of text which explains some of the many complicated laws that govern the art world. Includes numerous essays written by various experts on such subjects as the *droit de suite* and the rights to reproduce works of art; the purchase and sale of art objects; the representations, commissioned work, statutes of limitation, and relationship between artist and dealer; transport of works of art across national boundaries; the insuring of works of art; the lending of art objects; the tax aspects of works of art, including tax problems of the artist and of the collector, statutes and regulations, and appraisal forms; civil and criminal liabilities involving works of art, relating problems involved with desecration and restricted images, obscenity, defamation and right of privacy, nuisance, plus expert opinions and fake art; and private ownership and public trust, including control and disposition of fake art, bequests and gifts to museums, dispositions by museums, charitable gifts, and professional museum practices. There are numerous case studies and reproductions of forms and agreements. The appendix includes a table of the forms, agreements, and related documents that are reproduced; tables of the American and the foreign cases which are reported; and a table of treaties, statutes, and regulations which are cited.

Hodes, Scott, *What Every Artist and Collector Should Know About the Law.* New York: E. P. Dutton & Company, Inc., 1974.

Written by an attorney to try to give laymen some knowledge about such important subjects, such as creating and selling art works, copyright, *droit de suite,* taxes, purchasing art, and insurance. Numerous appendices reproduce various agreements, releases, and application forms.

Horwitz, Tem. *Law and the Arts—Art and the Law.* Chicago: Lawyers for the Creative Arts, 1979.

The law in relation to writers and artists of all media.

Merryman, John Henry and Elsen, Albert E. *Law, Ethics, and the Visual Arts: Cases and Materials.* New York: Matthew Bender, 1979. 2 volumes.

Discusses stolen art, limits of artistic freedom, copyright, the collector, the museum, and the artist. Some of the material is reprinted from other sources.

Handling and Shipping Works of Art

Dudley, Dorothy H.; Wilkinson, Irma Bezold; et al. *Museum Registration Methods.* 3rd revised ed. Washington, D.C.: American Association of Museums and Smithsonian Institution, 1979.

Written for museum personnel, but just as important for the exhibiting artist. Includes chapters on storage and care of objects, packing and shipping, insurance, preparing art exhibitions for travel, an ideal container and the travel of works of art, competitive exhibitions, and receiving centers for competitive exhibitions.

Keck, Caroline K. *Safeguarding Your Collection in Travel.* Nashville, Tennessee: American Association for State and Local History, 1970.

Well-illustrated pamphlet on how to prepare works of art for shipping.

Newman, Thelma R.; Newman, Jay Hartley; and Newman, Lee Scott. *The Frame Book: Contemporary Design With Traditional and Modern Methods and Materials.* New York: Crown Publishers, Inc., 1974.

An illustrated book composed of both an historical account of frames and a how-to-do section for mounting, matting, and framing works of art. Includes a list of sources for framing supplies, and a glossary.

United Nations Educational, Scientific and Cultural Organization. *Temporary and Travelling Exhibitions.* Paris: UNESCO, 1963.

Relates important information on how to pack, send and insure fine art; illustrated. Includes a bibliography and a sample insurance policy for fine arts coverage.

Suppliers of Products and Services

For Art and Antique Buyers and Sellers

American Society of Appraisers. *Professional Appraisal Services Directory.* Annual.

Listing of members and their specialties. Write society, P.O. Box 17265, Washington, D.C. 20041.

International Art & Antiques Yearbook: A Worldwide Dealers' and Collectors' Guide to the Art and Antiques Trade. London: National Magazine Company, Ltd. Annual

> Organized by countries. Provides names, addresses, specialties, and kinds of publications for (1) antiques and art dealers, (2) packers and shippers, and (3) auctioneers and salesrooms.

For Artists

The Artist's Handbook of Materials and Techniques. Ralph Mayer, compiler. 4th ed. revised and expanded. New York: Viking Press, 1982.

> Explains terminology; includes an annotated bibliography on materials, techniques, and conservation plus an appendix that contains tables providing a paint's name and the corresponding chemical composition, lists of weights and measurements, and a list of firms that manufacture artists' supplies.

The Frame Book: Contemporary Design With Traditional and Modern Methods and Materials. Thelma R. Newman, Jay Harley Newman, and Lee Scott Newman, editors. New York: Crown Publishers, Inc., 1974.

> An illustrated book composed of both an historical account of frames and how-to-do section for mounting, matting, and framing works of art. Includes a list of sources for framing supplies and a glossary.

Graphic Arts Encyclopedia. George A. Stevenson, compiler. New York: McGraw-Hill Book Company, 1968.

> A dictionary of terms that also contains a product index and a manufacturers' index, as well as tables of comparable sizes and weights.

MacRae's Blue Book: Materials, Equipment, Supplies, Components. Charles A. Burton, Jr., editor. Chicago: MacRae's Blue Book. 5 volumes. 1893+

> Contains a list of suppliers accompanied by their addresses and the locations of their branch offices plus a listing of trade or brand names accompanied by the firms that use those names. There is a subject index to the suppliers of various products. In 1929 *MacRae's Blue Book* superseded *Hendricks Commercial Register* which had been published since 1893. From 1929 to 1954 the title varied between these two names.

Ramsauer, Joseph F. *Directories of Fairs and Competitive Art Exhibitions.* Moline, Illinois: Black Hawk College. Revised biennially. Includes the following:

Directory of Competitive Art Exhibitions in the Midwest.

Directory of Good Quality Midwest Art Fairs.

Directory of International and National Competitive Art Exhibitions.

The Twenty Five Best Art Fairs in the Midwest, East, & Southeast.

Thomas Register of American Manufacturers and Thomas Register Catalog File. New York: Thomas Publishing Company. Annual, since 1905+

> First six volumes contain a subject index to the producers and suppliers; includes such subject categories as "Castings, Alloy," "Chairs," "Weaving Yarns," and "Printers' Rollers." Within each category records producers and their addresses. Seventh volume is an alphabetical list of all of the companies cited in the other volumes accompanied by their addresses and the locations of their branch offices. Eighth volume has a list of trademarks and special brand names accompanied by the firms that use these trade names plus an index to the subject classifications used in the first six volumes. The remainder of this multivolume reference reprints the sales catalogues of the companies that are listed in the other volumes. The last book includes an index to the advertisers.

The Thomas Register, 1905–1938: Guide to the Microfilm Collection. Woodbridge, Connecticut: Research Publications, Inc., 1982.

> Reprints of the earlier editions.

Sculpture: Tools, Materials, and Techniques. Wilbert Verhelst, compiler. Englewood Cliffs, New Jersey: Prentice-Hall, Inc., 1973.

> A well-illustrated dictionary which explains terminology, kinds of tools, and sculptural processes. Includes an annotated list of suppliers and manufacturers.

For Film and Multimedia Researchers

Audiovisual Market Place. New York: R. R. Bowker Company. First issue (1969) +

> Published erratically; provides a diverse collection of data. Lists (1) the names of producers and distributors of audiovisual materials with addresses, names of the directors, and kinds of materials produced; (2) the names of manufacturers and distributors of equipment and accessories needed by people involved with audiovisual materials; (3) United States educational television stations; (4) firms that rent audiovisual equipment and facilities; (5) audiovisual production companies; and (6) the titles of multimedia reference publications.

Catalog of Museum Publications & Media: A Directory and Index of Publications and Audiovisuals Available from United States and Canadian Institutions. 2nd ed. Detroit: Gale Research Company, 1980.

> Divided into 5 parts: the alphabetical listing of 992 institutions with information on the media they distribute and 4 indices: to titles and keywords, to subjects, to periodicals, and to geographical locations.

Educators Guide to Free Films. Randolph, Wisconsin: Educators Progress Service, Inc. First issue (1941) +

> This annual provides access to films that can be borrowed. There is a title index, a subject index, and a source and availability index that lists the names and addresses of distributing firms accompanied by the conditions under which the materials can be borrowed. The entries of the title index provide information concerning release date, performance time, name of distributor, and whether or not the film is 16 mm, sound or silent, and color or black and white.

For Interior Designers

The Old House Catalogue: 2,500 Products, Services, and Suppliers for Restoring, Decorating, and Furnishing the Period House—From Early American to 1930's Modern. Lawrence Grow, compiler. New York: Universe Books, Inc., 1976.

> A buyers' guide to material that can be used to restore America's historic homes. Divided into ten chapters covering structural products, woodwork and other fittings, hardware, fireplaces and heating, floors, lighting, fabrics, paints and papers, furniture, and accessories. Entries describe the items, provide the names and addresses of suppliers, report the availability and prices of producers' catalogues, and often reproduce illustrations of the items. Includes a selected bibliography and a list of suppliers.

See listings in Chapter 23 under "For Architects, Historic Preservation."

PART IV

Deciphering and Obtaining the Reference Material

Often a researcher has trouble locating books, periodical articles, or essays, because the references which mention them do not provide all the pertinent data. This section discusses some methods of deciphering these notations. Also included are the ways interlibrary loan request forms are verified and lists of some famous art research centers, photographic archives, and film and motion picture libraries.

Deciphering Bibliographical References and Requesting Interlibrary Loans

During the research process, the investigator frequently has trouble deciphering an abbreviated bibliographical reference or collecting enough data on a specific resource in order to be able to obtain it. Written to assist the student in learning some methods for solving these problems, this chapter is divided into two sections covering problems concerned with (a) locating books, articles, and *Festschriften* when a bibliographical entry is incomplete and (b) how to verify interlibrary loan requests.

Discovering the Titles of Books, Articles, and *Festschriften*

This section is composed of a number of specific kinds of research problems—written as if someone were posing each one—accompanied by some ways in which the queries might be solved. These include: (1) completing bibliographical data for a book, (2) discovering foreign-language books when only the publisher is known, (3) finding titles in a series, (4) discovering articles in *Festschriften*, (5) learning about changes in magazine titles, (6) locating an article when the name of the periodical is in doubt, (7) finding an article when the magazine is known, and (8) locating works published prior to 1900.

Completing Bibliographical Data for a Book

How can I find the title, publisher, and the date of John Rewald's book on Impressionism?

Often, art references do not provide either the first names of the authors or the names of the publishers of the books recorded in their bibliographies. Thus, readers are confronted with having to discover this information for themselves. The catalogues of holdings of large libraries can be used to complete bibliographical information on books and articles which may have been mentioned elsewhere. Particularly useful in completing bibliographical data are the materials published by the

U.S. Library of Congress: (1) *The National Union Catalog: Author List,* which has hardbound volumes that catalogue all of the books in the U.S. Library of Congress plus a number of other libraries from the earliest books in the records through December 1982; (2) *NUC Books,* which commenced publication on microfiche in January 1983; and (3) the two databases—*LC MARC* and *REMARC.* See Chapter 11, "National Libraries," for a more complete listing of these resource tools.

If the work was published prior to 1983, it may be located through one of the volumes of the *National Union Catalog: Author Lists.* Usually, the entries can only be found if the author or corporate entry is known. Example 24 illustrates the kinds of information provided in these catalogues. The 1961 revised and enlarged edition of Rewald's *The History of Impressionism* is listed as containing 662 pages; illustrations, part of which are in color; portraits; maps; and a bibliography that covers thirty-six pages. The height of the book as it stands on a shelf is twenty-six centimeters.

Rewald, John, 1912–
The history of impressionism. Rev. and enl. ed. New York, Museum of Modern Art ₁1961₎
662 p. illus. (part col.) ports. maps (on lining paper) 26 cm.
Bibliography: p. 608–644.
1. Impressionism (Art)
ND1265.R4 1961 759.05 61–7684
NjP MoSW GU NN KU CLSU PSt OCU CL
ViBlbV IU CU CtY OCIW N MB OU CSt
NIC OOxM MtU MiU IaU RPB InU ICU
NNMM NjR NNC MsU MH

Rewald, John, 1912–
The ordeal of Paul Cézanne. ₁Translation by Margaret H. Liebman₎ London, Phoenix House ₁1950₎
xvi, 192 p. illus. plates (part col.) ports. 26 cm.
"First published in 1936 in Paris as a Sorbonne thesis, under the title Cézanne et Zola."
Bibliography: p. 181–184.
1. Cézanne, Paul, 1839–1906. 2. Zola, Émile, 1840–1902. i. Title.
ND553.C33R42 1950 927.5 51–50992

Rewald, John, 1912–
Paul Cézanne, a biography. ₁Translation by Margaret H. Liebman₎ New York. Simon and Schuster ₁1948₎

Example 24: *Library of Congress and National Union Catalog Author Lists, 1942–1962: A Master Cumulation.* Detroit: Gale Research Company, 1969. Volume 114, page 187.

There is one subject term, "Impressionism (Art)"; the Library of Congress classification number is ND1265,R4,1961; while the Dewey decimal number is 759.05. The Library of Congress card number is 61–7684. There are abbreviations given for the thirty-one libraries which are connected with the National Union system and which own copies of the book. Except for the notation as to how many libraries in the National Union system possess a book, this information is the same data found on the Library of Congress catalogue cards.

The *NUC Books* can be used to complete a bibliographical entry for works published after 1982 when one of the following is known: (1) the name of the author, (2) the title of the work, (3) the subject, or (4) the name of any series to which the book might belong. Issued on microfiche, *NUC Books,* consists of (a) a register that provides a full entry for the work—similar to Example 24, but without the references to any libraries that own it—and (b) four indices—for authors, titles, subjects, and series—which refer the reader to the entries cited in the register. A listing of libraries which own the works is issued on separate microfiches in the *NUC Register of Additional Locations Cumulative Microform Edition,* abbreviated *RAL.* The entries to *RAL* are through the Library of Congress card number. In Example 24, this would be 61–7684. *RAL* is utilized by the Interlibrary Loan Service which is discussed later in this chapter.

The easiest method of locating bibliographical data is through (1) the *LC MARC Database* which provides access to the material in the U.S. Library of Congress from 1968 to the present for English-language books, a little later date for foreign-language ones, or (2) the *REMARC Database,* which has access to the computer tapes not in *LC MARC.* In the hardbound printed versions of the Library of Congress material, the corporate entry or author is used to locate the entry. In the microfiche version, four methods can be used—author, title, subject, or series. But in an online database search, there are numerous ways to find the entry: author, title, subject, series, named person, publisher, publication year, as well as language. However, it must be remembered that the broader the scope, the greater the number of entries that will be found, and the less likely that they will be pertinent.

If researchers cannot locate bibliographical entries for the needed reference works in the Library of Congress catalogues, they should consult the catalogues of holdings of the libraries cited under "General Art Libraries" and of the institutions whose collections reflect the same subject as the research topic and which are listed under "Specialized Libraries"; both sections are located in Chapter 11. For instance, in the Caillebotte entry in the *Thieme-Becker Künstlerlexikon,* illustrated in Example 5, all of the references to specific books were located under the name of the author in both the *Catalogue of the Harvard University of Fine Arts Library* and *The National Union Catalog: Pre-1956 Imprints,* which is a Library of Congress publication.

Discovering Foreign-Language Books

I saw an excellent series of books on French Romanesque churches. Lots of pictures and floor plans and with English summaries. Don't know the titles nor the authors, but they were published by the Zodiaque Company within the last decade or two.

Knowing the publisher, subject, and approximate date of issue, the reader has two places to begin the search for the title of a specific work or a series of books: the publishers' trade lists and the books-in-print references. The former, which are a collection of publicity brochures that various publishing firms in a particular country issue to sell their books, are alphabetized by the names of the companies and issued annually. Books-in-print references, which are also annuals, list the books available in a specific country in a particular year by titles, by authors, and sometimes by subjects. Chapter 22 describes these two types of publications as issued in the United States, England, and France.

Since Zodiaque is a French company, the French publishers' trade list, *Livres d'étrennes,* should be consulted. One of the issues has an entry under the name of the French publishing firm, Zodiaque, an entry that publicizes *Languedoc roman,* the forty-third book in the series, "La nuit des temps." Another page in *Livres d'étrennes* cites the titles and the prices of the other books in this series, but the essential data concerning the names of the authors and the years of publication are not included.

Knowing the name of the series and the titles of the individual books, the researcher can now study the French books-in-print reference, *Le catalogue de l'édition française,* a work which is published in several volumes. Looking up each title in the series of "La nuit des temps" will provide

the reader with the necessary data for purchasing the book or obtaining it through an interlibrary loan. Another method of discovering the titles in this French series on Romanesque art would be for the reader to check the subject volumes of *Le catalogue de l'édition française* or the catalogues of holdings of the art libraries, which often provide a listing of individual titles under a series name. For an online database search, see the next section.

Finding Titles in a Series

I need to locate the titles in the Style and Civilization Series.

Although a few librarians include a list of the individual titles published within a series under the name of the series—for instance, *the Pelican History of Art* or *Art in Context*—in the library's catalogue system, many do not. Discovering these books is simpler, if all the titles are similar, such as in the *Time-Life Library of Art Series* which all begin *The World of.* Unfortunately, the titles usually differ. For this reason individual titles of numerous works have been included in this book.

Chamberlin's *Guide to Art Reference Books,* 1959 and Arntzen and Rainwater's *Guide to the Literature of Art History,* 1980, both annotated in Chapter 13, have sections on books published in series. Neither work tries to list all of the titles in each series, but provides examples. These references report some of the essential facts needed for an online database search to find the material. Both books are especially valuable for information on foreign publications. Other resources that can sometimes be helpful are *Titles in Series,* which is cited in Chapter 22, and *Library of Congress Monographic Series,* which since January 1983 is included in *NUC Books.*

The steps used in the section on "Discovering Foreign-Language Books," which was discussed earlier, can be used to find a book in series. But the easiest method is through an online search of the computer files of the LC MARC tapes or RE-MARC. As explained in Chapter 2, the Library of Congress MARC tapes are available through OCLC, RLIN, and DIALOG. In a search of LC MARC through DIALOG for se=style and se=civilization, in which *se* meant series, the answer was ten. Interestingly, eight of the works were issued by Penguin Press of Harmondsworth, England between 1967 and 1975. Two were published in 1977 and 1979 by A. Lane of England.

Not all of the titles in the series were discovered, because some of the works were published before the computer files were compiled for LC MARC tapes. An online search of *REMARC,* a database available through DIALOG, brought forth the additional works.

Discovering Articles in *Festschriften*

I need to locate three works: (1) a collection of essays honoring Henri Focillon between 1945 and 1950, (2) the article written by P. O. Kristeller in a collection of essays which was published in 1971 or 1972, and (3) the Kristeller *Festschrift* of about 1979.

For an essay published in a work honoring Focillon, one of the works annotated under "References for Locating *Festschriften,*" in Chapter 22, might be consulted. Leistner's book cites under "Focillon, Henri," *"Mélanges Henri F*–N.Y. 1949 430 S Portr. (=Gazette des Beaux-Arts* 6 Ser., vol. 26, 86th year 1944)." This translates that a book entitled *Mélanges Henri Focillon* was published in New York in 1949, which was a reprint of the material first issued in the magazine, *Gazette des Beaux-Arts,* sixth series, volume twenty-six in 1944. Rave's book provides the same information with the added data that Wildenstein was the publisher of the book and a listing of the names of the twenty-two people who contributed to this collection of essays. Unfortunately, no titles for the articles are reported.

Usually the quickest way to find a *Festschrift* is through a computer search of the online databases of *LC MARC* or *REMARC* through DIALOG, depending upon the date of publication of the needed book. This database search process is detailed in Chapter 4. Some citations of the databases include the table of contents for books of collected essays. If this is the case, a free-text search will often discover the needed material. Example 25 illustrates the method used for answering the second question—an article written by P. O. Kristeller for a book published in 1971 or 1972. First the command of expand was given for *NA= Kristeller,* where NA indicates a named person. The asterisk at E3 indicates the command. The name is expanded for the ones preceding and following it. The number reports how many citations there are in the database for this person. *Kristeller, Paul Oskar* had three entries. In the Boolean statement—*Kristeller AND PY=1971:PY=1972*—the PY means *year.* In the

```
'? 'E 'NA=KRISTELLER'
Ref Items   Index-term
E1      2   NA=KRISHNARAJA WADIYAR
E2      1   NA=KRISHNASWAMI NAYUDU,
            W. S
E3          *NA=KRISTELLER
E4      3   NA=KRISTELLER, PAUL
            OSKAR
E5      1   NA=KRISTENSEN, THORKIL
E6      5   NA=KRISTENSEN, TOM
E7      1   NA=KRISTENSSON, FOLKE
E8      2   NA=KRISTEVA, JULIA
E9      1   NA=KRISTIAN
E10     1   NA=KRISTIANSSON FAMILY
                                        -more-
? SS KRISTELLER AND PY=1971:PY=1972
            3     10 KRISTELLER
          4163176 PY=1971:PY=1972
            5      1  3 AND 4

? T5/5
5/5/1
0080512   LCCN: 73021725
   Natl. Bibliography No.: C***
   Florilegium historiale; essays presented to Wallace K.  Ferguson Editors:
J. G. Rowe [and] W. H. Stockdale
   Ferguson, Wallace Klippert,,1902-; Rowe, John Gordon,,ed.; Stockdale,  W.
H.,,ed.
   [Toronto]  University  of  Toronto  Press  [1971]   xiii,  401 p.   illus.,
facsims., port.  26 cm.
   Publication Date(s): 1971
   Price: $16.50
   Place of Publication: Ontario
   ISBN: 0802016995
   LC Call No.: CB361.F56  Dewey Call No.: 914/.03/21
   Languages: English
   Document Type: Monograph
   Includes bibliographical references.
   Contents Note:  Wallace K.  Ferguson.--The  Italian  view  of  Renaissance
Italy,   by   D.   Hay.--Petrarch:   his  inner  struggles  and  the  humanistic
discovery of man's nature,  by H.  Baron.--A  little-known  letter  of  Erasmus
and the date of his encounter with Reuchlin, by P. O. Kristeller.--De modis
disputandi:  the apologetic works of Erasmus,  by M.  P.  Gilmore.--Jacques
Lefevre d'Etaples and the medieval Christian mystics, by E.  F.  Rice.--'By
little and little': the early Tudor humanists on the development of man, by
A. B. Ferguson.--Atropos-Mors: observations on a rare early humanist image,
by  M.  Meiss.--A  music  book  for  Anne  Boleyn,  by  E.  E.  Lowinsky.--The
enlargement  of  the  great  council  of  Venice,   by   F.   C.   Lane.--Biondo,
Sabellico,   and  the  beginnings  of  Venetian  official  historiography,   by  F.
Gilbert.--An  essay  on  the  quest  for  identity  in  the  early  Italian
Renaissance, by M.  B.  Becker.--Notes on the word stato in Florence before
Machiavelli, by N. Rubinstein.--Bonds,  coercion,  and fear:  Henry VII and
the peerage, by J. R. Lander.--Incitement to violence? by J. R.  Hale.--The
principal writings of Wallace K. Ferguson (p. 400-401)
   Descriptors: Renaissance-Addresses, essays, lectures
```

Example 25: *LC MARC Database* from DIALOG Information Services, Inc.

LC MARC Database there were ten citations for Kristeller and 163,176 for *PY=1971:PY=1972*. When sets 3 and 4 were combined, there was one citation. When this entry was typed, the article by P. O. Kristeller appeared in the table of contents.

Notice that although this was a collection of essays presented to Wallace K. Ferguson, there is no named person cited. The Library of Congress librarians have not always added this type of entry.

The last question can be answered by *RILA: International Repertory of Literature of Art,* which began in 1975. This abstract service provides access to *Festschriften* under the honored persons' names. Under "General Works: Collected Works," the 1979 issue has an entry for the "Kristeller *Festschrift.*" As Example 26 illustrates, reported are the title—*Cultural Aspects of the Italian Renaissance: Essays in Honor of Paul Oskar Kristeller,* the editor—Cecil Holdsworth Clough, bibliographical data, and a complete listing of titles and authors of all twenty-seven essays. The numbers in parentheses refer to separate entries on any individual articles which are cited in the abstract section of that volume of *RILA.* If the honored person had not been known, but the essay by Nicolai Rubinstein had been needed, it could have been located under the abstract entry, because there is a separate citation for this work. Remember, this is not true for all essays in the collected work. If the *Festschrift* is reviewed, *RILA* will report this in the following entry. Another method of finding the Kristeller *Festschrift* would be through a search of the *LC MARC Database.*

4320 [KRISTELLER FESTSCHRIFT] CLOUGH, Cecil Holdsworth, ed. Cultural aspects of the Italian Renaissance: essays in honour of Paul Oskar Kristeller. Manchester: Manchester University Press; New York: A.F. Zambelli, 1976. *Illus., index,* 0-7190-0617-1;0-9600860-1-3.
27 essays in honor of the American historian. Titles, authors, and RILA numbers for those articles with abstracts are as follows: Study of the Renaissance manuscripts of classical authors, by A.H. MCDONALD; Capranica before 1337: Petrarch as topographer, by Anthony LUTTRELL; Boccaccio and Lovato Lovati, by John LARNER; The cult of Antiquity: letters and letter collections, by Cecil H. CLOUGH; Studium Urbis and *gabella studii:* the University of Rome in the fifteenth century, by D.S. CHAMBERS; Ludovico da Pirano's memory treatise, by Frances A. YATES; Antonio Beccadelli: a humanist in government, by A.F.C. RYDER; The library of Cardinal Domenico Capranica, by A.V. ANTONOVICS; The library of Francesco Sassetti (1421-90), by Albinia de la MARE; Some notes on a fifteenth-century *condottiere* and his library: Count Antonio da Marsciano, by M.E. MALLETT; Michelozzo and Niccolò Michelozzi in Chios, 1466-67, by Nicolai RUBINSTEIN (5719); The 'Trattato d'abaco' of Piero della Francesca, by S.A. JAYAWARDENE; An unstudied fifteenth-century Latin translation of Sextus Empiricus by Giovanni Lorenzi (Vat. Lat. 2990), by Charles B. SCHMITT; Poliziano's horoscope, by Philip MCNAIR; The Deputati del denaro in the government of Ludovico Sforza, by D.M. BUENO DE MESQUITA; Bartolomeo Zamberti's funeral oration for the humanist encyclopaedist Giorgio Valla, by Paul Lawrence ROSE; 'Ogni dipintore dipinge se': a Neoplatonic echo in Leonardo's art theory', by Martin KEMP (5673); 'Lo insaciable desiderio nostro de cose antique': new documents for Isabella d'Este's collection of antiquities, by C. Malcolm BROWN (5032); Some notes on music in Castiglione's *Il libro del cortegiano,* by Walter H. KEMP; Whose New Courtier?, by Dennis E. RHODES; Aristo's continuation of the *Orlando innamorato,* by C.P. BRAND; Renaissance Latin poetry: some sixteenth-century Latin anthologies, by John SPARROW; Paolo Giovo and the evolution of Renaissance art criticism, by T.C. Price ZIMMERMANN (5069); Dominique Phinot, a Franco-Netherlander composer of the mid-sixteenth century, by Roger JACOB; The military education of the officer class in early modern Europe, by J.R. HALE; Manuscripts of Italian provenance in the Harleian collection in the British Museum, by C.E. WRIGHT; Manuscripts captured at Vitoria, by Anthony HOBSON.

Example 26: *RILA: International Repertory of the Literature of Art,* A Bibliographic Service of The J. Paul Getty Trust, Editorial Office at Sterling & Francine Clark Art Institute, Williamstown, Massachusetts, Volume V, 1979, page 380.

Although the citation was easily found by searching *Kristeller, Paul Oskar/NA,* the computer entry was not as complete as the one in *RILA.* All of the bibliographical data was included, but there was no listing of the individual essays contained in the book.

Changes in Magazine Titles

Revue des Arts, Revue de l'Art—are these two different magazines or the same one?

This kind of problem is very common, since periodical literature is always in a state of flux. Magazines are notorious for their instability, often changing titles and volume numbers. However, there are several references that might help the researcher sort out the tangle of titles that some periodicals have developed. These are William Katz's *Magazines for Libraries,* Mary Chamberlin's *Guide to Art Reference Books,* Arntzen and Rainwater's *Guide to the Literature of Art History,* and the third edition of the *Union List of Serials* accompanied by the volumes that supplement this reference, *New Serial Titles.* All of these works are annotated in Chapter 22.

Several of the previously mentioned books will have to be studied in order for the reader to find the many name changes of a periodical. The investigator should take special care to notice the date of the first issue of the publication and the name of the publishing company. For instance, the second edition of Katz's book lists *Revue de l'Art* as being published since 1968 by Librairie E. Flammarion. There is no reference to *Revue des Arts.* Chamberlin's book states that *La Revue des Arts* had been published by Conseil des Musées Nationaux since 1951 and that it superseded *Musées de France.* There is no entry for *Revue de l'Art,* since Chamberlin's guide was published in 1959. If the *New Serial Titles 1950–1970* had been consulted, the reader would have found an entry for each magazine. *Revue de l'Art* is cited as being issued in 1968 by Flammarion. *Revue des Arts* is listed as having been published by the Conseil des Musées Nationaux since 1951. The entry has the additional notation that *Revue des Arts* superseded *Musées de France.*

The best information was located in Arntzen and Rainwater's reference, which has annotated citations for both magazines. The report for *La Revue des arts* includes (1) that it was published quarterly from 1951–60 by the Conseil des Musées Nationaux, (2) that it replaced *Musées de*

France, and (3) that it is now continued under the title, *La Revue du Louvre et des musées de France.* Recorded for *Revue de l'art* are the facts that it has been issued quarterly since 1968, that the publisher has varied, and that there are English summaries. Both entries provide data on the types of articles and the services that index or abstract material from these periodicals.

Unsure of the Magazine, How to Find the Article

There is an article on the art of Odilon Redon that is terrific! It appeared in the magazine published during the 1950s by the Louvre Museum. You must find it for your research.

To answer this specific problem concerned with finding a particular magazine article, the researcher needs to (1) discover the names of any magazines published in the 1950s by the Musée National du Louvre, (2) find which indices of periodical literature covered this magazine during the 1950s, and (3) check the various volumes of these indices for articles on Odilon Redon which were published in the magazine. The first part of the research can best be accomplished by checking some of the books that report various data concerning magazines and serials. Annotated in Chapter 22, four important publications that provide lists of magazines by subject are *New Serial Titles 1950–1970 Subject Guide,* William Katz's *Magazines for Libraries, Ulrich's International Periodicals Directory,* and Arntzen and Rainwater's *Guide to the Literature of Art History.* These books record current serial titles and report for each the name of the publishing firm plus other pertinent data. Since publication of the desired magazine may have been suspended or have ceased, the reader may need to scrutinize previous editions of these three books, if a reference cannot be found in the current publications.

All of the previously mentioned books have only one reference that will fit the description stated in the problem: *Revue du Louvre et des Musées de France.* A listing for this publication is given in the second volume of *New Serials Titles 1950–1970 Subject Guide* under the category, "Galleries, Museums, France." The entry states that the magazine superseded *Musée de France* and that the title for volumes 1–10, 1951–60, was *Revue des Arts.* The *New Serials Titles 1950–1970 Subject Guide* does not include information as to which indices of periodical literature

index articles in specific magazines. Researchers will need to check other reference works to discover such data.

An entry for *Revue du Louvre et des Musées de France* is included in the supplement to the second edition of Katz's *Magazines for Libraries* under the category, "Museums and Art Galleries." The reference states that the publisher is the Conseil des Musées Nationaux, 10 rue l'Abbaye, Paris; that in each issue there are usually six-to-seven articles, numerous black-and-white illustrations, and a list of recent museum acquisitions; that there is an annual subscription rate of $10; and that the articles are indexed in *Art Index.*

The thirteenth edition of *Ulrich's International Periodicals Directory* has an entry, under "Art, General," that is very similar to the entry in Katz's book. Arntzen and Rainwater's book reports similar data to the other references, but the number of abstracting and indexing services covering the material is more comprehensive. *Art Index, ARTbibliographies MODERN,* and *Répertoire d'art et d'archéologie* are all cited.

The problem of finding a particular article on Odilon Redon was partially solved through the discovery of the title of the magazine, *Revue du Louvre et des Musées de France,* which probably contains the article and of the name of the services, such as *Art Index,* that cover the articles in this French magazine. The researcher should then consult *Art Index* in order to ascertain exactly which issue of *Revue du Louvre et des Musées de France* published the article. In view of the fact that the person, who told the researcher about the article may have erred as to the exact date of the desired article on Redon, a few years on either side of the approximate publication date should be checked. The magazine will be entitled *Musée de France* before 1951, *Revue des Arts* from 1951 to 1960, and *Revue du Louvre et des Musées de France* after 1960.

Once the correct bibliographical entry for the article is obtained, the reader must locate the periodical so that the article can be read. Most libraries have a card file or computer print-out sheets that indicate their serial holdings. If the library does not possess the necessary magazine, the researcher will need to consult a local union list of periodicals, if one is available, to determine which institutions in the immediate region might have the desired magazine. If the particular magazine that contains the article is not in the area,

the reader can sometimes obtain a photocopy of the article, for a fee, through interlibrary loan service, which is detailed later in this chapter. Remember that an online database search can be conducted for some articles, but only the ones which are recent enough to be included in the computer files that are available.

Knowing the Magazine, How to Find the Article

There was an article on patriotism in the nineteenth century published in *Art Bulletin* around 1976. How can I find it?

An online database search can sometimes be used to find a specific magazine article when neither the title nor the author is known. Utilizing the *ARTbibliographies MODERN Database* of DIALOG which covers *Art Bulletin,* a command was typed for a combined search of Patriotism AND JN=Art Bulletin in which *JN* stands for journal. The answer produced only one entry: "Painting and Politics: J.–L. David's Patriotism or the Conspiracy of Gracchus Babeuf and the Legacy of Topino-Lebrun," by J. H. Rubin, *Art Bulletin,* 58 (December 1976): 547–68. Not only did the computer reveal that there were twelve illustrations and a bibliography but it provided a more than seventy word abstract. If the printed volumes of *ARTbibliographies MODERN* had been searched, with as little data as the researcher knew, the article would not have been found. There was no subject indexing under the word patriotism, its synonyms or derivatives. If the reader did not know the exact serial, but thought it was an art history magazine, such as *Art Journal* or *Art Bulletin,* an online database search might still discover the desired work. In a request for a free-text search of *ARTbibliographies MODERN Database* for Patriotism AND PY=1974:PY=1978, in which the latter designation refers to magazines published between 1974 and 1978, the computer reported twenty-eight articles that referred to patriotism, 37,063 articles published between 1974 and 1978, but only seventeen articles which had both qualifications. When all of the abstracts for the articles were printed, one was the Rubin article in *Art Bulletin.*

Locating Books and Periodicals Published Prior to 1900

All of the abbreviated references on Caillebotte cited in the *Thieme-Becker Künstlerlexikon* were published in the nineteenth century. How can I complete the bibliographical entries and locate the reference works?

For data on nineteenth-century books and multivolume references when the surname of the author is known, the researcher should consult some of the works annotated in Chapter 11, "Catalogues of Holdings of Famous Libraries." By checking the library catalogues recorded in that chapter, the investigator may be able to find a bibliographical entry for the needed material under the author's name. If the book is cited in one of these catalogues, the problem of locating the work is also solved. The reader should also consult the following:

1. *The National Union List of Pre-1956 Imprints,* an author catalogue of books published before 1956 compiled retrospectively by the Library of Congress staff. The catalogue includes more than thirteen million entries in 754 volumes. Moreover, the participating libraries which own the references are reported.

2. The catalogues of the large art libraries, such as the *Catalogue of the Harvard University of Fine Arts Library, the Fogg Art Museum,* which is the catalogue of the holdings of one of the world's largest university art libraries, and the *Library Catalog of the Metropolitan Museum of Art,* which is the catalogue of the holdings of one of the largest art museum libraries in the world.

3. The catalogues of holdings of the libraries that have the same specialization as the research topic. For instance, for architectural problems, the reader should consult the catalogues of the Avery Architectural Library of Columbia University, New York City and of the British Architectural Library of the Royal Institute of British Architects, London.

Locating and completing the bibliographical entries for articles written in periodicals published prior to 1900 is a more difficult problem to solve, because often the references are abbreviated and difficult to decipher. For instance, there are four articles reported in the Caillebotte entry in the *Thieme-Becker Künstlerlexikon:* (1) Ch. Ephrussi, *Gaz. d. B.-Arts,* 1880; (2) *Le Temps,* v. 3, 1894; (3) *Chron. des Arts,* 1894; and (4) J. Bernac, *The Art Journ.,* 1895. Since the Thieme-Becker dictionary does not provide a list of the abbreviations used in the references, the reader who does not recognize these periodicals must first

complete the titles. Sometimes this kind of information can be found by checking the list of abbreviations used in some of the indices of periodical literature which are annotated in Chapter 12, especially the indices that either cover nineteenth-century publications or have indexed material over a long time span. For instance, if the researcher checked the first volume of *Art Index,* an entry would be found in the "Abbreviations of Publications Indexed" for *Chron, Egypte.* And although the researcher would know that this was not the correct publication, the problem of what *Chron.* represents may be solved, since the entry relates that *Chron.* stands for *Chronique.* Consequently, the reader will probably find one of the Caillebotte references in a magazine entitled *Chronique des arts.* The first volume of *Art Index* also has a listing for *Gaz. Beaux-Arts* which represents the French magazine, *Gazette des Beaux-Arts.*

Armed with the probable titles of the four magazines—*Gazette des Beaux-Arts, Le Temps, Chronique des arts,* and *The Art Journal,* the reader should consult the library's catalogue system or computer print-out sheets, available at most institutions, which indicate the library's serial holdings. If the library does not possess the necessary magazine—and relatively few institutions will have extensive holdings of nineteenth-century publications—the reader will need to consult a union list of periodicals to verify the title of the magazine and to locate a library which has the particular volume required. Most libraries have copies of the *Art Journal,* and the computer print-out sheet will indicate that the presently published *Art Journal* has had that title since 1960, that previous to that date it was entitled *College Art Journal,* and that the first volume was issued in 1942. Obviously, the reference in the *Thieme-Becker Künstlerlexikon* must be to a different magazine than the *Art Journal* which is presently being published.

The union lists of serials annotated in Chapter 22 usually provide some indication as to the history of a periodical as well as reporting which of the participating libraries own the various volumes of a serial. If the researcher consulted the various volumes of the third edition of the *Union List of Serials,* the following information would be found:

1. *Gazette des Beaux-Arts* has been published in Paris since 1859.

2. Eleven entries for various periodicals beginning with *Temps;* none of these entries is for a periodical which was publishing in 1894.
3. *Chronique des arts et de la curiosité* was published in Paris from 1859 through 1922 before publication ceased. The entry reports that this magazine was a supplement to *Gazette des Beaux-Arts.*
4. *The Art Journal* was published in London from 1839 through February 1912 before publication ceased.

In order to find information on *Le Temps,* the reader might also check for an entry under this title in Mary Chamberlin's list of magazines recorded in her *Guide to Art Reference Books* and in the union lists of periodicals compiled for foreign libraries. Chamberlin does not include this periodical; and since *Le Temps* is probably a French publication, the compilation of the Bibliothèque Nationale might be perused. *Catalogue collectif des périodiques du début du XVIIᵉ siècle à 1939* lists eighteen publications beginning with the word *Temps,* which is the French word for *time.* Moreover, there is an entry for a serial *Le Temps* which began publication in 1860. Because this periodical was recorded in a union list of serials owned by French libraries, locating a copy of *Le Temps* might be exceedingly difficult and might only be accomplished by a European trip.

Interlibrary Loan Service

Most large libraries have facilities for obtaining interlibrary loans—a process defined in Chapter 2—in which a book or a photocopy of an article is sent to the reader's institution. In order to set this process in motion, the investigator must complete a form similar to the one illustrated in Example 27. Example 28 is the reverse side of this request form which is used at North Texas State University. For an article, needed are the journal title; the volume, number, and date of the magazine; the source of the information—meaning in what reference was it cited, such as *Art Index;* plus the author and title of the article. For a book, the data required are author; series, if applicable; title; publication place and date; and name of publisher. On the back of the form, Example 28, is a list of some of the references which can be used for verification. In many institutions, loans for both articles and books must be verified. But recently, some librarians will accept a database printout for

identification, since this computer sheet provides such important data as the ISBN number. Inquire from the Interlibrary Loan Librarian as to what kind of verification is accepted.

The same process which was explained in the first section of this chapter on completing bibliographical data is used for verifying references. The best verification tools are the Library of Congress catalogues, which include most American publications plus many foreign ones. If the needed material is not listed in the many Library of Congress publications, one of the other catalogues of holdings of famous libraries can be examined. Obviously, highly specialized works are more likely to be located in libraries that reflect the same specialization as the works themselves. All of these references are described in Chapter 11.

Once a citation for the book or article is located, the researcher must verify the needed item. This means that the entry which the reader has written on the interlibrary loan form must correspond exactly with the entry listed in the verification reference. In addition, the interlibrary loan form will usually request the title of the catalogue which was consulted, plus the edition, volume, and page where the pertinent bibliographical information was found.

Some interlibrary loan forms also request the author, title, publishing firm, and the date of publication of the source from which the researcher learned of the material being sought. If the work is verified by one of the previously mentioned references, the source of the material usually does not have to be cited. Nevertheless, it is best for the reader to have the information available in the event that it is necessary. For in cases where a verification is difficult to locate, the source of the material becomes important.

There are several ways the researcher can assist the interlibrary loan service in finding the needed material. Providing the full name of the author is a necessity, as large libraries may have extensive holdings under certain surnames, such as "Jones, L." Moreover, abbreviated names or titles and incomplete bibliographical data can either cause delays in finding the needed material or result in an unsuccessful search. Some libraries, in answering requests, send photocopies of any work which consists of only a few pages. This method is cheaper and safer than sending the book or pamphlet itself. Under those circumstances, the lender is usually billed for such copy work.

During the research on Gustave Caillebotte, which has been used as an example throughout this book, a reference was found to an exhibition catalogue published in 1970 by Wildenstein and Company. The source of the citation was *ARTbibliographies MODERN,* Volume 3, 1971, page 135. The actual interlibrary loan request for the exhibition catalogue is duplicated in Example 27. The information was verified by the *Library of Congress National Union Catalog 1968–72,* where the entry was listed under Wildenstein and Company. The catalogue was found at the University of Texas at Arlington and borrowed for a period of three weeks. This notation was included in the working bibliography, as shown in Example 17, in case the book needed to be reexamined. Some works are not accessible through interlibrary loans. For example, *Gustave Caillebotte (1848–1894),* written by Marie Berhaut was located at both Harvard University and the New York Public Library. The former has a service charge per loan; the latter does not usually participate in them.

Periodical articles can be photocopied and sent to the researcher's library. It is especially important to include the exact page numbers of the article. Mistakes can be costly, since the article will be photocopied and charged to the reader. The interlibrary form requesting a photocopy of an article will also require the name of the source from which the reader learned of the material and a verification citation. The source of the material is often one of the indices of periodical literature or one of the catalogues of periodical articles owned by a large library. The verification citation, in this case, is not a verification of the article, but of the title of the periodical. This is usually easily accomplished by the researcher's checking the *Union List of Serials* or the *New Serial Titles,* both of which are annotated in Chapter 22. These multivolume works have entries for various magazines. Each entry provides such information as the first publication date, any changes in titles or suspensions of publication, and a list of libraries which have these periodicals.

The *Index to Art Periodicals,* reproduced in Example 29, cites an article by Marie Berhaut in *Musées de France.* The name of the magazine, *Musées de France,* was verified by the *Union List of Serials,* shown in Example 30, which relates that the French magazine was published in Paris between 1948 and 1950, that before that date it was called *Bulletin des musées de France,* and that

PHOTOCOPY of article

Last Usable Date:	Name (print here; sign at bottom):
MARCH, 1984	Student, Sally

Journal or Newspaper (full title):

Vol.:	No.:	Date:	Pages:	Source of your information:

Author(s) of article:	Title of article:

LOAN of book, thesis, dissertation, document, or music

Author(s): _Wildenstein + Company_ Series (if applicable):

Title: _One Hundred Years of Impressionism; A Tribute to Durand-Ruel_

Place of publication:	Publisher:	Copyright Date:
NYC	Wildenstein & Co.	1970

VERIFICATION - Sources listed on back

NUC 1968-72, Volume 101, p.631

FOR LIBRARY USE

☐ CCG NTSU: ☐ owns
☐ CCL ☐ lacks
 ☐ missing

Requested: Contacted –
Received: Phone:
Due: Ph. message:
Charges: Mail:
Paid: With others:
Completed: Phcopy sent:

STATUS - Check one

☐ NTSU Faculty ☐ NTSU Staff

☒ NTSU Graduate Student, currently enrolled

☐ Unenrolled NTSU Grad. Student-CC#:_____

course: instructor:

☐ NTSU U-grad:

NTSU ID no.:	Major/Dept.:	Phone:
452-49-340	ART	

Mailing address:
5726 Dillard Road
Denton, Texas 76202

Maximum cost willing to pay for loan or photocopy: $0 (\$5) $8 $10 $___ post.

Account Number:	Grant Number:

OCLC#_____
BIP_____
 ISBN_____
NUC_____

 LCCN_____
IUC_____
Ulrich's_____
 ISSN_____
TL_____
ULS_____
NST_____

CODEN_____

▶ ▶ ▶ Signature _Sally Student_

(Form 98-5/81)

Example 27: The Interlibrary Loan Request Form, North Texas State University Libraries.

VERIFICATION

Find the item that you need listed in any one of these sources. Copy the source, volume, and page number in the space marked "Verification."

SOURCES	CALL #	EXAMPLES OF CITATIONS
OCLC computer		OCLC 1914302
Journals		
AHE printout		AHE p. 387
Ulrich's Periodical Directory	Z6941 .U5	Ulrich's 77-78 p. 459 ISSN 0020-7721
Texas List	Z7403 .T4	TL 1974 p. 24
Union List of Serials	Z6945 .U45 1965	ULS v. I p. 74
New Serial Titles	Z6945 .N44	NST 71-75 v. 2 p. 1858
Chem. Abs. Ser. Source Index	Science Lib.	CASSI 1979 p. 27
Books		
Books in Print	Z1215 .P972	BIP 1976 v. 2 p. 2455 ISBN 0-8371-8887-3
National Union Catalog pre-56	Z1215 .U51	NUC pre-56 v. 132 p. 53
National Union Catalog	Z1215 .U522	NUC 1968-72 v. 33 p. 2
Dissertations		
Dissertation Abstracts Int.	Z5055 .U5A53	DAI v. 38/11B p. 5127
Theses		
Source of your information, incl. page no.		American Home Economics Assn. Titles of Diss. & Theses 1970-71 p. 31
U.S. Documents		
Monthly Catalog	3rd floor	M Cat, Sep 77 p. 407 77-11869
Newspapers		
Union List of Newspapers in Ft Worth-Dallas	Z6945 .U54	Newspapers in FW-D p. 41
Newspapers in Microform-U.S.	Micro-forms	NIM U.S. p. 156
Newspapers in Microform - Foreign	Z6945 .U515	NIM For. p. 66

POLICIES

Who may borrow?

Interlibrary loan at NTSU is a service provided in support of GRADUATE LEVEL RESEARCH.

Limited service may be provided for an undergraduate who has extensively searched NTSU Libraries without finding adequate materials.

Any student, faculty or staff member with an NTSU ID card can check out books at the TWU Library. Denton Public Library provides interlibrary loan services for Denton residents.

When will material arrive?

It usually takes anywhere from 3 days to 3 months, more or less, for material to be located and obtained. An item readily available in the local area ordinarily will arrive sooner than one not available in Texas.

Requests with the Last Usable Date indicated will be given high priority (the sooner the date, the higher the priority). If that date arrives and the request has not yet been filled, the request will be placed in the Closed File. If you wish the request to be re-activated, you should contact us.

If "Last Usable Date" is not applicable, write Open in that space. These requests will be processed as efficiently as circumstances permit. All possible means of locating the item will be pursued until it arrives or until we notify you of its unavailability.

How much will it cost?

If there is a charge, the fee is determined by the library supplying the material.

Example 28: The Interlibrary Loan Request Form, North Texas State University Libraries.

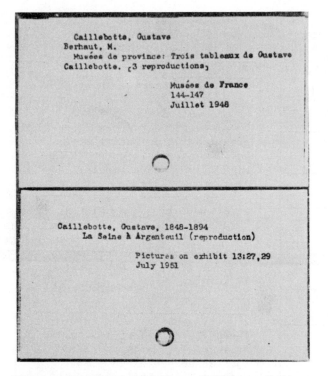

Example 29: The Art Institute of Chicago. *Index to Art Periodicals Compiled in Ryerson Library, The Art Institute of Chicago.* Boston: G. K. Hall & Company, 1962. Volume 2, page 1280.

MUSÉES de France. Paris. 1-12,1929-47; 1948-50‖

① 1-12,1929-47 as Bulletin des musées de France. Suspended between D 1938 and Mr 1946. Superseded by Revue des arts

Supersedes Musées de France?

DLC	NN [2]-10
ICR	NNC 2-10
ICU 1-8	NNFr
MBMu 9-10	NhD
MH	OCA 9-10
MiD-A 9[10]	

CU 11-12	MWM 9-12; 1948-50
CaV 1950	
CtY [1948]-50	MWelC 1947[48]
DLC 1-[11]12; 1948-50	MdBA 1946-50
	NBB [1947]48-50
ICR	NN [2]-12; 1948-50
ICU	NNC 2-12; 1948-50
IEN 1946-50	NNCoo [1947]-50
IU 1949-50	NNFr
IaU [1949]	NNMM 1948-50
MBMu	OClMA
MH	WaU

Example 30: Material from *Union List of Serials in Libraries of the United States and Canada* is reproduced by permission of The H. W. Wilson Company.

it was superseded by *Revue des arts.* Furthermore, the *Union List of Serials* related that a number of libraries owned this particular periodical, one being IEN: Illinois, Evanston, Northwestern University. The librarians at Northwestern kindly photocopied the article for a small charge. The meaning of the abbreviations, such as IEN, is located at the beginning of each volume of the *Union List of Serials.*

When using the interlibrary loan service, it is important for the reader to realize that some works are difficult, if not impossible to verify, locate, and borrow. This is especially true of Russian and Eastern European works, proceedings of conferences, and masters' theses. Many libraries will not lend periodicals or dissertations, as the former are available through photocopies and the latter through University Microfilms. Other works that usually cannot be borrowed include rare books or those issued prior to the nineteenth century; multivolume reference works, encyclopedias, and dictionaries; plus books which have just recently been published. The United States Copyright Law, which became effective January 1, 1978, has a number of stipulations concerning the photocopying of periodical articles which were published less than five years from the requesting date. The interlibrary loan librarian will have guidelines for the researcher to follow. Although not all items can be obtained through the interlibrary loan service, the large percentage that can will represent a tremendous saving over the time, expense, and worry often involved in one's having to travel to a particular library to use a certain reference work.

Famous Libraries and Research Centers of Europe and North America

After the resources of the public, the university, and the art museum libraries plus the capabilities of the interlibrary loan service have been exhausted, the reader may need to study some specific material in a faraway institution that does not circulate its holdings. Before embarking upon these distant trips, researchers should know exactly what items are needed, whether or not the material is at the specific institution, and if the entrance requirements can be met. If the library has published a catalogue of its collection, this should be consulted prior to the trip.

The location directories, annotated in Chapter 22 of this guide, will provide important information concerning libraries: the names of directors or librarians, addresses, telephone numbers, admission policies, and opening hours. Since the research centers are subject to change, readers should write the individual institutions prior to their visits to obtain the most current information.

This chapter is divided into four parts: (1) a discussion of the entrance requirements, that some libraries have, of which readers should be aware and for which they should be prepared, (2) a list of some large art research centers, (3) a list of some photographic archives, and (4) a list of film and motion picture libraries. The last three categories are subdivided as to the locations of the institutions: in Europe or in North America. All of the entries are alphabetized under the state, province, or country, followed by the city, where the research center is located.

Entrance Requirements

In some libraries, a Reader's Ticket must be obtained, if any extended use of the facilities is planned. In order to use London's National Art Library at the Victoria and Albert Museum, an applicant must write a letter stating the following: name, address, academic or professional status, dates of the contemplated visit, subject of the data to be collected, and reasons for requesting a Reader's Ticket. One of the requirements for using the library is that the research material is not obtainable elsewhere. The application must be accompanied by a letter of recommendation from a person of recognized position, such as the chairperson of a university art department. This letter should state how long the applicant has been known and whether the applicant is trustworthy and responsible.

In order to provide research materials that would reflect the art collection, art museum libraries were created for the use of the personnel. As a courtesy, many of these facilities have been extended to others. Due to the problems of space, some librarians have had to curtail the number of persons using the facilities. Often the library facilities are limited to graduate students, researchers, and scholars. In order to use the library, a reservation by letter or phone is sometimes required; proper identification may be requested. A letter, as far in advance as possible, stating exactly the materials wished and on what day the researcher will arrive, saves immeasurable time.

Most large libraries have the closed-shelf system. This makes it necessary for readers to know exactly what books or articles they need. If one has been published, the catalogue of holdings of the library should be scrutinized by the researcher in order to ascertain whether or not the specific work is in that particular library. Moreover, these catalogues, which are annotated in Chapter 11, usually provide the call numbers of the works.

Some large libraries use an identification system of numbering the furniture that readers use. Each chair or desk in the reading room has a different number attached to it. Once a researcher has been admitted to the reading room and has been seated at a particular place, the number attached to the desk or to the desk chair is considered to be the researcher's number. After the desired references have been checked in the card catalogue file for the call numbers, the researcher must fill out a request slip for each item and must present these slips to the Issue or Call Desk. There

may be a place on the request form for the researcher's desk or chair number. This designation allows the librarian, who may bring the books to the reader at the desk, to know exactly at which place in the reading room each book is located. At some institutions, there is a limit to the number of books which can be requested at any one time. If a researcher is to work at the library for any period of time, there is often a place where materials can be stored so that the books do not have to be requested again. Most institutions have some kind of photocopy service. The charge may be high. In some libraries, a request must be made in writing for this service, which may take two to three days for the photocopying.

Art Research Centers

In the following entries, only some of the most important publications of the research centers have been included. All inventory figures are approximate and have a limited value. Some libraries measure their holdings by linear feet or meters of shelving, thus counting duplicates and multivolume works as individual titles, while others add monographs, serials, and bound periodicals together. If a research center has special conditions that must be met before a person may use its facilities, these requirements have been included in the entry. But since requirements do change, it would be prudent for readers to write the staff of the library to ascertain whether or not the desired materials will be available at the time of the researchers' visits.

Europe

DEUTSCHLAND (GERMANY)

Through the Association of Art Libraries, whose objective is to foster the research of art history, six German art libraries decided to emphasize a different aspect of art.

Kunstibibliothek Staatliche Museen Preussischer Kulturbesitz; Jebensstrasse 2; D-1000 Berlin 12, Deutschland.

Emphasis on works of art of Spanish, Portuguese, Anglo-Saxon, and Scandinavian cultures up to 1900 plus twentieth-century architecture and city planning. Originally associated with the Museum of Decorative Arts founded in Berlin in 1867, the Kunstbibliothek contains about 145,000 volumes, 700 current periodicals, and 60,000 photographs. The Lipperheide Costume Library houses 23,000 volumes.

Kunsthistorisches Institut Florenz, Bibliothek. See entry under Italia.

Kunst- und Museumsbibliothek im Wallraf-Richartz-Museum; An der Rechtschule; D-5000 Köln 1, Deutschland.

This is the research library for the seven municipal museums whose total holdings are about 200,000 volumes. Emphasizes references relating to art in Belgium, Holland, and Luxembourg up to 1900 and all twentieth-century art, except architecture. The Rheinisches Bildarchiv has a vast photographic collection works on art in the Rhineland. This photographic collection of Art in Germany has been reproduced on microfiche, along with the Bildarchiv Foto Marburg at the Forschungsinstitut für Kunstgeschichte der Philipps-Universität Marburg, to form the *Marburger Index.* See Chapter 17.

Zentralinstitut für Kunstgeschichte Bibliothek/Photothek; Meiserstrasse 10; D-8000 München 2, Deutschland.

Contains 200,000 volumes, more than 1,200 current periodicals with an index to all articles and reviews held by the library since 1950 plus 550,000 photographs of European and German history of art from 800 to 1900. Emphasis on works of French art up to 1900, all art of the East European and Southeast European countries including twentieth-century art, iconography, art theory, plus the history of criticism and art appreciation.

Publication: *Kataloge der Bibliothek des Zentralinstituts für Kunstgeschichte.* Munich: K. G. Saur. On microfiches; has three separate catalogues: to the main catalogue, including museum, private collections, and exhibition catalogues; to articles and essays; and to subjects and artists.

Bibliothek des Germanischen Nationalmuseums; Kartäusergasse 1; Postfach 9580; D-8500 Nürnberg 11, Deutschland.

Founded in 1852, the library collects and indexes all literature on Albrecht Dürer. Contains about 500,000 volumes emphasizing art from German-speaking countries from early Middle Ages up through Expressionism. Receives about 1,500 current periodicals.

Bibliotheca Hertziana, Roma. See entry under Italia.

ENGLAND

The British Architectural Library, Royal Institute of British Architects; 66 Portland Place; London W1N 4AD, England.

Founded in 1834, this is one of the finest architectural libraries in the world. Contains more than 130,000 books and has a periodical collection of 13,000 serial titles, 600 of which are current. Has a number of special collections, such as (1) Early Works of 3,500 books published prior to 1841; (2) Handley-Read of about 1,350 titles on late 19th-century architecture, furniture and design;

(3) Manuscript Collection of papers of architects and organizations; and (4) RIBA Archives on the administrative records of the organization. Some of the library materials and papers are being microfilmed and sold; see entry under "Architecture," Chapter 11. The Drawings Collection, which is housed at 21 Portman Street, London W1H 9HF, is the largest collection of British architectural drawings in the world. Includes work by Palladio which had been bought by Inigo Jones in 1615. Has about 250,000 drawings.
Publications:
Catalogue of the Royal Institute of British Architects Library. London: RIBA, 1937–38; reprint ed.: London: Dawsons, 1972. 2 volumes.
Architectural Periodicals Index and RIBA Annual Review of Periodical Index, see listing under "Architecture," Chapter 12.
RIBA: The Drawings Collection, London: World Microfilms. *Catalogue of the Drawings Collection of the Royal Institute of British Architects.* London: Gress International, 1968–

The British Library Reference Division (formerly British Museum Library), Great Russell Street, London WC1B 3DG, England.
A depository library that possesses more than 10,000,000 printed books and periodicals, 83,500 volumes of western European manuscripts, 39,300 volumes of Oriental manuscripts, 100,000 charters and rolls, 18,000 detached seals and casts of seals, 3,000 Greek and Latin papyri, plus a fine collection of Egyptian papyri. In 1973 the library departments of the British Museum were transferred to the newly organized British Library along with the National Central Library, the National Lending Library for Science and Technology, and the British National Bibliography Ltd. The new organization is divided into three main divisions: reference, lending, and bibliographic services and two departments: the National Sound Archive (formerly the British Institute of Recorded Sound) and the Research and Development Department. All are administered by the British Library Board, 2 Sheraton Street, London W1V 4BH. The Department of Printed Books and the Department of Manuscripts are located in the British Museum building. The Department of Oriental Manuscripts and Printed Books is at Store Street, London WC1E 7DG. The facilities of the British Library are open to graduate students and researchers who are not able to find the necessary material elsewhere. A Reader's Pass must be secured. Passes may only be obtained on personal application. You will be asked to supply name, permanent address, and specific purpose of research and particulars to illustrate that the material is not available elsewhere. This must be accompanied by a letter of recommendation. For details of application write to the Reader Admissions Office, The British Library Reference Division, Great Russell Street, London WC1B 3DG.

Publications: The British Library publishes catalogues to its collections as well as a wide range of other publications including special exhibition catalogues. The *British Library Publications List* is published annually and can be obtained free from Reference Division Publications, Great Russell Street, London WC1B 3DG.
See entry under "National Libraries," Chapter 11.

National Art Library, Victoria and Albert Museum, South Kensington, London, S W 7, 2 R L, England.
About 1 million volumes covering fine and applied art. Includes medieval manuscripts, autograph letters, fine European and Oriental bindings, a good collection of twentieth century *livres d'artiste,* and an extensive collection of Sotheby's and Christie's sales catalogues. Has more than 75,000 exhibition catalogues, receives about 2,000 annually. A Reader's Ticket must be obtained and must be endorsed for the use of special material.
Publications: *National Art Library Catalogue, Victoria and Albert Museum: Author Catalogue.* Boston: G. K. Hall and Company, 1972. 10 volumes. plus *Catalogue to the Exhibition Catalogues,* 1972. One volume.
Microforms: Microfilms and Fiches in the National Art Library, compiled by Michael E. Keen, 1983.
The Victoria and Albert Museum Library: Subject Catalogue, London: Mindata. Microfiche.

The Warburg Institute Library, Woburn Square, London WC1, HOAB, England.
A library concerned with the history of the classical tradition in art, literature, religion, science, and magic. Contains about 244,000 volumes. Has about 1,250 serials. The Photographic Collection is discussed later in this chapter under "Photographic Archives."
Publications: *Catalog of The Warburg Institute Library.* 2nd ed. Boston: G. K. Hall & Company, 1967. 12 volumes. *First Supplement,* 1971. One volume.

Bodleian Library, University of Oxford, Broad Street, Oxford, OX1 3BG, England.
Founded in 1602; contains some 3,500,000 printed volumes and 65,000 manuscripts including Medieval manuscripts, English state papers particularly of the seventeenth century, topographical and antiquarian collectanea, and Oriental manuscripts.
Publications: *A Descriptive Catalogue of the Persian Paintings in the Bodleian Library,* 1958. (A catalogue of miniatures from manuscripts compiled by B. W. Robinson.)
Pächt, O. & Alexander, J. J. G. *Illuminated Manuscripts in the Bodleian Library.* London: Clarendon Press, 1966–73. 3 volumes.

de la Mare, A. C. *Catalogue of the Collection of Medieval Manuscripts Bequeathed to the Bodleian Library by James P. R. Lyell.* London: Clarendon Press, 1971.

FRANCE

Bibliothèque d'Art et d'Archéologie (Fondation Jacques DOUCET); 3, rue Michelet; F-75006 Paris, France.

Given in 1918 by Jacques Doucet to the University of Paris. Contains about 400,000 books and 4,500 periodicals. A letter of introduction is required.

Publication: *Bibliothèque d'art et d'archéologie (Fondation Jacques Doucet): Catalogue général périodiques,* Nendeln, Liechtenstein: Kraus-Thomson Organization, Ltd., 1972.

Bibliothèque Forney; Hôtel des Archevêques de Sens; 1, rue du Figuier; F-75004 Paris, France.

Founded in the nineteenth century as a Professional Art Industry Library. Contains about 260,000 books; 15,000 sales, exposition, and museum catalogues; and 50,000 periodicals. Includes both references to the fine and the decorative arts; has special collections of nineteenth- and twentieth-century drawings of furniture and fabrics.

Publications: *Catalogue d'articles de périodiques: Arts décoratifs et beaux-arts.* Boston: G. K. Hall & Company, 1972. 4 volumes.

Catalogue des Catalogues de ventes d'art. Boston: G. K. Hall & Company, 1972, 2 volumes.

Catalogue matières: Arts-décoratifs, beaux-arts, métiers, Paris: Société des amis de la Bibliothèque Forney, 1970. 4 volumes.

Supplément, 1979.

Bibliothèque Nationale; 58, rue de Richelieu; F-75002 Paris, France.

Contains more than 10,000,000 volumes of all kinds of books. The manuscript collection numbers over 300,000 volumes. A two-day pass, a card valid for 24 visits, and an annual pass are issued. In order to obtain permission, a letter—stating what specific material is needed and that it is not available in any other Paris library—must be written and accompanied by a letter of recommendation from the United States Ambassador or Counsel or the president of a university. This information must be presented in person, at which time the applicant's passport must be shown. A fee is charged depending upon the number of visits to be made. There are many libraries in Paris that are open to students and scholars without these stringent requirements; for a complete listing of these libraries the reader is referred to *Répertoire des bibliothèque et organismes de documentation,* published by the Bibliothèque Nationale.

Publications: *Les catalogues du département des imprimés.*

ITALIA (ITALY)

Biblioteca Medicea-Laurenziana; Piazza San Lorenzo 9; I-50123 Firenze, Italia.

Founded in 1571, this history library contains about 75,000 books and periodicals, 12,000 manuscripts, 4,000 books published in the fifteenth and sixteenth centuries, 3,000 Greek papyri, and 4,000 illuminated manuscripts of the sixth to the sixteenth century.

Biblioteca Berenson, Villa I Tatti, Harvard University; Via di Vincigliata, 26; I-50135 Firenze, Italia.

A collection of about 100,000 volumes on Renaissance history, art history, literature and music. The Berenson I Tatti Fototeca consists of about 350,000 black-and-white photographs of works by Italian painters printed on post-card size file cards. Organized by artists, these photographs have been made available to a number of other libraries.

Publication: *Catalogues of The Berenson Library of the Harvard University Center for Italian Renaissance Studies at Villa I Tatti.* Boston: G. K. Hall & Company, 1973. 4 volumes.

Kunsthistorisches Institut Florenz, Bibliothek; Via G. Giusti, 44; I-50121 Firenze, Italia.

Founded in 1897 by a group of scholars to promote international cooperation in the field of art history, the library contains more than 140,000 volumes, 1,000 current periodicals, and 300,000 photographs and has an index to inscriptions of fifteenth-century Florentine paintings, an index to the coats of arms of Florentine families, and a special collection of source books on the history of Futurism. In cooperation with the German Association of Art Libraries, emphasizes works pertaining to all Italian art from the time of the Renaissance.

Publication: *Catalog of the Institut for the History of Art, Florence, Italy.* Boston: G. K. Hall & Company, 1964. 9 volumes. Two supplements of 2 volumes each published in 1968 and 1972.

American Academy in Rome Library; Via Angelo Masina, 5; I-00153 Roma, Italia.

Founded early in the twentieth century, this research library of some 97,000 books emphasizes classical art and archeology plus having a small collection of books on the Middle Ages.

Bibliotheca Hertziana; Max-Planck-Institut; Via Gregoriana, 28; I-00187 Roma, Italia.

Opened in 1913 by the private foundation of Henrietta Hertz, it is located in the Palazzo Zuccari and Palazzo Stroganoff. In cooperation with the German Association of Art Libraries, emphasizes works pertaining to Italian art from early Christian period to the present. Contains about 150,000 volumes, 700 current periodicals of which some 400 are Italian publications, and 350,000 photographs.

Publications: *Römisches Jahrbuch für Kunst-geschichte.*
Römische Forschungen der Bibliotheca Hert-ziana. Römische Studien.

Pontificion Instituto di Archeologia Cristiana Biblio-teca; Via Napoleone III, N. 1; I-00185 Roma, Italia.
Founded in 1925, this religious library is restricted to graduate students and scholars. Contains over 40,000 volumes.

NEDERLAND (NETHERLANDS)

Kunsthistorische Bibliotheek, Rijksmuseum, J. Luy-kenstrasse la, 1007DD, Amsterdam, 1071-XY, Nederland.
Has about 85,000 volumes plus 30,000 auction catalogues, and 500 current periodicals.
Publication: *Catalogus der Kunsthistorische Bibliotheek in het Rijksmuseum te Amster-dam,* 4 volumes, 1934–36. (Fourth volume contains indices of authors, artists, illustra-tors, collectors and dealers, subjects, and anonymous works.)

Rijksbureau voor Kunsthistorische Documentatie, Korte Vijverberg 7, Den Haag ('S-Gravenhage) 2005, Nederland.
The library includes about 300,000 volumes of art history; museum, exhibition, and sales cata-logues; and periodicals. Special interest: Dutch and Flemish paintings and drawings. The De-partment of Archival Material has documents on Dutch artists and extracts from the archives of A. Bredius. The card index of Dutch and Flemish paintings and drawings was begun by C. Hof-stede de Groot. The Topographical Department includes a collection of photographs and repro-ductions as well as a card index of all painted and drawn identified sites and buildings depicted by artists from the Netherlands. Has in excess of 1,000,000 photographs and reproductions.
Publications: *Bibliography of the Netherlands Institute for Art History.* (Records books, arti-cles, and exhibition catalogues relating to Dutch and Flemish art, with the exception of architecture to 1830. Short critical comments in English. First volume was published in 1946 and covered the years 1943–1945. Since then each volume covers two years.)
The DIAL, A Decimal Index of the Art of the Low Countries, an iconographic index of Dutch and Flemish art on small photocards, 500 of which are published annually. About 14,500 photocards have been published.

VATICANO (VATICAN)

Biblioteca Apostolica Vaticana, Città del Vaticano, Italia.
This library contains over 1,000,000 books, 8,000 incunabula, 1,200 codices, and 60,000 manu-scripts. Liturgy is a specialty. Microfilm copies of many of the most precious codices are located at the St. Louis University Library in the United States.
Publications: Regolamento per gli studiosi della Biblioteca Vaticana, published erratically.
La Biblioteca Apostolica Vaticana, lists the nu-merous publications concerning the Vatican library's holdings.

North America: Canada

Centre Canadien d'Architecture/Canadian Centre for Architecture, 1440 ouest rue Sainte-Catherine, Montréal, Québec, Canada H3G 1R8
Founded in 1979 to promote knowledge of Ca-nadian architecture, the Centre plans to move to more permanent quarters in 1984. Contains more than 30,000 volumes, 5,000 architectural draw-ings, 25,000 photographs devoted exclusively to architecture, and archival material of individual architects and firms. Has begun CARS, an ac-ronym for the Canadian Architectural Records Survey.
Publication: "A Union List of Architectural Rec-ords in Canadian Public Collections," 1983.

National Gallery of Canada Library, 75 Albert Street, Ottawa K1A, OM8, Ontario, Canada.
Especially interested in Canadian art, library has about 72,000 volumes and subscribes to almost 1,000 periodicals. Contains 16,000 documenta-tion files on Canadian art and artists, the Witt Photo Library of the Courtauld Institute of Art.
Publications: *Catalogue of the Library of the National Gallery of Canada.* Boston: G. K. Hall & Company, 1973. 8 volumes. *Supple-ment.* 1981. 6 volumes.
Artists in Canada: A Union List of Files, Ot-tawa, 1982. Files on individual Canadian art-ists held in the National Gallery Library and in nineteen other Canadian libraries.

North America: United States

CALIFORNIA

University of California at Los Angeles, The Art Li-brary, Second Floor, Dickson Art Center, Los An-geles, California 90024.
The UCLA Art Library houses a non-circulating collection of over 72,000 volumes, 6,500 micro-fiche, 1,500 current serials, and 64,000 pam-phlets. Two major special collections are the Elmer Belt Library of Vinciana (incunabula, books and materials on the Renaissance with an emphasis on Leonardo de Vinci) and one of three copies in the U.S. of the Princeton Index of Christian Art. The UCLA Library System houses more than five million volumes in 18 branches which include the Art Library, the Architecture and Urban Planning Library (with a focus on contemporary architecture, urban planning, and selected environmental topics), the Theater Arts Library, and the William Andrews Clark Li-brary.

The J. Paul Getty Center for the History of Art and the Humanities, Library, 401 Wilshire Boulevard, Suite 400, Santa Monica, California 90401–1455.

Specializes in Classical archeology, 18th-century French decorative arts, and Western European paintings. Contains approximately 20,000 periodical volumes; 1,100 periodical subscriptions; 40,000 auction-sales catalogues; 20,000 catalogued monographs; and 60,000 uncatalogued monographs. The Photographic Collection is discussed later in this chapter under "Photographic Archives."

CONNECTICUT

Yale University Art and Architecture Libraries, Yale University, Box 1605 A, Yale Station, New Haven, Connecticut 06520.

Although there are separate collections, as described below, direct all letters of inquiry to the Reference Librarian of the Art Library. The Art Library has about 80,000 volumes on art and architecture, plus vertical files of museum and exhibition catalogues, as well as city-planning material. There are about 260,000 slides and 162,000 photographs in the reference collection. The Beinecke Rare Book and Manuscript Library contains letters and manuscripts concerning early American painters, especially John Trumbull and Samuel B. Morse. Includes the Gertrude Stein Collection, the Katherine Drier Bequest, the Steiglitz Archives, a collection of John Ruskin's manuscript writings as well as medieval manuscripts, Audubon prints, some American Indian material, and the Western Americana collection of early photographs. The Yale University Library has some 50,000 books on art and architecture that supplement the Art Library collection.

Art Reference Library/Photo Archive, Yale Center for British Art, Yale University. Box 2120, Yale Station, New Haven, Connecticut 06520.

The reference library contains about 10,000 books on British art—excluding decorative arts, medieval art, and architecture—and subscribes to 45 periodicals as well as to Sotheby's and Christie's sales catalogues. Well represented are travel guides, county histories, and some British literature. A section on paper conservation is being developed. Strong holdings on dissertations on British art.

The Photograph Collection is discussed later in this chapter under "Photographic Archives."

DISTRICT OF COLUMBIA

American Institute of Architects Library, 1735 New York Avenue, N.W., Washington, DC 20006.

Small collection of about 22,000 volumes and 450 periodical subscriptions. Librarians compile numerous bibliographies on architectural subjects which are available to interested parties; see entry in Chapter 23. Special Collections include the Library of Richard Morris Hunt.

Archives of American Art; five offices, processing and reference center office is AAPG Building, 8th & F Streets, Washington, D.C. 20560. Other offices include:
41 East 65th Street, New York, New York 10021.
5200 Woodward Avenue, Detroit, Michigan 48202.
87 Mount Vernon Street, Boston, Massachusetts 02108.
M. H. de Young Memorial Museum, Golden Gate Park, San Francisco, California 94118.

Founded in 1954 in Detroit as a national research institute for American art, the Archive became a bureau of the Smithsonian Institution in 1970. The collection of primary, secondary, and printed research material is of American painters, sculptors, craftsmen, dealers, critics, collectors, and art societies. Any artist who was born in America or immigrated here is considered an American artist. All of the original source material is microfilmed with a duplicate film for each branch office. Interlibrary loans are handled out of the Detroit office. Includes more than 8,000,000 items: letters, clippings, journals, and scrapbooks, plus 3,200 rolls of film and transcripts of 2,000 taped interviews with artists and other art world people.

Publications: *Archives of American Art: Collection of Exhibition Catalogs.* Boston: G. K. Hall & Company, 1979. One volume.

The Card Catalogue of the Manuscript Collection of the Archives of American Art. Wilmington, Delaware: Scholarly Resources, Inc., 1980. 10 volumes.

Archives of American Art Journal, a quarterly.

Dumbarton Oaks Research Library, Harvard University, 1703 32nd Street, N.W., Washington, D.C. 20007.

Has over 89,000 volumes on Early Christian, Byzantine, and Medieval Civilizations; subscribes to more than 815 journals and serials. Contains Dumbarton Oaks Research Archives, a copy of the Princeton Index of Christian Art, a census of Early Christian and Byzantine art found in American collections, and a bibliographical card file based on entries in the *Byzantinische Zeitschrift*—two catalogues: one arranged by authors, the other by subjects.

Publication: *Dictionary Catalogue of the Byzantine Collection of the Dumbarton Oaks Research Library.* Boston: G. K. Hall & Company, 1975. 12 volumes.

Freer Gallery of Art Library, Freer Gallery of Art, 12th and Jefferson, S.W., Washington, D.C. 20560.

Emphasizes references on art and cultures of the Far East, Near East, Indo-China, and India plus references concerned with James Abbott McNeill Whistler and his contemporaries.

Publication: *Dictionary Catalog of the Library of the Freer Gallery of Art.* Boston: G. K. Hall & Company, 1967. 6 volumes.

Library of Congress, Washington, D.C. 20540.

Created in 1800 to provide a reference library for United States legislators, this is now the largest library in the world. Storing more than 78 million items, of which more than 19 million are books and pamphlets on numerous subjects and in a variety of languages, the Library of Congress is open to anyone over high school age. There are special study desks available for researchers. The brochures listed below are provided free.

Publications include these three pamphlets:

Information for Readers in the Library of Congress.
Library of Congress Publications in Print.
Special Facilities for Research in the Library of Congress.

For additional publications refer to the section on national libraries in Chapter 11.

The Library of the National Museum of American Art and the *National Portrait Gallery,* F. Street at Eighth, N.W., Washington, D.C. 20560.

Over 45,000 volumes covering American paintings, sculpture, portraits, and biographies; receives more than 800 periodicals. Has over 300 vertical-file drawers on artists. For "Pre-1877 Art Exhibition Catalogue Index," see listing in Chapter 15 under "North American, 19th and 20th Centuries." For additional holdings, see entries in this chapter under "Photographic Archives."

National Gallery of Art Library, 6th Street and Constitution Avenue, N.W., Washington, D.C. 20565.

Contains about 10,000 book volumes, 12,000 bound periodical volumes, and 186 vertical-file drawers. Special collections consist of exhibition and sales catalogues. The collection strength is in western European and American art; artist monographs; museum, exhibition, private collection, and sale catalogues; the history of architecture; and Leonardo da Vinci material. Since 1979 when the library moved to the Gallery's new 9-story East Building, the library has broadened its purpose and the scope of its collection. It has become a major, national research center. The Photographic Collection is discussed later in this chapter under "Photographic Archives."

Smithsonian Institution, In Washington, D.C. see individual listings under such headings as Archives of American Art, Freer Gallery of Art, National Museum of American Art, and National Gallery of Art. In New York, see Cooper-Hewitt Museum.

ILLINOIS

Ryerson and Burnham Libraries, Art Institute of Chicago, Michigan Avenue at Adams Street, Chicago, Illinois 60603.

Has more than 140,000 volumes plus 60,000 pamphlets; particular emphasis on nineteenth- and twentieth-century painting, decorative arts, Oriental art, and Chicago architecture. Includes extensive microform collections. Maintains a card catalogue of auction catalogs. Catalogues are recorded in SCIPIO through RLIN. Special collections of architectural archives of Chicago architects: Louis Sullivan, Daniel Burnham, Frank Lloyd Wright, and Ludwig Hilberseimer. Architectural drawing collection (40,000) related to Chicago was transferred to the Department of Architecture in 1981. The Library has 33 microfilm reels on Chicago architectural drawings to 1922. The Burnham Index to Architectural Periodicals 1919–1963, which has an emphasis on midwestern architecture, is an in-house unpublished card file with approximately 90,000 cards from 135 periodicals. Other collections include the Mary Reynolds Collection on Surrealism, and the Percier Fontaine Collection, approximately 6,000 photographs of American Architecture and approximately 265,000 slides.

Publications: *Index to Art Periodicals.* Boston: G. K. Hall & Company, 1962. 11 volumes. *First Supplement,* 1974. One volume.

Architectural Records in Chicago: A Guide to Architectural Research Resources in Cook County and Vicinity. The Art Institute of Chicago, 1981.

MASSACHUSETTS

Harvard University Fine Arts Library, Fogg Museum of Art, Quincy Street, Cambridge, Massachusetts 02138.

About 195,000 volumes. Special coverage of Italian Renaissance, Islamic art and architecture, art and history of still photography, conservation, drawings, and graphic arts. Includes (1) photographs on Italian paintings from Berenson/I Tatti Fototeca, and repertory of the photographs assembled in Florence, Italy, at the Biblioteca Berenson of the Harvard Center for Italian Renaissance Studies and (2) a copy of *The DIAL, A Decimal Index of the Art of the Low Countries,* an iconographic index of Dutch and Flemish art on small photocards. Has approximately 350,000 slides and about 735,000 catalogued photographs. Over 350,000 total volumes on the visual arts divided among the Fine Arts Library of the Harvard College Library, the Widener Library, the School of Design Library, the Houghton Library, the Peabody Museum Library, and the two undergraduate libraries: Hilles and Lamont. For information on other Harvard University libraries see the entries for the Dumbarton Oaks Research Library, Washington, D.C. and the Berenson Library of the Harvard University Center for Italian Studies, Firenze, Italia.

Publications: Lucas, Louise. *The Harvard List of Books on Art,* 1952. Second edition entitled *Art Books: A Basic Bibliography,* Greenwich, Connecticut, New York Graphic Society, 1968.

Author and Subject Catalogues of the Library of the Peabody Museum of Archaeology and Ethnology. Boston: G. K. Hall & Company, 1963. 54 volumes. *First Supplement,* 1970. 12 volumes. *Second Supplement,* 1971. 6 volumes. *Third Supplement,* 1975. 7 volumes.

Catalogue of the Library of the Graduate School of Design. Boston: G. K. Hall & Company, 1968. 44 volumes. *First Supplement,* 1970. 2 volumes. *Second Supplement,* 1974. 5 volumes. *Third Supplement,* 1979, 3 volumes.

Catalogue of the Harvard University of Fine Arts Library. Boston: G. K. Hall & Company, 1971. 15 volumes. *First Supplement,* 1975. 3 volumes. *Catalogue of Auction Sales Catalogues,* 1971. One volume.

MISSOURI

Knights of Columbus Vatican Film Library, Saint Louis University, 3655 West Pine Blvd., St. Louis, Missouri 63108.

Since 1951 has photographed the collection of manuscripts owned by the Vatican Library in Rome; at present has copies of about three-fourths of the collection. The manuscripts range from the fifth to the nineteenth centuries. To supplement this project the library has obtained an extensive microfilm collection of documents of Jesuit activity in Latin America, North America, and the Philippines. Over 4,000 color slides of the choicest illuminated manuscripts owned by the Vatican help comprise their color-slide collection which numbers about 50,000 slides and illustrates many of the illuminated manuscripts owned by British and European libraries.

Publication: *Manuscripta,* a journal devoted to manuscript research, principally based upon the resources of the Vatican Library.

NEW JERSEY

Marquand Library of Art, Department of Archaeology and Architecture, Princeton University Art Museum, McCormick Hall, Princeton University, Princeton, New Jersey 08540.

The Marquand Library has approximately 128,000 volumes, 12,000 auction catalogues, and 12,000 uncatalogued exhibition catalogues. Subscribes to more than 900 serial titles. For information on visual material at Princeton University, see "Photographic Archives" in this chapter.

NEW YORK

Avery Architectural & Fine Arts Library, Columbia University, New York, New York 10027.

One of the world's great architectural collections. Subscribes to more than 900 periodicals. Has about 200,000 volumes of art and art-related books plus a special collection of architectural drawings.

Publications: *Avery Index to Architectural Periodicals.* 2nd ed. Boston: G. K. Hall & Company, 1973. 15 volumes. *First–Third Supplements,* 1975–79. 3 volumes.

Catalog of the Avery Memorial Architectural Library. 2nd ed. Boston: G. K. Hall & Company, 1968. 19 volumes. *First Supplement,* 1973. 4 volumes. *Second Supplement,* 1975. 4 volumes. *Third Supplement,* 1977. 3 volumes. *Fourth Supplement,* 1980. 3 volumes.

Avery Obituary Index to Architects and Artists. 2nd ed. Boston: G. K. Hall & Company, 1963. One volume.

On-line Avery Database available through RLIN.

Brooklyn Museum Libraries, Brooklyn Museum, 188 Eastern Parkway, Brooklyn, New York 11238.

The Art Reference Library contains about 100,000 books plus a collection of original American designer's sketches, 1900–1950. The Wilbour Library of Egyptology, which has about 20,000 volumes, is considered one of the best of its kind in the western hemisphere.

Cooper-Hewitt Museum, Doris and Henry Dreyfuss Study Center, The Smithsonian Institution's National Museum of Design, 2 East 91st Street, New York, New York 10028.

The library contains approximately 33,000 volumes, 300 periodicals, plus numerous auction catalogues. Archival materials include collections relating to the works and careers of several individuals important to the history of design. In addition, there is a picture collection of about 1,500,000 images pertaining to the decorative arts and design.

The Frick Art Reference Library, 10 East 71st Street, New York City, New York 10021.

Contains about 153,000 art books; 54,000 catalogues of auction sales; and a periodical index that covers art magazines before 1929 which was the first year covered by *Art Index.* Complete index of the *Gazette des Beaux-Arts* from 1859–1959 and of the *Burlington Magazine* from 1903–1959. Has 200 current periodical titles; however, the indexing of periodicals was discontinued in 1969. Interested especially in paintings, sculpture, drawings, and illuminated manuscripts created between about 325 and about 1930 A.D. in the United States and Western Europe. Does not include architecture, prints, or decorative arts. Has about 420,000 reproductions of works of art and 66,000 photographs of illuminated manuscripts. Indices to the reproductions have been compiled: a portrait index by the name of the sitter and an extensive iconographical index. Reproductions are also indexed under the name of the collection— both public and private— that owns the works of art. No fountain or ball point pens allowed. Jackets are required for men; skirts, for women.

Publications: *The Frick Art Reference Library Original Index to Art Periodicals.* Boston: G. K. Hall & Company, 1983. 12 volumes.

The Hispanic Society of America, Broadway and 155th Street, New York City, New York 10032.

Has references on the art, history, and literature of Spain, Portugal, and Colonial Hispanic Amer-

ica. About 200,000 volumes, a number of which were printed before 1701.

Publications: Penny, Clara L. *Printed Books, 1648–1700 in the Hispanic Society of America,* 1965.

The Catalogue of the Library of The Hispanic Society of America. Boston: G. K. Hall & Company, 1962. 10 volumes. *First Supplement,* 1970. 4 volumes.

Libraries of the Metropolitan Museum of Art, Fifth Avenue and 82nd Street, New York, New York 10028.

There are five separately administered libraries that are open to researchers. They are:

Thomas J. Watson Library, the central library of the Museum, houses more than 244,000 volumes including long runs of art periodicals and art exhibition catalogues. Large collection of European and American sales catalogues, partially indexed by names of collectors. *SCIPIO Database* of art auction catalogues published since January 1980 can be searched through RLIN. Vertical files, 100 drawers, of artists and art subjects. Special card file (the "Tietze catalogue") of books published before 1800 concerned with western post-classical art. Receives 1,400 current periodicals and serials.

Photograph and Slide Library has more than 250,000 black-and-white photographs of architecture, painting, sculpture, and decorative arts; 360,000 slides; 20,500 color transparencies of objects in the Museum collections.

Robert Goldwater Library, established in 1957, has 25,000 volumes on the art of Africa, Pacific Islands, and Pre-Columbian and Native America; 175 periodical subscriptions; 150,000 photographs.

Irene Lewisohn Costume Reference Library, founded in 1951, has 67,000 volumes on fashion and costume history; 49 periodical subscriptions.

Cloisters Library, housed in the Museum's separate Cloisters, in uptown Manhattan, contains 7,400 volumes and 15,000 slides on European medieval art.

Publications: *Library Catalog of the Metropolitan Museum of Art,* New York, Second edition, revised and enlarged, Boston: G. K. Hall & Company, 1980. 48 volumes. *First Supplement,* 1982.

Catalog of the Robert Goldwater Library, The Metropolitan Museum of Art, Boston: G. K. Hall & Company, 1982. 4 volumes.

The Museum of Modern Art, The Library, 11 West 53rd Street, New York, New York 10019.

Has 80,000 volumes, 250 periodical subscriptions, plus about 1,500 serial titles bound. Has extensive Vertical Files on approximately 15,200 artists, mostly living. Special collections on Dada and Surrealism, Latin American Art, Artists' Books, and Museum of Modern Art publications. Archival papers of Hans Richter (personal), the N.Y. art dealer Curt Valentin (business), and past MOMA directors—Alfred Barr (personal and business) and René d'Harnoncourt (business).

Publication: *Catalog of the Library of the Museum of Modern Art.* Boston: G. K. Hall & Company, 1976. 14 volumes.

The Research Libraries. The New York Public Library, Fifth Avenue at 42nd Street, New York, New York 10018.

Probably the largest public library in the world. Consists of various departments, the collections of which have been published and are now being added to RLIN, the RLG computer system.

Publications: *Dictionary Catalog of the Art and Architecture Division.* Boston: G. K. Hall & Company, 1975, 30 volumes.

Bibliographic Guide to Art and Architecture. 1975. Boston: G. K. Hall & Company, 1975+. A one-volume annual supplement to *Dictionary Catalog of the Art and Architecture Division.*

Dictionary Catalog of the Prints Division. Boston: G. K. Hall & Company, 1975. 5 volumes.

The Pierpont Morgan Library, 29 East 36th St., New York, New York 10016.

Owns the most extensive series of Medieval and Renaissance manuscripts in North America; about 965 of which are illuminated. Has an important collection of books printed before 1501 and the largest collection of Assyrian and Babylonian seals in the United States. Only pencils may be used in the Reading Room; all photocopy work must be requested in writing.

Photographic Archives

Some institutions have a photographic reference collection that is available to the public. Here the researcher can study all of the reproductions of art objects that the library has of one artist or all of the ones it has under a certain subject, such as madonnas. A photographic reference collection is an archive containing reproductions of art from all over the world. Although black and white, 8″ × 10″, glossy prints are preferred, often any reproduction of a work of art—small or large, black and white or color, good or bad—is saved. Each of the reproductions, which are collected from magazines and museum and sales catalogues is mounted on cardboard, identified as far as possible, and filed according to artist, country, subject, or period of history. Cross files on iconography, biography, and portraits sometimes are

compiled. No judgment is made upon the authenticity of the art objects that are reproduced. Although there are numerous photographic reference collections, the few that are listed in this chapter are either large collections that cover several kinds of art over a long period of history—such as the Witt and Conway Libraries in London—or large collections that specialize in a particular field of art—such as the Yale Center for British Art and British Studies at Yale University. Some of these archives have reprinted the photographic collection on microforms and made them available to other libraries. See Chapter 17 for details.

Europe

DEUTSCHLAND (GERMANY)

Bildarchiv Foto Marburg, see citation under *Kunst- und Museumsbibliothek im Wallraf-Richartz-Museum* under "Art Research Centers."

ENGLAND

The British Architectural Library, The Drawings Collection, see citation under this name in "Art Research Centers."

The Conway Library, Courtauld Institute of Art, University of London, 20 Portman Square, London W1H OBE, England.

> The Conway Library is a collection of about 800,000 photographs comprising architecture, sculpture, illuminated manuscripts, architectural drawings, medieval wall and panel paintings, mosaics, stained glass and metalwork. The collection covers Byzantine and Western European art from the classical Greek period to modern times. Parts of the collection are being published, see listing in Chapter 17.
>
> Publications: *Courtauld Institute Illustration Archives.* London: Harvey Miller Publishers. (1976/77)+

The Warburg Institute, University of London, Woburn Square, London WC1 HOAB, England.

> The Photographic Collection is primarily designed for the study of iconography with emphasis on the classical heritage in European art of the Middle Ages and the Renaissance. Most media in the fine and applied arts, from antiquity to the 18th century, are included. Organized by subjects under general categories: Antiquities, Gods and Myths, Magic and Science, Secular Iconography, Portraits, Literature, History, Social Life, and Religious Iconography. Illuminated manuscripts are kept separate, arranged by library, and indexed by author and subject. The card index provides cross references between the various sections of the collection. *The Census of Antique Works of Art Known to Renaissance Artists,* compiled in collaboration with Phyllis Bober, is incorporated in the subject files. Some

years ago, the Warburg Institute organized the making of photographs from prints which were reported in Adam Bartch's *Le peintre-graveur,* which contains no illustrative material. These small, 4¾ by 6½ inches, photographs were sold to various libraries who could organize them as they wished. At the Institute they are filed by subject.

The Witt Library, Courtauld Institute of Art, University of London, 20 Portman Square, London England. WIH OBE

> Contains more than 1,400,000 reproductions of paintings, drawings, and graphics of all European and Western schools from about 1250 to the present day. Covers over 50,000 artists. The Photographic Survey Department has photographed more than 300 private art collections in England, Wales, and Ireland and has made the photographs available to some 70 subscribers, many of whom are in the United States. The Witt Photo Library of the Courtauld Institute of Art is a reproduction of the picture collection on microfiche. A copy of the microfiches has been placed at The J. Paul Getty Museum; The National Gallery, Washington, D.C.; The National Gallery of Canada, Ottawa; The University of Melbourne, Australia; The Bildarchiv Foto Marburg, West Germany; and the Yale Center for British Art, Connecticut (British School only).
>
> Publication: Witt Library. *A Checklist of Painters c. 1200–1976 Represented in the Witt Library, Courtauld Institute of Art, London.* London: Mansell Information Publishing, 1978.

ITALIA (ITALY)

Berenson/I Tatti Fototeca, see listing *Biblioteca Berenson* under "Art Research Centers."

Kunsthistorisches Institut Florenz, see listing under "Art Research Centers."

Bibliotheca Hertziana, see listing under "Art Research Centers."

NEDERLAND (NETHERLANDS)

Rijksbureau voor Kunsthistorische Documentatie, see listing under "Art Research Centers."

United States

CALIFORNIA

The J. Paul Getty Center for the History of Art & The Humanities, Photo Archives, 401 Wilshire Blvd., Suite 400, Santa Monica, CA 90401–1455.

> Has about 150,000 catalogued photographs in four subject areas: European Painting, 8th–19th centuries; European Sculpture; European Decorative Arts of 17th & 18th centuries; and Greek, Roman, and Etruscan Antiquities. With new additions, especially in architecture and Medieval Art, will soon have approximately 700,000 catalogued photographs. Includes Douws Collection

of 200,000 photos of Dutch & Flemish paintings, Berenson/I Tatti Fototeca of 350,000 photos of Italian paintings, DIAL (Decimal Index of Art of the Low Countries), Witt Photo Library of the Courtauld Institute of Art, Christie's Pictorial Archive of Decorative Arts, the Marburger Index, and Fototeca Unione (Rome) of Roman Architecture.

CONNECTICUT

Art Reference Library/Photo Archive, Yale Center for British Art, Yale University, Box 2120, Yale Station, New Haven, Connecticut 06520.

The photo archive comprises some 100,000 black-and-white photographs after paintings, drawings, watercolors, and prints by British artists or foreigners working in the United Kingdom from about 1500 until 1945. Since 1976, have been in the process of computerizing the photo archive, stressing the British Art Center's own collection of paintings and drawings and working towards a census of British art in North American collections. Due to this computerization, there is now a subject access to about 38,000 photos. Owns a set of 4,000 microfiches of the British School photographs at the Witt Library in London and the Jennings Albums, consisting of 60 volumes of prints, photographs, and reproductions, about 200,000 images which provide a chronological survey of English sitters from King Egbert I (769–839) up to Elizabeth II. A card index for the individual sitters is being prepared.

DISTRICT OF COLUMBIA

Library of Congress, Prints and Photographs Division, First St. Between E. Capitol St. & Independence Ave., Washington, D.C. 20540.

A collection of 9,000,000 photographs, 110,000 prints, and 100,000 architectural items.

National Gallery of Art, 6th Street and Constitution Avenue, N.W., Washington, D.C. 20565.

The Photographic Archives of the Center for Advanced Studies in the Visual Arts contains almost 3,500,000 images consisting of 1,340,000 photographs and the rest microfiche. Has more than 120,000 photographic negatives of works of art sold at Parke Bernet from 1930s to 1963; the Richter Archives of 100,000 photographs, which are mainly of western European painting and sculpture; the Clarence Ward Medieval Collection, which contains over 1,200 rare negatives of European architecture photographed in the 1920s and 1930s, the Witt Photo Library of the Courtauld Institute of Art, as well as numerous microfiche collections.

National Museum of American Art, Smithsonian Institution, F. Street at Eighth, N.W., Washington, D.C. 20560.

"The Inventory of American Painting Executed Before 1914" was begun as a bicentennial project to celebrate 1976. The file, which is continuously increasing, presently includes a list of about 230,000 paintings and 45,000 photographic reproductions of these works. Approximately 20,000 artists are represented. The majority of the paintings are not precisely dated. The data which has been collected on the paintings is on a computer file. Three indices can be generated: by artists, by owners or locations, and by subject classification.

The National Portrait Gallery, Smithsonian Institution, F. Street at Eighth, N.W., Washington D.C. 20560.

"The Catalog of American Portraits" contains photographs and documentation on 60,000 historically important Americans. Painting, sculpture, drawings, miniatures, and silhouettes are included. Photographs and graphic arts are usually excluded. Organized by the sitters' names, there are cross references to the artists who did the likenesses. Computerized indices are updated quarterly. *Portraits of Americans* reproduces 1,926 portraits from the museum collection; see entries in Chapter 17 for the microfiche publication and the printed index.

NEW JERSEY

Princeton University, McCormick Hall, Princeton, New Jersey 08544.

There are three separate departments: (1) Department of Art and Archaeology has 1,000,000 photographs for research, 200,000 Western art slides, and 35,000 Oriental art slides; (2) Far Eastern Art Research Photograph Archive has 65,000 photographs; and (3) Index of Christian Art, which is an iconographical catalogue for works of Christian art which date before the year 1400. The Subject File of the Index consists of almost 600,000 catalogue cards listed under about 25,000 subjects, including persons, scenes, objects, and some aspects of the natural world. The subject cards are supplemented by the Photograph File, a collection of over 250,000 photographs of the art works cited in the Subject File. For a discussion on this index, the reader should see Chapter 6.

NEW YORK

Avery Architectural & Fine Arts Library, Drawing Collection, see listing under "Art Research Centers."

Cooper-Hewitt Museum, see listing under "Art Research Centers."

The Frick Art Reference Library, see listing under "Art Research Centers."

Film or Motion Picture Libraries

Any serious research on moving pictures requires the viewing of films. There are only a handful of large motion picture libraries accessible to

the scholar. Since not all of these institutions have published a catalogue of their film titles, correspondence is necessary to ascertain whether or not the library has the required film. A charge is often made to view the films. Usually an appointment must be made several weeks in advance.

Europe

ENGLAND

The National Film Archive; British Film Institute; 81 Dean Street, London W1V 6AA, England.

> Begun in 1935 to maintain a British national repository of films of permanent value. There have been several bills proposed in Parliament to make this a statutory deposit, just as the British Library is for books. None of the bills have yet passed. A computer system was designed in 1979 which will eventually have the Archive's records. This will provide more flexible retrieval. The film collection has about 75,000 titles comprised of feature films, documentaries, newsreels, and television programs from about 1895 to the present. *Publications: National Film Archive Catalogue of Viewing Copies, 1983* (list of 7,000 films which can be seen at the Institute). For other catalogues, see entry under "Films or Motion Pictures," Chapter 11.

United States

CALIFORNIA

University of California, Pacific Film Archive, 2625 Durant Avenue, Berkeley, California 94720.

> Special collection of 5,000 films with concentrations in Japanese, Soviet silent and Soviet Georgian, American avant-garde, and contemporary animation films. Has 2,500 volumes and 30 current periodical subscriptions. Has about 20,000 vertical files on films, filmmakers, festivals, and subjects. Recently received the Winsor McKay Collection of Materials on International Animation.

UCLA Film Archive, University of California, Theater Arts Department, Los Angeles, California 90024.

> Collection of about 20,000 film titles which are accessible to all researchers upon written application to the director. A catalogue of film titles is available; cooperates with the NATA/UCLA Television Library and the UCLA Radio Archive.

NEW YORK

Museum of Modern Art, Film Study Center, 11 West 53rd Street, New York, New York 10019.

> Has about 8,000 films, some of which circulate. There is also a collection of screenplays and dialogue continuities, extensive files of contemporary reviews, newspaper and magazine articles, program notes, and publicity material. Has the FIAF (International Federation of Archives of Films) International Index to Film Periodicals from 1972 to the present. Since there is no published catalogue, correspondence is necessary to establish the location of the needed film.

Film Department, International Museum of Photography at George Eastman House, 900 East Avenue, Rochester, New York 14607.

> Films which have been transferred to acetate stock are available. The absence of a film catalogue makes correspondence necessary. Has about 5,500 titles, more than 600 of these date from 1894 to 1914.

WASHINGTON, D.C.

Motion Picture, Broadcasting and Recording Sound Division, Library of Congress, Washington, D.C. 20540.

> Since film is one of the most fragile of all art media, the main concern of the library is film preservation. It is converting movies which were produced on highly combustible nitrate film to acetate film which is safer. Contains over 80,000 titles.
> Publications: See listing under "Films or Motion Pictures" in Chapter 11.

Appendices

The terms in these foreign-language dictionaries were culled from art museum catalogues plus biographical and location directories; the definitions reflect their use in these references. A number of adjectives and conjunctions have been included, because it is often these basic words that make translating a title of a work of art difficult. Appendix D contains terms denoting time and number and the names of animals as well as proper names and geographic locations. These words are not repeated in the individual dictionaries of French, German, and Italian words.

French-English Dictionary

Words that are the same or similar to the English equivalents have not been included, such as: *acquisition, addition,* and *âge.* Masculine nouns and adjectives are usually listed; the feminine form is often derived by adding *e* or *ne.* In French many of the adjectives are placed after the noun: *la robe bleue,* the blue dress. The definite articles are *le* (masculine), *la* (feminine), and *les* (plural); the indefinite: *un* (masculine), *une* (feminine), and *des* (plural); the subject pronouns: *je* (I), *tu* (you), *il* (he, it), *elle* (she), *nous* (we), *vous* (you), *ils* (they, masculine) and *elles* (they, feminine). Only the third person singular of the verb is listed; the verb forms are either the past definite (literary past) tense or the past participle.

French	English
à	To, into, by, at, for, from, on
A Bas	Down
Abbaye	Abbey
Abord	Arrival
d'abord	At first, at first sight
Abrégé	Abridged; summary
Abside	Apse
Absidiole	Small apse; chapels
Abstrait	Abstract
Académie	Academy
Académique	Academic
Accentuation	Emphasis
Accessoires	Accessories
Accroupissement	Crouching
Achat	Purchase
Acier chromé	Chrome
Acquis	Acquired
Acteur	Actor
Actif	Active
Adieu	Farewell, parting
Affiche	Poster
Âge d'or	Golden Age
Agonie	Agony of death; the death of Christ on the cross
Agrée	Student ready to apply for membership in the French Academy
Aiguière	Ewer, vessel with handle and spout
Aiguillon	Incentive, spur
Aile	Wing
Ailé	Winged
Ainsi	Thus, in this manner
Ainsi que	In the same way
Albigeois	Albigenses, a French religious sect of the twelfth century
Allongé	Lengthened
Âme	Spirit, soul
Ami	Friend, patron
Amour	Love
Amphore	Amphora
Anatomie	Anatomy
Ancêtres	Ancestors
Ancien	Ancient, old
Ange	Angel
Anneau	Ring, link
Annonciation	Annunciation
Annuaire	Annual, yearbook, directory
Anonyme	Anonymous
Anse	Handle of a pot or of a basket
Antienne	Anthem
Antiquité	Classical Antiquity

French	English
Apocryphe (Les Apocryphes)	Apocryphal (The Apocrypha)
Apôtre	Apostle
Appareil photographique	Camera, camera obscura
Appartenant à	Belonging to, pertaining to
Applique	Ornamental accessories, decoration
Après	After
Aquarelle	Watercolor
Aquatinte	Aquatint
Arbre	Tree
Arc	Arch
Arc outrepassé	Horseshoe Arch
Archaïque	Archaic
Argent	Silver, money
Argile	Clay
Arme	Weapon
Armoire	Large wardrobe with doors
Art décoratif	Decorative arts
Arts graphiques	Graphic art
Assyrien	Assyrian
Atelier	Workshop, studio
Attribué à	Attributed to
Aussi	Also, too, as, so
Autel	Altar
Auteur	Author, creator
Automne	Autumn
Auto-portrait	Self-portrait
Autre	Other, another
Avant	Before
Avant-garde	Leaders for change
Avant-plan	Foreground
Avec	With, by means of, together with
Avertissement	Information, caution
Aveugle	Blind
Avoisinant	Near by, neighboring
Badigeon	Whitewash; a disguise for defects
Baigneur	Bather
Baiser de Judas	Judas kiss
Baptistère	Baptistry
Barbare	Barbarian
Barque	Boat
Bas	Low
Basilique	Basilica
Bataille	Battle
Bâtiment	A structure or building
Beauté	Beauty
Beaux-Arts	Fine Arts
Bénissant	Blessing
Bénitier	Holy water basin
Berceau	Cradle
Berger	Shepherd
Bergère	Upholstered armchair with closed upholstered sides, shepherdess
Bestiaire	Bestiary, book of beasts
Bibliographie	Bibliography
Bibliothèque	Library
Biblique	Biblical
Bienheureux	Happy, blessed
Bijou	Jewel

French	English	French	English
Biographie	Biography	Chemin	Road, way
Blanc, blanche	White	Chevet	The eastern or apsidal end of a church, includes the apse, ambulatory, and chapels.
Bleu	Blue		
Bois	Wood		
Boiserie	Panelling	Chiffre	Amount; figure; monogram
Boîte	Box; chest	Chinoiserie	Object decorated with Chinese motifs
Bol	Bowl, basin		
Bord	Side, edge	Choeur	Choir
Bordure	Border, rim, fringe, edging	Choix	Choice, selection
Bosselé	Dented	Chrétien	Christian
Bouffon	Jester	le Christ	Jesus Christ
Boule	Ball, sphere, globe	Un Christ	Crucifix, depiction of Christ on cross
Boulle	Inlay of tortoiseshell and brass for furniture		
		Chute	Fall, collapse
Boutique	Shop; atelier	Ciel (plural: Cieux)	Heaven, sky
Bras	Arm	Cierge	Church candle
Broderie	Embroidery	Cime	Top
Brosse	Brush	Cinétique	Kinetic
Brume	Haze, fog	Circoncision	Circumcision
Brun	Brown	Cire	Wax
Bruni	Burnished, darkened	Cire-perdue	Lost wax method of casting bronze sculpture
Brut	Rough, raw, unpolished		
		Ciselure	Embossing, chasing, tooling (of leather)
Cabinet des dessins	Drawing department		
Cabriole	Furniture leg inspired by an animal form	Cité	City, town, an ancient nucleus of a town
Caché	Hidden	Clair-obscur	Chiaroscuro, use of lights and darks in paintings
Cadeau de	Gift of		
Cachet	Stamp, seal	Claire-voie	Clerestory, the upper part of the church which has windows that rise above the roof of the aisle and ambulatory
Cadre	Framework; skeleton; design		
Caisse	Chest, box, cashier's office		
Calcaire	Limestone		
Calendrier	Calendar		
Calice	Chalice, communion cup	Clarté	Light
Calvaire	Calvary	Classement	Classification
Camaïeu	Monochrome painting; colorless painting; cameo	Classique	Classical
		Clef	Key
Camée	Cameo; painting done in grey	Clocher	Belfry, steeple
Campagne	Country	Cloisonné	Enamel work in which a vitreous paste of various colors fills the areas defined by cloisons
Canapé	Sofa		
Cannelé	Fluted (column)		
Carré	Square		
Carte	Map; postcard	Cloître	Cloister
Cartouche	Ornamental scroll or shield	Coeur	Heart
Cathares	Albigenses, a French religious sect of the twelfth century	Coffret	Casket
		Colère	Anger
Carton	Cardboard, cardboard box	Collé	Glued, stuck
Cathédrale	Cathedral	Collectionneur	Collector
La Cène	Last Supper, Holy Communion	Colonne	Column
La Cène chez le Pharisien	Supper in house of the Pharisee	Colonne engagée	Engaged column
Centimètre	Centimeter, .3937 inch	Colorant	Coloring, dye
Céramique	Ceramic	Commissaire-priseur	Auctioneer
Chaise	Seat, chair	Commode	A chest of drawers
Chambre	Room	Commun	Common, universal
Champs-Elysées	Elysian Fields; in mythology the place where the good people went after death; place of happiness, a famous street in Paris	Comprit, compris	Understood
		Concile	Council
		Concret	Concrete
		Congrès	Congress, general meeting
		Connaisseur	Connoiseur, a critical judge of works of art
Chandeleur	Candlemas; celebration of infant Christ's presentation in temple and purification of Virgin Mary; on February 2.		
		Connu	Known, discovered, understood, knew
		Conquête	Conquest, acquisition
Changement	Change, alteration	Consacré	Consecrated
Chapelet	Rosary	Conservateur	Conservationist
Chapiteau	Capital of a column	Construit	Constructed, built
Chapitre	Chapter-house	Contemporain	Contemporary
Charbon	Charcoal	Contenu	Contained
Chasse	Hunting	Contraste	Contrast
Châssis	Framework, case	Contrefort	Buttress
Château	Mansion, manor house, medieval fortress	Coquille	Shell
		Coran	Koran
Chaud	Warm		

French	English
Corbeau	Raven; corbel in architecture
Corne à boire	Drinking horn
Corniche	Ledge, cornice
Corps	Body
Côté (à côté de)	Side, direction (beside, by)
Couché	Recumbent, lying in bed
Couche inférieure	Undercoat
Couleur	Color
Coup de pinceau	Stroke of the brush
Cour	Court, courtyard
Courbé	Curved, bent
Couronne	Crown
Couronnement	Coronation
Cours	Course, studies
Court	Short, brief
Court métrage	Short film
Coutume	Custom
Couture	Sewing, dressmaking
Craie	Chalk
Crayon	Pencil
Crayon de fusain	Charcoal crayon
Croisade	Crusade
Croisé	Crossed, crusader
Croisillon	Cross-bar
Croix	Cross, crucifix
Croquis	First sketch, rough draft
Crosse	Crozier
Crucifiement	Crucifixion
Cuir	Leather
Cuit	Cooked, done, ripe
Cuivre	Copper
Curateur	Curator
D'abord	At first, at first sight
Dadaïsme	Dada School
Dans	In, into
Danse macabre	Dance of death
De	Of
Déambulatoire	Ambulatory
Décédé	Deceased
Décoloré	Faded
Décoratif	Decorative
Découpage	Cutting out; decorated surface of object with paper cutouts
Découvert	Discovered
Décret	Decree
Défi	Challenge
Dehors	Outside, without
Déjà vu	Unoriginal; already seen; trite
Dépouilles	Spoils, remains
Depuis	Since, for, after
Dernier cri	Latest word (in fashion)
Derrière	Behind
Descente de la croix	Descent from the Cross
Désigné	Appointed, chosen
Dessin	Drawing, design, sketch, pattern
Dessin au pastel	Pastel drawing
Dessin à l'échelle	Scale drawing
Dessous	Under
Détrempe	Distemper, painting using an egg emulsion as a binding medium
Détruit	Destroyed
Devant	Before, in front of
Diable	Devil
Diamètre	Diameter
Diaphane	Translucent
Diapositive	Slide, transparency
Dieu	God
Dimensions	Size
Diptyque	Diptych, two panels or pictures hinged together

French	English
Directeur	Director
Dirigeant	Leader, director, directing
Disciple	Follower of
Disponible	Available, vacant
Dissimulant	Concealing
Dit	Called, said
Don de	Gift of
Donateur	Donor
Donneur, donneuse	Donor, giver
Doré	Gilt
Dot	Dowry
Doute	Doubt
Doux	Soft
Droit	Right
Droit de suite	A copyright system used in some European countries.
Dur	Hard
Dynastie	Dynasty
Eau	Water
Eau-forte	Etching
Ebauche	Preliminary painting on a canvas; outline
Ebène	Ebony
Ebéniste	Cabinet-maker, usually of verneer or inlay work
Ebrasement	Splaying
Ecaille	Tortoise shell
Ecaillé	Chipped
Echantillon	Pattern, sample
Echauguette	Watch-tower
Echelle	Scale, gradation
Eclairage	Illumination
Ecole (de)	School (of)
Ecolier	Student
Ecriture	Scripture, handwriting
Ecrivain	Author
Ecu	Shield, escutcheon, money
Edifice	Building
Editeurs d'art	Art publishers
Effet	Effect
Egalement	Equally, likewise, uniformily, also
Eglise	Church
Elévation de la croix	Raising the Cross
Elève	Student, apprentice
Email (plural: émaux)	Enamel
Embrassant	Embracing
Emplacement	Location
Emprunt (de)	Loan (on loan)
En	Within, at, to, in
En arrière de	Behind
En aval de	Below
Encadrement	Frame; border; margin
En passant	By the way
En plein	Fully, entirely
En vente	For sale, in print
Enchère	Bid, auction
Encre	Ink
Endroit	Place, locality
Enfant	Child, infant
Enfer	Hell
En haut	Up, above
Enseignement	Teaching, education, lesson
Ensevelissement	Entombment
Entendre	Understand, listen, hear
Enterrement	Burial
Entouré de	Surrounded by
Entre	Between, among
Entre-deux	Partition; space between
Entrelacé	Intertwined
Entreprit	Attempted
Epais	Thick

French	English	French	English
Epoque	Epoch, era, time	Fondeur	Founder; caster of metal sculpture
Epouse	Wife, bride		
Epoux	Husband, bridegroom	Fontaine	Fountain
Epreuve	Trial; test; proof-sheet	Fonts Baptismaux	Baptismal receptacle
Erudit	Scholar	Forme	Form
Escalier	Stair	Fort	Strong, large, difficult
Esclave	Slave	Fosse	Pit, grave
Espace	Space	Fossé	Moat, ditch
Espérance	Hope	Fou, folle	Insane, mad, foolish
Esprit de corps	Spirit of closeness developed by people associated with each other	Foudre	Large cask
		Fouille	Excavation
		Fraise	Strawberry
Esquisse	Sketch; rough plan	Frère	Brother
Essai	Trial, sample	Fresque	Fresco
Est	East, is	Frise	Frieze
Estampe	Print, engraving	Fronton	Pediment
Estampille	Trade mark; stamp of authenticity	Fuite en Egypte	Flight into Egypt
		Fureur Iconoclaste	Iconoclastic Controversy
et	And	Fusain	Charcoal
Etain	Pewter	Fut	Was
Etat	State, circumstances; condition	Fût	Column shaft
Eté	Summer		
Etoile	Star	Galerie	Gallery
Etouffant	Suffocating, close	Garçons	Boys
Etranger	Stranger	Gargouille	Gargoyle, water spout
Etude	Study	Gauche	Left, clumsy
Evangile	Gospel	Gauchi	Warped
Evêque	Bishop	Géant	Giant, gigantic
Exposition	Exhibition	Géminé	Double, twin
Ex-voto	Votive offering, given or offered because of a vow	Genre	Subjects from everyday life; family; race; kind
		Geste	Deed, exploit
Fabrique	Factory	Gisant	Lying; recumbent effigy on tomb
Façade	Front of building		
Faculté	Faculty; ability; power	Glacé	Frozen, glazed, glossy
Faïence	Fine quality glazed earthenware having brightly colored designs	Glaive	Sword
		Gothique	Gothic
		Gouache	Opaque water-color painting
Fauteuil	Arm chair	Gourde	Flask
Faux, fausse	False	Gramme	Gram, 15.432 grains
Femme	Woman	Grand	Large; great; important
Fenêtre	Window	Granit	Granite
Fer	Iron	Graphique	Graphics
Ferme	Farm	Grappe	Cluster of fruit
Fermé	Closed	Gravé	Engraved
Ferronnière	Chain with jewel decorating a woman's head	Graveur	Engraver
		Graveur sur bois	Wood engraver
Fête	Holiday, saint's-day or feast	Grenade	Pomegranate
Fête-Dieu	Corpus Christi Day	Grenier	Attic, loft
Fête-galante	Elegant festival developed by Antoine Watteau	Gris	Grey
		Grisaille	Done in shades of grey
Feu	Fire	Gros, grosse	Large, coarse
Feuille	Sheet of paper	Guérison	Cure, healing
Feuille d'or	Gold leaf	Guerre	War
Figure	Figure, face; form		
Fil	Thread, yarn, wire	Habilité	Skill
Filigrane	Filigree, water-mark on paper; embossing	Hausse	Lift, rise, advance
		Haut	High, loud, upper
Fille	Daughter	Hauteur	Height, elevation
Fils	Son	Héraldique	Heraldry
Fin	End, conclusion	Hérésie	Heresy
Fin de siècle	End of century (of the late 19th century)	Heure	Hour, time
		Histoire	Story, tale
Flâneur, flâneuse	Strolling spectator	Historié	Historiated, decorated with figures that tell a story (as a capital of a column)
Fleur	Flower		
Fleuve	River		
Foi	Faith, creed	Hiver	Winter
Fois	Time	Homme	Man
Fond	Bottom (of the sea or of a container); background	Homogène	Homogeneous
		Hors-concours	Above competition; not competing; in the academy exhibition, not having to be judged in order to have one's work shown
Fondamental	Fundamental		
Fondateur	Founder		
Fondement	Foundation		

French	English	French	English
Hospice	Convent, asylum, refuge for travelers	Litre	Liter, 1.76 pints
Hôtel	Town house	Livre	Book
Hôtel de vente	An establishment where auctions are held	Livret	Catalogue
		Long métrage	Feature film
Hôtel de ville	Town hall	Longueur	Length
Huile	Oil	Lumière	Light
		Lune	Moon
Icone	Icon	Lutte	Struggle
Iconographie	Iconography, study of significance of symbols and themes in art	Lycée	Secondary school
		Macramé	Hand-knotted fringe
Idéaliste	Idealistic	Madone	Madonna
Idée	Idea	Mages	Magi
Idolâtrie	Idolatry	Main	Hand
Il ne fit que	He only did, he only made	Maison	House
Il prit part	He took part	Maison natale	Birthplace
Il semble que	It seems that	Maître	Master
Illustré	Pictorial	Maître inconnu	Unknown master
Imitateur de	Imitator of	Majeur	Major
Impressionnisme	Impressionism	Malade	Sick
Imprimé	Printed	Maquette	Small rough model or sketch
Imprimeur	Printer	Marbre	Marble
Inconnu	Unknown	Marchand	Merchant, dealer, buyer
Incrustation	Inlay	Marin	Pertaining to the sea, seascape
Inférieur	Lower, inferior	Marque	Mark, imprint
Infini	Infinite	Matière	Material, subject, contents
Inné	Innate, inborn	Matière plastique	Plastic material
Inscrit	Inscribed	Matières textiles	Textiles
Intaille	Intaglio, incised or sunken design	Maure	Moor
		Melange	Blend, alloy of metals
Interne	Internal	Même	Same, self
Inventaire	Inventory	Même chose	Same thing, all one
		Menuisier	Joiner; cabinetmaker of plain or carved pieces
Jardin	Garden	Mer	Sea
Jaune	Yellow	Mère	Mother
Jeu de Paume	Tennis; name of the small building, which was once an indoor tennis court, now a part of the Musée du Louvre, Paris.	Méridional	Southern, person from southern France
		Mesure	Measurement
		Métal (plural: métaux)	Metal(s)
		Métier	Craft
Jeune	Young	Métrage	Measurement, film
Joie	Joy	Mètre	Meter, 3.28 feet
Journaux d'art	Art periodicals	Mettre	To put on, place
Jubé	Roodscreen in a church	Meubles	Furniture
Juif	Jew	Mezzo-tinto	Mezzotint
		Le Midi	The south of France
Lait	Milk	Milice	Militia
Laiton	Brass	Milieu	Center
Lancette	Lancet, a high narrow window with a pointed top	Millefleurs	Many different flowers (design on tapestries of 15th and 16th centuries)
Langue	Language	Millimètre	Millimeter, .039 inches
Lapidaire	Lapidary, stone inscriptions	Mineur	Minor
Laqué	Lacquered, enamelled	Mise	Placing, manner of dress, attire
Largeur	Width	Mise en scène	Setting, showing how figures or actors fit into the environment, production
Larron	Robber, thief		
Latérale	Side		
Lavé	Washed		
Légèrement	Lightly, swiftly	Miséricorde	Mercy; a small piece of wood attached to the underneath side of a choir seat upon which a standing singer can rest.
Legs	Legacy, bequest		
Leitmotiv	Themesong, any recurrent theme		
Lentille	Lens of a camera		
Lettre	Letter	Modèle	Model
Leur	Their	Moine	Monk, friar
Libéré	Liberated	Monastere	Monastery
Librairie	Book store	Monastique	Monastic
Libre	Free	Monde	World
Licet	Permission	Montage	Mounting, combining together a number of pictoral elements in one composition
Linéaire	Linear		
Linteau	Lintel		
Lis	Lily	Montagne	Mountain
Lisse	Smooth		

French	English	French	English
Monté	Mounted	Panneau	Panel
Monumentalite	Monumentality	Pape	Pope
Morceau	Piece, work, fragment	Papier	Paper
Mort	Dead	Pâques	Easter
Mosaïque	Mosaic	Parabole	Parable
Mou	Soft	Paradis	Paradise
Mouillé	Wet	Parchemin	Parchment
Moulage	Plaster cast, mold	Parfois	Sometimes
Moule	Mold	Parmi	Among
Moulure	Moulding	Parquet	Inlaid floor, often with geometric shapes
Mourut	Died		
Mouvement	Motion	Part	Share, part, portion, collaboration, concern
Moyen	Medium, middle		
Mur	Wall	Particulier	Particular, private, special
Musée	Museum	Partisan	Believer, supporter
Musée archéologique	Archaeological museum	Pascal	Paschal, pertaining to Easter or the Passover
Musée d'art	Art museum		
Musée des arts et métiers	Museum of crafts or decorative arts	Pâte dure	Hard paste
		Pâte tendre	Soft paste
Mystère	Mystery	Pater	Lord's Prayer
		Pauvre	Poor
N'a pas été restauré	Has not been restored	Pays	Country, land
Nature Morte	Still life	Paysage	Landscape
Né	Born	Péché	Sin
Nef	Nave	Pêche miraculeuse	Miraculous draught of fishes
Négociants d'art et d'antiquités	Art and antique dealers	Pêcheur	Sinner
Neige	Snow	Pêcheur	Fisherman
Nettoyé	Cleaned	Peintre	Painter
Neuf, neuve	New, inexperienced	Peinture	Paint, painting
Nicéen	Nicene	Peinture à l'huile	Oil-painting
Nimbe	Halo, nimbus	Peinture au pistolet	Spray-painting
Noces de Cana	Wedding at Cana	Peinture en mosaïque	Mosaic-painting
Noël	Christmas	Pèlerin	Pilgrim
Noir	Black	Pendaison	Hanging
Nom	Name, celebrity, noun	Pendant	Hanging, depending, during
Nom patronymique	Surname	Pendule	Clock
Non reproduit	Not reproduced	Père	Father
Nord	North	Périodique	Magazine, periodical
Notre-Dame	Our Lady	Pentecôte	Pentecost
Nouveau	New, recent	Petit	Small
Nouvelle	News, tidings, new, recent	Peuplade	Tribe, clan
Nu	Nude	Peuple	People, nation, crowd
Nuit	Night	Pied-droit	Jamb of the door, pillar, pier
Numéro	Number	Pied	Foot
		Pierre	Stone
Obélisque	Obelisk	Pinceau	Paint-brush
Obscurité	Darkness, dimness	Pionnier	Pioneer
Occidentale	The West, Europe and the Americas	Pittoresque	Picturesque, painterly
		Placage	Veneering (wood); plating (metal)
Œil	Eye		
Œuf	Egg	Plafond	Ceiling
Œuvre	Works of an artist taken singly or as a whole; production	Plage	Beach
		Plaie	Plague, wound, sore
Ombre	Shade, shadow, darkness	Planche	Plates, illustrations
On	People, they	Plancher	Floor
Onction	Anointing, unction	Plastique	Plastic
Or	Gold	Plâtre	Plaster
Orangé	Orange-colored	Plume	Pen
Ordre	Sequence, order	Pochade	Rough sketch, value study
Orfèvrerie	Gold or silver ware; jewelry	Poids	Weight
Orgues	Organ	(au) Point	In focus
Os	Bone	Poli	Burnished, polished
Ostensoir	Monstrance, a receptacle that holds and exposes the consecrated wafer or Host	Polyptyque	Polyptych, a work of art composed of several hinged panels
Ouest	West		
Outragé	Insulted, outraged	Pomme	Apple
Ouvert	Open	Pont	Bridge
Ouvrage	Work	Pont-levis	Drawbridge
Ove	Egg shaped	Populaire	Popular, folk
		Porcelaine	Porcelain
		Portail	Chief doorway, portal
Païen, païenne	Pagan	Porte	Door
Paix	Peace, tranquillity	Portefeuille	Portfolio, wallet
Palais	Palace		

French	English	French	English
Portement de la croix	Christ carrying the cross	Religieux, religieuse	One who belongs to a religious order
Possédé	Possessed	Reliquaire	Reliquary
Poterie	Pottery	Relique	Relic
Postérieur	Behind, subsequent	Reliure	Bookbinding
Pouce	Inch; thumb	Remise	Delivery
Pourpre	Purple	Reniement	Denial
Prêché	Preached	Repas	Meal
Précis	Precise	Répertoire	Table, index, catalogue, repertory
Prédécesseur	Predecessor		
Premier	First	Réplique	Replica; rejoinder
Préromane	Pre-Romanesque	Repos	Rest, repose
Près	Near, by	Repoussé	Thin sheet of metal with raised design produced by hammering the back side of the sheet
Prêt	Loan, ready, prepared		
Prêteur, prêteuse	Lender		
Prêtre	Priest		
Prie-dieu	Piece of furniture at which an individual kneels to pray	Ressuscité	Risen
Prière	Prayer, request	Restauré	Restored
Prieuré	Priory	Rétable	Altarpiece
Primitif	Early; primitive	Rêve	Dream
Printemps	Spring	Rinceau	An ornament composed of scrolls and a floral motif
Prix	Price; cost; value; prize		
Prix de Rome	A scholarship awarded annually in France; the recipient receives a stipend to study art in Rome	Robe	Dress
		Roche	Rock
		Roi	King
		Roman	Romanesque
Procédé	Process	Rond	Round
Proche	Near	Roue	Wheel
Profondeur	Depth	Rouge	Red
Projet	Project	Rue	Street
Prolongé	Elongated	Ruine	Ruin, decay (of a building)
Prophète	Prophet		
Propos (à propos)	Words, remark (apt)	Sacré	Holy
Provenance	Origin, source	Sage	Wise
Publié	Published	Saison	Season
Pudeur	Modesty	Salière	Salt cellar
Puis	Then, next, besides	Salle	Large room, hall, gallery of museum
Puits	Well; pit		
		Salon	Exhibition; drawing room
Quart	Quarter, fourth part	Sang	Blood
Quatre-feuilles	Quartrefoil	Sans	Without
Que (ne . . . que)	Whom, which, that, what, if, as, (only)	Sarcophage	Sarcophagus, stone coffin
		Sarrasin	Saracen
Quelque	Some; any; a few	Sauveur	Savior
Queue	Tail; end; rear	Savant	Expert, scholarly
Qui (à qui?)	Who, whom, which, that, (to whom)	Sceau	Seal, stamp
		Scénario	Screen play
Quoi	What, which	Sculpteur	Sculptor
Quotidien	Daily	Sec	Dry
		Seigneurie	Domain of a lord
Raccourcissement	Foreshortening in art	Sein	Bosom
Raisin	Grape	Séjourna	Stayed, sojourned
Raison	Reason, judgment	Sens	Sense (of touch, sight, direction)
Rameau	Palm		
Rangé	Odered, tidy	Sépulcre	Sepulcher, tomb
Rapport	Profit, relation, connection	Seulement	Only
Ravissement	Rape; rapture	Signalement	Description
Réalisme	Realism	Signé	Signed
Réalité	Reality	Signification	Meaning
Recherche	Research	Silencieux	Silent
Reconnu	Recognized, accepted	Singerie	Representations of monkeys
Recto	Front side of a work of art; right-hand page	Socialiste	Socialist
		Société	Association
Reçu	Recognized, accepted, received	Soeur	Sister
Recueil	Collection, miscellany, selection	Soleil	Sun
Rédacteur	Writer, editor	Sommaire	Summary
Réduit	Reduced	Sommeil	Sleep
Refaite	Rebuilt; repaired	Sommet	Top
Réflexion	Reflection	Songe	Dream
Règne	Reign	Souci	Care, anxiety
Régulièrement	Regularly, exactly	Soudé	Welded
Reine	Queen	Sourd	Deaf
Rejeté	Rejected		

French	English	French	English
Souriante	Smiling	Trame	Weft and woof in weaving
Sous	Under, below, with, upon, by	Travail (plural: travaux)	Work(s)
Souterrain	Subterranean	Trésor	Treasure
Souverain	Ruler	Triptique	Triptych, three panels or pictures hinged together
Squelette	Skeleton		
Statique	Static	Trompe-l'œil	A painting which at a distance gives an illusion of reality; deceiving the eye
Stylisé	Stylized		
Sud	South		
Suite	Those that follow, series	Trône	Throne
Suivant	Following, next	Trouvé	Found
Suivant de	Follower of	Trumeau	Pier between two doors supporting the lintel
Sujet	Subject		
Supplice	Pain, anguish, torture	Tua	Killed
Sur	On, over, in, about	Tympan	Tympanum
Surmoulage	Process of duplicating a bronze statue		
		Urne	Urn
Symbole de Nicée	Nicene Creed		
		Valeur	Value
Table des matières	Table of contents	Vécut	Lived
Tableau	Painting, picture, scene	Vélin	Vellum
Tailleur	Tailor, cutter	Vénitien	Venetian
Tapis	Carpet	Vent	Wind
Tapisserie	Tapestry	Vente	Sale
Tard	Late	Vérité	Truth
Tasse	Cup	Vernis	Varnish
Technologie	Technology	Verre	Glass
Teinte	Hue, tint, shade	Verrerie	Glass-works, glassmaking
Tempête	Tempest, storm	Vers	About, toward
Temps	Time	Verso	Reverse side of a work of art
Ténébristes	Tenebrists, users of sharply contrasted light and dark tones in paintings	Vert	Green
		Vertu	Virtue, chastity
		Victorien	Victorian
Tentateur	Temptor	Vie	Life
Tentation	Temptation	Vieillard	Old man
Tenture	Hangings, tapestry	Vierge	Virgin
Terme	Term	Vieux, vieil, vieille	Old, ancient
Terre	Earth	Vif, vive	Vivid (colors)
Terre cuite	Terra cotta	Ville	City, town
Tête	Head	Visage	Face, counterance
Théière	Teapot	Viscosité	Viscosity
Tirage	Drawing, hauling	Vitrail (plural: vitraux)	Stained-glass window(s)
Tissage	Weaving	Vivant	Alive
Tissu	Cloth	Voir	To see
Titre	Title, style	Vol	Flight; theft
Titres abrégés	Abridged titles	Volet	Shutter
Toile	Canvas	Voussoir	Wedge-shaped stone of an arch
Toile de Jouy	Finely woven cotton fabric printed with a classical scene	Voussure	The curve of an arch
		Voûte	Arch, vault
Toile de lin	Linen	Vrai	True, genuine
Toit	Roof	Vue	View
Tombeau	Tomb	Vue aérienne	Aerial view
Tome	Volume	Vue générale	General view, over-all view
Tour	Tower		

German-English Dictionary

The German language forms new words by the continuous additions of terms without any hyphens to assist the reader in their recognition; consequently, if words are separated, their meaning can often be discovered. For instance, in the word, *Phantasiekunst, Phantasie* stands for fantasy or inventiveness; *kunst,* for art. The researcher may need to try to divide some of the longer German words in order to learn their definition.

Words which are the same or similar to the English equivalent have not been included; such as *Allegorie, Archiv,* and *Film.* Most nouns in German form the plural by adding an *n, en, nen, e,* or *er.* The basic definite articles are *der* (masculine), *die* (feminine), *das* (neuter), *die* (plural); while the indefinite articles are *ein* (masculine and neuter), and *eine* (feminine). The subject pronouns are *ich* (I), *du* (you), *er* (he), *es* (it), *sie* (she), *wir* (we), *ihr* (you), *sie* (they), and *sie* (you). The negative is usually formed by placing a form of *kein* (no, not any) before a noun or *nicht* (not) in front of a verb or adverb.

All nouns are capitalized in German, no matter where they are placed in a sentence or a title. An umlauted vowel—ä, ö, ü—is sometimes written with an e—ae, oe, ue. The German script of *β* has been replaced with a double s in this dictionary.

German	English
Abänderung	Variation, modification
Abbildung	Illustration
Abdruck	Print, reproduction
Abendmahl	Supper
abklären	To clarify
abliefern	To deliver
Abmessung	Dimension
Abnahme	Taking down, decrease
Abrahams Schoss	Abraham's bosom, heaven
Abstrakte	Abstract
Abstraktgëmalde	Abstract painting
Abstufung	Gradation
Abtei	Abbey
Adressbuch	Directory
Ähnlichkeit	Likeness
Akademie	Academy
akademisch	Academic
Akt	Nude model, act
aktiv	Active
Allegorie	Allegory
allgemein	Common, general
alphabetisch	Alphabetical
alt	Ancient, old
Altargëmalde	Altarpiece
Altartafel	Altarpanel
altchristliche	Early Christian
Alter	Age
Ältere	Elder
altertümlich	Archaic
Altertumsforscher	Archaeologist
Anatomie	Anatomy
Anbetung	Adoration, admiration
Anbetung der Könige	Adoration of the Kings
Anblick	Aspect
Andachtsbild	Devotional image
andere	Other
Anerkennung	Acknowledged by, acknowledgment
Anfang	Beginning, origin
Anfänger	Beginner
Angeboren	Inborn, native

German	English
Angevin	Anjou, a province in western France
Anhänger	Disciple
Anleihe	Loan
Anmerkung	Note, comment
Anonym	Anonymous
Anordnung	Arrangement
Anschein	Appearance
Anschluss	Connection
Ansicht	View, opinion
Antiquariat	Antiquarian, dealer in old and rare books
Antiquitäten	Antiques
Antiquitäten-handlungen	Antique dealers
Antritt	Accession; start; entry room
Anzeige	Review
Apfel	Apple
Apokalypse	Apocalypse
Apostel	Apostle
Apsis	Apse
Aquarell	Watercolor
Aquarellmalerei	Watercolor painting
Arabeske	Arabesque
Arbeit	Work
Arbeiter	Worker
Archäolog	Archaeologist
Architekt	Architect
Architektur	Architecture
Archivolte	Archivolt
arm	Poor
Aspekt	Aspect
ästhetisch	Aesthetic
Atelier	Studio
Atmosphäre	Atmosphere
Ätzdruck	Etching
auch	Too, also
auf	In, on, upon, at
Auferstehung	Resurrection
Auflage	Edition of printing, contribution
aufrichten	To raise, to erect
Aufsatz	Article, essay
Aufsteig	Ascension, rise
Auge	Eye
Auktion	Auction
Auktionator	Auctioneer
Ausarbeitung	Elaboration, composition
Ausdruck	Expression, term
Ausführung	Execution
Ausgabe	Expenses
Ausgang	Exit, end
ausgestellt	Display
Auslegung	Interpretation
Ausmass	Scale, measure, degree
Ausschuss	Refuse, waste; best part; choice; committee
ausserhalb	Outside, beyond
aussetzen	To expose, to display
ausstellen	To exhibit
Ausstellung	Exhibition
Ausstellungshaus	Exhibition house
authentisch	Authentic

German	English	German	English
bald	Soon	Bildschnitzer	Wood-carver
Band	Volume	Bildstecher	Engraver
Barbar	Barbarian	Bildstreifen	Reel of film
Barock	Baroque	Bildtafeln	Illustrations
Barockstil	Baroque style	Bildung	Formation, fashion
Basilika	Basilica	Bildunterschrift	Title beneath illustration; signature on picture
Bau	Building, construction		
Bauart	Style of architecture	Biographie	Biography
Baukunst	Architecture	bis	Until, to, up to
Baukünstler	Architect	Bischof	Bishop
Bauleute	Builders	Bischofsmütze	Mitre
Baum	Tree, pole	Blatt	Newspaper, sheet of paper
Baum der Erkenntnis	Tree of Knowledge	blau	Blue
Baum des Lebens	Tree of Life	Bleistift	Pencil
Baumeister	Master builder	Blick	View, look
bedeutend	Important, significant	Blitz	Flash, lightening
bedeutungsvoll	Meaningful, significant	Blumen	Flowers
beendigen	To terminate	Blumenschmuck	Floral decoration
befreien	To liberate	Blumenstrauss	Bouquet of flowers
Begräbnis	Entombment	Blumenstück	Flower painting
Begriff	Concept, notion	Blut	Blood
behandeln	To handle, to manipulate	Boden	Bottom, ground
bei	Near	Bogen	Arch, bend, curve
Beiblatt	Supplement	braun	Brown
beide	Both	Braut	Betrothed
Beifügung	Addition	breit	Broad, flat, wide
beimessen auf	To attribute to	Brennpunkt	Focus
Beispiel	Example, illustration	Broschüre	Brochure, pamphlet
beitragen	To contribute	Bruchstück	Fragment
Beiwerk	Accessories	Brücke	Bridge
bekannt	Known	Bruder	Brother
Beleuchtung	Illumination	Brunnen	Well
bemalen	To paint over	Buch	Book
Bereich	Scope, sphere, area	Buchdeckel	Book cover
Bericht	Report	Bücherkunde	Bibliography
Berg	Mountain	Buchhändler	Bookseller
Beschreibung	Description	Buchhandlung	Bookstore
Beschriftung	Inscription, legend	Buckel	Bulge, bump
Besitz	Possession, property	Bühne	Stage
Bestiarium	Bestiary	buntes Glas	Stained Glass
betiteln	Entitled, name, style	Bürste	Brush
Beton	Concrete	Byzantinisch	Byzantine
Betrug	Fake		
Beweggrund	Motive	Chor	Choir
beweglich	Mobile, movable	Chorhaupt	Chevet; eastern or apsidal end of church
Beweinung Christi	Lamentation over the Dead Christ		
		Chorumgang	Ambulatory, choir gallery or passage
Beweisstück	Document		
bewundern	To admire	Christfest	Christmas
Bewusstsein	Awareness, knowledge	Christus	Christ
bezeichnend	Significant, characteristic	christlich	Christian
Bibliographie	Bibliography	Chrom	Chrome
Bibliothek	Library		
biblisch	Biblical	Dachboden	Attic
Bild	Picture, image, portrait	damalige	Of that time, then
bilden	To form, fashion, model	Dämon	Demon
bildend	Plastic, graphic	Dankopfer	Thank offering
Bildende Künste	Fine arts	dann	Then, at that time
Bildergallerie	Picture gallery	darbringen	To present, to offer
Bilderhändler	Picture-dealer	Darlegung	Exposition
Bilderhandschrift	Illuminated manuscript	Darstellung	Representation, presentation, exhibition
bilderstürmend	Iconoclastic		
Bildgrösse	Size of image	Darstellung im Tempel	Presentation in the Temple
Bildhauer	Sculptor	daselbst	There
Bildhauerarbeit	Sculptured piece	datiert	Dated
Bildhauerkunst	Sculpture	Datum	Date
bildlich	Pictorial, graphic	Decke	Ceiling, covering
Bildner	Sculptor, molder	Deckel	Cover, lid
Bildnis	Portrait, likeness	dekorativ	Decorative
Bildniskunde	Iconography	Dekoration	Scenery
bildsam	Plastic, adaptive	dekorieren	To decorate, to adorn
Bildsäule	Statue	dem	To whom, to which, to the
Bildsäule zu Pferde	Equestrian Statue		

German	English	German	English
derselbe	Same	Farbe	Color, hue, paint
Diapositiv	35 mm. slide	Farbstoff	Pigment
Diaverzeichnis	List of slides	Farbwert	Value of color
Dichter	Poet	Fassade	Facade
Diptychon	Diptych	fassen	To mount, to grasp
Direktor	Director	Feder	Feather
Dom	Cathedral, dome, cupola, vault	Fels	Rock, cliff
Dominikaner	Dominican	Festung	Fortress
Doppel	Duplicate, double	Feuer	Fire
dorisch	Doric	Figur	Figure
Drehbuch	Screen play	Firnis	Varnish
Dreifaltigkeit	Trinity	flach	Plane, low, flat
Drucker	Printer	Flachbildwerk	Bas-relief
dunkel	Dark, gloomy	Flasche	Flask, bottle
Dunkelkammer	Dark room	Flatterhaft	Volatile; fickle
durch	Through, by, across	fliessend	Smooth; flowing
Durchbrochenes	Triforium, something perforated	Flucht nach Ägypten	Flight to Egypt
		Flügel	Wing, arm; grand piano
Durchmesser	Diameter	Fluss	River
durchscheinen	To shine through	Folge	Series
		Forscher	Scholar, researcher
Ebenbild	Image	Forschung	Research
Ebenholz	Ebony	fortwährend	Continual
echt	Authentic	Franziskanermönch	Franciscan monk
Ehebrecherin	Adultress	Frau	Woman; wife
Eichenholz	Oakwood	Freiheit	Freedom
Einblick	Insight	fremd	Foreign
einfach	Simple	Fresko	Fresco
einfarbig	Monochromatic	Freude	Joy
Einfluss	Influence	Friedhof	Cemetery
einige	Some, several	früh	Early
Einlegeholz	Veneer	Frühling	Spring
Einlegen	Inlay	Frührenaissance	Early Renaissance
Einleitung	Introduction, preface	Führer	Guide, guide-book, leader
einschliesslich	Included	Führung	Tour, guide
einschreiben	To inscribe	für	For, instead of, against
Einsicht	Insight	fürbitte	Intercede
einzel	Particular, single	Furcht	Fear
Einzelheit	Detail	Furnier	Veneer
Eisen	Weapon, sword, iron	Fuss	Foot
Elfenbein	Ivory	Futurismus	Futurism
Emaille	Enamel		
Empfänger	Receiver, recipient	Gabe	Gift, donation
Engel	Angel	Galerie	Gallery
Entarte Kunst	Degenerate Art	ganz	Entire, entirely
entgegensetzen	To contrast	Garten	Garden
entwickeln	To develop	Gärtner	Gardner
Entwicklung	Evolution, development	Gastmahl	Banquet, dinner party
Entwurf	Design, sketch	Gattungsmaler	Genre-painter, one who depicts subjects of everyday life
Erde	Earth, ground		
Erdbeere	Strawberry	Gebäude	Building
Erfahrung	Experience	geboren	Born
Erhöhung	Rising, raising	Geburt Christi	Nativity
Erinnerungsbild	Memory pictures, memorial pictures	Geburtsort	Birthplace
		Gedenktafel	Plaque
Erklärung	Explanation, interpretation	Gefangenschaft	Captivity
Eroberer	Conqueror	Gefäss	Vessel
Eröffnung	Opening day (of an exhibit)	geflügelt	Winged
erscheinen	To appear	Gefüge	Texture; joining together
erst	First, prime	Gegen	Towards, opposed to, against, about
Erwähnung	Mention		
Erwerb	Acquisition	Gegensatz	Contrast
Erzherzog	Archduke	Gegenstand	Object, subject matter, theme
etwa	About	gegenüberstehen	To oppose
Evangelium	Gospel	Gehalt	Content
Expressionismus	Expressionism	Gehäuse	Case, casing
		gehören zu	To belong to
Fabelwesen	Fabulous creature	Geisselung Christi	The Flagellation
Fabrikat	Artifact	Geist	Spirit
Fach	Compartment	gelb	Yellow
Fahrt	Journey, trip	Geld	Money
falsch	False	Gelehrter	Scholar
Familie	Family		

German	English	German	English
Gemälde	Picture, painting	Greis	Old man
Gemäldegalerie	Picture gallery	Grenze	Limit, border
gemäss	Measure	gross	Large, tall
gemein	General, common	Grösse	Size, dimension
Gemetzel	Massacre	grösser	Bigger, higher
genannt	Surnamed, called	Gruft	Vault, tomb
genau	Precise	Gruftkirche	Crypt
Genosse	Partner, associate	grün	Green
Genrebild	Painting of scenes of everyday life	Grund	Ground, basis
		Grundfarben	Primary colors
Genremaler	Painter of scenes of everyday life	grundlegend	Fundamental
		Gründung	Foundation
Genreszenen	Scenes of everyday life	Guss	Pouring out, casting
genug	Enough	gut	Good
Geometrik	Geometric		
geradlinig	Rectilinear	Hafen	Harbour, port
gerecht	Just	Hälfte	Half, middle
Gerechtigkeit	Justice	Haltung	Attitude
gereinigt	Cleaned	Handlung	Action, act (play)
gering	Minor; limited	Handschrift	Manuscript
Gesamtbild	The whole picture	Handwerk	Handicraft
Geschenk	Gift	Handzeichnung	Sketch, drawing
Geschichte	History; story	Hauptfarbe	Primary color
Geschichtlichkeit	Historical relevance, authenticity	Hauptteil	Principal section
		Hauptwerke	Principal work
Geschicklichkeit	Skill	Haus	House
geschnitzelt	Chipped, cut	heilig	Sacred, holy
Gesellschaft	Society	heiliger	Saint
Gesicht	Face	Heim	Home
Gesichtspunkt	View-point	Heimsuchung	Visitation
Gestalt	Form, figure, shape	Heirat	Marriage of
Geste	Gesture	hell	Bright, clear
Gestell	Framework, support, easel	Helldunkel	Chiaroscuro
gestern	Yesterday	Herausforderung	Challenge
gestorben	Died	Herausgeben	Publish, edit
gewaltsam	Violent; powerful	Herausgeber	Editor, publisher
Gewand	Garment	Herkunft	Provenance, origin
Gewebe	Texture, weaving	Herrschend	Dominant
Gewerbekunde	Technology	Herrscher	Ruler
Gewicht	Weight	Herz	Heart
Gewölbe	Arch, vault	Herzog	Duke
Gewölbepfeiler	Buttress	Himmel	Heaven, sky
Gewölbestütze	Flying buttress	Himmelfahrt	Ascension
gezeichnet	Signed; designed	Hindernis	Obstacle
Giebelfeld	Tympanum, pediment	hinter	After, behind
Glanz	Brightness	Hintergrund	Background
Glas	Glass	Hinzufügung	Addition
glasen	To glaze	Hirt	Shepherd
Glasmalerei	Painting on glass	hoch	High
Glasur	Glaze	Hochländer	Highlander
glatt	Smooth	Hochzeit zu Kana	Wedding at Cana
Glaube	Faith	Hof	Palace, courtyard, farm, country house
Gleichgewicht	Balance		
Gleichnisse	Parables; similarities	Hoffnung	Hope
Glockenspiel	Clock which works with bells and has figures that move	Höhe	Height, elevation, top
		Hölle	Hell
Glockenturm	Clock tower	holperig	Bumpy
Glossar	Glossary	Holz	Wood, timber
Goldenes Zeitalter	Golden Age	Holzkohle	Charcoal
Goldschmiede-arbeiten	Goldsmith's work	Holzmosaik	Wood inlaying
gotisch	Gothic	Holzschneider	Wood-carver
Gott	God	Holzschnitt	Woodcut
Gottähnlich	Devine	Horizont	Horizon
Gotteshaus	Temple, church, chapel	Humanismus	Humanism
Götzenbild	Idol	Hunne	Hun
Grab	Tomb	Hut	Hat
Grablegung	Burial		
Granatapfel	Pomegranate	idealistisch	Idealistic
Graphik	Graphics	Idee	Idea
Graphiker	Graphic artist	Ikon	Icon
grau	Grey	immer	Always
Graveur	Engraver	Impressionismus	Impressionism
Gravüre	Engraving		

German	English	German	English
Ingenieur	Engineer	Klostergang	Cloister walk
Inhalt	Contents, subject, volume	Klugheit	Prudence
Inszenierung	Setting, actors or sculpture set in an environment	Kluniazensermönch	Cluniac monk
		Knabe	Boy
Intensität	Intensity	Knochen	Bone
Inventar	Inventory	Koje	Stall, berth, cabin
inwendig	Inner	koloriert	Illuminated; colored
irrtümlich	Erroneous	kompliziert	Complex
isoliert	Isolated	Komposition	Composition
		König (Königin)	King (queen)
Jahreszeit	Season	Königreich	Kingdom
Jahrgang	Annual (of a book)	Konzil	Council
Jahrzehnt	Decade	Kopf	Head
jeder	Every, each	Kopie	Copy
jeweils	At any given time	Körper	Body
Jude	Jew	Kostüm	Costume
Jungen	Boys	Kreide	Chalk
Jüngere	Younger	Kreis	Circle; district
Jungfrau	Virgin	Kreuz	Cross, crozier, crucifix
Jüngling	Youth, young man	Kreuzgang	Cloisters
jüngst	Latest, recent; youngest	Kreuzigung	Crucifixion
Juwel	Jewel, gem	Krieg	War
		Kristall	Crystal
Kalender	Calendar	Kritiker	Critic
Kamee	Cameo	Krone	Crown
Kamera	Camera	Krönung	Coronation of
Kampf	Struggle, battle	kubisch	Cubic
Kanne	Jug, tankard, pot	Kubismus	Cubism
Kapelle	Chapel	Kulisse	Scenery for theater
Kapetinger	Capetians, a ruling house of France	Kult	Cult, worship
		Kultur	Culture
Kapitell	Capital	Kulturgeschichte	History of Civilization
Kapselfarbe	Color from a tube	Kulturkreis	Cultural circle
Karikatur	Caricature	Kunst	Art, skill
Karmeliter	Camelite	Kunstakademie	Art school
Karolingisch	Carolingian	Kunstausstellung	Art exhibition
Kartäusermönch	Carthusian monk	Kunstbuchhandlung	Art book store
Karton	Cardboard; box	Kunstdruckerei	Printers of fine art works
Kastchen	Casket	Künste	Art, skill
Katalog	Catalogue	Kunstgewerbe	Practical arts, arts and crafts
Kathedrale	Cathedral	Kunstgewerbemuseum	Museum of crafts or decorative arts
Kauf	Purchase		
Kelch	Chalice	kunsthistorisch	Art historical
Keramik	Ceramics	Kunstkenner	Connoisseur
Kerze	Candle	Künstler	Artist
Kette	Necklace, chain	Künstlerlexikon	Directory of Artists
Keuschheit	Chastity	Kunstmuseum	Art museum
Kind	Child, infant	kunstreich	Artistic
Kinderporträt	Child's portrait	Kunstrichter	Art critic
Kindheit	Infancy	Kunstsammlung	Art collection
Kinematographie	Motion picture	Kunstschule	Art academy
Kino	Cinema, movie house	Kunsttheorie	Art theory
Kirche	Church	Kunstverein	Art Association
Kirchenbann	Excommunication	Kunstverleger	Art publisher
Kirchenchor	Choir	Kunstzeitschriften	Art periodicals
Kirchenfrevel	Sacrilege	Kupferstich	Copper plate engraving
Kirchenfürst	Prelate	Kupferstecher	Engraver
Kirchengerät	Sacred vessels or garments	Kupferstich	Copper engraving
Kirchengesetz	Ecclesiastical canon	Kupido	Cupid
Kirchenglaube	Dogma, creed	Kuppel	Dome
Kirchenlehrer	Early church father	Kurfürst	Elector (in the German states)
Kirchenordnung	Church ritual	Kurve	Curve
Kirchenschiff	Nave	kurz	Short
Kirchenstuhl	Pew		
Kirchenvater	Church father	Lack	Varnish
Kirchhalle	Church porch	Lackarbeit	Lacquered work
Kirchspiel	Parish	Lackfirnis	Lacquer
Kirchturm	Steeple	Lage	Position, location
Kitsch	Rubbish, inartistic trash	Landesmuseum	State museum
klassisch	Classical	Landschaft	Landscape
klein	Small, short	Landschafstmaler	Landscape painter
Kleinkindesalter	Infancy	lang	Lengthy, long
Kleinplastik	Small sculpture		

German	English	German	English
Länge	Length, size	Metall	Metal
lapidarisch	Lapidary, inscriptions on stones	Methode	Method
Laster	Vice	Miniatur, Miniaturbild	Miniature
laut	Loud, noisy; in accordance with	Mirakel	Miracle
Leben	Life, exist	Mirakelspiel	Miracle Play
lebendig	Alive	mit	With, by, as, to
lebensgross	Life size	Mitarbeiter	Assistant, collaborator
lebhaft	Vivid, bright, lively	Mitglieder	Members
Legende	Legend	Mittel	Medium, center, middle, means
Lehrer	Teacher	Mittelalter	Middle Ages
Leidenschaft	Passion	mittelalterlich	Medieval
Leihweise	On loan	Mittelpfeiler	Trumeau, center pier between two doors supporting the lintel
Leinen	Linen		
Leinwand	Canvas		
Leitmotiv	Recurring theme, leading motif	Mitteltafel	Middle panel
letzt	Latest, final, last	Möbel	Furniture
Licht	Light	Modell	Model
licht	Clear, bright	Moderne Kunst	Modern Art
Lichtbild	Photograph	Mohr	Moor, Negro
Liebe	Love, charity	Mönch	Monk
Liebe Frau	Our Lady, Virgin Mary	Mönchskloster	Monastery
Lieferung	Part, issue	Monumentalität	Monumentality
Lilie	Lily	Mosaik	Mosaic
Linie	Line, rank	Münze	Coin, medal
link	Left	Muschel	Shell
Linse	Lens of a camera	Museumsleiter	Museum director
Literatur	Literature	Musik	Music
Lithographie	Lithography	Musikinstrumente	Musical instruments
Lokalfarbe	Natural color	Muster	Design
		Mutter	Mother
Macht	Power	Mysterium	Mystery
Magier	Magi	Mystisch	Mystical
Mahl	Meal		
malen	To paint, portray	nach	After, towards, according to, to
Maler	Painter, artist	Nachahmung	Imitation, forgery
Malerei	Painting, picture	Nachantike	Pre-classical antiquity
Malerfarbe	Paint	Nachbildung	Replica
Malergold	Ormolu, gilded metal emulating gold	nachdem	After
		Nachdruck	Emphasis, reprint, reproduction
malerisch	Artistic, picturesque	Nachfolge	Imitation of
Malerkunst	Art of painting	Nachfolger	Follower of
Malerleinwand	Canvas	Nachricht	Report, account
Malerpinsel	Paint brush	Nächst	Next
Malerscheibe	Palette	Nächstenliebe	Charity
Malerschule	School of painting or for painters	Nachtrag	Addendum, supplement
		nackte Figur	Nude
Malerstaffelei	Easel	Namen	Name, title
manchmal	Sometimes	namenlos	Anonymous
Manieriertheit	Mannerism	Narr	Fool
Mann	Man; husband	nass	Wet
Männliches Bildnis	Portrait of a gentleman	Natur	Nature
Manuskript	Manuscript	natürlich	Natural
Marinemaler	Seascape painter	nautisch	Nautical
Marmor	Marble	neben	Beside
Mässigkeit	Temperance	Neigung	Tendency, inclination
masstäbliche Zeichnung	Scale drawing	neu	New, recent
Materie	Matter	Neuerung	Innovation
Mauer	Wall	neutestamentliche	Of the New Testament
Mauergemälde	Mural	neuzeitlich	Modern
Mauerzierat	Wall decoration	nicht	Not
Maurer	Mason	Niederlage	Defeat; warehouse
Medaille	Medal	Niedriger	Lower; inferior
Meeresfelsen	Seacliff	Nonne	Nun
mehere	Several	Nord	North
mehr	More	nötig	Necessary
Meister	Master	Nummer	Number
Meisterstück	Masterpiece	nur	Only
Mensch	Mankind, human being		
Mensur	Measure	oben	On high, above
Merkzeichen	Hallmark	oberhalb	At the upper part, above
Merowinger	Merovingian	Oberteil	Top
Messing	Brass	obige	Above mentioned
Messung	Measurement		

German	English	German	English
Objekt	Object	Produktion	Production
oder	Otherwise, or	Projekt	Project
offen	Open	Prozess	Process
offenbar	Manifest	Prozessionskreuz	Procession of the cross
Offenbarung	Apocalypse; revelation	Publikum	Public
öffentlich	Public	Punkt	Point
Öffnungzeit	Opening time	purpur	Purple
oft	Often	Putz	Ornament, plaster
ohne	Except, without		
Öl	Oil	Quadrat	Square
Ölfarbe	Oil color	Quellen	Sources
Ölgemälde	Oil painting	Querschiff	Transept
Ölmalerei	Oil painting		
optisch	Optical	Rad	Wheel
Orange	Orange-color	Radierung	Etching
organisch	Organic	Rahmen	Frame
organisieren	Organize	Rand	Border
Orgel	Organ	Rathaus	Town hall
Orgelchor	Organloft	rauh	Rough
Originell	Original	Raum	Space, room, place
Ort	Place	Realismus	Realism
Osmane	Ottoman	Rechnung	Bill, account
Ost	East	Recht	Right
Ostasien	Far East	rechtfertigen	Justify
Ostern, Osterfest	Easter	Rede	Conversation, speech
Ozean	Ocean	Register	Table of Contents
		Reich	Empire, state, reign
Palast	Palace	reich	Rich
Paneel	Panel, wainscot	Reihenfolge	Sequence
Papier	Paper	rein, reinlich	Clean
Pappelholz	Poplar wood	Reiter	Rider, horseman
Papst	Pope	reparieren	Repair
Parabel	Parable	Reproduktion	Reproduction
Pastell	Pastel, crayon	republikanisch	Republican
Pastellfarbe	Pastel color	Rest	Remains
Pastellgemälde	Pastel painting	Restaurator	Restorer
Pastellmaler	Pastel painter	rhythmisch	Rhythmic
Pastellstift	Crayon	Richtung	Direction, course, tendency
Pater	Father	Riese	Giant
Pergament	Parchment	Rokoko	Rococo
Periode	Period	romanisch	Romanesque
Perspektive	Perspective	Romanschriftstellar	Novelist
Pfarrkirche	Parish church	Romantik	Romanticism
Pfeil	Pillar	Rosenkranz	Rosary, garland of roses
Pfingsten	Pentecost	rot	Red
Phantasie	Fantasy, inventiveness	Rückseite	back, reverse side
phantastisch	Bizarre	Ruf	Reputation
Phasen	Phases	rund, rundlich	Round
philosophisch	Philosophical	Rundschau	Review
Photographie	Photograph		
physisch	Physical	Sach	subject
Pionier	Pioneer	sachdienlich	Relevant
Plakat	Poster	Sachkundiger	An expert
Planung	Planning	Sachregister	Table of Contents, Index to Subjects
plastisch	Plastic; formative		
platt	Flat	Sachwörterbuch	Encyclopedia
Platte	Printing or etching plate	Sage	Fable, myth, saga
Platz	Place	Salzfass	Salt-cellar
polieren	Burnish; polish	Sammler	Collector
Polyptychon	Polyptych	Sammlung	Collection
Popular	Pop	Sankt	Saint
Porträt	Portrait	Sarazene	Saracen
porträtieren	To portray	Sättigung	Saturation of color, purity of color
Porträtmaler	Portrait painter		
Porzellan	Porcelain	Säule	Column
prächtig	Magnificent	Schabkunst	Messotint
Prachtseite	Display side	Schafe	Lamb
Präraphaelit	Pre-Raphaelite	Schäfer	Shepherd
Predigt	Sermon	Schaft	Shaft, handle, stick
Primitiv	Primitive	Schale	Bowl
Prinzip	Principle	Schatten	Shade, shadow
privat	Private	Schatzkammer	Treasury
Privatsammlung	Private collection		

German	English	German	English
Schatzkästlein	Casket, box	Stellung	Attitude; position
Schau	View, review, exhibition	sterben	Die
Schauspiel	Spectacle, play	Stern	Star
Schauspieler	Actor	Stickerei	Embroidery
scheiden	Separate, part, depart	Stifter	Donor
Schiff	Boat, nave	Stil	Style
Schild	Shield, escutcheon, sign	stilisieren	Stylize
Schlacht	Battle	still	Silent, quiet
Schlaf	Sleep	Stilleben	Still life
schlecht	Bad, poor	Stoff	Cloth
Schliesse	Clasp	Strand	Shore, beach, seashore
Schloss	Palace	Strasse	Street
Schluss	End, conclusion	streben	Strive
Schlüssel	Key	Strebepfeiler	Buttresses
Schneelandschaft	Snow landscape	Streich	Stroke
Schnitzer	Wood-carver	streng	Severe, rough, stiff, sharp
Schnitzwerk	Wood-carving	Struktur	Structure
schön	Beautiful, lovely	Stunde	Hour
Schöne Künste	Fine Arts	Sturm	Storm
Schönfärberei	Dyeing, coloring, embellishment	Sturz	Fall, plunge
		Sturze	Lintel; cover
Schönheit	Beauty	Subjekt	Subject
Schoss	Bosom, lap	Süd	South
Schrein	Cabinet, shrine	Sünder	Sinner
Schriftsteller	Writer	Surrealismus	Surrealism
Schule	School	Symmetrie	Symmetry
Schüler	Pupil	synthetisch	Synthetic
Schützen	Protect	Szene	Scene, stage
Schutzheiliger	Patron saint		
schwarz	Black	Tafel	Tablet, plaque
schwer	Heavy, difficult	Täfelung	Wainscoting
Schwester	Sister	Tagesbericht	Bulletin
schwinden	Fade	täglich	Daily, every day
Seele	soul	Tapete	Hanging, tapestry
Seelenstärke	Fortitude	Tasse	Cup
Sehkraft	Vision	Täter	Doer, author
Seite	Page, side	tätig	Active, employed, engraved
Seitengebäude	Wing of building	Tätigkeit	Occupation, profession; ability
Seitenschiff	Side aisle	Taufe	Baptism
Sekundärfarbe	Secondary color	Taufkapelle	Baptistry
Selbstbildnis	Self-portrait	Tecknik	Technique, depth
selig	Blessed, happy	Teil	Section, piece
Separat	Separate	teilweis	Partial, fractional
Sieg	Triumph, conquest	Tempel	Temple
Siegel	Seal of	Tenebristen	Tenebrists, users of sharply contrasted light and dark tones in paintings ;
Signatur	Signature		
Silber	Silver		
Sinnbild	Emblem, symbol	Teppich	Carpet
Sinnlich	Sensual	teuer	Expensive
Sintflut	Deluge, flood	Teufel	Devil, demon
Skizze	Sketch, outline	Textilien	Textile
Skizzieren	To make a sketch	Textur	Texture
Skulptur	Sculpture	Thron	Throne
Sohn	Son	Thronender Christus	Enthroned Christ
Sommer	Summer	tiefdruck	Intaglio
sozial	Social	Tiefe	Depth
Sozialist	Socialist	Tierkreis	Zodiac
Spannung	Tension, bracing	Tinte	Ink
spät	Late	Tisch	Table
Spender	Donor	Titel	Title
Sphäre	Sphere	Tochter	Daughter
Spiel	Game, sport	Tod	Death
Sprache	Language	Ton	Clay, tone
Sprichwort	Proverb	Töpfer	Potter
Spur	Mark, trace	Töpferei, Töpferware	Pottery, ceramics
Staatliches Museum	State museum	töricht	Foolish
Stabil	Stable	tot	Dead
Stadt	City	töten	To kill
Stall	Stable	Totentanz	Dance of Death
Starb	Died	Tracht	Costume, fashion
Stein	Stone	Tränen	Tears
Steindruck	Lithography	Traum	Illusion, dream
Steingut	Stoneware	Treppe	Stairs

German	English	German	English
Trinkhorn	Drinking horn	Verzerrung	Distortion
Triptychon	Triptych	Verzierung	Ornament
Tugend	Virtue, chastity	verzückung	Ecstasy
Tür	Door	vicktorianisch	Victorian
Turm	Tower	viel	Much
Türpfosten	Door post, jamb of door	viele	Many
Türsturz	Lintel	viereckig	Square
Tuschmanier	Aquatint	Virtuos	Masterly performer
Typ	Type, standard, model	Vogelschau	Bird's-eye view
		Volk	People, nation
über	Over, on, above, upon, about	Völkerkundemuseum	Ethnological museum
überall	Everywhere	vollendet	completed
überarbeiten	To retouch	vollkommen	Entire
Überblick	Survey, general view	Volumen	Volume
Überdruck	Overprint, transfer	von	By, from, of, in, about
Übergang	Transition	vor	Before; ago
Überschreitung	Transgression	Vorbild	Model, pattern
Übersetzung	Translation	Vordergrund	Foreground
um	About, around, near	Vorgänger	Predecessor
Umfang	Size, scope	vorgeschichtlich	Prehistoric
umgeben von	Surrounded by, encircled by	Vorhall	Porch
Umgebung	Environment	Vorhanden	In print; available
Umwelt	Environment, milieu	Vorlesung	Course; lecture
unbekannt	Unknown	Vorliebe	Preference
und	And	Vorrätig	In print
undurchsichtig	Opaque	Vorraum	Narthex
unendlich	Infinite	Vorstellungskraft	Imagination
Unklarheit	Haze; murkiness	Vortragekreuz	Processional cross
unten	Beneath, at the bottom	Vorzeichnung	Preparatory drawing, sign
unter	Under		
Untergrund	Undercoat; underground	Waage	Balance
Unterschied	Difference	Wachs	Wax
Urkunde	Document	Waffe	Weapon
Urne	Urn, casket	Wahrheit	Truth
Ursprung	Origin	wahrnehmen	To perceive, to observe
		Wald	Forest
Vater	Father	Wandgemälde	Wall painting
Verallgemeinerung	Generalization	Wandteppich	Tapestry
Veraltet	Archaic	Wasser	Water
Veränderung	Change	Wasserfarbe	Watercolor
Veranlagung	Assessment, talent	Wasserspeier	Gargoyle
verbergen	To conceal	Wasserzeichen	Watermark
verdrehen	To warp	Weberei	Weaving
verehren	To admire	weder . . . noch	Neither . . . nor
Verein	Society, club, association	wegen	Because of
Vereinigung	Alliance, union, meeting	Weib	Wife, woman
vergoldet	Gilt, gilded	weich	Soft
Vergoldung	Gilding	Weid	Chase, hunt
Vergrösserung	Enlargement	Weihnacht	Christmas
Verhältnis	Proportion, relation	Weihnachtskind	Christ Child
Verkauf	Sale	Weihwasserbecken	Holy water basin
Verkäuflich	For sale	Weintraube	Grape
(Marie) Verkündigung	The Annunciation	weiss	White
Verlag	Publishers, publishing house	Weite	Width
Verlängerung	Elongation	Welt	World
Verleugnung	Denial	wenig	Little, few
Verloren	Lost	wenn	If
Vermächtnis	Legacy, bequest	Werk	Work
Vermählung	Marriage	Werkstatt	Workshop
vermutlich	Probably, likely, presumed	Wert	Value, worth
Verschiedenes	Various, miscellaneous	Wertschätzung	Appreciation, estimation
Verschlag	Partition	wesentlich	Essential
Verschlingen	Intertwined	Wichtigkeit	Importance
verschollen	Lost, missing	wichtigst	Most important
Verstehen	Understand	Widmung	Dedication
Versteigerung	Auction	wieder	Again
Versuchung	Temptation; attempt	wiederherstellen	To restore
Vertrauen	Faith	Wiege	Cradle
Verwalter	Curator, administrator	Wiesel	Weasel
Verwandtschaft	Relationship	wirken	To produce, to weave, to work
verweigern	To refuse	Wirkung	Effect
verworfen	Rejected	Wissenschaft	Knowledge
Verzeichnis	Index, list, catalogue		

German	English	German	English
Wollust	Lust	Zerstörung	Destruction
Wort	Word, term	ziehen	To draw, to pull
Wörterbuch	Dictionary	zierend	Ornamental
Wunder	Miracle	Zinn, Zinnern	Tin, Pewter
Wunderbare	Miraculous, amazing	Zinnwaren	Tinware, pewter
Würdigung	Elevation	Zisterziensermönch	Cistercian monk
		Zodiakus	Zodiac
zahlreich	Numerous	Zoll	Inch; customs
zart	Delicate	zu	To, towards, in addition to, for, in, by, towards
Zeichen	Symbol, sign		
Zeichner	Designer	zudem	Besides, in addition
Zeichnungen	Drawings	zufrieden	Content, satisfied
Zeit	Age, time	zugeschrieben	Attributed to
Zeitalter	Era, generation	zurück	Back
zeitgenössisch	Contemporary	Zurückstrahlung	Reflection
Zeitschrift	Magazine	Zusammenarbeit	Cooperation, collaboration
Zeïttafel	Chronology	Zuschreibung	Attribution
zeitweilig	Temporary, current	Zustand	Condition
Zentimeter	Centimeters	zuversichtlich	Confident
Zentrum	Center	Zuwachs	Accession
Zepter	Sceptre	Zweifel	Doubt, suspicion
zerstören	To destroy	zwischen	Between
		Zyklus	Cycle

Italian-English Dictionary

There are only twenty-one letters in the Italian alphabet; *j, k, w, x,* and *y* are only found in words of foreign origin. The plural is usually formed by changing the vowel: *o* to *i* in masculine words, *capitello* (capital) to *capitelli; a* to *e* in feminine words, *donna* (woman) to *donne; e* to *i* in both masculine and feminine words, *pittore* (painter) to *pittori*. The basic indefinite articles are *un, uno* (masculine) and *una* (feminine); the definite ones: *il* (masculine), *la* (feminine), *i* (masculine plural), and *le* (feminine plural). Subject pronouns are: *io* (I); *tu, Lei, voi* (you); *lui* (he); *lei* (she); *esso, essa* (it); *noi* (we); *voi, Loro* (you); *loro* (they). The negative is formed by placing *non* (not, no) before the verb. Adjectives are usually placed after the noun: *affresco secco* (dry fresco). An accent mark is placed on an Italian word to indicate that the stress falls on the final vowel or to differentiate between two words which are pronounced and spelled alike.

Italian	English
Accresciuto	Increased
Acquasantiera	Holy water vessel
Acquerello	Watercolor
Acquisatato	Acquired, purchased
Adorazione	Adoration
Affresco	Fresco
Agiografia	Hagiography, study of the Christian saints
Aiuto	Assistance, aide
Albero	Tree
Alla	On the, to the, at the
Allievo	Student, apprentice
Altare	Altar
Altezza	Height, depth
Alto rilievo	High relief
Altro	Except, next, other
Amanti	Lovers
Amò	Loved
Anche	Even, too, also
Anello	Link, ring
Angelo	Angel
Anno	Year
Annunciazione	Annunciation
Antichità	Antiques
Antico	Ancient
Antiquari	Art and antique dealers
Aperto	Open, opened
Apertura	Opening
Apocalisse	Apocalypse
Arabo	Arab
Arancio	Orange color
Arca	Sarcophagus, tomb, ark
Arcaico	Archaic
Arcare	Arch
Archeologico	Archeological
Architetto	Architect
Arcivescovo	Archbishop
Argenti	Silver
Arma Christi	Instruments of Christ's Passion
Arte antica	Ancient art
Arte moderna	Modern art
Artigiano	Craftsperson
Artista	Artist
Artisti di grafici	Graphic artists
Ascensione	Ascension, Christ's Ascension
Associazioni	Associations
Astratto	Abstract
Attivo	Active
Attore	Actor

Italian	English
Attrice cinematografica	Film actress
Autore	Author
Autunno	Autumn
Avorio	Ivory
Avventura	Adventure
Avvenuto	Happened, occurred
Bacio	Kiss
Bambino	Child
Barca	Boat
Barocco	Baroque
Basso rilievo	Low Relief
Battello	Boat
Battesimo	Baptism
la Beatissima Vergine	The Blessed Virgin
Beato	Blessed
Belle arti	Fine Arts
Bellissima	Beautiful
Benché	However, although
Bianco	White
Biblico	Biblical
Bibliografia	Bibliography
Biblioteca	Library
Bizantino	Byzantine
Blu	Blue
Bottega	Workshop, studio
Braccialetto	Bracelet
Braccio	Arm
Bronzo	Bronze
Calice	Chalice
Camera	Room
Campanile	Bell tower
I Campi Elisi	Elysian Fields
Campione	Trial, sample
Camposanto	Churchyard
Capitello	Capital
Capitolo	Chapter house
Cappella	Chapel
Carattere	Character, mark
Carboncino	Charcoal
Carità	Faith
Carta	Paper
Cartone	Cartoon, cardboard
Casa	House
Casa d'asta	Auctioneer house
Cassone	Large chest, similar to a hope chest
Castello	Castle
Catalogo	Catalogue
Cattedra	Chair, professorship
Cena	Supper
Cerchio	Circle
Che	Whom, who, thing, what
Chiaro	Clearness, light in color
Chiaroscuro	Graduations of lights and darks
Chiave	Key
Chiesa	Church
China	Slope, descent
Chiostro	Cloister
Chuiso	Closed
Cielo	Sky, heaven

Italian	English	Italian	English
Cimitero	Cemetery	Editore	Publisher
Cinematografico	Film, cinematographic	Editori d'arte	Art publishers
Città	Town, city	Edizione	Edition
Classico	Classical	Effemeride	Journal, diary
Classificazione	Classification	Enciclopedia	Encyclopedia
Cofanetto	Casket	Epoca	Epoch, period
Col	With the	Erba	Grass
Collezione	Collection	Eseguito	Executed, accomplished
Collezionisti	Collectors	Esempio	Model, pattern, example
Colonna	Column	Esperto	Expert
Colore	Color	Esposta	Exhibited
Combattimento	Battle	Est	East
Compianto	Lamentation	Estate	Summer
Compiuto	Completed	Estetica	Aesthetics
Con	By, with	Età	Age, epoch
Conchiglia	Shell		
Congresso	Congress, general meeting	Fabbricato	Building
Consacrato	Consecrated	Facciata	Façade, front
Conserva	Store, preserve	Ferro	Iron
Construzione	Construction	Fiasco	Flask, bottle
Conte	Count, earl	Figlio (figlia)	Son (daughter)
Conterraneo	Fellow-countryman	Finestra	Window
Contrafforte	Buttress	Finezza	Politeness, daintiness
Coperchio	Cover	Fino	Thin, fine, until
Coppa	Cup	Fiore	Flower
Corinzio	Corinthian	Firmato	Signed
Corno potorio	Drinking horn	La Flagellazione	Scouraging of Christ, The Flagellation
Coro	Choir		
Cortile	Courtyard	Fonte	Fountain, source
Cosiddetto	So-called	Fra	Between, among, brother
Credenza	Large sideboard	Frammento	Fragment
Cristiano	Christian	Fratello	Brother
Croce	Cross	Fu	Was
Crociata	Crusade	La fuga in Egitto	Flight to Egypt
Crocifisso	Crucifix		
Crocifissione	Crucifixion	Galleria	Gallery
Cubismo	Cubism	Galleria di Chiostro	Cloister walk
Cuoio	Leather	Gentiluomo	Gentleman
Cura	Care, solicitude	Genere	Kind, class, everyday subjects depicted in art
		Gesso	Plaster, chalk
Dapprima	At first	Giallo	Yellow
Datata	Dated	Giardino	Garden
Deceduto	Dead, deceased	Gioia	Jewel, joy
La Deposizione	Descent of Christ from the Cross	Gioielli	Jewelry
		Giornale	Journal, newspaper
Destinato	Destined, intended	Giornalmente	Daily
Destro	Right side	Giovane	Young man or woman
Detto	Called, proverb	Giù	Down
Dimensioni	Dimensions	Gli	The
Dipinto	Painting, picture, scene, mural painting	Grafica	Graphic art
		Grigio	Grey
Direttore	Director, editor	Grossezza	Thickness
Dirigente	Director, directing	Guida	Guide
Disegnare	To draw, to design		
Disegnatori	Engravers, designers	Ha	Has
Disegno	Drawing, design		
Distrutto	Destroyed, ruined		
Dittico	Diptych	Illustrazione	Illustrations
Dizionario	Dictionary	Imperatore	Emperor
Donato	Presented, given, donated	Impressionismo	Impressionism
Donna	Woman	Inchiostro	Ink
Doppio	Double	Incisione	Engraving
Dopo	After, afterwards	Incisore	Engraver
Dorico	Doric	Incoronazione	Coronation
Dorso	Back	Ingresso	Entrance
Duca	Duke	Intaglio	Incised or sunken design in carving or engraving
Ducale	Ducal		
Duro	Hard	Interamente	Entirely
		Internazionale	International
E	And	Intitolare	To dedicate, to name, to call
Ebano	Ebony	Intorno	About, around
Ebreo	Jew	Inverno	Winter
Edificio	Building	Ionico	Ionic

Italian	English	Italian	English
Lapis	Pencil	Ogni	Each, every
Larghezza	Width	Olio	Oil
Latta	Tin	Onice	Onyx
Lato	Side, direction	Opera	Works, opera
Lavoro	Work	Ornato	Decoration, ornamental design
Legge	Law	Oro	Gold
Legno	Wood	Oscuro	Dark, mysterious, dim
Legato	Legacy, bequest	Ottenere	To acquire, to obtain
Lettera	Letter	Ovest	West
Librerie d'arte	Art bookstores		
Libro	Book	Padre	Father
Lido	Beach	Paesaggio	Landscape
Listello	Lintel	Pagina	Page
Litografo	Lithograph	Pala d'Altare	Altarpiece
Luce	Light	Palazzo	Palace
Lumeggiamento	Emphasize, illuminate	Papa	Pope
Lunetta di portale	Tympanum	Participato	Participated
Luogo natio	Birthplace	Particolare	Private, personal
		Pasqua	Easter
Madre	Mother	Pastello	Pastel
Maniera	Manner	Pastori	Shepherds
Manierismo	Mannerism	Peccato	Sin
Manieristico	Manneristic	Peltro	Pewter
Manoscritto	Manuscript	Penitenza	Penance
Marca	Mark	Penna	Pen
Mare	Sea	Perduto	Lost
Marmo	Marble	Pergamena	Parchment
Martirio	Martyrdom	Pergamo	Pulpit
Materiale	Material	Periodico	Periodical
Matto	Insane, mad	Personaggio	Personality, character
Mattone	Tile, brick	Piano	Floor, softly
Medioevo	Middle Ages	Pianterreno	Ground floor
Menzionata	Mentioned	Piazza	Place, square
Metà	Half	Piccolo	Small, little, short
Miracolo	Miracle	Pietra	Stone
Mistico	Mystic	Pinacolo	Pinnacle
Misto	Mixture	Pinacoteca	Picture gallery
Misura	Measure	Pioniere	Pioneer
Mobili	Furniture	Pittore	Painter
Molle	Soft	Pittura	Painting
Molte	Numerous, many	Poi	After, then, later
Monaca	Nun	Polittico	Polyptych
Monastero	Monastery	Ponte	Bridge
Monografia	Monograph	Popolo	People
Monogramma	Monogram	Porcellana	Porcelain
Montaggio	Mounting, assembling, montage	Porpora	Purple
		Portale	Portal, chief doorway
Montagna, monte	Mountain	Possiede	Owns, possesses
Morte	Death	Pozzo	Water well
Morto	Dead, deceased	Predica	Sermon
Mostra	Exhibition, show	Pregio	Value, worth
Museo	Museum	Pregiottesca	Before Giotto
		Preistorico	Prehistoric
Nartece	Narthex	Preraffaelita	Pre-Raphaelite
Nascita	Birth	Presentazione	Presentation
Natale	Christmas	Presso	Near, by, in
Natività	Nativity	Prestatore	Lender
Nativo	Native	Presunta	Presumed
Nato	Born	Prezzi d'asta	Value at public auction, sales prices
Nature morte	Still life		
Navata	Nave	Primavera	Spring
Nel, nella	In the	Probabilmente	Probably
Nero	Black	Produttore	Producer, manufacturer
Nipote	Nephew, niece, grandchild	Proporzione	Scale or proportion
Nome	Name	Prova	Proof, experiment
Nord	North	Pure	Yet, however, still, also
Notevole	Important, remarkable		
Notizia	News, report, information	Quale	Who, what, which, as
Noto	Well-known	Qualità	Quality, attribute, kind, property
Nudo	Nude, naked		
		Questo	This one, this, the latter

Italian	English	Italian	English
Raccolto	Collected	Stipo	Cabinet
Ragazzo	Boy	Stoffa	Fabric
Rame	Copper	Storia	Story, history
Re	King	Storico	Historic, historical
Recente	New, recent	Strada	Street
Regista	Director	Strumenti musicali	Musical instruments
Regina	Queen	Studio	Study
Registro	List	Stupore	Astonished, amazed
Reliquiario	Reliquary	Su	Up
Renana	Rhenish	Sud	South
Restauratore	Restorer		
Resurrezione	Resurrection	Tabernacolo	Tabernacle
Riconoscere	Identify, recognized	Tappeti	Carpets
Rimane	Remains	Tappezzeria	Hangings, tapestry
Rinascenza	Renaissance	Tarsia	Inlaid woodwork
Riposo	Rest	Tartaruga	Tortoise shell
Riposo in Egitto	Rest on Flight to Egypt	Tavola	Panel, index, list, table
La Risurrezione	Resurrection of Christ	Teatrale	Theatrical
Ritratto	Portrait	Teatro	Theater
Riveduta	Revision	Tela	Canvas
Romanico	Romanesque	Tema	Theme, subject
Romanzesco	Romantic	Tema conducente	Themesong, any recurrent theme
Rosso	Red		
		Tempio	Temple
Sacra Famiglia	Holy Family	Tentatore	Temptor
Saggio	Wise	Tentazioni	Temptations
Sala	Room, hall	Tesoro	Treasure
Saliera	Salt cellar	Tessile	Textile
Sanguinare	Bleed	Testa	Head
Sansepolcro	Holy Sepulchre	Tomba	Tomb
Sarcofago	Sarcophagus	Tomo	Volume
Scala	Stairs, musical scale	Tra	Between
Scemo	Retarded	Transetto	Transept
Sceneggiatore	Scenario writer	Triforio	Triforium
Scenico	Scenic	Trittico	Triptych
Scenografo	Scene-painter	Trono	Throne
Scoprimento	Discovered		
Scorcio	Foreshortening	Ultima Cena	Last Supper
Scudo	Coat of arms	Ultima moda	Latest fashion
Scultura	Sculpture	Umido	Wet
Scuola	School	Unico	Unique, only, one
Scultore (scultrice)	Sculptor (sculptress)	Uomo	Man
Secco	Dry		
Secolo	Century	Vecchio	Old, elder
Seduto	Seated	Vedi	See
Sempre	Ever, always	Veduta	View
Sepolcro	Tomb, sepulchre	Velo	Veil
Sepoltura	Entombment	Verde	Green
Si	Yes	Vergine	Virgin
Sigillo	Seal, mark	Vescovato	Bishop's Palace
Sinistro	Left side	Vescovo	Bishop
Soggetto	Subject	Vigne	Vineyards, vines
Solo	Only, alone	Villaggio	Village
Sommario	Summary	Vino	Wine
Sono	I am, they are	Virtù	Virtue
Sopra	On	Visitazione	Visitation
Sorella	Sister	Vista	View
Sotto	Beneath, under	Vita	Life, spirit
Speranza	Hope	Vizio	Vice
Sperone	Jamb	Volta	Arch, dome, canopy, time, direction
Spessore	Thickness		
Sposalizio	Marriage	Volto	Face
Stampa	Print		
Stanza	Room		

Multilingual Glossary of French, English, German, Italian, and Spanish Terms

The following concordance, which is alphabetized according to the French terms, is divided into three sections: (1) proper names, (2) geographic locations, and (3) terms denoting time and number, (4) animals—real and imaginary, and (5) names in Greek and Roman mythology.

Proper Names

French	English	German	Italian	Spanish
Abraham	Abraham	Abraham	Abramo	Abrahán
Agnès	Agnes	Agnes	Agnese	Inés, Inez
Alexandre	Alexander	Alexander	Alessandro	Alejandro
Ambroise	Ambrose	Ambrosius	Ambrògio	Ambrosio
André	Andrew	Andreas	Andrèa	Andrés
Anne	Anne, Ann	Anna	Anna	Ana
Antoine	Anthony	Antonius	Antonio	Antonio
Augustin	Augustine	Augustinus	Agostino	Agustín
Bacchus	Bacchus	Bacchus	Bacco	Baco
Baptiste	Baptist	Täufer	Battista	Bautista
Barthélemy	Bartholomew	Bartholomäus	Bartolomèo	Bartolomé
Benoît	Benedict	Benedikt	Benedetto	Benito
Bernard	Bernard	Bernhard	Bernardino, Bernardo	Bernardo
Caïn	Cain	Kain	Caino	Caín
Catherine	Catherine	Katharina	Caterina	Catalina
Cécile	Cecilia	Cäcilia, Caecilia	Cecilia	Cecilia
César	Caesar	Cäsar	Cesare	César
Charlemagne	Charles the Great	Karl der Grosse	Carlo Magno	Carlomagno, Carlos el grande
Christophe	Christopher	Christophorus	Cristoforo	Cristóbal
Claire	Clare	Clara	Chiara	Clara
Clément	Clement	Klemens, Clemens	Clemente	Clemente
Clovis	Clovis	Chlodwig	Clodovèo	Clodoveo, Clovis
Denis	Denis	Dionysius	Diòniga	Dionisio
Denis	Dionysus, Dionysos	Dionysius	Dionísio	Dionisio
Dorothée	Dorothy	Dorothea	Dorotea	Dorotea
Edouard	Edward	Eduard	Edoardo	Eduardo
Eléanore	Eleanor	Leonore	Eleanòra	Leonor
Elisabeth	Elizabeth	Elizabeth	Elisabetta	Isabel
Esope	Aesop	Äsop	Esopo	Esopo
Etienne	Stephen	Stephan	Stéfano	Esteban
Eustache	Eustace	Eustachius	Eustachio	Eustaquio
Eve	Eve	Eva	Èva	Eva
François	Francis	Franz	Francésco	Francisco
Françoise	Frances	Franciska	Francésca	Francisca
Frédéric	Frederick	Friedrich	Federico	Federico
Gaspar	Jaspar	Kasper	Gàspare	Gaspar
Georges	George	Georg	Giorgio	Jorge
Gérard	Gerard	Gerhard	Gerardo, Gherardo	Gerardo
Gilles	Giles	Ägidius	Egìdio	Gil
Grégoire	Gregory	Gregor	Gregòrio	Gregorio
Guillaume	William	Wilhelm	Guglielmo	Guillermo
Héléne	Helen	Helena	Elena	Elena
Henri	Henry	Heinrich	Enrico	Enrique
Hercule	Hercules	Herkules	Ercole	Hércules
Isaïe	Isaiah	Isaias	Isaia	Isaías

French	English	German	Italian	Spanish
Jacques	James	Jakob	Giacomo	Iago, Diego, Jaime
Saint Jacques le Majeur	St. James, the Greater, the Elder	hl. Jakobus der Ältere, hl. Jacobus Major	San Giacomo, Il Maggiore	Santiago el Mayor
Saint Jacques le Mineur, le Juste	St. James, the Lesser	hl. Jakobus Minor	San Giacomo, Il Minore	Santiago el Menor
Jean-Baptiste	John the Baptist	Johannes der Täufer	Giovanni Battista	Juan Bautista, El Precursor
Jean l'Evangéliste	John the Evangelist	Johannes der Evangelist	Giovanni Evangelista	Juan Evangelista
Jeanne	Jean, Joan	Johanna	Giovanna	Juana
Jéhovah	Jehovah	Jehova	Geova	Jehová
Jérôme	Jerome	Hieronymus	Geròlamo	Jerónimo
Jésus-Christ	Jesus Christ	Jesus Christus	Gesù Cristo	Jesucristo
Job	Job	Hiob	Giobbe	Job
Jonas	Jonah	Jonas	Giona	Jonás
Joseph	Joseph	Joseph	Giuseppe	José
Judas	Judas	Judas	Giuda	Judas
Judith	Judith	Judith	Giuditta	Judit
Julien	Julian	Julianus	Giuliano	Julián
Laurent	Lawrence	Laurentius	Lorenzo	Lorenzo
Lazare	Lazarus	Lazarus	Làzzaro	Lázaro
Léonard	Leonard	Leonhard	Leonardo	Leonardo
Lothaire	Luther	Luther	Lutero	Lutero
Louis	Lewis, Louis	Ludwig	Luigi, Lodovico	Luis
Louise	Louise	Luise	Luisa	Luisa
Lucie	Lucy	Lucia	Lucia	Lucía
Luc	Luke	Lukas	Luca	Lucas
Marc	Mark	Markus	Marco	Marcos
Marguerite	Margaret	Margaretha	Margherita	Margarita
Marie	Mary	Maria	Marìa	María
Marie l'Egyptienne	Mary of Egypt	Maria Ägyptiaca	Marìa Egizïaca	María de Egipto
Marie Madeleine	Mary Magdalene	Maria Magdalena	Marìa Maddaléna	María Magdalena
Mars	Mars	Mars	Marte	Marte
Marthe	Martha	Martha	Marta	Marta
Martin	Martin	Martin	Martino	Martín
Matthieu	Matthew	Matthäus, Matthias	Mattèo	Mateo
Maurice	Morris	Mauritius	Maùrizio	Mauricio
Michel	Michael	Michel	Michèle	Miguel
Moïse	Moses	Moses	Mosè	Moisés
Nicolas	Nicholas	Nikolaus	Nicòla	Nicolás
Patrice	Patrick	Patrick, Patricius	Patrizio	Patricio
Paul	Paul	Paulus	Paolo	Pablo
Philippe	Philip	Philippus	Filippo	Felipe
Pierre	Peter	Petrus	Pietro	Pedro
Praxitèle	Praxiteles	Praxiteles	Prassitele	Praxiteles
Raphaël	Raphael	Raffael	Raffaello	Rafael
Raymond	Raymond	Raimund	Raimóndo	Raimundo
Renaud	Reginald	Reginald	Rainaldo	Reginaldo
Richard	Richard	Richard	Riccardo	Ricardo
Robert	Robert	Rupert	Roberto	Roberto
Rodolphe	Ralph	Rudolf	Rodolfo	Rodolfo
Roger	Roger	Rüdiger	Ruggero	Rogelio, Rogerio
Roland	Roland	Roland	Orlando	Rolando
Sébastien	Sebastian	Sebastian	Sebastiano	Sebastián
Théodore	Theodore	Theodor	Teodoro	Teodoro
Thérèse	Theresa	Theresia	Teresa	Teresa
Thierry	Theodoric	Detrich	Teodorico	Teodorico
Thomas	Thomas	Thomas, Thoma	Tommaso	Tomás
Timothée	Timothy	Timotheus	Timòteo	Timoteo
Titien	Titian	Tizian	Tiziano	Ticiano
Ursule	Ursula	Ursula	Órsola	Úrsula
Vénus	Venus	Venus	Venere	Venus
Véronique	Veronica	Veronika	Verònica	Verónica
Victor	Victor	Viktor	Vittóre	Victor
Vincent	Vincent	Vincenz	Vincenzo	Vicente
Zénobe	Zenobius	Zenobius	Zanobi	Zenobia

Geographic Locations

The italicized word is the spelling the people of the listed city or country use; if it is different from one of the following five languages, it is placed after the English spelling. For instance, the people of Czeckoslovakia call their capital Praha; the anglicized version is Prague; they spell their country Československo. Both of these Czech terms are italicized and are placed after the English version. Some bilingual countries, such as Switzerland, have more than one official spelling. Rivers are listed under their proper names, but all of the seas are placed under *Mer* and the lakes under *lac*.

The German terms usually add *er* to the stem to denote the person of the country and *isch* for the adjective; for instance, Europäer means a person who lives in Europe, and eropäisch, the adjective European. All nouns are capitalized in German; adjectives are written in lower case. The feminine form of the French noun is often formed by adding *e* or *ne*; only the masculine form is given here. In Romance languages the proper nouns are capitalized, but the adjectives deriving from these nouns are written in lower case.

French	English	German	Italian	Spanish
Afrique (africain)	Africa (African)	Afrika (Afrikaner)	Africa (africano)	África (africano)
Aix-la-Chapelle	Aachen	*Aachen*	Aquisgrana	Aquisgrán
Allemagne (allemand)	Germany (German)	*Bundesrepublik Deutschland (Deutscher)*	Germania (tedesco)	Alemania (alemán)
Alsace (alsacien)	Alsace (Alsatian)	Elsass (Elsässer)	Alsàzia (alsaziano)	Alsacia (alsaciano)
Amérique du Nord	North America	Nordamerika	Amèrica del Nord	América del Norte
Amérique du Sud	South America	Südamerika	Amèrica del Sud	América del Sur
Angleterre	*England*	England	Inghilterra	Inglaterra
Anvers	Antwerp	*Antwerpen*	Anvèrsa	Amberes
Arcadie (de l'Arcadie)	Arcadia(n) *Arkadia*	Arkadien (arkadisch)	Arcàdia (arcade, arcadico)	Arcadia (árcade, arcadico)
Asie Mineure	Asia Minor	Kleinasien	Asia Minóre	Asia Menor
Athènes	Athens *Athènai*	Athen	Atène	Atenas
Australie	*Australia*	Australien	Australia	Australia
Autriche	Austria	*Österreich*	Austria	Austria
Babylonie	Babylonia	Babylonien	Babilonese	Babilonia
Bâle	Basle	*Basel*	Basileà	Basilea
Basque	Basque	Baske	Basco	Vasco
Bavière (bavarois)	Bavaria (Bavarian)	*Bayern (Bayer)*	Baviera (bavarese)	Baviera (bávaro)
Belgique	Belgium	*Belgien*	Belgio	Bélgica
Berlin	Berlin	*Berlin*	Berlino	Berlín
Berne	Berne	*Bern*	Bèrna	Berna
Bohême (bohémien)	Bohemia(n) *Čechy*	Böhmen (böhmisch)	Boèmia (boemo)	Bohemía (bohemio, bohemo)
Bourgogne (bourguignon)	Burgundy (Burgundian)	Burgund (Burgunder)	Borgógna (borgognóne)	Borgoña (borgoñón)
Bretagne	Brittany	Bretagne	Bretagna	Bretaña
Bruges	Bruges	*Brügge*	Bruges	Brujas
Bruxelles	Brussels	*Brüssel*	Brusselle	Bruselas
Bulgarie (bulgare)	Bulgaria(n) *Bălgarija*	Bulgare (bulgarisch)	Bulgarià (bulgaro)	Bulgaria (búlgaro)
Caire	Cairo *Misr al-Qàhira*	Kario	Il Cairo	el Cairó
Calédonie	Caledonia, *Scotland*	Kaledonien, Schottland	Scozia	Caledonia, Escočia
Californie	*California*	Kalifornien	Califòrnia	California
Canada	*Canada*	Kanada	Cànada	el Canadá
Carthage	Carthage	Karthago	Cartàgine	Cartago
Castille	Castile	Kastilien	Castìglia	*Castilla*
Celtes	Celts	Kelten	Cèlti	Celtas
Chine (de Chine, chinois)	China (Chinese) *Chung-hua Jen-min Kung-ho Kuo*	China (Chinese, chinesisch)	Cina (cinese)	China (chino)
Chypre (cypriote)	Cyprus (Cypriot) *Kypros*	Zypern (Zyprer)	Cipro (cipriota)	Chipre (chipriota)
Cologne	Cologne	*Köln*	Colonia	Colonia
Copenhague	Copenhagen *Kφbenhavn*	Kopenhagen	Copenaghen	Copenhague
Copte (cophte)	Copt (Coptic)	Kopte (koptisch)	Copti (copta)	Copto (copto)
Corée	Korea *Chòsen*	Korea	Coreà	Corea
Corinthe (corinthien)	Corinth (ian) *Korinthos, Kóritho*	Korinth (korinthisch)	Corinto (corinzio, corintio)	Corinto (corintio)
Cracovie	Cracow *Kraków*	Krakau	Cracòvia	Cracovia
Croatie (croate)	Croatia(n) *Hrvatska*	Kroatien (Kroat)	Croàzia (croato)	Croacia (croata)
Cuba	Cuba	Kuba	Cuba	*Cuba*
Cyclades	Cyclades *Kiklàdhes*	Zykladen	Cicladi	Cíclades
Danemark	Denmark *Danmark*	Dänemark	Danimarca	Dinamarca
Le Danube	Danube River	*Donau*	Danùbio	Danubio
Ecosse (écossais)	*Scotland* (Scot)	Schottland (Schotte)	Scozia (scozzese, scoto)	Escocia (escocés)
Egypte	Egypt *Misr, Masr*	Ägypten	Egitto	Egipto

309

French	English	German	Italian	Spanish
Espagne	Spain	Spanien	Spagna	*España*
Etats-Unis	*United States*	Vereinigte Staaten	Stati Uniti	Estados Unidos
Ethiopie	Ethiopa *Ityopya*	Äthiopien	Ethiòpia	Etiopía
L'Etna	Etna	Ätna	*Ètna*	Ètna
Etrurie (étrusque)	Etruria (Etruscan)	Etrurien (etruskisch)	*Etruschi* (etrusco)	Etruria (etrusco)
L'Euphrate	Euphrates River *Firāt, al-Furāt*	Euphrat	Eufrate	Eufrates
Europe (européen)	Europe (European)	Europa (Europäer, europäisch)	Europa (europeo)	Europa (europeo)
Extrême-Orient	Far East	Ostasien, Ferne Osten	Asia orientale	Extremo Oriente
Flandre (flamand)	Flanders (Flemish) *Vlaanderen*	Flandern (flämisch)	Le Fiandre (fiamminga)	Flandes (flamenco)
Florence	Florence	Florenz	*Firenze*	Florencia
Fôret-Noire	Black Forest	*Schwarzwald*	Selva Néra	Selva Negra
France (français)	France (French)	Frankreich (französisch)	Frància (francese)	Francia (francés)
Galilée	Galilee	Galiläa	Galilèa	Galilea
Gand	Ghent	*Gent*	Gand	Gante
Gascogne	Gascony	Gaskogne	Guascògna	Gascuña
Gaule	Gaul	Gallien	Gallia	Galia
Gênes	Genoa	Genua	*Genova*	Génova
Genève	Geneva	*Genf*	Ginevra	Ginebra
Golfe Persique	Persian Gulf	Persischer Golf	Golfo Persico	Golfo Pérsico
Goth	Goth	Gote	Goto	Godo
La Grande-Bretagne	*Great Britain*	Grossbritannien	La Gran Bretagna	Gran Bretaña
Grèce (de la Grèce, grecque)	Greece (Greek) *Hellas, Ellādha*	Griechenland (griechisch)	Grècia (greca)	Grecia (griego)
Hambourg	Hamburg	*Hamburg*	Amburgo	Hamburgo
La Haye	The Hague *Den Haag*	Der Haag	L'Aia	La Haya
Hollande	Holland	Holland	Olanda	Holanda
Hongrie	Hungary *Magyar Népköztársaság*	Ungarn	Ungheria	Hungría
Ibérien	Iberian	Iberer	Iberico	Ibero, Ibérico
Indochine	Indo-China	Hinterindien	Indocina	Indochina
Ionie (ionien)	Ionia (Ionian) *Iōnia*	Ionien (ionisch)	Iònia (iònico)	Jonia (jónico, jonio)
Irlande (irlandais)	Ireland (Irish) *Eire*	Irland (irisch)	Irlanda (irlandese)	Irlanda (irlandés)
Italie	Italy	Italien	*Itàlia*	Italia
Japon	Japan *Nippon*	Japan	Giappóne	el Japón
Jérusalem	Jerusalem *Al-Quds, Yerūshālayim*	Jerusalem	Gerusalèmme	Jerusalén
La Judée	Judea *Al-Yahūdiyya*	Judäa	Giudèa	Judea
Le lac de Luzerne	Lake Lucerne	Luzerner See, *Vierwald- stätter See*	Lago di Lucerna, Lago dei Quattro Cantoni	Lago de los cuatro cantones
Le lac Léman	Lake Geneva	*Genfer See*	Lago Lemano	Lago Ginebra
Latin	Latin (person)	Lateiner	Latino	Latino
Lituanie	Lithuania *Lietuva*	Litauen	Lituania	Lituania
Lombardie	Lombardy	Lombardei	*Lombardìa*	Lombardía
Londres	*London*	London	Lóndra	Londres
Lorraine	Lorraine	Lothringen	Lorèna	Lorena
Luzerne	Lucerne	*Luzern*	Lucèrna	Lucerna
Le Maroc	Morocco *Al-Maghrib al-Aqsā*	Marokko	Maròcco	Marruecos
La Méditerranée	Mediterranean Sea	Mittelländisches Meer, Mittelmeer	Il mare Mediterraneo	Mar Mediterráneo
La Mer Adriatique	Adriatic Sea	Adria, Adriatische Meer	Adriatico	Mar Adriático
La Mer des Antilles	Caribbean Sea	Karaibishe Meer	Mare dei Caraibi	Mar Caribe
La Mer Baltique	Baltic Sea	Ostsee	Mare Bàltico	Mar Báltico
La Mer Caspienne	Caspian Sea	Kaspisee, Kaspisches Meer	Mare Càspio	Mar Caspio
La Mer Egée	Aegean Sea	Ägaische Meer	Mare Egèo	Mar Egeo
La Mer Morte	Dead Sea	Totes Meer	Mar Morto	Mar Muerto
La Mer du Nord	North Sea	Nordsee	Mare del Nord	Mar del Norte
La Mer Rouge	Red Sea	Rotes Meer	Mare Rosso	Mar Rojo
Meuse	Meuse River	*Maas*	Fiume Mosa	Río Mosa
Mexique	Mexico	Mexiko	Mèssico	*Méjico, México*
Milan (milanais)	Milan (Milanese)	Mailand (mailändisch)	*Milano* (milanese)	Milán (milanés)
Montagnes Rocheuses	*Rocky Mountains*	Felsengebirge	Montagne Rocciose	Montañas Rocosas

French	English	German	Italian	Spanish
Moravie	Moravia *Morava*	Mähren	Moràvia	Moravia
Moscou	Moscow *Moskva*	Moskau	Mósca	Moscú
Munich	Munich	*München*	Monaco	Munich
Mycènes	Mycenae *Mykênai*	Mykenä, Mykene	Micene	Micenas
Naples	Naples	Neapel	*Napoli*	Nápoles
Les Nations Unies	United Nations	Vereinte Nationen	Nazioni Unite	Naciones Unidas
Nice	Nice	Nizza	Nizza	Niza
Le Nil	Nile River *An-Nīl*	Nil	Nilo	Nilo
Normandie	Normandy	Normandie	Normandia	Normandía
Norvège	Norway *Norge*	Norwegen	Norvègia	Noruega
Nouvelle-Zélande	*New Zealand*	Neuseeland	Nuova Zelanda	Nueva Zelondïa
Nuremberg	Nuremberg	*Nürnberg*	Norimberga	Nuremberg
L'Océan Pacifique	Pacific Ocean	Grosser Ozean, Stiller Ozean	Il Pacifico	Océano Pacifico
Palatinat	Palatinate	*Pfalz*	Palatinato	Palatinado
Palestine	*Palestine*	Palästina	Palestina	Palestina
Paris (parisien)	Paris (Parisian)	Paris (Pariser)	Parigi (di Parigi, parigino)	París (parisiense)
Les Pays-Bas	Low Countries (Holland, Belgium, Luxembourg)	Benelux	Benelùx	Países Bajos
Pays de Galles	*Wales*	Wales	Galles	Gales, País de Gales
Perse (de Perse, persan)	Persia (Persian) *Iran*	Persien (Perser, persisch)	Pèrsia (persiano)	Persia (persa)
péruvien, de Pérou	Peruvian	Peruaner	peruviano	*peruano*
phénicien	Phoenician	Phöniker	fenicio	fenicio, fenicia
Pologne	Poland *Polska*	Polen	Polònia	Polonia
Polynésie	Polynesia	Polynesien	Polinesia	Polinesia
Portugal	*Portugal*	Portugal	Portogallo	Portugal
Prague	Prague *Praha*	Prag	Praga	Praga
Proche-Orient	Near East	Nahe Osten	Il Levante	Próximo Oriente
Prusse	Prussia	*Preussen*	Prùssia	Prusia
Pyrénées	Pyrenees	Pyrenäen	Pirenei	Pirineos
Reims	Rheims	Reims	Reims	Reims
Rhin	Rhine	Rhein	Reno	Rin
Rhénanie	Rhineland	*Rheinland*	Renania	Renania
romain	Roman	römisch	romano	romano
Rome	Rome	Rom	*Roma*	Roma
Royaume-Uni	*United Kingdom*	Grossebritannien und Nordirland	Regno-Unito	Reino Unido
Russie	Russia	Russland	Rùssia	Rusia
Saltzbourg	Salzburg	*Salzburg*	Salisburgo	Salzburgo
Saxe	Saxony	*Sachsen*	Sassonia	Sajonia
Scandinavie	Scandinavia	Skandinavien	Scandinavia	Escandinavia
Sienne	Siena	Siena	*Siena*	Siena
Slave	Slav	Slawe	Slavo	Eslavo
Suède	Sweden *Sverige*	Schweden	Svèzia	Suecia
Suisse	Switzerland	*Schweiz*	Svìzzera	Suiza
La Tamise	*Thames River*	Themse	Tamigi	Támesis
Terre-Neuve	*Newfoundland*	Neufundland	Terranova	Terranova
Thèbes	Thebes	Theben	Tebe	Tebas
Thrace	Thrace *Thrakê*	Thrazien	Tracia	Tracia
Turin	Turin	Turin	*Torino*	Turín
Toscane	Tuscany	Toskaner	*Toscana*	Toscana
Tchécoslovaquie	Czechoslovakia *Československo*	Tschechoslowakei	Cecoslovacchia	Checoslovaquia
Turquie	Turkey *Tükiye Cumhuriyeti*	Türkei	Turchia	Turquía
Tyrol	Tyrol	*Tirol*	Tirolo	El Tirol
Varsovie	Warsaw *Warszawa*	Warschau	Varsavia	Varsovia
Le Vatican	Vatican	Vatikan	Vaticano	*Vaticano*
Venise (vénitien)	Venice (Venetian)	Venedig (venedisch)	*Venezia* (veneziano)	Venecia (veneciano)
Vienne	Vienna	*Wien*	Vienna	Viena
La Vistule	Vistula River	Weichsel	Vistola	Vístula
Zurich	Zurich	*Zürich*	Zurigo	Zurich

Terms Denoting Time

French	English	German	Italian	Spanish
Avant Jesus-Christ, (Avant J-C)	Before Christ, (B.C.)	vor Christi (v.C.)	avanti Christo (a.C.)	Antes de Jesucristo, Antes de Cristo, (A.C.)
Après Jesus-Christ (Après J-C)	Anno Domini, (A.D.)	nach Christi (n.C.)	L'anno di Grazia	Después de Cristo, (D.C.)
siècle	century	Jahrhundert	sècolo	siglo
an, année	year	Jahr	anno	año
mois	month	Monat	mese	mes
semaine	week	Woche	settimana	semana
jour	day	Tag	giorno	día
heure	hour	Stunde	ora	hora
temps	time	Zeit	tempo	tiempo, hora
matin	morning	Morgen	mattina	mañana
après-midi	afternoon	Nachmittag	dopopranzo	tarde
soir	night	Nacht	notte	noche
janvier	January	Januar	gennaio	enero
février	February	Februar	febbraio	febrero
mars	March	März	marzo	marzo
avril	April	April	aprile	abril
mai	May	Mai	maggio	mayo
juin	June	Juni	giugno	junio
juillet	July	Juli	luglio	julio
août	August	August	agosto	agosto
septembre	September	September	settembre	septiembre
octobre	October	Oktober	ottobre	octubre
novembre	November	November	novembre	noviembre
décembre	December	Dezember	dicembre	diciembre
lundi	Monday	Montag	lunedì	lunes
mardi	Tuesday	Dienstag	martedì	martes
mercredi	Wednesday	Mittwoch	mercoledì	miércoles
jeudi	Thursday	Donnerstag	giovedì	jueves
vendredi	Friday	Freitag	venerdì	viernes
samedi	Saturday	Samstag, Sonnabend	sabato	sábado
dimanche	Sunday	Sonntag	domenica	domingo

Numbers

French	English	German	Italian	Spanish
premier, première	first	erst-	primo primario	primero
deuxième	second	zweit-	secondo	segundo
troisième	third	dritt-	terzo	tercero
quatrième	fourth	viert-	quarto	cuarto
cinquième	fifth	fünft-	quinto	quinto
un, une	one	eins	uno, una	uno, una
deux	two	zwei	due	dos
trois	three	drei	tre	tres
quatre	four	vier	quattro	cuatro
cinq	five	fünf	cinque	cinco
six	six	sechs	sei	seis
sept	seven	sieben	sette	siete
huit	eight	acht	otto	ocho
neuf	nine	neun	nove	nueve
dix	ten	zehn	dieci	diez
onze	eleven	elf	undici	once
douze	twelve	zwölf	dodici	doce
treize	thirteen	dreizehn	tredici	trece
quatorze	fourteen	vierzehn	quattordici	catorce
quinze	fifteen	fünfzehn	quindici	quince
seize	sixteen	sechzehn	sedici	dieciséis
dix-sept	seventeen	siebzehn	diciassètte	diecisiete
dix-huit	eighteen	achtzehn	diciotto	dieciocho
dix-neuf	nineteen	neunzehn	diciannove	diecinueve
vingt	twenty	zwanzig	venti	veinte
vingt-cinq	twenty-five	fünfundzwanzig	venticinque	veinticinco
trente	thirty	dreissig	trènta	treinta
quarante	forty	vierzig	quaranta	cuarenta
cinquante	fifty	fünfzig	cinquanta	cincuenta
soixante	sixty	sechzig	sessanta	sesenta
soixante-dix	seventy	siebzig	settanta	setenta
quatre-vingts	eighty	achtzig	ottanta	ochenta
quatre-vingt-dix	ninety	neunzig	novanta	noventa
cent	one hundred	hundert	cento	cien, ciento
mil, mille	thousand	tausend	mille	mil

Animals: Real and Imaginary

French	English	German	Italian	Spanish
abeille	bee	Biene	ape	abeja
agneau	lamb	Lamm	agnello	cordero
aigle	eagle	Adler, Aar	aquila	áquila
âne	ass, donkey	Esel	asino	asno, burro
animal	animal	Tier	animale	animal
araignée	spider	Spinne	ragno	entom
aspic	asp	Aspis	aspide	aspid
autruche, autrice	ostrich	Strauss	struzzo	avestruz
baleine	whale	Wal	balena	ballena
basilic	basilisk	Basilisk	basilisco	basilisco
belette, mostelle	weasel	Wiesel	donnola	comadreja
bélier	ram, male sheep	Widder	montone	morueco
boeuf	ox, beef	Ochse	bue	buey
caille	quail	Wachtel	quaglia	codorniz
canard	duck	Ente	anitra	anade
caster	beaver	Biber	castoro	castor
cerf	deer, stag, hart	Hirsch	cervo	ciervo
chameau	camel	Kamel	cammello	camello
chardonneret	goldfinch	Stieglitz	cardellino	jilguero
chat	cat	Katze	galto	gato
chauve-souris	bat	Fledermaus	pipistrello	murciélago
cheval	horse	Pferd	cavallo	caballo
chèvre	goat	Ziege	capra	cabra
chien	dog	Hund	cane	perro
chimère	chimera	Chimäre	chimera	quimera
cigogne	stork	Storch	cicogna	cigueña
cochon	pig	Schwein	porco	cochino
colombe	dove	Taube	colomba	palomba
coq	cock	Hahn	gallo	gallo
corbeau	raven	Rabe	corvo	cuervo
corneille	crow	Krähe	corvo	ornit
crapaud	toad	Kröte	botta	sapo
crocodile	crocodile	Krokodil	coccodrillo	cocodrilo
cygne	swan	Schwan	cigno	cisne
dauphin	dolphin	Delphin	delfino	deflin
dragon	dragon	Drache	drago, dragone	dragón
écureuil	squirrel	Eichhörnchen	scoiattolo	ardilla
éléphant	elephant	Elefant	elefante	elefante
faucon	hawk, falcon	Falke	falco, falcone	halcón
fourmi	ant	Ameise	formica	hormiga
grenouille	frog	Frosch	rana	rana
griffon	griffin	Greif	grifo	grifo
grue	crane	Kranich	gru	ornit
hérisson	hedgehog	Igel	riccio	erizo
hermine	ermine	Hermelin	ermellino	armiño
héron	heron	Reiher	airone	garza
hibou	owl	Eule	gufo	lechuza
hirondelle	swallow	Schwalbe	rondine	golondrina
hyène	hyena	Hyäne	iena	hiena
homard	lobster	Hummer	aragosta	langosta
lapin	rabbit	Kaninchen	coniglio	conejo
lézard	lizard	Eidechse	lucertola	lagarto
licorne	unicorn	Einhorn	unicorno	unicornio
lièvre	hare	Hase	lepre	liebre
lion	lion	Löwe	leone	léon
loup	wolf	Wolf	lupo	lobo
merle	blackbird	Amsel	merlo	mirlo
mouton	sheep	Schaf	pecora	carnero
oie	goose	Gans	oca	ganso
oiseau	bird	Vogel	ucello	ave
oiseau	fowl	Haushuhn	pollo	ave
ours	bear	Bär	orso	oso
paon	peacock	Pfau	pavone	pavón
papillon	butterfly	Schmetterling	farfalla	mariposa
passereau	sparrow	Sperling	passero	gorrión
pelican	pelican	Pelikan	Pellicano	pelicano
perdrix	partridge	Rebhuhn	pernice	perdiz
perroquet	parrot	Papagei	pappagallo	papagayo
phénix	phoenix	Phönix	fenice	fénix
pigeon	dove, pigeon	Taube	piccione	pichón
poisson	fish	Fisch	pesce	pescado

French	English	German	Italian	Spanish
poule	hen	Henne	gallina	gallina
renard	fox	Fuchs	volpe	zorra
rossignol	nightengale	Nachtigall	usignuolo	ruiseñor
sanglier	wild boar	Wildschwein	cinghiale	jabali
sauterelle	grasshopper	Heuschrecke	cavalletta	langosta
scie de mer	sawfish	Sägefisch	pesce sega	pescado sierra
serpent	snake	Schlange	serpente	serpiente
singe	ape, monkey	Affe	scimmia	mono
sirène	siren	Sirene	sirena	sirena
souris	mouse	Maus	topo	ratón
taupe	mole	Maulwurf	talpa	topo
taureau	bull	Bulle, Stier	toro	toro
tortue	tortoise	Schildkröte	testuggine, tartaruga	tortuga
tortue de mer	turtle	Schildkröte	tartaruga, testuggine	tortuga
tourterelle	turtledove	Turteltaube	tortora	tórtola
vautour	vulture	Geier	avvoltoio	buitre
veau	calf	Kalb	vitello	becerro
verrat	boar, male swine	Eber	verro	verraco

Names in Greek and Roman Mythology

For slightly different spellings of Bacchus, Dionysus, Hercules, and Venus, see listings under "Proper Names."

Greek	Roman
Aphrodite	Venus, Cythera
Ares	Mars
Artemis	Diana, Cynthia
Athena, Athene, Pallas Athena	Minerva
Demeter	Ceres
Dionysus	Bacchus, Dionysos
Eos	Aurora
Eros	Cupid, Amor
Hades	Pluto
Hephaestus	Vulcan
Hera	Juno
Heracles	Herakles, Hercules, Alcides
Hermes	Mercury
Odysseus	Ulysses
Poseidon	Neptune
Zeus	Jupiter, Jove

Index to Publications and Institutions

Page numbers are provided for the annotated entry and any lengthy discussion of the work. Abbreviated titles are provided for some of the works. Publications of museums are not indexed separately but are placed under the name of the institution. Page numbers for the examples used in the text are placed in parentheses. Mc is filed as Mac; umlauted vowels are filed as if there were no umlauts.

318

Index of Subjects, Terms, and Professions

Because of the quantity of material for people in specific disciplines of art, an index that pinpoints the sections of the guide most pertinent to various professions has been included. If a section of this book is concerned with a research method or a particular kind of reference, all of the pages of that part of the guide are cited regardless of whether or not the particular method or kind of reference is actually found on each page. Page numbers for the examples used in the text are placed in parentheses.